PAINTING AND ILLUMINATION
IN EARLY RENAISSANCE FLORENCE
1300-1450

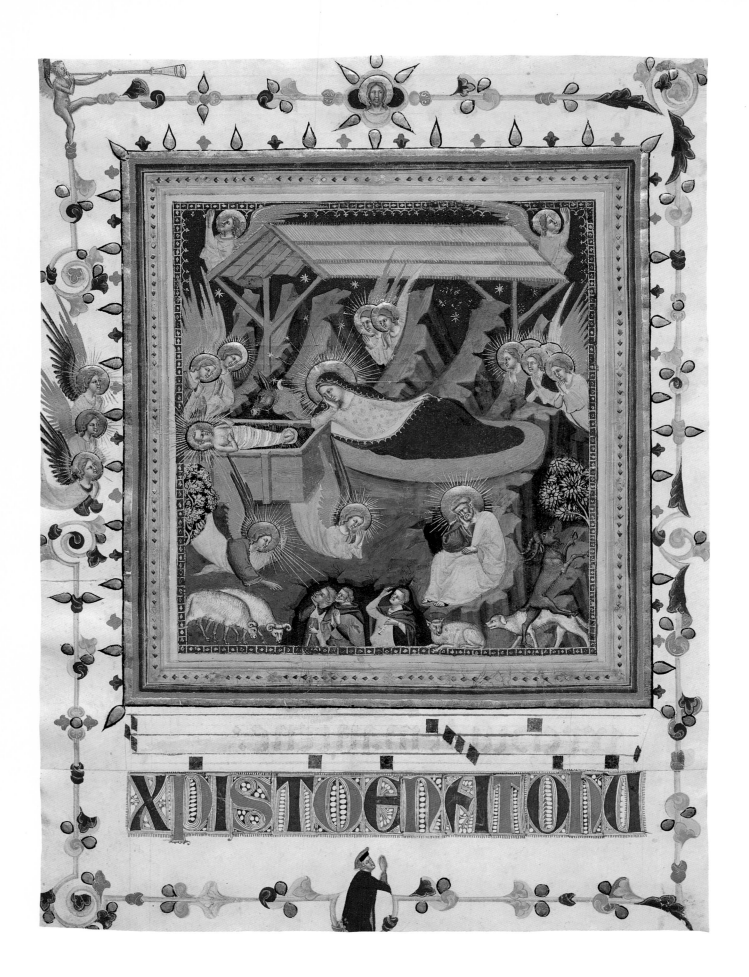

PAINTING AND ILLUMINATION IN EARLY RENAISSANCE FLORENCE 1300-1450

Laurence B. Kanter · Barbara Drake Boehm · Carl Brandon Strehlke
Gaudenz Freuler · Christa C. Mayer Thurman · Pia Palladino

THE METROPOLITAN MUSEUM OF ART, NEW YORK

Distributed by Harry N. Abrams, New York

This publication is issued in conjunction with the exhibition "Painting and Illumination in Early Renaissance Florence, 1300–1450," held at The Metropolitan Museum of Art, New York, from November 17, 1994, to February 26, 1995.

The exhibition was organized by The Metropolitan Museum of Art, New York.

The exhibition is made possible in part by the Robert Lehman Foundation and the William Randolph Hearst Foundation.

Published by The Metropolitan Museum of Art, New York

John P. O'Neill, Editor in Chief
Ann Lucke, Editor
Bruce Campbell, Designer
Jay Reingold, Production Associate

Objects in The Metropolitan Museum of Art's collection were photographed by Katherine Dahab, Bruce Schwarz, and Eileen Travell of The Photograph Studio, The Metropolitan Museum of Art. For a complete list of photograph credits, see p. 394.

Set in Galliard by The Sarabande Press, typographers, New York
Separations by Professional Graphics, Rockford, Illinois
Printed and bound in Belgium in cooperation with Ludion Press, Ghent

Library of Congress Cataloging-in-Publication Data

Painting and illumination in early Renaissance Florence, 1300–1450 / Laurence B. Kanter . . . [et al.].

 p. cm.

 Catalogue of an exhibition held at the Metropolitan Museum of Art in New York.

 Includes bibliographical references and index.

 ISBN 0-87099-725-4.—ISBN 0-8109-6488-0 (Abrams).—ISBN 0-87099-726-2 (pbk.)

 1. Illumination of books and manuscripts, Italian—Italy—Florence—Exhibitions. 2. Illumination of books and manuscripts, Renaissance—Italy—Florence—Exhibitions. I. Kanter, Laurence B. II. Metropolitan Museum of Art (New York, N.Y.)

ND3161.F7P35 1994

745.6′7′0945510747471—dc20

94–29418
CIP

Frontispiece: Master of the Dominican Effigies, The Nativity and the Annunciation to the Shepherds (cat. no. 4c)

Cover/jacket: Fra Angelico, *The Archangel Gabriel Annunciate* (cat. no. 51, detail)

Contents

Director's Foreword

While admiring the celebrated monuments of Renaissance culture that fill the city of Florence—sculpture in marble and bronze; the great churches, civic buildings, and palaces; paintings on panel and in fresco—we are unaccustomed to thinking about works of art in more delicate and perishable media, such as drawings, embroidery, paintings on glass, and, above all, manuscript illuminations. Few of us have been privileged to see more than a handful of these remarkable and frequently exquisite images, which are seldom displayed publicly and, unjustly, figure only peripherally, if at all, in general histories of Italian Renaissance art. Yet some of the most important Florentine masters were as skilled in painting small scenes within initial letters on parchment as sweeping cycles of frescoes on great expanses of walls or vaulted ceilings, and many of their finest creations are preserved between the leathern bindings of liturgical and secular books.

"Painting and Illumination in Early Renaissance Florence, 1300–1450," surveys the accomplishments, in various media, of five generations of manuscript painters in Florence, from the contemporaries of Giotto at the beginning of the fourteenth century to Fra Angelico and his followers in the middle of the fifteenth. Until now, a number of the works of art included have been virtually unknown even to specialists; others are here fully identified for the first time. Many are fragments of larger complexes that have been reassembled on this occasion for the first (and possibly the last) time since they were cut apart and dispersed in the nineteenth century. Among these are the unforgettable panels from an early predella by Fra Angelico (cat. no. 47), single leaves from choir books by Don Silvestro (cat. nos. 16, 17) and Lorenzo Monaco (cat. nos. 29, 30, 36, 38), and folios from the exceptional laudario (cat. no. 4) painted about 1340 by Pacino di Bonaguida and the Master of the Dominican Effigies. Together they present an unconventional but compelling portrait of the emergence of a Renaissance style in Florence, one of the most significant events in the history of Western painting.

Our debt of gratitude to the many institutions and private collectors around the world who have been willing to lend these fragile and consummately beautiful works of art is enormous and can only be inadequately expressed. Nonetheless, it is important to acknowledge specifically the truly exceptional generosity of Mr. Bernard H. Breslauer and of our colleagues at the Pierpont Morgan Library, the British Library, and the Biblioteca Apostolica Vaticana; loans from those institutions' rich collections, together with the holdings of The Metropolitan Museum of Art, form the nucleus of and the incentive for the present exhibition and its catalogue. We must also express our profound thanks to the directors of the Robert Lehman Foundation for their financial support, their encouragement, and their abiding commitment to scholarship at The Metropolitan Museum of Art. It is with equal gratitude that we extend our appreciation to the William Randolph Hearst Foundation for its support of this project.

Philippe de Montebello
Director
The Metropolitan Museum of Art

Acknowledgments

"Painting and Illumination in Early Renaissance Florence, 1300–1450" was conceived as an exhibition five years ago. It seemed to us then an opportunity to highlight one of the lesser-known strengths of the Metropolitan Museum's collections, as had been done so successfully in 1988 with the exhibition "Painting in Renaissance Siena," and at the same time to combine two very different historical disciplines—the connoisseurship of Italian painting and the arts of the book as well as liturgical codicology. We were aided almost from the start by the material assistance of three exceptionally able collaborators, who were willing to set aside their own professional obligations to contribute important sections of this catalogue and without whose help the project could never have been brought to a timely completion: Carl Brandon Strehlke, curator of the John G. Johnson Collection at the Philadelphia Museum of Art; Gaudenz Freuler, professor at the University of Zurich; and Christa C. Mayer Thurman, the Christa C. Mayer Thurman Curator of Textiles at The Art Institute of Chicago. Pia Palladino, research associate in the Robert Lehman Collection at The Metropolitan Museum of Art, had a hand in composing, reshaping, expanding, or refining nearly every paragraph in the book, and to her we owe our greatest debt of all.

The number of people who have been instrumental in securing loans or facilitating our research for this exhibition is almost too great to mention. With apologies for any inadvertent omissions, the authors wish to acknowledge Cristina Acidini Luchinat, Giovanni Agosti, Daniel Alcouffe, Dr. Heinz-Th. Schulze Altcappenberg, Pierre Arizzoli-Clémentel, François Avril, Robert G. Babcock, Janet M. Backhouse, Cyrilla Barr, Louise Basbas, Robert P. Bergman, George Bisacca, Dr. Ernst and Sonya Boehlen, Jack P. Brown and the staff of the Ryerson and Burnham Libraries, Moreno Bucci, Elizabeth Burin, Giovanni Cabras, Anselmo Carini, Marco Ciatti, Dominique Cordellier, Principe Filippo Corsini, Principessa Giorgiana Corsini, Piero Corsini, Giovanna Damiani, Alan Darr, Cara Dufour Denison, Inge Dupont, Elizabeth W. Easton, Helen Evans, Father John Fanning, Richard L. Feigen, Larry Feinberg, Manuela Fidalgo, Richard Field, Lorna Ann Fillippini, Nancy K. Finn, Chris Fischer, Stephen Fliegel, Giovanna Gaeta Bertelà, Heileg Geer, Laura Giles, Hiliard Goldfarb, Ruth Grönwoldt, Nicholas Hall, Christopher de Hamel, Anne Hawley, Tom Henry, Sandra Hindman, Holly Hotchner, William Hutton, Lauren Jackson-Beck, the Reverend Francis C. Jenks, Monique and Donald King, Thomas Kren, Guy Ladrière, Margaret Lawson, Robert Owen Lehman, Anna Lenzuni, Santina M. Levey, Mirella Levi D'Ancona, Teresa Lignelli, Yva Lisikewicz, Ruggero Longari, John Marincola, Nina Maruca, Massimo Medica, Lucia Meoni, Stanley Moss, Larry Nichols, Ria O'Fougludha, Lynne Federle Orr, Helen Otis, Jane Blaffer Owen, Beatrice Paolozzi Strozzi, Antonio Paolucci, Edmund Pillsbury, Doralynn Pines and the staff of the Thomas J. Watson Library, Ann Plogsterth, Lillian Randall, Frances Rankine, Martha Repman, Joseph Rishel, Elaine Rosenberg, Eliot Rowlands, Francis Russell, Paul Saenger, Piero Scapecchi, Marie Schoefer, Eva-Maria Schuchardt, David Scrase, Magnolia Scudieri, Mary B. Shepard, Hubert von Sonnenberg, the staff of the Frick Art Reference Library, Elisabeth Taburet-Delahaye, Mahrukh Tarapor, Françoise Viatte, Tom Vinton, Ian Wardropper, Anne

E. Wardwell, Ann Wassmann, Carolyn Wilson, Martha Wolff, Linda Woolley, Dr. Paul Woudhuysen, John D. Wright, Mickey Wright, Mary Wyly, and Rainer Y.

Embarking on a project of wide scope with the intention of creating, in a given period of time, an exhibition and catalogue of reasonable compass is a frustrating task. Whatever success we have enjoyed is due to the constant advice, support, encouragement, and expertise we have received from many of our colleagues, among whom special mention must be made of Jonathan J. G. Alexander, Joseph Baillio, George Bent, Miklós Boskovits, Prefetto Dottore Leonard Boyle, Bernard H. Breslauer, Angela Dillon Bussi, Keith Christiansen, Everett Fahy, Domenico Firmani, John Pope-Hennessy, Maria Safiotti, William Voelkle, Roger Wieck, and William D. Wixom. That the catalogue in its present form is readable and beautiful is a testimony to the skills of our editor, Ann Lucke, and our designer, Bruce Campbell; to attention to detail by Jay Reingold; and to the committed support of John P. O'Neill, our editor in chief, and of our director, Philippe de Montebello. We would also like to express our gratitude to David Harvey, who designed the exhibition, Sophia Geronimus, the graphics designer, and Zack Zanolli, lighting designer.

A special and final note of thanks extends to the directors of the Robert Lehman Foundation, whose financial support and personal enthusiasm for this project guaranteed its survival from drawing board to vernissage. No fewer than thirteen works of art included in this exhibition were at one time part of Robert Lehman's personal collection, and it is to his taste as a collector, as well as to future generations of collectors who may be inspired by him, that this catalogue is dedicated.

Laurence B. Kanter
Curator, Robert Lehman Collection

Barbara Drake Boehm
Associate Curator, Department of Medieval Art

Lenders to the Exhibition

Catalogue numbers appear in parentheses following an institution's name.

DENMARK
Copenhagen, The Royal Museum of Fine Arts
(36a, d, f)

ENGLAND
Cambridge, Fitzwilliam Museum (4e, j; 16b, j)
London, British Library (4d, g; 16c, d, g; 20b)
———, Victoria and Albert Museum (11; 17a, b)

FRANCE
Paris, Bibliothèque Nationale (44)
———, Musée du Louvre (4b, 27, 29a, 35)

GERMANY
Berlin, Staatliche Museen zu Berlin—Preussischer
Kulturbesitz (29b, c; 30a)

ITALY
Florence, Museo di San Marco (47b, 48)

SWITZERLAND
Bern, Dr. Ernst and Sonya Boehlen (20a)
Geneva, Bibliothèque Publique et Universitaire
(16a)

UNITED STATES
Baltimore, Walters Art Gallery (16e, 18, 53)
Boston, Isabella Stewart Gardner Museum (50)
Chicago, The Art Institute of Chicago (14, 28)
———, Newberry Library (24)

Cleveland, The Cleveland Museum of Art
(16f, i; 38b)
Detroit, The Detroit Institute of Arts (51)
Fort Worth, Kimbell Art Museum (47a)
New Haven, Yale University Library, The
Beinecke Rare Book and Manuscript Library
(13, 23)
New York, Bernard H. Breslauer (4h, 21, 26a, 37, 45)
———, The Brooklyn Museum (25, 41)
———, Richard L. Feigen (32b, 34b)
———, The Metropolitan Museum of Art (2, 5,
9, 10, 12, 15, 16h, 19, 22, 26b, 31b, 32a, 33, 34a, 40,
46, 49, 52)
———, The Pierpont Morgan Library (3, 4i, 8,
17c–g)
———, Mrs. Alexandre Rosenberg (54)
Philadelphia, Philadelphia Museum of Art (47c, 55)
San Francisco, The Fine Arts Museums of San
Francisco (47d)
Washington, D.C., National Gallery of Art (4a, c;
30b; 38a)

VATICAN CITY
Biblioteca Apostolica Vaticana (7; 29d; 36b, c, e)

PRIVATE COLLECTIONS
(1; 4f, k; 6; 31a; 39; 42)

Note to the Reader

Dimensions are given in inches and centimeters; height precedes width.

Abbreviated references used in the text, notes, and literature citations are listed in full in the bibliography.

English translations of extracts from Giorgio Vasari, *Le vite de' più eccellenti pittori, scultori, ed architettori*, are taken from Vasari 1912–14.

Citations from the Bible are taken from the Douay Version.

INTRODUCTION

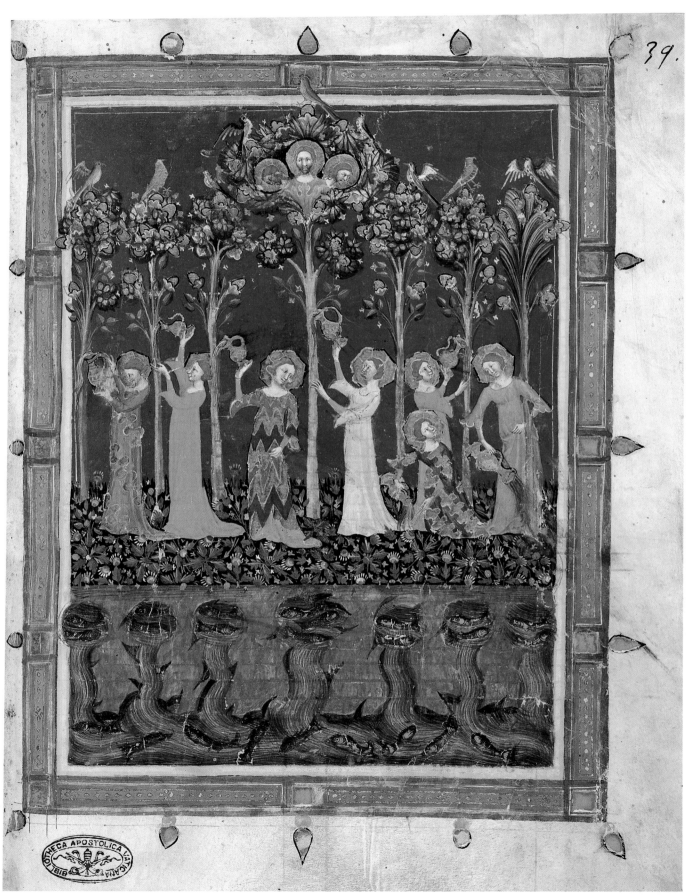

Figure 1. The Master of the Dominican Effigies, The Garden of the Virtues. Biblioteca Apostolica Vaticana, Vatican City (Barb. Lat. 3984, fol. 39r)

LAURENCE B. KANTER

The Illuminators of Early Renaissance Florence

One by-product of the invention of movable type in the middle of the fifteenth century has been a certain loss of appreciation for the rarity, importance, and value of books in the late Middle Ages and early Renaissance. The creation of illuminated manuscripts, handwritten not on paper but on parchment, was a labor not only of great expense, both in terms of materials and time, but also of great artistic enterprise. Giorgio Vasari recounts that in his day, the mid-sixteenth century, the right hands of a celebrated fourteenth-century scribe, Don Jacopo Fiorentino, and an equally famous illuminator, Don Silvestro, were preserved and venerated in a reliquary tabernacle at the church of Santa Maria degli Angeli, Florence (Vasari 1906, vol. 2, p. 23), a pious equivalent to the burial of Raphael in the Pantheon. Whatever the truth of this story,[1] the fact of its currency indicates the high esteem in which the arts of the book were held and also fuels the notion, very much alive today, that manuscripts were not only copied but also painted by monks in cloistered scriptoria, working meditatively in silent devotion far from the bustling workshops of secular artists. Ambrogio Traversari, a monk of Santa Maria degli Angeli and a distinguished and spiritually devout humanist who was to be elected general of the Camaldolese order in 1431, wrote to a Venetian friend in 1429: "There were always monks in our monastery (nor indeed are they lacking now) who used [ultramarine blue] in a most skillful and beautiful way for decorating manuscripts. This occupation is certainly not unworthy of religious repose" (Mehus 1759, vol. 6, p. 34; Stinger 1977, p. 4).

Most illuminators in early Renaissance Italy, however, were not monks and were not working in isolation from progressive artistic ideas. Indeed, a characteristic feature of fourteenth- and early-fifteenth-century manuscript illumination in Florence is that with one significant exception, that of Don Simone Camaldolese, its practitioners, whether monks or laymen, were equally accomplished and sometimes equally in demand as painters on a large scale—on panel or in fresco. This may have been a Tuscan phenomenon, since the same is true in Siena and remained true there throughout the fifteenth century, while elsewhere in Italy, in Bologna and Padua for example, the production and illumination of manuscripts developed as more of a specialized industry. The situation in Florence changed perceptibly over the last two-thirds of the fifteenth century: for most of that period, it is common to find manuscripts painted by artists who practiced no other trade; somewhat less usual to encounter illuminators, such as Gherardo di Giovanni, also known as small-scale panel painters; and a notable exception to discover a miniature painted, often signed, by one of the leading masters of the monumental arts, such as Domenico Ghirlandaio (Biblioteca Apostolica Vaticana, Vatican City; Cod. Rossiano 1192.15) or Pietro Perugino (British Library, London; Yates Thompson MS 29, fol. 132v).

This is not to say that the majority of monumental painters in fourteenth-century Florence also worked regularly as illuminators, although they may all be presumed to have provided designs for such decorative media as stained glass and embroidery (cat. no. 14). No painted manuscripts by Giotto or by his most distinguished follower, Maso, are known. Bernardo Daddi has not been identified as the author of any painted books, nor have any of the dominant figures at mid-century—Andrea, Nardo, or Jacopo di Cione. The so-called realist school of Florentine painting, headed by Giottino, Giovanni da Milano, and Andrea Bonaiuti, produced no identifiable illuminated manuscripts, and none have been successfully attributed to the largest studios active at the end of the century, those of Niccolò di Pietro Gerini, Spinello Aretino, and Giovanni del Biondo.[2] It is not surprising, therefore, that conventional histories of the arts in early Renaissance Florence have been only marginally concerned with manuscript painting. The exhibition that this volume accompanies is the first systematic attempt to reintegrate the accomplishments of the great Florentine illuminators with the larger visual tradition of which they formed a part.

The burgeoning economy of Florence in the fourteenth and fifteenth centuries and the remarkable demand for works of art that followed in its wake—a demand unparalleled before or since in the annals of Western civilization and a phenomenon that has defied explanation by economic, social, or art historians (Goldthwaite 1993)—led to the flourishing visual culture and self-conscious development of style that we associate with the Renaissance. A significant portion of this expanding field of opportunity for artists was represented by the proliferation of new monastic orders, especially reform orders, and the building of new monastic houses. A great deal has been written about the large decorative campaigns engendered by these new patrons, especially the Franciscans and the Dominicans, and about the evolving iconographic and narrative models they required. Rather less has been written about an equally compelling requirement of every new house—new liturgical furniture, especially choir books.

Whereas the writing and decorating of choir books in Florence had been something of an

Figure 2. The Magdalen Master, *Madonna and Child Enthroned*. The Metropolitan Museum of Art; Gift of George Blumenthal, 1941 (41.100.8)

Figure 3. The Saint Cecilia Master, *Virgin and Child*. Private collection

occasional undertaking before, by the third decade of the fourteenth century, perhaps slightly earlier, it may be described as an industry. In the spirit of a successful industrial entrepreneur, one artist quickly came to dominate, almost monopolize, commissions for manuscript illumination—Pacino di Bonaguida (cat. nos. 1–4)—and with his ascendancy came a certain standardization in page layout and decorative vocabulary that can now be recognized as typically Florentine. Pacino's training and talents particularly suited him to the demands of manuscript illumination, as he devised a means of translating the simple, brightly colored, almost pictographic narratives of dugento panel paintings, especially those of the Magdalen Master (fig. 2), to the flexible supports and often irregularly shaped picture fields of parchment leaves. The essentially conservative nature of Pacino's art, coupled with judicious borrowings from his more progressive contemporaries, especially Giotto, guaranteed an almost unlimited demand among Florentine consumers. Unfortunately, the sheer number of his surviving works, by their nature largely repetitive in form and content, has tended to obscure an appreciation of

Figure 4. Lippo di Benivieni, *The Lamentation over the Dead Christ*. Fogg Art Museum, Cambridge; The William M. Pritchard Fund (1917.195a)

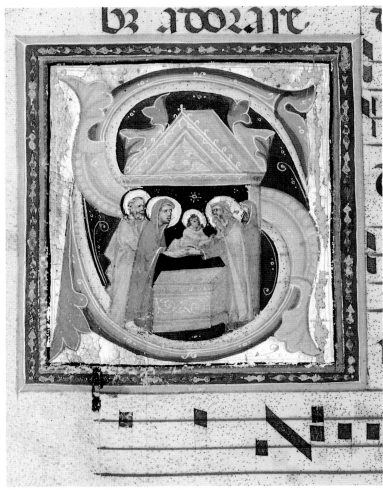

Figure 5. Follower of Lippo di Benivieni, The Purification in an initial S. The Metropolitan Museum of Art (41.100.91, fol. 45v)

their quality and of Pacino's very real accomplishments as an artist and one of the first true personalities in Florentine painting.

Illustrated books made in Florence prior to the advent of Pacino are not readily distinguishable from those painted in Siena or Bologna, and few distinctive hands or personalities can be isolated in what is essentially an anonymous corporate production. Such artists as the so-called Laudario Master (Chelazzi Dini 1979) or the first painter of the Badia a Settimo graduals (see cat. no. 6) are judged less for their own merits than for their proximity or distance from the style of one of the pivotal figures in early Florentine painting, the Saint Cecilia Master (fig. 3). But for all his enormous influence, no illuminated manuscripts directly attributable to the Saint Cecilia Master are known to survive, nor are any books or pages known by his equally influential, perhaps slightly younger, contemporary, Lippo di Benivieni (fig. 4). If any painter at the turn of the century in Florence emerged as a leading personality in the production of illustrated books, his works have not come down to us and his reputation has not survived.

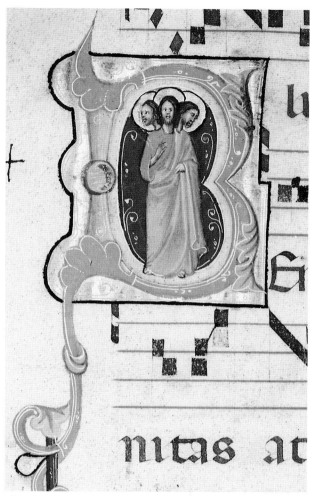

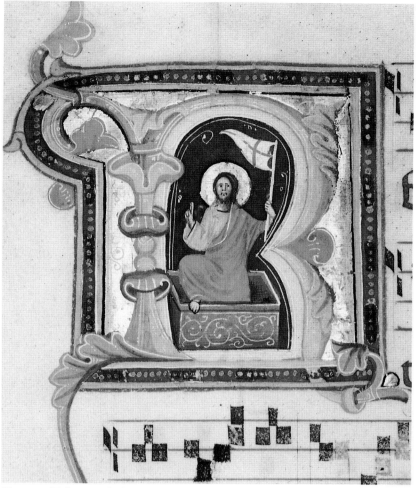

Figure 6. Follower of Lippo di Benivieni, The Trinity in an initial B. The Metropolitan Museum of Art (41.100.91, fol. 65v)

Figure 7. Follower of Lippo di Benivieni, The Resurrection in an initial R. The Metropolitan Museum of Art (41.100.91, fol. 55v)

An idea of the sort of illuminations that might have emerged from the workshop of an artist such as Lippo di Benivieni may perhaps be gleaned from a little-known gradual from the Blumenthal Collection at The Metropolitan Museum of Art (acc. no. 41.100.91; figs. 5–7), painted probably about 1310–15 by an artist close to Lippo. Of remarkably high quality, the miniatures in this book represent a blend of dugento conventions (in the rendering of backgrounds and settings) with an incompletely assimilated "modern" Roman or classicizing figure style and a casual naturalism in the observation of details, such as the fall of drapery folds or the torsion of limbs and bodies in space, which are hallmarks of Lippo's engaging personal manner. One key aspect of Lippo's style is lacking from the Blumenthal Gradual, however—his unmistakable expressive urgency. It is the emotive content of his art—more immediate and accessible than the superhuman pathos of Giotto—that sets Lippo di Benivieni apart from even the best of his Florentine contemporaries and inspired imitation by a group of gifted followers.

One of these followers, undoubtedly the most accomplished miniaturist in early-fourteenth-century Florence, was the Master of the Codex of Saint George (cat. nos. 6–9), the greater part of

whose career seems to have been passed not in his native city but in Avignon, where he was engaged by exalted Roman and French patrons attached to the papal court. His case, therefore, is atypical, and only recently has he even come to be recognized as Florentine in origin. The courtly and refined manner he developed was suited to the tastes of his patrons and to the nature of the work he was called upon to produce and in this regard differs significantly from the requirements of monastic, civic, or even private commissions in Florence. His prolonged absence in France, furthermore, and the closed, exclusive circles of patronage in which he moved left very few of his works, and among these not the most significant, available to younger Florentine painters. Though his reputation today is equal to or greater than that of almost any contemporary artist active in any medium, he enjoyed disproportionately little direct influence on subsequent generations.

One painter who did have access to works by the Master of the Codex of Saint George is a mysterious artist conventionally known as the Maestro Daddesco (cat. nos. 10–13), who seems to have been called upon to complete a commission abandoned by the older artist when he left Florence sometime about 1320. It is likely that the selection of the Maestro Daddesco for this task was an economic rather than an aesthetic decision, for although he has been called a "Master of the Saint George Codex in a minor key" (Bellosi 1974, p. 78), his artistic sympathies lay not with that painter's exuberant, expressive poetry so much as with the measured prose of Pacino di Bonaguida. Like Pacino, the Maestro Daddesco's pictographic narrative style was ideally suited to book illustration and made him the painter of choice in Florence for commissions of modest scale or expense throughout the second third of the fourteenth century. Restrained in palette, always pleasing, always technically accomplished, and sometimes highly sophisticated in the organization and depiction of space, his paintings reveal an eclectic mixture of influences, both Florentine and Sienese, that certainly contributed to their appeal among his contemporaries but that has confused modern critics seeking to characterize him either as a leading figure in the following of Bernardo Daddi (d. 1348), for whom he is named, or as one of Daddi's precursors. The Maestro Daddesco was a prolific artist, and most of his works seem to be datable close to mid-century, a period in which his domination of the market for manuscript illuminations in Florence was seriously challenged by only one other painter—the Master of the Dominican Effigies.

The Master of the Dominican Effigies was much less allied in temperament to Pacino di Bonaguida than was the Maestro Daddesco, yet it was he who was chosen to complete Pacino's work on the Santa Maria at Impruneta antiphonaries and the great laudario for the Compagnia di Sant'Agnese (cat. no. 4), the most elaborate book painted in Florence in the first half of the fourteenth century. Undoubtedly it was the sumptuous nature of the commission that determined this choice, since the Master of the Dominican Effigies seems to have dominated the upper end of the market for manuscript illuminations in Florence to the same degree that the Maestro Daddesco can be said to have monopolized the middle and lower ends. The Master of the Dominican Effigies was perhaps less instinctively an illuminator than either the Maestro Daddesco or Pacino; his style did not lend itself to the repetitive demands of illustrating liturgical texts. His lavish decorative sense, the insistent geometry of his compositions and borders, and his attention to narrative detail betray an obsessive preoccupation with the formal elements of design completely at odds with Pacino's or the Maestro Daddesco's casual story-telling, while the intensely emotional and expressive cast of his figures suggests exposure to the teaching of Lippo di Benivieni. Yet his greatest and most original creations are all to be found in manuscripts, such

as the *Biadaiolo* of Domenico Lenzi (Biblioteca Laurenziana, Florence; Cod. Tempiano 3) or Zucchero Bencivenni's Italian translation of the *Tractatus de virtutibus et vitiis* (Biblioteca Apostolica Vaticana, Vatican City; Cod. Barb. Lat. no. 3984), and among these are to be found some of the most original and memorable images of early trecento Florence (fig. 1).

No works by either the Maestro Daddesco or the Master of the Dominican Effigies can be dated with any confidence much later than 1360, and the fact that no comparably prolific or talented younger painter was active in the third quarter of the century implies a dramatic slackening of demand for illuminated manuscripts in Florence at that time. Between 1350 and 1358 an artist (or scribe, it is not clear which; Boskovits 1972, p. 43) named Ser Monte was commissioned to produce a series of books for the Florentine church of Santa Felicita, one of which is preserved at the Bodleian Library, Oxford (fig. 8). Ser Monte's illuminations, however, are little more than coarse reflections of the style of Taddeo Gaddi, and his system of border decoration an unimaginative reprise of Pacino di Bonaguida's designs. By contrast, the third quarter of the fourteenth century was a

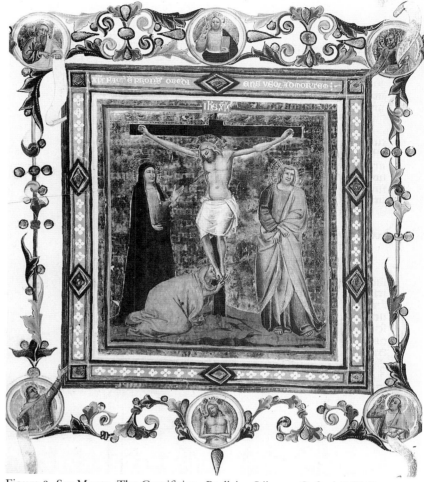

Figure 8. Ser Monte, The Crucifixion. Bodleian Library, Oxford (MS Canon. Lit. 382, fol. 132v)

period of intense activity in Siena, a period dominated by the vibrantly colorful and calligraphic style of Niccolò di Ser Sozzo (fig. 9) and the tireless productivity of Lippo Vanni (fig. 10). Perhaps not surprisingly, therefore, an overtly Sienese taste compensated for the broken continuity of Florentine workshop experience in the emergence, about 1375, of the next great luminary of Florentine manuscript painting, Don Silvestro dei Gherarducci, while the bulk of demand for illuminations in and around Florence between 1380 and 1400 was actually supplied by an artist born and trained in Siena, Don Simone Camaldolese.

Both Don Silvestro and Don Simone were Camaldolese monks, and consequently they have somewhat inaccurately been grouped together by modern historians as the heads of a supposed "scuola degli Angeli," named for the main house of the Camaldolese order in Florence, Santa Maria degli Angeli. It appears, however, that the two artists had very little contact with each other, one of them, Don Silvestro, being resident at and functioning almost exclusively for Santa Maria degli Angeli (cat. nos. 15, 16), while the other, Don Simone, was peripatetic and had a broad range of patrons, both secular (cat. no. 23) and religious (cat. nos. 24–26), which only rarely included monasteries of his own order. Nevertheless, the work of these two men so completely dominated the production of illuminated

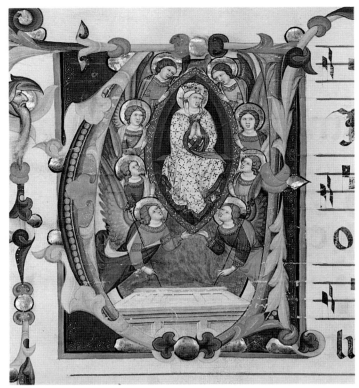

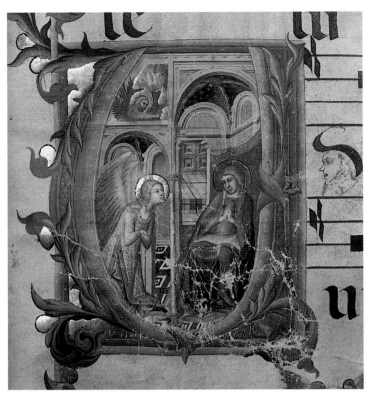

Figure 9. Niccolò di Ser Sozzo, The Assumption of the Virgin in an initial V. The Metropolitan Museum of Art; Gift of Louis L. Lorillard, 1896 (96.32.12)

Figure 10. Lippo Vanni, The Annunciation in an initial V. Museo dell'Opera del Duomo, Siena (MS 98-4, fol. 8r)

manuscripts in Florence in the last quarter of the fourteenth century—as did that of their Camaldolese successor, Lorenzo Monaco, in the first quarter of the fifteenth century—that the concept of a "scuola degli Angeli," understood not as referring to a particular scriptorium but as a term of convenience loosely defining a Florentine miniaturist style over a period of more than fifty years, is not entirely inappropriate.

The painters who may be grouped together under this umbrella term must not be assumed to have shared a specific artistic ideal in the manner of a modern school or ism. Don Simone's style, for example, is an unadulterated product of his native Siena and the influence of Ambrogio Lorenzetti, whereas Don Silvestro's figures and compositions, though overlaid with a veneer of Sienese decorative sensibility and frequently relying upon Sienese iconographic conventions, are recognizably dependent on Orcagna (Andrea di Cione) and particularly close in inspiration to the oeuvre of Orcagna's brother and workshop partner, Nardo di Cione, firmly rooting him in a Florentine pictorial tradition. The two artists have little in common beyond the Sienese derivation of their palette and of the type of foliate decoration enlivening their initials and the borders of their pages. This decorative style of borders and initials, however, was pervasively influential, surviving past the middle of the fifteenth century in the works of such temperamentally different artists as Matteo Torelli, his son, Filippo di Matteo Torelli, and the latter's sometime partner, Zanobi Strozzi (cat. nos. 53, 54).

The relative importance of Don Simone and Don Silvestro to manuscript painting in Florence in the last quarter of the fourteenth century may to a degree be compared with that of the Maestro Daddesco and the Master of the Dominican Effigies thirty years earlier. Like the Maestro Daddesco, Don Simone's narrative style was simple and clear, and his working method was ideally suited to the

repetitive demands of ecclesiastical patrons. Over a career probably not much longer than three decades, Don Simone worked for the Florentine Vallombrosans, Carmelites, Olivetans, and Franciscans, as well as for secular patrons and for monasteries as far away as Bologna, Arezzo, and Pisa belonging to the Franciscan, Camaldolese, and Olivetan orders. So large an output presupposes a certain formulaic approach to composition and a well-organized division of labor within a fairly large studio, both of which can be well documented in Don Simone's case by studying on the one hand the slight variations in his treatment of certain subjects as they are repeated from one commission to another (see cat. nos. 21, 22, 25, 26a), and on the other the wide variety of quality and technique visible within the apparently static format of his painted initials (cat. no. 24).

Don Silvestro, by contrast, was far more restrictive in his output during a career almost certainly as long as Don Simone's. He worked as an illuminator for no patrons outside his own Camaldolese order (his panel paintings may have been produced for a somewhat wider market) except for possibly the nearby Benedictine monastery of San Pier Maggiore (cat. no. 18). The total number of commissions unequivocally traceable to him is three, comprising no more than six books altogether. Like the Master of the Dominican Effigies before him, Don Silvestro approached each of these commissions as a new artistic problem requiring a unique compositional solution, so that even a basic task, such as painting numerous half-length prophets in small initials (cat. no. 17), involved none of the pattern book repetition of designs that is an essential ingredient of the commercially successful illuminator's output. Ironically it was Don Silvestro's work, not Don Simone's, that was adapted as a pattern book source of images by two North Italian illuminators assigned to decorate a set of graduals for the Venetian Camaldolese house of San Mattia (see cat. no. 17). Yet Don Silvestro may not have been more influential than Don Simone in the formation of their great Camaldolese successor, Don Lorenzo Monaco.

Equally proficient and equally innovative as a draftsman, illuminator, panel painter, and frescoist, Lorenzo Monaco completely dominated the pictorial arts in Florence during the first quarter of the fifteenth century. His death in 1423 or 1424 is sometimes cited as the end of the Gothic era in Florence in much the same way as Raphael's in 1520 is sometimes taken to mark the end of the High Renaissance in Rome. Modern historians invoke the personal achievements of both painters as definitions of the styles of their respective periods and as benchmarks against which to measure the work of their contemporaries and followers. Unlike Raphael, however, Lorenzo Monaco had few immediate followers since his workshop practice was not so mechanized as has occasionally been thought (Eisenberg 1989)—it was certainly not as broadly organized as Raphael's—and since his style became more personal and expressive as it developed rather than more classical and easily imitated. Furthermore, Lorenzo Monaco suffered the historical misfortune of living and working shortly before the appearance of a painter of genius, Masaccio, whose brief but brilliant career completely obscured Don Lorenzo's legacy precisely as Dante describes Giotto having overshadowed the fame of Cimabue more than a century earlier.

Lorenzo Monaco was not trained as an artist by either of his Camaldolese predecessors, Don Silvestro or Don Simone, although he was clearly receptive to the lessons of both. He emerged instead from one of the most fecund secular workshops in late trecento Florence, that of Agnolo Gaddi, taking religious orders only after he was already relatively established as a painter. In the small-scale works of art (cat. nos. 27, 28) he painted during the brief period of his residence within the cloistered ambience of Santa Maria degli Angeli, possibly totaling not more than five or six years, Don Lorenzo sought to

reconcile his training under Agnolo Gaddi with the experience of the altarpieces—by Nardo di Cione, Giovanni del Biondo, and Don Silvestro dei Gherarducci—that he studied during his daily prayers and the illuminated choir books that he used and watched being produced in the monastery scriptorium. Don Lorenzo was also employed in this scriptorium, but his ambitions were apparently grander than the opportunities circumscribed by the cloistered regimen of Santa Maria degli Angeli. He left the monastery about 1396, perhaps not coincidentally at the death of Agnolo Gaddi, to operate his own workshop, which was capable of accepting commissions on a much larger scale and from a greater range of patrons. However, he maintained close relations with Santa Maria degli Angeli and a virtual monopoly over Camaldolese commissions, for both illuminated manuscripts (which he painted for no one else; cat. nos. 29, 30, 33, 35, 36, 37) and altarpieces (cat. no. 32), which lasted until his own death nearly thirty years later.

By the middle of the first decade of the fifteenth century, Lorenzo Monaco was established as the preeminent painter of altarpieces and devotional panels in Florence. Following the example of an International Gothic taste imported to Tuscany on the return from Spain in 1403 by Gherardo Starnina and practiced with consummate grace and skill in sculptural relief by Lorenzo Ghiberti, Lorenzo Monaco introduced a freely calligraphic drawing style and a light, brilliant palette based on high-key pastels, bright primaries, and frequent effects of *changeant couleur* that were complete novelties in the normally severe world of monumental painting in Florence. Up to that time, Florentine painting had been dominated by such late followers of Orcagna as Giovanni del Biondo and Niccolò di Pietro Gerini and by the attempts at a revival of Giottesque classicism in the workshops of Agnolo Gaddi and Spinello Aretino. None of Lorenzo Monaco's contemporaries proved immune to his influence. Some, such as Lorenzo di Niccolò or Lippo d'Andrea (cat. no. 45), consciously grafted borrowings from Don Lorenzo onto their own otherwise unrelated styles. Others, such as Bartolomeo di Fruosino (cat. nos. 42–44), so closely and effectively imitated Lorenzo Monaco's work that their early careers, formed in the studios of other masters, are no longer recognizable. Still others, such as Francesco d'Antonio, may have trained directly with Don Lorenzo. But beyond the intrinsic value of his own creations, perhaps the most lasting of Lorenzo Monaco's contributions to the history of art was the influence he exercised over one young painter of sympathetic temperament, Fra Angelico.

Like Lorenzo Monaco, Angelico was a deeply intellectual and spiritually sincere artist of astonishing technical facility, and like Lorenzo Monaco he may already have been an established painter when he decided to take religious orders, in this case at the reformed Dominican convent of San Domenico, Fiesole. Angelico's training may or may not have been directly with Lorenzo Monaco: certainly his distinctive palette and his command of the painted effects of light more closely approach Don Lorenzo's than any other artist's, and his selection to complete Palla Strozzi's *Deposition* altarpiece (Museo di San Marco, Florence), begun by Lorenzo Monaco and abandoned at his death in 1423 or 1424, may not have been random or coincidental. But Angelico's genius for the observation and rendering of optical reality was his own personal contribution to the development of European culture. Nurtured by the example of Masaccio, the theorizing of Brunelleschi, and the occasional assistance of Ghiberti, he perfected a rational approach to painting in which the picture was conceived as a window onto an imaginary world that functioned according to the same physical laws as our own, an approach that came to characterize much of the subsequent history of painting down to the end of the nineteenth century.

Unlike Lorenzo Monaco, Fra Angelico never abandoned the duties and obligations of conventual life to operate a workshop, yet his output was vast. He clearly trained and orchestrated the work of a number of assistants to satisfy the endless demand placed upon him for altarpieces, frescoes, and illuminated manuscripts, both for his own Dominican order and for secular and religious patrons throughout Italy. It is particularly in the category of illuminated manuscripts that Angelico came to depend on the work of assistants, at least two of whom, Zanobi Strozzi (cat. nos. 52–55) and Battista di Biagio Sanguigni (cat. no. 37), are known by name and admired for their own independent creations. The decorative demands of book illustration were not entirely sympathetic to Angelico's artistic vision, and those pages confidently recognized as autograph works by him (cat. no. 48) are distinguished by the same tendency to the rational construction of space that pervades his panel paintings of more regular format. Angelico did not lavish a similar attention on the foliate decoration of borders and initials as did his great Florentine predecessors, and he introduced no great refinements of style to this aspect of the craft. Although both Strozzi and Sanguigni developed signature styles of border decoration, Angelico did not—the first significant break in a tradition reaching back to the emergence of Pacino di Bonaguida over a century earlier.

A key element unifying the arts of monumental and miniature painting in the early Renaissance was their common insistence on the decorative quality of the painted surface, regardless of medium or support. Crucial to this idea of painting is the conception of a frame as a shaped boundary or container inextricably integrated with the decorative scheme. In the later Renaissance the tangible coherence of frame and painted surface was ruptured as paintings aspired to simulate deep vistas perceived through and behind the classical architectural doorway of the frame. This same conceptual disjunction is not possible in manuscript illumination, however, where frame and painted scene are both rendered in the same materials and where often the materials themselves—gold and vivid, expensive colors—are prized as much as the rendering. Accordingly, developments in the art of illumination after the middle of the fifteenth century lagged behind those of monumental painting, and the work of Florentine miniaturists became largely derivative. Fra Angelico and his followers were the last great representatives of an earlier attitude that held illumination as fully equivalent to any other art form in its aesthetic demands and its formal and expressive potential. Together with such of their predecessors as the Master of the Codex of Saint George, Don Silvestro dei Gherarducci, and Lorenzo Monaco, they produced some of the most significant if most commonly overlooked achievements of Italian painting.

1. Bent (1992, p. 514 n. 29) presents convincing evidence that the relics seen by Vasari were not those of a scribe and an illuminator but of coincidentally homonymous Camaldolese beati. His further contention, however, that the historical figure of Don Silvestro dei Gherarducci was therefore not an illuminator is more tenuously argued on the grounds that the profession of painting is not compatible with the strictly cloistered life of Camaldolese monks, a contention contradicted by Ambrogio Traversari's nearly contemporary observations.

2. Mario Salmi (1954b, pp. 20–21, 43) first proposed an attribution to Giovanni del Biondo for several illuminations in two antiphonaries at Santa Croce—Cor. D, folios 125v and 150r, and Cor. P, folios 59v and 119r—an attribution correctly rejected by Miklós Boskovits (1972, p. 51 n. 4). More recently George Bent (1992, pp. 518 ff.) assigned several illuminations in Cod. C 71 at the Bargello to Giovanni del Biondo on the basis of a document of 1396 mentioning his name in connection with the purchase of blue pigment for Santa Maria Nuova. The illuminations in Cod. C 71, none of which can be related in style to Giovanni del Biondo, are probably all early works by Lorenzo Monaco. For an alternative interpretation of the 1396 document, see p. 234 n. 6.

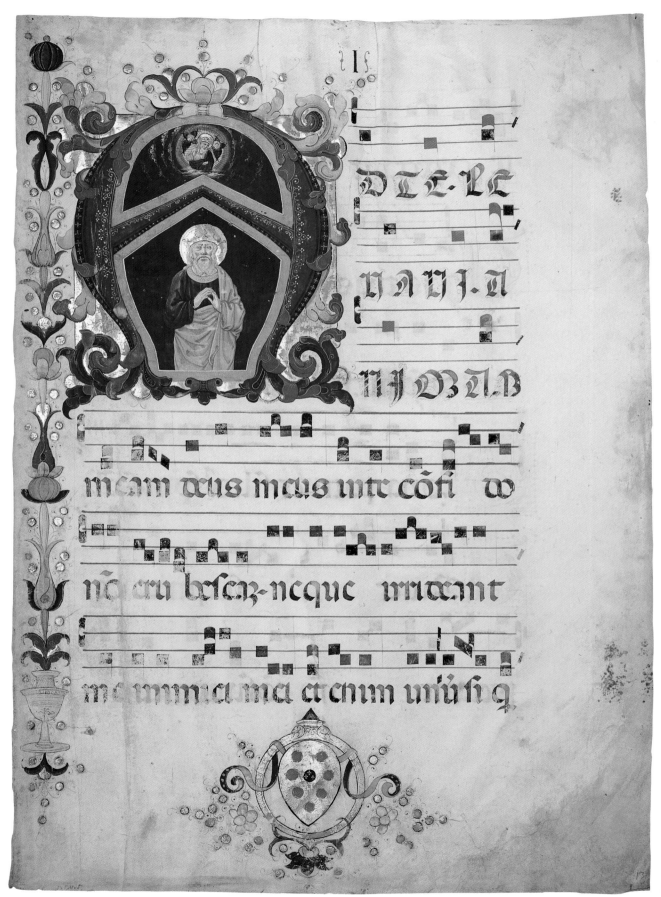

Figure 11. Francesco d'Antonio del Chierico, David in an initial A. Private collection, New York

BARBARA DRAKE BOEHM

The Books of the Florentine Illuminators

The bright palette, rich use of gold, and anecdotal narrative of the manuscript illuminations in the exhibition this publication accompanies ensured their preservation as paintings even when their original use as components of luxury books became outmoded or obsolete.[1] For nineteenth-century amateurs such as William Young Ottley, the foremost English collector of Italian miniatures and one-time owner of many works gathered here, they showed "upon a small scale, the style of Art that prevailed at the times . . . found in a more perfect state of preservation than the frescoes and other large works of paintings remaining to us of the same periods" (Munby 1972, p. 67). Ottley believed that they were to be treasured as "monuments of a lost art," since "the processes which were resorted to by the ancient Illuminists, in preparing and laying on the different metals used in decorating their paintings, and in mixing their colours, have long ceased to be remembered . . ." (ibid.). For John Ruskin they were appreciated for their romantic, evocative quality: he equated "a well illuminated missal" with "a fairy cathedral, full of painted windows" (Nelson 1991, p. 12).

Whether imported to England as single leaves to save on the tax imposed on bound volumes or acquired as souvenirs by wealthy tourists on the Grand Tour, fine examples of the art of Florentine illuminators have found their way into European and American collections alike. Though they have been divorced from their original context in illustrated books, their luster is not diminished; however, our understanding and appreciation of them is based on an imperfect sense of their original dynamic. Their subjects, sizes, and aesthetic were governed by their role within the manuscripts that they once illustrated as well as by the function of those books. To facilitate an understanding of the original context of the manuscripts, single leaves, and cuttings that are under scrutiny here, this essay will describe each of the types of books, its original form, and use. These comprise liturgical manuscripts—missals, graduals, and antiphonaries; devotional manuscripts—a laudario, psalter, and book of hours; and one secular text—Dante's *Divine Comedy*.

The missal, or book of the Mass, represented here by two bound volumes (cat. nos. 7, 8), contains all the texts for the priest's celebration of the Eucharist (Holy Communion). In this ceremony, bread and wine are believed to be transformed into the body and blood of Jesus, in a sacrament that has at its core the instructions given by Jesus to his apostles at the Last Supper: "And whilst they were eating, Jesus took bread; and blessing, broke, and gave to them, and said: Take ye. This is my body. And having taken the chalice, giving thanks, he gave *it* to them. And they all drank of it. And he said to them: This is my blood of the new testament, which shall be shed for many" (Mk 14:22–23). The Mass builds gradually to this climactic moment, when the priest echoes Christ's words and the changing of the bread and wine into the actual body and blood of Jesus are considered to occur. The script for the celebration of the sacrament was built around a nonvariable framework known as the ordinary of the Mass, which was

interwoven with prayers and readings particular to the day, constituting the proper of the Mass. Because of its many elements, variable and nonvariable, the missal texts could be divided among a number of volumes. The sequence for the celebration of the Mass outlined below, while having many elements likewise common to modern practice, follows the structure found in the Morgan Missal (cat. no. 8).

The Mass began as the priest entered the sanctuary. Opening preparatory prayers and the recitation of a psalm were followed by a confession of sin (Confiteor Deo Omnipotenti). The priest approached the altar, kissed it, and if there were no choir, recited himself the opening hymn, known as the introit. A prayerful rhythm was established as the kyrie, imploring God for mercy, was succeeded by the Gloria, praising God and invoking Christ, which begins with the words spoken by the angel at the Nativity. A collect, a short prayer for the day, and the first reading, or Epistle (since it is generally drawn from the letters of Saint Paul), followed. The gradual hymn plus the alleluia—or in a penitential season at vigils and at requiems, gradual hymn plus tract—preceded the celebrant's reading of the Gospel. Once the reading of the lessons was complete, the creed, a profession of faith summarizing the central dogma of Christianity, was declared. The Liturgy of the Word concluded with general prayers for the church.

Gifts of the faithful were brought forward to the recitation of the *offertorium*, signaling the people's pleasure in giving. The priest proffered the gifts of wine and bread at the altar with the words "Suscipe, sancte Pater" (Receive, O holy Father) and filled the chalice with wine and water while saying prayers. He then washed his hands, imploring the Trinity to receive the offering. Turning to the congregation, he asked that they pray for worthiness: "Orate, fratres ut meum ac vestrum sacrificium acceptabile fiat" (Brethren, pray that my sacrifice and yours may be acceptable). The secret, or prayer over the gifts spoken in hushed tones, succeeded the offertory. The preparation ended with a special preface, a preface in honor of the Trinity ("Vere dignum et justum est" [It is truly right and just]), and the Sanctus, which was drawn from the Vision of Isaias (6:3).

The canon of the Mass followed. Its text established at least by the time of Saint Gregory the Great (ca. 540–604), it opened with the words "Te igitur, clementissime pater" (Thou, therefore, most merciful father). The letter T, its form recalling the cross, was often illuminated with the scene of the Crucifixion, as in the Morgan Missal (cat. no. 8). Prayers of the Church and for fellowship with the saints (Communicantes) preceded a prayer that the gifts be acceptable (Hanc Igitur) and blessed (Quam oblationem). The narrative account of the Last Supper then ensued: "Qui pridie quam patere-tur . . ." (Who on the day before he suffered death . . .), after which the words of Christ to his apostles were recited. Christ's Passion was recalled (Unde et Memores), and God's grace was implored (Supplices te rogamus). Prayers in memory of the dead and for the communicants followed. The Communion began with the Lord's Prayer, which was succeeded by the Breaking of the Bread (Fractio Panis). The priest mixed a little bread in with the wine and implored Christ as the Passover Lamb (Agnus Dei). After further prayer, Communion took place to the singing of the Communion hymn, which was incorporated into the service as early as the fourth century with the use of either Psalm 144 or Psalm 32. Prayers ensued, then a blessing and a thanksgiving after Mass. Sometimes, as in the Morgan Missal, this took the form of the Canticle of the Three Young Men. Inspired by the account of the Three Hebrews in

the Fiery Furnace (Dn 3:1–100), the Canticle calls on all of creation—dew and rain, mountains and hills, dolphins and fishes—to praise the Lord.

The variable components of the Mass interspersed throughout the ordinary—the introit, collect, lessons, hymns, secret, and prefaces—conformed to the seasons of the church. Each year the liturgical calendar reviewed and celebrated the story of the life of Jesus, dividing it into the Christmas and Easter cycles. These constituted the temporale (temporal cycle, or proper of time). Each cycle had its own internal cadence of preparation, celebration, and prolongation. The Christmas cycle began in Advent, a penitential season of four weeks during which the faithful were to prepare themselves for the Coming of Jesus. Advent began on the Sunday closest to November 30 and ended on Christmas Eve, December 24. The celebration of Christmas continued through the week of Epiphany, which began on January 6, marking the arrival of the Three Magi in Bethlehem. The cycle closed on Septuagesima (the seventieth day) Sunday, or the ninth Sunday before Easter.

The Easter cycle had three stages of preparation—from Septuagesima Sunday to Ash Wednesday; the forty days of Lent, corresponding to Jesus' period of fasting in the wilderness; and Passion Sunday to the Easter vigil on Holy Saturday. The celebration began on Easter Sunday, the day of Jesus' Resurrection, observed on the Sunday after the first full moon after the vernal equinox, the earliest possible date being March 22. The celebration extended through the Descent of the Holy Ghost on the Apostles at Pentecost and the feast of Trinity Sunday. The season was prolonged for twenty-four Sundays after Pentecost (corresponding roughly in the modern secular calendar to late spring through Thanksgiving).

Concurrent with the temporal cycle, the dates of which, apart from Christmas, are predominantly movable, was the celebration of Christian saints on appointed feasts assigned to dates of the secular calendar. The relevant texts for this part of the Mass were contained in the sanctorale (sanctoral cycle, or proper of the saints). The sanctorale always included texts for the apostles, fathers of the church, the Virgin Mary, and universally honored saints, but its contents also varied according to the particular local or monastic use for which the book was intended. (Fixed feasts for the week after Christmas were generally contained in the temporale rather than the sanctorale.) For saints whose feasts were not marked by texts unique to them, the common of saints contained hymns and prayers appropriate to the saints according to their type, such as virgin martyrs, bishops, pontiffs, and doctors of the church. Votive masses, for particular intentions, required supplemental prayers, which were grouped in a single section of the missal. In the Morgan Missal (cat. no. 8), for example, these include prayers for sailors at sea, prayers to avoid temptation of the flesh, and prayers in honor of deceased parents.

The Psalter, or Book of Psalms, derives its name from a Greek word meaning "songs accompanied by string music." It consists of 150 songs of praise in poetic form, of which the biblical king David was believed to be the author. The text of the Psalms was frequently cited by both Jesus and Saint Paul, and the regular use of psalms in prayer was recommended by early church fathers, such as Saints Jerome and Ambrose. The image of David singing and playing the lyre often stands at the beginning of the Psalter, illustrating Psalm 1, "Beatus vir," the context from which the Zanobi Strozzi cutting comes (cat. no. 52), the only illumination from a psalter included in the present publication. Portions of the psalms recur frequently in Christian worship, and in the monastic office the cycle of psalms was intended to be

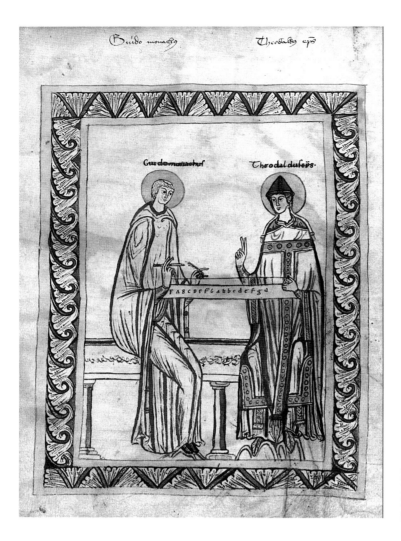

Figure 12. Guido of Arezzo Explaining His Musical Notation. Österreichische Nationalbibliothek, Vienna (Cod. 51, fol. 35)

completed each week. For Christian use, the Psalter was usually augmented by a calendar, canticles (biblical songs), and a litany of saints.

The rule of Benedict urges that the monks "take part in the psalmody in such a way that our mind may be in harmony with our voice" (Doyle 1948, p. 41). Indeed, the marriage of sacred text to music in the Christian Church was based on a much more ancient Hebrew tradition, a link that Protestant reformers like Calvin bemoaned, considering it an appeal to primitive instincts. The psalms were sung antiphonally, with participants vocalizing in alternation. To the medieval church, music was a means of fostering a sense of spirituality, and the psalms were a primary source for its development. Saint Ambrose was the most influential early churchman in the West to write hymns. In translation, texts by Venantius Fortunatus (d. 609), Gregory the Great (d. 604), Adam of St-Victor (d. ca. 1172), and Thomas Aquinas (d. 1274) are still to be found in modern hymnals. Neumatic notation was introduced in the second half of the ninth century and was further developed in the eleventh century by a Camaldolese monk, Guido of Arezzo, who introduced the use of letters as clefs (fig. 12).

The principal musical manuscripts of the medieval church (and those most frequently found in this catalogue) were the antiphonary and gradual. The gradual contains the parts of the Mass to be sung by a choir. Its contents were codified by Saint Gregory in the late sixth century, with the music falling at logical intervals to mark actions or movements in the service. (Such punctuation of the Communion

ceremony with musical sections continues in the modern Roman Catholic and in some Protestant liturgies.) The opening and most important hymn in the Mass was the introit. Its use first recorded in the *Liber pontificalis* (Book of the Popes) in the sixth century, the introit marked the entrance of the celebrant into the church. Its text is nearly always biblical and was often based on the opening verse of a psalm. Like the beginning of a new chapter in a book, the introit was most often singled out for special decoration. The dependence on the heritage of the biblical king was clearly recognized: in illuminations images of David served as a metaphor for the prayer (fig. 11). He gazes up toward God in the manner described in the text: "Ad te levavi animam meam, Deus meus, in te confido" (To thee, O Lord, have I lifted up my soul. In thee, O my God, I put my trust" [Ps 24:1–2]). Poetic images called forth by the prophets, like the Rorate Caeli (Drop down, dew [Is 45:8]), were incorporated in the text because of their association with the Incarnation and were visualized in images of the Annunciation. The gradual hymn followed the introit. Its text likewise derived from the psalms, the gradual hymn was first documented in the Carolingian era, when it was sung from the steps of the ambo. It was intoned after the reading of the Epistle, and it was excluded from the Mass only from the first Sunday after Easter until the Saturday before Pentecost. The alleluia, an expression of praise that is found in both the Old (Pss 11–117) and the New Testaments, was established as part of the Mass (and the Office) by Gregory the Great. Joined to a verse of scripture, it was used throughout the Latin liturgy except in the penitential season preceding Easter, beginning at Septuagesima Sunday. At that time its substitute was the tract, the psalm or part of a psalm sung without responsory. The practice of singing a psalmic hymn during the offertory, when bread and wine were brought to the altar, was first mentioned by Saint Augustine of Hippo (354–430). The Communion hymn was sung after the priest washed the chalice and his fingers after completion of the Eucharistic meal.

The graduals of each monastic order varied according to the requirements of its rule, and the sequence, elaboration, and decoration of different feasts reflected a gradual's particular function. Vasari recounts that the choir books of Santa Maria degli Angeli were so beautiful that they would have been taken to Rome were it not for their peculiarly Camaldolese use (Vasari 1906, vol. 2, p. 24), which dictated, for example, that the feasts of Saints Philip and James fall on May 3 rather than May 11 and that the feast of Saint Romuald be celebrated in June rather than January. The San Marco Gradual made for Dominican use (cat. no. 48) includes feasts particular to that order, feasts in honor of its founder, Saint Dominic, of Saint Peter Martyr, and of Saint Thomas Aquinas, as well as the feast of the Crown of Thorns, which the Dominicans had played a key role in procuring for the French King Louis IX (Bonniwell 1945, p. 114). A gradual for Bridgettine nuns, possibly prepared for a new monastery and chapel of that order begun in 1432, included a frontispiece (cat. no. 45) that combines an image of Saint Bridget and her followers with an image of the Annunciation.

The antiphonary, or antiphonal, contained the prayers and praise necessary for the Divine Office, the daily cycle of monastic devotions. Based on the Jewish practice of praying at appointed hours and on practices in the Acts of the Apostles (10:9; 16:25), the medieval cycle was instituted by Saint Benedict. His rule declared: "In the sight of the angels I will sing praise to you" (Doyle 1948, p. 40), and the singing of that praise shaped the waking and sleeping hours of monastic communities. Matins (the night office) was to be said about 2:30 A.M.; it was followed by the day hours: lauds at 5:00 A.M., prime at 6:00 A.M., terce at 9:00 A.M., sext at noon, none at 3:00 P.M., vespers at 4:30 P.M., and compline at 6:00

P.M. (Mass would be celebrated between terce and sext.) At each interval there was a specific round of prayers, those at matins being the most complicated. An invitatory and hymn were succeeded by a grouping of antiphons, or short introductory sentences to introduce psalms; lessons; and responses called nocturns (groupings of three psalms, of which there were three for use on different days of the week). These last were followed by the hymn of praise, the Te Deum. Each of the other hours incorporated antiphons, psalms, capitula (short headings), a hymn, an antiphon, a Benedictus, and a prayer. (The structure of Morning Prayer and Evensong in the Anglican Communion was adapted from the monastic Office at the time of the Reformation.) Like the gradual and missal, the antiphonary often reflected the use of a particular community through the selection of or emphasis on certain feasts in its text or its decoration. The Brooklyn antiphonary leaf by Don Simone (cat. no. 25), for example, includes the arms of Monte Oliveto Maggiore and an image of an Olivetan praying in the margin.

The illuminations in the missals, antiphonaries, and graduals in this publication provide glimpses of and instructions for the ceremonies in which they were employed. Instructions written in red and consequently known as rubrics guided the clergy and religious in their use of these liturgical books. The priest's movements were linked to the drama of the narrative and spelled out in the manuscripts. The rubric in the Morgan Missal (cat. no. 8) that immediately precedes the Te Igitur directs: "Here bow before the altar and say, with all humility." The lighting of the tapers seen at the *bas-de-page* is in keeping with an aspect of the ceremony decreed by Pope Innocent III. Even the varying cadences of the hymns can be judged by the form of notations in the manuscripts. Where general praise was intended, as in the alleluia or Gloria, there are often many notes per word or even per syllable; where narrative content is important, there is generally one note per syllable.

Young and old assembled for choral services. With the shortest standing near the front, they gathered around large lecterns that turned on pedestal bases, as depicted in an illumination from Cod. Cor. 3 from Santa Maria degli Angeli (fig. 13). Examples preserved in the Museo dell'Opera del Duomo, Florence, or in Gubbio (fig. 14) probably conform to the type that Fra Leonardo paid for as an additional gift following his donation of 100 florins for choir books at Santa Maria degli Angeli in 1374 (see cat. no. 16). The choir books were large enough for all to see. The parchment of which they were made was sturdy, unlike the more thoroughly processed, finer skin used for the Codex of Saint George (cat. no. 7); it needed to be thick and strong enough to withstand leaning against a slanted support and being held open with sash weights on a daily basis. The books were bound with boards covered in leather and decorated and protected by metal bosses like those of the two-volume Newberry Gradual (cat. no. 24).

These manuscripts were a focus of the monasteries and convents at all times of day and in every season. Without them the liturgical requirements and devotional obligations of the religious could not be met. Consequently, the acquisition of such books was of the highest priority. The rapid growth of the Franciscans and Dominicans in the fourteenth century created a new demand for choir books. In the thirteenth century the regulation of the Dominican liturgy was the order's principal objective, which was then imposed by requiring standardized liturgical manuscripts. The Olivetan order, founded in 1319, likewise required liturgical books for its communities, which were enormously successful in Italy, numbering over 100 abbeys by the end of the sixteenth century, most of them in Tuscany. The Vallombrosans, for whose community at San Pancrazio Don Simone illuminated an antiphonary in

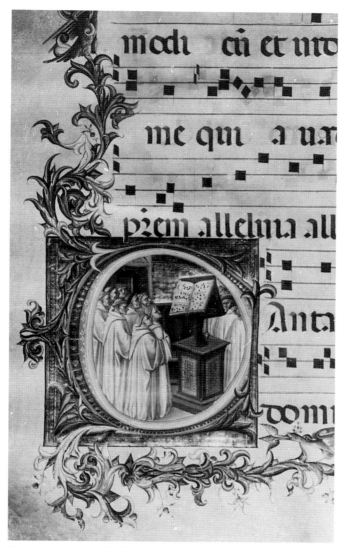

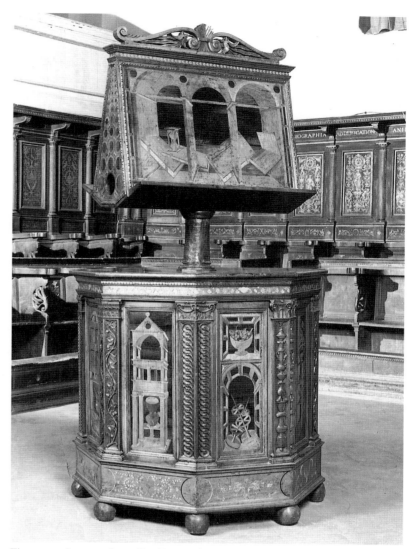

Figure 13. Battista di Biagio Sanguigni (?), Choir of Camaldolese Monks Chanting in an initial C. Biblioteca Medicea Laurenziana, Florence (Cod. Cor. 3, fol. 41v)

Figure 14. Lectern from San Domenico, Gubbio

1381, had grown from fifty abbeys in Tuscany at the end of the twelfth century to more than eighty by 1500. Documentary evidence frequently points to cooperation among various houses in the production of liturgical manuscripts, continuing a medieval tradition. A volume of an antiphonary used by the Benedictine nuns at San Pier Maggiore was borrowed as an exemplar for the production of books for the Camaldolese at Santa Maria degli Angeli and Santa Maria Nuova following a fire at Santa Maria degli Angeli in 1378.

The secular community of the faithful also created a growing demand for manuscripts during the thirteenth and fourteenth centuries. The singing of hymns by the laity became popular, apparently following the example of Saint Francis, who was described as going about "cantando e laudando magnificamente Iddio" (singing and magnificently praising the Lord). Under the influence of mendicant preachers, laymen adopted the practice of singing hymns (*laude*) to the Virgin in the morning and evening; before the end of the thirteenth century, these were translated from Latin into Italian. Perugia had forty societies for the singing of *laude* in the fourteenth century; in Florence twenty such confraternities had been founded by the end of the thirteenth century (Weissman 1982, p. 43). The

members of the Compagnia di San Zanobi and the Compagnia di Sant'Agnese of Florence gathered every evening to sing hymns to the Virgin, and many such *laude* were common to several companies. *Laudesi* were entitled to elaborate burial services, which were otherwise subject to sumptuary laws. The bier would be covered by the company and carried on a stretcher in procession, accompanied by torches and mourners in a ceremony more commonly associated with the church hierarchy. After death, company members stood to benefit from regular masses for their souls said by their surviving confreres, generally their neighbors. The hymnals created for the companies were the lay community's version of an antiphonary and gradual, and the organization of each was particular to its needs.

The prescribed devotional practices of the *laudesi* included the recitation of prayers, attendance at funeral and memorial masses, and participation in feasts. The company's distinctive songs of praise were gathered in a book of hymns, or laudario (cat. no. 4). Like modern-day members of university fraternities or the society of Masons, *laudesi* were subject to codes of secrecy, induction rites, and conventions of dress. The participation of women, a number of whom are represented in the margins of the laudario, was augmented during the fourteenth and fifteenth centuries. Wives and sisters of company members, while not allowed in meeting chambers, were part of the spiritual community and joined in the celebration of feasts. Children too were instructed in the singing of devotional hymns. The form of the hymns was similar to English carols still sung today, whose characteristics include a limited vocal range, a major key, and one syllable per note. *Laude* remained part of popular Italian religious music into the nineteenth century.

The quintessential book for the private devotions of the laity in later medieval Europe was the book of hours, here represented by two mid-fifteenth-century examples (cat. nos. 53, 54). Typically a book of hours began with a calendar of feasts. Written in different-colored inks or gold to denote individual items' relative importance, the list often provides vital clues to the original ownership of the manuscript. The four Gospel lessons that followed corresponded to the lessons for Christmas Day (Jn 1:1–14), the Annunciation (Lk 1:26–38), the Epiphany (Mt 2:1–12), and the feast of the Ascension (Mk 16:14–20) and had become standard by the beginning of the fifteenth century. The largest section was devoted to the Hours of the Virgin (the Little Office of the Blessed Virgin Mary). The day was divided into eight prayer sessions: matins and lauds at dawn, prime at 6:00 A.M., terce at 9:00 A.M., sext at noon, none at 3:00 P.M., vespers at sunset, and compline for evening. Each hour incorporated responses, psalms, hymns, canticles, capitula, and various types of prayers. The hours began with standard versicles: "Domine labia mea aperies" (O Lord, thou wilt open my lips) at matins; "Deus in adiutorium meum intende" (O God, come to my assistance) for lauds through vespers; and "Converte nos deus salutaris noster" (Convert us, O God our savior). At matins, lessons were added in three nocturns. The appropriate nocturn to be used depended on the day of the week.

The exact contents of a book of hours varied according to the location for which the manuscript was made. Typically, each hour was prefaced by an illustration either of the Passion or, more commonly, as in the Adimari Hours (cat. no. 53), of scenes from the Infancy of Christ—the Annunciation, Visitation, Nativity, Annunciation to the Shepherds, Adoration of the Magi, Presentation in the Temple, Flight into Egypt—and the Coronation of the Virgin. The Adimari Hours includes Christ Among the Doctors rather than an Annunciation to the Shepherds, as well as both a Death of the Virgin and her Assumption.

The Hours of the Passion, found in the Adimari Hours, was structured much like the Hours of the Virgin. The Hours of the Cross and of the Holy Spirit contained a similar cycle for the day but omitted lauds; they include hymns and prayers but not psalms and lessons. Two special prayers to the Virgin, "Obsecro te" (I implore thee) and "O intemerata" (O matchless one), could also be included. The Seven Penitential Psalms, first grouped by the monk Cassiodorus in the sixth century, are Psalm 6 ("Domine ne in furore"), Psalm 31 ("Beati quorum"), Psalm 37 ("Domine ne in furore"), Psalm 50 ("Miserere mei Deus"), Psalm 101 ("Domine exaudi"), Psalm 129 ("De profundis"), and Psalm 142 ("Domine exaudi"). As in the Rosenberg Hours (cat. no. 54), they were generally accompanied by one or more images of King David. The psalms were followed by the litany, or listing of saints whose prayers are sought, the Office of the Dead, and suffrages, again addressed to particular saints, to be read on their feasts.

Books of hours were much more popular in northern Europe, especially in France and in what is now Belgium and the Netherlands, than in Italy up to the mid-fifteenth century. Their small size and preciousness are a function of their use, as is the frequent appearance of personal mottoes or devices, like the diamond ring that appears in the margin of the Adimari Hours.

Personal devices were also a frequent hallmark of other manuscripts produced for secular patrons. In the case of the *Inferno* from the Bibliothèque Nationale, Paris (cat. no. 44), the coat of arms of the owner was added subsequent to the illumination of the manuscript.

Like the laudario both Dante codices in this volume demonstrate the growing importance of the Italian language concurrent with the growth of vernacular literature elsewhere in Europe. The intellectual foundations of the *Commedia* (not called the "Divine Comedy" until the sixteenth century) lie in medieval Christian faith. The text is divided into three books that describe hell, purgatory, and paradise in a series of vignettes (each called a canto) from a vision the author had during Holy Week of 1300. Yet Dante's text is characterized by an emerging emphasis not only on the secular realm, as evidenced by the historical characters who people the text and appear in the illustrations (cat. no. 44, fol. IV), but also on the beauty of the Italian language as a literary medium, a subject the author later treated in *De vulgari eloquentia*.

It is customary to think of the Renaissance as a rebirth of learning in all realms, and so the growth of vernacular literature and the proliferation of books is to be expected. But throughout the Middle Ages, the written word was no less important. Christian faith was tightly bound to the Holy Word. The Gospel of John begins: "In principio erat verbum, et verbum erat Deus" (In the beginning was the Word, and the Word was with God). In no other religion is God represented holding a book. The development of illuminated manuscripts in Florence was utterly dependent on the perpetuation of medieval traditions of faith and learning and the fervent pursuit of spiritual life within the city. In the fourteenth and fifteenth centuries, manuscript production flourished in Florence at a moment when the intellectual, secular, and spiritual realms were interwoven and demonstrated a like desire for illustrated books, many of which were created by the city's finest painters.

1. The substance of this essay is dependent on a number of scholarly studies that provide in-depth analysis for those interested in further reading: Alexander 1978; Apel 1966; Bonniwell 1945; Cabrol 1932; Calkins 1983; Doyle 1948; De Hamel 1986; *Gatherings* 1974; Henderson 1994; Hughes 1982; Jungmann 1959; Lugano 1903b; Munby 1972; O'Connell 1964; Plummer 1964; Toscani 1983; Wagner 1907; Wieck 1988; Wilson 1992; Ziino 1988.

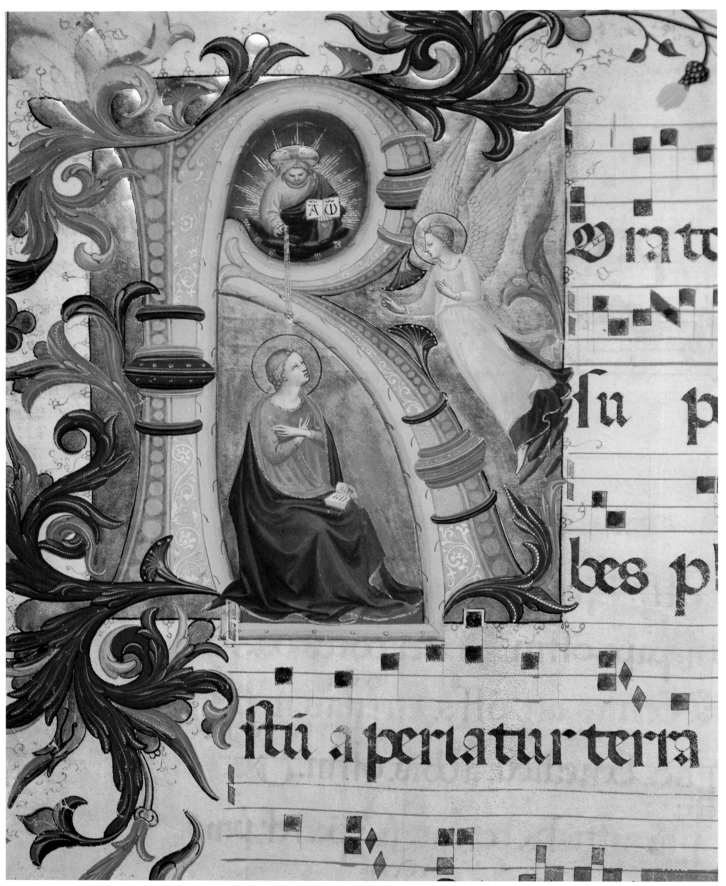

Figure 15. Fra Angelico, The Annunciation in an initial R. Museo di San Marco, Florence (Cod. 558, fol. 33v)

CARL BRANDON STREHLKE

Fra Angelico Studies

This biographical essay covers various aspects of the career of Fra Angelico, but its focus falls mainly within the early period. The chronology of the artist's earliest work remains shaky and needs reexamination. I have tried to broaden discussion of it by identifying (or attempting to identify) the patrons of his important first paintings and the altarpieces for San Domenico in Fiesole.

In late 1418 four Dominican friars reclaimed a dilapidated convent on the hill of Fiesole overlooking Florence. Members of the Observance, or reform branch, of the order, they had abandoned the place a decade before in disagreement with Florence over which contender for the papacy should be supported. When Oddo Colonna was elected Pope Martin V on Saint Martin's Day (November 11), 1417, the schism ended, and there was no longer any reason to stay away. Furthermore, in July 1418 Barnaba degli Agli had died, leaving six thousand florins for a new convent. The terms had been worked out with Leonardo Dati, the Dominican master general (Orlandi 1959–60, vol. 2, pp. 93–104), who wished to reestablish the Observants' presence in Florence,[1] and ground was broken after January 25, 1419.

Agli had instructed that in two years a church and a priory capable of housing thirty friars be inaugurated (Orlandi 1959–60, vol. 2, p. 97). While his expectations were not met—the construction lagged and only twenty cells got built—new members had to be recruited. A young painter named Guido di Pietro and his brother Benedetto, a scribe, decided to join. The exact circumstances and dates are a mystery. Guido is last mentioned with his lay name in June 1419, and he has not been found in any other document until June 1423, when he is identified as a friar.[2] He took on the name Fra Giovanni but is best known as Fra Angelico.

An Observant's life was organized around a regime of common prayer and liturgy,[3] but this did not prevent either Angelico or Benedetto from practicing his profession. The new convent, known as San Domenico, allowed a friar to integrate a religious and working life. Friars who held "jobs" were not looked upon adversely. Unlike the income of the Camaldolese monk and painter Lorenzo Monaco, Angelico's earnings went directly to the convent. Angelico and Benedetto did not ever have to set up outside its confines, and they were both able to advance up its administrative ladder.

Manfredi da Vercelli, a friar from northern Italy then living in Fiesole, may have had some weight in the brothers' choice. He had preached popular sermons on the spiritual and social value of work (Gilbert 1984; Hood 1993, pp. 9–10). While in 1419 their potentially divisive tone had earned papal censure, the Observants as well as the Florentine government protected Manfredi. He even attracted donations from powerful businessmen like Felice Brancacci and earned the sympathy of Antonino Pierozzi, several times prior of San Domenico and founder of the convent of San Marco. Pierozzi, who became archbishop of Florence, assimilated some of Manfredi's ideas on economics and social responsibility into his own writings on the subject.

Whatever the circumstances, Angelico's decision represents a deep personal commitment from which the widely recognized spirituality of his art originates. Indeed, the artist's religious fervor was recognized by his contemporaries: his first biographer (Murray 1957, p. 335), probably Antonio Manetti, writing between 1494 and 1497, asserted that the artist never neglected his religious duties for painting. Before going to Fiesole, Angelico had attended a religious club. This may have affected his decision to become an Observant friar. In October 1417 he registered as a member of the confraternity of San Niccolò di Bari, which held meetings in the basement of the church of Santa Maria del Carmine. Significantly, the organization counted on its rolls the founder of the convent in Fiesole, Giovanni Dominici. The two were probably never at assemblies in the Carmine concurrently because obligations as a cardinal and papal diplomat kept Dominici out of Florence (Maione 1914; Cohn 1955, pp. 208–9). But the Observants would have looked for postulants in Dominici's confraternity, which doubled as a recruitment center: during the years Angelico went, several members became monks or friars (Orlandi 1964, p. 3).

The best clue to Angelico's circumstances is information gleaned from the record of his enrollment in the confraternity.[4] First, he put down that he was a painter. This indicates that he was an independent artisan past apprenticeship. Second, his residence was in the parish of San Michele Visdomini, the same one that encompassed Lorenzo Monaco's monastery of Santa Maria degli Angeli. This was probably not a coincidence because, third, the man who sponsored his membership, the illuminator Battista di Biagio Sanguigni, also lived there.[5] Originally from Empoli,[6] Sanguigni was born about 1392–93 and had joined the club two years previously. In a tax declaration of 1427, Sanguigni noted that his house was leased from Santa Maria degli Angeli. The likelihood is that this was also true in 1417. The convent probably rented Sanguigni this space because he was an associate of its scriptorium.[7] Angelico may have had a similar arrangement, but with one major difference: Sanguigni is always called a *miniatore*, or illuminator, whereas Angelico is never qualified as anything but a painter.

The above documentary evidence points to an early training at Santa Maria degli Angeli in Lorenzo Monaco's circle, and such is supported by a stylistic reading of the few paintings that can be attributed to the young Angelico. The picture that best represents Angelico at this moment is a wonderful *Thebaid* in the Uffizi (fig. 16), which was first attributed to him by Roberto Longhi (1940, p. 173). While it shows such a close dependence on Lorenzo Monaco that a model by him may stand behind it (De Marchi 1992, pp. 148–49 n. 53), the panel also foreshadows aspects of the mature Angelico: the sculptural mountains, reminiscent of the geography of an early Ghiberti relief; the carefully constructed cubic buildings; and the sunlight that confidently moves across the landscape as if it were but another character in the sacred drama (evening has descended on the right side of the panel, while the sun still shines on the left).[8] Two other *Thebaids*, one by Mariotto di Nardo and the other, possibly by Giovanni Toscani or Angelico himself, are very similar to the picture in the Uffizi, even in such details as the church with the spire in the upper left background.[9] These correspondences suggest that the three pictures were painted for patrons with a common interest.

A *Thebaid* of about the same size as the Uffizi's panel was recorded as by Fra Giovanni (that is, Angelico) in the inventory of the Medici properties after Lorenzo de' Medici's death in 1492,[10] and it is probably the same painting. Its pre-Medici provenance is not known.[11] A Medici could have commissioned it, but more probably it and the other two *Thebaids* were originally made for religious houses.

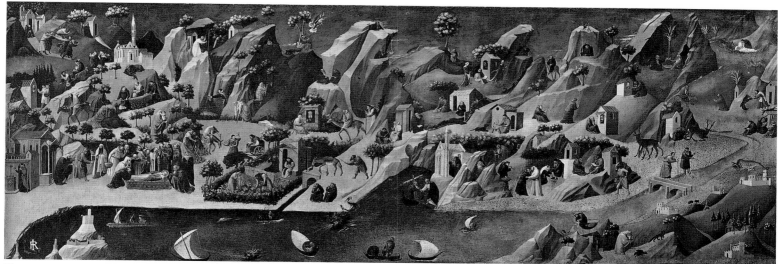

Figure 16. Fra Angelico, *Thebaid*. Galleria degli Uffizi, Florence (447)

The subject was particularly dear to the Observant Servites who had just established a community in the wilderness of Monte Senario, near Florence; the Observant Augustinians, who were largely grouped around Siena; the Observant Franciscans and Dominicans; and two traditional Tuscan monastic orders, the Vallombrosans and Camaldolese. Lorenzo de' Medici had close relations with both the latter orders (Volpi 1934; Elam and Gombrich 1988) and even visited their hermitages at Vallombrosa and Camaldoli, deep in mountainous woods. About 1450 a Camaldolese monk and artist named Giuliano Amidei painted a *Thebaid*, which although not based on the others, suggests that there was a particular tradition for the theme in his order.[12] A previous connection with Lorenzo Monaco, also a Camaldolese monk, may have helped Angelico obtain the commission. This would certainly be true if a model by Lorenzo Monaco stands behind the composition.

Angelico's possible relation to Lorenzo Monaco can be further deduced by a commission for an altarpiece in the church of Santo Stefano al Ponte. It is not known when Angelico received it, but payment was finalized in January and February 1418. This is his first known independent work, and unfortunately it is lost. The contract came from the officials of Orsanmichele, a charitable organization that had been delegated to oversee the decoration of a chapel in Santo Stefano for the late Giovanni de' Gherardini.[13] The elderly Ambrogio di Baldese had been their first choice, and in 1415 he had frescoed the walls.[14] Perhaps Angelico was hired for a more modern look. Another artist was also employed, as Giovanni Dal Ponte, not Angelico, painted the altar frontal. Dal Ponte's documented work from the late second decade of the fifteenth century reflects Lorenzo Monaco. Around the time of the Gherardini Chapel commission, he executed an altarpiece for the Camaldolese nunnery in Pratovecchio (near Florence).[15] Any painter who was then employed by a Camaldolese house surely enjoyed a close association with Lorenzo Monaco. That Giovanni Dal Ponte and Angelico collaborated in Santo Stefano suggests that Angelico was also working in the same stylistic current.

A *Virgin and Child*[16] in Pisa, attributed to Angelico by Carlo Volpe (1973, p. 19), likely resembles the style of the Gherardini altarpiece. Miklós Boskovits (1976b, pp. 34–35) proposed that it constituted the center of a triptych with two panels now in a private collection, one depicting Saints Catherine of

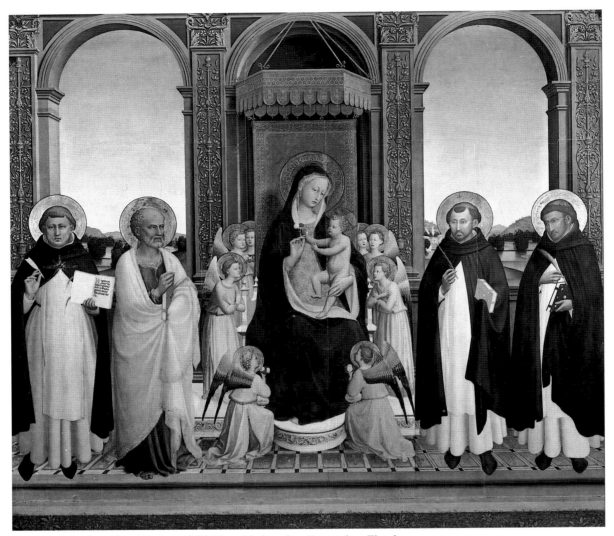

Figure 17. Fra Angelico, *Virgin and Child and Saints*. San Domenico, Fiesole

Alexandria and John the Baptist and the other a bishop saint and Saint Agnes.[17] The picture in Pisa had been owned in the late eighteenth century by Guglielmo Alessandri, prompting Boskovits to suggest a provenance from that family's chapel in the since-demolished Florentine church of San Pier Maggiore.[18] However, neither of the two arms on the original frame belong to the Alessandri or their close relatives the Albizi, who also had chapels there.[19] The best-preserved arms are clearly those of Giugni.[20]

As the Giugni arms are on the distaff, or female, side, it is somewhat problematic to identify who owned the painting; records of Giugni women are sparse. The painting could have been ordered for a wedding or by a widow in memory of her husband. The very fact that the female arms are there implies that a woman had a role in the commission. The Giugni had extensive properties in the Mugello, from whence Angelico came.[21] The family supported the monks of Santa Maria degli Angeli, suggesting another avenue to the early Angelico.[22] Also, several Giugni were Dominican nuns, and possibly one of them ordered the painting: in 1423 Giovanna di Filippo Giugni, widow of Giovanni di Andrea di Ugone, and her three daughters entered the Dominican Observant convent of San Pier Martire,[23] and in 1427 a Nicolosa Giugni is recorded in San Giuliano.[24]

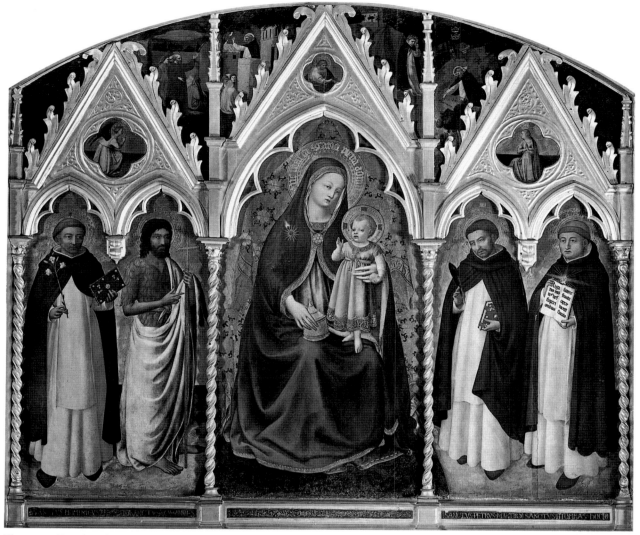

Figure 18. Fra Angelico, *Virgin and Child and Saints* and *Stories of Saint Peter Martyr*. Museo di San Marco, Florence

The *Virgin and Child* in Pisa and the two panels with saints are the paintings by Angelico that stylistically most resemble Lorenzo Monaco's work. Probably dating no later than the early 1420s, they demonstrate not only his total mastery of that artist's lessons but also that he was ready to move on. Whatever his early professional associations with Lorenzo and Santa Maria degli Angeli were, when Angelico embarked on the religious life, he made a conscious choice not to join that monastery. With Lorenzo still at the helm, Santa Maria degli Angeli had no use for another master painter, and the new convent in Fiesole offered more for a promising young artist.

It has often been suggested that during the required two-year novitiate Angelico gave up painting or turned to a supposedly more fit pursuit like illumination.[25] Neither scenario seems very likely, and in any case we do not know when the novitiate took place. One of Angelico's earliest tasks as a Dominican artist may have been for Santa Maria Novella. An early source, known as the *Libro* of Antonio Billi (ca. 1481–ca. 1530; 1892, p. 20), says that Angelico "giovanetto," or the young artist, painted some frescoes there as well as an *Annunciation* on canvas used for the protection of the pipes of an organ. Other works described by early sources may have been made for the church's consecration in 1420.

Angelico's first job at San Domenico, probably still a mass of bricks waiting to be mortared, was the principal altarpiece of the church, which the friars would have needed for services. This is the triptych (fig. 17) now in a chapel of the nave. The apostle Barnabas appears to the Virgin's right because the picture was paid for by Barnaba degli Agli's bequest. The Virgin and the angels are still dependent on Lorenzo Monaco, indicating that it is an early work. As the triptych was completely transformed in 1501, another near-contemporary painting (fig. 18), made for San Pier Martire in Florence, must serve as a guide to its original appearance.

Like San Domenico, San Pier Martire was a new Dominican Observant house. It had been established in late 1419 by Leonardo Dati in a former palace of Niccolò Buondelmonte, near the Porta Romana.[26] The first nuns came from Pisa early the next year, and soon widows and young women from prominent Florentine families joined the community.[27]

San Pier Martire's administrator, Fra Jacopo di Giovanni da Palaia, undoubtedly arranged for Fra Angelico's commission,[28] but its date is a disconcerting problem. In February 1429 the nuns are recorded as still owing San Domenico for the painting, and a further payment on January 10, 1430, made from the funds of a rich young nun, Apollonia Nicoli, may also refer to the triptych.[29] According to Giovanni Gaye (1839, p. 550), renovation of the nunnery was not completed until 1428. But the triptych's execution need not depend on any of these factors. A description of the church says that it was small and contained only one altarpiece.[30] The altar would have been put to use first, and payment for the painting made in installments lasting several years.[31]

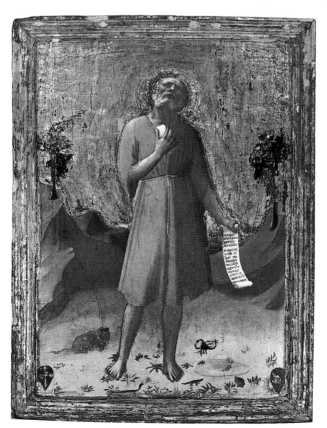

Figure 19. Fra Angelico, *The Penitent Saint Jerome.* The Art Museum, Princeton University; Bequest of Frank Jewett Mather Jr. (63.1)

Whereas Angelico's San Domenico triptych recalls Lorenzo Monaco, the San Pier Martire triptych has changed totally in the direction of Masaccio. Even the colors betray a new attitude: Angelico has abandoned Lorenzo's subtle tonal variations for more saturated and enamel-like hues. A likely date for its execution is in late 1424 or early 1425, as the Virgin most resembles Masaccio's contribution to the *Sant'Anna Metterza* altarpiece, painted in collaboration with Masolino for the church of Sant'Ambrogio probably sometime in late 1424.[32] The San Pier Martire triptych has often been compared with Masaccio's Pisa altarpiece of 1426, but the visual connections with that more-advanced stage of Masaccio are actually minimal. Lorenzo's death in May 1423 or 1424 may have had a liberating influence on Angelico that encouraged him to break away from his master's mode. The triptych seems to record that moment. Angelico's first appraisal of Masaccio would have been with that artist's most recent

work in Florence, and that was then the *Sant'*
Anna Metterza altarpiece.

A picture that documents Angelico's transi-
tion from the language of Lorenzo Monaco to
that of Masaccio is the *Penitent Saint Jerome* (fig.
19) in Princeton. It was once owned by Robert
and Elizabeth Barrett Browning (Eisenberg 1976,
esp. pp. 280–81); Robert described it in *Old Pic-*
tures in Florence (stanza 26) as "Some Jerome that
seeks heaven with a sad eye."

The saint looks like the ancient bronze figu-
rines sophisticated Florentines were then begin-
ning to collect. He could also have stepped out of
one of Ghiberti's reliefs for the first doors for the
Florentine Baptistery, which were finished and
put up on Easter Sunday (April 19) 1424. Essen-
tially, however, the *Jerome* is a study in the effects
of light and how light makes a body three-
dimensional and volumetric.

As with the Uffizi's *Thebaid*, the attribution
is Roberto Longhi's (1940, p. 174). Recently, the
picture had been accepted as by Giovanni

Figure 20. Fra Angelico, *The Virgin Annunciate*. Detail of an altarpiece. Museo di San Marco, Florence, on deposit from the Galleria degli Uffizi

Toscani, formerly known as the Master of the Griggs Crucifixion (Eisenberg 1976). That painter's name
piece, the Griggs *Crucifixion* (cat. no. 46), in The Metropolitan Museum of Art, is here also attributed
to Angelico. Angelico and Toscani followed similar directions. Like teenagers crazed for the latest rock
star, both artists went through all the mood swings that any young painter growing up in Florence in
the early 1420s would experience: Lorenzo Monaco, Gentile da Fabriano, and Masaccio. Angelico and
Toscani must have kept an eye on each other's work. For example, the kneeling Virgin of the
Annunciation in Angelico's altarpiece from the charterhouse of Galluzzo (fig. 20)[33] derives from
Toscani's similar figure in an altarpiece of 1423–24 for the Ardinghelli Chapel in Santa Trinita.[34]

Gentile da Fabriano, next to whom Toscani worked in Santa Trinita, smoothed these artists' way to
Masaccio. The Griggs *Crucifixion*, *The Adoration of the Magi*[35] in the Abegg-Stiftung, and the Princeton
Jerome represent the phase when Angelico was most like Gentile, about 1424 to early 1425.

The *Jerome* has two coats of arms that help date it. They indicate that it was made for Angelo di
Zanobi di Taddeo Gaddi and Maddalena di Niccolò Ridolfi. The two married in 1424, and the picture
was probably made for or soon after that event. It is therefore Angelico's first known work that can be
dated with some certainty. Gaddi is also the first patron of Angelico about whom some information can
be gleaned. A nephew of the painter Agnolo Gaddi and grandson of the painter Taddeo, he was one of
the richest men in Florence. His library survives in part and testifies to his scholarly ambitions as well as
religious interests.[36]

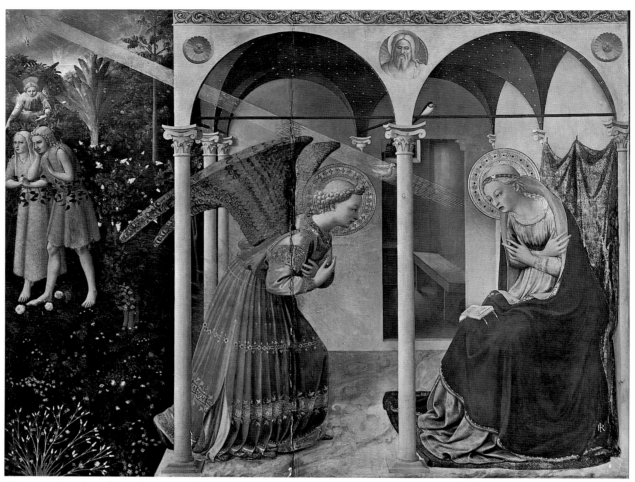

Figure 21. Fra Angelico, *The Annunciation*. Museo del Prado, Madrid (15)

The Princeton panel suggests that Gaddi was a devotee of Saint Jerome. We know that he even baptized a son with the name.[37] The saint was enjoying a great revival in Florence due to the hermits of Saint Jerome who had settled in Fiesole in the late 1300s. Whereas Florentines of the mid-trecento may have imagined Fiesole's hills running with nymphs as Boccaccio described them in the *Ninfale fiesolano*, in Angelico's day it resembled the *Thebaid* in the Uffizi, as hermits and friars had in the meantime populated the woods. The Hieronymites were particularly close to the Dominican Observants, who took over the spiritual care of a confraternity that had been founded in the hermits' oratory (Ridderbos 1984, pp. 76–83) but was relocated to Florence in 1413. The friars became the lonely Hieronymites' window on the world. In official processions they even paraded under the Observant banner (Ridderbos 1984, pp. 78–79).

Gaddi's commission of the Browning/Princeton *Jerome* was not a casual encounter with San Domenico. Like many prominent Florentines he had an interest in the growth of the Observant convent. His own relationship to the Dominican order was particularly close. A maternal uncle, Sinibaldo del Ricco Aldighieri, served as prior of Santa Maria Novella several times.[38] Giovanni Dominici had vested him as a friar in 1397–98. Gaddi's mother, Caterina, was part of Dominici's female clique: Gaddi himself jealously preserved a manuscript of Dominici's *Regole della vita religiosa* copied

out by his mother's hand in 1410 (BNCF, Magliabecchiano xxxv.89). In 1420 Gaddi made a donation to Santa Maria Novella for its consecration by Cardinal Giordano Orsini (Orlandi 1964), and in 1446 he established a familial sepulcher chapel in the church (Paatz and Paatz 1940–54, vol. 3, p. 752). His brother Luigi and mother also made large bequests to San Domenico, Fiesole. These legacies may have paid for one or both of the altarpieces Angelico painted after the triptych (fig. 17) for the high altar. They are the *Annunciation* (fig. 21) in the Prado and the *Coronation of the Virgin* (fig. 22) in the Louvre. The friars would not have had Angelico paint these altarpieces unless there were patrons willing to sustain the financial expenses of the chapels.[39] Besides paying for the construction and decoration, patrons endowed the maintenance costs, which ranged from the priest to the candles.

The altarpieces' patronage has not been investigated, but besides contributing to the social circumstances of Angelico's art, identification of the patrons might help settle questions of chronology. There is only an ample terminus ante quem: an early-sixteenth-century chronicle records that when the altars were consecrated in 1435,

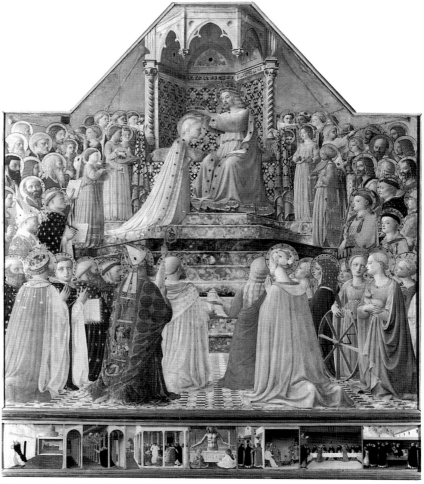

Figure 22. Fra Angelico, *The Coronation of the Virgin*. Musée du Louvre, Paris (314)

they had been provided with pictures by Angelico many years before ("plures annos antequam consecrata esset ecclesia predicta" [Orlandi 1959–60, vol. 2, pp. 111–12, doc. 15]). The *Coronation* has often been put as late as 1434–35, although Pope-Hennessy (1974) went as late as the 1450s. Some scholars have considered the *Annunciation* a workshop piece that had to date after the *Annunciation* of the early 1430s in Cortona. Indeed, a date in the early 1430s would put that painting in the sphere of Angelico's workshop because its hesitant perspective (despite the fact there is a single vanishing point), and some of its excessive detail, like the flowers in the meadow, recall the mode of Gentile da Fabriano. This could have interested Angelico in the mid-1420s but not in the 1430s.

The evidence for a Gaddi patronage of the *Annunciation* and *Coronation* is not firm, but indications are quite compelling. In 1488 Angelo Gaddi's son Taddeo paid for two new chapels in San Domenico's nave, to which Angelico's two paintings were removed (Chronica 1516, *carta* 4v; Ferretti 1901, p. 39). This transfer implies a previous Gaddi claim on the altarpieces. Furthermore, several saints in the foreground of the *Coronation* bear names of members of Angelo Gaddi's immediate family.[40] On the far left is Saint Louis—Louis IX of France. Although a supporter of Thomas Aquinas, who kneels next to him, Louis rarely appears in Dominican art, as he was the uncle of the Franciscan saint Louis of

Figure 23. Fra Angelico, *The Crucifixion*. San Domenico, Fiesole

Toulouse. However, Luigi, or Louis, was the name of Angelo's aforementioned brother who died about 1427 and who even had a farmhouse next to San Domenico.[41] The tax statement drawn up for his two bastard orphans contains a notice of a bequest to his maternal uncle Sinibaldo.[42] Sinibaldo managed a number of the family's charitable affairs: in 1431 Angelo Gaddi named him as a debtor for an unspecified bequest (ASF, *Catasto* 380, *carta* 39v), and a memorandum drawn up by Pietro d'Antonio Cecchi, the prior of San Domenico, on March 30, 1429, registers that after Sinibaldo's death the convent would be owed two hundred florins left to it by his sister Caterina.[43] In 1428 Sinibaldo himself endowed a chapel in San Remigio possibly on behalf of a Gaddi.[44] He most likely oversaw Gaddi dealings with San Domenico. A likely scenario is that the *Annunciation*, the earlier panel, was paid for with the money left by Luigi, who died in 1426 or 1427, and the *Coronation* with the bequest mentioned as left by Caterina in 1429.

I would like to propose a different alternative for the *Annunciation*, one that is entirely based on circumstantial evidence.[45] While I doubt it is correct, I mention this possibility as a way of understanding the richness of patronage at the convent and some of the people whom Angelico knew and worked with in the mid-1420s. Stylistically, the panel dates about 1426, which is the same year an important new friar entered the convent. His name was Bernardo Bartolini, and he brought with him a considerable inheritance from his father, Lorenzo, who died two years previously.[46] The legacy was managed by his mother, Giovanna di Antonio de' Cavalcanti. Either he, his mother, or a brother could have arranged to pay for the altarpiece. In 1429 his uncle Salimbene was also said to owe the convent money.[47] Both the Bartolini and Cavalcanti families were particularly devoted to the Annunciation. Salimbene and Bernardo's father had founded the chapel in Santa Trinita dedicated to the Annunciation, the decoration of which (Bellosi 1979, p. 62 n. 5) they commissioned from Lorenzo Monaco about 1415–17. The Cavalcanti were a large *consorteria*. *Annunciations* adorned at least two family sepulcher chapels: their chapel in the sacristy of Santa Maria Novella had an *Annunciation* by Giovanni del Biondo, and another Cavalcanti commissioned Donatello's *Annunciation* for Santa Croce. The Bartolini also owned a painting by Angelico of the *Thebaid*.[48]

The original location of the *Annunciation* and *Coronation* are not known. They may have stood on

altars in the rood screen of San Domenico, the Agli triptych (fig. 17) on the high altar behind them. They represent three distinct moments in early Angelico and show how quickly he developed in an arc of about seven years. The Prado and Louvre pictures are visibly more mature than the triptych. No other Florentine altarpiece of the 1420s quite resembled them. It is no wonder that their date and authorship have been questioned. The *Annunciation* is the first Florentine altarpiece to be a "tabula quadrata et sine civoriis" (an unornamented square panel)—such was the prescription that the architect Filippo Brunelleschi imposed in 1425 upon the paintings that would decorate his church of San Lorenzo. The main scene is painted on a rectangular panel with absolutely no gothicizing paraphernalia. With the predella the painting measures a perfect square. The Louvre's *Coronation* is a sophisticated study in perspective, which like Masaccio's fresco *The Trinity*[49] in Santa Maria Novella, is one of the first Florentine pictures to place a heavenly triumph in a totally believable space that could, if called for, be measured with a surveyor's instruments.

Nowhere is it more evident than in the *Coronation* that Masaccio was Angelico's great model. Painted shortly after Masaccio's death, it crystallizes many new ideas implicit in that artist's body of work. With Masaccio the art of painting became a science that strove to bestow a rational underpinning to the visible world. In this Angelico was Masaccio's closest follower. Throughout the 1420s the friar kept close tabs on Masaccio's doings and tried to integrate each new innovation into his own work. Indeed, the predella panels included in this volume (cat. no. 47) show how closely Angelico depended upon him. In his 1550 life of Masaccio, Giorgio Vasari listed Angelico as the first artist to have studied and profited from the frescoes of the Brancacci Chapel in the Carmine. Angelico took quick account of their innovation. He understood that Masaccio's art, which openly celebrates the human figure and brings it into tangible contact with its surroundings, could also serve as sacred imagery that exhorts its viewers to overcome corporal concerns in favor of a spiritual existence.

The *Coronation*'s insistence on volumetric form finds a counterpart in another work for San Domenico, the little-appreciated fresco of the crucified Christ (fig. 23), located high on the end wall of the chapter room. That fresco might date as early as 1426 and therefore probably a few years before the altarpiece. Masaccio had similarly foreshortened Christ's head in the pinnacle panel of the *Crucifixion* for the 1426 degli Scarsi altarpiece for the church of Santa Maria del Carmine, Pisa.[50] However, a large-scale fresco presents a different sort of compositional problem than a small panel painting does. For example, in the *Trinity* Masaccio made no such experiment with Christ's head. As in traditional representations, it leans to one side. Only Angelico would have taken such a daring step in a large fresco. Christ's head inclines directly forward so that the features of his face are obscured. Angelico wanted to tease the limits of perspective and foreshortening. A friar coming into the room from the church would have been immediately confronted by this imposing image then directly opposite the entry. He could not have been but dazed by the startling effect, which is made more realistic by its position and scale. Yet Angelico seemed to realize that the dramatic result was not totally successful, and he never did it again.

Jobs at San Domenico were tied to funding and the construction of the convent. Consequently, Angelico sought outside work. With the departure of Gentile da Fabriano, Masolino, and Masaccio from Florence to the Rome of Pope Martin V, he was winning the city's best commissions. His patrons consisted of private citizens and other religious houses. Two altarpieces were commissioned for the Dominican church in Cortona, where the friars had lived for a period while in exile, and another picture

was made for the Guidalotti Chapel in San Domenico, Perugia.[51] The Observant Servites of Brescia in northern Italy also ordered an altarpiece from him.[52] The tabernacle for the meeting hall of the Linen Workers' Guild was executed in 1433–36 in collaboration with the sculptor Lorenzo Ghiberti. For it Angelico acted as the sculptor's alter ego. The saints in the wings are based on Ghiberti sculptures.[53]

Angelico's affiliation with San Domenico was decisive in the tabernacle's commission because the son of the guild's *procuratore*, Giuliano di Filippo Lapaccini, had just professed as a friar (Orlandi 1964, p. 44). Angelico already knew the family because Giuliano's father had provided the altar curtain for Santo Stefano's Gherardini Chapel in 1417 (Orlandi 1964, p. 169, doc. 2). Family connections may also have helped with the commission to complete the *Deposition*, left unfinished by Lorenzo Monaco, for Palla Strozzi's chapel in the sacristy of Santa Trinita.[54] Two friars at San Domenico, Marco Bartolini and the aforementioned Bernardo, his brother, had close relations with Santa Trinita, their former parish.[55] In 1429 Marco was sent to collect money from Strozzi's bank, and in 1432 further sums were paid out. Shortly after, the altarpiece is said to have been installed (Orlandi 1959–60, vol. 2, pp. 119–22, doc. 23; Orlandi 1964, pp. 47–48; Padoa Rizzo 1982; Jones 1984, pp. 38, 68, doc. 45; Joannides 1989, p. 308 n. 12).

Angelico's time-consuming commitments did not go unnoticed by his contemporaries. When on April 1, 1438, the painter Domenico Veneziano solicits Piero de' Medici in a letter written from Perugia, he reminds him that a "good master" like "Fra Giovàne" has "much work to do" (Wohl 1980, p. 340). Piero would have already known this, as the Medici were undertaking to sponsor Angelico's next great and most onerous project—San Marco. Angelico's outside commissions were put on hold sometime after 1436, when his fellow friars took over the former Silvestrine convent. Michelozzo began its reconstruction in 1438, and from about that year to at least 1443, Angelico and his workshop undertook the decoration. They painted the church's high altarpiece and frescoed the chapter house, cloister, and cells. In January 1443 Pope Eugenius IV consecrated the church, but work in the convent may have continued until as late as 1445.

At San Marco Angelico was in the employ of Piero's father, Cosimo de' Medici, who paid for the renovations. The altarpiece is a magnificent celebration of this patronage.[56] It is often considered to be the first Renaissance *pala*, or altarpiece, because the polyptych's elaborate gothicisms have been abandoned. Angelico constantly challenged older altarpiece conventions. His early *Annunciation* for San Domenico already took account of Brunelleschi's new geometric rules for an altarpiece, which had to be *quadrata*, or square.[57] The San Marco picture has a rectangular picture field in which there are no framed divisions between the saints and the Virgin. This composition became known as a *sacra conversazione* (holy conversation) because it unified the figures within the same space as if at a social gathering. Whether this is the first example of the type is an open question. Another one made for Cosimo de' Medici, the so-called Annalena altarpiece, may predate it.[58] Whatever picture has precedence, the *sacra conversazione* seems to have been Angelico's personal invention.

The great undertaking of San Marco over, Fra Angelico went to Rome. In 1447 he is recorded as frescoing the no-longer-extant Sacrament Chapel in Saint Peter's and during the summer months the San Brizio Chapel in Orvieto cathedral (later finished by Luca Signorelli). From 1448 he frescoed several chapels in the Vatican Palace for Pope Nicholas V. His last project in Florence was the doors of the silver cupboard for Santissima Annunziata, which were commissioned in 1448 by Piero de' Medici.

Angelico worked on them over the next few years, relying heavily on assistants, because he was himself in Florence only rarely. In 1450 he was prior of San Domenico, and in 1452 he had to turn down the commission to fresco the choir of the Collegiata in Prato, a project subsequently undertaken by Filippo Lippi.

The pictures for the Annunziata earned the painter the name Fra Angelico, meaning the angelic friar. (This put him on par with that other great Dominican the theologian Thomas Aquinas, who was known as the Angelic Doctor.) He is first described as such by his fellow Dominican Fra Domenico da Corella in the *Theotocon*, written about 1468,[59] thirteen years after Angelico's death.[60] The epithet gained particular popularity after 1836 with the publication of Auguste-F. Rio's *De l'art chrétien*, a book that glorified the Christian spirit of Angelico's art. The name is still used today. In 1481 Cristoforo Landino used the word to characterize the painter's style: "Fra Giovanni angelico et vezoso et divoto et ornato con grandissima facilità" (Fra Giovanni, angelic and blithely charming, devout and ornate with the greatest of ease).[61]

1. Other orders were setting up similar communities in the area. After the Observant Franciscans came to Fiesole in the late fourteenth century, they received a large donation in 1399 from Guido di messer Tommaso del Palagio (Dei 1907, pp. 20–22). In 1404 the Servites established a reform community on Monte Senario. The community's new church was paid for by Ugo della Stufa and his wife Nicolosa Baroncelli in 1417 (Dal Pino, in *Istituti* 1980, cols. 705–6). Nicolosa later joined the Dominican Observant nunnery of San Pier Martire. In 1418 the Observant Franciscans started building on San Miniato with funding from Luca di Jacopo Della Tosa (Pellechia Nejemy 1979, pp. 272–75). See also Rubinstein 1990.

2. His birth date is not known, but he was undoubtedly over the minimum age of eighteen imposed by the Observant rule (see the *Constitutions* in Hood 1993, p. 292). In regular convents boys entered as early as fourteen. See Gilbert 1984 and also n. 4 below.

3. Agli asked that the friars "celebrare divina officia continuo" (Orlandi 1959–60, vol. 2, p. 97). On their life see Hood 1993.

4. This document is a 1564 transcription of the original (Cohn 1955). Except for Centi (1984, pp. 48–49), most scholars accept it. Centi noted that the persons named as rectors at the time of Angelico's entry are those who led the confraternity between 1400 and 1411, whereas the rectors in 1417 were different. Furthermore, although his lay name is given, Angelico is called frate. Other members who became friars are not designated with the title. Angelico would be the exception. These discrepancies merit explanation. Unfortunately, in 1966 the 1564 transcription was damaged in the flood. Part of the relevant page is reproduced in Orlandi 1964, pl. 11.

5. Sponsorship need not presuppose a professional relationship. On January 6, 1417, Sanguigni stood for Capponcino de' Capponi, who was not an artist (Orlandi 1964, p. 170, doc. 3).

6. Information that he comes from Empoli is in the will of Jacopo di Niccolò Corbizzi, who named Sanguigni an executor as well as a legatee. The other executors were Maso di Domenico di Rinaldo degli Albizi and the artist Zanobi Strozzi's brother Francesco. Corbizzi left monies to San Domenico as well as two books to San Pier Martire (Orlandi 1959–60, vol. 2, p. 128).

7. Lorenzo Monaco, a monk at Santa Maria degli Angeli, had a similar business relation. He rented a house from it (Eisenberg 1989, pp. 4, 49 n. 6, 212–13, doc. 11).

8. Drawings dated 1417 in the Fogg Art Museum, Cambridge, the Albright-Knox Art Gallery, Buffalo, and the Museum Boymans-van Beuningen, Rotterdam, illustrating the pilgrimage of a Dominican tertiary, Pietro della Croce, closely relate to the *Thebaid* (Degenhart and Schmitt 1968, pp. 274–76, nos. 173–79, pls. 198–99, 200a, b). The subject suggests a Dominican provenance. An attribution to Angelico or his circle has been advanced by Clark (1930, p. 175), Longhi (1940, p. 173), and Pope-Hennessy (1952, p. 205; 1974, p. 234).

9. These *Thebaid*s have been cut into fragments. Callmann (1957, p. 150 n. 7) recognized that the one by Mariotto di Nardo (Boskovits 1968a, p. 7) consists of both a panel in the Keresztény Múzeum, Esztergom (inv. no. 55.168), and another formerly in the Davenport Bromley collection (sale, Christie's, London, June 28, 1974, lot 47).

The other *Thebaid* consists of a panel in the Szépmüvészeti Múzeum, Budapest (inv. no. 7), and a panel once in the Bartolini Salimbeni collection (sale, Palazzo Internazionale delle Arte ed Esposizioni, Florence, November 20, 1970, lot 113). It was reconstructed by Boskovits (1968d) as early-fifteenth-century Florentine. Boskovits (in Warsaw 1990, p. 60 n. 12) has recently suggested the young Angelico, and De Marchi (1992, pp. 148–49 n. 53) Giovanni Toscani. The Bartolini Salimbeni provenance suggests a commission for the Vallombrosans of Santa Trinita or the Dominican Observants in Fiesole.

The Bartolinis had a chapel in Santa Trinita, and two Bartolinis became friars at Fiesole (Orlandi 1959–60, pp. 42–44).

10. "Nell'andito che va alla camera di Piero in una salletta: una tavoletta di legname di bra. 4 in circha, di mano di fra Giovanni, dipintovi più storie dei santi padri" (Gaeta Bertelà and Spallanzani 1992, p. 80). It was valued at 25 florins. Longhi (1940, p. 183 n. 17 [bis]) first noted the correspondence. Callmann (1975, p. 22 n. 74) recorded the entry without relating it to the Uffizi painting or Angelico. Bellosi (in Uffizi catalogue 1979, p. 487) and Conti (in Florence 1992, p. 41) recently reproposed it. The Medici had another *Thebaid* in their villa at Careggi (Gaeta Bertelà and Spallanzani 1992, p. 133).

11. Ignazio Hugford owned it in the late eighteenth century. Callmann (1975, pp. 18–19) suggested that he bought it from his brother Enrico, abbot of Vallombrosa. The Medici provenance precludes this.

12. For a reconstruction of Amidei's *Thebaid* and the recent literature, see Callmann 1957; Freuler 1991, pp. 250–52; and Damiani, in Berti 1992, pp. 84–86.

13. Orsanmichele's officials changed periodically. In the six months before Angelico was paid, they were Bartolo di Schiatto di Ridolfo, Niccolò Bartolini, Ugolino di Jacopo Macinghi, Antonio di Ser Tommaso Masi, Bartolo di Francesco Panni, Antonio di Piero Guidoni, Leonardo Antonio Nobili, and Rainaldo di Filippo Rondinelli (ASF, *Capitani di Orsanmichele*, 25, *carta* 19).

14. As far back as 1389, Ambrogio executed an altarpiece for the church (Paatz and Paatz 1940–54, vol. 5, p. 233). More recently, in 1412 Mariotto di Nardo had painted one for the chapel of Paolo di Filippo Tolomei Gucci. This was overseen by the Orsanmichele (ibid., pp. 223–24), which had received the bequest in 1365. However, the political exile of Tolomei Gucci probably accounts for the considerable delay in the commission.

15. National Gallery, London (inv. no. 580); see Guidi 1968, fig. 11.

16. Illustrated in color in Pisa 1993, pp. 83–84. The painting has traces of attachment on the sides, but it could also have been an independent panel.

17. First published by Pope-Hennessy (1974, p. 190, figs. 7, 8, and details pls. 8, 9).

18. The Alessandri had a trecento altarpiece by Lippo di Benivieni, to which about 1450 Benozzo Gozzoli added a predella. Four panels of this predella are in The Metropolitan Museum of Art (Zeri and Gardner 1971, pp. 9–10). A fifth is missing. The altarpiece was in the *cappellone*, or large chapel, where there was another altar belonging to the Fioravanti (Paatz and Paatz 1940–54, vol. 4, p. 640) with an altarpiece by Lorenzo Monaco (Vasari 1906, vol. 2, p. 20). In 1405 Maso di Niccolò Albizi had married Maddalena di Bartolomeo di Neri Fioravanti.

19. I thank Monica Bietti Favi for telling me that the arms cannot be those of either the Alessandri or the Albizi. The Alessandri were an offshoot of the Albizi; they took on the new name in 1372. Angelico was in close contact with the Albizi. On May 7, 1441, his sister Checca was named as a legatee of Guglielma, widow of Jacopo di Alessio Albizi. Her son Alessio was an Observant friar and in Rome at the same time as Angelico and his nephew Giovanni di Antonio, Checca's son (Orlandi 1959–60, vol. 1, pp. 64, 196–97; Orlandi 1964, pp. 71 n. 1, 85, 95–96, 109–11, 155, 189). Angelico oversaw aspects of Guglielma's inheritance (Orlandi 1954, pp. 186–88).

20. A red field with three silver hooves and a gold band at the top. The other arms are very worn. The bottom third of the shield is worn, although there are traces of blue paint. The top part consists of a descending blue band against a white field.

21. In San Jacopo at Cavallina, Repetti (1833–46, vol. 1, p. 694) saw a now-lost painting of the Virgin with an inscription identifying its commission in 1419 by Antonio di Domenico Giugni and his wife Ghetta di Giovanni Villani. It may have been a *Virgin and Saint Anne* seen by Guido Carocci on May 1, 1914 (SBASF, Ufficio Catalogo, *Schede Carocci*).

22. Although in the Badia there is a tomb of Bernardo di Filippo Giugni by Mino da Fiesole, the family has not been studied. Bernardo was a benefactor of Santa Maria degli Angeli (Cherubini 1723, p. 14). In later centuries the Giugni maintained a chapel there (ibid., p. 15; Paatz and Paatz 1940–54, vol. 3, p. 128). The palace the family acquired in 1640 was across the street. Besides Cherubini, see a family history by Niccolò di Andrea Giugni of 1603 (BNCF, Passerini 188) as well as Vespasiano da Bisticci on Bernardo (Del Furia 1843; Vespasiano da Bisticci 1976, vol. 2, pp. 321–29).

23. ASPMF, *Cartapecore*, *filza* 1, no. 7. The daughters were Brigitta, Chiara, and Giovanna. I thank Lucia Meoni for this information.

24. That year she made a loan (BNCF, *Poligrafo Gargani*, *carta* 398).

25. The *Constitutions* (in Hood 1993, p. 293) state that "novices within their probationary period should apply themselves . . . to the study of psalmody and the Divine Office. During their first year . . . time [should not] be taken up with any house job [in aliquo officio]."

26. The sale from the Augustinian nuns of San Gaggio was arranged by a priest of Santa Maria degli Ughi with funds from Niccolò di Giovanni da Uzzano, Amideo di Sante del Ricco (Aldighieri?), and Jacopo di Niccolò Corbizzi (ASPMF, *filza* 1, *Contratti e scritture dal 1416 al 1730*, no. 51, ins. 1). Lucia Meoni kindly shared her research on San Pier Martire.

27. Margarita Spini, widow of Bartolomeo Baldesi, entered San Pier Martire along with her daughters, making a will in the convent's favor on February 13, 1421 (ASPMF, *Estratto delle cartapecore*, *filza* 44, no. 30). Soon after, Donna Nera di Piero di Filippo Albizi, widow of Niccolò di Tornaquinci, became a nun (ASF, *Diplomatico*, San Pier Martire, 22). In 1423 a woman from Sesto Fiorentino, Donna Lapa, joined with the consent of her husband (ibid., 24). Bartolomea Portinari, a young novice, made the convent her heir on April 9, 1426 (ASPMF, *Cartapecore*, *filza* 45, no. 45). Piccuola di Giorgio di Tommaso

dell'Antella, wife of Piero di Michele, became a sister on the same day, naming Jacopo di Niccolò Corbizzi her *procuratore* (ASF, *Diplomatico*, San Pier Martire, 25). On the Giugni see n. 23 above. On Corbizzi see n. 6 above.

A principal figure was the vice-prioress Nicolosa Baroncelli. She and her late husband, Ugo della Stufa, had also made a hefty donation to the Servite hermitage of Monte Senario. His will dates August 22, 1415 (ASF, *Diplomatico*, San Pier Martire, 18). In 1421 Nicolosa confirmed its provisions. A copy of her will, which I have not consulted, is in the Archivio Generale of the Servite Order in Rome (*Annalistica* A, *filza* I, conventi, 101). On the couple see n. 1 above. Ugo's brothers founded a chapel in the church of San Lorenzo (ASF, *Catasto 78, carta* 86).

28. Fra Jacopo came from the Pisan convent of Santa Caterina (Orlandi 1955, vol. 2, p. 152). He was strict about conceding patronage rights. Spini renounced them although she gave the convent a considerable patrimony (see n. 27 above).

29. Meoni 1993, p. 165 n. 255. A wealthy fourteen-year-old orphan (ASF, *Catasto* 65, *carte* 264–65), Apollonia entered in 1427.

30. It also seems to have been frescoed. "La chiesa fuori era piccolina Quasi era tutta dipinta ipse chiesa con uno solo altare con bella et devota tavola" (ASPMF, *filza* II, docs. 1660–1771, no. 55, ins. 24, n.p. [*carta* 2]). The convent was destroyed in 1510, so this seventeenth-century account must be based on earlier sources.

31. Payments for Angelico's tabernacle for the Linen Workers' Guild took three years to settle.

32. See Joannides 1993, colorpl. 68. Only the central part of this altarpiece, now in the Uffizi, survives. The lateral panels seem to have been lost as early as 1568 because Vasari does not describe them. The picture is not mentioned in the first edition of his *Lives*.

33. The original location and patron are not known.

34. Boskovits 1976a, fig. 23b.

35. Ibid., colorfrontis.

36. Only Brunetto Latini's *Thesaurus* (BMLF, Gaddi 4) has an illumination (fol. 1, marked 8). It is an author portrait by an early trecento Florentine artist in the letter S. Another manuscript, Domenico Cavalca's *Speculum peccatorum* (BMLF, Gaddi 82), was originally owned by Gaddi's wife Maddalena. Among his books is an autograph copy of Giovanni Gherardi's *Philomena*, a poem in imitation of Dante (BNCF, Magliabecchiano VII.702; on this see Lanza 1989, pp. 182–88). On the library see Fava 1939, pp. 35–36, and Bec 1981, pp. 197–98. Gherardi was also the author of the better-known *Paradiso degli Alberti* as well as the Dante lecturer at the convent of Santa Maria Novella in the late second and early third decades of the fifteenth century. Gaddi's interest in Dante may be due to the fact that his mother, Caterina Aldighieri, was said to be related to the poet.

The Gaddi family made its artistic origins a matter of pride in the early quattrocento. Angelo or another relative undoubtedly commissioned the triple portrait, probably by Domenico di Michelino, of the three Gaddi artists, Gaddo, Taddeo, and Agnolo, now in the Uffizi (inv. no. 3281; Uffizi catalogue 1979, illus. p. 861).

37. A seventeenth-century printed genealogy (ASF, *Manoscritti [Carte Dei]*, 389, int. 26, *carta* 1) gives Girolamo, or Jerome, as the firstborn. In the tax declaration of 1427 (ASF, *Monte comune o delle graticole, copie del catasto dell'archivio del Monte*, 87, fol. 12), no such son is listed, but he could have died in infancy. In 1430 the Gaddi named their third son Girolamo (ASF, *Catasto* 380, fol. 40).

38. On Sinibaldo see Orlandi 1955, vol. 2, pp. 196–99. Educated in England and Paris, Sinibaldo had been a professor in Bologna. He was prior in 1433, when Pope Eugene IV moved into Santa Maria Novella. Sinibaldo was disinherited by his maternal grandmother in favor of his sisters Caterina and Andreuola. Caterina left him income that she designated should eventually go to San Domenico (see Orlandi 1959–60, vol. 2, p. 123).

39. San Pier Martire reimbursed Angelico's convent for its altarpiece, but the funds certainly came from an outside patron. The patron of Angelico's *Annunciation* for San Domenico in Cortona has not been identified. His other polyptych there may have been paid for by Giovanni di Tommaso di Cecco (Cole 1977b). A Guidalotti commissioned the altarpiece for San Domenico in Perugia. On his identity see Orlandi 1964, p. 61 n. 3, and Pope-Hennessy 1974, pp. 198–99.

40. Zenobius, the name saint of Angelo's father, is next to Thomas Aquinas. An apostle, possibly Thaddeus, the saint of his grandfather, kneels at the foot of the throne. There are also Mary Magdalen, the saint of Angelo's first wife, and Catherine of Alexandria, that of his mother and eldest daughter.

41. It was left to·Angelo (ASF, *Monte comune o delle graticole, copie del catasto dell'archivio del Monte*, 87, fol. 11v). Another brother, Taddeo, was born in Venice in 1391 while his father was on a diplomatic mission there (BNCF, *Poligrafo Gargani*, 885, *carte* 293, 294). He retained Venetian and Florentine citizenship.

42. ASF, *Catasto* 79, *carta* 617v. Luigi also made bequests to the monks of Santa Maria degli Angeli, the nuns of San Niccolò dei Freri at Porta San Piero Gattolino (now known as San Giovanni Battista della Calza [Paatz and Paatz 1940–54, vol. 2, pp. 272–84]), and the Observant friars of San Francesco in Fiesole. Luigi was still alive for part of 1426, during which he paid for a *feudo* granted him by Cardinal Amerigo Corsini (BNCF, *Poligrafo Gargani*, 885, *carta* 161).

43. Orlandi 1959–60, vol. 2, p. 123. This same document lists several outstanding bequests. Any number could have been toward the endowment of chapels. The names are Nepi de' Pazzi, whose donation dated to 1406; Antonio Cecchi and his son Ser Francesco, the prior's father and brother; Salimbene di Leonardo Bartolini, uncle of the friars Bernardo and Marco; and Bona, widow of Vannuccio, grandfather of the friar Basilio di Lorenzo, whose brother-in-law Ser Paolo di Pagno Bertini was the convent's notary. Unfortunately, his notarial acts before 1429 are lost (ibid., vol. 1, p. 49 n. 37).

44. A seventeenth-century historian described it as having "per arme una croce nera e il segno della Compagnia di S. Piero Martire. 1428" (Radda n.d., fol. 101v, n. 985; quoted in Orlandi 1955, p. 198 n. 18). The *croce nera* (black cross) might be a misinterpretation of the Gaddi arms, which still appear to the left of the choir.

45. The painting went to a Gaddi chapel in 1488, and this fact alone should prove my suggestion wrong. In the early sixteenth century, Taddeo Gaddi's granddaughter Costanza di Sinibaldo Gaddi wedded Lorenzo Bartolini, a great-nephew of Bernardo Bartolini, but this would not seem to have affected its patronage. The chapel was always called the Gaddi chapel. In 1611 the convent sold the picture to Mario Farnese, and in 1615 it paid Jacopo da Empoli for a replacement (Giglioli 1933, pp. 23–30). The Gaddi arms are on the frame.

46. On Bernardo's inheritance see Orlandi 1959–60, vol. 2, pp. 42–44, 116–17, doc. 19. Bartolini became prior of San Domenico and worked closely with Angelico in administration (ibid., pp. 131–32, 137, 150; Orlandi 1964, pp. 114–18). In 1461 he made a will bequeathing manuscripts including "a beautiful book in parchment" (Orlandi 1959–60, vol. 2, p. 152).

47. See n. 43 above.

48. See n. 9 above.

49. Joannides 1993, colorpls. 132–35.

50. Museo e Gallerie Nazionali di Capodimonte, Naples; for which see Joannides 1993, colorpl. 164.

51. Middeldorf (1955, pp. 188–89) and De Marchi (1985; in Florence 1990b, pp. 94–97) challenged the traditional 1437 date of the Perugia altarpiece based upon information contained in a late cinquecento chronicle. De Marchi dates it before March 1447. His argument is partially based on observations by Hall (1968, pp. 23–24). Using the same evidence—a portrait of Cardinal Albergati as Saint Jerome—Hall argued for an earlier date.

52. It was not unusual for Servite convents to hire Florentines. The Servites' motherhouse was in Florence, and a Florentine, Fra Francesco Landini, commissioned the Angelico painting. A payment of 1432 (Marchese 1854, vol. 1, p. 401, doc. 7) implies that the picture had already been executed. It is not clear what happened to it. The *Annunciation* now in the church was painted by Jacopo Bellini about 1443 (illustrated in color in Eisler 1989, fig. 18, where it is mistakenly associated with the Bridgettines of Venice [pp. 27–28]).

It is possible that the Angelico work never reached Brescia but instead went to a Tuscan Servite church. The Brescian community depended on the Observant hermitage of Monte Senario (Montagna 1963). In 1426 the hermitage had established a chapel dedicated to the Virgin across the road from San Domenico in Fiesole. Ten years later it was ceded to Cosimo de' Medici for the Badia (Dal Pino, in *Istituti*, vol. 6, 1980, col. 106). If Angelico's Servite *Annunciation* had gone there, it would have had to be removed. A picture now in San Giovanni Valdarno may fit the bill. It comes from the nearby Observant convent of San Francesco in Montecarlo. The building of

that church was not complete in 1438, but it is not known when Angelico's picture arrived. The Montecarlo altarpiece, which had much workshop intervention, has also been associated with the Brescia commission by Cardile 1976, pp. 303–6; Maetzke 1979, p. 33; and Joannides 1989, pp. 303–5.

53. On Angelico and Ghiberti's relations see Middeldorf 1955 and De Marchi 1992, p. 134.

54. The *Deposition* is illustrated in color in Hood 1993, figs. 76, 77, 78b.

55. The twenty-one-year-old Marco was still contemplating becoming a friar in 1427 (ASF, *Catasto* 75, *carta* 131).

56. Illustrated in color in Hood 1993, fig. 85.

57. Angelico instinctively considered the *pala quadrata* a particularly Florentine form. When he worked for patrons outside of Florence, he eschewed its modernism for the more traditional polyptych, such as in polyptychs for San Domenico in Cortona and Perugia. Unlike the earlier Prado altarpiece, the *Annunciation* for Montecarlo, near Florence, has rounded arches enframing it. This archaism helps support the possibility that it was originally commissioned by the Servites of Brescia (see n. 52 above).

58. Illustrated in color in Hood 1993, fig. 88. Hood (ibid., pp. 102–7) suggested that the Annalena altarpiece, dated by Pope-Hennessy (1974, p. 211) about 1445, was made for the Medici chapel in San Lorenzo about 1432 or 1434 (in 1433 the Medici were in exile). This idea was questioned by me in a review of Hood's book (Strehlke 1993b, p. 635). I now think that it is possible. On Angelico's previous connections with San Lorenzo, see Ladis 1981.

Another possible provenance (De Marchi, in Florence 1990b, p. 93) is Cosimo's private chapel in the quarters of the company of the Purification of the Virgin in San Marco. Angelico himself worked for the company, as a lost processional banner by him is recorded in an inventory (Hood 1993, pp. 318–19 n. 12).

It is not clear when Cosimo's chapel was set up (the company was founded in 1427 and its new spaces were ready in 1444). A description by Saint Antonino describes its altarpiece as depicting Saints Cosmas and Damian (Morçay 1913, p. 15 n. 2; Morçay 1914, pp. 473–74, no. 71). These Medici saints also appear in the Annalena altarpiece. Antonino only mentions those saints, not a Virgin or other saints. While this may have been an oversight, the description does not completely accord with the Annalena altarpiece. That painting was supposedly brought to the convent of Annalena near Porta Romana in Florence about 1452.

59. In reference to the Annunziata paintings, Corella wrote: "Angelicus pictor quam finxerat ante Johannes" (Which the painter Angelico who had been called Giovanni before made).

60. Some idea of Angelico's immediate posthumous fame is suggested by an oblique reference in a poem of 1460 by the Brescian poet Alberto Avogadro describing Cosimo's plans for the Badia of Fiesole, which had been taken over in 1439 by Benedictine reformers. Cosimo supposedly envisioned something equivalent to San Marco. Avogad-

ro refers to a painter who, seeking everlasting fame, could fulfill Cosimo's dreams: "Cosme, reor doctum pictorem te esse secutum, / Nomen qui eternum post sua fata cupit" (Gombrich 1962, p. 223 [fol. 35v, ll. 6–7]). The verse is an overt reference to the success of San Marco.

61. Baxandall's translation of Landino in *Painting and Experience in Fifteenth Century Italy*, first published in 1972, uses the word *angelico* as if it were part of Fra Giovanni's name, whereas in the original text printed by Nicholo di Lorenzo della Magna in August 1481, it appears as an adjective and in lower case. For a critical review of Baxandall's interpretation of Landino, see Middeldorf 1975, pp. 284–85. Vasari, in his *Lives*, preferred the artist's re-

ligious name of Fra Giovanni, although at the beginning of each biography he appended Angelico to it as if part of the name.

The adjective *angelico*, used by Landino, may well be best rendered by the words a near contemporary, Giovanni Santi, used for the artist. He called him "al bene ardente" (ardent for good [Santi 1985, vol. 2, p. 673, l. 366]). However, another early-sixteenth-century source, the so-called Anonimo Gaddiano, or Magliabecchiano (ca. 1541–46), even more nicely describes Angelico's character as "di molto humana natura" (of great humanity [Ficarra 1968, p. 102]). On the use of the word *angelico*, see also Berti 1962–63, pp. 304–5 n. 25.

Appendix: A Bibliographical Note on Early Angelico

For a long time it was thought that the artist was born in 1386 or 1387 and that he entered San Domenico in 1407, as recounted in the sixteenth-century *Chronica quadripartita*. Archival research undertaken by Stefano Orlandi (1954, 1964) and Werner Cohn (1955, 1956) about the time of the five-hundredth anniversary of Angelico's death undermined these assumptions and forced a revision in thinking about his beginnings and development. While the analysis needs to be rethought (see Centi 1984), the discoveries caused a revolution: they showed that the artist was not active until the late second decade of the fifteenth century and that he probably did not become a friar until about 1420.

In recent years several documents have come to light. A will written in 1425 (Ladis 1981) by Alessandro Rondinelli gives an idea of Angelico's early fame. Rondinelli directed his heirs to hire Angelico for an altarpiece for San Lorenzo. Wills were often dictated on the deathbed, and while funds were often bequeathed for altarpieces, artists' names are rarely if ever mentioned. Other items published by Roger Jones (1984, pp. 38, 60, doc. 45) show that Angelico finished the *Deposition* for the Strozzi Chapel in Santa Trinita in mid-1432. An early date for it had been suggested by Keith Christiansen (1982, pp. 72–73 n. 24), and the documents had been cited by Orlandi (1964, pp. 47–48) and Anna Padoa Rizzo (1982). Curiously, the picture had been thought to be from as late as 1440. Its now-confirmed early dating supports suggestions by Andrea De Marchi (in Florence 1990b, p. 90) and William Hood (1993, pp. 102–7) that the Annalena altarpiece was executed about 1434 rather than in the 1440s.

Diane Cole (1977b) published a document suggesting that Angelico's polyptych for San Domenico, Cortona, dates to 1438. However, stylistically the picture appears to be from about eight years earlier. Its relationship to Sassetta's altarpiece in the same church is intelligently discussed by Hood (1993, pp. 77–82). Another traditional, but undocumented, date of 1437 for the polyptych in Perugia has also been questioned. De Marchi (1985; in Florence 1990b, pp. 94–97) recently argued that this work belongs instead to Angelico's Roman period. This new dating has been questioned by Christiansen (1990, p. 739) and thought unconvincing by Hood (1993, p. 309 n. 46).

Roberto Longhi (1940, pp. 173–77) made several proposals for the young Angelico in the groundbreaking article "Fatti di Masolino e di Masaccio." His more daring attributions, including the Uffizi's *Thebaid* and Princeton's *Saint Jerome*, were not accepted in subsequent monographs (Pope-Hennessy 1952 and 1974; Salmi 1958; Baldini 1970). Mario Salmi's attribution (first proposed in Salmi 1950, pp. 75–77) of miniatures in a choir book from Santa Maria degli Angeli (Biblioteca Laurenziana, Florence; Cod. Cor. 3) was a willfully negative response to Longhi because external evidence suggested that those illuminations in a style so closely resembling Angelico's hand seemed to date to about 1409. However, the illuminations have been shown to be by a follower of Angelico, probably Battista di Biagio Sanguigni (see the opinions of Longhi 1940, p. 182 n. 15; Berti 1962–63, p. 34; Bellosi, in Turin 1990, p. 42; Kanter, in cat. no. 37 herein).

Of all scholars John Pope-Hennessy has been the most cautious about attributions to the young Angelico: in neither edition of his monograph did he accept fundamental works like the Prado's *Annunciation* and the Louvre's *Coronation* as autograph or as early. In light of Orlandi and Cohn's research, in the second edition he changed many dates,[1] and he published several pictures that showed how firmly the artist's beginnings were grounded in Lorenzo Monaco. These included two panels with pairs of saints in a private collection, which may relate to the *Virgin and Child* in Pisa. In a monograph on the Abegg-Stiftung *Adoration of the Magi*, Miklós Boskovits (1976a) made several suggestions for pictures by the young Angelico, including a predella in Bern. The *Adoration* showed how closely Angelico had also been influenced by Gentile da Fabriano. Both Boskovits (1976a, 1976b) and Umberto Baldini (1970) challenged Pope-Hennessy's opinions about the Prado and Louvre altarpieces. In doctoral dissertations Paul Julius Cardile (1976) and Diane Cole (1977a) came to the same conclusions. Cole (Cole Ahl 1980; Cole Ahl 1981) subsequently published two articles on the early major altarpieces.

Most important for the artist's very beginnings has been the recent return to Longhi's attributions of the *Thebaid* and the *Saint Jerome* to Angelico. In general, discussion has often been put forward in the form of notes buried in texts about other subjects (Boskovits 1990, p. 60 n. 12; De Marchi, in Florence 1990b, p. 1990; De Marchi 1992, esp. pp. 148–49 n. 53). Alessandro Conti's recent confirmation (in Florence 1992, p. 41) that the Uffizi's *Thebaid* was in the Medici palace appears in an entry on a painting attributed to Andrea Mantegna. In a brief mention appended to a biography of Giovanni Toscani, Luciano Bellosi (in Milan 1988, p. 196) suggested that the so-called Griggs *Crucifixion* must represent another fundamental stage in Angelico's early development.

1. See Boskovits 1976b, pp. 32–33, for a list of these changes.

PAINTING AND ILLUMINATION IN EARLY RENAISSANCE FLORENCE 1300-1450

PACINO DI BONAGUIDA

Pacino di Bonaguida is first mentioned in a document of February 20, 1303, that records the dissolution of a partnership formed one year previously with the otherwise unknown artist Tambo di Seraglio (Milanesi 1901, p. 17). The wording of this document, which describes him as "publicus artifex in arte pictorum," has been interpreted as implying that by 1303 Pacino was already an artist of repute and therefore the beginnings of his career are to be traced some way back into the thirteenth century (Boskovits 1984, p. 48). Alternatively it has been suggested, perhaps more reasonably, that the document denotes only that by 1303 Pacino was a member of the painters' guild (Levi D'Ancona 1962, p. 217). In 1316 the Florentine painters' guild was reconstituted under the aegis of the Arte dei Medici e Speziali, the guild of physicians and apothecaries, and Pacino's name appears on the register of matriculants in the new organization between 1327 and 1330 (Levi D'Ancona 1962, p. 217; Hueck 1972, p. 117), the only other preserved notice of his activity.

The artistic personality of Pacino di Bonaguida was reconstructed in a series of exemplary studies by Richard Offner (1922, 1927, 1930, 1956) on the basis of a single signed altarpiece in the Galleria dell'Accademia, Florence (inv. no. 8568), representing the crucified Christ between the Virgin and Saint John the Evangelist and four standing saints in lateral panels. For Offner, Pacino was a prolific painter of modest talent, "whose historic importance, due largely, doubtless, to personal or practical gifts, far exceeds his artistic endowments" (1930, pt. 1, p. 16). Pacino's "artistic endowments" were perhaps unfairly slighted by Offner, but his historical importance cannot be and has rarely been overestimated. The great number of panel paintings by him surviving today is alone testimony to the esteem in which he was held and the demand his works enjoyed. Even more imposing is the number of illuminated manuscripts confidently attributable to him, leading even Offner to label him "the head and centre" of the Florentine school of illumination, its first identifiable personality and the overwhelmingly dominant figure in the production of illustrated books during the first four decades of the fourteenth century.

A consensus concerning the relative chronology of Pacino's works has so far proven elusive, due primarily to the tantalizingly fragmentary date appended to his signature beneath the Accademia *Crucifixion* altarpiece: MCCCX. . . . Offner (1922, p. 4 n. 5) insisted on reading this date as not earlier than 1315 nor later than 1330, while Mirella Levi D'Ancona (1962, p. 217) asserted that almost any date between 1312 and 1341 is at least epigraphically possible. Most writers now agree that only a single digit is missing at the end of the inscription (Procacci 1951; Cämmerer-George 1966), and the altarpiece is therefore generally dated either 1315 (MCCCXV) or 1320 (MCCCXX). It seems to this writer, however, that the fragmentary paraph of the final digit still visible at the end of the inscription was continued by a vertical, not a diagonal, stroke, and that the date ought to be reconstructed either as 1311 or 1312 (MCCCXI; MCCCXII) or as 1340 (MCCCXL). The first two dates are clearly too early for the structure of the altarpiece: full-length standing saints in lateral panels are virtually unknown in Tuscan painting before about 1320, and it is difficult to ascribe to an artist of Pacino's caliber the role of an innovator in this regard. Furthermore, the trilobe arches of the frame, unique in Pacino's oeuvre, are typical of Florentine painting only after 1330. Though they were employed early in the century by Giotto in his polyptych from the Badia (Boskovits 1984, p. 48 n. 163), in this case they seem to depend on the example of Giotto's later altarpiece in the Pinacoteca Nazionale, Bologna. The soft, fully articulated modeling, elongated proportions, and swaying postures of the figures in the altarpiece are also more easily reconcilable with a date of 1340.

Establishing the Accademia *Crucifixion* altarpiece as a late work by Pacino helps to clarify some, though not all, of the questions concerning the relatively static development of his style. To approximately the same period at the end of his career should also be assigned the commissions for a set of illuminated antiphonaries at the Collegiata of Santa Maria all'Impruneta and an illuminated laudario for the Compagnia di Sant'Agnese at the Carmine (cat. no. 4). Probably the most elaborate Florentine book of the first half of the fourteenth century, the laudario may have been Pacino's last major undertaking and was perhaps left incomplete at his death. Its figure style and the refined execution of its pages recall the *Crucifixion* altarpiece of 1340 more nearly than do any other manuscripts or panel paintings by Pacino; those pages contributed to the book by the Master of the Dominican Effigies, who seems to have inherited the commission, are all independently attributable to a date about 1340 as well.

The majority of works by Pacino, both panel paintings and illuminations, incorporate heavier-proportioned and more coarsely rendered figures than do the pages of the Laudario of Sant'Agnese or the Accademia *Crucifixion* altarpiece. Firmly rooted in dugento conventions of narrative and composition not essentially different from those of such a painter as the Master of the Magdalen, Pacino's style was only superficially influenced by the pictorial innovations of his slightly older contemporary Giotto, from whom he borrowed little more than his technique for modeling flesh tones in light and shadow. Nevertheless, even Pacino's putative early paintings—among which may be numbered a *Virgin and Child* at the Accademia, Florence (inv. no. 6146), and its companion panel in the Barnes Collection, Merion (Pa.); the Murnaghan Dossal at the Walters Art Gallery, Baltimore; and possibly the large *Tree of Life* also at the Accademia (inv. no. 8459)—betray an awareness of Giotto's work in Florence after 1305 (the Ognissanti *Virgin*; Peruzzi Chapel frescoes). It is unlikely therefore that the artist had been practicing his craft for many years before the document referred to him in 1303.

Over the course of his long career, Pacino may be said to have become increasingly sophisticated in his appropriations of motifs or figure types from Giotto, but he never shared that artist's vision of a world populated by classical heroes enacting poignant, highly dramatic stories. Pacino's success lay in "baring the narrative to elements of the action alone, and by rejecting any details descriptive or evocative of mood, thought or emotion . . . the story is not allowed to be weighted by drama or other matter likely to arrest its progress" (Offner 1956, p. xiii). This pictographic narrative style, peculiarly well suited to the demands of illustrating text in an illuminated manuscript but also applicable to the composition of panel paintings and frescoes, led Offner to characterize Pacino as the leader of a "Miniaturist Tendency" in Florentine painting, a term whose validity has engendered much dispute among scholars but that may be understood to connote nothing more than the survival of thirteenth-century artistic ideas into and beyond the age of Giotto.

LK

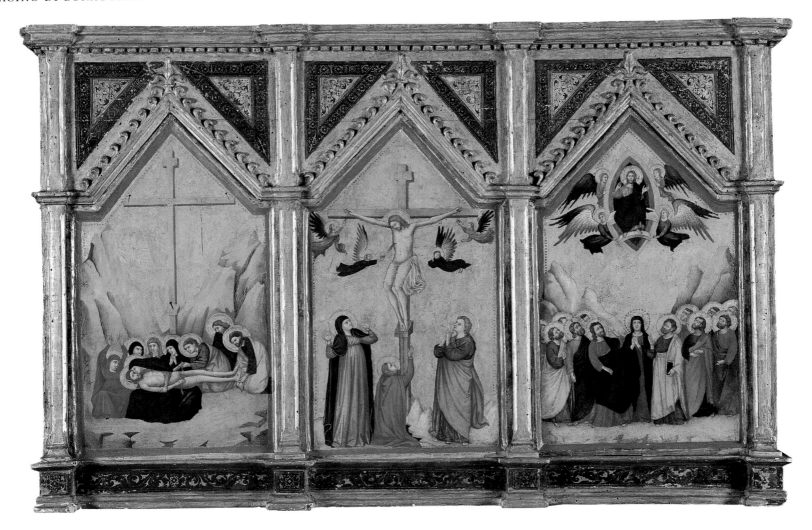

1. Triptych: Crucifixion, Lamentation, and Ascension

Tempera on panel
Overall, each panel: 16³/₈ × 9³/₄ in. (41.5 × 24.8 cm); picture surface, each panel: 15 × 8⁵/₈ in. (38 × 22 cm)

Private collection

As presently reconstituted, the triptych has at its center a scene of the Crucifixion, with Christ on the cross surrounded by four mourning angels, three of whom collect the blood flowing from his wounds. Mary Magdalen kneels in the foreground at the center of the panel, embracing the foot of the cross. At the left and right, respectively, stand the Virgin and Saint John the Evangelist, their hands raised in grief. The scene of the Lamentation is portrayed in the left-hand panel, with the empty cross rising in a stony landscape, three nails affixed to its crossbars and suppedaneum. The rigid

body of Christ is stretched across the foreground in the lap of his mother, who is attended by Mary Magdalen and three Holy Women, Saint John the Evangelist, Joseph of Arimathea, and Nicodemus. In the Ascension in the right-hand panel, the risen Christ is seated in a mandorla borne heavenward by four angels, while the Virgin and eleven apostles gaze wonderingly upward from below.

In first publishing these panels, Richard Offner (1956) commented on the unusual form—unknown to him in other Italian examples—of the triptych they constitute, with lateral panels that are the same height and width as the center panel and therefore intended, he supposed, to fold over it sequentially rather than simultaneously. He furthermore concluded that notwithstanding the Gospel order of the events portrayed, the *Ascension* originally stood at the left of the complex and the *Lamentation* at the right, ostensibly because of the orientation of their

compositions and the irregular height of the spring of their gables. These conclusions, however, are based on the assumption that the complex is complete in its present form, whereas it is likely that it originally composed a pentaptych, with two missing scenes—among them possibly the Agony in the Garden, Flagellation, or Via Crucis—to the left of the *Crucifixion*, and the *Lamentation* and *Ascension*, in that order, to the right.

Formerly on the back of the *Lamentation* panel were the remains of a painted figure of Saint Peter, and a figure of Saint Paul (now removed; fig. 24) was painted on the back of the *Ascension*. If the three panels had been intended as a folding triptych, one of these two saints would never have been visible, being folded beneath the other. A pentaptych with equal-sized compartments also cannot fold in such a way as to allow the backs of any two contiguous compartments to remain visible, and it may be concluded that the complex was never intended to fold closed. The direction of Saint Paul's glance, furthermore, turned three-quarters to the right, makes sense only if the five panels were meant to remain open and rigid. Viewed from the back, he would have been seen at the extreme left of the complex, looking toward the center, with Saint Peter alongside him. Two other saints, possibly John the Baptist and John the Evangelist, would have occupied the backs of the now-missing panels on the right, resulting in an arrangement similar to that in an altarpiece by Lippo di Benivieni (Offner 1956, pl. X).

A careful iconographic analysis by Offner (1956) of details of the three scenes on these panels, such as the nails protruding from the cross in the *Lamentation* and the seated figure of Christ in the *Ascension*, linked them to other examples of the subjects from Pacino's studio. In particular, the motif of Christ seated rather than standing in a mandorla in the Ascension, typical of Byzantine painting and mosaics, is encountered in the fourteenth century almost exclusively in works by Pacino. For example, it appears in an illumination (fol. 32) in the *Scenes from the Life of Christ* (cat. no. 3), though the artist also used the more common formula of the standing Christ in a page from the laudario of the Compagnia di Sant'Agnese (cat. no. 4f). The *Passion* triptych is earlier than these works, however, and closer to the Byzantine examples from which it depends. Miklós Boskovits (1984, pp. 50–51, n. 172) noted stylistic links between the triptych and the miniatures in the *Life of Christ*, and he proposed dating them both to the second decade of the fourteenth century. Offner (1927, pp. 12ff.) thought the Morgan *Life of Christ* a more mature work than the triptych, and, indeed, some of the similarities between the two are fortuitous, due primarily to the comparable scale of their narratives. The treatment of the figures

Figure 24. Pacino di Bonaguida, *Saint Paul*. Private collection

in the *Passion* triptych is more meaningfully compared with that of Pacino's great *Tree of Life* altarpiece in the Accademia, Florence (inv. no. 8459), which is generally considered one of the artist's earliest surviving paintings. Though their narrative structure is unrelated—the scenes in the *Tree of Life* being carefully summarized to fit within small circular enclosures, those in the triptych expanded to full landscape settings—the two works are likely virtually contemporary and in all probability painted at the end of the first decade or the beginning of the second decade of the fourteenth century.

LK

EX COLL.: Steinmeyer, Lucerne (1932); Edward Hutton, London (1939).

LITERATURE: Offner 1956, pp. 137–40; Boskovits 1984, p. 51; idem 1987, p. 71; idem 1988, p. 63.

2. Diptych: Saint John on Patmos, the Virgin and Child Enthroned with Saints Paul and Francis, and the Death of the Virgin; the Crucifixion

Tempera on panel
Overall, left wing: 24 3/8 × 16 in. (61.9 × 40.6 cm); overall, right wing: 24 3/8 × 15 3/4 in. (61.9 × 40 cm)

The Metropolitan Museum of Art; Gift of Irma N. Straus, 1964 (64.189.3 a, b)

The left wing of the diptych is divided into three scenes. In the upper left quadrant, in a red robe worn over a green tunic, Saint John the Evangelist, facing right, is seated on the ground beneath a tree in a mountainous landscape meant to signify the island of Patmos. He holds on his lap an open book, which is inappropriately painted as a choir book but undoubtedly meant to represent the Book of the Apocalypse, and raises his left hand to his cheek. In the upper right quadrant, the Virgin, wearing a blue dress lined with green, and child,

in a red gown with white sleeves, are seated on a large marble throne inlaid with red on the arms and riser of the platform and with blue on the front of the seat. At either side stand diminutive figures of Saint Paul (left), in a red cloak over a blue gray robe, and Saint Francis, perched uneasily on the edges of the platform before the throne. The lower half of the panel is filled with a scene of the Death of the Virgin. Wrapped in a blue mantle, the Virgin lies full-length on a white linen shroud above a pink sarcophagus decorated with white, red, and black

cosmatesque inlay. She is surrounded by the Twelve Apostles, two of whom hold the ends of the shroud, while Saint Peter, at the left, wearing a stole over his robe, reads the Mass of the Dead. Standing behind the sarcophagus in the center of the composition is Christ, wearing a blue cloak over a white robe and attended by two angels. He holds the soul of the Virgin, shown as a doll-sized figure wrapped in white, in his left arm and gestures in benediction with his right.

The right valve of the diptych is occupied by one large

scene only—the Crucifixion. Christ on the cross fills the upper two-thirds of the composition, while three angels in robes of blue, violet, and red and with white-and-red wings hover around him collecting the blood that flows from the wounds in his hands and side. On the ground below, and somewhat smaller in scale, are (left to right) Saint John the Baptist, wearing a rose-colored cloak over his hair shirt and holding a scroll and crossed staff; the Virgin, wearing a blue mantle over a rose gown, her hands clasped in grief; Saint Mary Magdalen, dressed in red and kneeling at the foot of the cross; Saint John the Evangelist, wearing a rose cloak over a blue tunic; and an unidentifiable bishop saint.

The Metropolitan Museum diptych, formerly in the Straus collection, New York, was one of the key works included by Richard Offner (1927; 1930) in his initial reconstructions of the artistic personality of Pacino di Bonaguida. Notable for its large size and relatively good state of preservation, it incorporates all of the elements of Pacino's emblematic approach to narrative. In the scene of the Crucifixion, for example, each of the figures is portrayed on a modestly different scale, but only the larger size of Christ is hierarchically significant. Among the saints standing in the "foreground" (that is, at the bottom of the composition), each figure's size is determined by his or her posture without regard to the illusion of his or her placement in space or relationship to the others. Similarly, though the perspective of the Virgin's throne at the upper right of the left valve is competently rendered by early-fourteenth-century standards, its purpose in establishing a believably naturalistic setting is countermanded by the impossible dichotomy of scale between the Virgin and the two saints and by the awkward placement of the latter, who hover or float at the edges of the platform.

The scene of the Death of the Virgin might more appropriately be called the Entombment of the Virgin, since she lies not on a bed but on a sarcophagus (Offner 1957, p. 102 n. 2). The scene, appearing in the bottom half of the left valve of the diptych, was loosely derived by Pacino from a prototype by Giotto, the *Death of the Virgin* in the Gemäldegalerie, Berlin, possibly painted for the church of the Ognissanti between 1305 and 1310 (Bologna 1969, p. 88 n. 1; Boskovits 1988, p. 60). Pacino's composition simplifies the spatial complexities of Giotto's scene by eliminating the crowds of angels and Holy Women surrounding the Virgin's bier. Giotto's angels fulfilled an important function in the train of mourners through their censing, holding tapers, and chanting a dirge. The two angels retained by Pacino serve instead a decorative and iconic function, isolating the figure of Christ within the improbably symmetrical (notwithstand-

ing one angel's frontal stance and the other's turn in three-quarters profile) brackets of their wings. Such a device does not occur in Giotto's prototype, where the figure of Christ is distinguished only by his placement and demeanor, and is antithetical to Giotto's naturalistic temperament, recalling instead such earlier prototypes as Pietro Cavallini's mosaic in Santa Maria in Trastevere, Rome. Pacino also eliminates the two apostles kneeling before and behind the Virgin's tomb. He does repeat the motif of two figures holding up the ends of the cloth above the sarcophagus, converting them from angels to apostles to economize on the number of figures required to complete the scene, and, like Giotto, he identifies the apostles Peter and John by their occupations as priest and chief mourner, respectively.

A terminus post quem of about 1310 is established for the Metropolitan Museum diptych by its dependence on Giotto's Berlin *Death of the Virgin*. Among Pacino's better-known works, the figure style in the two New York panels is most closely related to that in the Morgan *Life of Christ* (cat. no. 3) and in the three surviving panels of an altarpiece painted for San Procolo, Florence (Accademia, Florence; inv. nos. 8698–8700), as had initially been recognized by Offner (1930, pt. 2, pp. 221–23, 225). The style of the diptych is particularly close to that of the five predella panels showing scenes from the Legend of Saint Proculus in the Fogg Art Museum, Cambridge, and elsewhere that undoubtedly originated from the San Procolo altarpiece. An early date, shortly after 1310, might be argued for the San Procolo altarpiece on the basis of the horizontal grain of the wood of its panel support, in the manner of a dugento altar retable. However, that early date is belied by the fact of the altarpiece's completion with a predella—the earliest known predelle in Tuscan painting occur in the second decade of the trecento, but they are not common in Florence before the late 1320s—and by the evident maturity of its figure style relative to that of the Accademia *Virgin and Child* (inv. no. 6146), once incorrectly associated with it. Miklós Boskovits (1984, p. 50) dated the San Procolo altarpiece (and the Morgan *Life of Christ*) to the second decade of the fourteenth century, which is possible, but his proposal to date the Metropolitan Museum diptych about 1320–25 is more plausible and may comfortably be applied to the group as a whole.

LK

EX COLL.: Said to have been purchased from a private collection, Impruneta, by Bellini, Florence (1924); Jesse Isidor Straus, New York (1924–36); Irma N. Straus, New York (1936–64).

LITERATURE: Offner 1927, pp. 8 ff., fig. 11; Salmi 1929,
p. 134; Offner 1930, pt. 1, pp. ii, vii, viii, 5; pt. 2, pp. 201,
221, 225; Salmi 1931–32, p. 264; Florence 1937, p. 49, no. 131;
Sinibaldi and Brunetti 1943, pp. 405–6; Toesca 1951, p. 605
n. 125; Walcher Casotti 1962, p. 25; Boskovits 1966, pp. 61 ff.,
fig. 14; Kermer 1967, p. 44; Klesse 1967, pp. 47, 166, 199;
Bologna 1969, p. 88 n. 1; Fahy 1971, p. 432; Gosebruch 1971,
p. 248; Smart 1971, p. 199; Zeri and Gardner 1971, p. 91;
Fredericksen and Zeri 1972, pp. 101, 600; Baetjer 1980, vol. 1,
p. 138; Boskovits 1984, p. 51 n. 176; Ciardi Dupré dal
Poggetto 1984, p. 248; Boskovits 1987, pp. 162–65.

3. Scenes from the Life of Christ and Life of the Blessed Gerard of Villamagna

Tempera and gold leaf on parchment
9 $^5/_8$ × 6 $^7/_8$ in. (24.5 × 17.6 cm)

The Pierpont Morgan Library, New York (M. 643)

The thirty-eight miniatures of this codex constitute the
richest surviving manuscript painted by Pacino di
Bonaguida. With its extensive christological cycle, it is
the manuscript counterpart to Pacino's *Tree of Life*
painting in the Accademia, Florence; with its miniatures
depicting the Life of Blessed Gerard of Villamagna, it
contains the earliest pictorial narrative cycle of a beloved
Florentine hermit saint, one of whose relics was listed by
Boccaccio in the *Decameron* (6.10).

The illuminations in the Morgan Library codex begin
with an image of King David—probably an allusion to
Jesus' royal ancestry. The sequence of the Life of Christ,
including both biblical and apocryphal scenes, is as
follows: the Annunciation, Visitation, Nativity, Adora-
tion of the Magi, Presentation in the Temple, Flight into
Egypt, Christ Among the Doctors, Baptism of Christ,
Miracle of Changing Water into Wine, Mary Magdalen
Washing Christ's Feet with Her Hair, Raising of Laza-
rus, Entry into Jerusalem, Last Supper, Washing of the
Feet, Christ on the Mount of Olives, Betrayal, Christ
Before Pilate, Flagellation, Mocking of Christ, Carrying
of the Cross, Ascent of the Cross, Crucifixion, Lamenta-
tion, Resurrection, Three Marys at the Tomb, Noli me
tangere, Road to Emmaus, Supper at Emmaus, Doubting
Thomas, Christ Appearing to the Apostles, Ascension,
and Pentecost.

Following this series are four leaves illustrating the Life
of Gerard of Villamagna (ca. 1174–?1245), whose feast was
celebrated on the Monday after Pentecost. According to
his legend, first recorded in the sixteenth century (by

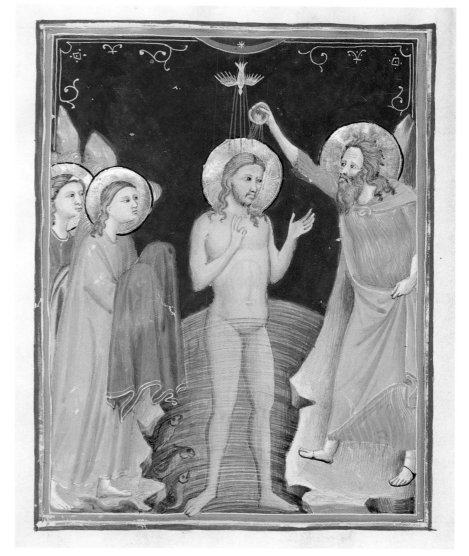

Fol. 9

Bartolomeo di Giovanni dalla Quercia; AA.SS., May 13;
MAII TOMUS III, pp. 246 ff.), Gerardo grew up as an
orphan on the estate of the Folchi family in Villamagna.
He participated as a page to Federigo Folchi in the Third
Crusade, during which he was captured. Later he made a
second trip to the Holy Land, becoming a member of
the Order of Saint John of Jerusalem.[1] The set of four
miniatures begins with Gerard's acts of charity and
devotion in his native Tuscany, to which he returned
after participating in the Crusades. In the first, Gerard—
represented throughout as barefoot and wearing a simple,
hooded brown robe—distributes bread to the poor and
lame from a large basket set on the back of a donkey.
The second is divided horizontally into two registers. In
the upper register, Gerard kneels in prayer before the

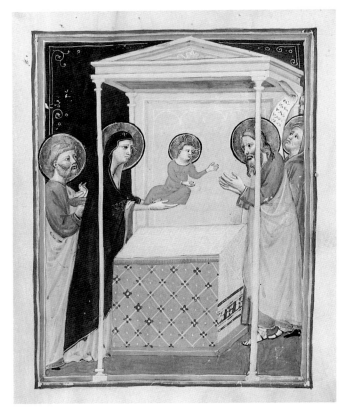

Fol. 6

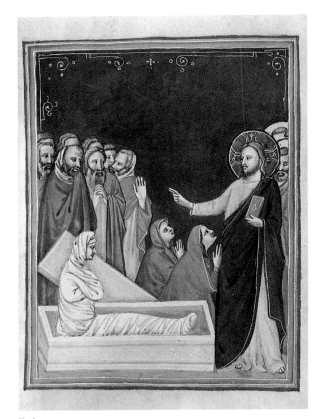

Fol. 12

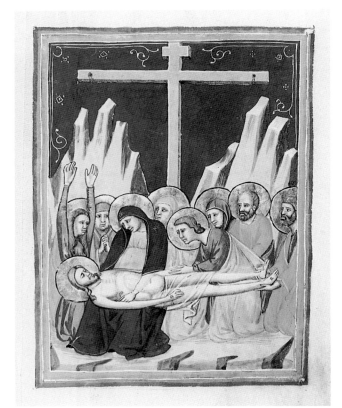

Fol. 24

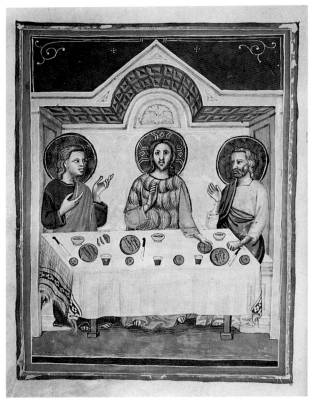

Fol. 29

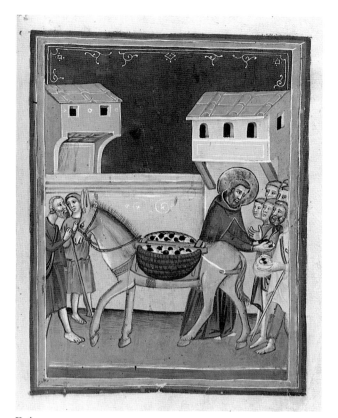

Fol. 34

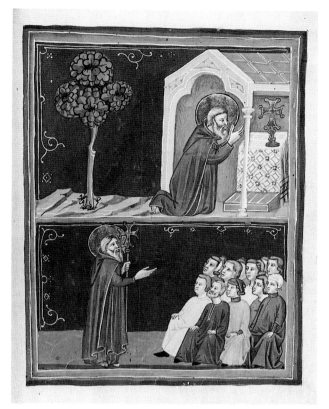

Fol. 35

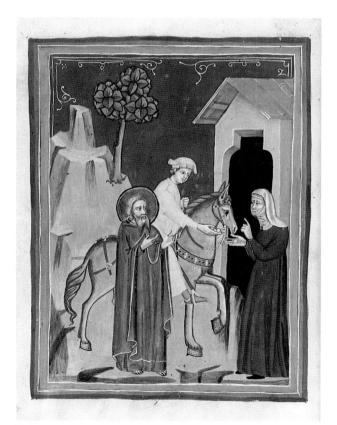

Fol. 36

Fol. 38

Fol. 22

who said to the children of Israel: *A prophet shall God raise up to you of your own brethren, as myself: him shall you hear.*"

The Morgan codex was first associated with the workshop of Pacino di Bonaguida by Richard Offner in 1927, an attribution supported by iconographic, compositional, and stylistic comparison with the *Tree of Life*. Each vignette is framed by blue and orange bands and set against a deep blue ground decorated with delicate white pen work, betraying Pacino's debt to thirteenth-century conventions of manuscript illumination. At the same time, Pacino's awareness of Giotto is demonstrable in his use of landscape elements to accentuate the arrangement of figures in space. Scenes like Christ's appearance to Mary Magdalen after the Resurrection (the Noli me tangere) are set off in this way to make them more legible rather than to confer the dramatic impact that distinguishes Giotto's work. Offner believed that three distinct hands within Pacino's workshop were engaged in the production of this manuscript, the most accomplished being responsible for the early scenes of the Life of Christ (1–16), the second for the remainder of the scenes of Christ's life through the Ascension (17–32), and the third for the last six (cited as five). While some variation in quality among the scenes is apparent, it is not greater than that in any other work by Pacino, and so neat a distinction of collaborators does not seem to be justified.

The iconography of the christological cycle has been strongly influenced by Franciscan theology, especially in the inclusion of scenes emphasizing Christ's willing sacrifice. Jesus is first shown carrying his own cross and then climbing energetically up the ladder to be nailed to the cross, following a Byzantine formula introduced into Italy in the mid-dugento (see Boskovits 1965; Derbes n.d.).

The codex contains no text and may have been made as a picture book (Offner 1958; Voelkle 1984). It has been suggested that the miniatures once illustrated an evangeliary (Corsi 1984, p. 48) or a psalter, the latter presumably because of the combination of the image of King David with a christological cycle. It is difficult to imagine, however, that a cycle of Gerard of Villamagna would have been appropriate to either of these uses. Nevertheless, a review of the development of his cult may provide clues to the origin of the manuscript.

Following his death about 1245, an oratory was established at Villamagna in honor of Gerard, and his body enshrined within. A dependency of the church of San Jacopo tra le Vigne (San Jacopo in Campo Corbolini), the oratory was first dedicated to Saint John of Jerusalem and subsequently to Gerard himself. A lost altarpiece from this oratory, which illustrated the same narratives from the Life of Blessed Gerard as the Morgan

altar of a small chapel, on which is set a large gold cross. In the lower register, the saint holds the cross, now mounted on a shaft, in his hand and preaches in the open air to a crowd seated in front of him. The scene may allude to Gerard's peregrinations to the churches near Villamagna. In the third illumination, Gerard stands by a man on horseback, perhaps soliciting the coins that the gentleman hands to a woman who gestures toward the saint (Offner 1958, p. 196). In the final miniature, the body of Gerard is laid in the branches of an oak for the veneration of the faithful. Its placement in the tree and the presence of two armed guards offer protection from the zealous crowd, some of whom have come seeking a cure. The last page of the manuscript represents the horned Moses preaching to the Israelites, which perhaps is linked to both the christological and hagiographical series as an illustration of Acts 7:37: "This is that Moses

codex, was described in the seventeenth century, leading to the suggestion that the manuscript was made for that chapel (Offner 1958, p. 196; Voelkle 1984). The small size of the manuscript and its fine condition suggest rather that it was made for the private use of an individual who had a particular devotion to Gerard of Villamagna, most likely either a knight of Saint John of Jerusalem or a Franciscan tertiary (both groups claimed Gerard as a patron)[2] and perhaps a member of one of two prominent Florentine families associated with the saint's oratory, the Bardi and the Cavalcanti. A fourteenth-century tabernacle within the saint's chapel bore the arms of the Bardi, the most prominent banking family of that time, who owned land and property in Villamagna (see Carocci 1968, vol. 2, pp. 28–29; the Bardi arms appeared alongside those of the Magli family). One of the Bardis, Jacopo, had been installed in 1299 as prior of San Jacopo in Campo Corbolini, where the remains of the saint were interred before being transferred to the oratory of San Gerardo (Davidsohn 1896–1908, vol. 4, p. 267). In 1313 a member of one of Florence's wealthiest merchant families, Aldobrandino di Tegghia de' Cavalcanti, provided for a residence that a priest and cleric associated with the oratory could use. His gift was made "for the redemption of his soul" and "in honor and reverence of God, the Virgin, and San Gherardo da Villamagna" (Corsi 1984, p. 52).[3] The date of this testament of devotion to Gerard of Villamagna is particularly attractive due to its coincidence with the recorded career of Pacino as a painter and the probable date of the Morgan codex at the end of the second decade or the beginning of the third decade of the fourteenth century.

BDB

1. See Goodich 1982, p. 77; Richa 1754–62, vol. 3, pp. 297–98; Razzo 1593, vol. 1, p. 347. The cult of Blessed Gerard was officially sanctioned in 1833.

2. The publication of Don Silvano Razzo appears to be the first documentation associating Gerard of Villamagna with the Third Order of Saint Francis.

3. Arrangements were made through the Hospitallers' administrator for San Gerardo, San Jacopo, and San Sepolcro in Florence. The prior of San Sepolcro and of the Hospitallers of Pisa and Sardinia recorded in 1295 bore the name Gerardus de Gragna (Davidsohn 1896–1908, vol. 4, p. 424). While his Christian name could hint at a special devotion to Gerard of Villamagna, it could equally have been in honor of the eleventh-century founder of the Knights of the Order of the Hospital of Saint John of Jerusalem, Master Gerard. It may not be coincidence that both the Bardi and the Cavalcanti families were also patrons of the Franciscans at Santa Croce, Florence.

Fol. 37

EX COLL.: Abbot Celotti, London (sold 1825); the Reverend Mr. David T. Powell, London (sold 1848); Lord Ashburnham (by 1861); Henry Yates Thompson, London (1897–1919); [Quaritch, London].

LITERATURE: Celotti sale 1825, p. 34, no. 518; Powell sale 1848, p. 47, no. 853; Ashburnham 1861, app., no. 72; Thompson sale 1919, p. 23, no. 12; Offner 1927, pp. 12 ff.; Salmi 1929, p. 134; Offner 1930, pt. 1, pp. 1–22; Kaftal 1952, cols. 447–49; Harrsen and Boyce 1953, pp. 13–14; Boskovits 1965, p. 84, fig. 18; Corsi 1984, p. 48, figs. 7–10; Voelkle 1984, no. 10; Derbes n.d.

MASTER OF THE DOMINICAN EFFIGIES

Named for a panel showing Christ and the Virgin enthroned with seventeen Dominican saints and blesseds (Archivio di Santa Maria Novella, Florence), the Master of the Dominican Effigies was, with the Maestro Daddesco (q.v.), the dominant figure in Florentine illumination in the second quarter of the fourteenth century. He appears to have inherited a number of incomplete commissions—among them the Laudario of Sant'Agnese (cat. no. 4a–l) and a set of antiphonaries from the Collegiata of Santa Maria all'Impruneta—from the workshop of Pacino di Bonaguida, perhaps at the older master's death about 1340. On at least one occasion (Biblioteca Apostolica Vaticana, Cod. Lat. Barb. 3984), he collaborated with the Maestro Daddesco. However, his artistic training cannot be ascribed to either artist. His style blends the influences of an earlier generation of painters, among them Lippo di Benivieni and above all the Master of San Martino alla Palma, with those of his older contemporaries Bernardo Daddi and Jacopo del Casentino to form an animated and highly personal expression of his own.

Since he was first identified by Osvald Sirén (1926), who christened him the Master of the Lord Lee Polyptych, and Richard Offner (1930, 1957), who gave him his present name, the Master of the Dominican Effigies has always been considered in close relationship to two other artists isolated by Offner, the Biadaiolo Illuminator and the Master of the Cappella Medici Polyptych. Bernard Berenson (1931) grouped paintings by all three masters under the rubric Master of Terenzano (see also Procacci 1960, p. 134; Marcucci 1965, pp. 68–70), while Miklós Boskovits (1984, pp. 55 ff.; 1987, p. 10; followed by Freuler 1991, no. 67, p. 182) proposed amalgamating the first two—the Biadaiolo Illuminator and the Master of the Dominican Effigies—into a single artist who probably trained under the related but much more Pacinesque Master of the Cappella Medici Polyptych. John Pope-Hennessy and Laurence Kanter (Pope-Hennessy 1987, no. 26, pp. 55–57) as well as Luciano Bellosi (1992, p. 30, n. 15) instead followed Offner in reiterating the differences in quality and inspiration between these artists, whom they maintained as fully separate personalities.

The manuscripts and panels attributed by Offner to the Biadaiolo Illuminator, including Catalogue Number 5 in this publication, are all datable either before or about 1335, whereas the majority of works he associated with the Master of the Dominican Effigies were produced after that date. Correspondences of figure types, compositional structure, decorative format, and iconographic motifs between these two groups are so close and diverge sufficiently from those of other Florentine painters as to lead to the inevitable conclusion that the two are in fact successive stages of a single career. The very tangible differences in quality that led in the first instance to their separation must instead be explained as a sign of the progressive standardization of production within a successful and highly prolific workshop. This workshop may have included the Master of the Cappella Medici Polyptych, a painter of charming if derivative talents who was more likely to have been a follower than a precursor of the Master of the Dominican Effigies.

The earliest works by the Master of the Dominican Effigies are those that may be associated stylistically with the extraordinary illustrations in Domenico Lenzi's manuscript known as the Biadaiolo (Biblioteca Laurenziana, Florence, Cod. Tempiano 3: *Specchio unamo ove si tractera . . . quanto è venduto il grano e altra biada*; Offner 1930, pt. 2, pl. XVIII), which are datable on internal evidence to about 1335 (Boskovits 1987). The master's eponymous work in Santa Maria Novella (Offner 1930, pt. 2, pl. XXV) may be dated after 1336, based on the presence among the Dominican saints and blesseds

portrayed there of Maurice of Hungary, who died in that year. Probably it was painted almost immediately after that date, since of all the works formerly excluded from the so-called Biadaiolo Illuminator's oeuvre, it is the one that most closely resembles the Biadaiolo manuscript. An illustrated *Divine Comedy* in the Biblioteca Trivulziana (Castello Sforzesco, Milan, Cod. 1080; Offner 1957, pl. XIV) is dated 1337 in a colophon, though the illuminations may not be exactly coeval with the text. A polyptych formerly in the collection of Lord Lee of Fareham (Courtauld Institute, London; Offner 1930, pt. 2, pl. XXVIII) is dated by inscription 1345, the last secure date associated with any of the artist's works, though a double-sided altarpiece in the Accademia, Florence (inv. no. 4633/4; Offner 1930, pt. 2, pls. XXI–XXII), probably painted for Santa Margherita delle Romite di Cafaggiolo,[1] may have been painted after this. Whereas the archaic, almost dugento structure of the Accademia altarpiece was undoubtedly a requirement of its patrons, its heavy-featured, hard-edged figures imply a late date within the Master of the Dominican Effigies' career, and the cusped arches and punched borders of its individual compartments suggest that this date may not have been earlier than midcentury.

A proposal (Marcucci 1965, p. 69) that the Master of the Dominican Effigies may himself have been a Dominican is not supported by the modestly greater number of Dominican commissions he fulfilled relative to those for Franciscan, Camaldolese, Benedictine, or secular patrons. Among other suggestions for identifying him with an artist named in documents (Levi D'Ancona 1962), such as Lippo Schiatta or Girolamo di Vanni, the one that has attracted the most attention associates him with Ristoro d'Andrea. Ristoro d'Andrea was active from 1335 to 1364, lived in the *quartiere* of Santa Maria Novella in at least the early part of his career, and was paid for illuminating a laudario for the Compagnia di San Zanobi, a surviving fragment of which has sometimes been identified with a cutting by the Master of the Dominican Effigies (Offner 1957, pl. XIIIc; Boskovits 1984). This cutting, however, which illustrates the funeral of Saint Zenobius, once formed part of the laudario made for the Compagnia di Sant'Agnese at the church of Santa Maria del Carmine (cat. no. 4a–l) and does not provide a firm basis for identifying the Master of the Dominican Effigies.

LK

1. Among the saints portrayed in this altarpiece are Benedict, wearing a white habit, Romuald, and Scholastica (not the blessed Gherardesca of Pisa, as proposed by Kaftal [1952, col. 452], Steinweg, and Boskovits [1987, p. 274]), wearing the habit of a Camaldolese nun. Flanking the central image of the Coronation of the Virgin on one side of the altarpiece are Saints Mary Magdalen and Margaret, the titular saint of the Camaldolese monastery of Santa Margherita delle Romite, which, until it was abandoned in 1368, stood next to Santa Maria degli Angeli (Paatz and Paatz 1940–54, vol. 3, p. 102). Alternatively, Santa Maria Maddalena dei Pazzi, originally known as Santa Maria Maddalena la Penitente, in 1319 became the residence of Cistercian nuns from Santa Lucia di Montisone (Paatz and Paatz 1940–54, vol. 4, p. 90). If the Accademia altarpiece were painted for that community, the figure identified as Saint Romuald should instead be understood to represent Saint Bernard of Clairvaux. The habit worn by Santa Scholastica, however, lacks the black or gray scapular typical of Cistercian nuns and is more likely to be Camaldolese.

The Laudario of the Compagnia di Sant'Agnese

(Catalogue Number 4a–l)

Dispersed today among a number of collections in both Europe and America are nearly two dozen leaves and cuttings from a single laudario, or book of hymns to be sung in Italian by the members of a lay confraternity. The vernacular equivalent of a gradual or an antiphonary, this illustrated hymnal was undoubtedly one of the most ambitious and lavish manuscripts created in Florence in the first half of the fourteenth century. Its leaves have been recognized as works of art of considerable distinction since at least the beginning of the nineteenth century, when a number (if not all) of them were in England. One (cat. no. 4f) is described in the sale catalogue of William Young Ottley (1838) as "supposed to be painted by Giotto"; another (cat. no. 4g), at the time of the cataloguing of the collection of John Malcolm of Poltalloch (Robinson 1876), was said to have been cut from books in the Sistine Chapel during the French occupation of Rome.

A number of codicological, textual, and stylistic details offer proof that the leaves, which were first linked by Richard Offner, come from a single manuscript.[1] Immediately striking are the size of the leaves and the format of the ten illuminations for major feasts. Each of the ten consists of a large rectangular miniature dominating the page, a single opening musical stave, and a single text line in gilt capitals against a dark block.[2] In the hymns, certain letters are distinctively formed, notably the D, G, and Z (Ziino 1978, p. 68), and the leaves are ruled with the same size musical staves. The original pagination in alternating red and blue roman numerals can be seen on some leaves. In a number of instances, the hymn found on the recto of one of the preserved illuminations can be linked to another surviving illumination and its text, confirming that they were once bound sequentially, though they represent the work of two distinct hands.

All but five of the surviving illuminations from the laudario were painted by Pacino di Bonaguida, the most prolific manuscript painter in Florence in the first half of the fourteenth century. The remaining leaves are by the Master of the Dominican Effigies, whose work likewise appears alongside Pacino's in a choir book at the Collegiata of Santa Maria all'Impruneta (Offner 1956, p. 210; idem 1957, p. 48), in a *Divine Comedy* in the Biblioteca Laurenziana, Florence (Cod. Plut. XL, 12; Offner 1956, p. 248), and in an antiphonary for the church of Santa Maria Novella, Florence (Cor. H;

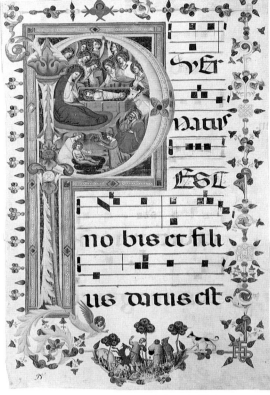

Figure 25. Master of the Dominican Effigies, Nativity. Staatliche Museen zu Berlin; Kupferstichkabinett (Min. 1228)

Boskovits 1987, pp. 568, 582). The Corpus Domini leaf by the Master of the Dominican Effigies, now in the Museum Mayer van den Bergh, Antwerp, is numbered LXXXV, while the Morgan Library's Trinity (cat. no. 4i) by Pacino is numbered LXXXVII; on its verso is part of a unique hymn, "[san]gue et carne pura" (blood and pure flesh), which appears to relate to the theme of Christ's eucharistic sacrifice seen in the Antwerp leaf.

Painted against burnished gold grounds enhanced only by tiny, simple round punches, Pacino's illuminations are notable for their palette, in which clear, strong colors predominate, including a recognizable and distinctive acid yellow. The figures are often shown in profile and are characterized by easily legible gestures, which are particularly appropriate to book illustration. The rectangular central compositions are more iconic than narrative in focus. These are framed by stylized foliate decoration, with oculi disposed at the corners and center of margins providing narrative or iconographic detail. The margins are filled with elegant and simple foliate decoration, birds, and angels.

Pacino's figures are among the most elegant and Gothic of his oeuvre. Even so gruesome a scene as the flaying of Saint Bartholomew (cat. no. 4k) is portrayed with a dancelike grace. In one scene, the Resurrection (cat. no. 4e), the whole company floats, almost incorporeal, against their golden ground. Throughout, the figures' elongated proportions distinguish them from the earlier, charming but more naive, large-eyed, and solid figures of the Gerard of Villamagna manuscript (cat. no. 3) and the narrative roundels in the *Tree of Life* in the Accademia, Florence. The laudario leaves also bear comparison with the miniatures from Santa Maria all'Impruneta, on which the Master of the Dominican Effigies also collaborated; this commission was possibly a second inheritance from Pacino, who may have been over sixty when he undertook the laudario, given that he is recorded as a painter as early as 1303 (see the biography above).

Sharing with Pacino's leaves the overall disposition of the page and its decoration, yet distinct from them in style, are the leaves attributable to the Master of the Dominican Effigies: the Nativity (cat. no. 4c), Corpus Domini (fig. 28), Pentecost (cat. no. 4h), and All Saints

Figure 26. Master of the Dominican Effigies, border decoration with a bishop in a letter N. The Art Institute of Chicago; Gift of Emily Crane Chadbourne (1926.1573)

(cat. no. 4l). The scenes are more anecdotal, and the margins more crowded. The palette is deeper and richer, with a greater use of primary colors and dark tones, and the overall effect more highly decorative. The compositional and iconographic components of the Nativity are variants of those in other illuminations and paintings by the artist, notably in Berlin (Kupferstichkabinett, inv. no. 1228; fig. 25). A date of approximately 1340, consistent with Pacino's late career, can be suggested by a comparison of the Washington All Saints leaf (cat. no. 4l) with the Master of the Dominican Effigies' eponymous work at Santa Maria Novella (Offner 1930, pt. 2, pl. xxv), which is datable after 1336. Two other fragments by the Master of the Dominican Effigies may also have come from the laudario: a border and letter N with a bishop in The Art Institute of Chicago (acc. no. 1926.1573; fig. 26) and a *bas-de-page* with the funeral of Saint Zenobius, formerly in the Salmi collection, Rome. Consistent in dimensions (especially the width of the *bas-de-page*), stave height, and style with other leaves in the series, these may have decorated the folios with the hymn to Saint Zenobius, "Novel canto tucta gente," the text of which appears in part on the reverse of the leaf with the Pentecost (cat. no. 4h).

A first clue to the provenance of the choir book was detected by Offner (1957, p. 56), who, noting the prominence of two Carmelite saints in the Master of the Dominican Effigies' miniature for All Saints, proposed that the laudario had been made for the Compagnia di Sant'Agnese of Santa Maria del Carmine in Florence. Agostino Ziino (1978, pp. 62–63) recognized additional evidence provided by the Pacino leaf of Saint Agnes, the miniature of which is exceptionally large—approximately the same size as the All Saints leaf in the National Gallery of Art, Washington, D.C.—and significantly larger than that of the apostle Andrew, for example. Ziino noted that this large scale would have been appropriate for the confraternity at the Carmine. Founded in 1248, the Compagnia di Sant'Agnese was a lay religious society whose devotion to Saint Agnes was established as early as 1291.[3] Members of the company included both men and women, as the illuminations' marginal images of lay figures in attitudes of prayer suggest.[4] They worshiped together and performed works of mercy, abiding by a prescribed rule. Within the church, they had their own oratory as well as a chapel in the left aisle, where members could be buried. Indeed, confraternity members were entitled to more imposing funerals than other citizens, and this seems to have been an incentive for membership. During the fifteenth century, the Compagnia di Sant'Agnese was famous for its theatrical

production of the Ascension, complete with elaborate costumes, props, and mechanical equipment.

In 1466 an inventory of the property of the Compagnia di Sant'Agnese was prepared by one of its officers (*sindaco*), the painter Neri di Bicci. The listing includes the books that belonged to the confraternity. Five *laude*, four of them illustrated, are described as follows:

> Uno libro grande choverto d'assi, choperte di chuoio chompassi d'otone e bullette grosse, richiamente fatto, suvi iscritto molte laude cho' molti begli mini, istoriato, di charta pechora. U' libro choverte d'assi e di chuoio, di charta pechora, suvi molte laude antiche, dipintovi suso in crocifiso e più altri mini. Adoperasi ogni dì. Uno libro di laude, choverto d'assi, charta pechora, miniato di mini grandi a penello e a penna. Uno libro di laude choverto d'assi chon bullette, charte di pechora, iscritovi suso molte laude zolfate e fighurate basso. Uno libro di charta pecora, choverto d'asse, imbulletato, iscritovi suso laude. (CRS 115, 164r; cited in Barr 1989, p. 219 n. 30)

(One large book covered with boards and leather, fastened with large brass tacks, and richly made, in which are written many *laude* with many beautiful historiated miniatures on parchment. A book covered with wood and leather, made of parchment, in which are many ancient *laude*, with a crucifix painted on it and many other miniatures. Used every day. A book of *laude* covered with boards, made of

parchment painted with large illuminations done with paintbrush and quill. One book of *laude* on parchment, covered in boards with tacks, in which are many *laude* that are . . . [set to musical notation], figured below. A parchment book, covered with board and tacked, in which *laude* are written.)

The second of these books, noted as having old ("antiche") *laude*, perhaps refers to the dispersed laudario, which, with its monophonic music, may have been considered "antique" by the mid-fifteenth century.

Reconstructing the original appearance of the dispersed laudario is complicated because no two surviving laudario codices share a common text sequence (Moleta 1978, p. 31), nor is the order of hymns in the surviving bound volumes necessarily logical. In the laudario for the Fraternità di Santa Maria delle Laude at Santo Spirito of about 1330, preserved in the Biblioteca Nazionale Centrale, Florence (Mgl1; now Banco Rari 18), for example, the hymn for the Pentecost precedes those for the Nativity (Moleta 1978, p. 32 n. 18). In general the *laude* of Santo Spirito and of the Compagnia di Sant'Egidio, of about 1380 (Biblioteca Nazionale Centrale, Florence; Mgl2, now Banco Rari 19, containing hymns without musical notation), follow the same pattern, with hymns to Christ and the Virgin followed by hymns to the saints, as indicated in the rubrics of the index (Moleta 1978, p. 43, n. 71).

The sequence of the surviving leaves from the laudario, to the extent it can be reconstructed from the original pagination, suggests that it began with one or more hymns to the Virgin. Part of one is visible on the reverse of the leaf with the Calling of Saint Andrew (cat. no. 4b), which is numbered XI. This may have been preceded by a hymn or hymns to Christ, with the leaf with the image of Christ and the apostles (cat. no. 4a) at the opening of the hymnal, like the Christ in Majesty at the opening of the Sant'Egidio Laudario (Banco Rari 19). As is standard in graduals and antiphonaries, the hymn for Saint Andrew on November 30 heralded the beginning of the liturgical year in December with the penitential season of Advent. Then followed the sequence of the major feasts for the life of Christ (with the feasts of Pentecost, Corpus Domini, and Trinity Sunday falling in close succession as pages LXXXIII, LXXXV, and LXXXVII). One would ordinarily have expected the feast of Corpus Domini to have followed Trinity Sunday, since it is now celebrated on the Thursday after Trinity Sunday. The inversion may simply be a function of the erratic sequence of feasts sometimes found in laudario manuscripts, but the celebration of the two feasts was not universally established in the West until the fourteenth century—

Figure 27. Pacino di Bonaguida, Saint John on Patmos in an initial G. Free Library of Philadelphia; J. F. Lewis Collection (M. 25:8)

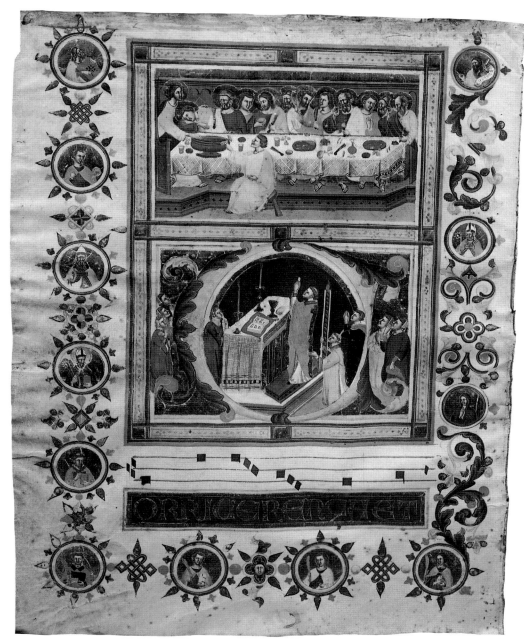

Figure 28. Master of the Dominican Effigies, The Last Supper and the Celebration of the Eucharist. Museum Mayer van den Bergh, Antwerp (MS 303)

Trinity Sunday in 1334. The leaf for the feast of All Saints, which falls on November 1, nearly a full year after the feast of Saint Andrew, bears the number CXXI. There are no preserved leaves for the Lenten season or for the Sundays after Pentecost. These may have been among the other volumes listed in the inventory, or they may never have existed, as they also do not form part of the body of hymns in the Florentine laudario for the Fraternità di Santa Maria delle Laude at Santo Spirito. The probable sequence of the twenty-three surviving leaves is proposed as follows:

1. Christ in Majesty with the Twelve Apostles, National Gallery of Art, Washington, D.C. (B-20,651; cat. no. 4a).

2. The Calling of Saint Andrew in an initial A (November 30) ("Andrea beato laudi tucta la gente" [Let all the people praise the blessed Andrew]), Musée du Louvre, Paris (inv. no. 9828; cat. no. 4b).

3. The Nativity and the Annunciation to the Shepherds (December 25), National Gallery of Art, Washington, D.C. (B-15,393; cat. no. 4c).

4. Saint John on Patmos in an initial G (December 27), Free Library of Philadelphia (fig. 27).

5. The Adoration of the Magi (January 6), Kisters Collection, Kreuzlingen (Freuler 1992).

Figure 29. Pacino di Bonaguida, border decoration with Carmelite saint and donor. Staatliche Museen zu Berlin; Kupferstichkabinett (Min. 6059)

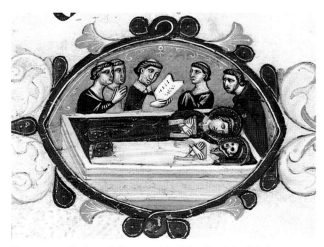

Figure 30. Pacino di Bonaguida, The Burial of Saint Lawrence with Saint Stephen. Free Library of Philadelphia; J. F. Lewis Collection (M. 25:7a)

6. Saint Agnes Enthroned and Scenes from Her Legend (January 21), British Library, London (Add. MS 18196; cat. no. 4d).

7. The Annunciation (March 25), private collection, Florence (Boskovits 1984, pl. CXE, p. 270).

8. The Resurrection and the Three Marys at the Tomb (Easter Sunday), Fitzwilliam Museum, Cambridge (MS 194; cat. no. 4e).

9. The Ascension, private collection, New York (cat. no. 4f).

10. The Apparition of Saint Michael (May 8), British Library, London (Add. MS 35,254 B; cat. no. 4g).

11. The Baptism and the Martyrdom of Saint Pancras (May 12) in an initial S ("Sancto Pancrazo martir glorioso da Cristo" [Saint Pancras, glorious martyr of Christ]), formerly in the Forrer collection, Strasbourg (Offner 1956, pl. LXX).

12. Saint Zenobius in an initial N (May 25), The Art Institute of Chicago.

13. Three Miracles of Saint Zenobius (May 25) (*bas-de-page*), formerly Salmi collection, Rome.

14. The Descent of the Holy Spirit (Pentecost), Bernard Breslauer collection, New York (cat. no. 4h).

15. The Last Supper and the Celebration of the Eucharist in an initial C ("Corriverenza et" [With reverence and . . .])(Corpus Domini), Museum Mayer van den Bergh, Antwerp (MS 303, fig. 28).

16. The Trinity (Trinity Sunday), The Pierpont Morgan Library, New York (M. 742; cat. no. 4i).

17. The Martyrdom of Saints Peter and Paul (June 29), Fitzwilliam Museum, Cambridge (Marlay Cutting It. 83; cat. no. 4j).

18. The Martyrdom of Saint Lawrence (August 10), formerly van Beuningen collection, Vierhouten (Offner 1930, part I, pl. XI).

19. The Burial of Saint Lawrence with Saint Stephen (August 10), fragment of a *bas-de-page*, Free Library of Philadelphia (25.7a; fig. 30).

20. The Martyrdom of Saint Bartholomew (August 24), private collection, New York (cat. no. 4k).

21. The Instruments of the Passion in an initial O ("Ognuomo ad alta voce laudi la verace croce" [Let all men praise the True Cross in a loud voice]), the Exaltation of the Cross (September 14), formerly Carlo Bruscoli collection, Florence (Offner 1956, pl. LIV).

22. All Saints (November 1), National Gallery of Art, Washington, D.C. (B-22,128; cat. no. 4l).

23. Cutting from a border with Carmelite saint and donor for an unknown feast, Kupferstichkabinett, Berlin (Min. 6059; fig. 29). BDB

1. Offner initially grouped the leaves representing the Trinity, Resurrection and Three Marys, Ascension, and All Saints (Offner 1930, pt. 2, p. 231; idem 1956, p. 212, n. 1). Additional sister leaves have been identified subsequently, for which, see literature below.

2. The format is used for the following leaves: the Morgan Library Trinity, the British Library Saint Michael, the Cambridge Resurrection and Three Marys, the Ascension, the National Gallery Nativity, the National Gallery All Saints, and the Breslauer Pentecost (all in the exhibition), as well as for the Antwerp Corpus Domini and Florence Annunciation. It was probably the case with the National Gallery Christ and Apostles as well, which has been cut away from its text page.

3. See Barr 1989, p. 217 n. 3. On the history of the confraternity, see Bacchi 1930–31. The alternative suggestion—that a fragmentary *lauda* to Saint Zenobius found on the reverse of the Breslauer Pentecost could indicate that the laudario was made for the company of that bishop saint of Florence—is not tenable, given that *laude* to Saint Zenobius occur in three other surviving laudario manuscripts (see Moleta 1978, p. 48, n. 89).

4. See Weissman 1991, p. 212.

LITERATURE: For references to individual leaves, including exhibition catalogues, see those entries. The following references are to the ensemble: Offner 1930, pt. 2, p. 231; idem 1956, p. 212, n. 1; idem 1957, p. 56; Hartford 1965, p. 45; Chelazzi Dini 1977, pp. 140–45; Ziino 1978; Barr 1988, pp. 125–28; Ziino 1988, p. 122; Barr 1989; Ziino 1989, pp. 1465–1502; Barr 1990.

4a

4a. Christ in Majesty with the Twelve Apostles

Tempera and gold leaf on parchment
10 7/8 × 8 1/8 in. (27.7 × 20.6 cm)

National Gallery of Art, Washington, D.C.; Rosenwald Collection (1952.8.277)

Christ, wearing a white mantle over a yellow green robe, appears in a mandorla, his right hand raised in blessing, his left holding a book. Four apostles appear in pairs to his immediate left and right; eight others appear below against a field of blue, kneeling before him, their heads and hands raised in prayer. The miniature has been cut away from its original page and laid down on a protective backing, through which musical staves and lettering can be discerned. Both the style of the miniature and its format are consistent with the leaves taken from the Laudario of the Compagnia di Sant'Agnese.

The illumination may have been set at the beginning of the laudario, heading a hymn to Christ, like the Master of the Dominican Effigies' Christ in Majesty that precedes the first hymn of the laudario from Sant'Egidio (Offner 1930, pt. 2, pp. 326–33, pl. 138, p. 327).

BDB

EX COLL.: C. G. Willoughby (sold 1929); [Quaritch, London (1929–51?)]; E. Rosenthal, Berkeley; L. J. Rosenwald, Jenkintown, Pa. (1951).

LITERATURE: Nordenfalk et al. 1975, no. 6, pp. 22–25 (with previous literature).

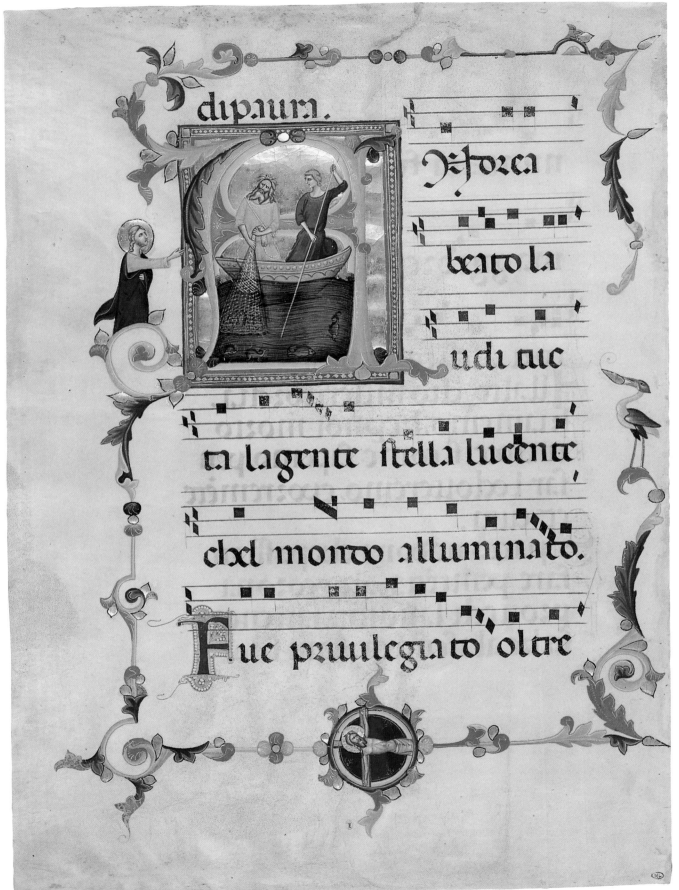

4b

4b. The Calling of Saint Andrew in an Initial A

Tempera and gold leaf on parchment
18 5/16 × 13 5/16 in. (46.6 × 33.9 cm)

Musée du Louvre, Paris; Département des Arts Graphiques (9828)

The miniature illustrates the Calling of Saint Andrew, following the Gospel accounts of Matthew (4:18–20) and Mark (1:16–18), in which Jesus, finding Andrew and his brother Simon, called Peter, casting their nets into the Sea of Galilee, asks them to become Fishers of Men. Andrew, dressed in a pink robe, stands in his fishing boat, his hands grasping the net made heavy by fish. Beside him a nimbed figure, with blond hair and a blue robe, more youthful than the usual representations of Peter and sometimes thought to represent Saint John the Evangelist, pushes against the sea bottom with a pole. The nimbed and gray-bearded Andrew cocks his head slightly as he gazes toward Jesus, who calls to him from outside the initial, which is framed in dark red with a gold diaper pattern. Poised on the foliate terminal of the letter A and wearing a blue mantle, Christ appears slightly windswept as he gestures toward the fishermen with his right hand. In a roundel framed in yellow and blue at the center of the lower margin, Andrew appears crucified on a cross lying horizontally, following one of the conventional means of representing his martyrdom (Réau 1955–59, vol. 3, pt. 1, pp. 78–79). The leaf is painted with great delicacy, which is noticeable in such details as the green water, through which the bottom of the boat and the swimming fish, both caught and free, are perceptible.

The feast of Saint Andrew falls on November 30, close to the beginning of Advent and the church year. Judging from the number XI on the reverse of the leaf, the hymn for the feast of Saint Andrew came near the beginning of the laudario, following an arrangement common to graduals and antiphonaries. The relevant hymn, found also in the laudarios from Santo Spirito and Sant'Egidio (Banco Rari 18, 19), reads: "Andrea beato laudi tucta la gente stella lucente chel mondo alluminato. Fue privilegiato oltre . . ." (Let all the people praise the blessed Andrew, the shining star who lighted the world. He was privileged beyond . . . [see Tenneroni 1909, p. 57]). The reverse bears part of the text of a hymn to the Virgin, "laude Vergine sancta Maria" (praise the Holy Virgin Mary), indicating that one or more hymns to the mother of Jesus preceded the Advent sequence.

BDB

LITERATURE: Reiset 1856–60, vol. 5, no. 9828.

4c. The Nativity and the Annunciation to the Shepherds

Tempera and gold leaf on parchment
14 1/2 × 10 3/4 in. (36.7 × 27.3 cm)

National Gallery of Art, Washington, D.C.; Rosenwald Collection (1949.5.87)

This sumptuously decorated leaf is closely related to a number of Nativity compositions created by the Master of the Dominican Effigies, including the panel painting published in this volume (cat. no. 5). In a rocky, nocturnal landscape, the Virgin Mary, wearing a blue mantle and rose gown, reclines on a vibrant orange bed superficially protected by a stable that is supported by two poles. She rests her right elbow on the manger-crib of her infant son, who is wrapped in swaddling and attended by the ox and ass and paired angels. From behind the rocks other angels look on adoringly at mother and son, while two flanking the stable roof turn their gaze heavenward through the star-studded sky. Below the Virgin sits the gray and bearded Saint Joseph, resting his head in his hand. Near Saint Joseph's feet graze the sheep of three shepherds, who are shown in half-length as they turn to receive the angelic message of the birth of Jesus. At the lower right a blue goat stands on its hind legs to nibble the branches of a tree. The Nativity scene is enclosed in a rectangular painted frame, the bottom edge of which is painted to resemble marble. The graceful lines of foliage that frame the scene are enlivened at the left by three additional angels, at the upper left corner by a horn-blowing putto, at the upper center by the face of Christ set in a quatrefoil, and at the lower center by the kneeling figure of a man, presumably a member of the lay confraternity of Sant'Agnese, for which the manuscript was made.

The opening words of the hymn, "Xpisto e nato [e] hu[manato per salvar la gente]" (Christ is born and made human to save the people), are also used for the feast of the Nativity in the laudarios from Santo Spirito and Sant'Egidio. They are spelled out in Lombard capitals of alternating blue and red set beneath a single stave of monophonic music. Part of an unidentified hymn appears on the reverse: "Lauda: Ogn'om si sforci d'ordinare" (Let every man seek to prepare).

BDB

EX COLL.: Conti della Gherardesca, Florence; Sig. Bosi, Florence; H. Rosenthal, Lucerne; E. Rosenthal, Berkeley; L. J. Rosenwald, Jenkintown, Pa. (1949).

LITERATURE: Offner 1957, p. 64, pl. XXI; Hartford 1965, no. 80, p. 45; Nordenfalk et al. 1975, no. 7, pp. 26–28; Partsch 1981, p. 61, no. 51.

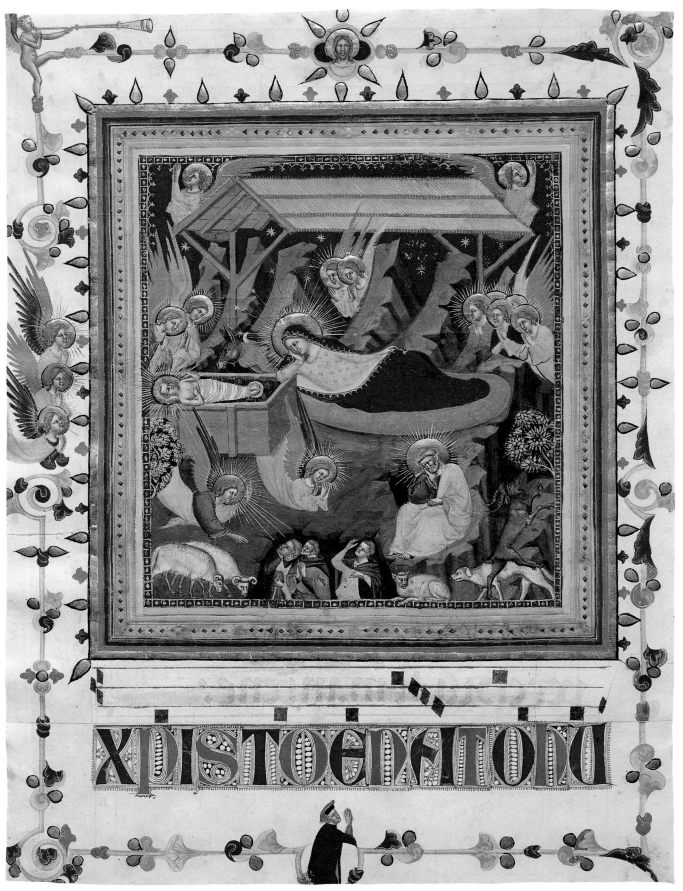

40

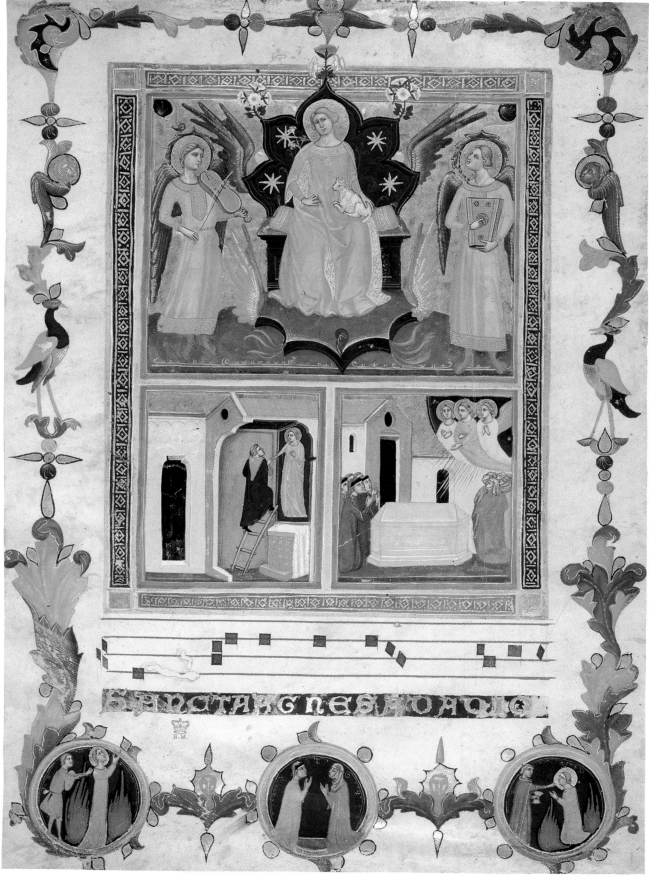

4d

4d. Saint Agnes Enthroned and Scenes from Her Legend

Tempera and gold leaf on parchment
16 1/2 × 11 3/4 in. (42 × 29.9 cm)

British Library, London (Add. MS 18196)

The large rectangular miniature is divided into an upper and a lower register, the lower one then divided vertically into two smaller rectangular compartments. In the upper register Saint Agnes, in a pink gown and a yellow mantle lined in gold, sits on an elaborate throne with a winged, flower-shaped back decorated with stars, from which roses grow and green-and-orange wings and flames emerge.[1] She holds her symbol, a lamb, on her lap and is flanked by two standing angels dressed in pink and playing musical instruments.

At the lower right Agnes's relatives maintain a vigil beside the virgin martyr's tomb: "They saw a choir of virgins in robes of gold; and among them was the blessed Agnes, with a lamb whiter than snow at her right side. And she said to them: 'Look upon me, in order that ye may not mourn me for dead, but may rejoice and be glad with me; for I have been admitted henceforth to sit in the midst of this company of light!'" (Voragine 1969, p. 112).

A second apocryphal legend is depicted at the lower left. Paulinus, a priest of the church of Saint Agnes, dressed in blue with an orange hood, implores her statue to allow him to marry, holding out an emerald ring sent to him by the pope. "And when the priest asked Saint Agnes to allow him to marry, the statue all at once held out its ring finger, slipped on the ring given by the pope, and then withdrew the hand. And straightway the priest was freed of all his temptations" (Voragine 1969, p. 113).

Three additional figurative scenes appear in oculi along the lower margin of the leaf. At the left and right, the prayerful Saint Agnes survives being thrown into flames at the order of Aspasius (Voragine 1969, p. 112). In the center a man and woman, who may be presumed to be members of the Compagnia di Sant'Agnese, kneel in prayer. The leaf has been trimmed on all sides.

The feast of Saint Agnes, celebrated on January 21, was established as one of the principal feasts at the Carmine as early as 1291 (Ziino 1978, p. 62), along with that of the mystery of the Ascension. The church had received a relic of the saint's foot from the bishop of Florence, Giovanni de' Mangiardori, and had placed it in a reliquary beneath the altar in the chapel of the laudesi (Richa 1754–62, vol. 10, pp. 16–17).

The hymn—"Sancta Agnese da dio amata" (Saint Agnes, loved by God)—is also recorded in the laudario of Santa Maria delle Laude from Santo Spirito (fol. 129), an earlier Florentine laudario that was richly illustrated but artistically less ambitious than the present one. In that laudario, the hymn to Saint Agnes occurs before All Saints. Here it clearly falls in chronological sequence, since the reverse of the leaf has part of the hymn of Saint Anthony, whose feast occurs on January 17: "Ciascun ke fede sente" (Each one who feels faith).

This leaf was omitted from Freuler's listing of the leaves surviving from the Laudario of Sant'Agnese (Freuler 1991, p. 180).

BDB

1. In the *lauda* Agnes is referred to as "fresca rosa" (fresh rose). For the *lauda* text see Liuzzi 1935, p. 386.

Ex coll.: William Young Ottley, Esq., London (sold 1838); [Payne and Foss, 1850].

Literature: Ottley sale 1838, no. 177.

4e. The Resurrection and the Three Marys at the Tomb

Tempera and gold leaf on parchment
18 × 13 in. (45.6 × 33 cm)

Fitzwilliam Museum, Cambridge (MS 194)

At the center of the upper register of the large rectangular miniature, the standing Christ, wearing a yellow robe trimmed with gold and a white mantle, rises from his tomb, his head and shoulders in front of the decorative frame of the miniature. The soldiers guarding his tomb lie in confusion at either side of the sarcophagus in a rocky landscape. In the lower register the angel of the Resurrection, his countenance and hands glowing crimson, sits on the edge of the open sarcophagus and greets the three Marys, who have come to anoint the body of Christ.

The margins are filled with eight oculi depicting the appearances of Christ to Mary Magdalen and to his apostles after the Resurrection. Reading counterclockwise from upper left, they are: Christ appearing to his mother (Voragine 1969, p. 221); Christ appearing to Mary Magdalen in the garden (Mk 16:9; Jn 20:14–18); Christ appearing to Peter and John(?) (derived from Jn 20:1–10); Christ appearing to James the Less (Voragine 1969, p. 263); the road to Emmaus (Lk 24:13–29); the supper

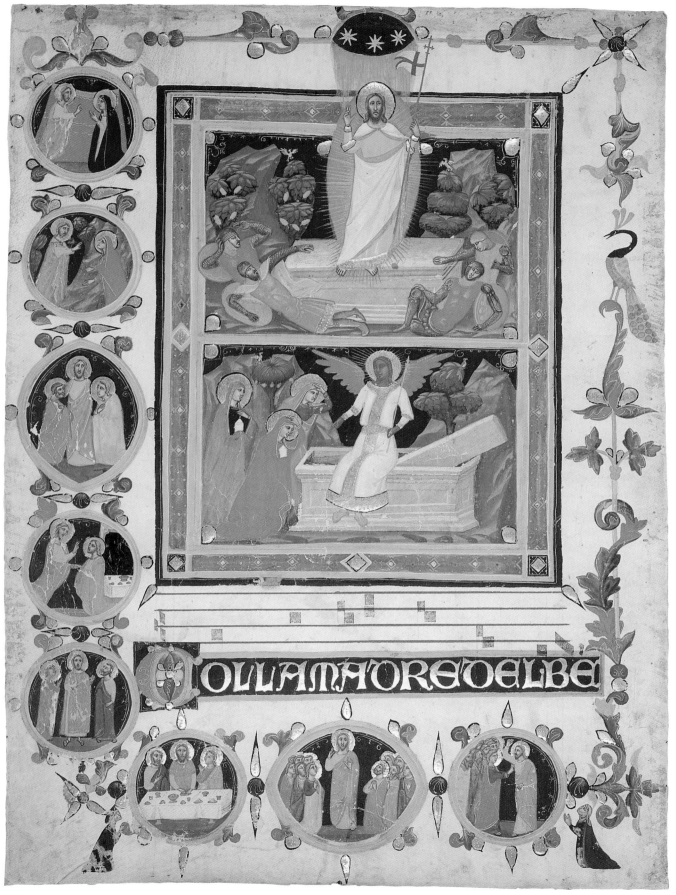

OLLAMAOREOELBE

at Emmaus (Lk 24:30–44); Christ appearing to the disciples in the absence of Thomas (Mt 28:18; Mk 14:18; Lk 23:36–49; Jn 20:19–23); and Christ appearing to Saint Thomas (Jn 20:24–29). Two lay figures kneel in witness to the Supper at Emmaus and the Doubting of Thomas along the bottom margin. A peacock in the right margin is symbolic of eternal life.

The hymn of praise "Colla madre del be[ato]" (With the mother of the blessed) is spelled out in gilt capitals across the bottom. The same hymn is found in both the Santo Spirito and Sant'Egidio laudarios.

BDB

EX COLL.: William Young Ottley, Esq., London (sold 1838); purchased by the Fitzwilliam Museum in 1891.

LITERATURE: Ottley sale 1838, no. 178; Partsch 1981, cat. 5, pl. 19, fig. 61; Henderson 1994, pl. 3.4.

4f. The Ascension

Tempera and gold leaf on parchment
17 1/2 × 12 1/2 in. (44.4 × 31.8 cm)

Private collection, New York

Resplendent in white, Christ appears in a mandorla in the sky, flanked by pairs of angels. Below him on the ground are the assembled apostles and the Virgin Mary, gazing heavenward. In the margins at the left and right stand two angels playing the psaltery and lute (Ziino 1978, pp. 59–60). While the depiction of Christ is ultimately Byzantine in origin, the disposition of the figures against the landscape shows Pacino's awareness of the innovations of Giotto. The leaf is striking for its use of brilliant color contrasts silhouetted against gold and especially for the presence of Pacino's distinctive yellow.

At the bottom appear the opening words of the hymn, its text in first-person plural: "Laudamo la resurrec[tione]" (Let us praise the Resurrection). The very personal nature of the hymn of praise is emphasized in the oculus at lower center, where paired members of the Compagnia di Sant'Agnese look up at the scene, witnesses, like the apostles, to the miracle. The members of the compagnia maintained a special devotion to the miracle of the Ascension, which was best expressed in its annual theatrical production. Elaborate props were employed to simulate the miracle, including a hoist designed by Filippo Brunelleschi (Barr 1990, p. 381).

The same hymn occurs in the laudarios from Santo Spirito and Sant'Egidio.

BDB

EX COLL.: William Young Ottley, Esq., London (sold 1838, perhaps no. 179); Frank Channing Smith, Jr., Worcester, Mass.; Robert Lehman, New York.

LITERATURE: Ottley sale 1838, p. 11, no. 179, apparently describing this miniature; Gómez-Moreno 1968, no. 1.

4g. The Apparition of Saint Michael

Tempera and gold leaf on parchment
17 1/4 × 12 5/8 in. (43.8 × 32.2 cm)

British Library, London (Add. MS 35,254 B)

This most monumental of Pacino's illuminations for the laudario is based on the account found in the Book of the Apocalypse (12:7). Saint Michael, dressed in heavenly armor and accompanied by two other archangels, plunges his lance into the devil's throat. Christ and the company of heaven look down from above the stars as the devil's hellish companions cluster below around his snakelike form.

At the lower left is the scene of the shooting of the bull on Mount Gargano in Apulia. According to *The Golden Legend* (Voragine 1969, p. 579), a wealthy man named Garganus pursued a wayward bull from his herd to the mountain, where, angered by his straying, he attempted to shoot it with a poison arrow. Caught up by the wind, the arrow turned and killed Garganus instead. Saint Michael then appeared to the local bishop, declaring that he was responsible for the death of the man and proclaiming that the mountain and creatures there were under his protection. This is the only instance in the laudario where Pacino, like the Master of the Dominican Effigies, has created a narrative outside the confines of the central illumination or the framing oculi. Two lay figures in prayer appear nearby, one in a roundel, the other poised on the foliate ornament of the border.

The manuscript has been cut at the top and left sides. Agostino Ziino believed that from the photographic transparency he could read the roman numerals LXXIII on the reverse; this would place the hymn for the Apparition of Saint Michael, celebrated on May 8, and

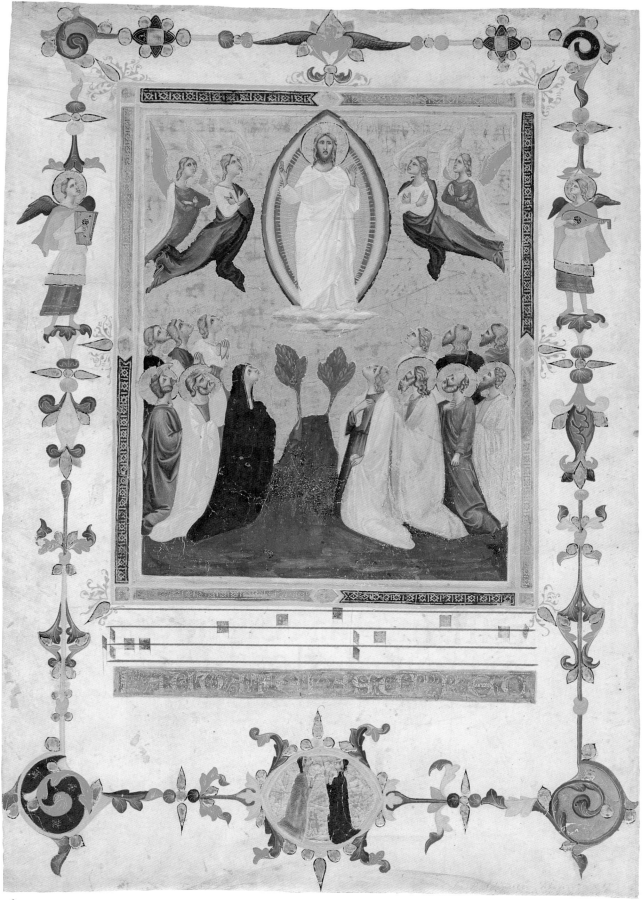

4f

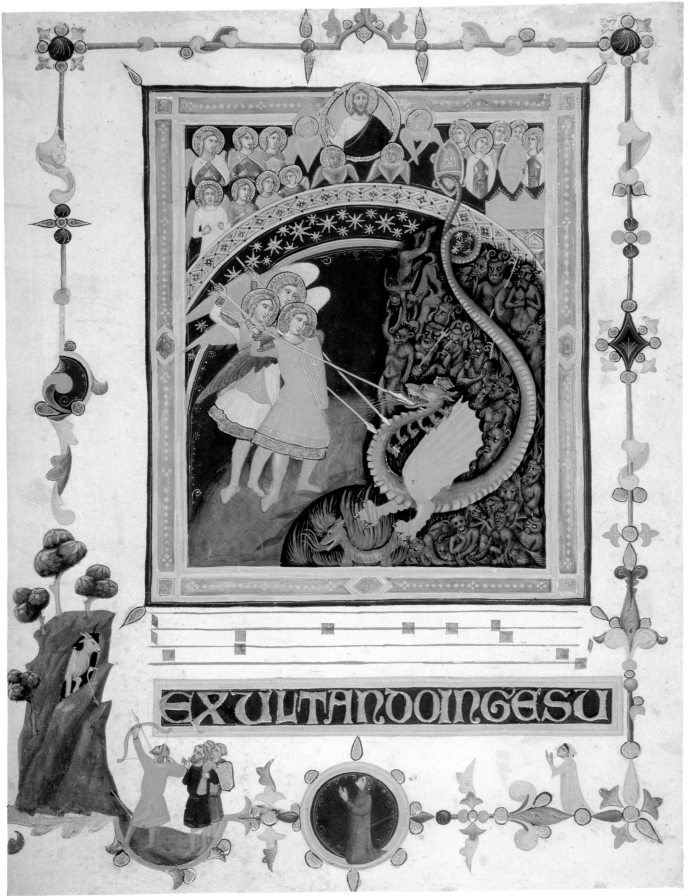

EXULTANDOINGESU

4g

the page for the feast of Saint Pancras (May 12), which bears the end of its text on its reverse, in the middle of the feasts for the Life of Christ. This is not inconsistent with the layout of the book, in which, for example, the *lauda* for Saint Zenobius's feast on May 25 appears on the reverse of the Breslauer Pentecost (cat. no. 4h).

The hymn of praise to Saint Michael, "Exultando in Gesu" (Rejoicing in Christ), is spelled out in gilt capitals across the bottom of the page. The hymn also appears in the laudario of Santo Spirito. The present location of the sequential leaf with Saint Pancras, last published in the Robert Forrer collection, Strasbourg, at the beginning of this century, is unknown.

BDB

EX COLL.: John Malcolm of Poltalloch (Robinson 1876, p. 277).

4h. The Pentecost

Tempera and gold leaf on parchment
16 7/8 × 12 1/2 in. (43 × 31.7 cm)

Bernard H. Breslauer, New York

As the Virgin Mary and Christ's apostles gather in a circle, some praying, some reading sacred texts, the dove of the Holy Spirit descends from the star-studded roof of an open Gothic aedicula. The Virgin wears a blue mantle; the apostles are dressed in blue, yellow, green, and orange. The figure of Christ blessing appears in a roundel at the pinnacle of the Gothic arch, flanked by angels enclosed in foliate decoration. The scene is a rather tame depiction of events described in the Acts of the Apostles (2:1–4), wherein a rushing wind filled the house and cloven tongues of fire descended on each of the apostles, causing them to speak in tongues. The inclusion of the Virgin, who is described as praying with the apostles in Acts 1:14, is a tradition dating to the sixth century and known in both the Eastern and Western Churches (see cat. no. 29d).

At the bottom center is the profile figure of a layperson in prayer, apparently a member of the Compagnia di Sant'Agnese, for which the laudario was made. Roundels at each of the corners contain representations of Saints Dominic and Francis, a martyr saint, and a sainted queen.

The opening lyrics of the hymn for Pentecost—"Spirito Santo Glorio[so]"—are spelled out in gilt capitals across

the bottom of the page. The same hymn is recorded in the laudario for Santo Spirito (Banco Rari 18). The end of the hymn occurs on the recto of the Antwerp Corpus Domini leaf (fig. 28).

On the recto of the Breslauer page are the page number, LXXXIII, and a fragmentary text from another *lauda*—"A la nostra tenebria e zenobio veramente dimostrandone la via" (In our darkness appears Zenobius verily showing us the way). This is from the hymn for the feast of Saint Zenobius on May 25, indicating that fixed and temporal feasts were interwoven in the original layout of the laudario. A fragment in The Art Institute of Chicago (acc. no. 1926.1573), with foliate border ornament of the type used by the Master of the Dominican Effigies in this laudario and a letter N enclosing the half-length figure of a bishop, may be from the opening of this same hymn to Florence's bishop saint: "Novel canto tucta gente canti cum divoto core" (Let everyone sing a new hymn with a pious heart). Another manuscript cutting by the artist, representing the funeral of Saint Zenobius, formerly in the Salmi collection, Rome (Offner 1957, pl. XIIIc), the width of which corresponds to the laudario fragments, may be the *bas-de-page* from the same hymn.

BDB

EX COLL.: William Young Ottley, Esq., London (sold 1838); [H. P. Kraus, New York (1961–90)].

LITERATURE: Ottley sale 1838, p. 12, no. 180; Kraus 1961, p. 51, no. 14; Hartford 1965, no. 82, p. 45; Kraus 1965, p. 23, no. 9; Voelkle and Wieck 1992, no. 66, pp. 178–80.

4i. The Trinity

Tempera and gold leaf on parchment
17 3/4 × 13 1/8 in. (45 × 33.3 cm)

The Pierpont Morgan Library, New York (M. 742)

The leaf is dominated by the figure of Christ in Majesty framed within a circle and attended by angels holding liturgical implements and playing musical instruments. Beneath them are the spheres of the heavens. Standing in the left and right margins are two nimbed figures, the one at the left bearing a crown, the one at the right offering flowers. In oculi at the corners are representations of the Trinity: God the Father as the Ancient of Days, with Jesus in his lap and the dove of the Holy Spirit, at the upper right; the Synthronos, or three-headed Trinity, at the lower right; the three angels at Mamre at the lower left; and Abraham and the Three

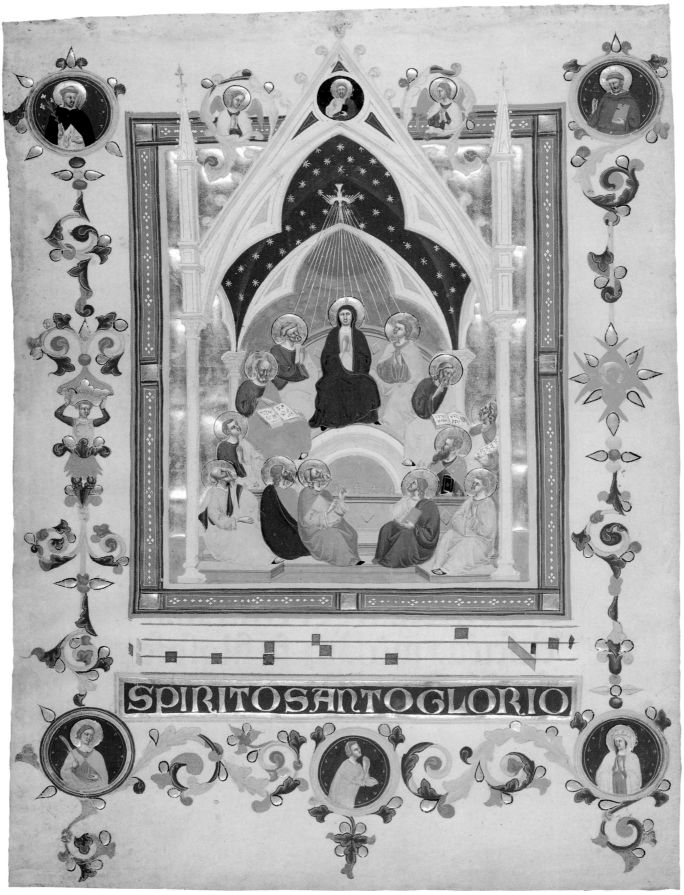

SPIRITOSANTOGLORIO

4h

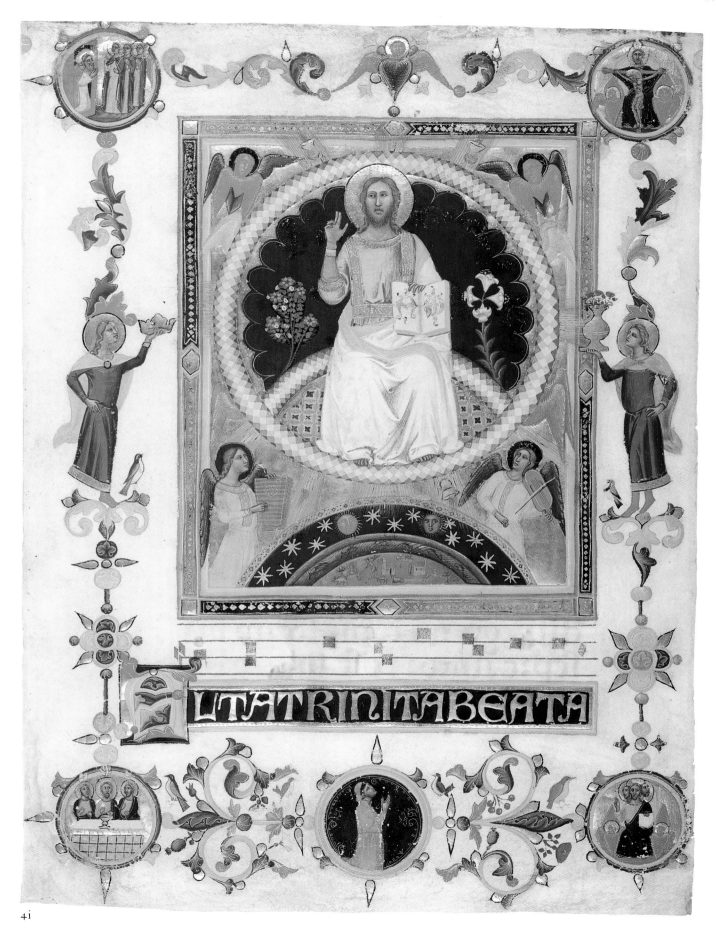

41

75

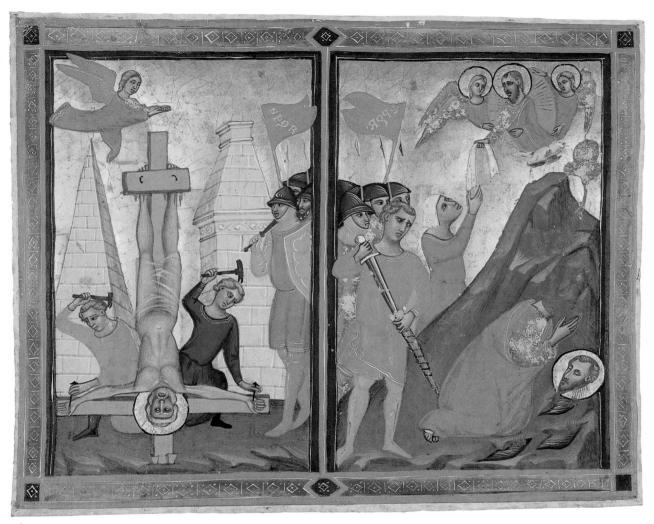

4j

Angels at the upper left (Gn 18; for this combination, see cat. no. 17f; on the iconography of the Trinity, see D'Achille 1991).

In an oculus at the center of the lower margin is a kneeling layman, a member of the Compagnia di Sant'Agnese, for which the laudario was made. He gazes up toward the principal image and the opening words of the hymn, "Alta trinita beata" (Highest blessed Trinity), which begins with a decorated letter A and continues in gilt capitals. The original page numbering for this leaf, LXXXVII, and the one of the Pentecost in the Breslauer collection, LXXXIII, indicate that the Pentecost page preceded the Trinity page, contrary to established liturgical sequence. Erratic sequences of feasts are, however, not uncommon in laudario manuscripts.

The leaf is among the richest painted by Pacino for the laudario, varied in its palette and rich in the iconography of the Trinity, a feast that was officially established in the Western Church in 1334.

BDB

LITERATURE: Harrsen and Boyce 1953, p. 14, no. 23, colorpl. 1; Offner 1956, pp. 145 n. 29, 225; idem 1958, p. 200; Hartford 1965, no. 79, p. 44; Partsch 1981, no. 41, pl. 25, fig. 74; D'Achille 1991, fig. 48.

4j. The Martyrdom of Saints Peter and Paul

Tempera and gold leaf on parchment
7⅝ × 9 in. (19.5 × 23 cm)

Fitzwilliam Museum, Cambridge (Marlay Cutting It. 83)

The rectangular miniature for the feast of Saints Peter and Paul on June 29 is divided vertically into two compartments. The original format of the page must have resembled that of the leaf with the Martyrdom of Saint Bartholomew (cat. no. 4k). At the left is the Martyrdom

of Saint Peter, which takes place between two Roman *metae*, or goal markers, believed to represent the actual site of the apostle's execution in Rome (see Huskinson 1969, pp. 140–43). Two youths dressed in orange and blue drive nails through the hands of Peter, clad in a transparent loincloth, crucifying him on an inverted cross, following the apostle's humble request not to be crucified upright in the manner of Christ. Three soldiers bearing the banner of ancient Rome watch from the right, and an angel hovers over Peter in the sky. At the right kneels Saint Paul, dressed in a salmon-colored mantle over a green robe. Blood spills forth from his neck as his severed head falls to the ground, from which three springs emerge. The executioner places his sword back in its sheath, while soldiers again watch from behind. The saint in glory attended by angels gives to Plautilla, a devout Christian woman, the veil that she had lent him to shield his eyes during his execution (Voragine 1969, p. 344; for this iconography, see Gardner 1974, pp. 82–83).

Only a letter Q is legible through the protective backing that covers the reverse, and the text has not been identified.

BDB

Ex COLL.: Thomas Miller Whitehead (by 1855); Charles Brinsley Marlay (by 1886).

LITERATURE: Wormald and Giles 1982, vol. 1, pp. 142–43.

4k. The Martyrdom of Saint Bartholomew

Tempera and gold leaf on parchment
18 1/2 × 13 3/4 in. (47 × 35 cm)

Private collection, New York

A large miniature depicts the final moments of the martyrdom of the apostle Bartholomew. Outside a city gate three tormentors peel away the skin of his legs and arms as he stands in their midst. At the right the saint, forced to wear his skin tied about his neck, kneels in prayer before a rock, his haloed head tumbling to the ground as the bearded executioner, an aide standing behind him, returns his sword to its sheath. At the upper right angels escort the apostle's soul heavenward. In a roundel at left center, Bartholomew preaches to a crowd, probably in India, where, according to his legend, he

evangelized. At the upper left the saint is laid in his tomb.

The figure of the saint bears close comparison with figures found in an antiphonary at the church of Santa Maria all'Impruneta painted by Pacino and to which the Master of the Dominican Effigies contributed a single miniature (fol. 158). The image of John the Baptist in a letter M (fol. 172, "Misit Herodes") has a similarly rendered facial type, articulation of the beard, and definition of the hands and fingers with a dark outline. The foliage and roundels that border the Saint Bartholomew leaf are echoed in the leaf with the Birth and Naming of John the Baptist from the same manuscript (fol. 79v, "Fuit homo"), and the roundel with the laying of the saint in his tomb recalls the fragment in the Free Library, Philadelphia, with the Burial of Saint Lawrence with Saint Stephen (fig. 30).

The hymn for the feast of Saint Bartholomew (August 24), "Apostolo beato di Gieso Criso amato bartholomeo te laudiam" (Blessed apostle beloved of Jesus Christ, Bartholomew, you we praise), recurs in the laudario from Santo Spirito (Banco Rari 18; fol. 69v), as well as in the one from Santa Maria Nuova (Banco Rari 19). The leaf is numbered CI on the reverse.

BDB

Ex COLL.: [Mori, Paris]; Robert Lehman, New York (1924).

41. All Saints

Tempera and gold leaf on parchment
16 1/16 × 12 1/4 in. (40.8 × 31 cm)

National Gallery of Art, Washington, D.C.; Rosenwald Collection (1950.1.8)

Christ, his right hand raised in blessing and his left holding a book, sits opposite his mother on a large banquette-type throne covered with silk. Set before them is a golden two-handled vase. Flanking the throne on each side are two saints, identified by Richard Offner as Miniato and Pope Victor I at the right hand of Christ and Reparata and Zenobius at the right hand of the Virgin, all patrons of Florence. Beneath the throne, on Golgotha, thirty-six additional saints are disposed in three rows flanking the cross, which has a bloody nail still affixed to the suppedaneum. These include the Twelve Apostles and Saints John the Baptist, Dominic, Francis, Stephen, Lawrence, and Lucy(?). Among the

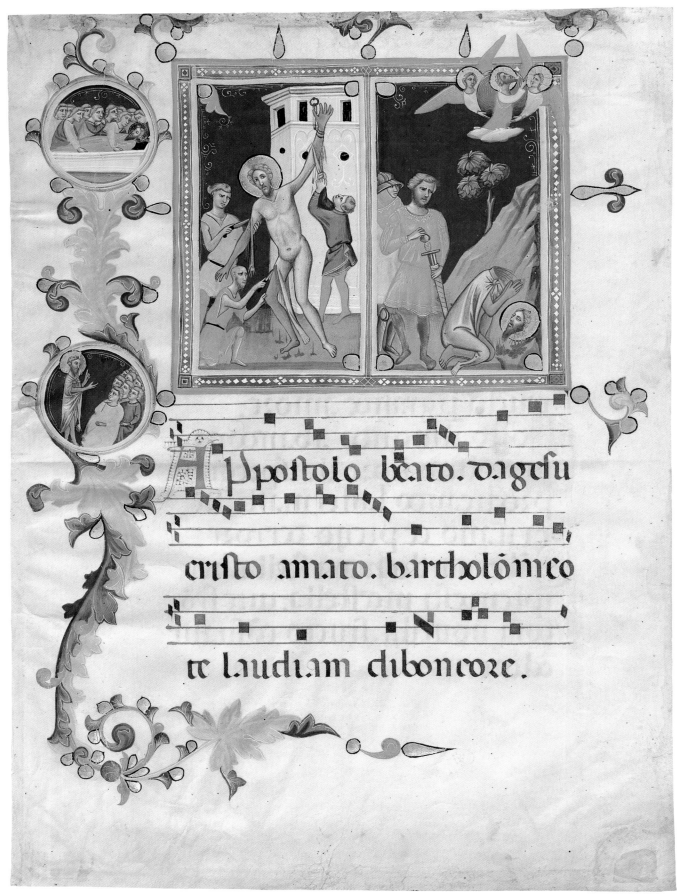

4k

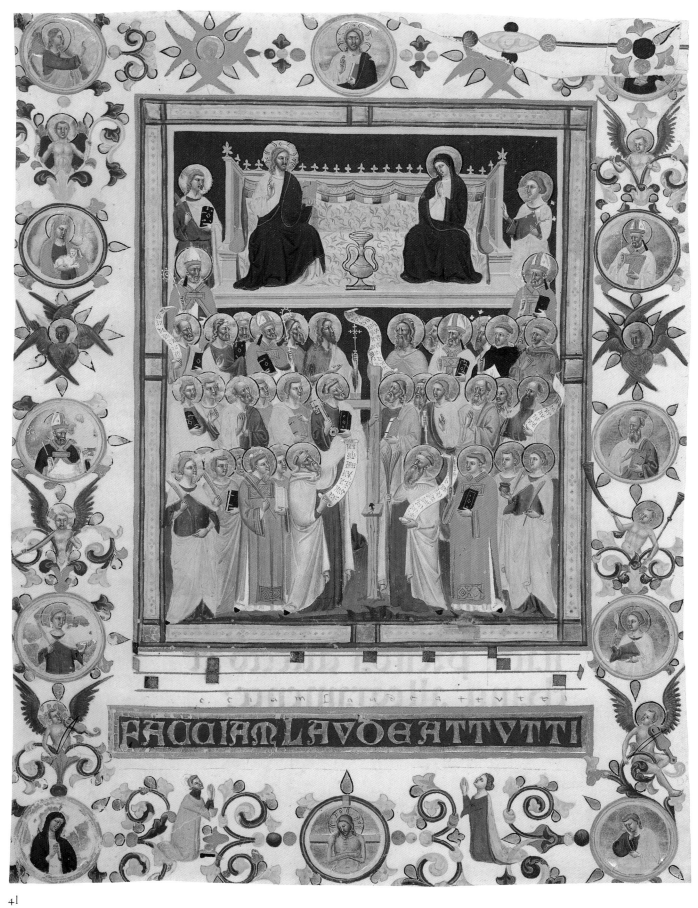

41

company of saints are two figures in Carmelite dress, probably Elias and Elisha, the Old Testament prophets believed to have been founders of the order (Koch 1959, pp. 547–48).

The margins are filled with music-making angels poised on rich foliage, radiant cherubim, and twelve gold-ground oculi. At the center top is the blessing Christ, flanked by the angel of the Annunciation and the Virgin Mary (largely cut off). At the bottom are Christ as the Man of Sorrows flanked by the Virgin and Saint John the Evangelist. At the left and right are Saints Agnes and Lucy, two bishop saints (one of them probably Zenobius), a third female martyr, and an elderly bearded saint, perhaps an apostle.

The space is highly artificial in its rendering, with the throne hovering over the company of saints, who are stacked in rows, some of them suggested, in medieval fashion, only by their halos. Nonetheless, their poses, attributes, and vestments vary to produce a composition that is both highly decorative in texture and iconographically interesting. The faces of the assembled saints are individually characterized and beautifully modeled.

With its Carmelite figures, partial *lauda* to San Minias, and roundel with Saint Agnes in the left-hand margin, this leaf was the basis for Offner's initial suggestion that the laudario belonged to the Compagnia di Sant'Agnese at the church of Santa Maria del Carmine. Two members of that company appear in prayer in the bottom margin, gazing up at the assembled saints.

The opening words of the hymn for the feast of All Saints (November 1), "Facciam laude at tutti [i Sancti]" (Let us praise all the saints), were first written in lightly over the block and then rendered in gold leaf. The same song of praise to the saints occurs in the Florentine laudarios from the companies of Santo Spirito and Sant'Egidio. The page number, CXXI, appears on the reverse.

<div align="right">BDB</div>

EX COLL.: E. Rosenthal, Berkeley; L. J. Rosenwald, Jenkintown, Pa. (1956).

LITERATURE: Offner 1957, p. 56, pl. XVIII; Hartford 1965, no. 81, p. 45; Nordenfalk et al. 1975, no. 8, pp. 29–32; Barr 1990, p. 390.

5. The Last Judgment; Virgin and Child with Saints; the Crucifixion; the Glorification of Saint Thomas Aquinas; the Nativity

Tempera on panel
26 5/16 × 18 11/16 in. (66.8 × 47.4 cm) overall

The Metropolitan Museum of Art; Robert Lehman Collection, 1975 (1975.1.99)

The gabled panel, probably once the center of a folding triptych, is divided by painted red borders into five scenes. The tympanum is filled with a scene of the Last Judgment. At the center is Christ seated in a mandorla surrounded by four angels, two bearing the cross and instruments of the Passion, two sounding the trumpets of the resurrection of the dead. Beneath the mandorla are two empty tombs, one white and one pink. At the left (that is, at the right hand of Christ), behind a low marble parapet and a rose hedge symbolizing paradise, stands a crowd of the blessed, dressed in white robes and crowned. They are presented to the Judge, who gestures to them with his upraised palm, by the Virgin, while alongside her stands an angel carrying a scroll inscribed: VENITE BENEDITT[I] PATER MEI EPOSIDETE [PARATUM VOBIS REGNUM] (Come, ye blessed of my Father, possess you the kingdom prepared for you; Mt 25:34). At the right (that is, at the left hand of Christ), the damned are delivered naked to the clutches of demons and the fires of hell, while Saint John the Evangelist pleads for them before Christ. Behind Saint John stands an angel with a scroll inscribed: GITE [A ME] MALLADITTI IN IGNAM ETTERNA (Depart from me, you cursed, into everlasting fire; Mt 25:41).

Beneath the Last Judgment are two nearly square compartments. At the left are the Virgin and child seated on a white marble throne draped with a red-and-gold cloth of honor. The Virgin holds a spray of flowers in her right hand, and the child a finch in his left. Alongside the throne at the left stands a bishop saint wearing a red cope and holding a red book but bearing no other distinguishing attributes. At the right of the throne stands Saint Peter Martyr in a Dominican habit. In the compartment at the right is the Crucifixion, with the Virgin fainting into the arms of the Holy Women at the left, Mary Magdalen embracing the foot of the cross in the center, and the grieving Saint John the Evangelist and a crowd of soldiers at the right. A bearded figure gesturing to Christ at the right and another in the left margin of the scene with a sword belted at his waist may be intended to represent Pharisees, who are commonly

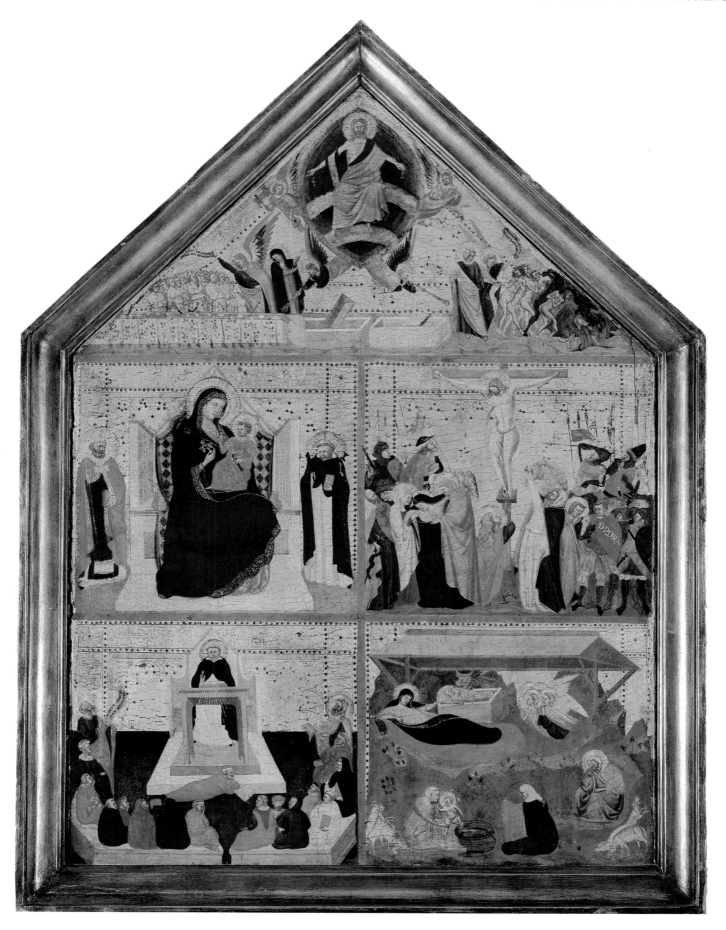

included in Sienese portrayals of the Crucifixion but are not always present in Florentine versions of the subject.

Across the bottom of the panel are two further compartments, showing the Nativity at the right and the Glorification of Saint Thomas Aquinas at the left. In the *Nativity* the Virgin is shown reclining beneath the pitched roof of a shed in a rocky landscape. The Christ child lies in a small crib beside her, adored by the ox, the ass, and a cluster of angels, two of whom are visible in half-length, while two more are indicated by their halos only. In the foreground at the right sits Saint Joseph, and at the left two attending women bathe the Christ child. Two groups of sheep and goats fill the lower corners of the scene. In the left-hand compartment Saint Thomas Aquinas is seated in the center on a white throne behind a pink desk raised on a dais. His right hand is raised in benediction as he reads from a book from which gold rays emanate downward. Before the dais at his feet is the figure of Averroës (Ibn Rushd; 1126–1198), lying prostrate with a book on the ground before him, symbolizing the triumph of Thomist Aristotelianism over prevailing (and, in the eyes of the Dominicans, heretical) Scholastic doctrine. Arrayed on two long curved benches stretched across the foreground of the scene are pupils and disciples of Aquinas, among whom may be seen two Franciscans, two Dominicans, a Camaldolese, a cardinal, and seven laypersons. Standing at the ends of the benches at the left and right are two saints wearing rose-colored cloaks over blue robes. The saint at the left holds a scroll inscribed: A[U]SCULTA O FILII P[RE]CEPTA MAGISTRI (Listen, O children, to the teachings of the Master), the incipit to Saint Benedict's rule.

Throughout its early history this beautiful and beautifully preserved panel was associated with either the Roman style of Pietro Cavallini or with Giotto's Riminese followers. Only Bernard Berenson (cited in Lehman 1928), who called it "close to Daddi," and Richard Offner (1930) recognized it as Florentine, the latter attributing it to the anonymous illuminator responsible for the nine miniatures in Lenzi's Biadaiolo manuscript (Biblioteca Laurenziana, Florence; Cod. Tempiano 3). As John Pope-Hennessy (1987) and Miklós Boskovits (1987) have affirmed, there can be no doubt of this attribution. The Lehman panel and the Biadaiolo manuscript are in complete accord in style and quality, both in overall character and in detail: the portrayal of the Virgin and child in a tabernacle on folio 79 of the manuscript[1] is all but identical to that of the same figures in the Lehman panel. One lingering point of contention lies in Boskovits's assertion that both the manuscript and the panel, together with Offner's other attributions to the so-called Biadaiolo Illuminator, are actually early

works of the prolific and qualitatively uneven Master of the Dominican Effigies.

Iconographic links between the groups of paintings attributed to the Biadaiolo Illuminator and the Master of the Dominican Effigies are numerous. The unusual form of the shed in the Nativity scene on the Lehman tabernacle, for example, constructed of only two pole supports, is virtually identical to that in the Nativity page from the Laudario of Sant'Agnese (cat. no. 4c) and to that in the gradual from Santa Verdiana, Castelfiorentino (Propositura, Cod. A, fol. 8v; Offner 1957, pl. xxa), both of which are by the Master of the Dominican Effigies. The treatment of the Virgin and child in these three scenes is also closely similar, as is the general disposition of Saint Joseph and the adoring angels. Both the Biadaiolo Illuminator and the Master of the Dominican Effigies are predisposed to extending their narratives continuously across the lower margins of the page, as in the Parma Dante (Offner 1957, pl. IIIa), the Saint Zenobius fragment (Offner 1957, pl. XIIIc), and the Assumption of the Virgin from the Impruneta antiphonaries (Offner 1957, pl. XVI), in a scenographic manner sharply at odds with the firmly compartmentalized *mise-en-pages* of Pacino di Bonaguida, the Maestro Daddesco, or any other manuscript painter of the first half of the fourteenth century in Florence. As the two painters also share numerous peculiarities of figure type, amounting almost to signatures of their styles, there is a strong presumption that they are in fact, as Boskovits claimed, successive phases in the career of a single artist.

The chief obstacle to accepting Boskovits's amalgamation of the Biadaiolo Illuminator and the Master of the Dominican Effigies has been the wide range of quality among the works commonly attributed to the latter compared with the remarkable inventiveness, immediacy, and polished execution of those by the former. This impression, however, is due in part to a misunderstanding of the nature of the workshop presided over by the Master of the Dominican Effigies and in part to several persistent misattributions to the artist, including an illuminated gradual at Poppi (Biblioteca Comunale, Cod. 1; Offner 1930, pt. 2, pl. XXX); an illuminated antiphonary in Kraków (Offner 1957, add. pl. XVI); a gradual in the Seminario Maggiore at Cestello, Florence (Offner 1957, pl. XVII); and an illumination in the *Libro dei lasciti alla Compagnia di Or San Michele* of 1340 (Archivio di Stato, Florence; MS 470; Offner 1930, pt. 2, pl. XXIX). Not only are these incompatible with works by the Biadaiolo Illuminator, but also they are divergent in style from the Master of the Dominican Effigies at any point in his development, revealing an artist at once more dependent on the example of Pacino di Bonaguida and more

strongly influenced by Jacopo del Casentino. This unknown painter may have practiced as an independent master or as a later workshop assistant of the Master of the Dominican Effigies: the Or San Michele account book was completed in 1347, which may be a more nearly accurate date for its illumination than the commonly accepted date of 1340. Isolating his works from those of the Master of the Dominican Effigies reveals the latter to have been an artist of consistent accomplishment, at no point incompatible with that of the Biadaiolo Illuminator.

The much-vaunted originality and inventiveness of the Master of the Dominican Effigies (cum Biadaiolo Illuminator) is evident in a consideration of several details of iconography within the Lehman tabernacle. As Offner (1947, pp. 255–57) pointed out, a number of motifs in the scene of the Last Judgment in the tympanum of the panel, such as the crowning of the blessed and the indication by the rose hedge of their reception in paradise, the intercession of Saint John the Evangelist on behalf of the damned, and the texts held by the angels at each of Christ's hands, here make their appearance in Florentine painting for the first time. Other motifs— such as Christ seated in judgment, partially robed to reveal his wounds, his right hand extended palm upward, his left palm downward; the angels trumpeting the resurrection of the dead above two empty sarcophagi; two further angels bearing the "Signs of the Son of Man"; and the indication of hell by flames emerging through fissures in the rocky ground—are derived from earlier Byzantine or Roman prototypes but are creatively combined in a manner that would become standard in many later versions of the scene. Similarly, different motifs in the Nativity—the reclining Virgin, the attendants bathing the Christ child, or the goat climbing the right margin of the scene—may be traced to a variety of sources but are blended and disposed across the surface of the panel with a calculated geometric precision that is typical of his work both as an illuminator and a panel painter but that is distinctive among his Florentine contemporaries.

The scene of the Glorification of Saint Thomas at the lower left of the Lehman panel is a complete novelty in Tuscan painting. Though its content (very little of which conforms to that of a celebrated painting of the same subject in the church of Santa Caterina at Pisa sometimes attributed to Lippo Memmi) was undoubtedly prescribed, perhaps even dictated in detail, by the image's unknown, probably Dominican patron, its remarkable composition can have been an invention only of the Master of the Dominican Effigies himself. The scene combines a precocious awareness of the illusionistic possibilities of one-point perspective in the projection of Aquinas's throne and desk (mirroring the projection of the Virgin's highly architectonic throne in the scene above) with the artist's characteristic tendency toward decorative symmetry and a planar disposition of bodies in the figures seated on the benches filling the bottom (that is, front) and sides of the composition. It must have enjoyed some notoriety among Florentine Dominican communities, since it was clearly cited as a prototype— fully a century after it was painted—in a lunette fresco of the Glorification of Saint Thomas Aquinas by a follower of Fra Angelico at the church of San Marco, Florence (Kaftal 1952, fig. 1109). The fresco follows the content and composition of the small scene in the Lehman tabernacle so closely— if allowance is made for the increased naturalism typical of its later date—as to suggest that the tabernacle may have been immediately available to the frescoist and may even have been in the possession of the community at San Marco at that time.

LK

1. This image is commonly adduced as a record of the venerated painting of the Virgin and child in Or San Michele, which was replaced in 1347 by Bernardo Daddi's monumental panel housed in Orcagna's tabernacle (Cohn 1957). If so, the resemblance must have been intended to be generic, as the distinguishing feature of that panel—the censing angels at the bottom corners—is conspicuously absent. The Virgin and Child painted on folio 1 of the *Libro dei lasciti alla Compagnia di Or San Michele* (Archivio di Stato, Florence; MS 470; Offner 1930, pt. 2, pl. XXIX), written between 1340 and 1347, is likely to be a more accurate reflection of its prototype (see also Bellosi 1977b).

Ex coll.: Édouard Aynard, Lyons (before 1877–1913); R. Langton Douglas, London; Philip Lehman (1916).

Literature: Sirén 1916, p. 30; van Marle 1921–22, pp. 248–61; idem 1923–38, vol. 3, p. 288; Lehman 1928, pl. 73; Offner 1930, pt. 2, p. 46; Medea 1940, pp. 2, 4, 16, 29, 39; Offner 1947, pp. 255–57; Antal 1948, pp. 184–85, 248, 263; Thieme-Becker, vol. 37 (1950), p. 46; Meiss 1951, p. 76 n. 12; Kaftal 1952, col. 981; Cincinnati 1959, p. 18, no. 89; Goméz-Moreno 1968, no. 11; Bellosi 1974, p. 80; Sutton 1979, p. 428; Baetjer 1980, vols. 1, p. 93, 2, p. 79; Boskovits 1984, p. 55 n. 190, p.|56 n. 194; idem 1987, pp. 260–65; Pope-Hennessy 1987, no. 26, pp. 55–57.

MASTER OF THE CODEX OF SAINT GEORGE

The Master of the Codex of Saint George, named for a volume from an illuminated missal in the Biblioteca Apostolica Vaticana (cat. no. 7) that includes a life of Saint George written by Cardinal Jacopo Stefaneschi, has been characterized as the outstanding Italian miniaturist of the first half of the fourteenth century. Based on the coincidence of Cardinal Stefaneschi's continuous residence at the papal court in Avignon from 1309 to his death in 1341[1] and on the supposed resemblance of an illumination of Saint George Killing the Dragon in the Vatican codex to Simone Martini's lost fresco of the same subject from the portico of Avignon cathedral, it was traditionally assumed that the Master of the Codex of Saint George was one of Simone's Avignonese followers (Venturi 1907; De Nicola 1908). At the same time the lyrical elegance of his style, rich palette, elaborate decorative schemes, and eccentric treatment of space seemed to confirm his Sienese origins. It has recently (Volpe 1951; Bellosi 1974; Howett 1976; Boskovits 1984) been recognized, however, that the sources of the Saint George Codex Master's style are Florentine, not Sienese, and that, though the influences of Duccio and Simone Martini on his art are undeniable, they were not formative. He must instead have received his training in Florence in the circle of such artists as Lippo di Benivieni and the Master of San Martino alla Palma, from whom his early figure style and decorative vocabulary, as well as his treatment of space and narrative composition, are derived.

Though there has been a consensus on the attribution of the handful of works reasonably accepted as by the Master of the Codex of Saint George, there has been no agreement on the relative chronology of these works or, consequently, on the lines of development of the artist's career; proposals for dating his activity range from as early as the last decade of the thirteenth century (Ciardi Dupré dal Poggetto 1981) to as late as 1380 (Da Costa Greene 1930). The Saint George Codex itself can be dated only approximately on internal grounds to after 1313, the date of the canonization of Saint Peter Morrone (Pope Celestine V), to whom Cardinal Stefaneschi is shown presenting a codex in one of the illuminations (fol. 123r), and before 1341, the year Stefaneschi died. The Saint George Codex is widely recognized as only one of a series of commissions undertaken for Cardinal Stefaneschi (see cat. no. 7), a prolific author and bibliophile who may have been the patron of a large portion of the master's surviving works. The implication (Bellosi, in Siena 1982) that the Master of the Codex of Saint George was attached to Cardinal Stefaneschi's household in Avignon or at least that he was continuously resident there for some extended period of time could in part explain the "international" character of his work, which has so long confused scholars (however, Howett [1976] sees no evidence of an Avignonese residence for the Master of the Codex of Saint George; see also Condello 1989).

If the Master of the Codex of Saint George was indeed a retainer of Cardinal Stefaneschi's, as seems likely, it would be possible to suggest more restrictive termini for at least that part of his career passed in the cardinal's service. Until 1319, when the cardinal had a second edition prepared of his *Opus metricum* (Biblioteca Casanatense, Rome; Cod. 45 G 14), which recounts the history of Pope Celestine V and the coronation of Boniface VIII, all known early manuscripts of his writings were illuminated by Roman or Bolognese artists, implying that the Master of the Codex of Saint George was not yet in his employ. The recent discovery (Dykmans 1981, p. 109; Avril, in Siena 1982, pp. 174–75) of two miniatures by the Master of the Codex of Saint George in a manuscript of the *Liber visionis Ezechielis* by Enrico da Carreto (Bibliothèque Nationale, Paris; MS Lat. 503), a text apparently finalized and illuminated in Avignon between 1321 and 1323, probably indicates the first presence of the artist at the papal court and may have

been the vehicle for his introduction to Cardinal Stefaneschi.[2] The last of the cardinal's writings to survive in an illuminated copy, the *Historia de miraculo Mariae facto Avignone*, is ornamented with a drawing by Simone Martini (Degenhart 1975), suggesting that the Master of the Codex of Saint George was no longer in Avignon or possibly had already died by the date of Simone's arrival in France about 1336 and certainly sometime before Cardinal Stefaneschi's death in 1341. That the earlier of these dates for the master's demise is likely to be accurate may be deduced from the fact that a double-sided cutout crucifix (*crocifisso sagomato*) in the Musée des Augustins, Toulouse, painted probably in Avignon before 1335 for Cardinal Guillaume de Peyre Godin (Testi Cristiani 1990, p. 48), was begun by the Master of the Codex of Saint George—his only known monumental painting—but completed by another artist.

Only four works by the Master of the Codex of Saint George were either demonstrably painted for a Florentine patron or are arguably wholly Florentine in style, and all of them appear to be early works: two panel paintings—a diptych in a private collection (cat. no. 6) and the *Virgin and Child with Saints John the Evangelist and John the Baptist* in the church of the Carmine in Florence—and two sets of manuscript illuminations—seven miniatures in a gradual painted after 1315 for the Cistercians at the Badia a Settimo near Florence (Santa Croce in Gerusalemme, Rome; Cod. D) and a series of seventeen cutout illuminations in Berlin, which may also have formed part of the Badia a Settimo commission. All of these works must be close in date to 1320; none is likely to be earlier than about 1315, and the latest, the Badia a Settimo Gradual, which was left incomplete, closely resembles the *Liber visionis Ezechielis* of 1321–23. Nearly all the other known works by the Master of the Codex of Saint George, numbering only four illuminated books and an equal number of panel complexes,[3] either may be associated directly with Cardinal Jacopo Stefaneschi or may reasonably be said to betray the influence of French manuscript painting and therefore represent a hypothetical Avignonese period in the Saint George Codex Master's career. As the number of these works is small and the range of stylistic development among them slight, it is likely that they were all executed within a relatively short period of time, possibly not greatly exceeding the decade or so ending about 1335.

LK

1. For Cardinal Stefaneschi, see especially Frugoni 1950. The date of Stefaneschi's death is mistakenly recorded as 1343 in most of the extensive literature concerning him and his important patronage of works of art but is corrected to 1341 in Condello 1987.

2. Condello (1989, pp. 207–8) inexplicably doubts Avril's hypothesis for dating this book as "molto incerto," though it seems historically grounded and is not contradicted by stylistic observations. Enrico da Carreto, bishop of Lucca (Dykmans 1981, p. 109), was a Franciscan summoned to Avignon by Pope John XXII, to whom the *Liber visionis Ezechielis* is dedicated, to defend the Franciscan Spirituals against the charge of heresy. Cardinal Stefaneschi was intimately involved with Franciscan causes throughout his career, culminating in 1334 with his appointment as protector of the order (Condello 1987, p. 24, n. 15).

3. These consist of 1) an Annunciation diptych formerly in the Stoclet collection, Brussels; 2) a double-sided panel of the Annunciation and Saints Lawrence and Stephen in the Muzeum Czartorycki, Kraków, which must originally have been a valve of a diptych; 3) a *Virgin and Child Enthroned with Angels and Saints John the Evangelist and John the Baptist* in the Musée du Louvre, Paris, which must originally have been the center panel of a triptych; and 4) a series of four panels showing the Crucifixion, Lamentation (The Metropolitan Museum of Art, New York; The Cloisters Collection), Resurrection, and Coronation of the Virgin (Museo Nazionale del Bargello, Florence), which originally formed part of a single folding complex (see cat. no. 9). The last three of these have putative or possible French provenances; the first, the Stoclet diptych, was discovered in Spain.

6. Diptych: Virgin and Child Enthroned with a Donor; Crucifixion with a Donor

Tempera and gold leaf on panel
Overall, left panel: 11 × 6 in. (28 × 15.2 cm); overall, right panel: 11 1/8 × 5 5/8 in. (28.2 × 14.3 cm)
Picture surface, left panel: 8 15/16 × 4 1/4 in. (22.7 × 10.7 cm); picture surface, right panel: 8 7/8 × 4 1/4 in. (22.6 × 10.8 cm)

Private collection

In the left panel the Virgin, wearing a blue cloak lined with green over a pink dress and turning slightly to the right, is seated on a red cushion placed on an elaborately carved marble throne with a gabled back and pierced arms. She holds the Christ child above her left knee as he pulls at the hem of her cloak and looks across at the diminutive figure of a supplicant at the lower left, who is tonsured and garbed in cardinal's robes. In the right panel the body of Christ hangs heavily from a cross that rises the full height of the panel and is topped by an oversize titulus inscribed I.N.R.IUD. Blood runs from his wounds down past the foot of the cross onto a skull resting in a crevice of the hill below. At the right stands Saint John the Evangelist in a pink cloak over a green robe, looking up at the Savior with his hands clasped before him. Opposite him at the left is the Virgin in a blue cloak over a red dress, and kneeling in front of her, in supplication to the crucified Christ, is a diminutive figure of a donor wearing secular dress—a red cloak over a blue gown with double sleeves—with her hair uncovered and unbound.

This jewel-like diptych, in a remarkably pure state of preservation[1] and complete with its original frame moldings and painted *faux-marbre* backs, is virtually unknown to scholars of early Florentine painting and is presented to the public for the first time in the exhibition that this catalogue accompanies. The authorship of the painting was recognized, correctly, by Federico Zeri (Zeri and Gardner 1980, p. 41), who described it as the "earliest surviving work" by the Master of the Codex of Saint George and "the most Florentine." The solidly built, almost inelegant figures in the Crucifixion scene are less mature versions of their counterparts in the Cloisters panel of the same subject (cat. no. 9), while both the Virgin and the projection of the throne upon which she sits could have been conceived as trial pieces for the small panel of the Virgin and child with Saints John the Evangelist and John the Baptist in the church of the Carmine, Florence (Boskovits 1984, pl. LXXV). Even more closely related in type, attitude, and disposition are the figures in two sets of manuscript illuminations uni-

versally attributed to the Master of the Codex of Saint George: seven initials in a volume of a gradual painted for the Badia a Settimo near Florence (Santa Croce in Gerusalemme, Rome, Cod. D; Boskovits 1984, pls. LXVI–LXVII) and seventeen small illuminations cut from a breviary possibly also intended for the Badia a Settimo (Kupferstichkabinett, Berlin; Boskovits 1984, pl. LXVIII). The diptych additionally displays the full range of the Saint George Codex Master's decorative vocabulary, as in the "feather" motif engraved in the halos, the exquisite and highly naturalistic rendering of marble with flecks of white paint, and the delicate play of light and shadow across the cut marble surfaces of the Virgin's throne.

The Florentine roots of the Saint George Codex Master's style are, as Zeri observed, even more apparent in this diptych than in any other work by him. Though somewhat ungainly compared with his later efforts, the figures in both scenes of this diptych have a spatial presence and an emotional intensity that precociously reflect the innovations of Giotto, notwithstanding their intimate scale, and that are directly reminiscent of the Saint George Codex Master's probable teacher, Lippo di Benivieni. These two painters share a similar expressive urgency, unique among their Florentine contemporaries, and numerous morphological, Morellian traits, such as the unusual cranial structure of their figures and the patterns of the engraved decorative friezes along the margins of their gold grounds (no longer visible in the present diptych). The enthroned Virgin in Lippo di Benivieni's Czartorycki triptych (Offner 1956, pl. VII) provided a prototype for the same figure in the diptych illustrated here, much as the scene of the Annunciation in the left wing of that triptych would later be a source for two versions of the same subject by the Master of the Codex of Saint George—a diptych formerly in the Stoclet collection and a single panel in Kraków.

Other than the present diptych, only three works by the Master of the Codex of Saint George were arguably painted for a Florentine patron: the initials in a gradual from the Badia a Settimo, now in Rome; the cutout illuminations in Berlin; and the *Virgin and Child with*

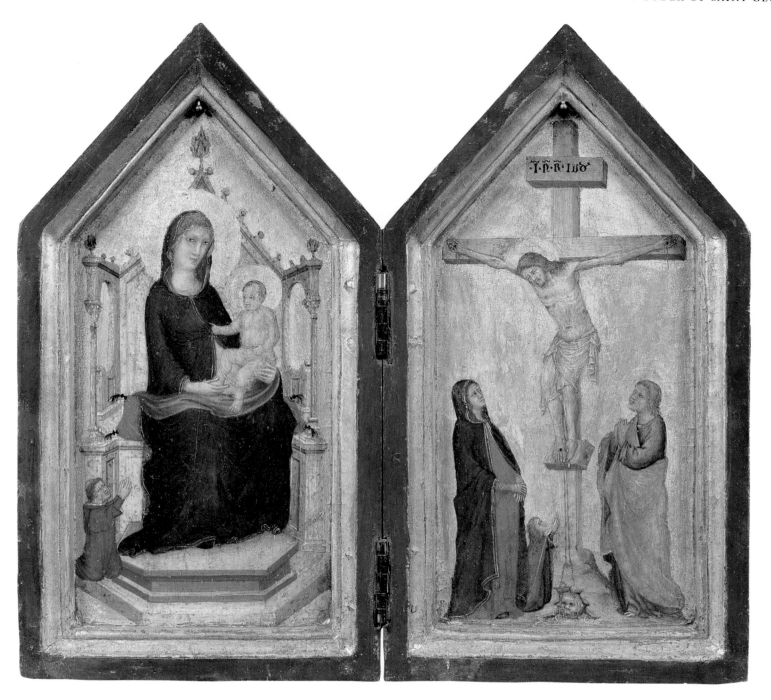

Saints John the Evangelist and John the Baptist, enframed as part of a sixteenth-century reliquary in the Carmine, Florence. That all of these are early works may be deduced from their heavier, fuller figure types and their close dependence on Lippo di Benivieni's example, in contrast to the master's later, more elegant, and refined works, all or nearly all of which may be associated with his stay in France. As the Master of the Codex of Saint George can be assumed to have been in Avignon as early as 1321–23 (Dykmans 1981; Avril, in Siena 1982) and was probably continuously resident there until at least the mid-1330s, it is reasonable to suppose that his early Florentine works were produced in the second decade of the fourteenth century, making them roughly contemporary with those paintings by Lippo di Benivieni, especially the Czartorycki triptych and the Alessandri polyptych (Offner 1956, pl. XI), that they so closely resemble (for the likely dating of these works, see Boskovits 1984; Bietti Favi 1990, pp. 243–52).

The only approximately datable work among these putatively early efforts is Codex D from the Badia a Settimo, which the Master of the Codex of Saint George illuminated in collaboration with an unknown Pacinesque painter and the so-called Maestro Daddesco (q.v.). A colophon containing the date 1315 at the end of this volume has been variously interpreted either as recording the completion of the entire book, including its illuminations (Bellosi 1974, pp. 79–80; Chelazzi Dini 1979, pp. 17–18; Boskovits 1984), or, more convincingly, as referring to the completion of only the text and therefore providing a terminus post quem for the seven illuminated initials contributed to it by the Master of the Codex of Saint George (see especially Guidotti 1979, 1990). In the latter case, the commission for the manuscript's illuminations must have been awarded very shortly after 1315, probably before 1319, when the abbot under whose auspices the project was begun, Dom Garzia, died (Calzolai 1976). Certainly the Master of the Codex of Saint George had abandoned work on it before his departure for France, which was possibly as early as 1319; the Maestro Daddesco completed the illuminations, including some left unfinished by the Master of the Codex of Saint George, at an uncertain later date. If it can be argued on stylistic grounds that the Carmine reliquary is roughly contemporary with Codex D and that the Berlin illuminations shortly precede them both, then the diptych shown here, the earliest of the series, is likely to have been painted just before the middle of the second decade of the thirteenth century.[2]

The identity of the donor in the left wing of the present diptych is elusive. The circumstances of its commission would be more plausible if he was an Italian (rather than a non-Italian) cardinal. However, other than Cardinal Jacopo Stefaneschi, whose other portraits by the Master of the Codex of Saint George this figure does not resemble, only five Italian cardinals were alive in the second decade of the thirteenth century, and one of these, Cardinal Gentile da Montefiore, a Franciscan, died in 1312, perhaps too early for the present work. Of the others, including Cardinal Riccardo Petroni of Siena (d. 1314), Cardinal Francesco Caetani (d. 1317), and Cardinal Guglielmo Longo (d. 1319), the most compelling candidate is Cardinal Niccolò Albertini da Prato, a Dominican (d. 1321), who not only had strong connections to Florence—and thus access to an otherwise unknown young Florentine painter—but also is known to have been a patron of the arts. Niccolò da Prato, accompanied by Gentile da Montefiore and Riccardo Petroni, was dispatched to Rome as legate by Pope Clement V for the coronation of Henry VII as Holy Roman Emperor in May 1312, and his return to Avignon may have provided the opportunity for an encounter with the Master of the Codex of Saint George.[3]

Regardless of the identity of the cardinal kneeling at the foot of the Virgin's throne in the left panel of the diptych, no explanation for the presence of the female figure kneeling at the foot of the cross in the right panel is obvious. Her relation to the cardinal is certain to have been familial, but no comparable objects with pairs of painted portraits survive to offer a basis for further conjecture.

LK

1. The painted surfaces of both panels have suffered very little from abrasion, though the gold grounds have been rubbed—effacing much of the engraved pattern that once defined the margins of the panels—and in places repaired (for example, the Virgin's halo and the lower right quarter of the child's halo in the left panel; scattered areas throughout the background of the right panel). Retouching is largely confined to the child's left shoulder and the side of his face in the left panel and to Christ's right knee and thigh and his torso in the right panel. Though the hinges that presently connect the two panels are modern, the claw ends of the original hinges are clearly visible along the gilt inner margin of the frames. The gables of both panels are pierced along the back edges of their frames with holes for hanging straps.

2. The Saint John the Baptist painted on the cover of the *Constitutum artis monetariorum* of 1314 (Archivio di Stato, Florence) does not provide a standard for dating the present diptych. Its resemblance to the work either of the Master of the Codex of Saint George, to whom it has been attributed by Bellosi and Boskovits, or of Lippo di Benivieni is at best superficial, and Offner's attribution to the "circle of the Saint Cecilia Master," though generic, is likely to be correct.

3. It may be presumed that Cardinal Niccolò da Prato commissioned the triptych by Duccio now in the National Gallery, London (Cannon 1980, pp. 270, 315 n. 240), and possibly also the triptych in the Museum of Fine Arts, Boston, at this time, and therefore that he passed through Siena (and necessarily Florence) on his return from Rome to Avignon. The cardinal, who was associated with the Dominican community at Santa Maria Novella, would have been familiar with Duccio as the author of the great *Maestà* hanging in the Ruccellai Chapel at Santa Maria Novella and would have heard of his fame subsequent to the installation of the *Maestà* on the high altar of Siena cathedral in 1311. Niccolò da Prato is not documented as returning to Italy after 1312 and is reported to have lived in relative political seclusion in Avignon after the election of John XXII in 1316. Boskovits (1984, p. 43) cites evidence suggesting that Niccolò da Prato and not Jacopo Stefaneschi, as is often assumed, may have been the patron of the Paris Pontifical (Bibliothèque Nationale, MS Lat. 15619), to which the Master of the Codex of Saint George contributed an illumination on folio 2. If so, not only might the identification of the cardinal in the present diptych be circumstantially corroborated, but also it would be possible to date the pontifical and the arrival in Avignon of the Master of the Codex of Saint George before the cardinal's death on April 1, 1321.

LITERATURE: Zeri and Gardner 1980.

7. The Codex of Saint George

Tempera and gold leaf on parchment, edges gilt; 132 folios; page size, 14 ¹¹/₁₆ × 10 ³/₈ in. (37.3 × 26.3 cm). 15 lines of text in *libraria gotica rotunda*; justification, 8 ³/₈ × 5 ¹/₄ in. (21.4 × 13.3 cm) inner margin; stave height, ⁷/₈ in. (2.3 cm); quires of 10 (altered in rebinding). The text contains the sanctorale (March 25–June 9) and a history of Saint George, as well as hymns in his honor written by Cardinal Jacopo Stefaneschi. There are numerous filigree and decorated initials. 17th-century leather binding.

Biblioteca Apostolica Vaticana, Vatican City; Archivio di San Pietro (C 129)

The eighteen historiated initials and one *bas-de-page* are as follows:

Folio 1r: The Faithful Worshiping the Virgin in an initial V ("Vultum tuum deprecabunter omnes divites plebis" [All the rich among the people seek your favor]), introit to the Mass for the feast of the Annunciation.

Folio 1v: The Annunciation in an initial D ("Deus qui de beatae mariae virginis utero" [God who from the womb of the Blessed Virgin Mary]), collect from the Mass of the Annunciation.

Folio 4v: The Annunciation in an initial I ("In illo tempore missus est Gabriel" [In that time Gabriel was sent; Lk 1:26]), Gospel reading for the Mass of the feast of the Annunciation.

Folio 17r: Portrait of Cardinal Stefaneschi at His Writing Desk in an initial E ("Et si gloriosi martyris" [And so glorious a martyr]).

Folio 18v: Saint George Slaying the Dragon in an initial E ("Erat in provincie Cappodocie" [There was in the province of Cappadocia]).

Folio 41r: Portrait of Cardinal Stefaneschi at His Writing Desk in an initial I ("Illustrissimum beati Georgii Martirium" [Most illustrious blessed George the martyr]).

Folio 42v: The Martyrdom of Saint George in an initial I ("Imperantibus igitur" [To those who command therefore]).

Folio 68r: Pope Zacharias Translating the Head of Saint George in an initial Z ("Zacharias natione grecus" [Zacharias of the nation of Greeks]).

Folio 85r: Saint George Saving the Princess by Slaying the Dragon in an initial D ("Deus qui nos beati Georgii martyris" [God who to us blessed George the martyr]); with Cardinal Stefaneschi Kneeling Before His Patron Saint at the *bas-de-page*.

Folio 89r: Christ Blessing in an initial I ("In illo tempore" [In that time]).

Folio 91v: Saint Gregory the Great in an initial P ("Propterea quesumus omnipotens deus San Gregorio" [Therefore . . . omnipotent God Saint Gregory]).

Folio 96v: Saint Mark Writing in an initial D ("Deus qui beatum Marcum" [God who blessed Mark]).

Folio 102r: Saints Philip and James the Less in an initial D ("Deus qui nos" [God who to us]).

Folio 103v: Christ Blessing in an initial I ("In illo tempore" [In that time]).

Folio 106r: Emperor Constantine Praying Before an Altar in an initial D ("Deus qui" [God who]).

Folio 111v: Saint John the Evangelist in an initial D ("Deus qui conspicis" [God who behold]).

Folio 114v: Saint Michael in an initial D ("Deus qui miro ordine angelorum" [God who in the marvelous order of angels]).

Folio 116r: Saint Michael in an initial I ("In illo tempore accesserunt" [In that time they approached]).

Folio 123r: Cardinal Stefaneschi in the Company of Monks Offering His Book to Pope Celestine V (Saint Peter Morrone) in an initial G ("Gratia tibi" [Thanks to you]).

One of the earliest art-historical references to the Codex of Saint George appears in the volume itself on an introductory leaf dated 1601, which was written by the canon of the Vatican library, recording that it had belonged to Cardinal Jacopo Stefaneschi and assigning

Fol. 17r

its miniatures to Giotto (Howett 1968, p. 113). This attribution was undoubtedly based on the same tradition that led Vasari (1906, vol. 1, pp. 384–85) to state that Stefaneschi had Giotto illuminate manuscripts for the papal library (Howett 1968, p. 37), a tradition maintained during the frequent publications of this celebrated manuscript into the nineteenth century. In that century the manuscript was also attributed to Simone Martini (first hinted by Lanzi 1795–96) and then to the semi-mythical Oderisio da Gubbio, who was praised by Dante (*Purgatorio* 11.78–81; initially by Crowe and Cavalcaselle 1864–66, vol. 2). The author of its miniatures was first christened the Master of the Codex of Saint George by Giacomo De Nicola in the twentieth century (1908, pp. 385–86).

The Saint George Codex comprises a portion of the sanctorale, from the feast of the Annunciation on March 25 to the feast of Saints Primus and Felician on June 9,

and several prayers from the commons for the Easter season (fols. 7–12). It also contains a history of Saint George and hymns honoring him written by Stefaneschi after he became cardinal (fols. 16v–69v, 70–82). The history appears in all respects contemporary with the sanctorale apart from its narrower margins, which indicate that it was trimmed and bound to the sanctorale volume later, leading Marc Dykmans (1981, p. 99) to suggest that the sanctorale was intended for use in the cardinal's chapel and the history for his own private use. The work is richly illustrated, with eighteen historiated letters, as well as a *bas-de-page* miniature.

The manuscript contains four portraits of its patron, who was a scholar, champion of the Franciscans, and a grandnephew of Pope Nicholas III. Two show him in the act of writing. Folio 17 presents, enclosed within a letter E, a portrait of Cardinal Stefaneschi seated at his desk, apparently composing the life of Saint George that

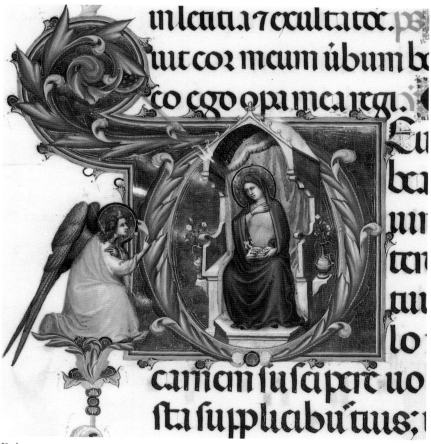

Fol. 1v

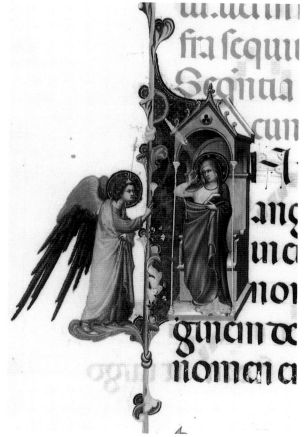

Fol. 4v

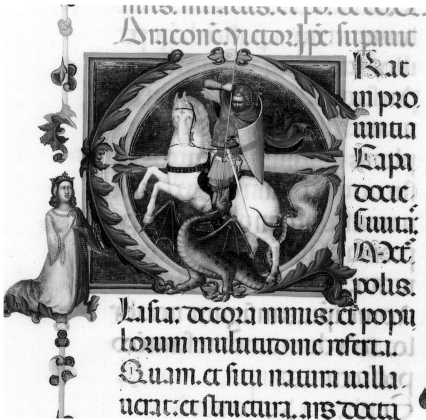

Fol. 18v

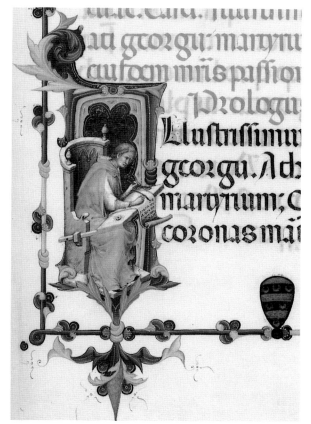
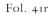

Fol. 41r

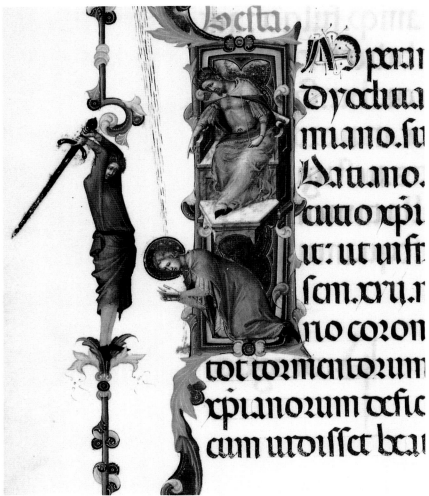

Fol. 42v

Fol. 68r

begins here: "Et si gloriosi martyris et athlete beati Georgii gesta, laudes, pugnam, palmeque victoriam . . ." (And [in this way?] you should praise the deeds, the fight, and the victory of the palm of the glorious martyr and blessed athlete, George). Following the standard medieval formula for portraits of authors and evangelists (but surely without specific reference to the Reims Gospel Book of Ebbo seen as a source by Maria Ciardi Dupré dal Poggetto [1981, p. 135]), he holds his pen in his right hand and a scraper in his left. An inkpot is set into the slant-top desk, which appears to be ruled. The cardinal's feet rest on a cushion, and his red hat is poised above him, outside the arc of the letter. The back of his chair is outfitted with shelves on which lie a number of books. His coat of arms appears across the bottom of the page. In the portrait on folio 41, the cardinal again sits at his writing desk.

Stefaneschi's history of Saint George is based on Jacobus de Voragine's *Golden Legend* and is similarly anecdotal, describing, for example, the dragon's ability to

strangle its victims in its tail. According to the text Saint George discovers the princess when he stops to give his horse water (Dykmans 1981, p. 124), and, in the *bas-de-page* miniature, the struggle between the knight and the monstrous green dragon takes place at the swampy edge of "the lake where the dragon dwelt" (Voragine 1969, p. 234). Saint George, wearing a blue cape lined with green over his pinkish gray armor edged in gold, is seen astride his white horse as he sinks his lance into the dragon's mouth. The princess kneels nearby in a pink-and-blue gown. Ducks swim in an adjacent body of water, and waterfowl feed on the fish that are perceptible through the translucent water behind the dragon. On the hill behind the princess is the green tower of the city, with a gray steeple and an orange terracotta roof. Its populace peers out in prayer from the ramparts.

The text and the illuminations also treat of the history of the saint's relics. The account of the translation of the head of Saint George is found on folio 69r–69v, the illumination on folio 68. Pope Zacharias (r. 741–52),

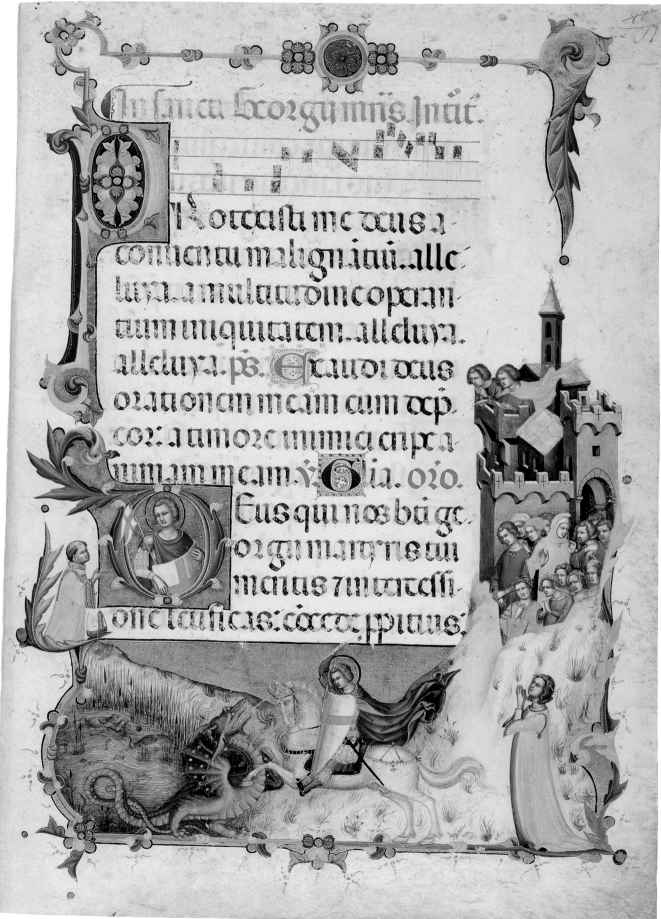

Fol. 106r

1981, p. 100) and is consistent with other manuscripts recognized as having been produced for Stefaneschi in Avignon. Indeed, the manuscripts that were illuminated exclusively by the Master of the Codex of Saint George or his workshop all seem to have been produced in the French city during the cardinal's continuous residence from 1309 until his death at the age of eighty in 1341. This group includes the *Liber visionis Ezechielis* of 1321–23 (Bibliothèque Nationale, Paris; MS Lat. 503), a pontifical in Paris (Bibliothèque Nationale, MS Lat. 15619),[1] an ordinary in Boulogne-sur-Mer (Bibliothèque Municipale, MS 86), and a volume of a missal at The Pierpont Morgan Library (cat. no. 8).

Internal textual and visual evidence offers only slightly narrower parameters for dating the Vatican codex. On folio 123 the cardinal offers a book to Saint Peter Morrone, who was canonized in 1313. The Vatican manuscript, like those in Boulogne-sur-Mer, Paris, and New York, contains an image of a pope, which has been recognized as a portrait of John XXII (r. 1316–34) (Boskovits 1984, p. 42, n. 136). Relative dating of these four on stylistic grounds is complicated by several factors—the Paris Pontifical has only one miniature by the master, and the Vatican text, with its hagiographic focus, offers significantly more room for creative illustration than that in Boulogne-sur-Mer—but they must all postdate the first of the Avignon manuscripts, the *Liber visionis Ezechielis* of 1321–23, with its conservatively rendered historiated initials. Liturgical practice reflected in the Paris Pontifical is consistent with use at Avignon until about 1328 (Condello 1989, p. 204). The text of the Boulogne-sur-Mer manuscript, which Boskovits considers contemporary with the Paris manuscript and later than the Vatican's, comprises an ordinary for the Mass and an order of ceremony for the investiture of a pope. There is, however, no scholarly consensus concerning the latest possible dating of its text, given in some literature as 1328 (Howett 1968, p. 67; Boskovits 1984, pp. 43–44, 202–3; Dykmans 1981, p. 131).

Among these books, the volume most closely related to the Saint George Codex is clearly the volume of a missal in the Morgan Library. The text for both is set in blocks of fifteen lines per page, is of closely approximate dimensions, and was originally bound in quires of ten. The filigree initials and border decorations—specifically the tubular vine stem knotted along its length and at the corners shaped into squared interlace—as well as the decorated letter forms, are virtually interchangeable between the manuscripts. Decorated letters in both manuscripts share a common palette and design. Illuminated letters, such as that with Constantine Praying Before an Altar from the Vatican codex (fol. 106r), have in common, for

dressed in white, with a rose cope edged in yellow and a papal tiara, holds the head of Saint George in his hand and gazes up at the church where the martyr was interred, San Giorgio in Velabro, which is represented as a basilica in a foliate roundel above him. That image looks surprisingly like the church in Rome without the added Romanesque bell tower and porch.

The decorative vocabulary and palette of the Saint George Codex in large measure are Florentine, whereas the mise-en-scène and preciousness have been appropriately linked to contemporary French illumination (Freeman 1962; Ciardi Dupré dal Poggetto 1981; Avril, in Siena 1982, p. 60). The text itself is richly decorated, including not only blue, red, and violet but also green and yellow inks. The lettering has been characterized by Dykmans as typifying Italian work in Avignon (first noted by A. Birkenmaier in Ameisenowa 1939; see also Dykmans

example, with the scene of the sacrament of marriage in the Morgan Missal the foliate form of the initial as well as the knotted vine of the border decoration. With its action-filled scene and its precisely rendered landscape, the *bas-de-page* of Saint George Fighting the Dragon is unquestionably the counterpart from hagiographic legend to the narrative presentation of the Annunciation to the Shepherds in the Morgan Missal.

The Morgan Library manuscript bears a colophon on the verso of the last leaf indicating that it was part of a seven-volume set, of which the Vatican manuscript may have been one (Howett 1968; for further discussion, see cat. no. 8). Ciardi Dupré dal Poggetto, while detailing their similarity, does not accept the notion that the two volumes are part of the same set. She has suggested rather that only the Vatican manuscript, executed between 1325 and 1330, was intended for the funerary chapel that the cardinal planned for Saint Peter's, which according to the codicil of his will dictated in 1329, was not yet built (Dykmans 1981, pp. 28–29). The Vatican codex, like the volume in the Morgan Library, was among the manuscripts numbered at the Vatican between 1485 and 1489, but its earlier history cannot be established with certainty. It does not appear in the list of manuscripts inventoried among the papal possessions at Avignon in 1369, 1375, or 1411 (see Ehrle 1890), nor does it appear in the inventory of the sacristy of the Vatican of 1361 (Mercati 1938, p. 127) or among the books left to the papacy in 1438 by Giordano Orsini, of the family of Stefaneschi's mother and his executors (see Condello 1989, p. 196). Giovanni Mercati (1938, pp. 127, 150–51) identified the Saint George Codex with a manuscript of Stefaneschi's described in an inventory of the liturgical furnishings supposedly from the sacristy of Saint Peter's that was found in the Roman residence of A. de Vetulis, bishop of Fermo (d. 1405): "Item liber Iacobi sancti georgii ad velum aureum diaconi card. cum corio copertus" (In like manner, a book of [or by] Jacopo, cardinal deacon of San Giorgio in Velabro, covered with leather [fol. 8r]), a description that might equally be associated with a text written by the cardinal.

BDB

Fol. 123r

1. For an alternative suggestion that the Paris manuscript may have been made for Cardinal Niccolò da Prato (d. 1321), see Boskovits 1984, p. 43.

LITERATURE: Dykmans 1981, pp. 98–100, 108–11, with previous literature; Boskovits 1984, pp. 38–39, 196–200, pls. LXIX–LXXI; Condello 1987, pp. 26–27; idem 1989, pp. 195–98, figs. 1, 2.

8. Missal

Tempera and gold leaf on parchment, edges gilt and gauffered; 167 folios; page size, 14 3/4 × 10 in. (37.5 × 25.5 cm). 15 lines of text in *libraria gotica rotunda*; justification, 8 1/2 × 5 5/16 in. (21.6 × 13.5 cm); stave height, 7/8 in. (2.3 cm); 16 quires of 10. There are numerous filigree and decorated initials, 2 and 3 lines high. The text contains the preparation for the Mass, the ordinary of the Mass, Communicantes, the Canticle of the Three Young Men, the Mass of the Dead, the Nuptial Mass, votive masses, and the Asperges. Modern leather binding, 15 1/8 × 10 1/2 in. (38.4 × 26.7 cm).

The Pierpont Morgan Library, New York (M. 713)

The four historiated initials are as follows:

Folio 1: The Preparation for the Mass in an initial Q ("Quam amabilia sunt tabernacula tua domine" [How lovely are thy tabernacles, O Lord]).

Folio 55: The Nativity in an initial C ("Communicantes et noctem ul diem sacratissimam celebrantes" [In the unity of holy fellowship, celebrating the night and most sacred day]).

Folio 58: A Consecration in an initial T ("Te igitur clementissime Pater" [Thou, therefore, most merciful Father]).

Folio 152: The Sacrament of Marriage in an initial E ("Exaudi nos omnipotens" [Hear us, omnipotent and merciful God]).

Four historiated scenes decorate this luxury manuscript. The first occurs at the opening prayer of the preparation for the Mass. Within the framing oval of the letter Q, a half-length figure of a pope, wearing the vestments of a celebrant and distinguished by his tiara, raises his gloved hands to his chest, palms out, in a gesture of prayer. His hair and brows are white, and his face is subtly modeled by means of a clear red orange glaze highlighting his cheeks, lips, and chin. The miniature has been slightly rubbed, but the chasuble is carefully rendered, with white used to give definition to the drapery. Establishing the palette for the codex, the foliate decoration is rose and blue, with pale green and brilliant orange accents, flourishes of white, and black centers in the decorated letters.

The second miniature illustrates the opening preface for Christmas. The figure of the Virgin Mary in a blue mantle emerges from the foliage at the left margin of the page. Leaning forward, her arms outstretched, she reaches into the block of the letter C to lay the infant Jesus in a manger filled with soft hay and cradled by the bottom arc of the letter. The letter provides the enclosure for the manger, which only the Virgin and child enter. The latter reaches back toward his mother,

his right arm free of the swaddling, almost in an attitude of blessing. The ox and ass, symbolizing the Jews and the Gentiles, stand by his nimbed head, while the dove of the Holy Spirit descends to the child from the blue firmament dotted with white stars, which is set in the upper arc of the letter. Joseph, with gray curling beard and brows and wearing a rose mantle over dove gray, is poised behind the Virgin in the margin, his head resting on his left hand, while attending angels hover above and behind him.

In the left border below Joseph, two angels swoop down toward the lower part of the page, their drapery and movement echoing both the palette and the rhythmic cadence of the surrounding foliage. They carry the message of the Nativity to the shepherds watching their flocks, who appear at the bottom of the page. Against an azure night sky, the shepherds, barefoot and clad in gray leggings, idle away their time. One of the two at the left, in a hooded cape of blue over orange, plays a pipe, oblivious to the startled companion seated at his right, who turns his head, craning his neck, and lifts one arm to shield his eyes as the angels appear above him. Some sheep and black goats huddle together for warmth in the center foreground, while others feed quietly on the vegetation of the rocky hillock. At the right a lean dog gazes up at its master, who wears a hooded green cape over a salmon robe. His gray hat slung over his rounded back, he leans on his stick, his wide-eyed stare suggesting that he has just seen the angelic intruders.

In the third miniature, denoting the beginning of the canon of the Mass, during which the bread and wine are consecrated, a tonsured priest in white, with a pale rose chasuble decorated with golden orphreys, bows before an altar, the arc of his back following the curve of the blue foliate T that surrounds him. His gesture and bearing reflect the rubricated instructions above, "Hic inclinet se ante altare et cum omnum humilitate dicet" (Here bow before the altar and with all humility say)—the attitude appropriate for this most solemn section of the Mass. A pair of candlesticks (one obscured by the foliation) burns at the cloth-covered altar, on which appear the gifts—a gold chalice for the wine and a Host. A tonsured deacon and subdeacon attend him from foliate consoles in the left margins, the deacon kneeling with arms folded humbly across his chest, the subdeacon standing and holding aloft a golden paten veiled in diaphanous cloth. Along the bottom at either side, two half-length tonsured acolytes clad in white reach out of the foliate roundels in which they are confined. In accordance with established practice for the beginning of the canon of the Mass (Jungmann 1959, p. 385), they use long tapers to light a pair of candlesticks. These are held in the hands

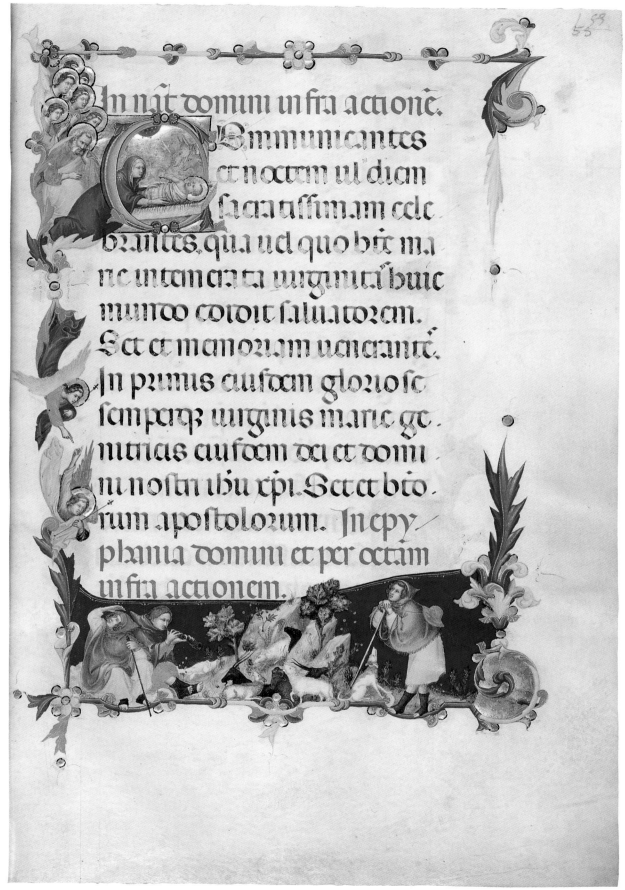

Fol. 55

Fol. 1

Fol. 152

of an angel clothed in blue, its arms and wings of silver gray and gold projecting from the central medallion.

In the final historiated scene, the sacrament of marriage takes place within the letter E that begins the Nuptial Mass. A couple kneels before the officiating priest vested in an orange chasuble, who holds an open book over their heads. The bridegroom, in blue, his feet bare, wears a transparent cap secured under his chin; the bride has a long braid that trails down the back of her rose gown. The altar, rendered in Gothic perspective, is set with a cross flanked by candlesticks, behind which appear three witnesses.

Since its acquisition in 1927, the Morgan Missal has been heralded as a masterpiece of Italian Gothic manuscript painting and almost universally attributed to the Master of the Codex of Saint George. While there has been a consensus about the attribution, the date of the manuscript has fluctuated according to differing views about the parameters of the artist's work.

The filigree decoration in the Morgan Missal, with its capitals in red, blue, green, yellow, as well as purple, appears to be by the same hand as that in the *Liber visionis Ezechielis* (Bibliothèque Nationale, Paris; MS Lat. 503; Avril, in Siena 1982), which was completed in Avignon in 1321–23, and the scribe is considered to be the same as the one who wrote the Vatican Saint George Codex, the Paris Pontifical (Bibliothèque Nationale, MS Lat. 15619), and the manuscript in Boulogne-sur-Mer (Bibliothèque Municipale, MS 86).

The Boulogne-sur-Mer manuscript comprises an ordinary for the Mass and an *ordo*, or order of ceremony

for the investiture of a pope, and must date to after 1320, judging from details of the service it contains for Holy Thursday (Condello 1989, p. 205, n. 27). The ordinary of the Mass uses the same standardized text as the Morgan codex, which must also postdate 1320. The text of the Paris Pontifical reflects the liturgy of the papal court until about 1328 (Condello 1989, p. 204).

No iconographic evidence offers incontrovertible proof that the Morgan manuscript was made at the order of Cardinal Jacopo Stefaneschi, patron of the Codex of Saint George (cat. no. 7), now in the Vatican, and there are no prayers that pertain specifically to his interests. Yet the close relationship between this codex and the eponymous work by the Master of the Codex of Saint George leads inexorably to the conclusion that they were part of the same commission for the cardinal. In addition to the comparable filigree decoration and the coincidence of scribes, the decorated letters are noteworthy for their similarity, as are the borders, specifically the vine knotted along its length, which at the corners is shaped into open interlace. The text for both the Morgan and Vatican manuscripts is set in blocks of fifteen lines per page of closely approximate dimensions; the musical sections have the same stave height.

Neither manuscript is complete in itself. The Morgan codex contains the text for the preparation and ordinary of the Mass, votive masses, as well as preparatory prayers and ceremonies, such as the blessing of salt and water. It lacks those prayers for the Mass that vary according to the liturgical year, specifically the temporale, the sanctorale, and the common of the saints. In fact, the

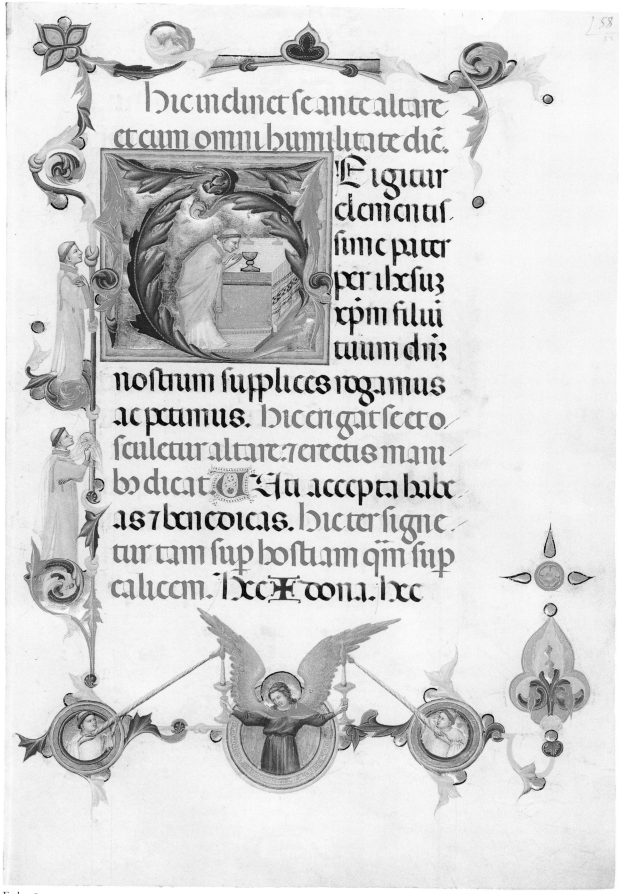

Fol. 58

Morgan manuscript has a colophon on the verso of the last leaf indicating that it was part of a seven-volume set (Howett 1968): "The seventh volume of a missal in which is found the Ordinary of the Mass, and all prayers for votive masses in nineteen quires and eight leaves."[1] The Vatican codex contains the sanctorale for about a quarter of the year, from the feast of the Annunciation on March 25 to the feast of Saints Primus and Felician on June 9, a history of Saint George and hymns honoring him written by Cardinal Stefaneschi, and several prayers from the commons corresponding to the Easter season. It is possible to infer that there would have been additional volumes for the rest of the sanctorale, as well as for the temporale and commons, which easily amounts to seven all together. It is not surprising that the complete provenance of these volumes has not been established, given the complex history of the papal libraries at Avignon and Rome, especially during and after the Papal Schism of 1378–1417. Yet the Morgan volume, like the Saint George Codex, was among the manuscripts numbered at the Vatican between 1485 and 1489 and is designated on folio 1 as CCCLII (Dykmans 1981, p. 102).

Maria Ciardi Dupré dal Poggetto surmised from the preservation of the Saint George Codex at the Vatican that it had been intended for Stefaneschi's funerary chapel at Saint Peter's (see cat. no. 7). There is nothing in its text or in the text of the Morgan volume, however, particularly appropriate to memorial use. An alternative possibility is that the missal was commissioned as the personal property of Jacopo Stefaneschi. In such a context, however, it is curious that the cardinal named James should place no emphasis on the feast of Saints James the Less and Philip (fol. 102). In addition, had the manuscript been made for Stefaneschi's personal use, it would likely have been assumed as papal property at his death, acquired under the right of spoil and later inventoried at Avignon.

An alternate explanation for both the content of the Vatican manuscript, particularly the emphasis in text and illumination on the translation of the relic of Saint George's head—and the Roman collection history of both the Vatican and Morgan volumes—is that they were commissioned for the cardinal's titular church, San Giorgio in Velabro. Ciardi Dupré dismissed this possibility on the grounds that the manuscript was unlikely to have traveled from there to the Archivio di San Pietro. Such a provenance is not inconceivable, however. One of Stefaneschi's successors as cardinal deacon of San Giorgio in Velabro was Oddo Colonna, who was appointed in 1405 and entered his church on July 12, 1412, when the curia was at Rome under the antipope John XXIII. Colonna was elected Pope Martin

V on November 11, 1417 (see Eubel 1913–68, vol. 1, p. 26). As the first pope permanently resident in Rome after the Schism, he oversaw the transfer of papal archives from Geneva to Rome (Boyle 1972) and was actively involved in the refurbishing of Rome, including restoration of the Vatican and Lateran basilicas (Pastor 1969, pp. 214–19). It would be consistent with these activities if he had been responsible for the Vatican's acquisition of the missal of one of his most illustrious predecessors as cardinal deacon of San Giorgio in Velabro, Jacopo Stefaneschi.

BDB

1. The colophon was first published by Howett in 1968. I am grateful to Roger Wieck and Maria Safiotti for reading this translation. The information in it indicates that three quires and eight leaves are missing.

EX COLL.: Anonymous Italian collection; [Lathrop C. Harper, New York].

LITERATURE: Da Costa Greene 1930, p. 63; Harrsen and Boyce 1953, p. 13, no. 21; Castelnuovo 1962, p. 42; Freeman 1962, pp. 303–4; Howett 1968, pp. 53–58, 114–15; Rotili and Putaturo Murano 1970, p. 94; Howett 1976, p. 102; Ciardi Dupré dal Poggetto 1981, pp. 90–97, 240–43, figs. 144–48; Dykmans 1981, pp. 101–2, 112–13; Boskovits 1984, pp. 39–40, 200–201, pls. LXXIIa,c–LXXIII; Voelkle 1984, no. 14; Condello 1989, p. 203, fig. IV.

9. The Crucifixion; The Lamentation

Tempera and gold leaf on panel
Overall, each panel: 18 1/8 × 11 3/4 in. (46 × 29.8 cm); picture surface, each panel: 15 5/8 × 10 5/8 in. (39.7 × 27 cm)

The Metropolitan Museum of Art; The Cloisters Collection, 1961 (61.200.1, 2)

In the *Crucifixion* Christ hangs limply from the cross—its wood grain meticulously rendered—rising the full height of the panel in its center. Blood from the wounds in Christ's hands, side, and feet flows in rivulets down the shaft of the cross to collect in pools on the small hill and broken skull below. Standing at the left are the Virgin Mary, her arms crossed before her face in grief, three Holy Women, and four soldiers in blue helmets. At the right are Saint John the Evangelist and six soldiers, of whom one—the centurion Longinus, who became the first Roman convert and martyr—gestures toward Christ

and is distinguished by a halo. The palette is dominated by the deep blue of the Virgin's cloak, the lighter blue of the soldiers' armor and Saint John's robe, and the bright pink cloaks of Saint John and Mary Magdalen, with lesser accents of orange, yellow, and green.

The cross, without the inscription on its titulus, and the hill of Golgotha rise behind the scene of the Lamentation. An empty tomb stretches obliquely across the foreground, and the rigid body of Christ, wrapped in a transparent shroud, lies parallel to it across the knees of both the Magdalen, who kisses the wounds on his feet, and the Virgin, who faints into the lap of another Holy Woman behind her. Saint John the Evangelist, Nicodemus, and Joseph of Arimathea close off the composition at the right. A fourth Holy Woman and two laborers, one holding a basket and a hammer, balance them at the left.

These two paintings have long been recognized as masterpieces of the Master of the Codex of Saint George (Venturi 1907) and are generally considered in relation to two other panels of identical shape in the Carrand Collection at the Museo Nazionale del Bargello, Florence, representing the Risen Christ appearing to Mary Magdalen and the Coronation of the Virgin (figs. 31, 32). The Carrand panels, which retain their original frames (those now on the Cloisters panels are modern copies), are 1⅛ inch (3 cm) smaller in height and width than the Cloisters panels but otherwise differ from them only in the engraved motif filling the decorative borders of their gold grounds—a continuous ivy rinceau in the Cloisters panels and a frieze of four-petaled rosettes in the Carrand panels. Early writers were unanimous in accepting the origin of these four panels in a single complex, some (De Nicola 1908, p. 385; Marcucci 1965, pp. 165–66) adding to them a fifth panel in the Louvre, which depicts the Virgin and child enthroned with angels and Saints John the Evangelist and John the Baptist. This last proposal has not met with universal agreement and is, indeed, inherently improbable.[1] Recent scholarship (Howett 1976; Ciardi Dupré dal Poggetto 1981; Bellosi, in Siena 1982), furthermore, tends to consider the two pairs of panels in the Cloisters and the Bargello as independent diptychs, the latter having been painted significantly earlier in the master's career than the former.

Consideration of the carpentry of the Cloisters and Bargello panels (see below) demonstrates that neither pair could have been conceived as an independent diptych. That they did originally form parts of a single complex has been recognized by Federico Zeri and Elizabeth Gardner (1980), as well as Miklós Boskovits (1984), who argue, correctly, that proposed distinctions of style between these four panels are more apparent than real. They are all composed with a similar sense of the symmetrical arrangement of bodies across the picture field and their circular disposition in space. Figure types and color schemes (muted by a darkened varnish in the Bargello panels) are continuous across all four, and the conformity of their unusual shapes,[2] the overall pattern of decoration of their gold grounds, and their figure scale and halo size are too close to be coincidental. The iconography of the four scenes, furthermore, is continuous and complementary across the four panels, the first of the Bargello panels completing the narrative of the Crucifixion and Lamentation with the Resurrection, which is indicated by the angel perched on the lip of the empty tomb at the left and the sleeping soldiers behind. The Magdalen kneeling in the foreground in front of the Risen Christ, who carries the banner symbolizing his victory over death, is a visual conflation of two events following the Resurrection—the three Marys approaching the tomb of Christ and the Noli me tangere.

The Bargello panels, with their engaged frames intact, retain the metal hinges that originally joined them. The heights of the hinges to the right of the "Resurrection" (Noli me tangere) and to the left of the *Coronation of the Virgin* correspond, suggesting that they were initially attached to each other with no intermediary panels. There are no hinges or traces of missing hinges on the right edge of the *Coronation of the Virgin*, indicating that it was the right end panel of its complex. The two panels in the Cloisters have lost their original frames, but wooden inserts along the edges of the panel supports undoubtedly repair damages caused by the removal of metal hinges. These are closer together and of corresponding heights along the right edge of the *Crucifixion* and the left edge of the *Lamentation*—implying that these two panels were joined—and farther apart along the left edge of the *Crucifixion* and the right edge of the *Lamentation*. The same discrepancy exists between the heights of the hinges on the two sides of the Bargello "Resurrection," and the wider spacing of the hinges on its left side corresponds to that on the right of the Cloisters *Lamentation*, which is evidence that the two panels were undoubtedly once attached to each other. The probable presence of hinges along the left edge of the Cloisters *Crucifixion* implies that the series of four panels is not complete and that one or more panels are missing. Zeri and Gardner proposed a suite of seven panels, with the Cloisters *Crucifixion* in the center and three panels from the left side missing. Boskovits thought the series should comprise six panels, with the slightly taller pair of panels in the Cloisters in the center, flanked by slightly smaller pairs of panels on either side. The hitherto unnoticed fact that the hinges on the left side of the Bargello "Resurrec-

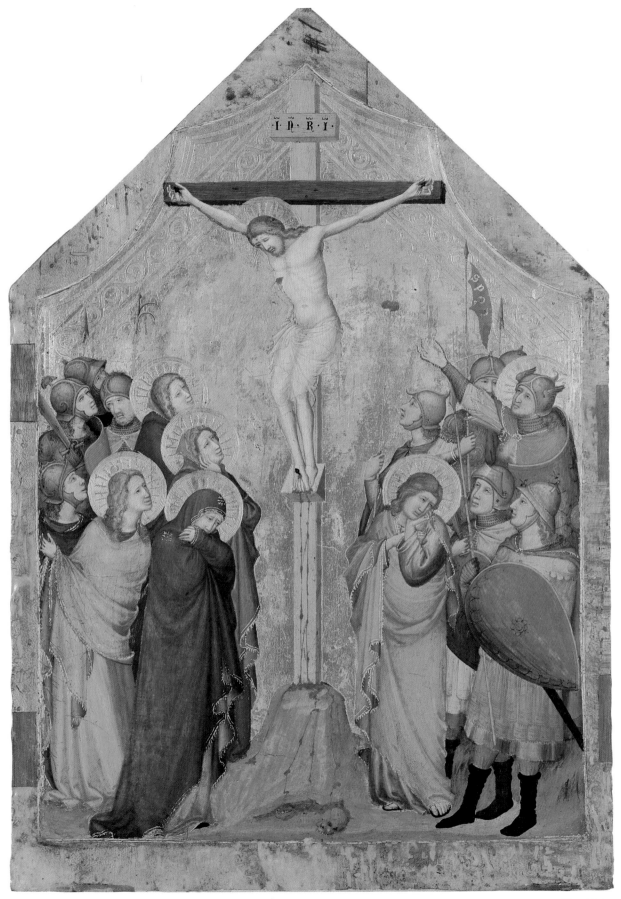

9: Crucifixion

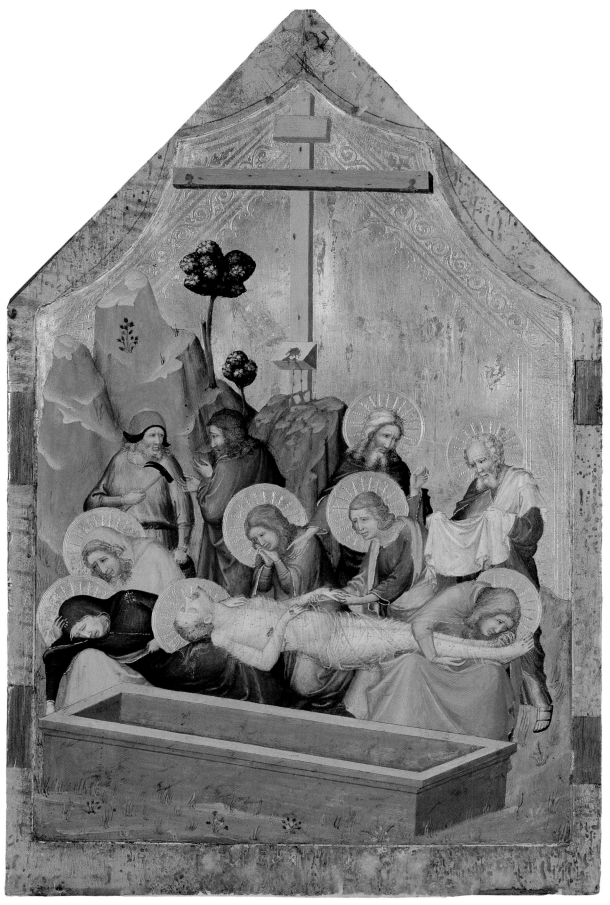

9: Lamentation

tion" are set at the back edge of the frame rather than at the front edge indicates that the complex from which it came must have consisted of an even number of panels. The "Resurrection" and *Coronation of the Virgin* in the Bargello closed over each other face-to-face (as, presumably, did the *Crucifixion* and *Lamentation* at the Cloisters), but the Cloisters *Lamentation* and the Bargello "Resurrection" were clearly meant to close over each other back-to-back, creating an accordion-like structure for the entire complex. If, as therefore seems likely, two panels are now missing at the beginning of the sequence, these may have represented the Annunciation and the Nativity, completing the cycle of humanity's redemption through the Incarnation, Birth, Death, and Resurrection of Christ, together with his glorification through the establishment of the church in the *Coronation of the Virgin*.

The Cloisters *Crucifixion* and *Lamentation* are commonly assumed to have been painted by the Master of the Codex of Saint George in Avignon and have sometimes been thought to have been commissioned from the artist by Cardinal Stefaneschi. Nearly all scholars agree that they must represent the moment of greatest maturity

of the master's style, though John Howett and Maria Ciardi Dupré dal Poggetto argued that this would have transpired in Florence or Rome rather than at Avignon, citing unconvincingly rigid analogies of composition to Giotto's Stefaneschi altarpiece. The Bargello panels, too, have been described as quintessentially Florentine and specifically Giottesque, though the balance of probability suggests that they were, indeed, painted in France. The provenance of neither pair of panels can be traced earlier than the nineteenth century, but in both cases they may have been discovered in France: the Cloisters panels were first recorded in the collection of Marshal Nicolas Soult, and the Bargello panels belonged to the Lyonnais dealer Carrand, much of whose collection was formed in France. The fact that the unusual shape of the panels, their highly refined decoration, and the highly individual iconography of the scenes of the Lamentation and Resurrection spawned no imitations in Florence suggests that the panels were not known to artists in that city, and it has been observed (Boskovits) that the peculiar shape of the double throne in the Bargello *Coronation of the Virgin* is specifically French in derivation. While there is no evi-

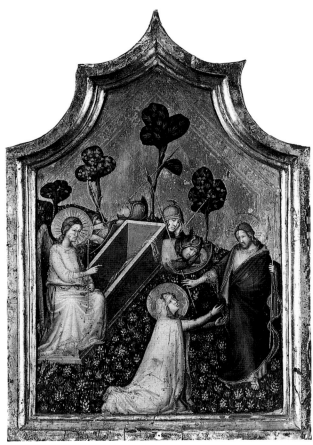

Figure 31. Master of the Codex of Saint George, *The Risen Christ Appearing to Mary Magdalen*. Museo Nazionale del Bargello, Florence (2017c)

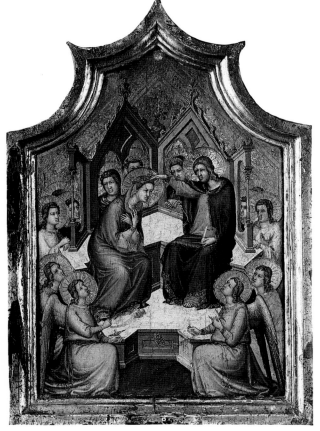

Figure 32. Master of the Codex of Saint George, *The Coronation of the Virgin*. Museo Nazionale del Bargello, Florence (2018c)

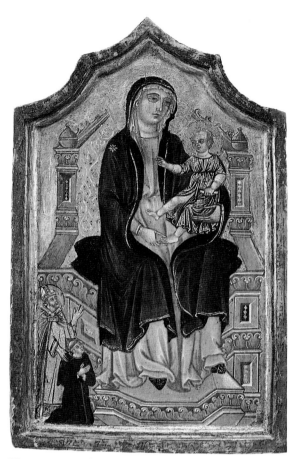

Figure 33. Deodato Orlandi, *Virgin and Child*. Present location unknown

dence to connect the commission for these panels directly to Cardinal Jacopo Stefaneschi (notwithstanding Ciardi Dupré dal Poggetto's aberrant interpretation of their iconography as topical references to the cardinal's political career), it is clear that they must have been conceived and executed while the Master of the Codex of Saint George was otherwise employed by the cardinal at Avignon. They may well be among his latest surviving works, finding their closest figural parallels in the illuminations for the Boulogne-sur-Mer Ceremonial (Condello 1989, pp. 205–7) and, despite their difference of scale, in the double-sided crucifix in the Musée des Augustins, Toulouse (Testi Cristiani 1990), which was left incomplete by the Master of the Codex of Saint George, possibly at his death, probably shortly before 1335.

LK

1. The Louvre panel is of a type not uncommon in late-thirteenth- and early-fourteenth-century Tuscan painting that is invariably encountered as the center panel of a portable triptych in which narrow lateral panels are intended to fold closed over the principal scene and to fit within its framing arch, leaving the painted spandrels and pediment—frequently, as here, showing God the Father and angels—exposed. X rays of the Louvre panel reveal no traces of metal hinges, however, and the presence of fixed battens across its back led Boskovits (1984) to assume that the structure of which it formed the center was rigid. The battens may be later additions, though probably not so late as the architectural frame added to the panel in the nineteenth century. Ciardi Dupré dal Poggetto (1981, pp. 84–89) erroneously adduced the architecture of this frame to demonstrate a connection between the Master of the Codex of Saint George and Pietro Cavallini in Rome and also misidentified the kneeling saint (Saint John the Evangelist) in the right foreground of this panel as Saint Peter.

2. Boskovits 1984, pp. 40–41, records only two other examples of this "tented arch" shape among panel paintings of the period: a *Crucifixion* by the Master of San Martino alla Palma (who must have been in close contact with the Master of the Codex of Saint George at some point in his career) in the Gemäldegalerie, Berlin (inv. no. 1428), and a Ducciesque triptych in the Christ Church Gallery, Oxford. Neither, however, provides an exact parallel for the structure of the present complex, and in the case of the Christ Church triptych the "tented" shape of the wings was meant to conform to the trilobe profile of a missing gable so that all three could fold neatly closed over the central rectangular panel of the Virgin and child. More closely related in shape to the Cloisters and Bargello panels is an unpublished *Virgin and Child* (fig. 33) by the Lucchese master Deodato Orlandi, possibly of the second decade of the fourteenth century. It is unclear how the Master of the Codex of Saint George might have been in contact with Lucchese painting, whether the relationship of these paintings is purely coincidental, or whether they are unique surviving members of an originally far more numerous class of objects.

Ex coll.: Marshal Nicolas Soult, Paris; Augustus Stevens, London; H. G. Bohn, Twickenham; Charles Butler, London; R. H. Benson, London; John D. Rockefeller Jr., New York.

Literature: Zeri and Gardner 1980, pp. 40–43 (with previous literature); Ciardi Dupré dal Poggetto 1981, pp. 162–71; Bellosi, in Siena 1982, pp. 166–70; Boskovits 1984, pp. 209–11; Santi, in Florence 1989, pp. 386–87; Testi Cristiani 1990, p. 59.

MAESTRO DADDESCO

Though he has been characterized as the most significant miniaturist in Florence in the second quarter of the fourteenth century, both for the quantity and quality of his work (Ciardi Dupré dal Poggetto 1973, pp. 57–58), the so-called Maestro Daddesco remains probably the least clearly defined personality of his time. He was first individuated and christened only forty years ago (Salmi 1952, pp. 15ff.), and there is little clear agreement over the extent of his oeuvre and none over the precise period of his activity. Scholars are now divided between those who follow Mario Salmi in seeing the decisive influence of Bernardo Daddi on the master's style (hence his sobriquet) and in dating his works for the most part after 1330 (Guidotti) and those who view him as a contemporary or even a precursor of Bernardo Daddi's and as probably active between 1310 and 1330 and more aptly nameable the "Maestro Pre-Daddesco" (Chelazzi Dini 1979, pp. 17ff.; Boskovits 1984, p. 44 n. 147).

The source of contention for these two disparate views is a volume of an illuminated gradual painted for the Badia a Settimo near Florence, which is preserved at the conventual library of Santa Croce in Gerusalemme, Rome (Cod. D). In a colophon at the end of this book, its scribe, Don Vincenzo Monocolo, claims that he finished the text and the pen-work initials in 1315 and that he was paid eighty lire for the complete work.[1] Don Vincenzo's statement has been interpreted by some scholars to mean that the entire book, including the historiated initials supplied by three different artists—an unknown Pacinesque master, the Master of the Codex of Saint George, and the Maestro Daddesco—was complete by 1315, and by others that the text and pen-work initials only were complete by that date and that the illuminations were added later. Among the latter group, Emma Condello (1989) believes that the illuminations were added before 1322, the date of Don Vincenzo's death, on the assumption that the final sentence of the colophon recording his payment is autograph but not coeval with the rest of the inscription. Alessandro Guidotti (1979, 1990) has shown that the inscription is integral but claims that it is irrelevant in dating the miniatures, which are not referred to in the colophon and which he places in the middle 1330s, when the outmoded style of the Pacinesque master might credibly have been supplanted by the spatial and decorative innovations of the Master of the Codex of Saint George and the Maestro Daddesco.

Internal evidence alone provides no basis for resolution of the issue. It has been stated above (cat. no. 6) that the seven initials contributed to this book by the Master of the Codex of Saint George probably date between 1315 and 1320 and that possibly his (and the Pacinesque master's?) work was abandoned in 1319, at the death of the abbot, Dom Garzia, under whom the project was begun. That the Maestro Daddesco replaced these artists and was not their collaborator may be deduced from additions he supplied to several incomplete initials by both earlier painters, such as the initial I on folio 8r, in which the letter was painted by the Pacinesque master, but the borders of the page, including the figures of Saints John the Evangelist and Bernard, were added by the Maestro Daddesco. If the Maestro Daddesco's intervention in the volume is to be understood as a reversion of the commission sometime after 1319, it can be argued that his work postdates 1338, when a newly elected abbot, Remigio Sapiti, ordered an inventory of the monastery's library in the wake of alleged embezzlement on the part of his predecessor, Andrea de' Pucci (Calzolai 1976). The inventory, which lists books by their liturgical contents only and does not specify whether they are illuminated, includes several duplicate volumes of antiphonaries; yet further volumes, now in the Museo dello Spedale degli Innocenti, Florence, were

commissioned between 1339 and 1350. On both stylistic and circumstantial grounds, it is not unreasonable to suppose that the Maestro Daddesco's work for the Cistercians fell into this period.

The Maestro Daddesco has been called a "Master of the Codex of Saint George in a minor key," and the appearance of the two artists together in the Badia a Settimo Gradual has led naturally to the assumption that the former was trained by the latter. The two artists share certain peculiarities of figure style and the treatment of the decorative borders of pages that depart from earlier conventions of Florentine illumination, but their styles are not otherwise so closely linked as necessarily to imply a master/pupil relationship. Where the Master of the Codex of Saint George is generally irrational in his spatial constructions, subordinating his settings to the expressive content of his images, the Maestro Daddesco is unremittingly precise, rational, and measured in his construction of space, as though he were familiar (as many of his Florentine contemporaries were) with the innovations of Ambrogio Lorenzetti in Siena. Also by comparison with the Master of the Codex of Saint George, the Maestro Daddesco is somewhat formulaic in the emotional content of his images. In this regard he more closely resembles an artist who may be his almost exact contemporary, the Master of the Dominican Effigies, and it is effectively the styles of these two painters that define the art of book illustration in Florence in the second third of the trecento.

LK

1. The colophon, on folio 296v, is recorded by Guidotti as: "Iste liber est fratrum monasterii Sancti Salvatoris de Septimo cisterciensis Ordinis florentine diocesis, scriptus et notatus et pro maiori parte versus finem de penna miniatus a fratre Vincentio Monoculo, eiusdem monasterii modico monacho, anno milleno tercentum iuncto quindeno. . . . Constitit autem liber iste absque scriptura et notatura et miniatura de penna, omnibus aliis computatis, circa quantitatem octoginta librarum" (This book belongs to the Cistercian brothers of the monastery of San Salvatore a Settimo, in the diocese of Florence, written, notated, and for the greater part toward the end decorated in pen by Brother Vincenzo Monocolo, a humble monk of that monastery, in the year 1315. . . . Moreover, this book amounts to, counting everything else without the writing, notation, and pen decoration, a cost of approximately 80 lire).

10. The Annunciation in an Initial M

Tempera and gold leaf on parchment
5 $^{1}/_{2}$ × 6 in. (14.1 × 15.3 cm); stave H.: 1 $^{3}/_{8}$ in. (3.5 cm)

The Metropolitan Museum of Art; Robert Lehman
Collection, 1975 (1975.1.2478)

Framed within the left arch of the letter M and set against a deep blue ground, the angel Gabriel kneels on a wooden floor. He wears a vibrant orange mantle over a soft gray robe. His left hand clasps a scepter, and he raises his right hand, the long index and middle fingers extended, as he announces the forthcoming birth of Christ to the Virgin Mary. At the right, Mary, in a gray blue mantle over a rose gown, stands with her arms crossed over her chest, her nimbed head slightly lowered.

The M, painted in rose, with green, orange, and blue foliate decoration against a burnished gold ground, signals the opening antiphon at vespers on the feast of the Annunciation (March 25): "Missus est Gabriel Angelus ad Mariam Virginem desponsatam Joseph" (The Angel Gabriel was sent to the Virgin Mary, who was betrothed to Joseph). On the reverse a rubricated letter *a* precedes a filigree capital S of a secondary antiphon, "Sicut myrrha electa odorem dedisti suavitatis, sancta Dei Genitrix" (Like precious myrrh you gave forth an odor of sweetness, Holy Mother of God), which is derived from a passage in Ecclesiasticus associated with feasts of the Virgin (24:19–20).

Mirella Levi D'Ancona (*in litteris*) associates the Lehman Annunciation with two cutout leaves by the Maestro Daddesco in London and Paris, each representing two standing saints within a letter S (cat. no. 11; fig. 34). There can be no question about the attribution of all three to the Maestro Daddesco. Hallmarks of his style seen in such works as the choir books from the Badia a Settimo are present in each. They include the broad, round, almost pasty white faces; the hair waving softly back from the face; clear gestures; drapery falling straight with occasional V-folds; and the simple foliate letter. The Lehman Collection initial, however, cannot be from the same manuscript as those in London and Paris, nor are the three demonstrably from the same series of choir books. The dimensions of the London and Paris leaves match each other but not the Lehman initial; the stave height on the reverse of the London initial is greater than that on the reverse of the Lehman cutting. While the foliate decoration and the dark blue grounds edged with white pen work are very similar (the white pen work representing a convention frequently found in Italian Gothic illumination), the London and Paris letters also have a frame with a

repeating pattern of quatrefoils and lack the burnished gold ground. The harder, more calligraphic line of the figures in the Lehman Annunciation is distinct from the Paris and London cuttings and has more in common with another initial M by the Maestro Daddesco representing the Three Hebrews in the Fiery Furnace (present location unknown; Boskovits 1984, pl. LXXXIVb).

In comparing the Lehman Annunciation with the Badia a Settimo choir books, Levi D'Ancona further suggests that the initial may have been excised from one of the volumes of that set, an antiphonary comprising the temporale from Quinquagesima Sunday to the Sunday within the octave of Easter (Museo dello Spedale degli Innocenti, Florence, Cod. CXXIX.4; Bellosi 1977a, p. 253). With the exception of Easter Sunday, however, that manuscript has only decorated letters for Sundays, including Palm Sunday. Neither is there any indication of illuminations having been cut from it or of any quires removed, apart from seven folios at the beginning. Moreover, in the Badia a Settimo choir books, the feast of the Annunciation is included in the antiphonary Cod. CXXI/2, a sanctorale comprising the feasts from the Purification of the Virgin to the Dedication of a Church. The decorated letter for "Missus est Gabriel" is still in place on folio 98v.[1]

None of the published manuscripts with illuminations by the Maestro Daddesco is known to lack a historiated initial for the feast of the Annunciation.[2] Nor can any other published single leaf by the artist be unequivocally established as a sister leaf of the Lehman cutting—the M with the Three Hebrews, for example, which has a similar disposition of figures in the letter and harder line of drapery and features, has a diaper pattern border and beading of the letter not found in the Lehman example, as well as different dimensions. It is clear that the full extent of the Maestro Daddesco's work is not yet known, and attempts to fit the published cuttings into the known body of manuscripts are premature. On the whole, published manuscripts have not been subject to extensive codicological examination (an exception being Luciano Bellosi's publications of the Badia a Settimo volumes), and there are clearly dismembered manuscripts that have not yet been identified.[3]

BDB

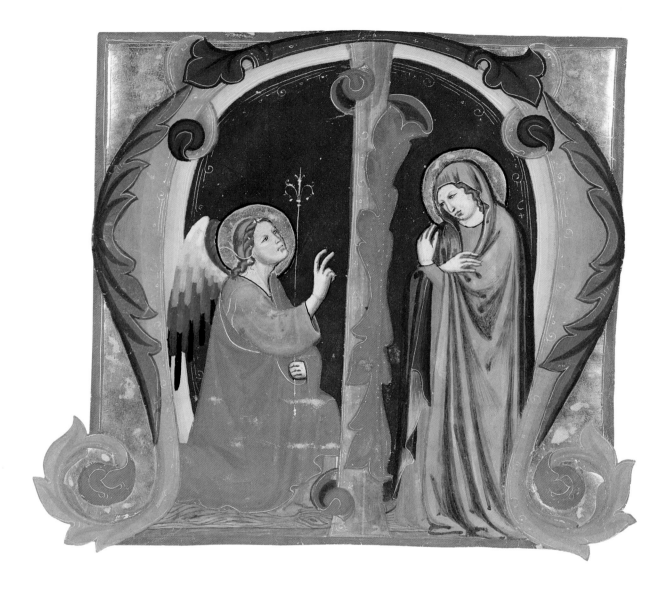

1. The manuscript has only one historiated initial, the V of the Assumption of the Virgin on folio 170, which is attributed to Pacino's workshop (see Bellosi 1977a, pp. 252–53).

2. The only other antiphonary known to lack illuminations is the one from Santo Stefano al Ponte (Museo Civico, Montepulciano; Cor. B) containing the sanctorale. The Annunciation is still in place on folio 55v.

3. The leaves in Kraków, for example, all acquired from the same dealer in the late nineteenth century, trace to an unknown gradual.

EX COLL.: Madame Fould, Paris (sold 1926); [Altounian, Mâcon]; Robert Lehman, New York.

LITERATURE: Galerie Georges Petit sale 1926, p. 14, no. 47, pl. V; De Ricci and Wilson 1935–37, vol. 2, p. 1704, no. C10; Paris 1957, no. 177, pl. LXXII; Szabo 1983, fig. 22.

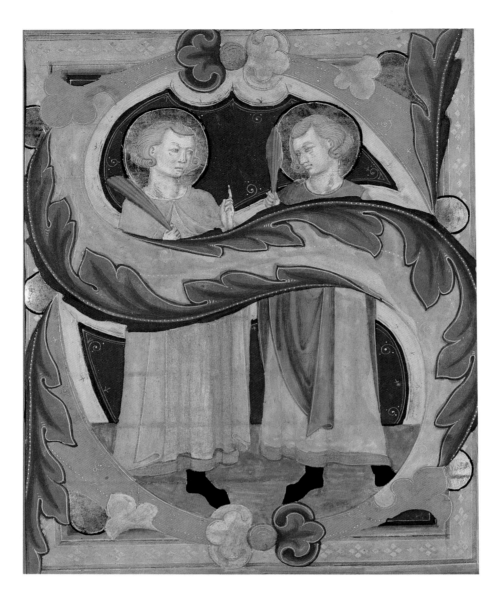

11. Two Martyr Saints in an Initial S

Tempera and gold leaf on parchment
6 × 5 in. (15.2 × 12.7 cm)

The Board of Trustees of the Victoria and Albert Museum, London (MS 996 [810–1894])

Two youthful male saints stand within a pink letter S, their palms of martyrdom held up near their halos. The saint at the left wears a mantle of soft gray over pink with a fawn-colored hem and a pointed black shoe, while his companion at the right wears a mantle of green over pink. The saints are presented as if sandwiched between the foliate letter and its yellow outline. The figures and letter are set against a deep blue ground highlighted with white pen work of delicate beads and curls like fine wood shavings, and the block of the letter is framed in pink with a gray diamond pattern.

The leaf is clearly a sister to another in the Wildenstein Collection, Paris (fig. 34), which has the same dimensions and virtually the same composition. Both initials could have come from a common of the saints in a gradual, where the initial S ("Sancti tui domine benedicent te" [Let your saints bless you, O Lord]) would have begun the introit to either the first Mass for two martyrs in the Easter season or the second and third masses for two martyrs outside Easter; from a volume of the sanctorale in a gradual for two martyr saints (as in the gradual from the Collegiata of Santo Stefano at Empoli, now in the Biblioteca Laurenziana, Florence, Cor. 41, fol. 302; Boskovits 1984, p. 246); or from the common of martyrs in an antiphonary.

Among the illuminations from the choir books of the Badia a Settimo—the Maestro Daddesco's most cele-brated commission—the works that most resemble the

Figure 34. Maestro Daddesco, Two Saints in an Initial S.
Musée Marmottan, Paris; Wildenstein Collection

London and Paris initials are those in three of the four volumes of the gradual now in the convent of Santa Croce in Gerusalemme, Rome (Cor. A, B, C). The figures of the saints, with their slim elegance, their supple drapery, and their broad, moonlike faces framed by cap-like hair waving back softly from the side part, are close, if less animated, counterparts to the figures in the narrative scenes from these books (see especially Boskovits 1984, pl. xcviiid from Gradual B). The surviving series of four graduals at Santa Croce in Gerusalemme—three volumes of the temporale and one of the sanctorale—lacks the common of the saints, which, according to the 1338 inventory of Badia a Settimo, was in two volumes. Given the stylistic affinities between the cuttings and the gradual volumes from the Badia a Settimo preserved in Rome, the London and Paris cuttings may have been excised from the now-missing common of the saints from that commission.

BDB

LITERATURE: Boskovits 1984, p. 228, pl. LXXXIXb.

12. The Nativity

Tempera and gold leaf on panel
Overall: 11 5/8 × 8 3/8 in. (29.5 × 21.3 cm); picture surface:
8 1/2 × 6 7/8 in. (21.7 × 17.5 cm)

The Metropolitan Museum of Art; Robert Lehman
Collection, 1975 (1975.1.60)

The Virgin, wearing a red robe and blue cloak, kneels at the upper left in a rocky landscape. She places the Christ child, wrapped in striped swaddling clothes, in the manger beneath a thatched roof supported by four poles. The ox and the ass, kneeling, look on from the right, and two angels who wear red robes fly in from the left, adoring the child. Saint Joseph, in a violet-and-blue cloak, sits in a cleft of the rock in front of the manger. Below him in the foreground, an angel announces the birth of Christ to two shepherds, whose dog and flock of sheep fill the lower left corner of the panel. The reverse of the panel is painted to show four quadrants of alternating red and green bordered with yellow. Each quadrant is filled with a quatrefoil interlace surrounding a center rosette.

This charming but somewhat damaged panel (the lower half of the landscape is abraded, and the sheep,

dog, and shepherds in the foreground are largely reconstructed) has been little discussed in the literature of Florentine trecento painting. It was attributed to the circle of Bernardo Daddi by John Pope-Hennessy and Laurence Kanter (Pope-Hennessy 1987, p. 52) and by Miklós Boskovits, first to an anonymous painter familiar with the work of both Daddi and Taddeo Gaddi (cited in ibid., p. 54) and subsequently (Boskovits 1989) to Bernardo Daddi himself. This last attribution—an indication of the painting's quality—is based on the general similarity of its composition and the correspondence of specific motifs, such as the action of the Virgin placing the child in the manger or the pensive attitude of Saint Joseph, to numerous examples of the subject by Daddi and his studio from the 1330s and 1340s. These similarities, however, must be considered a matter of influence rather than an indication of paternity, as the differences between this composition and those attributable to Daddi are at least as significant as their points of resemblance.

In all his scenes of the Nativity, Daddi places the Virgin and the Christ child as near to the center of the panel as possible rather than in the upper half of the scene, as here, deploying the ox, ass, and adoring angels

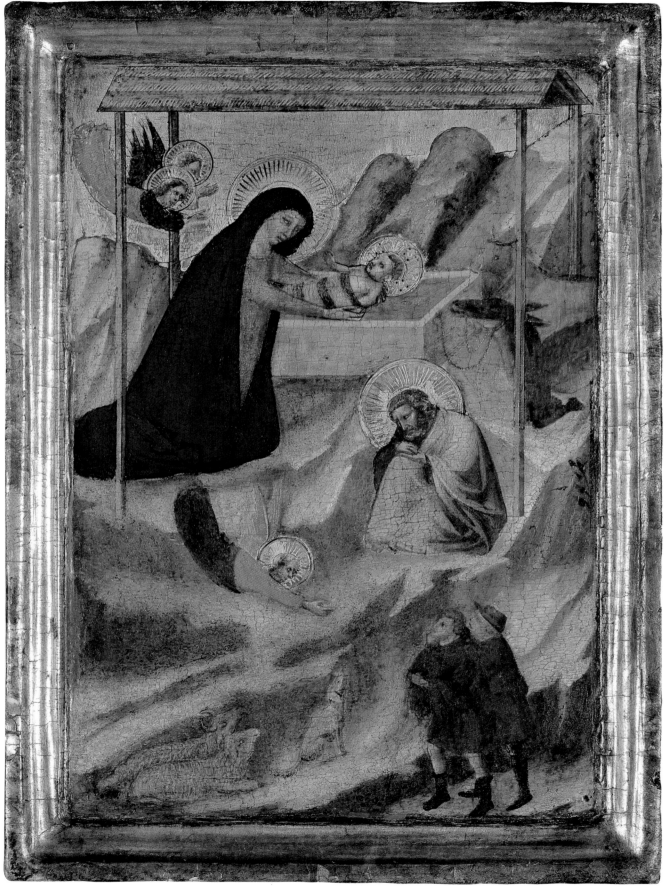

above the manger rather than alongside it in order to balance the figure of Saint Joseph below. The Virgin and Saint Joseph are invariably painted to the same scale for naturalistic effect, whereas here the diminutive figure of Saint Joseph makes him an emblematic adjunct to the narrative only slightly more important than the ox, ass, or shepherds. Finally, Daddi almost always paints the Virgin in pure profile, not three-quarter profile, as here, and the figure types in this panel are only distantly reminiscent of Daddi's stock cast of characters. Instead they correspond in every particular to the figures of the Maestro Daddesco; the shepherds, for example, replicate those in a *bas-de-page* from Cod. D at Santa Croce in Gerusalemme (Boskovits 1984, pl. LXXXVIC). The principal figures of the Virgin, child, and Saint Joseph, furthermore, are repeated, with only minimal variation, in the scene of the Nativity on folio 32r of the Beinecke Antiphonary (cat. no. 13). Such reprises of figures, motifs, and sometimes whole compositions are typical of the Maestro Daddesco's working method.

Convincing proposals for an internal chronology of the Maestro Daddesco's works have been frustrated by the complete lack of securely dated works and the intentionally repetitive nature of his output, but some general observations may be attempted. An unusual panel in the Museum of Fine Arts, Boston (Kanter 1994, pp. 57–59), showing the Virgin and Child Enthroned, the Crucifixion, and Christ and the Virgin Enthroned, for example, is later in style—more complicated in structure but less expressive—than either the Lehman *Nativity* or a panel depicting the Crucifixion also by the Maestro Daddesco, now in a Swiss private collection (Boskovits 1984, pl. LXXXVIIa; Freuler 1991, no. 60, p. 162).[1] The work in Boston is probably to be dated after the middle of the fourteenth century, possibly as late as about 1360, on the basis of its elaborate carpentry and such details as the circular extension of the dais before the Virgin's throne in one of its painted scenes. The *Nativity*, which cannot be as late as midcentury, can be dated only approximately by referring to the models by Bernardo Daddi from which it depends. As these were mostly painted in the middle and late 1330s, the Lehman *Nativity* is likely to have been executed about or shortly after 1340.

Preserving traces of hinges on its right edge, the Lehman *Nativity* was once the left half of a diptych and was probably joined to a *Crucifixion* similar to that now in Switzerland, but because these two panels differ in height by ³/₄ inch (2 cm) and use different systems of decorating the figures' halos, they most likely originated in different complexes.

LK

1. Bellosi (1992, p. 30 n. 14) has recently suggested that none of the panel paintings attributed to the Maestro Daddesco by Boskovits (1984) and others are, in fact, by him. Though the Ottawa and Santa Croce Madonnas (Boskovits 1984, pls. XCII, CI) may, indeed, be by other artists, there can be no doubt over the attributions of the *Crucifixion* formerly in the collection of E. V. Thaw, now in a Swiss private collection, and the panel in the Museum of Fine Arts, Boston (Boskovits 1984, pls. LXXXVIIa, XC). Bellosi described the latter as an early (pre-Giottesque) effort of the Biadaiolo Illuminator. Neither contention is tenable.

Ex coll.: Robert Lehman, New York.

Literature: Pope-Hennessy 1987, no. 25, pp. 52–54; Boskovits 1989, pp. 46–47, 354–55.

13. Antiphonary (Temporale)

Tempera and gold on parchment; 245 folios; page size, 20 ¹/₈ × 14 in. (51.2 × 35.5 cm). Leaves ruled with 10 staves of 4 lines each; stave height, ¹³/₁₆ in. (2.1 cm); interspace, ³/₄ in. (2 cm). Two bifolia also added in the 17th century. 17th-century binding with blind-tooled brown leather and applied metal bosses.

Yale University, New Haven; Beinecke Rare Book and Manuscript Library, Gift of Thomas E. Marston, 1953 (MS 178)

The three historiated initials are:

Folio 32r: The Nativity in an initial H ("Hodie nobis celorum rex de virgine nasci dinatus est" [Today the king of heaven is born of a virgin for us]), lauds antiphon for Christmas.
Folio 152r: The Three Marys at the Tomb in an initial A ("Angelus domini descendit de celo" [The angel of the Lord comes down from heaven]), lauds antiphon for Easter.
Folio 179r: The Descent of the Holy Spirit in an initial D ("Dum complerentur dies pentecostes erant omnes pariter in eodem loco" [When the days of Pentecost were drawing to a close, they were all together in one place]), lauds antiphon for Pentecost.

The Beinecke Antiphonary, the only bound manuscript by the Maestro Daddesco known in an American collection, contains three historiated initials, which signal the opening antiphons for Christmas, Easter, and Pentecost.

The Nativity shows the Virgin Mary kneeling in a stable whose tiled roof projects over her head; the scene

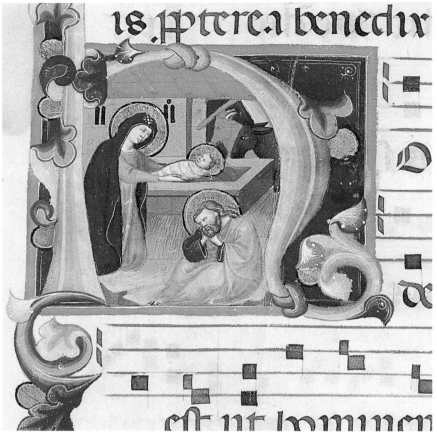

Fol. 32r

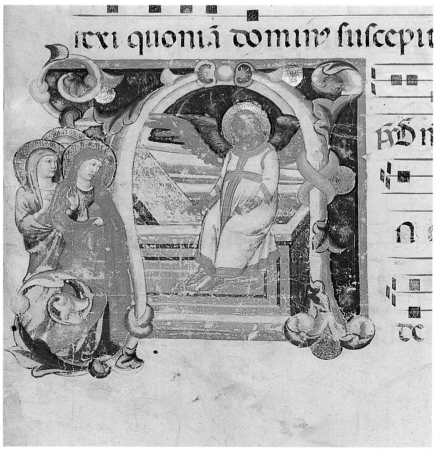

Fol. 152r

is sheltered within the arch of a pink letter H. Wearing a red gown and blue mantle, she lays the infant Jesus, wrapped in swaddling and with a cruciform nimbus around his head, in a brick-colored manger in the form of an open rectangular trough. The ox and ass stand behind, while Saint Joseph, in a red mantle over blue, rests on the rocky ground before them, his hands cupped under his bearded chin. The letter is decorated with knots and simple rhythmic foliage of green, yellow, pink, and blue.

The illumination of the Three Marys at the Tomb displays an angel, resplendent in a white gown trimmed with gold, with orange-and-green wings and with an orange countenance and hands, sitting on Christ's tomb within a letter A. The pink letter A is embellished with green, blue, and orange foliage. The lid of the tomb juts up at a sharp angle from the troughlike tomb, the form of which recalls that of the manger in the illumination of the letter H. The three Marys appear at the left, Mary Magdalen holding an unguent jar. Poised on the foliate terminal of the letter, they are grouped so that only the gilt nimbus and the top of the mantle of the third Mary are visible behind her companions.

In the D of the antiphon for Pentecost, the Twelve Apostles are grouped around the bust-length image of the bearded Saint Peter, who wears a gold mantle over blue. He holds a book in his left hand and the keys to the kingdom of heaven in his right. Two youthful apostles appear in three-quarter profile views at either side, while only the foreheads and nimbuses of the remaining nine can be seen behind them.

The compositions of the Beinecke historiated initials echo the types found in other preserved manuscripts by the Maestro Daddesco. The Pentecost scene is similar to the one used in the gradual made for the Fraternità del Latte of Montevarchi (Museo della Collegiata di San Lorenzo, Montevarchi; Cor. C, fol. 171), with Peter at the center, two youthful apostles flanking him, and the rest of the company splayed out horizontally in the bottom arc of the S that begins the gradual introit. The scene of the Three Marys at the Tomb reflects the composition of the lower half of the letter R from the gradual from Santo Stefano at Empoli (Biblioteca Laurenziana, Florence; Cor. 41, fol. 167v). The Nativity most closely resembles the composition of the leaf of a diptych in the Robert Lehman Collection (cat. no. 12), especially in the pose of the Virgin and the somnolent figure of Saint Joseph, both of which display affinities to the work of Bernardo Daddi.

The illuminations in the Beinecke Antiphonary, and indeed in other of the Maestro Daddesco's manuscripts, employ standard medieval iconography and formulaic

Fol. 179r

compositions that make them eminently legible. His adoption of these conventions was no doubt a key to his success as an illuminator: he seems to have dominated the production of illustrated books in Florence in the decades following Pacino di Bonaguida's death about 1340. By the same token, however, such standardization makes it difficult to chart the development of the Maestro Daddesco's style on the basis of the relative complexity or simplicity of his compositions. Frequently a single book—as is the case with the Beinecke Antiphonary— will draw on examples notionally datable at opposite ends of the artist's career. The figure style employed in the Beinecke manuscript does closely resemble that in two other books illuminated by the Maestro Daddesco (Museo Civico, Montepulciano, Cor. H/1 [Boskovits 1984, pl. XCVc]; Museo della Collegiata di San Lorenzo, Montevarchi, Cor. B [Boskovits 1984, pl. XCIIIb]), but it is not at present possible to suggest a precise date for any of these works.

<div align="right">BDB</div>

EX COLL.: C. A. Stonehill (sold 1933); Thomas E. Marston (1933–53).

LITERATURE: Faye and Bond 1962, p. 37, no. 178; Shailor 1984–87, vol. 1, pp. 241–42, pl. 21.

14. Two Bands and Three Fragments from an Orphrey

Linen, plain weave; embroidered with silk and gilt- and silvered-metal strips wrapped around silk-fiber cores in split and surface satin stitches; couching and padded couching
a. $43\frac{3}{4} \times 7\frac{1}{8}$ in. (111 × 18.2 cm)
b. $32\frac{7}{8} \times 7$ in. (83.5 × 17.6 cm)
c. $6\frac{7}{8} \times 5\frac{5}{8}$ in. (17.6 × 14.2 cm)
d. $6\frac{1}{8} \times 6\frac{1}{4}$ in. (15.5 × 15.8 cm)
e. $6\frac{7}{8} \times 5\frac{1}{2}$ in. (17.3 × 14.1 cm)
f. $3\frac{3}{4} \times 7$ in. (9.6 × 17.8 cm; study fragment, not included in this presentation)

The Art Institute of Chicago; Robert Allerton Endowment (1992.742a–e)

Each of thirteen complete and two fragmentary quatrefoils contains a half-length figure of a saint turned three-quarters to the left or right. Ten of the quatrefoils and one of the fragments are arranged in two vertically running orphrey bands,[1] and each of these quatrefoil cartouches is set within an illusionary oval formed by curling acanthus leaves and presented in a repeat pattern interconnected by circular rosettes. The composition is further held in place by a curious and most unusual step pattern forming vertical borders for the bands. Another fragment, showing the lower half of a quatrefoil and the garments of a saint, was presumably cut from the end of one of the two bands. Three further quatrefoils are distinguished from the others by their horizontal orientation; they have geometric step borders running along the top and bottom edges. Inscriptions on banderoles identify the figures in these three quatrefoils as three of the Four Evangelists: INITIUM.S (cat. no. 14c) stands for the Gospel of Saint Mark 1:1–2: "Initium Evangelii Iesu Christi filii Dei. Sicut scriptum est in Esaia propheta" (The beginning of the gospel of Jesus Christ, the Son of God. As it is written in Isaias the prophet); INPRINCIP[IO] (cat. no. 14d) signifies the Gospel of Saint John 1:1: "In principio erat Verbum, et Verbum erat apud Deum, et Deus erat Verbum" (In the beginning was the Word, and the Word was with God, and the Word was God); and DEUS (cat. no. 14e) can be associated with the words of Christ in the Gospel of Saint Matthew 27:46: "Deus meus, Deus meus, ut quid dereliquisti me?" (My God, my God, why hast thou forsaken me?). There could have been a fourth fragment, which would have had to personify Saint Luke. Of the ten and a half images in the two vertical bands, only three can be identified with certainty. They are Christ, shown with a raised right hand and cruciform halo (fig. 35), Saint Paul with a sword (fig. 36), and Saint Margaret,

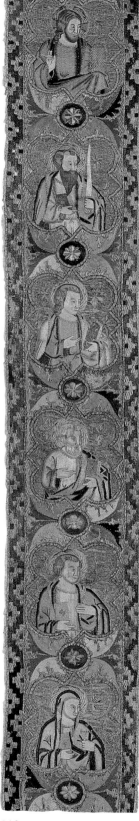

14a

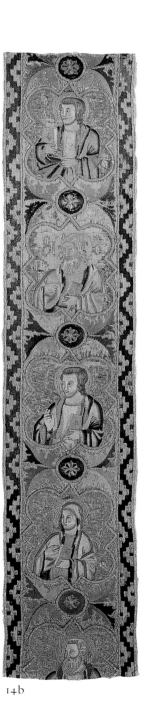

14b

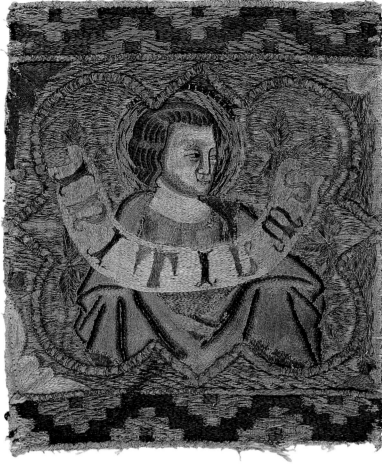

14c

one of the two female figures in the bands, who holds a small cross (fig. 37).

The foundation fabric for all the pieces is a double-layered linen, plain weave, embroidered with silk and gilt- and silvered-metal strips wrapped around a silk-fiber core.[2] The needlework utilizes split and surface satin stitches with areas of couching and padded couching. Each quatrefoil cartouche is outlined by cotton cording once covered with silvered thread, which has worn away in many places. The quatrefoil itself and the geometric border design are worked in couched gilt thread. A rinceau attached to a stem fills the lobed sections of each quatrefoil and, in instances where there is enough space, introduces additional rinceaux into the pointed sections of the quatrefoil. All halos, except for Christ's, are executed in patterns that swirl in one direction in one band and in the opposite direction in the other band. The same swirling motion is also found in the treatment of some of the beards worn by the older men, while the hair of the younger men follows a standard pattern of a combed-up front and rippling falling locks to the right and left sides of the face. Highlights in the hair

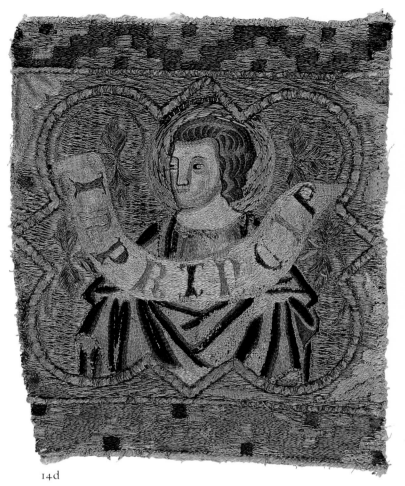

14d

14e

are suggested through the introduction of darker embroidered lines. A circular arrangement of surface satin stitches is also used in building up the faces, and all garments and hands are created through split stitches following the direction and orientation of the design. The relatively unfaded colors are strong and feature the primary colors of the spectrum, as well as related shadings. Most subtle color treatments are found in the needlework that fills the outlining acanthus leaves at the top and bottom of each quatrefoil.

Originally the various pieces shown here were not in the shape in which they are being presented in this publication and accompanying exhibition. When they were discovered on the art market and acquired in 1992 by The Art Institute of Chicago, they were in two parts, one in the form of a cross and the other a shorter band. These two parts decorated the front and back of a dalmatic (see fig. 38). It is not known when the two pieces were attached to the dalmatic, for surely their use on a chasuble would have been far more appropriate. In fact, the pieces may have had several incarnations. However, if we assume that they were once attached to a chasuble, the cross-shaped orphrey would have been on the back, while the shorter band would have been used on the front of the garment. Upon closer examination of the orphrey cross, it became apparent that the band was extended in its upper quadrant by attached squares to the right and to the left to form the necessary horizontal portion of the cross. Furthermore, the scrap (cat. no. 14f) with the curved side was attached at the very top of the cross to lengthen the vertical band so that the cross would cover the entire back of a chasuble, that is, from the back of the neck down to the hemline. These added fragments had all been cut and were attached to the main band through stitching. An examination of the shorter band revealed that this band as well had been lengthened at the very top with a square sometime during the nineteenth century and outlined on three sides with a braid or a galloon. This addition was needed to lengthen the shorter band so that the strip could be used to embellish the front of the chasuble.

Given the consistent widths of the bands and fragments, it is likely that they formed a single continuous band, which was intended to decorate the

Figure 35. *Christ*, detail of cat. no. 14

Figure 37. *Saint Margaret*, detail of cat. no. 14

Figure 36. *Saint Paul*, detail of cat. no. 14

uppermost portion of a cope (see diagram of proposed reconstruction, fig. 39). The illustrated arrangement shows how the two bands could have been fitted within the orphrey section of a cope. When the cope was draped over the wearer's shoulders, two parallel running bands would have embellished the front of the garment, and the opposite sides would then be directly related in that the portrayed images would have faced each other. Once such an arrangement has been introduced, a precise pattern becomes apparent, which alternates older and younger saints and ultimately two female images. Yet once this reconstruction was attempted, it also became clear that the two sections were not long enough to complete an entire orphrey band for a cope. At least three and perhaps five further quatrefoils are missing from the present composition. Generally an orphrey band for a cope should be at least roughly ten feet (305 cm) in length.

The three horizontal fragments—one piece, which had lengthened the shorter band and was outlined on three sides with a nineteenth-century tape or galloon, and the other two, which had formed the lateral portion of the longer orphrey band—together with a probable fourth showing Saint Luke, now missing, could have been used above the hood on the back of the cope. An extant cope

utilizing such an arrangement is in the church of Santa Margherita a Montici, near Florence (Rome 1937, pl. 63). Although this cope has been dated between 1420 and 1430, it nevertheless introduces a plausible composite arrangement that could have existed during the previous century. The horizontal placement of the stepped patterning device would then have created a continuation and a link to the vertical bands. In examining the fragments, it became clear that DEUS and INPRINCIP, once unified in a single piece, had been cut apart. This leads one to assume that the missing image of Saint Luke would have been placed between INITIUM.S and DEUS.

It is also conceivable that the three horizontally oriented squares, together with the missing fourth square, were part of a totally different composition, perhaps an altar frontal. Altar frontals in rowlike arrangements were also common during this time, not only in Italian needlework compositions but also in many a surviving example originating in another country. One such example is the central portion of an altar frontal in Braunschweig at the Herzog Anton Ulrich-Museum (MA no. 54; Kroos 1970, no. 7); it dates from the same time as the orphreys under discussion, that is, the third quarter of the fourteenth century. It is also plausible that the bands and fragments were once associated with a set of pontifical vestments rather than one garment only.

Records from the fourteenth century describing vestments and specifically pontifical copes (pluvialia pontificalia) exist and are most valuable for documentary purposes. The inventory of Saint Peter's, for example, under the year 1361 lists vestments that are recorded and identified as "opere Anglicano," "opere Romano," "opere Lucano," "opere Senensi," "opere Senarum," and "opere Veneto." Since the descriptions are not accompanied by illustrations, what is referred to by "aurifrisio" with "foliis diversium colorum," "ymago Salvatoris," and "ymagine domine nostre et sancti Johannis, ab utraque parte ymagines apostolorum et aliorum sanctorum et sanctarum" (Müntz and Frothingham 1883, pp. 13–23) is not certain and could have described a variety of different compositions within the orphrey vernacular. Furthermore, to glean fabric and color references for a pluvial is most intriguing but for precise documentary purposes again inconclusive, as it is known that throughout the history of textiles orphrey bands were removed and remounted once a liturgical garment was worn out, needed to be updated, or changed hands. Also, unless full documentation of a given piece exists or a particular coat of arms associates a specific vestment with an important family connected with one of these cities, a precise designation to a particular city, such as Lucca, Siena, Venice, or Rome, would not necessarily

indicate a specific school or workshop operating in that town. What is most curious is the fact that Florence is not listed among the cities in this inventory. As Florentine work is not mentioned, it is possible that works executed by Florentine artists in Rome became thereafter known as "opere Romano." It is also possible that Roman needlework establishments were inspired by Florentine art of the time and that the embroiderers aspired to the Florentine style but did not identify it as such: Rome was not known to have had a school of painters of any renown at that particular time.

However, Florence's preeminence in the field of needlework is recognized. One only has to read the inventories pertaining to the possessions of the duc de Berry (1401), Philip the Bold (1404), and Philip the Good (1420) to document the importance of "Ouvraige de Florance." In the duc de Berry's inventory alone, thirteen embroidered altar hangings are listed as having been created in Florence (Grönwoldt 1961, pp. 55–57). Two major Florentine fourteenth-century altar frontals are still extant, and one of them, in the Palazzo Pitti, is signed by Jacobus Cambi Florentinus and dated 1336 below the Coronation of the Virgin scene (see Cavallo 1960, p. 510 n. 17, for all authors and publications that have discussed this piece). Close to equal in craftsmanship and historic importance is another altar frontal, in the collegiate church of Santa Maria at Manresa in Catalonia; it is signed by Geri Lapi, "rachamatore [embroiderer] . . . in Florentia" (Salmi 1931, p. 385). Further Florentine attributions identify an altar frontal in the collection of the Toledo Museum of Art that portrays scenes from the Life of the Virgin and dates between 1330 and 1350 (acc. no. 1954.85; Grönwoldt 1969). A frontal in The Cleveland Museum of Art also illustrates scenes from the Life of the Virgin (acc. no. 1978.36; Wardwell 1979). Although the Toledo piece was initially identified as an orphrey, it becomes clear in Anne Wardwell's article that the Cleveland and Toledo pieces once composed a portion of the same superfrontal (Wardwell 1979, pp. 322–25).

Technical and structural comparisons between the Cleveland piece and the Chicago orphreys point toward a great many similarities with respect to thread counts and twists of a double-layered linen ground, the silvered and gilt threads[3] wound around silk cores, and the frequent use of shades of two or more colors in one thread. Although the compositions are quite different, it is the craftsmanship that ties these pieces together, and the particular type of work seems in keeping with what has survived and carries all the characteristics one normally associates with Florentine needlework dating from the first half of the fourteenth century. (For full

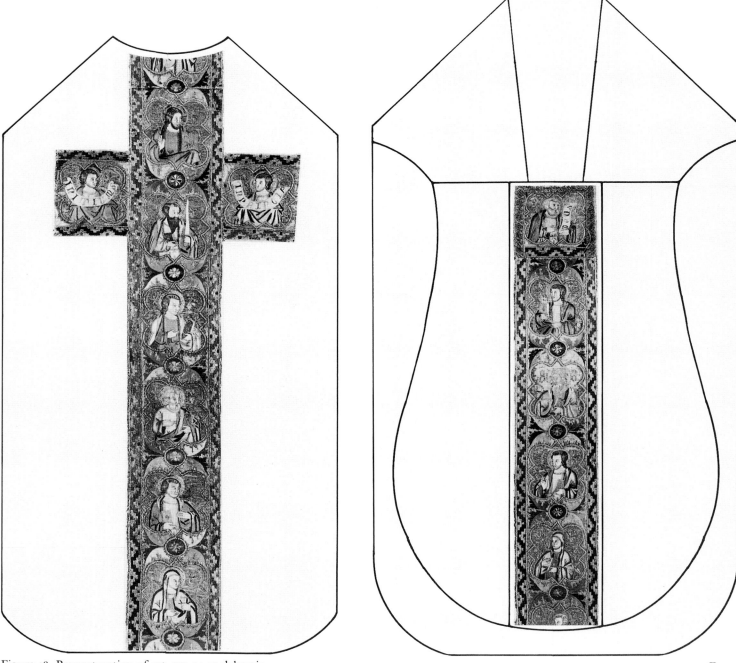

Figure 38. Reconstruction of cat. no. 14 as dalmatic Front

documentation of substantiating evidence, see the writings from the 1930s on of Salmi, Kurth, Grönwoldt, King, Cavallo, Van Fossen, and Wardwell.)

Decorative elements, such as the ivy rinceaux, can be traced to several other trecento Florentine embroidered pieces, among them twelve panels that were once part of an altar frontal and in the Iklé collection in Switzerland. Today these altar frontal components are divided among The Metropolitan Museum of Art, New York; Museum of Fine Arts, Boston; The Cleveland Museum of Art (acc. no. 29.904); and a private collection (Van Fossen 1968). Further closely related Florentine embroidered items in other collections include two fragments that have been in the collection of the Würtembergisches Landesmuseum, Stuttgart, since 1971 (inv. no. 1972–118a, b; Grönwoldt 1989). Differences in composition are apparent, principally in the outer enframing border to the right and left of the orphrey bands and the

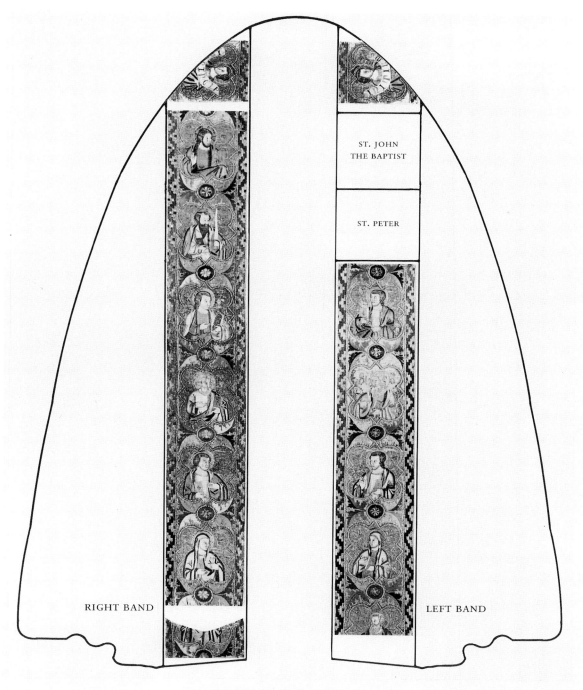

ST. JOHN
THE BAPTIST

ST. PETER

RIGHT BAND

LEFT BAND

FRONT OF COPE

Figure 39. Reconstruction of cat. no. 14 as cope

connecting device between the quatrefoils, which is a rhombus carried by suspended, confronted angels rather than a rosette. Nor are the quatrefoils placed against illusionary ovals. The widths of the bands are almost identical, and so is the gilt work with its barely noticeable rinceau pattern. Admittedly, technical disparities exist and the stitch vocabulary differs slightly. The pieces in Stuttgart have been dated to about 1350. They, like the Chicago bands, in all probability faced

each other and as the ends are rounded undoubtedly represent the end portions of the right and left orphrey bands of a cope.

Another related orphrey band, considerably narrower and made of two fragments stitched together, is in the collection of the Victoria and Albert Museum, London (acc. nos. 7028–1860, 8641–1863; De Farcy 1890). The bust-length haloed images all face in one direction and are placed against a metal thread background but

without a rinceau design. Instead, zigzag lines fill the quatrefoils. Rhombuses that are flanked with confronted parrots alternate with sprays of leaves, possibly again acanthus, to separate the quatrefoils. Meandering garlands of rinceaux, periodically interrupted by smaller rhombus motifs, enframe the orphrey band to its right and left. The drawing, the needlework execution— predominantly in chain stitch on linen in colored silks— and the general style of the work relate to the orphreys under discussion. Furthermore, the outlining cords, also cotton, are worked in related metal threads, and the typical couching technique in both the silk and metal areas can be found as well. This band is dated to the mid-fourteenth century and has been attributed to Italy. It is composed of two stitched-together portions acquired in 1860 and 1863, respectively. A third orphrey mentioned in the Donald King Festschrift as part of the Museum für Angewandte Kunst collection, Vienna, no longer exists (Dreger 1904). It is my contention that this band was probably once part of the Victoria and Albert Museum's joined orphrey band. As all three pieces once belonged to Canon Bock, whose collection was subsequently divided between the Victoria and Albert and the Museum für Angewandte Kunst, the pieces were undoubtedly formerly part of the same band. As this volume goes to press, two related fragments, one showing Saint Peter, the other an unknown apostle, have surfaced in the collection of the Cluny Museum, Paris. These fragments also belong to this group.

Quatrefoil medallions, acanthus leaves, and ivy rinceaux are not exclusively Florentine elements of design, though they do figure prominently in Florentine trecento painting and sculpture, notably in Andrea Pisano's bronze doors (1330–38) for the Baptistery or the nearly contemporary fresco decoration surrounding the entrance arch to the Baroncelli Chapel in the church of Santa Croce. Pacino di Bonaguida employed quatrefoil cartouches with half-length figures not unrelated in style to those on the Chicago orphreys in designing the stained-glass windows in the Peruzzi Chapel at Santa Croce (Boskovits 1984, pl. cv), while acanthus-leaf border decoration is typical of the manuscript illuminations produced in his shop. A close parallel for the vertical arrangement of the saints in the Chicago orphreys, though in circular rather than quatrefoil medallions, is provided by several pages from the Laudario of Sant'Agnese by Pacino and the Master of the Dominican Effigies, probably of the 1330s (see cat. no. 4), but the closest of all the parallels, perhaps, are two paintings by Lorenzo di Bicci from the second half of the century, both showing actual Florentine liturgical garments with orphrey bands. His painting of Saints Julian and

Figure 40. Older Man, detail of cat. no. 14

Zenobius in the Accademia, Florence (Marcucci 1965, no. 87), probably of the 1390s, shows the bishop saint wearing an early casula, or chasuble, with matching miter that displays quatrefoil designs with rinceaux backgrounds in the orphrey. Similarly, Lorenzo di Bicci's *Saint Martin Enthroned* of about 1380–85, now in the church of San Nicolò a Ferraglia (Marcucci 1965, no. 88), shows Saint Martin wearing a cope decorated with a quatrefoil morse and an orphrey band filled with elongated quatrefoil medallions, as well as a miter embellished with related quatrefoils, all filled with half-length figures.

Needlework during the Middle Ages was looked upon as high art; it was not relegated to the minor or decorative arts. There was little difference in importance between a painted or an embroidered antependium. The mere fact that gilt and silvered threads were used in the background in needlework pieces would suggest their connection with gold leaf in panel paintings. Similarly, the embroidered counterpart to incising or building up a background pattern in a gold-leafed panel painting, interpreted according to the medium's advantages and characteristics, was raised work over padding and cording.

The remarkable handling of the embroidered images and supporting designs of orphrey bands in general and of the Chicago orphreys in particular was greatly aided by the skillful underdrawing that obviously would have preceded them. The technique of underdrawing prevalent at the time is clearly described in a passage from Cennino Cennini's *Il libro dell'arte* of 1437, which carries elaborate instructions for painters on how to paint directly on fabric:

> Again, you sometimes have to supply embroiderers with designs of various sorts. And, for this, get these masters to put cloth or fine silk on stretchers for you, good and taut. And if it is white cloth, take your regular charcoals, and draw whatever you please. Then take your pen and your pure ink, and reinforce it, just as you do on panel with a brush. Then sweep off your charcoal. Then take a sponge, well washed and squeezed out in water. Then rub the cloth with it, on the reverse, where it has not been drawn on; and go on working the sponge until the cloth is damp as far as the figure extends. Then take a small, rather blunt, minever brush; dip it in the ink; and after squeezing it out well you begin to shade with it in the darkest places, coming back and softening gradually. You will find that there will not be any cloth so coarse but that, by this method, you will get your shadows so soft that it will seem to you miraculous! (Cennini 1960, p. 105)

Thus, the embroiderer did not always transfer patterns or pounce designs through holes onto a fabric. The painter-craftsman was greatly involved with the embroiderer's work. The illustrated detail (fig. 40) from the shorter orphrey band shows the front of a damaged area that documents this aspect superbly. This damage is a blessing in disguise, for it reveals the linen ground. The area was probably damaged during the time that this orphrey band was attached to the front of a chasuble. More than likely, the needlework was rubbed off by the celebrant while officiating at the altar and by coming in contact with both the chalice and the altar in doing so.

To the extent that the figure style of the drawings underlying the Chicago orphreys is legible through these areas of damage, as well as more generally through its translation into needlework by the embroiderers, it argues for an attribution to a Giottesque workshop in midcentury Florence, such as that of Taddeo Gaddi. Taddeo's polyptych of 1353 in San Giovanni Fuorcivitas, Pistoia (Ladis 1982, pls. 19.1–14), and that of the following year in Santa Felicita, Florence (Ladis 1982, pls. 58.1–6), employ figures with the same distinctive fully rounded heads, high cheekbones, and gently turned shoulders, which are far more sophisticated spatial and anatomical devices than any present in the works of Pacino di Bonaguida or the painters of his generation. Another artist brought to mind by the rounded yet solid features of the Chicago saints is the Master of the Orcagnesque Misericordia, who has been tentatively identified with Taddeo Gaddi's son and Agnolo Gaddi's older brother, Giovanni (Boskovits 1975, fig. 218, p. 366). Giovanni Gaddi seems to have been increasingly responsible for the management of his father's commercial affairs from the 1350s on, possibly collaborating on a number of Taddeo's commissions during that decade. By the mid-1360s he was an established painter in his own right, being called to Rome to work at the Vatican palace in 1369. Though he arrived too late for the 1361 inventory of Saint Peter's cited above, it is interesting to speculate whether Giovanni Gaddi (alias the Master of the Misericordia?) may have been one of the designers of *Opus Romanum* needlework and whether the Chicago orphreys might be a unique surviving example of his work in this precious medium.

CCMT

1. The word *orphrey* derives from the Latin *aurifrisium* or *auriphrygium*, the word *aurum* meaning gold and *phrygium* referring to the Phrygians. Therefore, *aurifrisium* initially stood for metalwork carried out by the Phrygians. Within the more precise context of embroidered textiles, the word began to represent very rich work, gold in appearance. As many of these embroidered bands were placed on either sacerdotal vestments or altar frontals and extensively utilized gilt and silvered threads, the use of the word *orphrey* for this type of work is most logical and appropriate.

2. The two bands, the three fragments, and the study scrap are embroidered on two layers of Z-spun linen, plain weave. The upper layer is of a finer quality linen, twenty threads per square centimeter; the lower layer carries a count of sixteen threads per centimeter. The silk used in the needlework is S- and Z-plies of two to five varying shades of colors of non-appreciably twisted elements. The silk is primarily embroidered in split stitches and some surface satin stitches. The metal threads are laid and secured in underside couching. The metal threads are constructed of silvered- or gilt-metal strips wrapped in an S-direction around an S-plied silk core of two to three nonappreciably twisted elements. The padding used throughout is a natural cotton, S-ply of four Z-spun elements. Diameters: silk, .3–.55 mm; metal, .2–.4 mm; cotton, 1.5–2.5 mm. For complete detailed technical analysis, consult the conservation files for 1992.742a–f at the Department of Textiles, The Art Institute of Chicago.

3. The gilt and silvered threads were tested by Bruce Christman, Chief Conservator, The Cleveland Museum of Art, through an X-ray fluorescence spectrometer. The gilt threads seem to be composed of silver metal with a thin layer of gold on top (report dated May 6, 1993).

DON SILVESTRO DEI GHERARDUCCI

Vasari states that among the monks of Santa Maria degli Angeli there was a distinguished team of illustrators, including "Don Jacopo, a Florentine, who . . . was . . . a better writer of large letters than any who lived either before or after him, not only in Tuscany, but in all Europe . . . together with . . . another monk called Don Silvestro, who, according to the standard of those times, illuminated the said books no less excellently than Don Jacopo had written them."[1] Based on that assertion, there was already a tendency, as early as the first decades of the nineteenth century, to label miscellaneous initials and pages from choir books as the work of Don Silvestro. The definitive identification of Don Silvestro as a painter and an illuminator occurred less than forty years ago, however, due to a happy intuition of Mirella Levi D'Ancona (1957), whose point of departure, paradoxically, was what we now know to have been a nineteenth-century forgery of the artist's signature. Proceeding from the author of a series of stylistically related pictures and miniatures grouped by Richard Offner around a panel of the *Madonna of Humility* now in the Accademia, Florence (inv. no. 3161), and named by him the Master of the Cionesque Humility,[2] Levi D'Ancona believed she could substitute for this name of convenience that of the Camaldolese monk Don Silvestro dei Gherarducci, an artistic personality whose existence is substantiated by documents.[3] The basis for Levi D'Ancona's proposed identification was an illuminated initial now in the Nelson-Atkins Museum, Kansas City (fig. 51), that bore the signature "Don Silvestro." This illumination belonged to a stylistically coherent series that came partially to light in 1838 in the estate of William Young Ottley (sale 1838, lots 181–88; see cat. no. 16), all of which could be added to Offner's grouping of works attributed to the Master of the Cionesque Humility. Furthermore, Levi D'Ancona demonstrated that several of the painter's works, specifically several choir books (Biblioteca Laurenziana, Florence; Cod. Cor. 2, 6, 9, 19), came from the Camaldolese monastery of Santa Maria degli Angeli in Florence. Since it was in this very house and just at this very time that a monk named Don Silvestro is known to have existed and who is mentioned by Vasari as a book illuminator of outstanding talent, Levi D'Ancona concluded that the painter in question must have been none other than Don Silvestro dei Gherarducci. Even though it was later shown that the signature on the miniature now in Kansas City was spurious,[4] thereby discrediting the crucial link in Levi D'Ancona's chain of evidence, Don Silvestro's historical authenticity can hardly be contested.

Surviving documents regarding Don Silvestro mainly concern details of his life among the Florentine Camaldolese at the monastery of Santa Maria degli Angeli. Born in 1339 to a family in the parish of San Michele Visdomini, he joined the Camaldolese order in 1348 at the tender age of nine. He professed his vows at the age of thirteen, after a four-year novitiate. There is no further mention of him until 1362, when Don Silvestro's name reappears in connection with the monastery. Based on the evidence of his mature paintings, it seems very likely that his career during this interval was not centered upon Santa Maria degli Angeli in Florence but upon Siena, where he might have been trained as a painter in Jacopo di Mino del Pellicciaio's workshop. There is little recorded of his later years; however, it seems that Don Silvestro remained in Florence. This may be deduced from his involvement with an altarpiece presumably destined for the Cappella d'Ognissanti, consecrated in 1365 (cat. no. 15), in the chapter house of Santa Maria degli Angeli, and from the number of later panel paintings that may be associated with his hand, all related in style to the circle of painters dominated by the Cione brothers.

In 1370 and 1372 Don Silvestro is mentioned again in connection with monastic affairs, and it is shortly after this that his earliest known activity as an illuminator occurs, an activity that from then on increasingly occupied his time but ran parallel to his career as a panel painter. The gradual illuminated

for Santa Maria degli Angeli (Biblioteca Laurenziana, Cod. Cor. 2; cat. no. 16) twice bears the date 1370 (1371, according to modern reckoning: fols. 161v, 207r). However, this date can apply only to the copyist responsible for the liturgical text and perhaps to the decoration of the smaller and larger initials that were probably written by Don Jacopo. That Don Silvestro, as a miniaturist, furnished the large historiated initials after the date on folio 207 is supported not only by the practice common to all the other illuminated choir books from Santa Maria degli Angeli (see cat. nos. 20, 29, 30, 33, 35–37) but also by recently discovered documents of 1374–75 that may apply to the final decoration of this book. Another document informs us that in 1383 the Olivetan monks of San Miniato al Monte paid Don Silvestro for paints. It remains uncertain whether this payment concerned one of his own artistic commissions or whether Don Silvestro merely furnished the pigments to another painter's workshop (see cat. no. 26).

Various documents have survived from between 1384 and 1389 regarding Don Silvestro's involvement with affairs of his monastery. By 1389, when he was fifty years old, he is mentioned as the subprior of Santa Maria degli Angeli and consequently was foreseen as the future prior. Several payments to Santa Maria degli Angeli exist for the execution of a series of antiphonaries begun in 1385 (Levi D'Ancona 1979, pp. 461ff.; idem 1985, pp. 451ff.). Don Silvestro's name appears in the record of one of these payments in 1396, from which Levi D'Ancona deduced that he kept the funds for his own artistic labors. On the other hand it could be argued that Don Silvestro accepted this money for the production of the antiphonaries, not in compensation for his personal work on them as a miniaturist but rather in his capacity as subprior of Santa Maria degli Angeli and, since Don Jacopo's death, the most prominent member of its scriptorium (Bent 1992). At about the same time, Don Silvestro almost certainly illuminated the initials of two important graduals for the Camaldolese monastery of San Michele a Murano (Vasari 1906, vol. 2, p. 23; cat. no. 17). Don Silvestro is cited in further documents concerning monastic affairs during 1397, when he was elected prior of Santa Maria degli Angeli. He died two years later, at the age of sixty, in 1399.

Recently, George Bent (1992) has reinterpreted the evidence of Vasari's text and the documents from Santa Maria degli Angeli to suggest that Don Silvestro was not a painter, that the scriptorium at Santa Maria degli Angeli subcontracted all its painted illuminations to secular artists, and therefore that the works associated with the Master of the Cionesque Humility, alias Don Silvestro, must for the present remain anonymous. While it may be acknowledged that Vasari is notoriously unreliable as a source of information for fourteenth-century painters, the coincidence of his attributions of choir books in houses so distantly removed as Santa Maria degli Angeli and San Michele a Murano with works now known to be by the same hand implies that he was writing from informed tradition. Also, the considerable sum of 100 florins—comparable to the cost of an elaborate altarpiece—paid to the scriptorium at Santa Maria degli Angeli in 1375 for the making of Cod. Cor. 2 (cat. no. 16) almost certainly included the task of illuminating the initials. These initials, furthermore, may be dated on stylistic grounds to two different periods; the bulk of them clearly were completed about 1375, while several others relate instead to the illuminations for San Michele a Murano of the 1390s. The likeliest explanation for this interrupted and resumed activity being entrusted to the same painter is his continuous presence within the scriptorium, a likelihood made all but certain by the fact that none of the many illuminations attributable to this artist were executed for patrons other than the Camaldolese of Santa Maria degli Angeli and San Michele a Murano. The conclusion seems inescapable that this artist was indeed, as Vasari claimed, Don Silvestro dei Gherarducci.

GF

1. Vasari 1912–14, vol. 2, p. 57. "Don Iacopo fiorentino che fu . . . il miglior scrittore di lettere grosse che fusse prima o sia stato poi, non solo in Toscana, ma in tutta Europa . . . insieme con . . . un altro monaco chiamato Don Silvestro; il quale non meno eccelentemente, per quanto porto la condizione de que'tempi, minio i detti libri, che gli avesse scritti Don Jacopo" (Vasari 1906, vol. 2, pp. 22–23).

2. Offner's detailed considerations on the Master of the Cionesque Humility remain unpublished, but in a note of 1956, he listed all the works that in his opinion belonged to this painter (Offner 1956, p. 145 n. 82). Offner's reconstruction of this master's oeuvre was earlier referred to by Shorr (1954, pp. 33 n. 11, 74 n. 26) and was acknowledged by Levi D'Ancona (1957, pp. 9–11 n. 12).

3. The identification of Vasari's Don Silvestro with the historical figure of Silvestro dei Gherarducci and of Don Jacopo with Jacopo dei Franceschi was due to T. Mini (1706, p. 500) and G. Farulli (1710, pp. 10–11). All known documents pertaining to the life of Don Silvestro dei Gherarducci will be published by Gaudenz Freuler in a forthcoming volume of *A Critical and Historical Corpus of Florentine Painting* (sec. 4, vol. 7) dedicated to Don Silvestro.

4. See Stokstad 1972; Russell 1979. It is difficult to explain how Don Silvestro's signature came to be forged alongside the illuminated initial M now in Kansas City, which originally decorated folio 119 of Cod. Cor. 2 at the Biblioteca Laurenziana, Florence. Paleographic evidence excludes Russell's suggestion that the script could have been original and that with the partial dismemberment of the choir books the signature was cut out and pasted onto the initial. The signature's letters are much more slender than those of the original liturgical text and are quite unlike trecento script. It cannot be ruled out that the false signature might have been added at some unspecified date while the choir book was still intact at Santa Maria degli Angeli, where the usually well-informed monks were certainly aware of Vasari's description of their patrimony. The most likely explanation is that the forged signature was added by William Young Ottley because there is now hardly any doubt that he acquired all the miniatures cut out from Cod. Cor. 2 directly from the original owners—the Florentine Camaldolese monks of Santa Maria degli Angeli.

15. The Crucifixion

Tempera on panel
54^1/$_8$ × 32^1/$_4$ in. (137.4 × 82 cm)

The Metropolitan Museum of Art; Robert Lehman Collection, 1975 (1975.1.65)

The irregularly shaped panel, originally the central pinnacle of an altarpiece, shows a highly emotional representation of Christ's suffering on the cross, with the cross extending the full height of the composition at its center. At the base and to the left, the fainting Virgin Mary is supported by one of the Holy Women and Saint John, while Mary Magdalen grieves, clutching the bloodstained cross. To the right of the cross are various bearded men who introduce the beholder to the tragic scene. Eight angels hover around the Savior on the cross, either lamenting Christ's death or collecting his precious blood. Six larger angels framed separately at the sides originate from a different altarpiece, probably painted by Jacopo di Cione, and were added to the *Crucifixion* by a nineteenth-century collector.

Miklós Boskovits (1972) convincingly reassembled the various panels of an altarpiece—including the Lehman *Crucifixion*—all of which he felt were by Don Silvestro dei Gherarducci. In addition to the present panel as the central pinnacle, they include the left wing of the main register with several female saints in the Greco collection, Rome (fig. 41); the right wing with various male saints in the Musée National d'Histoire et d'Art, Luxembourg (fig. 42); the *Noli me tangere* in the National Gallery, London (fig. 43), thought to be the pinnacle over the left side panel; and the *Man of Sorrows* in the Denver Art Museum (fig. 44), as the central element of the predella. The other parts of this altarpiece, including the central panel, which probably represented the Coronation of the Virgin or the Virgin and Christ in Glory as Rex Iustitiae (King of Justice) and Regina Misericordiae (Queen of Mercy), the right pinnacle, and the lateral panels of the predella are as yet unidentified. In Boskovits's persuasive reconstruction (Boskovits 1975, fig. 273), which may be confirmed by a physical examination of the individual panels, the altarpiece emerges as a triptych combining two different types common in Jacopo di Cione's workshop, one of them represented by an altarpiece reconstructed by Richard Offner (1960, pp. 13–17) and the other, of a more modest form, exemplified by the altarpiece for San Pier Maggiore in Florence (Davies 1988, pp. 45ff.). However, Boskovits's hypothesis concerning the provenance of the triptych from the Cappella di San Pietro at Santa Maria degli Angeli and the authorship of the various elements needs some comment.

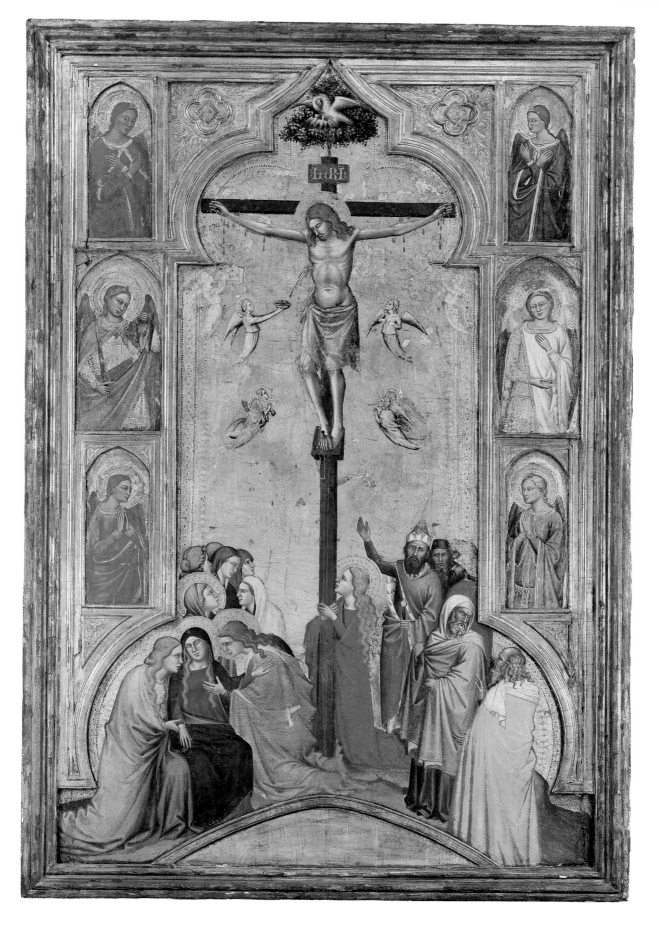

Figure 41. Don Silvestro dei Gherarducci, *Female Saints*. Greco collection, Rome

Figure 42. Don Silvestro dei Gherarducci, *Male Saints*. Musée National d'Histoire et d'Art, Luxembourg

Compared with the lateral panels carried out in a somewhat schematic style, with serried ranks of saints clearly attributable to Don Silvestro, the two gables now in London and New York, as well as the central predella panel now in Denver, all have a refined, better articulated spatial composition and a more polished painterly handling. But it would be simplistic to conclude that such stylistic divergencies were the result of two different artists working side by side. Admittedly, the Lehman *Crucifixion*, with its spatial equilibrium and its dramatic but never awkwardly distributed figures, far surpasses any of Don Silvestro's other known works and remains an exceptional episode in his career. Thus it is understandable that Offner (1981, p. 7) did not include this panel in his grouping of putative works by the Master of

the Cionesque Humility, placing it instead directly in the circle of Orcagna (Andrea di Cione; active by 1343, d. 1368) and naming its painter the Master of the Lehman Crucifixion, an attribution recently maintained by Dillian Gordon (in Davies 1988, pp. 76–78), who dismissed the idea of Don Silvestro as its author.

The composition of the Lehman panel is not based upon Sienese models, as in Don Silvestro's other early works, but rather is directly connected to Andrea Orcagna's later works. The Florentine source for this *Crucifixion* is betrayed by such details as the image of the Virgin under the cross, who, overwhelmed by grief, collapses between two figures. The frontal view of her head, tipped slightly toward the left, is a distant echo of Giotto's treatment of the subject in the Arena Chapel at

consider that even a painter as close to Orcagna as his brother Jacopo di Cione lacks a similar sensitivity for the space-creating compositional principles of his older brother. His London *Crucifixion* altarpiece, with its limp, linear arrangement of figures, differs considerably in this respect from Orcagna's compositions as well as from Don Silvestro's *Crucifixion*.

It might therefore be concluded that the Lehman *Crucifixion* and the closely related Denver and London panels are not by Don Silvestro but by someone else—an anonymous painter from Orcagna's immediate circle, perhaps. This position, however, is untenable because, analyzed in detail, the underlying structure of the figures is quite different from that of Orcagna or of any of his Florentine contemporaries. It is true that several features come from the Orcagnesque formal repertory, especially that of Orcagna's brother Nardo: the female profiles with their characteristic short pointed noses, the eyes stylized into slits, the protruding upper lips, and the pronounced cleft chin. But other features betray the Sienese-trained Don Silvestro: the delicate modeling of heads and hands, the wonderfully articulated refinement of the dead Christ, whose body is at once miniaturistic and monumental in conception, and the vibrant draftsmanship of draperies and faces. The latter emerges with particular clarity in the penetrating description of aged faces as well as in Christ's head. It is in the graceful features of Christ in both the Lehman *Crucifixion* and the London *Noli me tangere* that the painter unmistakably betrays his familiarity with Sienese painting by clearly paraphrasing from Simone Martini.

Although Don Silvestro was stylistically dependent upon the Cione brothers, especially upon Orcagna, his claim to the authorship of the *Crucifixion*, along with the stylistically related Denver and London panels, is strengthened by comparison with his somewhat later miniatures illustrating Cod. Cor. 2 (ca. 1374–75; cat. no. 16) in the Biblioteca Laurenziana, Florence. This is evident in the Denver *Man of Sorrows* and in the dead Christ in the Lehman *Crucifixion*, whose bodies have an Orcagnesque stamp in the extreme plastic articulation of their rib cages and swollen abdomens (similar to Nardo di Cione's *Man of Sorrows* in the Národni Galeri, Prague [Offner 1960, pl. VI]), and yet are modeled like the dead Christ on folio 75v of Cod. Cor. 2 (see Boskovits 1972, p. 37). Don Silvestro's slightly nervous draftsmanship, present in all three of these figures, is particularly evident in the treatment of the hair in the *Man of Sorrows*. Unlike Nardo's version of the same subject in Prague, where the hair seems heavy and massive, in Don Silvestro's three paintings its waves fall animatedly over the shoulders.

These details, minor as they may seem in deviating

Figure 43. Don Silvestro dei Gherarducci, *Noli Me Tangere*. National Gallery, London (3894)

Padua. The arrangement of the figures, with impressive rear, frontal, and three-quarter profile views, creates a convincing sense of space, which communicates tension and zeal in the same manner that Andrea Orcagna's formal concepts do, for example, in his triptych of the *Pentecost* now in the Accademia, Florence (inv. no. 165). As in Orcagna's painting, Don Silvestro here shows a tendency to articulate the single figures clearly as volumes by enveloping them in elaborate, heavy draperies. This is especially evident in the kneeling figures with their mass of folded garments extending beyond the lower legs, which increases their scale and enhances the monumental effect. In his rendering of the Lehman *Crucifixion*, Don Silvestro observed Orcagna's formal concepts with remarkable skill that is all the more surprising if we

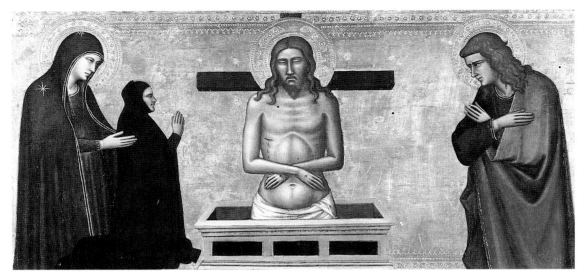

Figure 44. Don Silvestro dei Gherarducci, *Man of Sorrows*. Denver Art Museum (1961.154)

from examples by the Cione brothers, suggest that all the panels so far connected with the triptych can be attributed to Don Silvestro, notwithstanding the differences found among them. This brings us back to the problem of how the painters associated with Orcagna worked within his orbit. Don Silvestro's alliance with the Orcagna circle, established on the basis of style and technical data (such as the punches shared by these painters; see Skaug 1983), allowed him to pick up pictorial ideas that circulated freely among the group. It is even possible that participation reached a point such that a single picture might not have been painted by the same artist who planned it; in short, it may well have involved, occasionally, a separation between invention and execution. This might also be the key in explaining the artistic discrepancies within a painting such as the *Madonna of Humility* attributed to Orcagna in the National Gallery of Art, Washington, D.C. Its figure style undoubtedly reveals Jacopo di Cione's hand; compositional subtleties never seen in Jacopo's oeuvre, however, are characteristic of Orcagna himself. The same seems to be true of Don Silvestro's magnificent painting of the same subject in the Accademia (inv. no. 3161), which again reveals Orcagna's model but translates it into the tooled splendor of Simone Martini's nostalgic Sienese followers of the third quarter of the fourteenth century.

If Don Silvestro's altarpiece had been partially designed by Orcagna, it might be argued that it was painted at an earlier date than envisioned by Boskovits. Boskovits linked the triptych with the altarpiece in the Cappella di San Pietro (consecrated in 1372) in Santa Maria degli Angeli, Florence, mainly on the basis of the stylistic relationship of the lateral panels with the

illuminations in Cod. Cor. 2 in the Biblioteca Laurenziana, which were painted in the first half of the 1370s, and the fact that Saint Peter figures in the foreground of the right wing. However, Saint Peter's prominent position among a larger group of saints is hardly unusual in the context of the altarpiece. As Prince of the Apostles and head of the heavenly court, he would merit a dominating position in an altarpiece whose missing central panel probably contained the Virgin and Christ in Glory or the Coronation of the Virgin. Saint Peter's appearance in the right lateral panel is therefore not a sufficient reason to assume that it came from the chapel dedicated to him. It seems likely that the Metropolitan Museum's altarpiece was instead painted in the years immediately before Orcagna's death in 1368. This is a period when the Cione brothers—especially Nardo—were repeatedly involved with artistic commissions for the Camaldolese monastery in Florence.

It might well be that the artistic *compagnia* of Nardo di Cione, which in the years around 1365 produced many large altarpieces for Santa Maria degli Angeli (Gordon, in Davies 1988, pp. 90–91), could not cope with all the commissions and that other painters were hired to collaborate. In 1365 alone, Nardo di Cione and his assistants finished two altarpieces, one for the Cappella di San Giobbe and one for the Cappella di San Romualdo. The previous year Giovanni del Biondo, who is said to have collaborated with the Cione brothers in this period, produced another large triptych, which was placed in the chapel of Saint John the Baptist. In these same years two further chapels are known to have been furnished with altarpieces, the chapels dedicated to Saint Anthony (1364) and to All Saints (1365). The latter was financed with

funds from a rich Florentine *notaio*, Ser Francesco di Ser Berto degli Albizzi.[1]

Neither of these altarpieces has as yet been securely identified. But if we consider the probable date of the reassembled triptych by Don Silvestro and that it included in its main register two choirs of saints, iconography appropriate for a chapel dedicated to All Saints, we are tempted to identify it as the one in this very chapel. An indication that the reconstructed altarpiece may indeed have come from the church of Santa Maria degli Angeli is the fact that its finest element, the Lehman *Crucifixion*, once belonged to William Young Ottley, who could have acquired it when he bought the illuminations cut from Cod. Cor. 2 (cat. no. 16).

GF

1. ASF, Conventi Soppressi, 86, 95, fol. 30v (1365):

> Memoria fra noi e a chi succedera dopo di noi che Ser francieschino di Ser Berto notaro da San Miniato del tedesco il quale dimorava in Firenze nella via larga popolo S. Lorenzo lascio a noi la terza parte della sua reditade e l'altra terza parte alla compagnia della misericordia e l'altra terza parte alla compagnia d'orto San Michele. Testamento fatto per mano di Ser Tino notaio della detta compagnia della misericordia della quale reditade noi avemmo in tutto della detta compagnia della misericordia fiorini 194 d'oro e soldi. E cosi gli confessiamo per mano del detto Ser Tino di [Ser Attaviano].

> E quali denari noi ne fornimo la cappella dell'enfermeria nostra per rimedio dell'anima del detto Ser Franceschino e ponemo nome alla detta cappella per lo di della festa di tutti santi. Il quale fornimento costo.

> La tavola dell'altare fiorini 76 d'oro per lo legname e dipintura e lo rimanente costo il calice, e messale e pianete e altre cose che ssi richiede a fornimento dell altare e paramento da prete. et gli detti danari distribuimo nel detto fornimento e cappella e parola e volonta delle dette compagnie. Et tutta la detta cappella d'ogni bene che in essa si fara atribuimo e cosi ordinamo che sieno a fructo e rimedio dell anima del detto Ser Franceschino per li predetti denari avuti per lo detto suo testamento. Et anche per anima di certe persone che ci avevamo fatti alcuni altari in quali ce convenuti disfare per fare alcuni nostri lavori per nostri aconcimi che cerano necessarii.

ASF, Conventi Soppressi, 86, 96, fol. 16v; see as well ibid., fol. 117:

> Ser Francesco di Ser Berto [*sic*] degli Albizzi di Sanminiato fece suo testamento di del mese . . . per Ser Tino di Ser Attaviano nel quale ci fece reda per un terzo e avemone solo fior 194 per quali danari noi ne fornimo la cappella d ogni sancti e attribuimo che d ogni bene che si fa nella decta cappella sia affrutto e remedio del anima sua. Et anchora per l anima de certe altre persone che ci avevano fatto alcuno altare in casa con le quali ci convenne disfare per certo nostro acconcime e dicio aparisse ancora inanzi a carta 117.

Gradual (Sanctorale) from Santa Maria degli Angeli

(Catalogue Number 16a–j)

Among the various choir books that Don Silvestro illuminated for his monastery, Santa Maria degli Angeli, one, Cod. Cor. 2, now in the Biblioteca Laurenziana, Florence, clearly stands out for its high artistic quality as well as for the fact that it is the only one bearing a date. However, the date 1370 (1371, according to the modern calendar), found on folios 161v and 207r, does not necessarily refer to the illuminations. The somewhat awkwardly formulated passage on folio 207r—"This book was completed on the twenty-sixth day of February 1371 [modern reckoning] in the monastery of Santa Maria degli Angeli in Florence, which owns it. We thank our Lord, amen. I hand this book over to the reader, who may pass it on to the illuminator. Christ reigns with his word, and after our death we will rejoice in him"[1]—

suggests that the date refers to the completion of the writing only. The scribe responsible for writing the liturgical text, having finished his work on the date mentioned, handed the book over to the illuminator who was to paint the Lombard and filigree initials. It was only at a later stage that the miniaturist could have filled the blank fields of the ornamented initial letters with narrative scenes or figures of saints. New documentary and stylistic evidence confirms this interpretation.

From an unpublished document written in 1375 we learn that to honor his father a certain Fra Leonardo of Santa Maria degli Angeli left a considerable sum of money to his monastery.[2] Among the donations recorded in this document, 100 florins were spent on the monastery's new choir books. This respectable sum was

Figure 45. Don Silvestro dei Gherarducci, Saint Stephen Enthroned in an initial E. Private collection, England

undoubtedly used for a new gradual and not for the later series of antiphonaries, which were not begun until 1385 (Levi D'Ancona 1979, pp. 463–64; idem 1985, p. 454).

The gradual was part of the project for a new choir for Santa Maria degli Angeli, commenced in the early 1370s and completed by the end of 1374.³ This is confirmed by the fact that mentioned in the same context as the gradual were further sums of money contributed by Fra Leonardo for a new lectern—"lo leggiò di chiesa, dove si chanta"—and for a white cloth dossal for the high altar (see n. 2). Moreover, many other important donations in 1372 were used to finance the decoration of the new choir. It is therefore not unreasonable to assume that the new gradual was produced at this time. In keeping with a completion date of the end of 1374 for the choir, most of the gradual's illuminations reflect Don Silvestro's style of about 1370. However, a few initials, both among those still in the original choir book and those cut out from it, are closer to Don Silvestro's later style.⁴ There is there-fore good reason to believe that the initials were probably already drawn but not completed by the time of the con-secration of the new choir and that they were finished at a later date.

As were most of the Santa Maria degli Angeli choir books, which entered the Biblioteca Laurenziana on August 29, 1809,⁵ Cod. Cor. 2 was mutilated in the Napoleonic period. Twenty pages—many of them among the most important and most beautiful—were cut from this gradual and found their way into the collection of William Young Ottley, first keeper of the Department of Prints at the British Museum and an avid collector of prints, illuminated initials, and gold-ground paintings.

Figure 46. Don Silvestro dei Gherarducci, The Four Evangelists in an initial I. Museu Calouste Gulbenkian, Lisbon

No fewer than twelve of the twenty miniatures cut from Cod. Cor. 2 are known to have belonged to Ottley, which could indicate that he bought all the missing pages as a body shortly before 1800 (see Sartain 1900, p. 98). Some of the initials cut from Cod. Cor. 2 were sold during Ottley's lifetime, such as that now in the Walker Art Gallery, Liverpool, which was acquired from Ottley by William Roscoe, who in turn sold it as early as 1816 (Roscoe sale 1816, lot 10), and some were sold after his death (Ottley sale 1838). With one exception, they can now all be found in various private collections and museums in Europe and America.

The reconstruction of Cod. Cor. 2, which was begun by Mirella Levi D'Ancona (1978), may be corrected and completed based on an examination of the liturgy of the

mutilated gradual. This task is facilitated by an index preserved on folio 173r, which discloses the beginning of the introit for each Mass included in the volume and its corresponding page number. The thirty-eight present and missing illuminations in Cod. Cor. 2 are as follows:

Folio 1r: The Consecration of a Church by a Bishop with Two Deacons in an initial T ("Terribilis est locus iste" [Awesome is this place]), introit to the Mass for the commons of the dedication of a church.

Folio 6v: Saint Nicholas of Bari in an initial S ("Statuit ei dominus testamentum pacis" [The Lord established a covenant of peace with him]), introit to the Mass for the feast of Saint Nicholas (December 6).

Folio 9v: Saint Lucy in an initial D ("Dilexisti iustitiam et odistis iniquitatem" [You loved justice and hated wickedness]), introit to the Mass for the feast of Saint Lucy (December 13).

[Folio 15]: Saint Stephen Enthroned in an initial E ("Et enim sederunt principes et adversum me loquebantur" [And princes met and spoke against me]), introit to the Mass for the feast of Saint Stephen (December 26); private collection, England (fig. 45).

[Folio 18]: The Four Evangelists in an initial I ("In medio ecclesiae" [In the gathering of the Church]), introit to the Mass for the feast of Saint John the Evangelist (December 27); Museu Calouste Gulbenkian, Lisbon (inv. no. M34; fig. 46).

Folio 20v: The Adoration of the Lamb by the Holy Innocents in an initial E ("Ex ore infantium deus et lactantium perfecisti laudem" [Out of the mouths of babes and sucklings, O God, you have fashioned praise]), introit to the Mass for the feast of the Holy Innocents (December 28).

[Folio 23]: Saint Silvester in an initial S ("Sacerdotes tui, Domine, induant iustitiam" [Let your priests be clothed with justice, O Lord]), introit to the Mass for the feast of Saint Silvester (December 31); Nationalmuseum, Stockholm (N.M.B. 1797; fig. 47).[6]

Folio 26v: Saint Maurus in an initial I ("In virtute tua domine, laetabitur justus" [The just man rejoices in your strength, O Lord]), introit to the Mass for the feast of Saint Maurus Abbot (January 15).

Folio 29v: Saints Fabian and Sebastian in an initial I ("Intret in conspectu tuo, Domine, gemitus compeditorum" [Let the sighs of the imprisoned

Figure 47. Don Silvestro dei Gherarducci, Saint Silvester in an initial S. Nationalmuseum, Stockholm

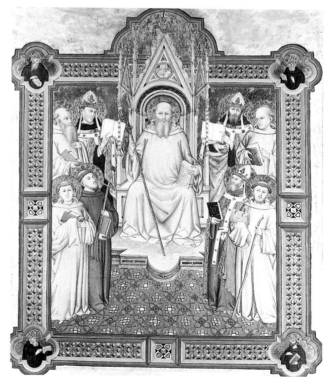

Figure 48. Don Silvestro dei Gherarducci, Saint Benedict Enthroned with Eight Saints. Museu Calouste Gulbenkian, Lisbon

come before you, O Lord]), introit to the Mass for the feast of Saints Fabian and Sebastian (January 20).

[Folio 32]: Saint Agnes in an initial M ("Me exspectaverunt peccatores" [The wicked have lain in wait]), introit to the Mass for the feast of Saint Agnes (January 21); Bibliothèque Publique et Universitaire, Geneva (cat. no. 16a).

Folio 34r: Saint Vincent in an initial L ("Letabitur iustus in Domino" [The just man rejoices in the Lord]), introit to the Mass for the feast of Saint Vincent (January 22).

Folio 37v: Saint Paul in an initial S ("Scio cui credidi et certus sum" [I know whom I have believed, and I am certain]), introit to the Mass for the feast of the Conversion of Saint Paul (January 25).

[Folio 42]: The Presentation in the Temple in an initial S ("Suscepimus Deus, misericordiam tuam in medio templi tui" [We have received your kindness, O Lord, within your temple]), introit to the Mass for the feast of the Purification of the Virgin (February 2); Fitzwilliam Museum, Cambridge (Marlay Cutting It. 13A; cat. no. 16b).

Folio 46r: Saint Agatha in an initial G ("Gaudeamus omnes in Domino" [Let us all rejoice in the Lord]), introit to the Mass for the feast of Saint Agatha (February 5).

[Folio 49]: Saint Scholastica in an initial V ("Vultum tuum deprecabuntur omnes divites plebis" [All the rich among the people seek your favor]), introit to the Mass for the feast of Saint Scholastica (February 10); this is the only initial missing from Cod. Cor. 2 that has not yet been identified.[7]

[Folio 56]: Saint Benedict Enthroned with Eight Saints (probably Romuald, Celestine V, Gregory the Great, Maurus, Bernard of Clairvaux, Leo IV, John Gualbert, and Placidus), introducing the liturgy for the feast of Saint Benedict (March 21); Museu Calouste Gulbenkian, Lisbon (inv. no. M35; fig. 48).

[Folio 60]: The Annunciation in an initial R ("Rorate caeli desuper" [Drop down dew, you heavens, from above]), introit to the Mass for the feast of the Annunciation (March 25); British Library, London (Add. MS 35,254 C; cat. no. 16c).

Folio 68v: Saint Mark in an initial P ("Protexisti me deus" [You have protected me, O God]), introit to the Mass for the feast of Saint Mark (April 25).

Folio 72r: Saints Philip and James in an initial E ("Exclamaverunt ad te Domine" [They cried to you, O Lord]), introit to the Mass for the feast of Saints Philip and James (May 3, according to the Camaldolese calendar).

Figure 49. Don Silvestro dei Gherarducci, The Birth of Saint John the Baptist. Walker Art Gallery, Liverpool

Folio 75v: The Man of Sorrows in an initial N ("Nos autem gloriari" [But it is fitting that we should glory]), introit to the Mass for the feast of the Invention of the Holy Cross (May 3).

[Folio 80]: Saint Michael Fighting the Dragon in an initial B ("Benedicite dominum omnes angeli eius" [Bless the Lord, all you his angels]), introit to the Mass for the feast of the Apparition of Saint Michael (May 8); Abegg-Stiftung, Riggisberg.

[Folio 90]: Saint Romuald Enthroned with Four Saints in an initial O ("Os justi meditabitur sapientiam" [The mouth of the just man utters wisdom]), introit to the Mass for the feast of Saint Romuald (June 19, according to the Camaldolese calendar); British Library, London (Add. MS 37,472, fol. 3; cat. no. 16d).

Folio 94r: Saints Gervase and Protase in an initial L ("Loquetur dominus pacem in plebem suam" [The Lord speaks peace to his people]), introit to the Mass for the feast of Saints Gervase and Protase (June 19).

[Folio 97]: The Birth of the Baptist in an initial D ("De ventre matris meae" [From my mother's womb]), introit to the Mass for the feast of the Nativity of Saint John the Baptist (June 24); Walker Art Gallery, Liverpool (inv. no. 2764; fig. 49).

[Folio 104]: Saints Peter and Paul in an initial N ("Nunc scio vere" [Now I know for certain]), introit to the Mass for the feast of Saints Peter and Paul (June 29); private collection, England.[8]

Folio 110r: Saints Peter and Paul in an initial S ("Sapientiam sanctorum narrent populi" [Let the people show forth the wisdom of the saints]), introit

to the Mass for the octave of the feast of Saints Peter and Paul (July 6).

[Folio 113]: Saint Margaret, Adored by a Camaldolese Nun, Emerging from the Mouth of a Dragon in an initial L ("Loquebar de testimonis tuis" [I spoke of your testimonies]), introit to the Mass for the feast of Saint Margaret (July 20); private collection, Milan (fig. 50).⁹

Folio 117V: Saint Mary Magdalen in an initial G ("Gaudeamus omnes" [Let us all rejoice]), introit to the Mass for the feast of Saints Benedict, Romuald, and Mary Magdalen (July 22).

[Folio 119]: Saints James and Andrew(?) in an initial M ("Michi autem nimis honorati sunt amici tui, Deus" [Your friends are greatly honored by me, O Lord]), introit to the Mass for the feast of Saint James the Greater (July 25); Nelson-Atkins Museum of Art, Kansas City (F61–14; figs. 51, 52).

Folio 129V: Pope Saint Sixtus II in an initial S ("Sacerdotes dei benedicite Dominum" [You priests of the Lord, bless the Lord]), introit to the Mass for the feast of Saints Sixtus, Felicissimus, and Agapitus (August 6).

[Folio 134]: Saint Lawrence in an initial C ("Confessio et pulchritudo in conspectu ejus" [Praise and beauty go before him]), introit to the Mass for the feast of Saint Lawrence (August 10); Walters Art Gallery, Baltimore (W 416; cat. no. 16e).

[Folio 137]: The Virgin and Child in an initial S ("Salve sancta parens" [Hail, Holy Mother]), introit to the Mass for the vigil of the Assumption (August 14); The Cleveland Museum of Art (acc. no. 24.1012; cat. no. 16f).

[Folio 142]: The Death and Assumption of the Virgin, introducing the liturgy for the feast of the Assumption (August 15); British Library, London (Add. MS 37,955 A; cat. no. 16g).

[Folio 148]: The Birth of the Virgin in an initial G ("Gaudeamus omnes" [Let us all rejoice]), introit to the Mass for the feast of the Birth of the Virgin (September 8); The Metropolitan Museum of Art (acc. no. 21.168; cat. no. 16h).

Folio 153V: Saint Minias in an initial I ("Iusti epulentur et exultent in conspectu dei" [Let the just feast and rejoice before God]), introit to the Mass for the feast of Saint Minias and companions (October 25).

[Folio 155V]: The Virgin and Christ in Glory Surrounded by Saints and Angels in an initial G ("Gaudeamus omnes" [Let us all rejoice]), introit to the Mass for the commemoration of All Saints (November 1); The Cleveland Museum of Art (acc. no. 30.105; cat. no. 16i).

[Folio 159]: Pope Saint Clement in an initial D ("Dicit dominus sermones mei" [The Lord said, "My words"]), introit to the Mass for the feast of Saint Clement (November 23); Fitzwilliam Museum, Cambridge (MS 5–1979; cat. no. 16j).

Folio 165V: A Skeleton in a Sarcophagus in an initial R "Requiem aeternam dona eis" [Grant them eternal rest]), introit to the Mass for the Dead.

Compared with Don Silvestro's earlier panels from the Ognissanti altarpiece (see cat. no. 15), the miniatures painted after 1371 for Cod. Cor. 2 show an artistic maturity characterized by spontaneity and a greater freedom of design and handling. Perhaps the artist was less restrained in this medium than in panel painting since the choir books' use was restricted to his own monastery church, while an altarpiece might have encountered such limitations as a donor's insistence upon particular Florentine pictorial conventions. Furthermore, it can be assumed that Don Silvestro executed the miniatures for Cod. Cor. 2 entirely on his own outside the Orcagnesque associations that prevailed during his work on the Ognissanti altarpiece. Although Orcagnesque figure types (particularly those derived from Nardo di Cione) are still to be found among the illuminations, all

Figure 50. Don Silvestro dei Gherarducci, Saint Margaret, Adored by a Camaldolese Nun, Emerging from the Mouth of a Dragon in an initial L. Private collection, Milan

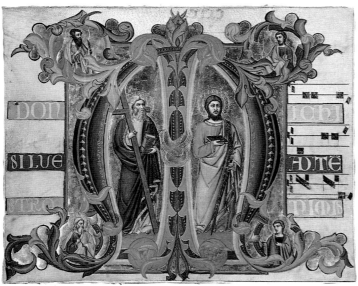

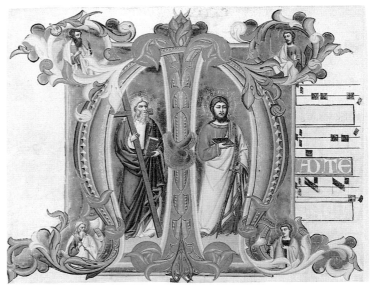

Figure 51. Don Silvestro dei Gherarducci, Saints James and Andrew(?) in an initial M. The Nelson-Atkins Museum of Art, Kansas City; Purchase acquired through the bequest of Ida C. Robinson (F61-14). Before conservation

Figure 52. Don Silvestro dei Gherarducci, Saints James and Andrew(?) in an initial M. After conservation

the forms are adapted and refined into Don Silvestro's version of the Sienese Gothic style filtered through Simone Martini. The strong Orcagnesque physiognomies, with their harsh light and dark modeling, encountered throughout the panels of the Ognissanti altarpiece, now become subdued and polished through gradated tones and meticulous yet generous drawing, giving the faces an expression of quiet introspection. The earlier somewhat angular articulation of the figures has likewise given way to a calmer, quiet monumentality filled with an inner joyousness. In the narration of sacred events as well as in the representation of individual figures, a celebratory quality has emerged. This is felt primarily in the courtly elegance of the draperies, the balanced yet festive color sequences, and the pronounced sensitivity to materials and decoration, all of which develop within a spatially well-articulated pictorial arrangement.

Despite their small format Don Silvestro's illuminations were monumentally conceived. His saints completely fill and almost burst forth from the space created by the framing initials, rather in contrast to the compositions of Don Simone Camaldolese (cat. nos. 20a, 21–25), who gave greater freedom of movement to the figures within their initials. Don Silvestro's pictorial concept of integrating figures and scenes into the initials is, as Miklós Boskovits (1975, p. 68) acutely observed, typical of an artist trained as a panel painter who here tackles the problems of an illuminator for the first time, albeit with highly successful results. In fact, the busts of saints in several of the initials (cat. nos. 16e, 16j) would, if enlarged, be just as effective on a polyptych panel or in

a fresco cycle, such as Biagio di Goro Ghezzi's trefoiled saints painted on the arch of the choir at Paganico (Freuler 1986, figs. 17, 19–21, 23, 26). In Don Silvestro's miniatures the painted architecture and the ornamented initial hardly relate to each other; each seems almost self-sufficient, and in some cases (cat. nos. 16c, 16g; fig. 48) even the initial itself is subordinated to the cosmatesque pattern of a painted outer frame, which makes the illumination appear like a small-scale fresco. Unlike his Sienese contemporary Lippo Vanni, whose initials are conceived as plastic entities to which both figures and composition relate, Don Silvestro renders the letters as the frontal limit of an autonomous space. In Vanni's miniatures the letter is often understood either as having a material density sufficient for a reclining figure to support itself upon or as a point of departure for painted architecture. In addition, the initial's form is imbued with a rhythm to which the figures are subordinated (see Siena 1982, p. 267). For Don Silvestro color is the primary means of unifying the letter's ornament with the imagery; usually the subtle color sequences of the saints and scenes echo those of the initial. These characteristics of Don Silvestro's illuminations are easily understood in the light of a style that subscribed to linear dynamism, precious materials, and gold—in brief, to an art of courtly elegance.

Considering that the choir books' use was restricted to the monastery of Santa Maria degli Angeli and only at best might have been lent out as a model for the decoration of other such volumes, it hardly seems realistic to propose that Don Silvestro's gradual, though one of

the richest examples of Florentine and even of Italian book illumination in the third quarter of the fourteenth century, had a decisive role in the development of contemporary painting in Florence. Yet Don Silvestro's tendencies toward a refined, lyrical Gothic style may not have been lost from view to other Florentine artists as long as he was still active as a painter of altarpieces.

<div align="right">GF</div>

1. COMPLETUS EST LIBER ISTE ANNO DOMINI MCCCLXX. VII KALENDAS FEBRUARIAS. IN LOCO SANCTE MARIE DE ANGELIS DE FLORENTIA CUIUS LIBER EST ISTE. DEO GRATIAS, AMEN MANDO EGO LECTORI UT DET SCRIPTORI CHRISTUM REGET ORE SED POST MORTEM GAUDIA CH[RISTI].

2. ASF, Conventi Soppressi, 86, 96, fol. 122v:

> Di quello che avemmo di frate Leonardo e dello anniversario del padre [added by another hand] Maso di Feo Maffei. Memoria ch' egli è vera chosa che ci sono rimasi della ragione de' danari che abbiamo avuti di que' de frate Lionardo nostro monaco . . . fiorini trecentoquarantadue d'oro, i quali abiamo dispensati e spesi come dicemmo appresso. Pagamone per uno dossale di drappo bianco dall'altare maggiore e per cinque pianete e cinque fregi, costarono in tutto fior LXIIII d'oro. Item ne spendemmo in certi lavori della nostra chiesa f. L. Item ne spendemmo per lo leggiò di chiesa, dove si chanta. f. XL. Item ne togliemmo per gli antifonari nostri f. C. Item mettemone entrata a di XXXI di dicembre 1375, a carte 49 f. LXXXVIII. Somma in tutto f. CCCXLII d'oro.

In medieval Camaldolese terminology both graduals and antiphonaries were called *antifonari*, as can be seen in the inventory of the library in Camaldoli drawn up in 1406. This inventory has been dismembered, and its various parts are to be found in different libraries. Number 15 of the inventory—this section is in the British Museum (MS Egerton 3036)—cites: "Item unum Antiphanare diurnum dominichale quod incipit: ad te levavi, et fini: pulsanti aperietur. . . ." The liturgical text "ad te levavi," with which the choir book begins, clearly reveals that the "Antiphanare" was a gradual, since this text is the introit for the first Sunday of Advent. See also Catalogue Number 25.

3. Various donations in the early 1370s went toward financing the new choir in Santa Maria degli Angeli:

> Antonio di Sancti, del popolo di San Lorenzo di Firenze, ci diede nell'Anno 1373 fiorini cinquecento d'oro per lo lavorio del nostro coro della nostra chiesa per l'anima sua e de' suoi vivi e morti. I quali denari spendemmo per fare il detto choro, siccome appare al quaderno de' lavori. Cominciamovi a dire l'uficio adì XXV di dicembre 1374. Item a dì XXV di dicembre 1377 ci diede il decto Antonio per fare uno leggio grande di choro e delle figure che sono ne' canti del predetto choro cioè dall' uno canto la Nostra Donna e dall'Altro l'agnolo, fiorini cinquanta d'oro. Morì il detto Antonio di luglio 1417 e avea facto il testamento adì 22 di dicembre 1415 per ser Davanzato Iacopi, il quale abiamo compiuto, ove lascia lire 12 ogni anno in perpetuo per uno officio o pietanza per l' anima sua. Abbiamo preso a fare il

di d'Ognissanti come egli cominciòe a sua vita. (ASF, Conventi Soppressi, 86, 96, fol. 122)

> Anthonio di Santi di Firenze, del popolo di San Lorenzo, ci diede nell'anno MCCCLXXIII fiorini cinquecento d'oro per lo lavorio del nostro coro della nostra chiesa, per sua anima e de' suoi vivi e morti. I quali danari spendemmo per fare il detto coro, sicome appare al quaderno de' lavori, a carte XXXV. Cominciamovi a dire l'uficio adì XXV di dicembre MCCCLXXIIII. Item, che a dì . . . di dicenbre MCCCLXXVII ci diè il detto Antonio per aiuto de' Leggio grande di coro e delle figure che sono ne' canti del predetto coro, cioè dall'uno canto la Nostra donna e dal' altro l'Agnolo fiorini cinquanta d'oro. (ASF, Conventi Soppressi 86, 95, fol. 35)

Records of further important donations toward the new choir include:

> Nel 1372 si crebbe la chiesa e avemmo aiuto da Tellino Dini fior 500, da Don Niccolò degli Albizzi, inanzi fosse nostro frate fior C da bando Corsi f.cc, da messer Bartolomeo Benini f. CC e da Bindo Benini f. C, da Galasso da Uzano per testamento f L da Michele di Vanni castellani f XXX, dal Comandatore di Sancto Antonio f C. E avevamo da Antonio di Santi per lo coro f 500 et per lo leggio grande e figure di sopra il coro f. L. Et avevammo da Bernardo di Cino per lo ciborio che è sopra l'altare maggiore et per le graticole di ferro di S. Michele f CCCC d'oro. (ASF, Conventi Soppressi, 86, 96, fol. 13v)

> Bernardo di Cino Bartolini di Firenze, del popolo di Sancta Maria sopra Porto, ci diede fiorini quatrocento d'oro per lo lavorio del tabernacolo di sopra l'altare maggiore della nostra chiesa e delle graticole del ferro del ferro [sic] della decta chiesa, per sua anima e di tucti suoi vivi e morti. I quali danari noi spendemo nelle predecte cose, sicome appare al quaderno de'lavori, a carte XXXVI. Furono conpiute del mese d'agosto, anno MCCCLXXV. (ASF, Conventi Soppressi, 86, 95, fol. 35)

4. Seven illuminations appear to have been executed at a somewhat later date: the Adoration of the Lamb, still in Cod. Cor. 2 (fol. 20v); Saint Stephen, private collection, England (fig. 45); the Presentation in the Temple, Fitzwilliam Museum, Cambridge (cat. no. 16b); Saint Michael Fighting the Dragon, Abegg-Stiftung, Riggisberg; the Birth of Saint John the Baptist, Walker Art Gallery, Liverpool (fig. 49); the Virgin and Christ in Glory, The Cleveland Museum of Art (cat. no. 16i); and the Death and Assumption of the Virgin, British Library, London (cat. no. 16g). A number of the choir books from Santa Maria degli Angeli were left incomplete and were finished at a later date. This is true, for instance, of Cod. Cor. 3, which bears the date 1409 and contains miniatures by Lorenzo Monaco, as well as others of a considerably later date by Battista di Biagio Sanguigni (cat. no. 37).

5. Cod. Cor. 2 is mentioned in the inventory of the "Catalogo dei Manoscritti scelti nelle Biblioteche Monastiche del Dipartimento dell'Arno dalla Commissione degli Oggetti d'Artisti e Scienze, e della Medesima Commissione rilasciati alla Pubblica Libreria Laurenziana (l'anno 1809)" (see ASF,

"Cataloghi di Codici manoscritti," 1809, vol. 3). The various manuscripts—among them the choir books of Santa Maria degli Angeli—cited in this inventory are in numerical order, and at the foot of the last page after the last item is: "Io infrascritto Francesco del Furia Bibliotecaris ho ricevuto in deposito i sudetti libri questo di 29 Agosto 1809."

6. The index on folio 173r, as well as numerous cross-references throughout Cod. Cor. 2, identifies the text missing on folio 23 as "Sacerdotes tui," not "Ecce sacerdos magnus," as supposed by Levi D'Ancona (1978, p. 221), who assumed the missing folio contained the Mass for Saint Thomas Becket (December 29). The Stockholm Saint Silvester was erroneously associated by Levi D'Ancona (1993, p. 26) with volume 1 of the gradual from San Michele a Murano (cat. no. 17), but its provenance from the Ottley collection and its rubricated cross-references (above the initial) to the introit "Laetabitur iustus" still present on folio 34 of Cod. Cor. 2 demonstrate its relation to the latter.

7. The text for the missing folio is established by the index on folio 173r. Levi D'Ancona (1978, p. 221) incorrectly supposed the initial to represent Saint Blaise and the text "Sacerdotes Dei."

8. Russell 1977, fig. 480. Levi D'Ancona (1978, p. 224) identified the subject of this initial as Saints John and Paul (June 26), since Cod. Cor. 2 already contains an image of Saints Peter and Paul. The attributes and types of the two saints, the initial beginning the introit to the Mass for their feast, and the rubric for the vigil of Saints Peter and Paul (June 28) appearing on folio 102r leave their identity in no doubt, however.

9. Levi D'Ancona (1978, p. 223) supposed the missing folio 113 to represent the Translation of Saint Benedict, following a partial rubric visible at the foot of folio 112v. The index to Cod. Cor. 2, however, specifies the introit to the Mass for a Virgin Martyr, "Loquebar. . . ." The nun kneeling in adoration of the saint in the left margin of the initial may be meant to portray the Blessed Paola, abbess of Santa Margherita at Cafaggiolo, who at her death in 1368 willed all the properties of her monastery to the community at Santa Maria degli Angeli (Tantini 1864).

16a. Saint Agnes in an Initial M

Tempera and gold leaf on parchment
7 7/16 × 6 7/8 in. (18.9 × 17.4 cm)

Bibliothèque Publique et Universitaire, Geneva; Fonds Comités Latentes

The initial M is painted in orange, red, and yellow, with blue and green foliation against a gold ground. It encloses a half-length figure of Saint Agnes wearing a richly tooled golden dress and wrapped in a light blue cloak. With both hands she holds a sheep, which is her attribute. The blue ground within the initial bears a magnificent floral decoration.

The initial M begins the introit to the Mass for the feast of Saint Agnes on January 21. On the back of the cutting are the last letters, [x]xxii, of the missing folio 32 and fragments of the offertory and Communion hymns for the previous feast day, that of Saints Fabian and Sebastian on January 20: "[Et gloriamini omnes] recti corde; Communio: . . . Multitudo [languentium et qui vexabantur]" (Shout for joy, all you upright of heart. Communio[n]: A multitude of sick and those who were troubled). This initial M, therefore, appeared on the verso of folio 32 from Cod. Cor. 2.

Unlike most of the other single figures of saints in or removed from Cod. Cor. 2, who seem to completely fill and almost burst forth from the space created by the letter, the saint here is more diminutive. This is undoubtedly owing to the fact that she was conceived as defining the central element of the letter M, which is visible only at the top. The figure type recalls that of Saint Agnes in the panel from the Ognissanti altarpiece (fig. 41), especially in the way she holds the lamb. Her general appearance is, however, more refined and more serene. Of extraordinary effect is Don Silvestro's rendering of the precious gold tooling on the saint's dress, which seems to be a further tribute to Sienese panel painting and once again demonstrates his familiarity with the Sienese tradition.

GF

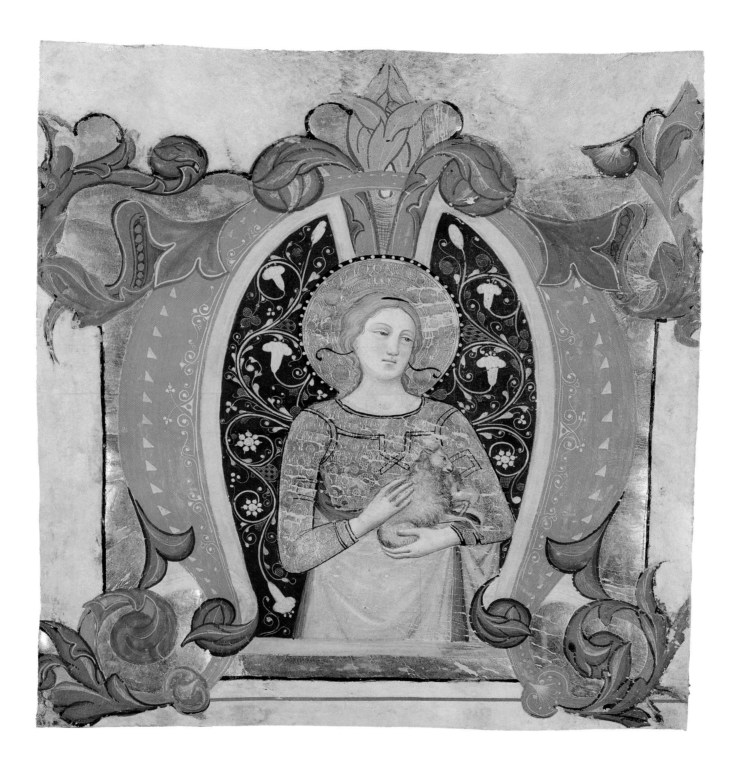

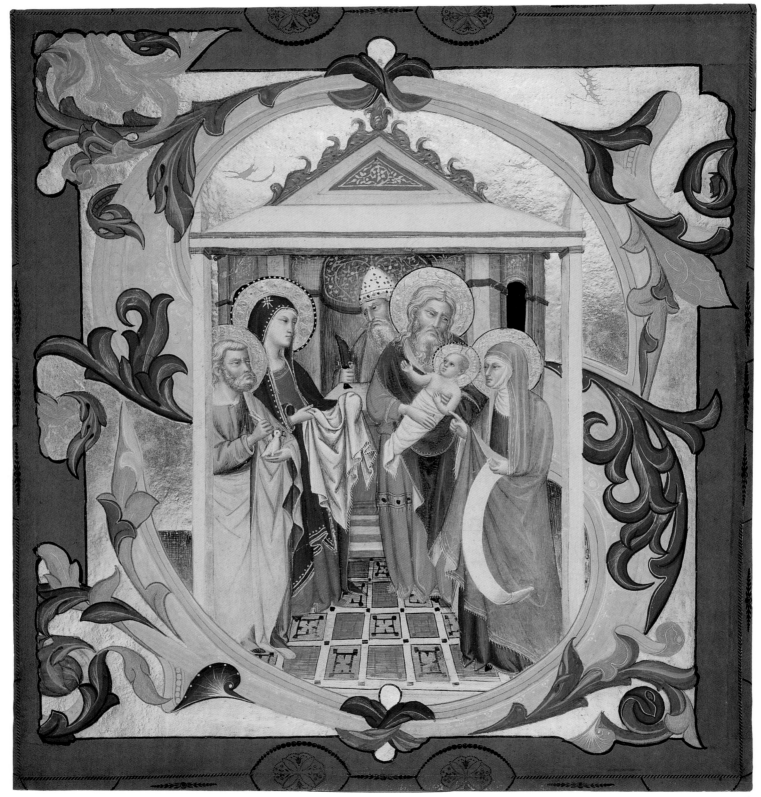

16b

16b. The Presentation in the Temple in an Initial S

Tempera and gold leaf on parchment
11 ¹³/₁₆ × 10 ⁵/₈ in. (30 × 27 cm)

Fitzwilliam Museum, Cambridge (Marlay Cutting It. 13ᴬ)

The sacred ceremony of Christ's Presentation in the Temple is visualized here with disarming spontaneity and simplicity. The scene is situated in a temple of a somewhat bizarre shape, which at the same time serves as a spatial backdrop. The Virgin, with a cloth in her hands, and her worldly spouse, Joseph, next to her quietly observe the prophecy of Hannah, who has raised her right hand in a gesture of allocution. Simeon, with the little Savior in his arm, listens to her words, while behind the altar the high priest holds the instrument of Christ's circumcision.

The initial S begins the introit to the Mass for the feast of the Purification of the Virgin (February 2) and was originally on folio 42 of Cod. Cor. 2 from Santa Maria degli Angeli (Levi D'Ancona 1957, 1978).

Don Silvestro's Presentation in the Temple clearly paraphrases Ambrogio Lorenzetti's panel—now in the Uffizi—for the Crescentius Chapel in Siena cathedral (see van Os 1984, vol. 1, p. 78, fig. 90). However, the simple rendering of the architecture, which shares little with Ambrogio Lorenzetti's superb three-dimensional experiments, and its abstract style are more in the spirit of such later Sienese painters as Bartolo di Fredi (Musée du Louvre, Paris, MI 394; see Freuler 1994, fig. 237) and Niccolò di Buonaccorso. With the latter he shares the strategy of moving the figures to the side in order to carefully define pictorial space through the motif of the floor tiles seen in foreshortened perspective (Boskovits 1975, p. 115).

GF

Ex coll.: Francis Douce (1757–1834); Sir Samuel Rush Meyrick (1783–1848); Charles Brinsley Marlay (by 1886; until 1912).

Literature: London 1886, p. 3, no. 6; Levi D'Ancona 1957, pp. 18–19; Boskovits 1975, pp. 114, 216 n. 86, 421; Levi D'Ancona 1978, p. 221; Wormald and Giles 1982, p. 110; London 1983, p. 65, no. 45; Freuler n.d.

16c. The Annunciation in an Initial R

Tempera and gold leaf on parchment
13 ³/₈ × 11 ³/₈ in. (34 × 29 cm)

British Library, London (Add. MS 35, 254 C)

Under the portico of a fanciful architectural form resembling a palace, the angel Gabriel, still hovering in the air, addresses the Virgin Mary, bringing her the good news of her maternity of the Savior. While she intently listens to the heavenly messenger, God's word takes flesh, symbolized by the descending dove and the golden rays emanating from God's mouth. At the top and center of the outer frame, there is a cropped scroll with the inscription *Ecce propheta mag[nus] surget i[n] medio vestrum* (Behold a great prophet will rise among you). This banderole was undoubtedly held by a bust-length prophet testifying to the coming of the Lord. Six bust-length prophets with banderoles in the Nationalmuseum, Stockholm (B 1797; fig. 53), and two others now missing must have been cut from this initial. Their position around the miniature is suggested by their gestures and the direction of their faces. That they originally belonged to a page of Cod. Cor. 2 and not to another choir book, as was recently hypothesized by Mirella Levi D'Ancona (1993), is suggested not only by their stylistic and thematic relation to the British Library Annunciation but also by their earlier provenance from the collection of William Young Ottley (sale 1838, lot 188), who seems to have owned the complete series of initials from Cod. Cor. 2. It is said that the Annunciation was brought to England about 1820 by the abbot Celotti, who believed it to have been cut out of a book in the Vatican Library during the time of the French occupation of Rome (Robinson 1876, pp. 277, 279, app. 2, no. 2). However, it is not mentioned in the sale catalogue of the miniatures of Celotti (see sale 1825), and it is more likely that the cutting once belonged to William Young Ottley, who would have sold it before his death.

The initial R introduced the introit to the Mass for the feast of the Annunciation and was originally on folio 60 of Cod. Cor. 2. On folio 61 is the continuation of this Mass with the offertory hymn Ave Maria Gratia Plena. Despite its small format the splendid miniature has the monumental quality of a fresco painting. This effect is enhanced by the initial's outer frame, which, with its cosmatesque pattern, refers to the great picture cycles of fourteenth-century Tuscany and would have been further intensified by the now-excised prophets in quatrefoils that once surrounded the frame. The influence of fresco painting may ultimately explain why the painted scene and the ornamented initial relate so little to each other

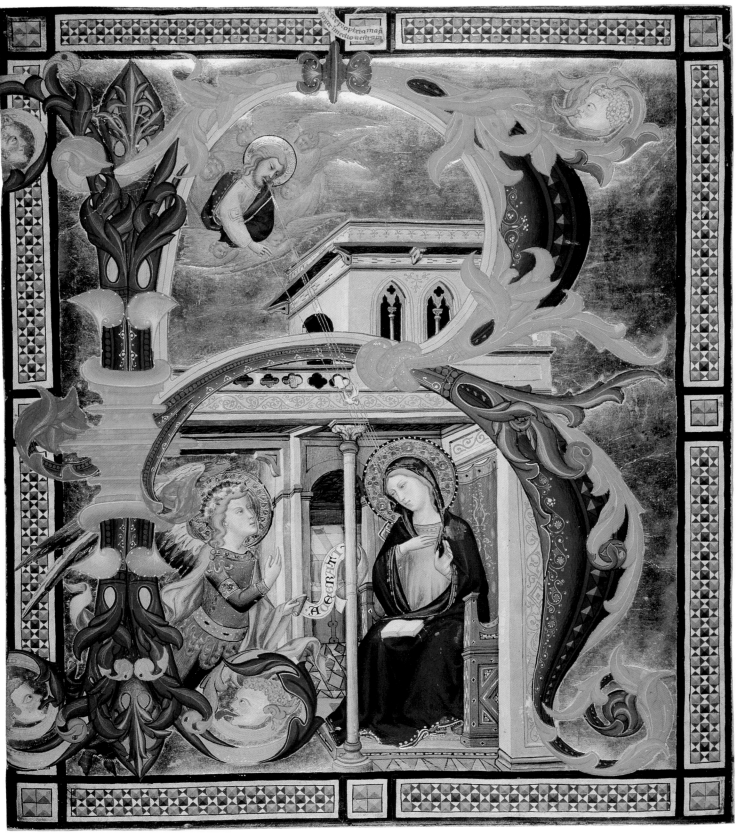

16c

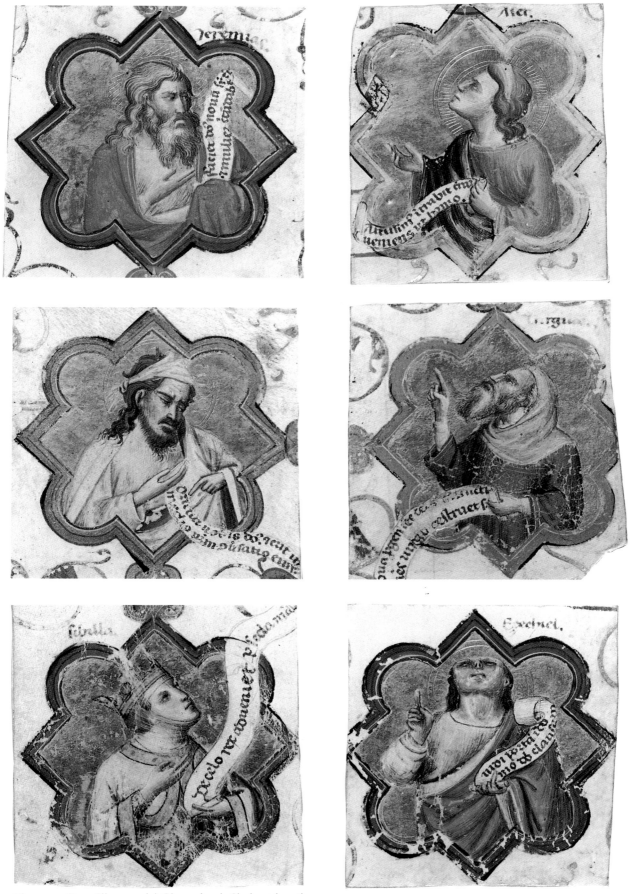

Figure 53. Don Silvestro dei Gherarducci, Six bust-length prophets. Nationalmuseum, Stockholm (NMB 1797)

that each seems almost self-sufficient. The composition is subordinated not to the initial (which seems to cover it only partially) but to the square outer frame. Furthermore, the composition of the scene, including the representation of the airborne heavenly messenger descending to the Virgin, probably refers to a Sienese fresco, such as that by Biagio di Goro Ghezzi in Paganico (1368). The fresco in Paganico is a precise visualization of the Annunciation as narrated in the *Meditationes vitae Christi*: "Then he [Gabriel] arose cheerfully and gaily and flew down from heaven and in a minute stood in human form before the Virgin, who was in a room of her little house. But his flight was not so swift that God did not enter before him, and thus the Holy Trinity was present entering before His messenger" (Ragusa and Green 1977, p. 16).

The visual representation of the Annunciation as narrated in the *Meditationes*, especially the motif of the angel still in flight, is in all likelihood based on an invention by Ambrogio Lorenzetti. Sigismundo Tizio (1458–1528; *Historiae Senenses*, Biblioteca Apostolica Vaticana, MS Chigi G.I, fol. 104) mentioned a now-lost *Annunciation* by Ambrogio Lorenzetti on the facade of San Pietro del Castelvecchio with a "tam decoro Angeli descensu," that is, with a flying angel. Lorenzetti's fresco and probably other lost variations by his contemporaries must have inspired a series of later and closely related Sienese *Annunciation*s of this type, extending into the sixteenth century (Freuler 1984; idem 1986, p. 39). Don Silvestro could well have based his miniature on the same model (Boskovits 1975, pp. 68, 216 n. 86, 423; Eisenberg 1989, p. 71 n. 159).

GF

EX COLL.: John Malcolm of Poltalloch (by 1876; until 1895).

LITERATURE: Robinson 1876, pp. 277, 279, app. 2, no. 2; Levi D'Ancona 1957, pp. 16–17, n. 15; Boskovits 1975, pp. 68, 216 n. 86, 423; Levi D'Ancona 1978, p. 222; Freuler 1984; idem 1986, p. 39; Eisenberg 1989, p. 71 n. 159; Freuler n.d.

16d. Saint Romuald Enthroned with Four Saints in an Initial O

Tempera and gold leaf on parchment
11 3/8 × 11 7/8 in. (28.9 × 30.2 cm)

British Library, London (Add. MS 37,472, fol. 3)

The richly ornamented initial O in the shape of a floral garland opens into a well-defined picture space, where Saint Romuald sits on an ornate tabernacle throne. The founder of the Camaldolese order is surrounded by a bishop saint, possibly Saint Augustine, and three monastic saints, among whom may be identified Maurus and Placidus in the front row, wearing Camaldolese habits. The saint in the background at the right is John Gualbert.

The initial introduced the introit to the Mass for the feast of Saint Romuald, which followed the liturgy of a confessor, not a pope. The text continues on the back of this miniature—"Amen dico vobis quod uni ex minimis meis fecistis michi fecistis venite benedicti patris" (Amen I say to you that which you have done to one of my least you have done to me. Come blessed of the Father)—which was originally on folio 90 of Cod. Cor. 2 from Santa Maria degli Angeli (Levi D'Ancona 1957, pp. 17–18).

GF

EX COLL.: Unknown. Purchased for the British Museum in 1854.

LITERATURE: London 1925, p. 49; Levi D'Ancona 1957, pp. 17–18; Boskovits 1975, p. 423; Levi D'Ancona 1978, p. 222; Freuler n.d.

16e. Saint Lawrence in an Initial C

Tempera and gold leaf on parchment
5 3/4 × 5 7/8 in. (14.5 × 15 cm)

Courtesy of the Walters Art Gallery, Baltimore (W 416)

The initial C encloses a half-length frontal figure of Saint Lawrence wearing a richly ornamented garment. In his left hand, elegantly hidden by drapery, he holds a book, while his other hand is poised on the instrument of his martyrdom, the gridiron. He is distinguished by a quiet introspection and an air of solemn gravity.

The initial C introduced the introit to the Mass for Saint Lawrence, which is missing from folio 134 of Cod.

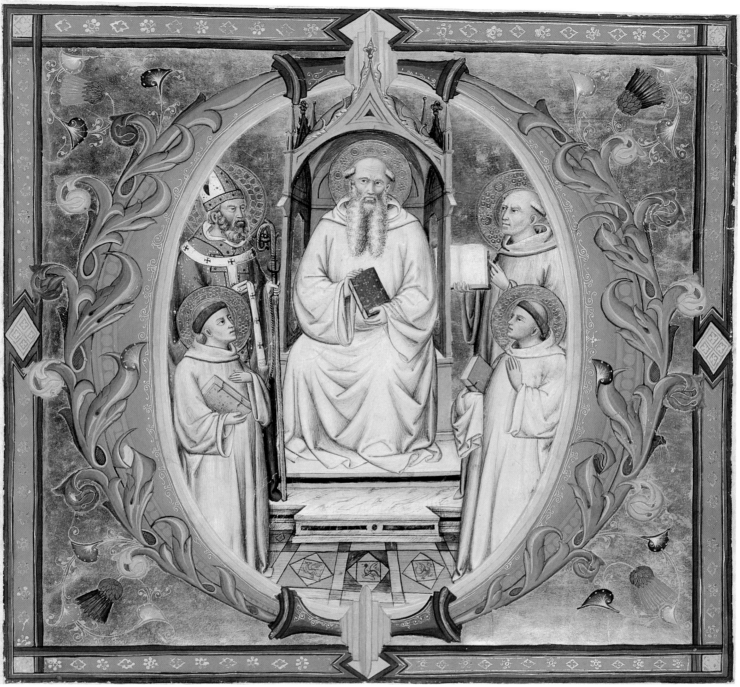

16d

16e

Cor. 2. The festivities of Saint Lawrence began with the liturgy of the vigil, which is on folio 131 of Cod. Cor. 2. Mirella Levi D'Ancona (1978, p. 224) claims an initial C with Saint Lawrence by Don Simone Camaldolese (cat. no. 22) is the missing initial from Cod. Cor. 2. This is obviously wrong, since all the miniatures of Cod. Cor. 2 were painted by Don Silvestro, and Don Silvestro's Baltimore Saint Lawrence is stylistically congruent with them.

The initial is glued onto card and heavily outlined in black ink around the cut edges, a mount similar to that on the initial L with Saint Margaret now in a private collection in Milan. It is therefore probable that both cuttings at one time belonged to the same owner.

GF

LITERATURE: Freuler n.d.

16f. The Virgin and Child in an Initial S

Tempera and gold leaf on parchment
6 ¹/₄ × 5 ³/₄ in. (15.8 × 14.7 cm)

The Cleveland Museum of Art; Gift from J. H. Wade (24.1012)

From the lower curve of the initial S rises the erect three-quarter-length figure of the Virgin with the Christ child in her arms. She gently bows her head to the young boy, who holds a globe in his right hand and in his left a scroll without an inscription. Presumably this should have been lettered "Ego sum lux mundi," since representations of the Christ child holding a globe often contain an explanatory reference in a scroll. This generally refers to Christ as the Light of the World, as in Domenico

16f

di Bartolo's altarpiece in the Galleria Nazionale dell' Umbria, Perugia.

The letter S begins the introit to the Mass from the common for feasts of the Virgin, and it is traditionally decorated with the Virgin and Child. The continuation of this Mass appears on folio 138 of Cod. Cor. 2: "Inventa es mater Salvatoris. Virgo dei genitrix" (You became the mother of our Savior. O Virgin, Mother of God), making it clear that the Cleveland initial S was cut from folio 137 of Cod. Cor. 2. Since the preceding folio, 136v, contains rubrics for the feasts of Saints Tiburtius and Valerian (August 11) and Saints Hippolitus and Cassian (August 13), the Cleveland initial must have begun the Mass for the vigil of the Assumption (August 14). Mirella Levi D'Ancona (1978, p. 230) proposed instead an unlikely identification of the Cleveland initial with the miniature missing from folio 158 of Cod. Cor. 12 in the Biblioteca Laurenziana, Florence, which is dated 1397. However, the text "Spiritus Sanctus in te descendet," which, according to Levi D'Ancona, would have appeared on that page, is not traditionally illuminated with the Virgin and Child. If the Cleveland initial were from a choir book painted after 1397, it would be expected to agree stylistically with Don Silvestro's late miniatures of the San Michele a Murano graduals (1390s). This does not apply to our miniature, which is totally congruent in style with those in Cod. Cor. 2. As with Catalogue Numbers 16b and 16d and the initial L with Saint Margaret in a private collection in Milan—all from Cod. Cor. 2—the contours of the cutting are heavily outlined in black ink.

The Florentine character of this miniature led to its

early attribution to the circle of Bernardo Daddi. The stylistic affinities with Florentine art, especially with Virgins by Jacopo and Nardo di Cione, are undeniable; however, iconographically Don Silvestro's Virgin and Child seems to draw on ideas developed in Sienese painting. The Cleveland initial is reminiscent of folio 87v in Gradual LXVIII in the Museo d'Arte Sacra, San Gimignano, illuminated by Niccolò di Ser Sozzo, in which the initial S is adorned by a similar three-quarter-length figure of Saint Anne holding her heavenly daughter (De Benedictis 1976, fig. 27). The motif of the mother and child in Don Silvestro's initial is also related to Jacopo di Mino del Pelliccciaio's Virgin in Santi Martino e Vittoria, Sarteano (Bellosi 1972, fig. 8). This is especially true of the way the child is somewhat awkwardly and stiffly turned toward a frontal position, by which it sets a strange diagonal accent. It seems, therefore, that here Don Silvestro has superimposed a Sienese idea on the Florentine stylistic idiom he absorbed during his association, in the 1360s, with the Cione brothers (see cat. no. 15).

GF

EX COLL.: J. H. Wade, Cleveland (by 1924).

LITERATURE: Boerner sale 1912, no. 23; Milliken 1925, pp. 66, 69; Gibson 1929, p. 20; De Ricci and Wilson 1935–37, vol. 2, p. 1930; Levi D'Ancona 1957, pp. 10 n. 12, 21; Cleveland 1963, p. 209, no. 58; Marcucci 1965, p. 136; Boskovits 1975, pp. 216 n. 86, 217 n. 91, 421; Levi D'Ancona 1978, p. 230; Freuler n.d.

16g. The Death and Assumption of the Virgin

Tempera and gold leaf on parchment
15¼ × 12 in. (38.8 × 30.5 cm)

British Library, London (Add. MS 37,955 A)

The monumentally rendered narration of the Virgin Mary's death visualizes three crucial moments in a single composition: her entombment, the passing of her soul to Christ, and her assumption to the heavenly realm. A great multitude of apostles and angels—appropriate to the illumination's provenance from a choir book made for the monastery of Santa Maria degli Angeli—and Christ have gathered around the Virgin's sarcophagus. Two of the apostles, assisted by angels, gently lay the Virgin's body over a precious garment and into the open

sarcophagus. Another figure, seen from the back, has knelt down to invite the beholder to do the same and meditate on this mystery. Christ receives his mother's soul in the form of a child that he holds in his arms. Above this scene, within a mandorla held up by angels extending over the imitation fresco upper border, the Virgin is carried into her heavenly reign.

In her first study of Don Silvestro, Mirella Levi D'Ancona (1957, pp. 19–20) associated this miniature with Cod. Cor. 2, though she later argued (1978, pp. 224, 235), inexplicably, that the Assumption of the Virgin in the London miniature had filled an initial H and therefore could not have introduced the liturgical text appropriate to that volume, which she erroneously gave as "Benedicta et venerabilis es" (You are blessed and venerable). This text, however, is not the beginning of the introit to the Mass but of the gradual hymn, which traditionally was not associated with any illuminations. Without producing plausible evidence Levi D'Ancona stated that the miniature should instead be identified as folio 90, now missing, of Don Silvestro's later Corale 19. The London Death and Assumption of the Virgin agrees fully in style with other pages and cuttings from Cod. Cor. 2; its cosmatesque frame corresponds to those surrounding the Gulbenkian Saint Benedict (fig. 48) or the British Library Saint Romuald (cat. no. 16d); and like most of the other cuttings from Cod. Cor. 2, it can be traced to the collection of William Young Ottley. There can be no doubt that the miniature in London was cut from folio 142 of Cod. Cor. 2 and illustrated the introit to the Mass of the Assumption of the Virgin, "Gaudeamus omnes in Domino, diem festum celebrantes" (Let us all rejoice in the Lord as we celebrate the feast). The continuation of this text, "sub honore beate Marie Virginis de cuius assumptione gaudent angelis" (in honor of the blessed Virgin Mary whose assumption the angels praise), follows on folio 143r.

The iconography of the scene closely resembles a painting of the same subject executed a few decades earlier by the Sienese painter Niccolò di Ser Sozzo (Museum of Fine Arts, Boston; Kanter 1994, pp. 100–103). The earliest example of this type—at least, with respect to the Virgin's Death—is, however, not Sienese, but Giotto's *Death of the Virgin* in Berlin (Boskovits 1987, pp. 292–98). Nevertheless, rather than constituting the original model, the Berlin panel might reflect a larger picture also including the Assumption of the Virgin, or it might even have inspired a later painting of this subject. Whether the source of this particular representation of the Virgin's Death and Assumption is by Giotto himself or by a Sienese artist familiar with Florentine painting still remains an open question. All we know is

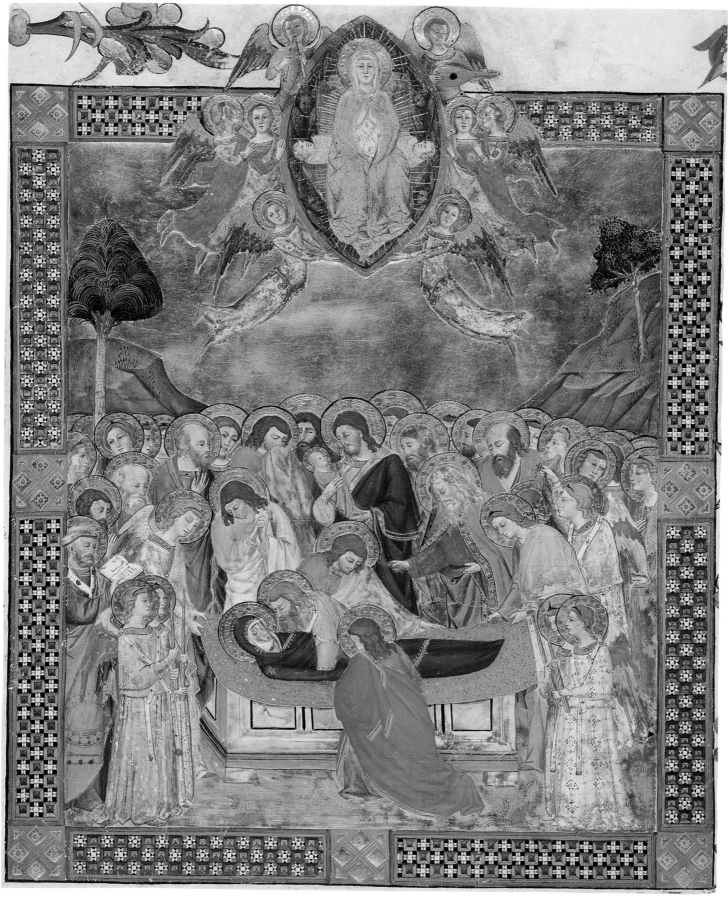

16g

that the earliest representation that combines both the Virgin's Death and her Assumption is by Niccolò di Ser Sozzo, a Sienese artist. Niccolò's familiarity with Florentine illumination—his early miniatures show some similarity to the so-called Maestro Daddesco—might, however, be an indication that he brought a Florentine idea to Siena, the more so as it is in later Florentine painting that this particular type of representation occurs most frequently (Previtali 1974, p. 109; Boskovits 1987, pp. 56–60).

GF

EX COLL.: William Young Ottley, London (until 1838); Rev. J. Fuller Russell, Eagle House near Enfield (until 1885); [Colnaghi, London]; George Salting, London (until 1909).

LITERATURE: Waagen 1837–39, vol. 1, p. 401; Ottley sale 1838, lot 181; Burger 1857, p. 25; Waagen 1857b, p. 35; London 1874, p. 34, no. 1; London 1879, p. 34, no. 177; Russell sale 1885, lot 124; Bradley 1889, p. 242; London 1908, p. 129, no. 129; London 1925, p. 190, no. 37955A; De Ricci and Wilson 1935–37, vol. 2, p. 1932; Thieme-Becker, vol. 31 (1937), p. 40; Levi D'Ancona 1957, pp. 19–20; Levi D'Ancona 1962, p. 238; Boskovits 1975, p. 423; Russell 1977, p. 195; Levi D'Ancona 1978, pp. 224, 235; Freuler n.d.

16h. The Birth of the Virgin in an Initial G

Tempera and gold leaf on parchment
11 1/2 × 11 3/4 in. (29.2 × 29.9 cm)

The Metropolitan Museum of Art; Rogers Fund, 1921
(21.168)

The letter G, overgrown by rich foliage with lilies, opens into the interior of Saint Anne's bedroom. Having given birth to a daughter, she sits up on her bed and glances at her child, who is about to be bathed. A maiden with the heavenly child on her lap is testing the temperature of the water in the bowl, while another adds some more water to it. Other maidens are gathered around Saint Anne. A nimbed female figure, probably Saint Anne's sister, Hismeria, sits on the edge of the bed and with a prophetic glance turns her head upward.

This initial G was the first letter of the introit to the Mass for the feast of the Birth of the Virgin (September 8) and was originally situated on the missing folio 148 of Cod. Cor. 2. The continuation of this text, "Anne de cuius solennita te gaudent angeli et collaudant filium de ipse. Eructavit cor meum" (Anne, upon whom the angels

rejoice and praise the Son of God. My heart overflows), appears on folio 149. The reverse of the Metropolitan Museum initial bears the text "leluia. . . . Amavit eum Dominum et ornavit eum stola[m] glo[riae]" (leluia. . . . He loved the Lord and adorned him with the cloak of glory), which is part of the liturgy for the preceding feast of Saint Egidius (September 1), a rubric for which appears on folio 147v.

The iconography is Sienese, faithfully following the composition of Pietro Lorenzetti's *Birth of the Virgin* altarpiece for Siena cathedral. This, together with Lorenzetti's other variation on this theme in fresco, once on the facade of the Ospedale di Santa Maria della Scala but now lost, was the model for all later Sienese interpretations of this subject.

In the past this scene was interpreted as the Birth of Saint John the Baptist, mainly because of the presence of the second Holy Woman, who, understandably enough, was identified as the Virgin Mary. However, as Mirella Levi D'Ancona (1978, p. 225; 1985, p. 457) has pointed out, the Birth of John the Baptist would have decorated the initial D beginning the introit to the Mass for the feast day of this saint. Levi D'Ancona thought that Don Silvestro erroneously painted the Birth of John the Baptist instead of the Birth of the Virgin and later added the lilies as a symbol of the Virgin to mask his mistake. This interpretation is highly doubtful, since there is no evidence to suggest that the lilies were a later addition. This type of floral ornamentation is also present in two other initials from the same gradual: S with Saint Silvester in the Nationalmuseum, Stockholm (fig. 47), and M with Saint Agnes in the Bibliothèque Publique et Universitaire, Geneva (cat. no. 16a). However, in this iconographic context the lilies probably do symbolize the purity of the Virgin and hence indicate that this is indeed a representation of the Birth of the Virgin. It would be difficult to imagine that Don Silvestro, as a learned monk, could have committed such a gross error as to paint a Birth of the Baptist with the text of the Birth of the Virgin in front of him. Who, then, is the second woman with the halo? She closely resembles the woman holding a flag in Lorenzetti's picture. This Holy Woman, as noted, might be Anne's sister, Hismeria, who, according to *The Golden Legend* (131.586), gave birth to Saint Elizabeth, the mother of Saint John the Baptist. To give her a halo, although unusual, would not have been inappropriate, as she belonged to the Holy Family.

GF

EX COLL.: [Durlacher Bros., London, 1921].

LITERATURE: De Ricci and Wilson 1935–37, vol. 2, p. 1308; Hartford 1965, p. 47, no. 86; Boskovits 1975, p. 424; Levi D'Ancona 1978, p. 225; idem 1985, p. 457; Freuler n.d.

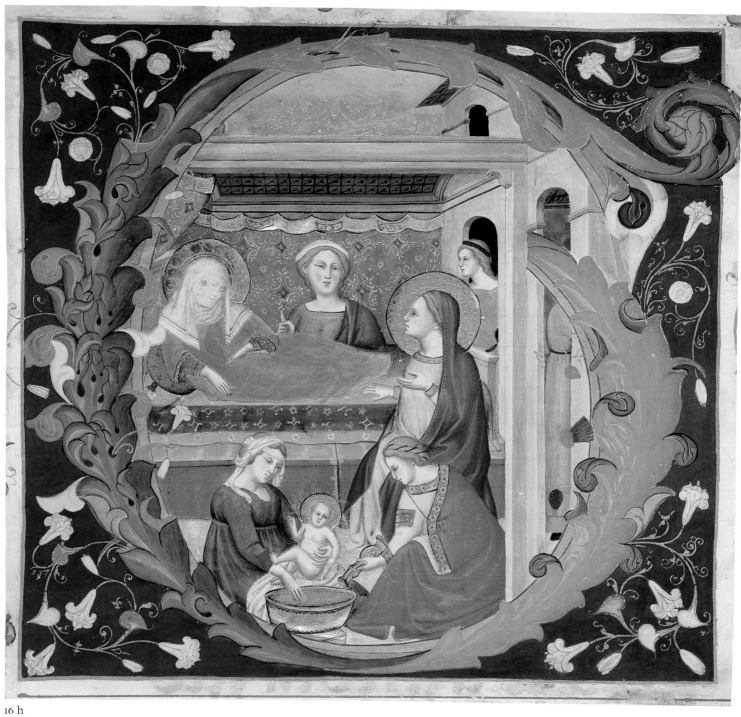

16 h

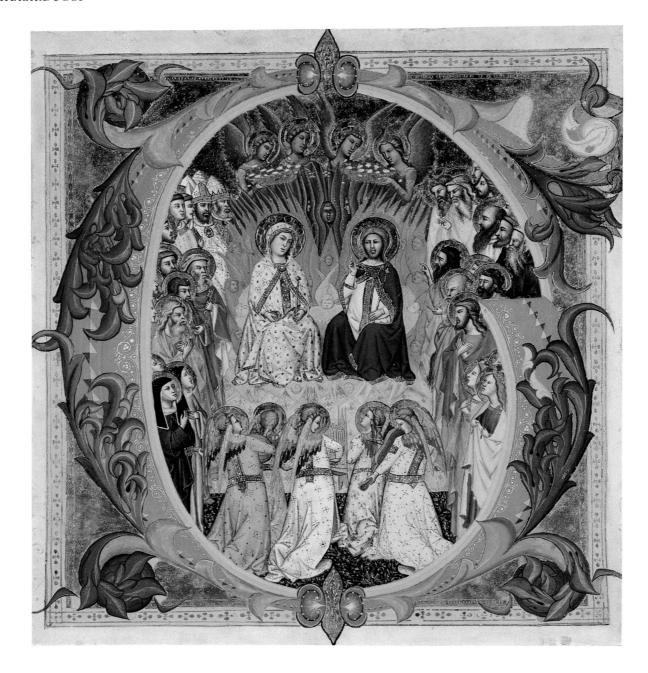

16i. The Virgin and Christ in Glory Surrounded by Saints and Angels in an Initial G

Tempera and gold leaf on parchment
13 3/4 × 13 1/4 in. (34.9 × 33.7 cm)

The Cleveland Museum of Art; Purchase from the J. H. Wade Fund (30.105)

Hovering over a flowery meadow are Christ and his Heavenly Mother as, respectively, Rex Iustitiae (King of Justice) and Regina Misericordiae (Queen of Mercy). They hold scepters, emblems of their sovereignty, and are seated on a bright throne of seraphim. High above,

angels offer flowers, while others dance and play music. A heavenly host with saints in precious and colorful garments are gathered in devotion around Christ and the Virgin.

The initial G begins the introit to the Mass of All Saints (November 1) and appeared on the verso of folio 155 in Cod. Cor. 2. The preceding folio, 154, still in the choir book, contains the liturgy of the vigil of All Saints.

The iconography of this splendid initial, which was repeated in a simplified manner by Don Simone Camaldolese (Victoria and Albert Museum, London, R.C.K. 1, fol. 121v; Boskovits 1972, fig. 28a), is firmly rooted in the Sienese tradition and draws from two distinct sources. The Virgin and Christ in this miniature

appear to hover amid a cloud of seraphim that extends to the point it almost converges with the large mass of figures on either side. For the composition of this miniature, Don Silvestro undoubtedly used a Sienese pictorial idea that assumed a form very like Niccolò di Buonaccorso's small panel in the Metropolitan Museum collection in New York, which was possibly painted a little later (Pope-Hennessy 1987, no. 14, pp. 33–35). However, compared with this Sienese picture, Don Silvestro's illuminated initial has a weightless, floating quality, and altogether it has a more intense, visionary, and transcendental character. This was achieved primarily through the apparent psychological detachment of the Christ and Virgin and the artist's rendering of fictive space by means of an airy, flowery meadow instead of the highly foreshortened pavement used in Buonaccorso's small panel, a solution similar to that achieved by Bartolo di Fredi about 1383–88 in his *Coronation of the Virgin* in the Museo Civico, Montalcino (see Freuler 1985, pp. 21 ff.). The hovering, weightless, yet compact character of Don Silvestro's composition is further intensified by the musical angels in the foreground, who seem to set off the undulating motion of the heavenly host. Don Silvestro's intentions were the same in the exquisite sequence of color harmonies and the great variety of figures presented. In Buonaccorso's picture—which admittedly portrays the Coronation of the Virgin, not the heavenly court of All Saints—rather stereotyped angels are set concentrically around the holy pair. Don Silvestro includes a varied heavenly host, with apostles, deacons, Old Testament heroes, church fathers, hermit saints, and virgins. Their distinct characterizations and draperies in jubilant colors generate a vibrant tension. Desirous of distancing this image from the stiff, vertically composed Florentine versions of the subject, Don Silvestro deliberately avoided anything static. This is particularly evident in the way he integrated the angel musicians, which are exact replicas of those in Jacopo di Mino del Pelicciaio's *Coronation of the Virgin* altarpiece in Montepulciano (Zeri 1965, p. 255). In Pelicciaio's grandiose panel, the plastically articulated angels shield Christ and the Virgin from the viewer by means of their loose semicircular arrangement and by the device of depicting them from the rear, which clearly demarcates the untraversable sacred realm. Don Silvestro, on the other hand, through the stronger rhythmic treatment of his angels, creates a dynamic that is transmitted to the heavenly host and leads to Christ and the Virgin. His concept of dynamic elegance eventually attracted such artists as Agnolo Gaddi, the Master of the Straus Madonna, and, especially, Lorenzo Monaco, all of whom share with him a distinct orientation toward refined, courtly Gothic ele-

gance. Don Silvestro created the effect of vibrant rhythm by offering a slight variant of Pelicciaio's angel concert at the feet of Christ and the Virgin. By adding a fifth angel, he broke through Pelicciaio's symmetry, creating dynamic movement, and this was further intensified by the inflection of the angels' bodies (in contrast to Pelicciaio's picture, the two angels at the right are set one behind the other in the pictorial space) and also by placing them close together so that they overlap. Even though Don Silvestro did not exactly copy Pelicciaio's grouping of the angels, his quotation of the individual angels in the Montepulciano *Coronation* is astounding. Notwithstanding the miniatures' small format, Don Silvestro's faithful copy of single drapery passages, the rich ornament of the garments, and even the decorative borders on the tunics leaves no doubt of his direct experience of the Montepulciano picture.

Don Silvestro's miniature comprises a synthesis of two Sienese versions of the Coronation of the Virgin, which not only clarifies his relation to Sienese art but also suggests the existence of another Sienese *Coronation*, now lost, possibly by Simone Martini. This, judging from its influence on the Florentine initials as well as on the small panel in New York painted later by Niccolò di Buonaccorso, possibly served as a model for both of them.

With its sharper drawing of the faces and increased dynamics of the composition, this work differs in execution, as does the Assumption of the Virgin of the British Library (cat. no. 16g), from the remaining miniatures of Cod. Cor. 2. These two cuttings are instead closer in style to the series of miniatures for the San Michele a Murano graduals, illuminated in the 1390s, which may indicate that they were executed later than the remaining illustrations.

GF

EX COLL.: William Young Ottley, London (until 1838); Foster; [Quaritch, London, 1895]; Edouard Kann, Paris (by 1926); [Messrs. Seligmann and Rey, New York].

LITERATURE: Ottley sale 1838, lot 182; Sotheby's sale 1895, lot 898; Quaritch sale 1895, lot 28; Boinet 1926, pp. 6, 25, no. 21; Milliken 1930, pp. 132–33; Cleveland 1936, p. 58, no. 135; De Ricci and Wilson 1935–37, vol. 2, p. 1932; Boston 1939, p. 58, no. 135; Baltimore 1949, p. 64, no. 175; Toesca 1951, p. 811 n. 14; Los Angeles 1953–54, p. 31, no. 100; Levi D'Ancona 1957, pp. 22, 24–25; Miner 1958, pp. 18, 19; Offner 1960, p. 50; Baltimore 1962, p. 75, no. 74; Faye and Bond 1962, p. 426, no. 30.105; Cleveland 1963, p. 209, no. 59; London 1965, p. 12, no. 19; Zeri 1965, p. 255; Cleveland 1966, p. 57; Florence 1966, p. 8; Boskovits 1975, pp. 216 n. 86, 217 n. 91, 421; Russell 1977, p. 193; Levi D'Ancona 1978, p. 224; Freuler n.d.

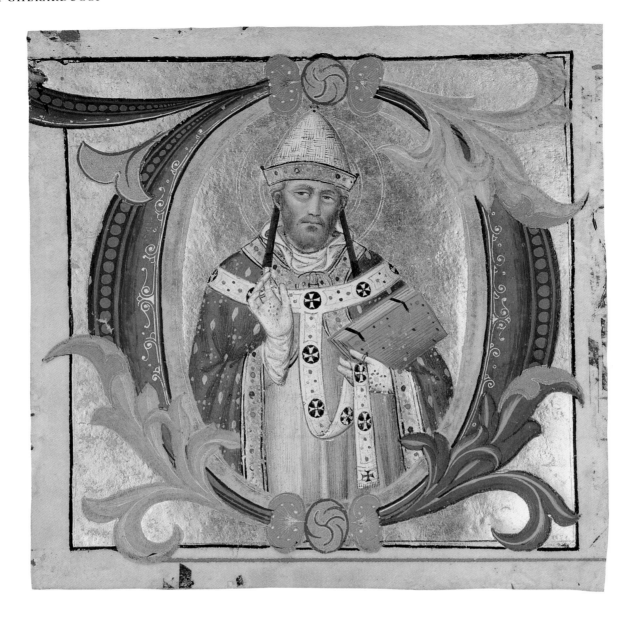

16j. Pope Saint Clement in an Initial D

Tempera and gold leaf on parchment
6 ⁵/₈ × 6 ⁵/₈ in. (16.9 × 16.7 cm)

Fitzwilliam Museum, Cambridge; Leverton Harris and
University Purchase Funds (MS 5–1979)

His eyes slightly turned to the left and his right hand
somewhat raised, the frontal three-quarter-length figure
of Pope Clement addresses the beholder. In his left hand
he holds a book and gently lifts up his stole.

The initial D with Saint Clement begins the introit to
the Mass of Saint Clement. The beginning of this Mass,
which would have appeared on folio 159, is missing from
Cod. Cor. 2, but its liturgy continues on the following
pages (fols. 160ff.).

Don Silvestro draws on types established by Simone
Martini and his followers: for instance, the holy popes in
Simone's Pisa altarpiece (see Gozzoli 1970, pls. VIII, IX).
His simplifications in the drawing and the psychological
characterization recall the works of later generations of
Sienese trecento painters, such as Paolo di Giovanni Fei
and Bartolo di Fredi.

GF

EX COLL.: J. H. Fitzhenry; Sir Thomas Merton,
Maidenhead (by 1950).

LITERATURE: Scharf 1950, p. 40, pl. XV; Levi D'Ancona
1978, p. 224; Wormald and Giles 1982, vol. 2, pp. 611–12;
London 1983, no. 51; Freuler n.d.

Gradual for San Michele a Murano

(Catalogue Number 17a–g)

In his life of Don Lorenzo Monaco, Vasari mentions the existence at Santa Maria degli Angeli in Florence of an excellent illuminator, Don Silvestro (dei Gherarducci), and he refers to twenty choir books there, which, in his opinion, were written by a certain Don Jacopo and illuminated by Don Silvestro. Vasari points out that several other choir books by the same masters were in the magnificent libraries in the monasteries of the same order in Murano, that is, San Mattia and San Michele.[1] The choir books from Santa Maria degli Angeli have long been recognized as a series of volumes in the Biblioteca Laurenziana, Florence (D'Ancona 1914, vol. 1, pp. 123–41; Levi D'Ancona 1957, p. 5; idem 1978, pp. 213 ff.), and it is now clear that these volumes were not illustrated exclusively by Don Silvestro but by various artists, among them Lorenzo Monaco. But while the choir books for Santa Maria degli Angeli still survive, there seems to be no trace of the Florentine choir books for the monasteries in Murano. However, it would be wrong to dismiss Vasari's statements as mere fantasy if only because one book from San Michele a Murano, now in the Museo Correr, Venice (MS V, 29), bears an inscription which states that it was written in 1368 in Santa Maria degli Angeli in Florence ("Completus anno domini MCCCLXVIII in loco sancte Marie angelis de Florentia").

Whether this book was actually commissioned and written for the monastery in Murano or was one of a number of books documented to have been sent from Santa Maria degli Angeli to San Michele a Murano in 1422[2] is an open question. It does testify to the close ties between the two monasteries in connection with manuscript illumination. This is further confirmed in a letter written in 1401 by the prior of Santa Maria degli Angeli, Matteo Guidoni, to the Sienese Dominican Tommaso d'Antonio Caffarini, who at the time was involved with the Dominican scriptorium in Venice, in particular with the illuminated edition of the Life of Saint Catherine of Siena.[3] In this letter, dated April 5, 1401, Guidoni assures Caffarini of the assistance of the abbot of San Michele a Murano and offers him advice on how to carry out the writing of his texts. He suggests such details as the size of the paper, the composition of the pages, and the salary of the scribe. He also recommends that Caffarini ask the abbot of San Michele a Murano for counsel. Caffarini seems to have followed Guidoni's advice, for many of his texts bear drawings and illuminations by Cristoforo Cortese, who also worked for San Michele a Murano (Freuler 1987, pp. 570 ff.).

Thus a triangle was formed between the scriptorium of the Dominicans in Venice, the Camaldolese in San Michele a Murano, and the Camaldolese of Santa Maria degli Angeli in Florence. This is not only of considerable interest in understanding religious life in Venice about 1400, then dominated by the Tuscan Dominicans and Camaldolese, but it might also shed light on Vasari's statements regarding the involvement of Florentine illuminators from Santa Maria degli Angeli in the scriptorium of their fellow monks in Murano.

In an interesting letter written on February 15, 1401, to the Venetian Dominican Mantellate of Corpus Christi, the leading Florentine Dominican, Giovanni Dominici, advises the nuns involved in the production of choir books to base their illuminated pages on the graduals he saw in San Michele a Murano during the period he spent in Venice (1388–99).[4] Since Dominici left Venice in 1399 and the letter was written in 1401, these graduals must date from the fourteenth century. They would have been painted by illuminators of the trecento, and—if we are to believe Vasari—might well have been those written by Don Jacopo and illuminated by Don Silvestro. This is even more likely because at the time Venice could not boast illuminators of great significance. That the Florentine Dominici, himself involved in illumination, expressed such admiration for these graduals could indicate that he was familiar with them and that they might therefore have been carried out by a leading artist of his hometown, Don Silvestro, for example, and hence be recommended as models to the nuns under his stewardship.

In this context one factor in Dominici's statements gains special significance, which is that the gradual he referred to was the volume concerning the feast days between Easter and Pentecost. It could therefore be concluded that Dominici had seen a gradual that was a volume of the temporale for the Easter cycle.

Single illuminated pages representing a number of scenes from a large gradual by Don Silvestro from this period have survived in various museums. Together with several other stylistically consistent historiated pages and with a considerable number of cut initials scattered in various museums, they formed the major portion of the illuminated decoration of a temporale for Easter to the twenty-fourth Sunday after Pentecost and another for the first Sunday of Advent to Easter (Freuler 1992, pp. 480–85, 502 n. 15). Among the miniatures of these two newly reassembled graduals, there are several full pages, for

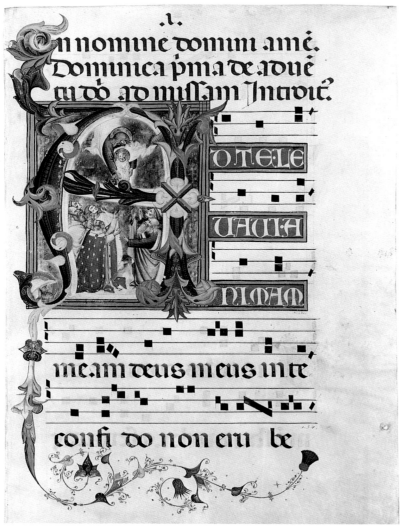

Figure 54. Don Silvestro dei Gherarducci, *God the Father Presenting the Infant Christ to a Group of Saints* in an initial A. Victoria and Albert Museum, London

example the Resurrection of Christ in the Musée Condé, Chantilly (fig. 60), the Trinity in The Pierpont Morgan Library, New York (cat. no. 17f), and God the Father Presenting the Infant Christ to a Group of Saints in the Victoria and Albert Museum, London (fig. 54), as well as some initials including busts of prophets, which must have been known to Cristoforo Cortese, mentioned above, as well as Belbello of Pavia, two artists who in the first decades of the quattrocento dominated the art of illumination in Venice. Both are known to have illuminated manuscripts for the Venetian Dominicans and the Camaldolese in Murano, and as Giordana Mariani Canova (in Milan 1988, pp. 232ff.) rightly pointed out, it is precisely in the graduals (Biblioteca Nazionale Braidense, Milan, MS AB-XVII.28; Kupferstichkabinett, Berlin, MS 78) for the Camaldolese monasteries in

Murano by Cortese and Belbello that Don Silvestro's compositional innovations were repeated and developed.

Keeping in mind that Cortese and Belbello worked in the region around Venice and that they consequently must have seen Don Silvestro's miniatures in Venice, we can draw two important conclusions: first, all of Don Silvestro's illuminations copied by the later artists in Venice, as well as the related initials, belong to the same series of graduals; second, these choir books, probably produced in Santa Maria degli Angeli, Florence, and then sent to Venice, were commissioned for Don Silvestro's fellow monks in Murano. Mirella Levi D'Ancona's proposal (1993) that the two volumes of a temporale were instead produced for Santa Maria degli Angeli is manifestly incorrect (see also cat. nos. 35–37).

Don Silvestro's graduals, of exquisite quality, to judge from the few full pages that have come down to us, must have been the most splendid examples of illumination visible at that time in Venice or anywhere else in Italy. It is not surprising that they were recommended by Giovanni Dominici and that they were indeed closely followed by the later artists of the Camaldolese scriptorium in Murano. The fame that Don Silvestro's choir books enjoyed in Venice later also ensured them the attention of Vasari, who bore witness not only to their existence but also to their great splendor. In this case, one of Vasari's statements, which are often unreliable with regard to medieval art, has turned out to be accurate.

Don Silvestro's graduals for San Michele a Murano were divided into several volumes, as were the later ones by Cortese and Belbello. The first volume concerned the liturgy for the first Sunday of Advent up to the last Mass of the Passion, and the second, the one admired by Dominici, started with Easter and finished with the last (twenty-third or twenty-fourth) Sunday after Pentecost. Among the many initials and pages of the temporale, two bear the original number 1—the page dedicated to the Mass for the first Sunday of Advent (Victoria and Albert Museum, London, MS 434; fig. 54) and the page with the introit for the Easter Mass in Chantilly (fig. 60). These two volumes of a temporale seem to be Don Silvestro's only surviving graduals from San Michele a Murano, since all his other initials concern either antiphonaries or a sanctorale (propers of the saints) and may be associated with the choir books of Santa Maria degli Angeli.

Having clarified the provenance and knowing that Don Silvestro's illuminations were part of two large graduals for San Michele a Murano, we also have—as Mariani Canova pointed out (in Milan 1988, pp. 232ff.)—a clear indication of their date. Giovanni Benedetto Mittarelli

Figure 55. Don Silvestro dei Gherarducci, Saint Paul in an initial G. The Pierpont Morgan Library, New York

(1779), who published a study on the library of San Michele a Murano, states that the fourteenth-century choir books of this monastery were produced at the time of the abbot Paolo Venier, who did not take up this position until 1392. In view of the fact that Don Silvestro died in 1399, we may conclude that the graduals were illuminated between 1392 and 1399. This dating is confirmed by Dominici, who reports that he saw one of these graduals during his presence in Venice in 1388–99. If, as Vasari states, the graduals were written by Don Jacopo, whom we know died in 1396, it would seem plausible that Don Silvestro painted them before or in any case not long after this date.

Fifty-one full pages and initials have been discovered so far that can now be firmly associated with the San Michele a Murano graduals. Two further miniatures of this complex, once in the Victoria and Albert Museum, were lost or destroyed during the Second World War.[5] The liturgical context of all but one of the illuminations can be established as follows:

Gradual 1 (The First Sunday of Advent to Passion Week)

1. God the Father Presenting the Infant Christ to a Group of Saints in an initial A ("Ad te levavi animam meam deus meus" [I have lifted up my soul to you, O my God]), introit to the Mass for the first Sunday of Advent (Victoria and Albert Museum, London; MS 434, no. 1 30-A [fig. 54]).

2. Saint Paul in an initial G ("Gaudete in domino semper" [Rejoice in the Lord always]), introit to the Mass for the third Sunday of Advent (The Pierpont

Morgan Library, New York; M. 478, fol. 6 [fig. 55]). The text on the reverse, "[Nihil solli]citi sitis sed [in omni or]atione pe[titiones vestrae innotescant apud Deum]" (Have no anxiety; but in every prayer let your petitions be made known to God), is the continuation of the introit for the third Sunday of Advent.

3. Foliate decoration in an initial M ("Memento nostri domine in beneplacito populi tui" [Remember us, O Lord, among your blessed people]), introit to the Mass for the fourth Sunday of Advent (Victoria and Albert Museum, London; MS 983, no. 2868).

Figure 56. Don Silvestro dei Gherarducci, A Prophet Looking Up to the Enthroned Christ in an initial I. The Pierpont Morgan Library, New York

4. The Nativity of Christ in an initial D ("Dominus dixit ad me filius meus es tu" [The Lord has said to me, "You are my son"]), introit to the first Mass of Christmas (Victoria and Albert Museum, London; MS 966, no. 3074 [cat. no. 17a]).

5. The Adoration of the Shepherds in an initial L ("Lux fulgebit hodie super nos" [A light shall shine upon us this day]), introit to the Mass for Christmas morning (Victoria and Albert Museum, London; MS 967, no. D. 229–1906 [cat. no. 17b]).

6. The Nativity and the Annunciation to the Shepherds in an initial P ("Puer natus est nobis" [A child is born to us]), introit to the Mass for Christmas Day (The Pierpont Morgan Library, New York; M. 653, fol. 1 [cat. no. 17c]).

7. A Prophet in an initial D ("Dum medium silentium tenerent omnia" [When all things were in quiet silence]), introit to the Mass for Sunday within the octave of Christmas (Victoria and Albert Museum, London; MS 973, no. D. 222–1906). The text on the reverse, "[Iusti]tia et iudi[cium pre]paratio [sedis tuae]" (Justice and judgment are the foundation of your throne), is the end of the offertory hymn of the Mass for Christmas Day.

8. The Adoration of the Magi in an initial E ("Ecce advenit dominator dominus et regnum in manu eius et potestas et imperium" [Behold, the Lord, the ruler, is come. He has dominion over all, and in his hand is power and might]), introit to the Mass for the feast of Epiphany (The Pierpont Morgan Library, New York; M. 653, fol. 5 [cat. no. 17d]).

9. A Prophet Looking Up to the Enthroned Christ in an initial I ("In excelso throno vidi seder virum quem adorat multitudo angelorum" [I saw a man seated upon a high throne, and a host of angels worshiping him]), introit to the Mass for Sunday within the octave of Epiphany (The Pierpont Morgan Library, New York; M. 478, fol. 7 [fig. 56]). A similar iconography for the same feast day is to be found on folio 66 of the gradual in the Biblioteca Nazionale Braidense, Milan, which closely follows the scheme of Don Silvestro's illuminations (see Mariani Canova, in Milan 1988, pp. 232–39).

10. A Prophet in an initial O ("Omnis terra adoret te deus" [Let all on earth worship you, O God]), introit to the Mass for the second Sunday after Epiphany (The Art Institute of Chicago; acc. no. 1915.550 [fig. 57]). The text on the reverse, "[Ser]vite domino in [laetitia]" (Serve the Lord with gladness), is the end of the introit to the Mass for Sunday within the octave of the Epiphany; it is followed by abbreviations for the Gloria and the gradual hymn.

11. A Prophet in an initial A ("Adorate deum omnes angeli eius" [Worship God, all you his angels]), introit to the Mass for the third Sunday after Epiphany (The Pierpont Morgan Library, New York; M. 478, fol. 10).

Figure 57. Don Silvestro dei Gherarducci, A Prophet in an initial O. The Art Institute of Chicago

Figure 58. Don Silvestro dei Gherarducci, A Prophet in an initial E. Victoria and Albert Museum, London

The text on the reverse, "[Dominus regnavit exultet terra letentur insule] multe. Gloria. Timebunt [gentes nomen tuum]" (The Lord is king; let the earth rejoice; let the many isles be glad. The nations shall revere your name), is the continuation of the introit to and the beginning of the gradual hymn from the Mass for the third Sunday after Epiphany.

12. A Prophet in an initial C ("Circumdederunt me gemitus mortis" [The moaning of death surrounded me]), introit to the Mass for Septuagesima Sunday (Victoria and Albert Museum, London; MS 976, no. D. 227–1906). The text on the reverse, "[Dextera domini exaltavit] me non mo[riar sed viva]m et narra[bo opera Domini]" (The right hand of the Lord has lifted me up. I shall not die, but live, and shall declare the works of the Lord), is the end of the Offertory hymn for the third Sunday after Epiphany.

13. A Prophet in an initial E ("Esto michi in deum protectorem" [Be a God of protection to me]), introit to the Mass for Quinquagesima Sunday (Victoria and Albert Museum, London; MS 982, no. D. 219–1906 [fig. 58]). The text on the reverse, "[Misericord]ias tuas. [Qui salvos fa]cis sperantes [in te]" (Show your wondrous kindness, O savior of those who trust in you, O Lord), is the end of the offertory hymn from the Mass for Sexagesima Sunday.

14. A Prophet in an initial R ("Reminiscere miserationum tuarum Domine" [Remember, O Lord, your compassion]), introit to the Mass for the second Sunday of Lent (Museo Civico, Padua; M.C. 887). The conclusion of the Communion hymn from the Mass for the preceding Ember Saturday, "[Libera me ab omni]bus perseq[uentibus me] et eripe [me]" (Save me from all my persecutors, and rescue me), is visible above the initial.

15. A Prophet in an initial O ("Oculi mei semper ad Dominum" [My eyes are ever toward the Lord]), introit to the Mass for the third Sunday of Lent (Victoria and Albert Museum, London; MS D. 217–1906). The text on the reverse, "[Quoniam unicus et pauper] sum ego. P[s. Ad te domine le]vavi animam [meam]" (For I am alone and wretched. Psalm: I have lifted up my soul to you, O my God), continues the introit for the third Sunday of Lent.

16. An Initial I ("Iudica me Deus et discerne causam meam de gente non sancta" [Do me justice, O God, and fight against a faithless people]), introit to the Mass for Passion Sunday (Museo Civico, Padua; M.C. 886). This cutting preserves part of the Communion hymn from the Mass for the Saturday before Passion Sunday above the initial ("[In loco pascuae ibi me

Figure 59. Don Silvestro dei Gherarducci, The Entry into Jerusalem in an initial D. Musée Marmottan, Paris; Wildenstein Collection

col]locavi[t super aquam refecti]onis ed[ucavit me]" [He has set me in a place of pasture; he has led me to refreshing waters]) and part of the introit for Passion Sunday following the initial. On the back is the conclusion of the introit for Passion Sunday: "[Quia tu] es deus [meus et fortitu]do me[a Emitte lucem] tuam, et ve[ritatem tuam: ipsa me] deduxe[runt et adduxerunt in m]ontem sanctum [tuum et in tabernacula tua]" (For you, O God, are my strength. Send forth your light and your truth; they shall lead me on and bring me to your holy mountain, to your dwelling place).

17. The Entry into Jerusalem in an initial D ("Domine ne longe facias auxilium tuum a me" [O Lord, be not far from me with your aid]), introit to the Mass for Palm Sunday (Wildenstein Collection, Musée Marmottan, Paris; fig. 59).

Gradual 2 (Easter to the Twenty-fourth Sunday After Pentecost)

1. The Resurrection in an initial R ("Resurrexi et adhuc tecum sum" [I arose and am still with you]), introit

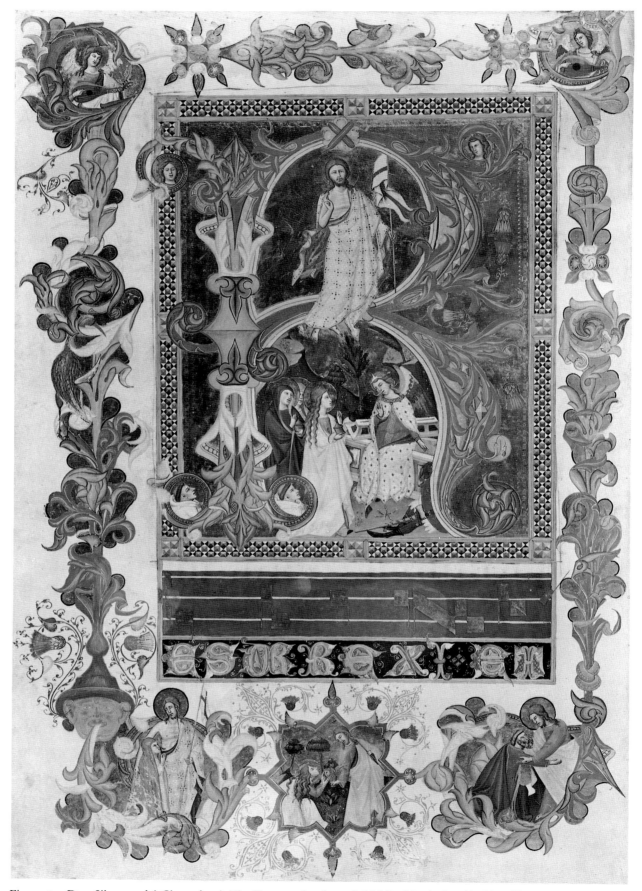

Figure 60. Don Silvestro dei Gherarducci, The Resurrection in an initial R. Musée Condé, Chantilly

to the Mass for Easter Sunday (Musée Condé, Chantilly; fig. 60).

2. A Prophet in an initial A ("Aqua sapientie potavit eos" [He gave them the water of wisdom to drink]), introit to the Mass for Easter Tuesday (Victoria and Albert Museum, London; MS 969, no. 432 [fig. 61]). The text on the reverse, "Quem queritis [surre]xit si[cut dixit] alle[luia]" (He whom you seek has risen as he said, alleluia), is the conclusion of the offertory hymn from the Mass for Easter Monday.

3. A Prophet in an initial V ("Venite benedicti patris mei" [Come, blessed of my Father]), introit to the Mass for Easter Wednesday (The Pierpont Morgan Library, New York; M. 478, fol. 17). The text on the reverse, "Si consur[rexisti cum x]pisto que [sursum sunt quaerite]" (If you have risen with Christ, seek the things that are above), begins the Communion hymn from the Mass for Easter Tuesday.

4. A Prophet in an initial V ("Victricem manum tuam Domine" [They praised with one accord your victorious hand, O Lord]), introit to the Mass for Easter Thursday (Victoria and Albert Museum, London; MS D. 226–1906). The identification is based on the text on the back of the initial, "[Allel]uia Can[tate Domino canticum novum]" (Sing to the Lord a new song), which is the continuation of the introit.

5. A Prophet in an initial E ("Eduxit eos domine in spe" [The Lord led them on in hope]), introit to the Mass for Easter Friday (The Pierpont Morgan Library, New York; M . 478, fol. 3). The text on the reverse, "Populus acquisitionis [an]nuntiate [virtu]tes eius" (O purchased people, proclaim the perfections of him), is a fragment of the Communion hymn for Easter Thursday.

6. A Prophet in an initial M ("Misericordia domini plena est terra" [The earth is full of the mercy of the Lord]), liturgy for the second Sunday after Easter (The Pierpont Morgan Library, New York; M. 478, fol. 9). The text on the reverse, "[In Galile]am [Mitte m]anum tuam" (. . . in Galilee. Put in your hand), concludes the alleluia versicle and begins the Communion hymn for Low Sunday.

7. An initial I ("Iubilate deo omnis terra" [Shout joyfully to God, all the earth]), introit to the Mass for the third Sunday after Easter (Museo Civico, Padua; M.C. 878). Above the initial appears a fragment of the Communion hymn from the Mass for the second Sunday after Easter, "[Et cognosco] oves m[eas et cognoscunt me] mee a[lleluia alleluia]" (And I know my sheep, and mine know me). The introit to the Mass for the third Sunday after Easter is

Figure 61. Don Silvestro dei Gherarducci, A Prophet in an initial A. Victoria and Albert Museum, London

continued on the back of the cutting: "[Gloriam laudi ei]us alle[luia alleluia al]lelui[a Ps. Dicite Deo] quam terri[bilia sunt opera t]ua domi[ne in multitudine vi]rtutis [tuae mentientur tibi i]nimi[ci tui]" (His glorious praise, alleluia, alleluia, alleluia. Ps[alm] Say to God, "How tremendous are your deeds, O Lord. Because of your great strength your enemies cringe before you").

8. A Prophet in an initial C ("Cantate domino canticum novum" [Sing to the Lord a new canticle]), introit to the Mass for the fourth Sunday after Easter (Victoria and Albert Museum, London; MS 968, no. 431–4). The text on the reverse, "[Alle]luia Mo[dicum et non vi]debitis me" (A little while and you shall see me no longer), begins the Communion hymn from the Mass for the third Sunday after Easter.

9. A Prophet in an initial V ("Vocem iocunditatis annuntiate" [Declare it with the voice of joy]), introit to the Mass for the fifth Sunday after Easter (Victoria and Albert Museum, London; MS 970, no. 3087). The text on the reverse, "[Cum vene]rit para[clitus spiritus veritatis]" (When the Paraclete, the spirit of

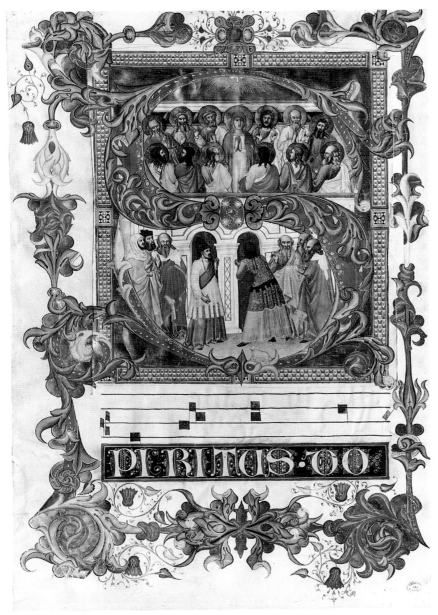

Figure 62. Don Silvestro dei Gherarducci, The Pentecost in an initial S. Victoria and Albert Museum, London

on the reverse, "[Vultum tuum requi]ram ne avert[as faciem] tuam a me" (Your presence, O Lord, I will seek; hide not your face from me), continues the introit to the Mass for Sunday within the octave of the Ascension.

12. The Pentecost in an initial S ("Spiritus Domini replevit orbem terrarum" [The spirit of the Lord has filled the whole world]), introit to the Mass for the feast of Pentecost (Victoria and Albert Museum, London; inv. no. 3045 [fig. 62]).

13. A Prophet in an initial A ("Accipite iucunditatem gloriae vestrae" [Receive with joy the glory that is yours]), introit to the Mass for Tuesday within the octave of Pentecost (Victoria and Albert Museum, London; MS 975, no. D. 224–1906). The text on the reverse, "[Allelu]ia allel[uia] Attendite po[pule meus legem meam]" (Alleluia, alleluia. Hearken, my people, to my law), continues the introit to the Mass for Tuesday within the octave of Pentecost.

14. A Prophet in an initial R ("Repleatur os meum laude tua" [Let my mouth be filled with your praise]), introit to the Mass for Friday within the octave of Pentecost (The Pierpont Morgan Library, New York; M. 478, fol. 14). The text on the reverse, "[Pacem relinquo vobis alleluia pac]em meam do [vobis]" (Peace I leave with you, alleluia! my peace I give to you), is the Communion hymn from the Mass for Wednesday within the octave of Pentecost.

15. The Trinity in an initial B ("Benedicta sit Sancta trinitas" [Blessed be the Holy Trinity]), introit to the Mass for Trinity Sunday (The Pierpont Morgan Library, New York; M. 653, fol. 2 [cat. no. 17f]).

16. The Last Supper in an initial C ("Cibavit eos ex adipe frumenti" [He fed them with the finest wheat]), introit to the Mass for the feast of Corpus Domini (The Pierpont Morgan Library, New York; M. 653, fol. 4 [cat. no. 17g]).

17. A Prophet in an initial D ("Domine in tua misericordia speravi" [O Lord, I have trusted in your mercy]), introit to the Mass for the first Sunday after Pentecost (Victoria and Albert Museum, London; MS 974, no. D. 225–1906). The text on the reverse, "[Mortem domini annuntiabitis do]nec veni[at itaque quicu]mque mandu[caverit panem]" (You proclaim the death of the Lord, until he comes. Therefore whoever eats this bread), is a fragment of the Communion hymn from the Mass for Corpus Domini.

18. A Prophet in an initial D ("Dominus illuminatio mea" [The Lord is my light]), introit to the Mass for the fourth Sunday after Pentecost (Kupferstichkabinett, Berlin; MS 682 [fig. 63]). The text on the reverse, "[Quoniam non est] oblitus [orationem] pauperum"

truth, has come), begins the Communion hymn from the Mass for the fourth Sunday after Easter.

10. The Ascension of Christ in an initial V ("Viri Galilei quid admiramini aspicientes in caelum" [Men of Galilee, why do you stand looking up to heaven?]), introit to the Mass for the feast of the Ascension (The Pierpont Morgan Library, New York; M. 653, fol. 3 [cat. no. 17e]).

11. A Prophet in an initial E ("Exaudi domine vocem meam" [Hear, O Lord, my voice]), introit to the Mass for the Sunday after the Ascension (The Pierpont Morgan Library, New York; M. 478, fol. 4). The text

Figure 63. Don Silvestro dei Gherarducci, A Prophet in an initial D. Staatliche Museen zu Berlin; Kupferstichkabinett

Figure 64. Don Silvestro dei Gherarducci, A Prophet in an initial O. The Pierpont Morgan Library, New York

(For he has not forgotten the cry of the poor), concludes the offertory hymn from the Mass for the third Sunday after Pentecost.

19. A Prophet in an initial D ("Dominus fortitudo plebis suae" [The Lord is the strength of his people]), introit to the Mass for the sixth Sunday after Pentecost (Victoria and Albert Museum, London; MS 981, no. D. 221–1906). The text on the reverse, "[Ne commov]ear. C[omm. Unam pe]tii a Domin[o]" (Not be disturbed. Communion: One thing I have asked of the Lord), is the conclusion of the offertory hymn and the beginning of the Communion hymn for the fifth Sunday after Pentecost.

20. A Prophet in an initial O ("Omnes gentes plaudite manibus" [Clap your hands, all you people]), introit to the Mass for the seventh Sunday after Pentecost (The Pierpont Morgan Library, New York; M. 478, fol. 11 [fig. 64]). The text on the reverse, "[Domi]ne com. Cir[cuibo et im] molabo in ta[bernaculo] ejus hostiam jubilationis" (Lord. Communion: I will draw near and joyfully offer a sacrifice in his tabernacle), is the conclusion of the offertory hymn and the beginning of the Communion hymn from the Mass for the sixth Sunday after Pentecost.

21. A Prophet in an initial S ("Suscepimus deus misericordiam tuam" [We have received your kindness, O God]), introit to the Mass for the eighth Sunday after

Pentecost (Victoria and Albert Museum, London; MS 978, no. D. 218–1906). The text on the reverse, "Quia non [est confusi]o confiden[tibus in te Domine]" (For there is no confusion to those who trust in you, O Lord), concludes the offertory hymn from the Mass for the preceding seventh Sunday after Pentecost.

22. A Prophet in an initial E ("Ecce deus adiuvat me" [Behold, God is my helper]), introit to the Mass for the ninth Sunday after Pentecost (The Pierpont Morgan Library, New York; M. 478, fol. 5). The text on the reverse, "Gustate et [videte]" (Taste and see), begins the Communion hymn from the Mass for the eighth Sunday after Pentecost.

23. A Prophet in an initial D ("Deus in loco sancto suo" [God is in his holy place]), introit to the Mass for the eleventh Sunday after Pentecost (The Pierpont Morgan Library, New York; M. 478, fol. 1). The text on the reverse, "[Ipse dabit virtutem et fortitudinem] plebi [suae. Ps. Ex]surgat Deus [et dissipentur inimici eius]" (It is he who gives power and strength to his people. Ps[alm] Let God arise and let his enemies be scattered), continues the introit to the Mass for the eleventh Sunday after Pentecost.

24. A Prophet in an initial D ("Deus in adiutorium meum intende" [O God, come to my assistance]), introit to the Mass for the twelfth Sunday after Pentecost (The Pierpont Morgan Library, New York;

M. 478, fol. 2). The text on the reverse, "[Honora Dominum de tu]a sub [stantia et] de primiti[is frugum tuarum]" (Honor the Lord with your substance and with the first of all your fruits), begins the Communion hymn from the Mass for the eleventh Sunday after Pentecost.

25. A Prophet in an initial R ("Respice domine in testamentum tuum" [Advert to your covenant, O Lord]), introit to the Mass for the thirteenth Sunday after Pentecost (The Pierpont Morgan Library, New York; M. 478, fol. 15). The text on the reverse, "[Ut educ]as panem [de terra et vin]um laeti [ficet cor hominis]" (That you may bring forth food from the earth and wine to cheer the heart of man), is a fragment of the Communion hymn from the Mass for the twelfth Sunday after Pentecost.

26. A Prophet in an initial P ("Protector noster aspice deus" [O God, our protector, look]), introit to the Mass for the fourteenth Sunday after Pentecost (The Pierpont Morgan Library, New York; M. 478, fol. 13). The text on the reverse, "[Quia melior est dies una atriis tui]s super mi[lia Ps. Quam dilec[ta tabernacula tua Do]mi[ne virtutum]" (Better indeed is one day in your courts than a thousand elsewhere. Ps[alm] How lovely is your dwelling place, O Lord), continues the introit to the Mass for the fourteenth Sunday after Pentecost.

27. An initial I ("Inclina Domine aurem tuam ad me" [Incline your ear, O Lord]), introit to the Mass for the fifteenth Sunday after Pentecost (Museo Civico, Padua; M.C. 904). The text on the reverse, "[Mis]erere [mihi Domi]ne quoniam [ad te clama] vi tota [die]" (Have pity on me, O Lord, for to you I call all the day), continues the introit to the Mass for the fifteenth Sunday after Pentecost.

28. A Prophet in an initial M ("Miserere mihi domine" [Have pity on me, O Lord]), introit to the Mass for the sixteenth Sunday after Pentecost (The Pierpont Morgan Library, New York; M 478, fol. 8). The text on the reverse, "[Et immisit in os meum canticum novum y]mnum de[o nostro.] Co. Qui [manducat carnem meam]" (And he put a new song into my mouth, a hymn to our God), concludes the offertory hymn and begins the Communion hymn from the Mass for the fifteenth Sunday after Pentecost.

29. An initial I ("Iustus es domine" [You are just, O Lord]), introit to the Mass for the seventeenth Sunday after Pentecost (Museo Civico, Padua; M.C. 879). Above the initial is a fragment of the Communion hymn from the Mass for the sixteenth Sunday after Pentecost, "[Deus] ne d[erelinquas me]" (God, forsake me not). The text on the reverse,

"[Cantate Domino canticum novum q]uia [mirabilia fecit] do[minus]" (Sing to the Lord a new canticle, for he has done wondrous deeds), is part of the gradual from the same Mass.

30. A Prophet in an initial D ("Da pacem domine" [Grant peace, O Lord]), introit to the Mass for the eighteenth Sunday after Pentecost (Victoria and Albert Museum, London; inv. no. D 228–1906). The text on the reverse, "Laetatus [sum in his quae d]icta sunt mi[hi]" (I rejoice at the tidings which were told me), continues the introit to the Mass for the eighteenth Sunday after Pentecost.

31. A Prophet in an initial S ("Salus populi ego sum" [I am the salvation of the people]), introit to the Mass for the nineteenth Sunday after Pentecost (The Pierpont Morgan Library, New York; M. 478, fol. 16 [fig. 65]). The text on the reverse, "[Et ero illorum] dominus [in per]petuum" (And I will be their Lord forever), continues the introit to the Mass for the nineteenth Sunday after Pentecost.

32. A Prophet in an initial O ("Omnia qua fecisti nobis domine" [All that you have done to us, O Lord]), introit to the Mass for the twentieth Sunday after Pentecost (The Pierpont Morgan Library, New York; M. 478, fol. 12). The text on the reverse, "[Sed da gloriam] nomini [tuo]" (But give glory to your own name), continues the introit to the same Mass.

33. A Prophet in an initial I ("In voluntate tua domine" [All things depend on your will, O Lord]), introit to

Figure 65. Don Silvestro dei Gherarducci, A Prophet in an initial S. The Pierpont Morgan Library, New York

the Mass for the twenty-first Sunday after Pentecost (Museo Civico, Padua; M.C. 880). The text on the reverse, "[Super flumi]na [Babylonis illic sedimu]s et [flevimus]" (Upon the rivers of Babylon, there we sat and wept), begins the offertory hymn from the Mass for the twentieth Sunday after Pentecost.

34. A Prophet in an initial D ("Dicit dominus ego cogito cogitationes pacis" [Said the Lord, I think thoughts of peace]), introit to the Mass for the twenty-third Sunday after Pentecost (The Pierpont Morgan Library, New York; M. 718, fol. 18). The text on the reverse, "[Ut placeant verba mea in] conspec[tu principis]" (That my words may be pleasing in the presence of the prince), concludes the offertory hymn from the Mass for the twenty-second Sunday after Pentecost.

GF

1. Vasari 1878–85, vol. 2, pp. 22–23:

> Onde non mi pare da passare in niun modo con silenzio un Don Jacopo fiorentino, che fu molto innanzi al detto Don Lorenzo . . . così fu il miglior scrittore di lettere grosse che fusse prima o sia stato poi non solo in Toscana, ma in tutta Europa: chome chiaramente ne dimostrano non solo i venti pezzi grandissimi di libri da coro che egli lasciò nel suo monasterio . . . ma infiniti altri ancora che in Roma ed in Venezia ed in molti altri luoghi si ritrovano; e massimamente in San Michele ed in S. Mattia di Murano, monasterio della sua religione Camaldolese . . . Don Silvestro; il quale non meno eccellentemente, per quanto portò la condizione di que' tempi miniò i detti libri, che gli avesse scritti Don Jacopo . . . perciochè furono le opere di questi monaci intorno agli anni di nostra salute 1350, o poco prima o poi; come in ciascuno di detti libri si vede.

The Don Jacopo much praised by Vasari as an outstanding scribe was Don Giacobbo dei Franceschi, who took the habit in 1350 and died at the age of sixty in 1396. In the list of monks at Santa Maria degli Angeli, there is a clear reference to his quality as an excellent writer: "Omnium scriptorum suo tempore existentium gloria cuius industria ac indefesso usque ad mortem labore abundantia omnium generum librorum ecclesia nostra refloret" (ASF, Conventi Soppressi, 86, 96, fol. 37). It is highly likely that Vasari, who was apparently very familiar with the affairs of Santa Maria degli Angeli, had seen this volume and in particular the lists of monks. This could explain his assertion that the works of Don Jacopo and Don Silvestro were carried out about 1350. Vasari probably saw the date 1350 in reference to Don Jacopo's entry into the monastery and the commendation of his writing skills, hence the eulogy in his *Lives*.

2. ASF, Conventi Soppressi, 78, 95, fol. 67v, at the margin:

> Libri venduti al'abate di S. Michele
> Vendemo adì 5 di lugl[i]o 1422 all'abate di Sancto Michele da Murano da Vinegia uno messale per fiorini 30 nuovi, uno libro di Morali di Sancto Gregorio fiorini 20 nuovi, le legende Troche di frate Jacopo per fiorini 5 nuovo, L'Expositione di Sancto Ambruogio sopra il Salmo Beati Iudinclati [*sic*] fiorini 5. E avemo tucti questi fiorini sexanta nuovi per lectera di cambio dalla tovala [tavola] di Giovanni di Bicci, e perche le dette Morali furono della Badia di Monte Christo, facemo di patto che se mai l'abate di detto monastero lo rivolesse, l'abate di S. Michele ce lo fosse tenuto a rendere, rendendo noi fiorini 20 nuovi, che fu il pregio suo.

3. The letter is recorded in Caffarini 1974, pp. 2–5:

> Igitur, ut consulitis scribo abbati sancti Michaelis de Murano . . . Ideo quicquid aliud habetis quomodocumque dicta vel facta, faciatis transcribi, ea videlicet, que nec correctione vel ordinatione egent alia, in formatum littere quantum est possibile quam magnitudinis cartarum edinarum et lineamentorum sicut istam cartam videbitis presentibus alligatam, excepto dicto fine capituli duodecimi partis secunde . . . Et si quid ultra est, pur littera cursiva scribatur, quia eam addere volo libro iam facto et ligato, in quo spatium idcirco dimissum est. Alia vero, que revidenda vel translatanda aliter viderentur, pur littera cursiva bombisina scribi faciatis, ut si quando aliter componerentur per alium, perdiderim impensas. Et ideo videatis que habetis vel habere potestis, et secundum dictam formam traditam et qualitatem operis copiari celeriter faciatis. De salario scriptoris et cartis vestre caritati relinquo. Sitis cum domino dicto abbate et, si in suo monasterio fieri potest, bene quidem, sin autem, alibi procuretis. Valete in Domino . . . Florentie die 5 aprilis 1401 Vester prior heremitarum ordinis Camaldulensium.

Guidoni's letter to Caffarini encloses detailed recommendations concerning the production of a manuscript on the Life of Saint Catherine of Siena. It is easy to imagine that such contacts and precise recommendations also existed with respect to illuminated choir books. In the case of the Tuscan friars in Venice, this is demonstrated by Giovanni Dominici's letters to the Dominican Mantellate in Venice (see n. 4).

For Fra Tommaso d'Antonio Caffarini, his scriptorium, and his propaganda in favor of the Dominican order and Saint Catherine of Siena, see Freuler 1987, pp. 570 ff.

4. Dominici 1969, p. 113: "Dilectissime Sorores . . . Libros miniare potestis, quia bene operamini satis et spatia magna pro nunc dimittatis; ne forte peteretis ab Abbate Santi Michaelis de Muriano Gradualia sua, in quibus sunt aliqua minia magna, facta cum penna, et maxime infra octavas Resurrectionis et Pentecostes et secundum illa exemplaria possetis et vos operari."

5. The initials lost during World War II were an initial L (MS D. 220–1906) and an initial E (MS D. 223–1906). These two initials with prophets were included in a catalogue of 1908 (Cockerell and Strange 1908, p. 85). According to the information given me by Frances Rankine of the Victoria and Albert Museum Department of Prints and Drawings, these miniatures were lost after the early 1940s. The initial E may be identical with a cutting now in an English private collection that possibly illustrates the introit to the Mass for

Sexagesima Sunday, "Exurge quare obdormis domine exsurge" (Awake! Why are you asleep, O Lord? Arise!); however, the initial also could have introduced the introit to either the Saturday after Pentecost or the fifth Sunday after Pentecost, neither initial to which has yet been identified.

17a. The Nativity of Christ in an Initial D

Tempera and gold leaf on parchment
22 7/8 × 15 3/4 in. (58 × 40 cm)

The Board of Trustees of the Victoria and Albert Museum, London (MS 966 [3074])

The Holy Parents are gathered around the crib to adore their newborn child, who gazes out at the beholder. He is sheltered by the roof over the entrance to the cave and is warmed by the breath of the ox and donkey. Kneeling, Mary and Joseph silently meditate on the mystery of the newborn Savior. Descending from the gold-illuminated sky, an angel clad in luminous orange red garments joins them in their prayer. The scene of the Adoration of the Christ Child is harmoniously enclosed in the rounded shape of the letter D. Golden tendrils with cornflowers and thistles adorn the lateral and lower margins of the page. The precious quality of this floral ornament is enhanced by the peacock proudly displaying his feathers in the *bas-de-page*.

The text of this page is the introit to the Midnight

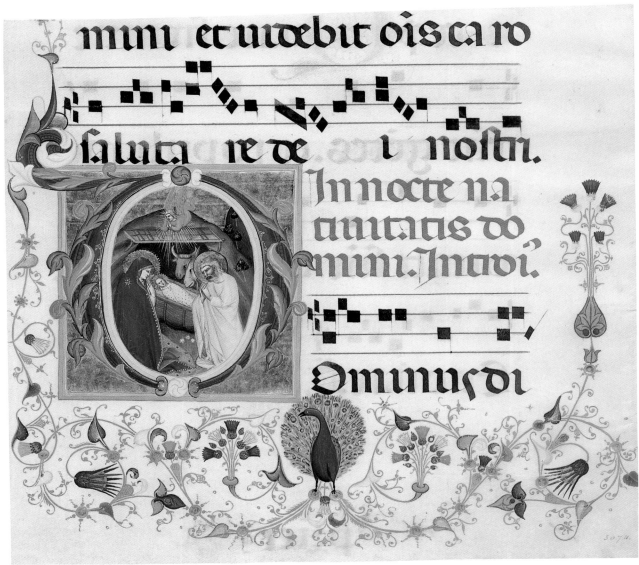

Mass for Christmas. The page was folio 32 of Gradual 1 from Murano.

Don Silvestro's depiction of the Nativity as well as the Adoration of the Shepherds in an initial L from the same choir book (cat. no. 17b) is clearly rooted in the Sienese tradition and echoes an invention by the Lorenzettis that, to judge from various later interpretations, must have enjoyed great popularity in Siena. It was probably the Lorenzettis who, stimulated by the narration of the *Meditationes vitae Christi*, in their Nativities began to focus on the introspective element—on the adoration of the child by his parents and the shepherds rather than on the Divine Incarnation itself. To my knowledge the earliest Sienese depiction of this iconography, which combines the Adoration of the Child by His Parents and the Annunciation to the Shepherds and their subsequent arrival at the crib, is a small panel from Ambrogio Lorenzetti's workshop (Städelsches Kunstinstitut, Frankfurt). However, rather than being the immediate source for the later Nativities of this kind (including the ones by Don Silvestro), the panel might reflect a highly successful lost painting by Ambrogio Lorenzetti (Freuler 1986, pp. 56ff.).

Despite the vibrant colors of lapis lazuli, dark green, various beige tones, and the angel's luminous orange red, the present leaf is of a somewhat feebler execution than many others from the San Michele a Murano Gradual; this weakness is seen in the draftsmanship of its figures, which suffers by comparison with other illuminations from the same choir book. It seems to have been painted by an assistant of Don Silvestro's, who shows some exaggerated graphic tendencies that are especially noticeable in the treatment of Joseph's mantle.

GF

LITERATURE: Cockerell and Strange 1908, p. 85; Levi D'Ancona 1993, pp. 10, 19, fig. 2; Freuler n.d.

17b

17b. The Adoration of the Shepherds in an Initial L

Tempera and gold leaf on parchment
12 ¹/₂ × 6 ¹/₂ in. (31.8 × 16.5 cm)

The Board of Trustees of the Victoria and Albert Museum, London (MS 967 [D. 229–1906])

The scene within the initial L is set in the same hilly landscape with a grotto as appears in Catalogue Number 17a. The Christ child lies swaddled in a wattle crib beneath a canopy propped against the hillside. Two shepherds have knelt down to worship the newborn Savior. A sheep from their flock has joined them and raises its head toward the luminous apparition of two adoring angels hovering over the crib.

The initial L introduced the introit to the Mass for Christmas morning. As with the Victoria and Albert Nativity (cat. no. 17a), the composition of this charming Adoration unmistakably echoes a Sienese painting, in all likelihood a lost *Nativity* by Ambrogio Lorenzetti. The motif of the two kneeling shepherds worshiping the newborn child seems to be drawn from the same pictorial source as those in Bartolo di Fredi's various paintings of the Adoration of the Shepherds (Metropolitan Museum, acc. no. 25.120.288; the church of Sante Flora e Lucilla, Torrita di Siena; Musée du Petit Palais, Avignon; Freuler 1994, figs. 110, 111, 322). Not only is the age difference between the two shepherds—one middle-aged and dark-haired, the other elderly—duplicated in those compositions, but also their poses, as they pray and lean on sticks, are similar to those in Bartolo di Fredi's paintings. If Bartolo di Fredi's paintings directly derive from the lost painting by Lorenzetti mentioned above, there is good reason to suppose that Don Silvestro's shepherds reflect the lost Lorenzetti *Adoration* as well.

GF

LITERATURE: Cockerell and Strange 1908, p. 85; Levi D'Ancona 1957, pp. 21–23; Boskovits 1975, pp. 115, 217 n. 91, 423–24; Mariani Canova, in Milan 1988, p. 235; Freuler 1992, pp. 480–85; Levi D'Ancona 1993, p. 10, fig. 3; Freuler n.d.

17c. The Nativity and the Annunciation to the Shepherds in an Initial P

Tempera and gold leaf on parchment
22 7/16 × 15 in. (57 × 38 cm)

The Pierpont Morgan Library, New York (M. 653, fol. 1)

The letter P of this richly decorated page—a masterpiece of coloration—encloses a later episode in Christ's Nativity than that of the two previous illuminations. Here the newborn Christ is outside the crib, which is placed obliquely in the entrance to the grotto. He sits on his mother's lap and suckles her breast. The Virgin Mary, here represented as a Madonna of Humility sitting on a vivaciously patterned cushion, gazes toward her spouse, who with deepest devotion kisses his son's little feet. Various angels fly joyfully toward the Holy Family, having brought the good tidings to the shepherds, one of whom, appearing behind the hill, is about to arrive. The actual Annunciation to the Shepherds is not narrated within the initial but extends to the border decoration in the lower left margin, which consists of stylized flowers

and leaves. At the left two shepherds turn their faces toward the heavenly messenger, who points to the scene within the initial and offers an olive branch, symbolizing peace between heaven and earth. The shepherd's flock continues over the entire decoration of the lower border and guides us to another shepherd, at the lower right, who, accompanied by his dog, joyously plays a bagpipe. The busts of two more shepherds appear within the foliage.

The leaf contains the introit to the Mass for Christmas Day. The roman numeral XXXVIII on its verso indicates that the chorals of the Christmas Mass commenced on folio 38v in Gradual 1 from San Michele a Murano.

There exists an earlier Florentine leaf of the same liturgy in which a similar decorative arrangement is to be found; it is a cutting attributed to the Master of the Dominican Effigies now in the Staatliches Kupferstichkabinett, Berlin (no. 1228; fig. 25). The idea of depicting the Annunciation to the Shepherds in the foliage growing out of the bottom of the letter P is repeated in an illuminated page by Lippo Vanni (1363–70; Archivio Capitolare di San Lorenzo, Florence, Cor. E, fol. 42v). Since this came from Florence, it might well have been known to Don Silvestro (Wainwright 1988, pp. 26–36, fig. 8). By representing Mary as the Madonna of Humility, Don Silvestro drew on the panel by Andrea Orcagna and Jacopo di Cione in the National Gallery of Art, Washington, D.C., which he repeated on various occasions (Galleria dell'Accademia, Florence, inv. no. 3161; formerly the de Clemente collection, Florence; Herrington Collection, Indianapolis; Fine Arts Museums, San Francisco). Even in the small format of a miniature, Don Silvestro followed the model of Orcagna's Madonnas of Humility with surprising precision (see, for instance, the elegantly drawn, sinuous folds in the hem of the Virgin's mantle), deviating from them only in iconography. Instead of turning toward the suckling child, the Virgin gazes to the right, to Joseph, who kisses the child's feet.

GF

EX COLL.: W. Bromley-Davenport, Capesthorne Hall [sale, Quaritch, London, 1907, lot 181]; J. Pierpont Morgan (1910).

LITERATURE: Da Costa Greene and Harrsen 1934, p. 44, no. 93; De Ricci and Wilson 1935–37, vol. 2, p. 1479; Harrsen and Boyce 1953, p. 16, no. 27; Salmi 1954b, p. 42; Levi D'Ancona 1957, pp. 22, 23; Berkeley 1963, p. 25, no. 40; Bellosi 1965, p. 42 n. 16; New York 1967, no. 3a; Offner 1967, p. 53 n. 4; Rotili, in Rotili and Putaturo Murano 1970, pp. 89–90; Boskovits 1975, pp. 115, 217 n. 91, 422, 424–25; Levi D'Ancona 1978, p. 234 n. 57; New York 1984, no. 12; Levi D'Ancona 1985, p. 456; Mariani Canova, in Milan 1988, p. 235; Freuler 1992, pp. 480–85; Levi D'Ancona 1993, pp. 12–14, pl. 1; Freuler n.d.

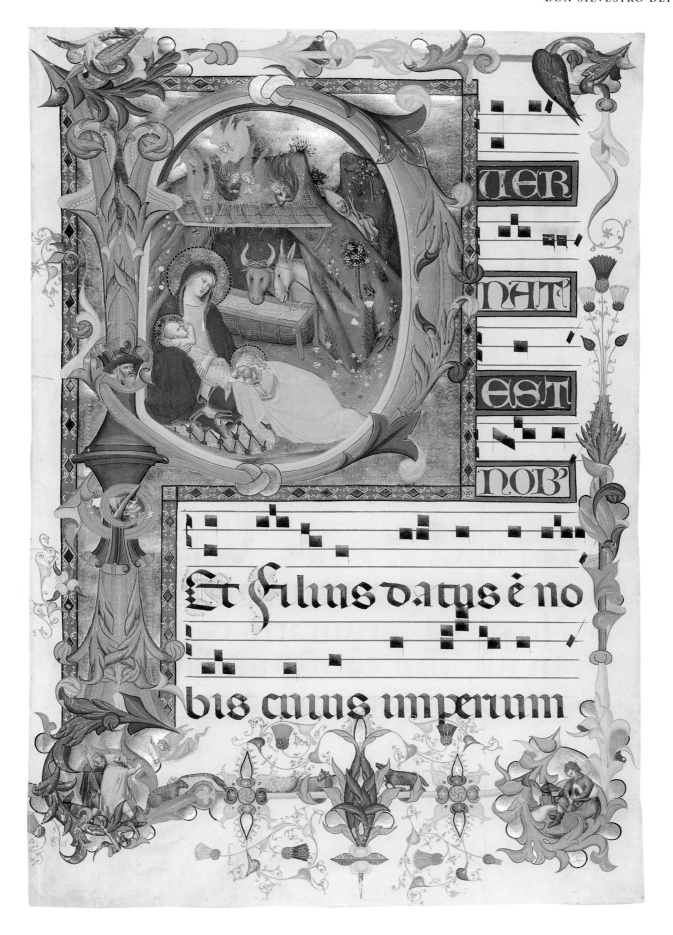

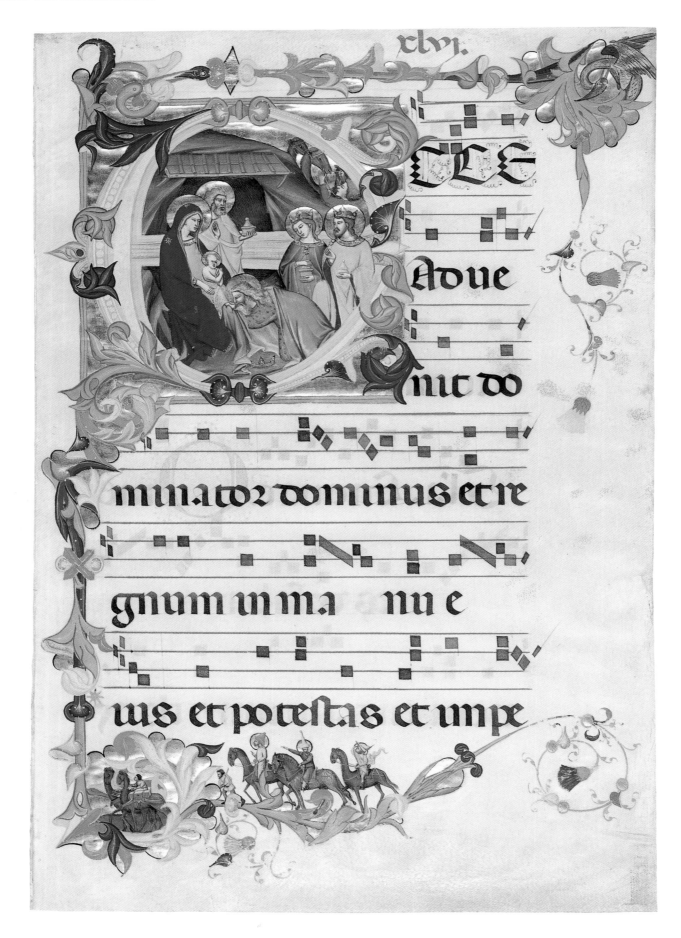

17d. The Adoration of the Magi in an Initial E

Tempera and gold leaf on parchment
22 7/8 × 15 3/4 in. (58 × 40 cm)

The Pierpont Morgan Library, New York (M. 653, fol. 5)

The initial E encloses the Adoration of the Magi in a setting much the same as that of the three initials narrating events of the Nativity (cat. no. 17a–c). The horizontal bar of the initial E divides the protagonists from the background, where a knight is about to tame a nervous camel appearing behind the hill. The Three Magi, characterizing the three ages of man, have knelt down in reverence to the newborn King. The eldest, in a moving gesture, kisses the feet of the child (Offner 1947, p. 212 n. 1), who, sitting in his mother's lap, blesses the Magus in turn. Joseph, standing next to his spouse and holding the eldest Magus's gift, meditates on the king's submission to the new King of Kings. As in the leaf with the Nativity of Christ and the Annunciation to the Shepherds (cat. no. 17c), the narration of the Epiphany extends from the initial into the border decoration of the lower margin — made up of stylized flowers and leaves — where we see the Journey of the Three Magi and their suite.

The initial E begins the introit to the Mass for the feast of Epiphany (January 6). The leaf bears a number (XLVI) and was consequently folio 46 of Gradual 1 from San Michele a Murano.

Though the action here develops from right to left rather than the usual left to right, the iconography of Don Silvestro's Adoration of the Magi seems to have been inspired by a pattern dear to the most distinguished Sienese painters and illuminators, such as Pietro Lorenzetti, Lippo Vanni, and particularly Niccolò di Ser Sozzo (Wildenstein Collection, Musée Marmottan, Paris, no. 89; Museo Diocesano d'Arte Sacra, San Gimignano, Cod. LXVIII.I, fol. 17 [Siena 1982, p. 243]).

In the Journey of the Magi in the lower border, however, such vignettes as their lively reaction to the guiding star of Bethlehem or the page riding on the camel might have been inspired by a nearly contemporary Sienese painting — Bartolo di Fredi's large panel for the Tolomei Chapel in Siena cathedral (1385–89, Pinacoteca Nazionale, Siena, 104; Freuler 1994, pp. 284–300). The lively portrayal of the theme here as well as in Bartolo di Fredi's panel might have been suggested by Johannes von Hildesheim's *Liber trium regum* (ca. 1370), a text well known in Tuscany.

In comparison with other illuminations from the same choir book, the present leaf is of a somewhat feeble execution with respect to the draftsmanship of the figures. It was painted by the same hand responsible for the leaf with the Nativity in the Victoria and Albert Museum (cat. no. 17a) — an assistant of Don Silvestro's, who shows some extreme graphic tendencies that are especially evident in the treatment of Joseph's mantle.

GF

EX COLL.: W. Bromley-Davenport, Capesthorne Hall [sale, Quaritch, London, 1907, lot 181]; J. Pierpont Morgan (1910).

LITERATURE: Da Costa Greene and Harrsen 1934, p. 44, no. 93; De Ricci and Wilson 1935–37, vol. 2, p. 1479; Harrsen and Boyce 1953, p. 16, no. 27; Levi D'Ancona 1957, pp. 22, 23; Berkeley 1963, p. 25, no. 40; Bellosi 1965, p. 42 n. 16; New York 1967, no. 3a; Offner 1967, p. 53 n. 4; Rotili, in Rotili and Putaturo Murano 1970, pp. 89–90; Boskovits 1975, pp. 115, 217 n. 91, 422, 424–25; Levi D'Ancona 1978, p. 234 n. 57; New York 1984, no. 12; Mariani Canova, in Milan 1988, p. 235; Freuler 1992, pp. 480–85; Levi D'Ancona 1993, pp. 12–14, pl. 1; Freuler n.d.

17e. The Ascension of Christ in an Initial V

Tempera and gold leaf on parchment
22 7/8 × 15 3/4 in. (58 × 40 cm)

The Pierpont Morgan Library, New York (M. 653, fol. 3)

The letter V of this richly decorated page encloses the Ascension of Christ. The apostles have gathered in a circle around the Virgin. Amazed by the apparition of Christ, they gaze up at him as he ascends to heaven. The apostles' emotional expressions and gestures contrast sharply to the Virgin's quiet demeanor.

The initial V introduces the Mass for the feast of the Ascension. The leaf bears the number XLIIII on its reverse and was therefore folio 44 of Gradual 2 from San Michele a Murano.

Don Silvestro's lively narration of the Ascension is a synthesis of two distinct pictorial traditions, documenting his artistic formation in Siena as well as his subsequent association with Andrea Orcagna and his circle, who dominated Florentine painting in the third quarter of the trecento. Don Silvestro's manner of arranging the apostles in a circle seems to have been suggested to him by Jacopo di Cione (National Gallery, London, inv. no. 577; Davies 1988, p. 49), whereas other details, such as the Virgin's prominent central position

17e

and Christ's dynamically rendered departure from the earthly regions, are drawn from Sienese sources. A comparable compositional organization appears in Andrea Vanni's panel in the Hermitage, Saint Petersburg, where the dynamics of Christ's Ascension are similarly rendered—his body ascends diagonally, his drapery fluttering. This subtle description of movement, an idea perhaps suggested by Ambrogio Lorenzetti, is in sharp contrast to Christ's static rendering in Jacopo di Cione's panel.

GF

Ex coll.: W. Bromley-Davenport, Capesthorne Hall [sale, Quaritch, London, 1907, lot 181]; J. Pierpont Morgan (1910).

Literature: Da Costa Greene and Harrsen 1934, p. 44, no. 93; De Ricci and Wilson 1935–37, vol. 2, p. 1479; Salmi 1952, pp. 17, 18; Harrsen and Boyce 1953, p. 16, no. 27; Salmi 1954b, p. 42; Levi D'Ancona 1957, pp. 22, 23; Berkeley 1963, p. 25, no. 40; Bellosi 1965, p. 42 n. 16; Hartford 1965, p. 46, no. 83; New York 1967, no. 3a; Offner 1967, p. 53 n. 4; Rotili, in Rotili and Putaturo Murano 1970, pp. 89–90; Boskovits 1975, pp. 115, 217 n. 91, 422, 424–25; Levi D'Ancona 1978, p. 234 n. 57; New York 1984, no. 12; Levi D'Ancona 1985,

17f

p. 456; Mariani Canova, in Milan 1988, p. 235; Freuler 1992, pp. 480–85; Levi D'Ancona 1993, pp. 12–14, pl. 1; Freuler n.d.

17f. The Trinity in an Initial B

Tempera and gold leaf on parchment
22 × 15 in. (56 × 38 cm)

The Pierpont Morgan Library, New York (M. 653, fol. 2)

The initial B is formed of red intertwining tendrils with abundant foliage that grows and extends into the margins. It offers space for two different representations of the Trinity. In the upper section, behind a richly ornamented altar and two candelabra, appear the Three Divine Persons: at the left is the Holy Ghost, symbolized by the dove above his head; in the center is the Son holding the eucharistic symbols of the chalice and the Host and with an open Bible above his head, where we read "Ego sum via veritas et vita" (I am the way, the truth, and the life); and at the right is God the Father,

who is indicated by an armillary sphere as an emblem of the universe. The lower section of the letter includes an Old Testament antetype for the Trinity (Gn 18:1ff.). In the courtyard of a palace, Abraham kneels before the three angels, who announce to him the miraculous birth of a son.

The initial B introduces the Mass of the Holy Trinity. The folio is numbered LXXIIII on the back, which confirms that it was folio 74 of Gradual 2 from San Michele a Murano.

This particular page gives important proof that Don Silvestro's two reconstructed graduals were not created for Santa Maria degli Angeli, as has recently been claimed (Levi D'Ancona 1993), but for San Michele a Murano. This leaf, as several others did, served as a model for the pictorial decoration by Cristoforo Cortese and Belbello of Pavia for the graduals for the Camaldolese monastery of San Mattia in Murano (Mariani Canova, in Milan 1988, p. 235; Freuler 1992, pp. 480–85). Belbello's page with the Trinity (Kupferstichkabinett, Berlin; MS 78), which follows Don Silvestro's concept with respect to both the figural compositions and the decoration of the initial with intertwining tendrils, makes Dominici's exhortation to decorate according to the graduals in San Michele a Murano ("et secundum exemplaria possetis vos operari") sound as if it were addressed not to the Sisters of Corpus Christi but directly to Cortese and Belbello.

Don Silvestro's page with the Trinity seems also to have inspired his fellow Camaldolese illuminator Don Lorenzo Monaco, for the latter's initial in the National Gallery, London (fig. 93), which was itself once attributed to Don Silvestro (Levi D'Ancona 1957, p. 22; Eisenberg 1989, p. 188), is clearly indebted to the older master. Possibly under Don Silvestro's influence, Lorenzo Monaco's draftsmanship, which was formerly somewhat restrained under the neo-Giottesque influence of Spinello Aretino and Agnolo Gaddi, in the London miniature became more fluid and at the same time more decisive, and he began to give his forms greater volume. But already in this miniature, Don Lorenzo goes beyond Don Silvestro's example. The psychological interpretation of Don Silvestro's figures is primarily limited to facial detail and manual gesture, whereas Don Lorenzo skillfully extends this to the entire figure in a forceful yet unexaggerated manner. Also in Don Lorenzo's miniature, the group of angels appears as a unit but, unlike Don Silvestro, he conceives the movement of each figure individually. Despite the somewhat forced emotional expression in the vehement turn of Abraham's head as he looks upward and in the angels' spiritual communication, the little picture radiates a calm monumentality that is enhanced by simpler and at the same time more clearly rendered volumes. The calculated interplay between line and mass that evidently Don Silvestro strove to achieve in his last work for the choir books of San Michele a Murano is developed further. The individual characterization and naturalistic details are achieved by him through conventional trecento means, that is, primarily through draftsmanship, whereas in Lorenzo's work (including the prophets in his choir books) these are subordinated to a dominant form conceived in abstract yet tangible volumes.

GF

EX COLL.: W. Bromley-Davenport, Capesthorne Hall [sale, Quaritch, London, 1907, lot 181]; J. Pierpont Morgan (1910).

LITERATURE: Da Costa Greene and Harrsen 1934, p. 44, no. 93; De Ricci and Wilson 1935–37, vol. 2, p. 1479; Harrsen and Boyce 1953, p. 16, no. 27; Salmi 1954b, p. 42; Offner 1956, p. 145 n. 32; Levi D'Ancona 1957, pp. 22, 23; Offner 1957, p. 18 n. 2; Berkeley 1963, p. 25, no. 40; Bellosi 1965, p. 42 n. 16; New York 1967, no. 3a; Offner 1967, p. 53 n. 4; Rotili, in Rotili and Putaturo Murano 1970, pp. 89–90; Boskovits 1975, pp. 115, 217 n. 91, 422, 424–25; Levi D'Ancona 1978, p. 234 n. 57; New York 1984, no. 12; Levi D'Ancona 1985, p. 456; Mariani Canova, in Milan 1988, p. 235; Freuler 1992, pp. 480–85; Levi D'Ancona 1993, pp. 12–14, pl. 1; Freuler n.d.

17g. The Last Supper in an Initial C

Tempera and gold leaf on parchment
$22\,7/8 \times 15\,3/4$ in. (58×40 cm)

The Pierpont Morgan Library, New York (M. 653, fol. 4)

The scene of the Last Supper is harmoniously enclosed in the round shape of the letter C. Animated twisting foliage, including precious golden tendrils with cornflowers and thistles, adorns the lateral and lower margins of the page.

The initial opens into a space reminiscent of that of the Lorenzettis, especially Ambrogio, but here it is conceived merely as a backdrop. The apostles sit encircling a round table and react animatedly to Christ announcing that one of them will betray him: some are intent in conversation with their companions, while others turn to the beholder to involve him in their discomposure. Judas, the subject of this general agitation, is about to eat a piece of bread (Jn 13:26). His black halo

containing scorpions and the flashing red money bag at his belt define him as Christ's betrayer (see Offner 1967, p. 53 n. 4).

The initial C introduced the Mass of Corpus Domini. The leaf bears the number LXXVIII and was consequently folio 78 of Gradual 2 from San Michele a Murano.

The compositional device of the round table in the scene of the Last Supper was popular in Florentine painting (Offner 1958, p. 170 n. 2) and, through the inspiration of Giotto's work in Padua and Rimini, was common in Emilian and Lombard painting as well (Trachsler 1977, fig. 7, p. 161). As is demonstrated by Pietro Lorenzetti's splendid fresco in the lower church of San Francesco in Assisi and later Sienese paintings from the workshops of Niccolò di Buonaccorso (Pinacoteca, Siena, inv. no. 163; Torriti 1977, p. 211) and Andrea di Bartolo (Pinacoteca, Bologna, no. 288; Kanter 1986, p. 25), it was also known in Sienese art.

Various aspects of Don Silvestro's miniature, however, indicate that, once again, he might have been inspired primarily by Sienese painting. The spatial setting is in the tradition of the Lorenzettis (cf. Ambrogio Lorenzetti's fresco *Saint Louis of Toulouse Before Pope Boniface VIII* in the church of San Francesco, Siena), but Don Silvestro, in keeping with his Sienese contemporaries Luca di Tommè, Paolo di Giovanni Fei, and Bartolo di Fredi, reduced the complex Lorenzettian space to a simple backdrop. Even the parsimonious architectural ornament, such as the simple friezes with lozenge-shaped elements, seems to be drawn from Sienese examples, and the protagonists of the scene, Christ and the apostles in animated communication, are depicted in the Sienese spirit found in the examples mentioned above.　　GF

EX COLL.: W. Bromley-Davenport, Capesthorne Hall [sale, Quaritch, London, 1907, lot 181]; J. Pierpont Morgan (1910).

LITERATURE: De Ricci and Wilson 1935–37, vol. 2, p. 1479; Harrsen and Boyce 1953, p. 16, no. 27; Salmi 1954b, p. 42; Levi D'Ancona 1957, pp. 22, 23; Bellosi 1965, p. 42 n. 16; Hartford 1965, p. 46, nos. 83, 84; New York 1967, no. 3a; Offner 1967, p. 53 n. 4; Rotili, in Rotili and Putaturo Murano 1970, pp. 89–90; Boskovits 1975, pp. 115, 217 n. 91, 422, 424–25; Levi D'Ancona 1978, p. 234 n. 57; New York 1984, no. 12; Levi D'Ancona 1985, p. 456; Mariani Canova, in Milan 1988, p. 235; Freuler 1992, pp. 480–85; Levi D'Ancona 1993, pp. 12–14, pl. 1; Freuler n.d.

CENNI DI FRANCESCO

Cenni di Francesco di Ser Cenni's long career is amply documented between 1370 and 1413 by a regular series of dated paintings. He is first recorded in 1369, when he enrolled in the painters' guild (Arte dei Medici e Speziali), and from the following year is a dated triptych in the church of San Cristofano a Perticaia, Rignano sull'Arno, which forms the basis for attributions to his early period. The Rignano triptych reveals Cenni to have been a follower of Orcagna, but probably not at first hand: while its rigid, frontal figures and sharply chiseled draperies imitate some of the externals of Orcagna's style, its lively palette and focused attention to detail are entirely at odds with the sculptor/painter/architect's uncompromising monumentality and dramatic severity. Cenni demonstrates instead a greater affinity with such Orcagnesque masters as Giovanni del Biondo, with whom he collaborated on at least one occasion, possibly in the 1370s, and with Don Silvestro dei Gherarducci, with whom he collaborated on the illuminations of a choir book for San Pier Maggiore (see cat. no. 18). Alongside these masters he perfected a clearly legible compositional technique relying on gesture and setting often described in superabundant naturalistic detail, which is largely devoid of emotional or expressive content but is not infrequently enlivened by a true novelty of narrative approach.

Though his greatest talent is perhaps in the painting of small-scale narrative scenes and densely populated devotional images, Cenni di Francesco was much in demand as a painter of altarpieces and fresco cycles. Among the latter, dated commissions for San Donato in Polverosa near Florence (1383), San Miniato al Tedesco (1393), Volterra (1410), and San Gimignano (1413), as well as altarpieces in Montalbino (1400), Volterra (1408), and San Miniato al Tedesco (1411), chronicle his development in a period otherwise dominated by the accomplishments of such artists as Niccolò di Pietro Gerini, Agnolo Gaddi, Spinello Aretino, and Lorenzo Monaco. These works show Cenni di Francesco to have continued working in a conservative, if highly personal, Orcagnesque style wholly independent of the main trends in Florentine painting of his day, yet his painstaking craftsmanship and engaging, intuitively legible narratives seem to have garnered him a certain commercial success, to judge only from the great number of his paintings surviving today. An unusual proportion of these works were produced for patrons outside of Florence, many in the Pisan provinces of Tuscany, and Cenni's influence on a younger generation of Florentine painters was therefore somewhat limited. The last preserved notice of Cenni di Francesco is of 1415, when he matriculated in the Compagnia di San Luca, and it is reasonable to suppose that he died shortly afterward.

LK

18. Antiphonary

Tempera and gold on parchment; 56 folios; page size, 23 $^{15}/_{16}$ × 16 $^1/_2$ in. (60.8 × 41.8 cm). 8 miniatures in initials; numerous pen-work initials.

Courtesy of the Walters Art Gallery, Baltimore (W 153)

The eight illuminated initials in this book are:

Folio 3r: Saint Peter Enthroned in an initial T ("Tu es pastor ovium, Princeps Apostolorum: tibi traditae sunt claves regni celorum" [You are the shepherd of the sheep, O Prince of the Apostles; to you have been given the keys to the kingdom of heaven]), the antiphon of the magnificat for first vespers of the feast of Saints Peter and Paul (June 29). Peter's throne is a lion-headed faldstool. He holds the keys to heaven in his right hand and an open book in his left.

Folio 4v: Christ Giving the Keys to Saint Peter in an initial S ("Symon Petre antequam de navi vocarem te novi te . . . et claves regni celorum tradidi tibi" [Simon Peter, before I called you away from your boat I knew you . . . and I have given you the keys to the kingdom of heaven]), first response of the first nocturn.

Folio 13v: Saints Peter and John the Evangelist Healing a Cripple on the Steps of the Temple in an initial P ("Petrus et Iohannes ascendebant in templum ad horam orationis nonam" [Peter and John were going up into the temple at the ninth hour of prayer]), first antiphon of lauds.

Folio 16v: Saint Peter as Priest in an initial I ("Iuravit Dominus et non penitebit eum: tu es sacerdos in eternum" [The Lord has sworn, and he will not repent: You are a priest forever]), first antiphon for second vespers. Peter, vested as a priest in a chasuble and alb, holds a chalice and paten in his right hand and the keys in his left. A bust-length figure of Christ appears in a curl of the foliate border at the upper left.

Folio 19v: The Crucifixion of Saint Peter in an initial H ("Hodie Symon Petrus ascendit crucis patibulum . . . hodie claviclarius regni gaudens migravit ad Christum" [Today Simon Peter ascended the wood of the cross . . . today the key-bearer of the kingdom of heaven went joyously to Christ]), antiphon of the magnificat for second vespers. Above the initial, Saint Peter's soul is borne by two angels into the waiting arms of Christ.

Folio 27v: Saint Nicholas of Bari Staying the Execution of Three Young Men in an initial M ("Muneribus datis necesic iuvenes innocenter"), first antiphon of vespers for the feast of Saint Nicholas of Bari (December 6). At the left Saint Nicholas seizes the arm and upraised sword of the executioner, while the three condemned youths kneel before two armed horsemen at the right.

Folio 35v: Saint Peter Enthroned and the Liberation of Saint Peter in an initial N ("Nunc scio vere quia misit dominus angelum suum et eripuit me de manu herodis" [Now I know for certain that the Lord has sent his angel and rescued me from the power of Herod]), the introit to the Mass for the feast of Saints Peter and Paul (June 29). In the upper half of the initial, Saint Peter is enthroned on a lion-headed faldstool, with two angels supporting a cloth of honor behind him. Below the dais of the throne is a separate scene of the angel leading Peter by the hand out of prison.

Folio 39v: Saint Nicholas of Bari Enthroned and Christ Blessing in an initial B ("Beatus Nicholaus urbis mire et pontifex celos penetravit" [Blessed Nicholas of the city of Myra and bishop, he penetrated the skies]), the introit to the Mass for the feast of Saint Nicholas of Bari (December 6).[1] In the lower half of the initial, Nicholas holds a bishop's miter and three gold balls; in the upper half of the initial, Christ holds an unlettered scroll and raises his right hand in benediction.

Though the Baltimore Antiphonary is fragmentary, ending abruptly on folio 56v, and was rebound in the nineteenth century, its contents are not fortuitously

Fol. 27v

35

Fol. 4v

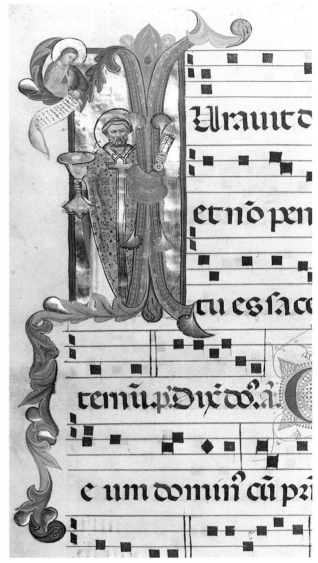

Fol. 16v

limited: its texts and pagination are continuous without hiatus, and it is clear that from the outset the volume was dedicated to Saints Peter and Nicholas of Bari. Furthermore, the offices for these two feasts conclude on folio 34r; folios 34v and 35r are blank; and on folio 35v the introit to the Mass for the feast of Saint Peter begins, followed by the introit to the Mass for the feast of Saint Nicholas on folio 39v.[2] The combination of texts from an antiphonary and a gradual in a single volume and its restriction to two feasts imply that rather than being intended for the general use of a community or congregation, the book may have been commissioned for a chapel dedicated to one of the saints in a church dedicated to the other. This has reasonably been identified (Levi D'Ancona 1962, p. 76) as the chapel of Saint Nicholas of Bari, which was located to the immediate right of

the choir in the church of San Pier Maggiore, Florence (Paatz and Paatz 1940–54, vol. 4, p. 638).

The attribution, dating, and significance of the illuminations in the Baltimore Antiphonary were the subject of a detailed analysis by Mirella Levi D'Ancona (1979), who supposed it to have been commissioned by Bartolomeo Alessandri degli Albizzi (d. 1381) and to contain specific allusions among its miniatures to the end of the Papal Interdict of Florence in 1378 (Saint Peter as Priest) and to the return of the papacy to Rome from Avignon in 1377 (The Liberation of Saint Peter). Carl Strehlke (*in litteris*) correctly rejects any topical interpretations of these illuminations as a basis for establishing the period of their execution, as all the Petrine subjects represented in the antiphonary, with the exception of Saint Peter as Priest, also occurred in the

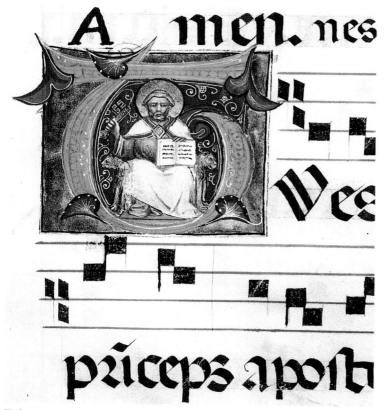

Fol. 3r

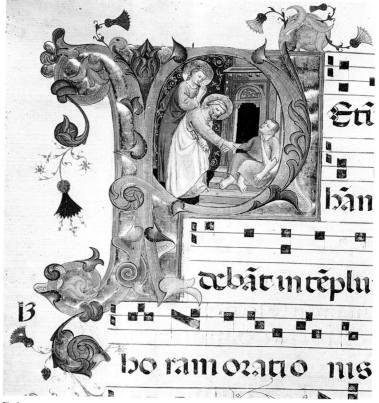

Fol. 13v

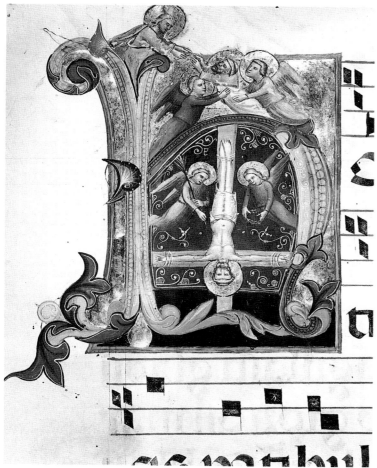

Fol. 19v

Fol. 39v

predella of Jacopo di Cione's high altarpiece of 1371–72 from San Pier Maggiore. In fact, the iconography of all the illuminations in the antiphonary is closely and literally tied to the texts they illustrate: their selection and the details of their compositions were determined exclusively by the liturgy of the Divine Office, not by any symbolic coincidence with contemporary political events.

It has long been recognized that more than one painter was involved in the completion of the Baltimore Antiphonary. Dorothy Miner (Baltimore 1949, no. 162) distinguished three hands among the illuminations, all of which she characterized as Orcagnesque and which Richard Offner (in Baltimore 1962, p. 75) suggested bore a general resemblance to Pietro Nelli and Tommaso del Mazza. Miklós Boskovits (1972, p. 52; 1975, p. 220 n. 128) distinguished four hands in the book. The best of them, the author of the Saint Peter Enthroned and the Liberation of Saint Peter on folio 35v, he identified as the Master of the Orcagnesque Misericordia. He identified Cenni di Francesco di Ser Cenni as the author of the Christ Giving the Keys to Saint Peter on folio 4v and the Miracle of Saint Nicholas of Bari on folio 27v, and perhaps also the Saint Nicholas Enthroned on folio 39v, which, however, he felt shared some features with the work of the Master of the Orcagnesque Misericordia. The remaining initials he divided between two unidentified miniaturists: one responsible for Saints Peter and John Healing a Cripple on folio 13v and Saint Peter as Priest on folio 16v, the other responsible for Saint Peter Enthroned on folio 3r and the Crucifixion of Saint Peter on folio 19v. Levi D'Ancona (1979) attributed the illuminations in the antiphonary to two artists only: the Master of the Orcagnesque Misericordia, whom she identified as Tommaso dei Mazza and to whom she assigned folios 16v and 35v, and Cenni di Francesco.

The basis for Levi D'Ancona's identification of the Master of the Orcagnesque Misericordia with Tommaso del Mazza is a document of payment to the latter for work on the antiphonaries at San Pier Maggiore in 1373, although she also proposes a significantly later date (1378–81) for the Baltimore Antiphonary. Tommaso del Mazza has recently been identified with the artist formerly known as the Master of Santa Verdiana (Deimling 1991), and neither his hand nor that of the Master of the Orcagnesque Misericordia can be isolated among the illuminations in the present manuscript. The eight initials in this volume seem to be the work of only two artists. One, a relatively coarse painter with a limited command of the representation of space, was responsible for the illuminations on folios 3r, 13v, 16v, and 19v. The other, who may be ranked among the most accomplished Florentine miniaturists of the second half of the four-

teenth century, is certainly Cenni di Francesco, as a consideration of even such simple details as his characteristically oversize and sharply faceted hands with elongated, briskly drawn fingers will reveal (see cat. no. 19). Cenni is documented as providing "fighure di mini a pennello" (figures painted in miniatures) for the choir books of San Pier Maggiore in 1376 (Levi D'Ancona 1962, p. 77), but this note probably does not refer to his work on the Baltimore codex, which appears to be slightly later in date, but rather to the larger series of antiphonaries (no volumes of which are known to survive), which were subsequently (1385) lent to Santa Maria degli Angeli to be copied.

Though Cenni di Francesco was responsible for painting the principal miniatures in the Baltimore Antiphonary, their designs may not be attributable entirely to him. The punch tools used to decorate the gold ground in all four of his initials are those of Don Silvestro dei Gherarducci, as are the patterns in which they are deployed; this is especially noticeable in Saint Peter's vestments on folio 35v, which recall a number of pages from Cod. Cor. 2 (for example, cat. no. 16a, fig. 47). Two of the initial letters (fols. 35v, 39v) are also typical of Don Silvestro's designs, as is one of the letters surrounding a scene by the second artist working on the book (fol. 13v). The other initials are decorated with simplified, broadly rendered foliage that does not closely follow the more complicated underdrawing clearly visible beneath. The design of these initials and of the painted scenes they contain most closely recalls Don Silvestro's illuminations in Cod. Cor. 9 from Santa Maria degli Angeli (after 1385), and a date sometime in the 1380s, close to Cenni's work on the San Donato in Polverosa frescoes (1383), seems appropriate for the planning and execution of the entire Baltimore Antiphonary.

Relations between the monasteries of San Pier Maggiore and Santa Maria degli Angeli were close at this period. Both houses operated scriptoria, providing codices for their own use and on commission from other patrons,[3] though the scriptorium at San Pier Maggiore seems to have relied upon outside, usually lay, artists as illuminators. It may be that the commission to illuminate the Baltimore Antiphonary was originally awarded to Don Silvestro dei Gherarducci, who either abandoned it incomplete, with several initials gilt and partially painted and others little more than sketched in, or else conceived it from the beginning as a collaboration with Cenni di Francesco di Ser Cenni.

LK

1. Levi D'Ancona (1979, p. 476 n. 43) incorrectly records this text as "Benedicat vobis Miree Pontifex Nicolaus" and misidentifies it as an antiphon. The introit is rubricated.

2. The Mass of Saint Nicholas is followed by texts from the ordinary of the Mass (fol. 43v), and a fragment of the Mass for the feast of Saints Simon and Thaddeus (October 28) begins on folio 56r. The significance of the inclusion of the latter and whether or not the book once contained further masses cannot now be determined, but the antiphonary is complete and restricted to two feasts only.

3. The Franciscans at Santa Croce ordered a choir book from the scriptorium at San Pier Maggiore in 1383 (Levi D'Ancona 1979, p. 463). This book has been identified by Freuler (n.d.) with Cod. D at Santa Croce, the illuminations in which were attributed to Cenni di Francesco by Boskovits (1968c, p. 291 n. 18; 1975, p. 287).

EX COLL.: A. Firmin-Didot, Paris (until 1884); Marshal C. Lefferts, New York (until 1901); Henry Walters, Baltimore.

LITERATURE: De Ricci and Wilson 1935–37, vol. 1, p. 780; Baltimore 1949, no. 162; Diringer 1958, pl. VI–16c; Baltimore 1962, no. 73; Levi D'Ancona 1962, p. 76; Boskovits 1972, p. 52; idem 1975, pp. 78, 220 n. 128, 285, 367; Levi D'Ancona 1979, pp. 461–87.

19. Saint Catherine Enthroned with Two Saints and Two Donors

Tempera on panel
Overall: 22 3/4 × 18 1/4 in. (57.8 × 46.4 cm); picture surface: 21 1/4 × 16 3/4 in. (54 × 42.5 cm)

The Metropolitan Museum of Art; Bequest of Jean Fowles, in memory of her first husband, R. Langton Douglas, 1981 (1982.35.1)

Saint Catherine, wearing a dark blue robe richly embroidered in white, red, and gold with gold collar, cuffs, and hem, a gold belt, and an ermine-lined cape, is seated on a large and elaborate marble throne pierced with Gothic bifora and open trelliswork carving and decorated with red, white, and black cosmatesque inlay. In the foreground at the right are two youthful saints in red robes conversing with each other and, apparently, with Saint Catherine, each figure telling off points on his or her fingers. Kneeling on the tiled or carpeted pavement in the left foreground are diminutive figures of two donors in white habits that are belted at the waist, each wearing a white scapular with a red cross at the breast. The elder figure, behind, wears a white wimple and dark blue or black veil, now largely scraped away; the younger figure before her is bareheaded, her short-cropped hair probably denoting her status as a novice not yet professed of solemn vows.

Both the authorship and the exact subject of this exquisite and beautifully preserved panel, rich in decorative detail, have long been a matter of debate. The principal figures have sometimes been thought to represent a personification of Charity with Saints Cosmas and Damian (Sirén and Brockwell 1917; Cole 1977) or, inexplicably, the Virgin Mary with two angels (M'Cormick 1925); Bernard Berenson's suggestion (1926) that the seated saint is Catherine of Alexandria is undoubtedly correct. As denoted by her crown and ermine-lined cloak, Saint Catherine was supposedly a fourth-century princess of Alexandria, though her doubtful historicity has recently led to her deletion from the Roman calendar, notwithstanding her enormous devotional popularity. She is usually accompanied in Renaissance painting by one of the symbols of her martyrdom, a sword or a spiked wheel, neither of which is visible here; a scene of the martyrdom of Saint Catherine may have been depicted on a now-lost panel once joined to this one (see below). Renowned for her great learning, Catherine was converted to Christianity and mystically wed to Christ—another commonly represented scene from her legend, which may be alluded to here by the ring on the saint's finger but which may also have been portrayed on a lost companion panel. The emperor Maxentius, who desired Catherine for his own bride, sent fifty pagan philosophers to dispute her faith, but they were all confounded by her greater wisdom and converted to Christianity, whereupon they were all put to death by Maxentius. The two figures in doctors' robes at the right are presumably meant to represent two of the pagan philosophers debating with Catherine, their hands raised in traditional gestures of rhetorical dispute. Their halos, which have generally led to their identification as Saints Cosmas and Damian (who, however, are usually shown hatted, with fur-lined robes, and as physicians carrying a box of ointment or a lancet), indicate their conversion to Christianity and their attendant martyrdom.

The identities of the kneeling donors at the left of the panel are more difficult to unravel. The white habit and dark veil of the elder figure could indicate a nun of the Camaldolese order, but the red cross worn prominently on the scapular of each figure is not known to pertain to any Camaldolese house. Kneeling donor figures of two nuns in white habits with dark veils are included in the fresco of the Nativity and Adoration of the Magi by Cenni di Francesco in San Donato in Polverosa of 1383,[1] though they do not wear red crosses. The Daughters of the Cavalieri Gaudenti—distinguished by the insignia of a red cross—were resident after 1353 at the monastery dedicated to Saint Catherine at San Gaggio. They lived there, however, under the Augustinian rule and there-

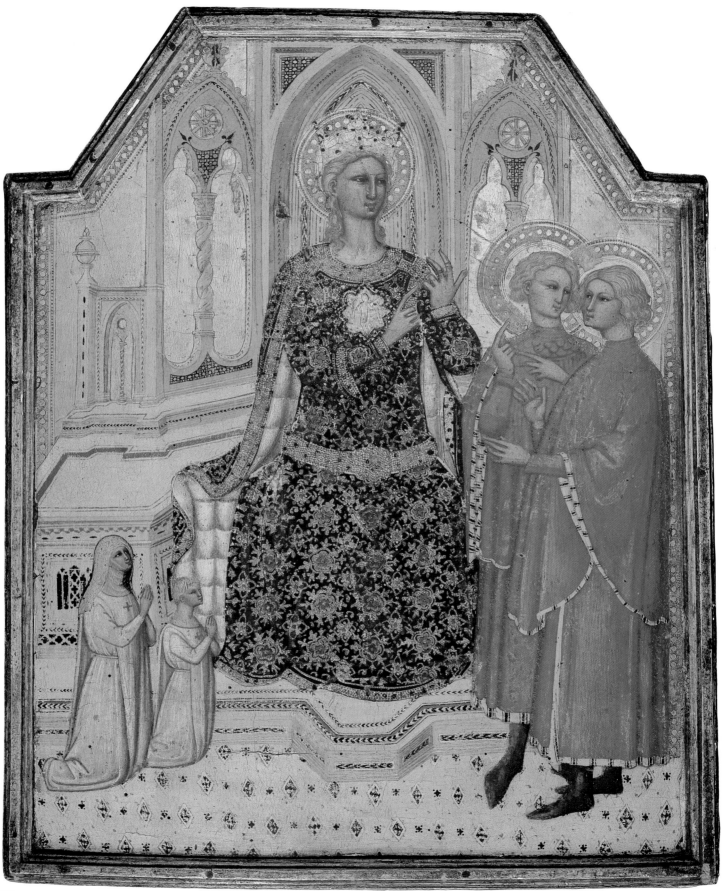

19

fore wore black, not white, habits. The Order of the Humiliati wore white habits with red crosses, but it is not clear whether their veils were dark. The Humiliati, whose origins are Lombard, established a male house in Florence early in the thirteenth century at San Donato in Polverosa. Prominent in the wool trade, the community in 1251 transferred to a site within the city walls more convenient to the families of the Arte della Lana, where they constructed the present-day church and convent of the Ognissanti. In 1341 a female house of the Humiliati was established at Santa Marta a Montughi by a donation from Lottieri di Davanzato Davanzati. Among the first twelve nuns to enter the new convent in 1343, all from noble families, including the Davanzati and Corsini, was a certain Suor Caterina di Jacopo Guiderelli (Manni 1739–86, vol. 8, p. 98), who could possibly be portrayed here as the elder of the two donors.

When it first appeared in the collection of New York financier Otto Kahn, the *Saint Catherine Enthroned* was attributed to Agnolo Gaddi (Sirén and Brockwell 1917; van Marle 1923–38, vol. 3 [1924]), an ascription correctly shifted to the school of Orcagna when Berenson (1926; 1930; 1932a; 1936) assigned it instead to Giovanni del Biondo as a late work. Berenson's attribution gained general acceptance among scholars, though with some reservations by Frederick Antal (1948), who thought it closer in style to Cenni di Francesco, and Richard Offner (1981), who considered it the work of an independent Orcagnesque painter named by him the Rohoncz Master (after a painting in the Thyssen collection attributed by Rudolf Heinemann [1930; 1937] to Cenni di Francesco). Berenson himself was later (1963) induced to withdraw the name of Giovanni del Biondo, proposing instead an artist baptized the Master of the Kahn Saint Catherine (after the present painting). Federico Zeri (1963) almost immediately pointed out that the Master of the Kahn Saint Catherine is actually a phase of the early career of Cenni di Francesco di Ser Cenni, a contention supported by Heinemann (1971) and Miklós Boskovits (1968c; 1975), who also amalgamated the works given by Offner to the Rohoncz Master with Cenni's oeuvre.

That Cenni di Francesco was indeed the author of the Kahn *Saint Catherine* is clear from a general similarity of figure types and proportions, composition, and exuberantly decorative architecture with known works by the artist, as well as from a consideration of smaller details, such as the artist's idiosyncratic method of rendering hands and long, tapering fingers with straight, sharply engraved outlines. Cenni's (formerly) signed and dated panel of 1411, showing Saint Jerome in his study, in the

Museo Diocesano, San Miniato al Tedesco (Berti and Paolucci 1990, pp. 90–91), though radically different in scale, is likewise overwhelmed with a profusion of minutely detailed architectural motifs, delightful for their own decorative vitality and technical finesse, but ultimately distracting from the iconic presence and impact of the panel's principal subject. The Kahn *Saint Catherine* is certainly an earlier work than the San Miniato *Saint Jerome*: not only is its architectural vocabulary more decidedly Gothic, but also its hieratic frontality and thin, rigidly posed figures connect it with his earliest efforts, which were still strongly under the influence of Giovanni del Biondo. The remarkable embroidery of Saint Catherine's dress, a tour de force unusual even for the consummate decorative skills of Cenni, recalls the cope of Saint Peter Enthroned in the Baltimore Antiphonary (cat. no. 18, fol. 35v) or the robes of such figures by Don Silvestro dei Gherarducci as Saints Agnes or Silvester from Cod. Cor. 2 (see cat. no. 16) and may indicate a date for the Saint Catherine shortly after these two artists came into close contact in the mid-1370s. Almost certainly the Kahn *Saint Catherine* predates Cenni's frescoes of 1383 at San Donato in Polverosa, where his figures have assumed the fuller proportions of his mature style.

The engaged frame surrounding the panel of *Saint Catherine Enthroned* is modern, but the punched margin of the gold ground that follows it along the sides indicates that the panel has not been altered significantly in shape. The punched margin does not, however, continue across the top of the panel, and it may be assumed that originally the picture surface continued upward into a pointed gable, allowing for an even more elaborate termination of the architecture of Saint Catherine's throne. Though such a shape would not be unusual among late trecento Tuscan panels, the composition and subject of the Kahn *Saint Catherine* are far from common, and it is unclear whether it was intended as an independent votive or devotional image, a valve of a diptych or the center of a small folding triptych (evidence of lateral hinges is obscured by the modern frame), or part of some larger narrative complex. Damage to the paint surface to the left of Saint Catherine's head caused by a nail embedded in the panel implies that a horizontal batten was once fixed across the back at this point. Though the evidence is inconclusive, such a batten is normally required only to fix a panel in plane to other panels alongside it, but it is difficult to envision in the present case what such panels may have looked like.

LK

1. See Boskovits 1975, pl. 137. San Donato in Polverosa was variously an Augustinian convent, a monastery of the Humiliati, and at the time of these frescoes a Cistercian convent. The Cistercian habit was white, and the black veils of the donors in Cenni's fresco are unusual. Perhaps significantly for the provenance of the Kahn panel, the standing figure at the left of the San Donato fresco may be Saint Catherine of Alexandria.

EX COLL.: Otto Kahn, New York (by 1917; until 1934); Mogmar Art Foundation, New York (1934–41); R. Langton Douglas, London (1941–51); Mrs. R. Langton Douglas (later Mrs. Edward Fowles), New York (1951–81).

LITERATURE: Sirén and Brockwell 1917, no. 9, p. 33; van Marle 1923–38, vol. 3 (1924), p. 557 n. 1; M'Cormick 1925, p. 82; Berenson 1926, p. 308, fig. 22; idem 1930, p. 116; Venturi 1931, pl. liii; Berenson 1932a, p. 242; Venturi 1933, pl. 64; Berenson 1936, p. 208; Antal 1948, p. 350 n. 71, fig. 89; Kaftal 1952, col. 225; Berenson 1963, p. 216, fig. 299; Zeri 1963, p. 225 n. 5; Boskovits 1968c, pp. 273, 290 n. 4; Heinemann et al. 1971, p. 77; Boskovits 1975, pp. 127, 291, fig. 307; Cole 1977, p. 73; Padoa Rizzo 1979, p. 536; Offner 1981, p. 52; Boskovits 1990, p. 56 n. 4.

DON SIMONE CAMALDOLESE

Though virtually no biographical information concerning the life of Don Simone has yet been discovered—the dates of his birth and death and the absolute limits of his active career are unknown—the contours of his artistic personality may be more fully outlined than those of any of his contemporaries. Four signed works by him survive, of which one is included in this publication (cat. no. 21); documents of payment for two major commissions may be confidently associated with other surviving works (see cat. no. 26); and, rarest of all for miniaturists of this period, an unusual number of his signed, documented, or securely attributable works are dated. Yet notwithstanding this uncommon abundance of information, Don Simone remains one of the least well understood and most frequently overlooked artists of his generation.

Don Simone's career differs from those of his better-known Camaldolese brothers, Don Silvestro dei Gherarducci and Lorenzo Monaco, in two significant respects: only one of his many surviving works (Don Simone was a prolific artist) can be associated with a commission for Santa Maria degli Angeli (cat. no. 20b), and no panel paintings have yet been successfully linked to his name. Don Simone is not once mentioned among any lists of the monks resident at Santa Maria degli Angeli, nor can he be shown to have collaborated at any time with either Don Silvestro or Don Lorenzo, suggesting that the three artists not only trained but also operated in distinct artistic circles. Because they were the dominant illuminators of their respective ages, stylistic interconnections from one to another are certainly apparent but are, in the final analysis, superficial and assist little in clarifying the origins or development of the personal manners of any of the three.

In his first dated work, an antiphonary painted in 1381 for the Vallombrosan house of San Pancrazio in Florence (Biblioteca Laurenziana, Cod. Cor. 39), Don Simone signed himself in the codex's explicit "Dom. Simon de Senis monachus ordinis camaldulensis" (Don Simone of Siena, monk, of the Camaldolese order). In this context the epithet "de Senis" was undoubtedly intended to refer only to the place of the artist's birth, but it is also an accurate description of his style and therefore probably of his training. The closest parallels for the distinctive foliate borders and decorative motifs incorporated in Don Simone's initials are to be found in Lippo Vanni's illuminations of the 1360s; his idiosyncratic and highly sophisticated spatial constructions are derived from the example of Ambrogio Lorenzetti and are unlike anything to be found in contemporary Florentine painting; his rich palette of high-key contrasting colors is quintessentially Sienese; and his particular method of modeling shadows in draperies through color intensity rather than hatching or shading resembles most of all the practice of Jacopo di Mino del Pellicciaio and his pupils, especially Niccolò di Buonaccorso (see Muller 1978). No manuscript illuminations by Niccolò di Buonaccorso have been identified, but his surviving panel paintings are predominantly miniaturist in scale and share a number of peculiarities of figure type and composition with the works of Don Simone. The two artists may or may not have been master and pupil, but they unquestionably reflect a common source of inspiration in Sienese painting of the 1370s.

Don Simone's figure style in the San Pancrazio antiphonary of 1381 and in three other antiphonaries painted for San Pancrazio probably contemporaneously or in the immediately succeeding years (Biblioteca Laurenziana, Cod. Cor. 38, 37, 40) is harsher, more angular, and less anatomically resolved than in any other work attributable to him, and these four books may plausibly be assumed to represent his earliest known efforts. A set of books from a documented commission of 1379 for the hospital church of Santa Maria Nuova is not known to survive, and attempts to identify works by Don Simone datable to

the 1370s have not been convincing.[1] Clearly related to the San Pancrazio antiphonaries, though visibly more assured in handling, are two graduals in Santa Croce sull'Arno; an initial A ("Aspiciens alonge") with Saint Peter Enthroned Between Saints Francis and Bonaventure, formerly in the Lewis collection, Philadelphia;[2] an antiphonary in the Museo Diocesano at San Miniato (Pisa); and an antiphonary (Cor. B) at Santa Croce, Florence. These are probably all works of the mid-1380s, with Santa Croce Cor. B closest in date to Don Simone's documented commission of 1387 for San Miniato al Monte (see cat. no. 26). In 1388 Don Simone painted a gradual from which at least one cut illumination survives (cat. no. 21), and in 1388–89 he illuminated five antiphonaries for Santa Maria del Carmine, now in the Biblioteca di San Marco (Levi D'Ancona 1962, pp. 239–40; Chiarelli 1981, pls. VII–X).

These books painted in the second half of the 1380s represent the apogee of Don Simone's style. In them are to be found his most structurally complex compositions, his most ambitious narratives, his most naturalistic figure style, and his most elaborate range of color and decorative detail. In his immediately successive works, culminating in an illustrated codex of the *Divine Comedy* (Biblioteca Laurenziana, MS Tempi 1) dated 1398 in its explicit—the latest dated work by Don Simone—his illuminations become formulaic in their regularly repeated compositions; their elegant, doll-like, but unvaryingly predictable, figure style; their schematized backgrounds; and their simplified palette. It is possible that Don Simone's career extended some years into the fifteenth century, but it is difficult to believe that the "Don Simone" who reportedly decorated an antiphonary for Santa Lucia dei Magnoli as late as 1426[3] can possibly be the same artist.

LK

1. Levi D'Ancona (1962, p. 240; 1979, p. 469) proposes to identify a badly damaged miniature of the Nativity in Bargello Cod. C 71 (fol. 82v), an antiphonary from Santa Maria Nuova, as a remnant of the 1379 commission. The miniature bears no relation to Don Simone's style, however, and Cod. C 71 is documented as being written after 1385. See "The Choir Books of Santa Maria degli Angeli" (p. 232) for a proposal to identify this book as the work of Lorenzo Monaco in 1396. Boskovits (1972, p. 40, followed by Firmani 1984, pp. 8, 152) proposes that a gradual in the Victoria and Albert Museum, London (acc. no. 18.v.1868), was painted by Don Simone in the 1370s, possibly on the basis of its simplified compositions and reduction of decorative detail. This simplification, however, is to be imputed foremost to the volume's small size. It is a typical mature work of Don Simone's, probably datable to the middle or late 1390s. The representations of Saint Benedict in a White Habit Enthroned on folio 41r and the Apotheosis of Saint Romuald on folio 74r of the London gradual indicate that it was a Camaldolese commission, most likely for a female house (a female donor is portrayed in a Camaldolese habit—white with a black veil—on folio 98v, alongside scenes from the life of Mary Magdalen), probably in the diocese of Arezzo (Saints Donatus and Hilarion, patrons of Arezzo, are portrayed in a large initial D on fol. 145v). This may have been the convent of San Benedetto in Arezzo or, more likely, its motherhouse of Saint John the Evangelist in Pratovec-

chio. In contrast to full-page illuminations of the Magdalen (fol. 98v), Saint Margaret (fol. 97r), and Saint Catherine of Alexandria (fol. 125r), the only male saint accorded the visual prominence of a full-page illumination, including *bas-de-page* scenes from his life, is John the Evangelist (fol. 13v).

2. This page, though exhibited with the Lewis collection at the Philadelphia Museum in 1931, is not to be found with the other leaves given subsequently by Mr. Lewis to the Free Library of Philadelphia. Its present whereabouts are unknown. On the analogy of the corresponding illumination in the San Pancrazio antiphonaries (Biblioteca Laurenziana, Cod. Cor. 39, fol. 1v), showing Saint Pancras Between Two Benedictine Saints, the antiphonary from which the ex-Lewis page was cut and from which no other pages have yet been identified was probably commissioned for a Franciscan community dedicated to Saint Peter, perhaps San Piero a Ripoli, a dependency of Santa Croce in Florence.

3. Milanesi (in Vasari 1906, vol. 2, p. 22, n. 2), without citing his source. Milanesi also cites a *memoriale* of Santa Maria degli Angeli that records a Don Simone di Stefano from the quarter of San Michele Visdomini in Florence, who professed his vows on October 21, 1386, at the age of twenty-two and died at the monastery on July 29, 1437. This cannot be the painter Don Simone, who was already a Camaldolese monk in February 1381.

20a. Saint Stephen in an Initial S

Tempera and gold leaf on parchment
Overall: 12 × 12 3/8 in. (30.5 × 31.5 cm); initial: 7 7/8 × 6 3/4 in.
(20 × 17 cm)

Dr. Ernst and Sonya Boehlen collection, Bern

The blue initial S is lined with white, highlighted with
white filigree ornament, and decorated with green,
orange, and gray foliate tendrils. Portrayed as though
standing between the initial and its white lining is the
half-length figure of Saint Stephen wearing a white

dalmatic and turned three-quarters to the right. The
saint holds a red book with green clasps and blue
bosses in his right hand and a martyr's palm in his left.
Atop his head rest two large stones, symbols of his
martyrdom.

The initial S begins the first responsory of the first
nocturn for the feast of Saint Stephen (December
26), fragments of which are visible below the letter:
"Ste[phanus] autem plenus gr[atia et fortitudine]" (Now
Stephen, full of grace and power). It was cut from the
missing folio 51 from Cod. Cor. 16 at the Biblioteca
Laurenziana, Florence, one of the volumes of an

Figure 66. Don Simone Camaldolese, Saint John the Evangelist in an initial V. Staatliche Museen zu Berlin; Kupferstichkabinett (Min. 1900)

Figure 67. Don Simone Camaldolese, The Christ Child in an initial T. Musée Marmottan, Paris; Wildenstein Collection

antiphonary written for Santa Maria degli Angeli. In her reconstruction of the missing illuminations from the Santa Maria degli Angeli choir books, Mirella Levi D'Ancona (1978), who did not know the present initial, proposed identifying two other miniatures as fragments of Cod. Cor. 16: the Infant Christ in an initial T ("Tamquam sponsus Dominus procedens da thalamo suo" [Like the bridegroom the Lord is coming forth from the bridal chamber], the second antiphon of the first nocturn of Christmas) in the Wildenstein Collection at the Musée Marmottan, Paris (fol. 6; fig. 67); and Saint John the Evangelist in an initial V ("Valde honorandus est Beatus Joannes" [Very highly we must venerate Blessed John], the first responsory of the first nocturn for the feast of Saint John the Evangelist, December 27) in the Kupferstichkabinett, Berlin (inv. no. 1900; fol. 79; fig. 66). The height of the musical staves (not visible in the Paris cutting) and the style of the foliate decoration and of the script in these three initials correspond to those in the rest of the book.

The commission to illuminate the antiphonaries from Santa Maria degli Angeli, twelve volumes of which were written between 1385 and 1397 and another added in 1406, seems at first to have been entrusted to Don Silvestro dei Gherarducci (see remarks preceding cat. no. 29), who had earlier been responsible for decorating the sanctorale of the gradual (Biblioteca Laurenziana, Cod. Cor. 2; cat. no. 16). Don Silvestro completed only three of the twelve antiphonary volumes, however—Cod. Cor. 9, containing the movable and fixed feasts for the period of Advent, presumably the first volume of the series that was written and almost certainly the first volume of the series that was painted; Cod. Cor. 6, containing the movable and fixed feasts for October and November; and Cod. Cor. 19, containing feasts in July and August. He may also have prepared designs for two further volumes, Cod. Cor. 11 and 16, but both of these were painted by other artists, working within decorated initials perhaps planned and partially executed by Don Silvestro.

Cod. Cor. 16, the second volume of the antiphonary series, containing feasts from the later part of Advent through the end of December, retains only one of its illuminated initials, an elaborate Lombard H ("Hodie Christus natus est" [This day Christ is born], the antiphon of the magnificat from the second vespers for Christmas Day), with the Christ Child Blessing and numerous half-length figures in medallions and roundels, on folio 40v. Though the style of the initial's decoration, especially the thistles and vines in the margins, is clearly dependent on Don Silvestro, the technique of its execution (relying on heavy black outlines) and its figure types are unrelated to his work. It was correctly attributed by

Miklós Boskovits (1975, p. 373) to the Master of the Ashmolean Predella, an Orcagnesque painter who is also to be credited with the illuminations in Cod. Cor. 11 (cat. no. 20b). The three initials removed from Cod. Cor. 16, however, were all painted not by the Master of the Ashmolean Predella but by Don Simone Camaldolese.

The circumstances under which Don Simone was asked to collaborate on illuminations in a choir book for Santa Maria degli Angeli, where he was not resident and from whom he received no other commissions at any point in his career, are difficult to reconstruct. Furthermore, although the device of situating his figures in a notional space behind the initial but in front of its painted lining is fully characteristic of Don Simone's work, the style of the foliate decoration of the three initials from Cod. Cor. 16 for which he was responsible is atypical of Don Simone, and they may, as was certainly the case with the illuminations painted by the Master of the Ashmolean Predella, have been executed over designs by Don Silvestro. Generically similar, Don Silvestro's foliation is denser, more agitated, and more symmetrical in structure than Don Simone's and is built around continuously curving fronds. Don Simone prefers looser, more organic forms, rarely draws leaves emerging symmetrically opposite each other along a single stem, and frequently introduces angular, abrupt changes of direction in his looping fronds.

Though no specific documentation survives, visual evidence suggests that, as with the Master of the Ashmolean Predella, Don Simone was here completing a commission abandoned by Don Silvestro; this then is the only known instance of the two Camaldolese artists working on a single book. On circumstantial grounds alone, it may be surmised that Don Simone intervened in the completion of Cod. Cor. 16 sometime about 1392: after that date Lorenzo Monaco was entrusted with painting the remaining volumes of the antiphonary, and his is the only hand that appears among them (see cat. nos. 29, 30, 33). A date earlier than 1390 is not plausible within the course of Don Simone's stylistic development.

LK

EX COLL.: Unknown (sale, Christie's, London, June 23, 1993, lot 6).

20b. Christ and the Apostles in an Initial E

Tempera and gold leaf on parchment
Overall: 18 5/8 × 17 1/2 in. (47 × 44.2 cm); initial: 11 × 11 in. (28 × 28 cm); main fragment: 13 5/8 × 13 1/2 in. (34.7 × 34.3 cm); *bas-de-page* fragment: 4 3/8 × 13 1/2 in. (11 × 34.3 cm); right margin fragment: 17 7/8 × 3 3/4 in. (45.5 × 9.5 cm)

British Library, London (Add. MS 38,896)

Christ, his right hand raised in a gesture of blessing or instruction and with a book propped open in his left, is seated on a raised dais in the center of a domed hexagonal temple. The Twelve Apostles are seated against the walls of the temple, ranged in two semicircles around and before Christ, with Saint Peter (left) and Saint John the Evangelist (right) closest to him in the center. A half-length figure, probably of David, set in a roundel in the center of the *bas-de-page* (which was cut either from a different page or from a different part of the same page as the initial), points upward and bears a scroll inscribed: IN TE DOMINUS SPERAVI (In you, O Lord, have I hoped), a paraphrase of Psalm 30:2 or 70:1. Yet another cut *bas-de-page* has been pasted along the right margin in an inappropriate vertical orientation. Numerous small cutout patches and some painted reinforcement complete the "collage," masking some of the discontinuity between the foliate friezes where they meet along the cut edges.

The initial E begins the third responsory of the first nocturn for the common of apostles and evangelists: "Ecce ego mitto vos sicut oves in medio luporum" (Behold I send you as sheep in the midst of wolves). It was cut from the missing folio 5 of Cod. Cor. 11 at the Biblioteca Laurenziana, Florence (a volume of the antiphonary commons of the saints written for Santa Maria degli Angeli). In Cod. Cor. 11 the text of the responsory continues at the top of folio 6: "[. . . in medio lupo]rum, dicit Dominus: estote ergo prudentes sicut serpentes et simplices sicut columbe" (Said the Lord: therefore be wise as serpents and innocent as doves). The figure style of the initial, the complexity and density of its foliate border decoration, the techniques of punching small circles or clusters of circles in the gilt lobes of the borders and surrounding the figures' halos with a ring of small dots, and the height of the fragmentary musical stave visible below the initial at the left (2 1/8 in. [5.3 cm]) all correspond to the two illuminated pages remaining in this volume: a Pope, Bishop, Deacon, Confessor, and Two Martyrs in an initial A ("Absterget Deus omnem lacrimam" [God will wipe away every tear], the second responsory of the first nocturn for the common of more than one martyr outside of Paschaltide) on folio

20b

38r; and an Enthroned Bishop Saint in an initial E ("Euge serve bone et fidelis" [Well done, good and faithful servant], the second responsory of the first nocturn for the common of a confessor bishop) on folio 88r.

Though the present initial was unknown to him, there can be no doubt that Miklós Boskovits's (1975, p. 373) attribution of the two related illuminations in Cod. Cor. 11 to the Master of the Ashmolean Predella, the artist responsible for the initial H on folio 40v of Cod. Cor. 16, is correct. An intriguing, if elusive, artist, the Master of the Ashmolean Predella began his career as an assistant of Orcagna's, working alongside that master in 1367–68 on the *Saint Matthew* triptych in the Uffizi (Boskovits 1975, p. 51). He seems to have remained in Orcagna's workshop after Jacopo di Cione inherited its obligations upon his brother's death in 1368: he is recognizable as Jacopo's collaborator in, among other works, the *Crucifixion* altarpiece in the National Gallery, London, probably of the early 1370s. Independent works from his late career are markedly looser in handling, more influenced by Jacopo than by Andrea di Cione, and include all the paintings formerly attributed to the Master of the Golden Gate, so called from a predella panel of that subject in the Museum of Fine Arts, Houston. It is from this phase of his career, close to 1390, that a triptych in the Pinacoteca Vaticana (fig. 68) must date, as well as the illuminations in Cod. Cor. 11 and 16.

Recognizing the relationship between Cod. Cor. 11 and Cod. Cor. 16 and assuming Don Simone to have been responsible for the illuminations in the latter, Mirella Levi D'Ancona (1978, p. 230) proposed identifying his collaborator on these two volumes as Paolo Soldini, whose name appears alongside Don Simone's in the colophon to Cod. Cor. 39 at the Biblioteca Laurenziana. Paolo Soldini, who may not have been a painter but a specialist in pen-work initials (Boskovits 1972), died in 1386 (Levi D'Ancona 1962, p. 220) and is therefore unlikely to be identifiable with the Master of the Ashmolean Predella or to have been involved in any way with the commission for the Santa Maria degli Angeli antiphonaries, copying of the texts for which began only in 1385. Additionally, the British Library initial E was not associated by Levi D'Ancona (1978, pp. 218–19) with Cod. Cor. 11 but rather with the missing folio 23 from Cod. Cor. 1 at the Biblioteca Laurenziana (see cat. no. 29) and was attributed by her to Matteo Torelli. Neither contention is plausible.

In addition to folio 5 with the initial E in the British Library, two other pages have been cut from Cod. Cor. 11: folio 63, containing the office of first vespers for the

Figure 68. Master of the Ashmolean Predella, *Crucifixion and Last Supper with Scenes of the Passion*. Pinacoteca Vaticana, Vatican City (143)

common of a single martyr, and folio 119, containing the first nocturn from the common of a virgin. Neither of these has yet been identified.

LK

Ex coll.: Samuel Rogers, London (sale, Christie's, London, May 6, 1856).

Literature: Levi D'Ancona 1978, pp. 218–19.

21. The Resurrection and the Three Marys at the Tomb in an Initial R

Tempera and gold leaf on parchment
11 × 9 ½ in. (28 × 24 cm)

Bernard H. Breslauer, New York

The blue initial R with green, orange, and white foliation and its surrounding gold ground are enclosed within a painted framework of blue and red fictive stone moldings with mosaic inlay corners (fully visible only at the upper right) and a frieze of gold ivy rinceaux against a black ground. The black frieze at the bottom of the painted frame omits the ivy rinceaux and is filled instead with an inscribed signature: HOC OPVS FECIT D[ON] S[IMONE] O[RDINIS] K[AMALDULENSIS] ANNO MCCCLXXXVIII (This work was made by Don Simone of the Camaldolese order in the year 1388).[1] In the upper circle of the initial R, the risen Christ, wearing a white robe shot with blue and holding a staff that flies a white banner with a red cross, stands before his empty tomb, his right hand raised in a gesture of blessing. Behind the tomb at the right are visible the heads of two sleeping soldiers, while a summary landscape of trees, hills, and grass balances the composition at the left. The empty tomb is shown again, on a larger scale, in the lower half of the initial, its displaced lid set obliquely across it at the right. An angel dressed in white robes shaded green and holding an olive branch perches on its front edge and addresses the three Holy Women—Mary Magdalen, Mary Cleophas, and Mary Salome (Mk 16:1–7)—who approach at the left.

The initial R begins the introit to the Mass for Easter Sunday: "Resurrexi et adhuc tecum sum" (I arose and am still with you). Frequently it is found on the opening page of the second volume of a gradual (see cat. no. 24), which covers the liturgical year from Easter through the twenty-fourth Sunday after Pentecost. The Breslauer initial must have been painted on the verso of the first page of a gradual, since its reverse is blank. Of all the known graduals illuminated by Don Simone, none are lacking this page,[2] and it must therefore be presumed that the book from which this cutting was removed has either been destroyed or so mutilated as to be unrecognizable. Furthermore, the identification of other cuttings that may have been removed from the same book can only be a matter of conjecture, since no text, neumes, or ruled staves are preserved on the reverse for objective comparison with other leaves.

As one of only two signed and dated works by Don Simone, the Breslauer Resurrection is an important document in the reconstruction and critical appraisal of that artist's work. Its date, 1388, places it immediately before the commission for the Santa Maria del Carmine antiphonaries (now in the Biblioteca di San Marco, Florence) and immediately after that for a vaguely described set of graduals and antiphonaries for San Miniato al Monte: stylistic comparison with the Breslauer leaf confirms the identification of several surviving fragments from these latter books (see cat. no. 26). The painted border of this initial, with a stylized ivy rinceau in gold against a black ground, is extremely rare in Florentine illumination but occurs with some frequency among Don Simone's works. The device may derive from an earlier Sienese tradition; it appears in a modified form in illuminations by Niccolò di Ser Sozzo (for example, in the Museo Diocesano d'Arte Sacra, San Gimignano; Cod. LXVIII.1, fol. 22) and is commonly found in the painted borders of Sienese verre églomisé panels.[3] Conversely, the punched decoration of the gold ground both along the borders of the initial and in the halos of the saints, typical of Florentine manuscript illumination of this date, is unusual in Don Simone's work and is found only in a limited number of examples (Santa Croce sull'Arno, San Miniato al Monte, Santa Croce Cor. B), all plausibly datable within a very few years of this cutting.

Though slightly rubbed, especially in the flesh tones, and apparently covered with a (discolored) varnish obscuring some of the coloristic éclat typical of Don Simone's best work, the Breslauer Resurrection must certainly be judged among the artist's most ambitious and artistically significant efforts. The foliate decoration of the initial, albeit less organically complex than Don Silvestro's, is crisper and more exuberant than is typical for Don Simone. The complicated spatial structure of the lower scene, with the three Holy Women crowded around and behind the open tomb and viewed obliquely from the right, would not be out of place in a composition of the mid-fifteenth century, though the awkward foreshortening of the sarcophagus lid reminds one that even the most accomplished masters of empirical perspective in the trecento, among whom Don Simone must certainly be numbered, brought no scientific or mathematical understanding to their craft. In the upper scene the beautifully proportioned and gracefully counterpoised figure of Christ is shown standing on the running tendrils of foliage that compose the leg of the initial R. He is centered within the circular picture field for proper hieratic effect, but too rigid an impression of symmetry is mitigated by the oblique view from the left across his body and outstretched left hand to the tomb and partially hidden soldiers behind. Comparing this half

of the initial alone with another, later scene of the Resurrection by Don Simone (cat. no. 24, vol. 2, fol. iv)—frontally composed, schematized in rendering, and conventional in its spatial effects—underscores the difference between the artist's capabilities and the often criticized, disappointing results apparent in the bulk of his work.

LK

1. The initials in this signature were read D.S.O.R. and explained as "Don Simone Ordinis Romualdi" by G. Freuler, in Freuler 1991, p. 208.
2. The upper half of folio 2v of Biblioteca Laurenziana Cod. Cor. 38 (an antiphonary) is missing. The text remaining in the lower half of that page is drawn from the lesson for Easter Sunday: "[In illo tempore Maria] Magdalene, et Maria Jacobi, et Salome emerunt aromata, ut venientes ungerent Iesum" (And when the sabbath was past, Mary Magdalen, and Mary *the mother of* James, and Salome, bought sweet spices, that coming, they might anoint Jesus [Mk 16:1]). Though this is the scene represented in the lower half of the Breslauer cutting, the initial missing from Cod. Cor. 38 should be an I ("In illo tempore"), and its recto should contain the concluding lines of the lesson for the Easter vigil ("Vespere autem sabati" [And in the end of the sabbath; Mt 28:1]), with which the volume begins on folio 1r.
3. See Leone de Castris 1979. The *verre églomisé* reliquary triptych in the Società di Esecutori di Pie Disposizioni, Siena, unconvincingly attributed to Lippo Vanni and dated about 1340 by Chelazzi Dini (in Siena 1982, pp. 246–49), may have been produced about or shortly after 1370 in a Sienese workshop close to that in which Don Simone received his training.

EX COLL.: Otto Schafer, Schweinfurt; purchased for the Breslauer collection in 1992.

LITERATURE: Vienna 1962, p. 198, no. 167; Degenhart and Schmitt 1968, p. 263, fig. 373; Boskovits 1975, p. 430, fig. 379; Firmani 1984, pp. 22, 172, fig. 157; Voelkle and Wieck 1992, pp. 192–93, no. 73.

22. Saint Lawrence in an Initial C

Tempera and gold leaf on parchment
Overall: $5^5/8 \times 7^1/2$ in. (14.4 × 19.1 cm); initial: $5^1/8 \times 5^1/4$ in. (13.1 × 13.4 cm); stave H.: $1^1/4$ in. (3.3 cm); interspace: $1^5/16$ in. (3.4 cm)

The Metropolitan Museum of Art; Bequest of Mrs. A. M. Minturn, 1890 (90.61.2)

The initial C is painted in sections of white, blue, and orange, lined with yellow, and decorated with green, blue, white, and orange foliation against a gold ground. It encloses a full-length standing figure of Saint Lawrence wearing a white dalmatic shaded in blue and lined with green, with amice and apparels of gold with red brocade. The saint holds a red book in his right hand, and with his left he supports the iron grill of his martyrdom resting on an ocher pavement. At the left margin of the parchment is an ink notation in fourteenth-century script: "figura."

The initial C ("Confessio et pulchritudo in conspectu eius" [Praise and beauty go before him]) begins the introit to the Mass for the feast of Saint Lawrence, August 10. On the reverse of the page are fragments of the text from the offertory hymn for the vigil of Saint Lawrence: "[quia] ibi est iudex [meus, et con]scius me[us in excelsis]" (for behold my witness is in heaven, and he that knoweth my conscience is on high). This initial C, therefore, appeared on the verso of a page from a gradual containing the sanctorale (propers of the saints). An attempt by Mirella Levi D'Ancona (1978, p. 224) to associate the Metropolitan Museum Saint Lawrence with a page missing from one of the Santa Maria degli Angeli graduals (Biblioteca Laurenziana, Cod. Cor. 2, fol. 134; cat. no. 16e) is disproved by the certainly later date of this cutting; by the fact that every other illumination in or reasonably presumed to have come from Cod. Cor. 2 was painted by Don Silvestro dei Gherarducci rather than Don Simone; and by the difference between the stave height ($1^1/4$ in. [3.3 cm]) and interspace ($1^5/16$ in. [3.4 cm]) in the present cutting and those ($1^7/16$ in. [3.6 cm]; $1^3/8-1^1/2$ in. [3.5–3.8 cm]) in Cod. Cor. 2. No other cuttings by Don Simone are known that can certainly have come from the same context as the Saint Lawrence. It is related to the Breslauer Resurrection (cat. no. 21) by a close correspondence of figure style and palette, as well as by the punched decoration of its gold ground, which is highly unusual in Don Simone's work. Though the two illuminations cannot have come from the same book, they were probably painted close to each other in time.

Don Simone's experimentation with illusionistic spatial

devices is clearly in evidence in the Metropolitan Museum miniature. The yellow inner lining of the initial C is broken by the artist at the level of the pavement on which Saint Lawrence stands, where it is drawn across the back "wall" of gold as a baseboard. The saint and his grill, an early attempt at linear perspective, stand in front of this baseboard, and so the grill is properly shown projecting over the lining at the upper right. A pentimento visible at the bottom of the grill indicates that it was originally drawn receding to the right rather than the left, which would more closely have followed the contour of the surrounding initial. Reversing it allowed the painter to heighten the spatial presence of his figure, pushing it forward from the initial, but confused the placement of the saint's left arm. As originally conceived, this arm extended to support the grill resting alongside the figure. The edge of the grill that he holds is depicted

as decidedly farther back in space, but the saint's arm still reaches out casually to his side. A slightly earlier image of Saint Lawrence in an initial C by Don Simone, on folio 87v of a gradual in the Collegiata di San Lorenzo, Santa Croce sull'Arno (Cor. N. I), is richer in representational detail than the present example, adding a martyr's palm to the saint's attributes and providing him with a beautifully rendered cloak draped over his dalmatic; however, it avoids the complications and confusion of the present cutting's spatial devices by rendering the figure in half-length.

LK

Ex coll.: Mrs. A. M. Minturn, New York (1890).

Literature: Levi D'Ancona 1978, p. 224.

23. *The Divine Comedy* by Dante Alighieri

Tempera and gold leaf on parchment; 83 folios; page size, 12 × 8⅞ in. (30.5 × 22.5 cm). 16th-century leather binding.

Yale University, New Haven; Beinecke Rare Book and Manuscript Library (MS 428)

The masterpiece of the Florentine poet Dante Alighieri (1265–1321), *The Divine Comedy* was the most widely illuminated book of medieval literature, embraced as a subject for manuscript illumination within a decade of the author's death (Biblioteca Nazionale, Florence, B.N. Palat. 313; Brieger, Meiss, and Singleton 1969, p. 37). Conceived as an epic poem in three parts—*Inferno* (Hell), *Purgatorio* (Purgatory), and *Paradiso* (Paradise)—which are in turn subdivided into short sections called cantos, the *Comedy* is Dante's personal account of a vision, his own spiritual odyssey, that he had during Holy Week in the year 1300. Guided by the Latin poet Virgil as his classical mentor, Dante visits Hell, passing through each of nine circles to reach the mountain of Purgatory; there he meets his beloved, Beatrice Portinari, who transports him to Paradise. Written in Italian—as opposed to the Latin favored by humanist scholars—and addressing a vast repertory of then current philosophical, moral, and political issues in a manner that is at once graphic in detail and melodious in tone, Dante's poem was accepted and admired throughout most of the fourteenth century as an authentic account of a journey through the other world granted to the author by God, as it had been granted to the apostle Saint Paul. (The latter's apocryphal Apocalypse is cited by Dante in the *Inferno* [2.28].) In the words of the contemporary Florentine historian Filippo Villani (ca. 1390), the author, inspired by the Holy Spirit, had written so that "he might benefit his fellow citizens and the world at large through recalling those who walk in darkness to the paths of light" (Brieger, Meiss, and Singleton 1969, pp. 88–89).

The Beinecke codex is one of the finest examples of early *Divine Comedy* manuscripts to have survived, its remarkable state of preservation allowing full appreciation of the brilliant decoration and regular, harmonious writing. The text consists of the three books—the *Inferno*, *Purgatorio*, and *Paradiso* (fols. 1–80v)—followed by the commentaries of Busone da Gubbio and Dante's son Jacopo (fols. 81r–82v). Verses in a colophon on folio 82v indicate that it was written by a friar, "Francis of the Dominican order" ("Manus scriptoris. francisci predicatoris").

Conforming to an early type of *Divine Comedy* illustration, the illuminations in the Beinecke Library codex are confined to the first page of each book (fols. 1r, 27v, 54r) rather than to the whole text, as in later, fifteenth-century examples (see cat. no. 44). On folio 1r, within an orange initial N ("Nel mezzo del cammin di nostra vita" [In the middle of the journey of our life]), marking the beginning of the first canto of the *Inferno*, appears an enthroned figure of Divine Justice (Kraus 1965; Cahn and Marrow 1978; Shailor 1984–87). Winged, with a polygonal nimbus framing her head, and wearing a white and pink gown lined with green, she is seated on a lion, bearing a raised sword (a symbol of power) in her right hand and scales (a symbol of impartiality) in her left. The brilliant palette, large, simplified forms, and schematic rendering of the features are clear indicators of Don Simone's authorship, as is the exuberant border of fleshy acanthus leaves in pink, olive green, blue, orange, and gold, which frames the letter and the page, cascading down the left margin and curling up around the top margin and down between the paired columns of text. At the *bas-de-page*, between two splendid-looking birds with blue, green, and orange feathers, is the coat of arms of the original owners of the manuscript, the wealthy and influential Bini family of Florence: azure, a chevron or, between two roses in chief argent, a mount of six in base argent (Luzzati 1968, pp. 503–6; Popoff 1991, p. 95). Below this, written in a later hand, is the ex libris of the convent of San Miguel de los Reyes, Valencia ("Es de la libreria de S. Miguel de los Reyes"), which came to possess the codex in the seventeenth century (Shailor 1984–87).

The next illuminated leaf is folio 27v, on which a large initial P in the middle left of the page, containing a second nimbed female figure with pink wings and an orange robe over a gilt tunic, illustrates the first canto of the *Purgatorio* ("Per correr migliore acqua alza le vele" [To course over better waters (now) lifts her sails]). Seated on a bank of clouds against a blue background, the figure cradles in her lap a nest in which perches a pelican feeding her young with blood from her own breast; an image known as the Pelican in Her Piety, it was a popular medieval symbol for the sacrifice of Christ and emblematic of Charity.[1] The figure style on this page is consistent with that in the previous initial, as is the exuberant foliate decoration, here interrupted in the right margin by another fancifully conceived pink-and-blue bird whose elegantly curving neck is intertwined with the foliage. In the top margin the head of a second bird grows magically out of the pink-and-green leaves, twisting around itself to take hold of them between its long orange beak.

The last illuminated page is folio 54r, containing a large letter L to illustrate the beginning of the first canto of the *Paradiso* ("La gloria di colui che tutto muove"

Fol. 27v

[The glory of him who moves all things]). Within the initial stands a third nimbed figure with green wings, wearing a white cape lined with green and orange and a blue dress, on which is emblazoned a head surrounded by golden rays. She is holding burning flames in both hands, while above her head floats a blue disk studded with stars, among which is visible a small crescent-shaped moon. The identity of this figure is less easily ascertained than in the previous two initials, partly due to the lack of any exact iconographic precedent. H. P. Kraus (1965) identified her as Divine Love, while Walter Cahn (in Cahn and Marrow 1978), followed by Barbara Shailor

(1984–87), identified her as Caritas, noting that burning flames, usually issuing from torches held in one or both hands, are an attribute of this Virtue. Since there is no question that the attribute of the pelican feeding her young, seen in the previous allegorical image at the opening of the *Purgatorio*, belongs only to personifications of Charity, it is more likely that Kraus's original identification of the present figure as Divine Love is correct.

Such an interpretation seems to be confirmed by the consideration that the principle of Divine Love, "Amor Dei," governing Dante's text, stood at the core of fourteenth-century Thomistic doctrine, which was derived from Saint Thomas Aquinas's *Summa theologiae*. This principle is summed up in the pages of the *Paradiso*, in which Dante's journey to Paradise, accompanied by his beloved, Beatrice, is defined in terms of a gradual ascent. Passing through nine heavens or planets, each one increasing in brightness, toward the divine radiance of God, the All Mover ("Colui che tutto muove"), Dante comes to comprehend fully the immense power of that "Amor che muove il sole e l'altre stelle" (Love that moves the sun and the other stars [Scartazzini 1896, 30.145]). Further in accordance with Dante's text, the disk above the figure of Divine Love should be seen as an illustration of the first heaven or planet of the moon, which the poet is to visit in the second canto. As for the emblazoned head in the center of the Virtue's blue robe, it may be taken to symbolize the divine radiance of God, conceived as Eternal Light illuminating the world.[2]

Significantly, the closest precedent for Don Simone's personification of Divine Love is to be found in the Spanish Chapel, the chapter house of the Dominican monastery of Santa Maria Novella in Florence, which was decorated by Andrea Bonaiuti between 1365 and 1367; characterized as a nimbed and winged figure holding flames in both hands and with a third flame above her head, she is given most prominence above the throne of Saint Thomas in the scene of the Triumph of Saint Thomas Aquinas (Offner and Steinweg 1979, pp. 27–28). Within such a context, it does not seem unreasonable to suggest that the allegorical emphasis in Don Simone's illustrations could have been determined by a possible affiliation of the Dominican scribe of the Beinecke codex, Fra Francesco, to the very monastery of Santa Maria Novella, where an attempt was first made to give visual expression to the complex theological concepts derived from the *Summa theologiae* of Aquinas and where, incidentally, one member of the Bini family, the original owners of the manuscript, was buried in 1388 wearing the habit of the order.[3]

In addition to the Beinecke codex, Don Simone was

responsible for decorating two other manuscripts of the *Divine Comedy*, one now in the Biblioteca Laurenziana (MS Tempi 1) and the other in the Biblioteca Vaticana (MS Lat. 4776), which are similarly illustrated with single allegorical figures at the beginning of each book. The Biblioteca Laurenziana manuscript contains two explicits dated 1398, and although clearly by the same hand, it appears more ambitious in concept than the Beinecke volume, for it includes wide narrative bands above the historiated initials (Brieger, Meiss, and Singleton 1969, pls. 8a, 21, 26). The Vatican codex, on the other hand, is closer in both style and conception to the Beinecke *Divine Comedy*, with which it shares virtually identical iconographic details (Brieger, Meiss, and Singleton 1969, pls. 9, 20). Both should be dated somewhat earlier than the Biblioteca Laurenziana codex, close to Don Simone's works of the second half of the 1380s, such as the Breslauer initial R (cat. no. 21), signed and dated 1388, with which the Beinecke illuminations share the distinctive punched decoration of the gold ground.

BDB

1. In Christian exegesis the allusion is linked to Psalm 101:7: "I am become like to a pelican of the wilderness" (see Ferguson 1972, p. 23).

2. A similar image of a face surrounded by rays appears in the illuminated border of the first canto of the *Paradiso* in a mid-fourteenth-century codex in Paris, where it is pointed at by Dante, shown bust-length in the initial (Bibliothèque de l'Arsenal, Paris, 8530; Brieger, Meiss, and Singleton 1969, pl. 426).

3. Santa Maria Novella, "Libro de' morti": "XIX Augustus, c. 116r: 1388 Domina Nicolosa vestita nostra uxor Michaelis Bini populo nostro" (Calzolai 1980, p. 140).

Ex coll.: The Bini family, Florence; Don Juan de Borja, duke of Gandia (1495–1543); Ramón Fazell (March 15, 1522); Fernando of Aragon, duke of Calabria; the monastery of San Miguel de los Reyes, Valencia (text censored in part while there by Fr. Antonio Oller of the Inquisition, ca. 1613); Leonel Harris, Ellis and Elvey; Charles Fairfax Murray; C. W. Dyson Perrins (1906–1958); [H. P. Kraus, New York, 1958–65].

Literature: London 1908, p. 119, no. 76; D'Ancona 1914, vol. 2, p. 169, n. 188; Warner 1920, vol. 1, p. 156; vol. 2, pl. LXII; Casella 1924, p. 6; Marinis 1947–52, vol. 1, p. 198, vol. 2, pp. 61, 221; Perrins sale 1958, pp. 36–38; Kraus 1962, pp. 26–29; idem 1965, pp. 2–4; Brieger, Meiss, and Singleton 1969, vol. 1, p. 38, n. 24, p. 47; Boskovits 1972, p. 40, n. 40; idem 1975, p. 429; Cahn and Marrow 1978, pp. 212–13; Firmani 1984, pp. 154–55; Shailor 1984–87, vol. 2, pp. 353–55.

Fol. 54r

24. Gradual (Temporale)

Tempera and gold leaf on parchment; 132 folios (vol. 1), 140 folios (vol. 2); page size, 21 1/4 × 15 3/8 in. (54 × 39 cm). Pages ruled with 8 staves of 4 lines each. Each volume is bound in its original wooden boards with unstamped leather and applied metal trefoils, quatrefoils, and large bosses. Volume 1, distinguished by red decoration of the appliqués, covers the period from Advent through Lent and contains 3 historiated initials (as below) and 58 foliate initials. Volume 2, distinguished by green decoration of the appliqués, covers the period from Easter through the 24th Sunday after Pentecost and contains 4 historiated initials (as below), 46 foliate initials, plus 29 unnumbered folios of kyries.

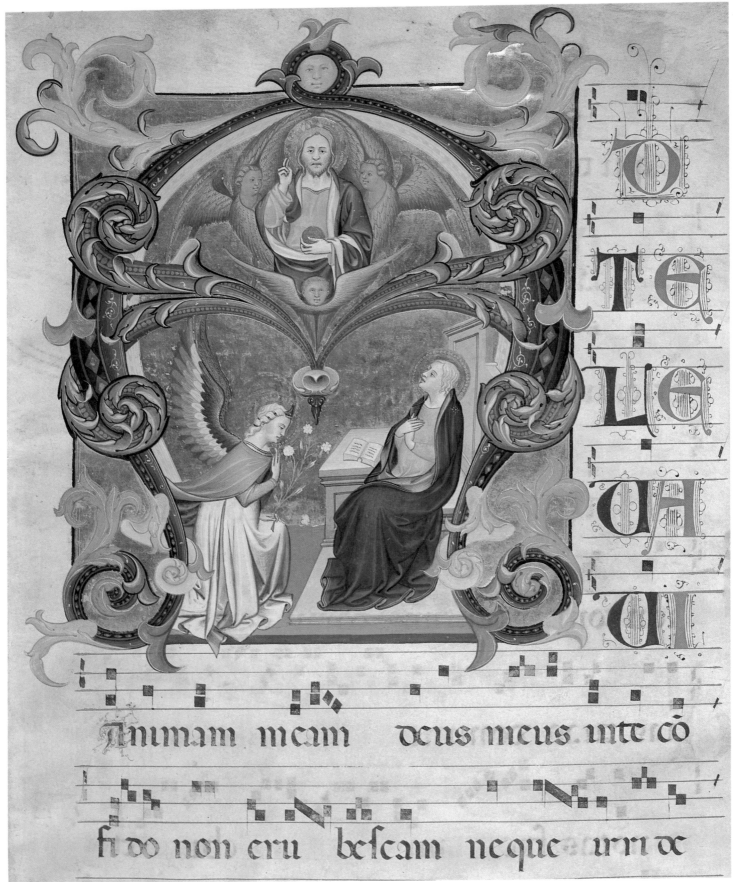

Vol. 1, fol. 22r

Vol. 1, fol. 26r

Newberry Library, Chicago (MS +74)

Volume 1

Folio 1r: The Annunciation in an initial A ("Ad te levavi animam meam deus meus" [I have lifted up my soul to you, O my God]), introit to the Mass for the first Sunday of Advent.

Folio 22r: The Nativity in an initial P ("Puer natus est nobis et filius datus est nobis" [A child is born to us, and a son is given to us]), introit to the third Mass (Mass of the day) for the Nativity.

Folio 26r: The Adoration of the Magi in an initial E ("Ecce advenit dominatorum dominus et regnum in manu eius" [Behold, the Lord, the ruler, is come]), introit to the Mass for the feast of Epiphany.

Volume 2

Folio 1v: The Resurrection in an initial R ("Resurrexi et ad huc tecum sum" [I arose and am still with you]), introit to the Mass for Easter Sunday.

Folio 23v: The Ascension in an initial V ("Viri galilei quid ammiramini aspicientes in celum" [Men of Galilee, why do you stand looking up to heaven?]), introit to the Mass for the feast of the Ascension.

Folio 30v: The Pentecost in an initial S ("Spiritus domini replevit orbem terrarum" [The spirit of the Lord has filled the whole world]), introit to the Mass for the feast of Pentecost.

Folio 96r: A Kneeling Saint in a Landscape Adoring the Trinity in an initial B ("Benedicta sit sancta trinitas"

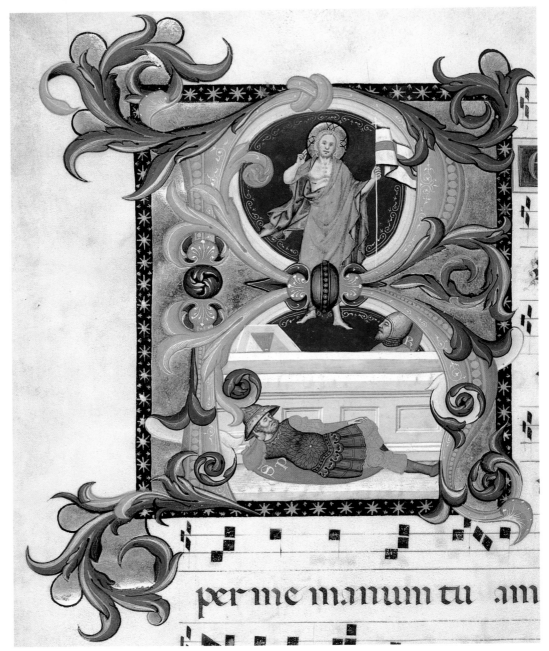

Vol. 2, fol. IV

[Blessed be the Holy Trinity]), introit to the Mass for Trinity Sunday.

The figure style in the seven historiated initials of the Newberry Gradual most closely recalls, among Don Simone's securely dated works, that of the five antiphonaries painted for Santa Maria del Carmine, Florence, in 1388–89 (now in the Biblioteca di San Marco). In the Newberry Gradual, however, the figures are slightly more conventional and formulaic in their arrangements, attitudes, and gestures and more

generalized in their rendering, perhaps suggesting a date in the first half of the 1390s for the book. Though the artist at this period still experimented with rather ambitious spatial devices—such as the complex desk and bench on which the Virgin sits in the Newberry Annunciation (vol. 1, fol. 1r), the soldiers asleep before and behind the open tomb in the Resurrection (vol. 2, fol. IV), or the church and crenellated towers set into a landscape in the upper half of the Pentecost (vol. 2, fol. 30v)—these were treated as isolated pictorial motifs rather than the organizing principle of his compositions.

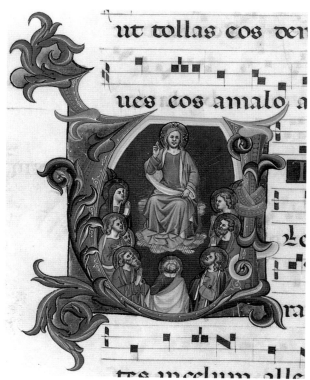

Vol. 2, fol. 23v

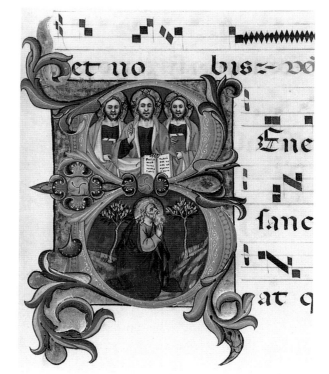

Vol. 2, fol. 96r

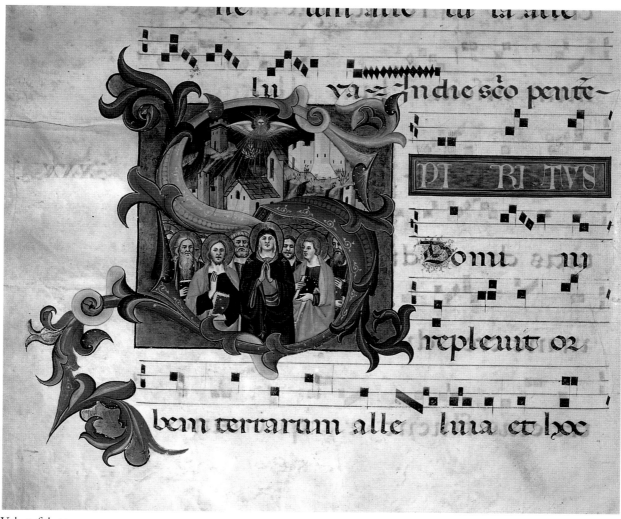

Vol. 2, fol. 30v

A comparison of these scenes with any related images from the 1380s, such as the Breslauer Resurrection (cat. no. 21) or the Beinecke *Divine Comedy* (cat. no. 23), underscores the increasing planarity of Don Simone's later works and their tendency toward greater simplification of detail in rendering and in composition.

A simplification of detail and looser, broader rendering may also be observed in the foliated borders of Don Simone's initials when compared with his earlier efforts, though this must not be understood to imply any diminution of quality. The seven historiated and 104 foliate initials in the two volumes of the Newberry Gradual display the full range of Don Simone's decorative repertoire and the brilliant effects he achieved with a palette of high-key contrasting colors and his signature use of black as a ground color, both in the framework of large historiated initials and, not infrequently, in the centers of smaller foliate initials. The Newberry Gradual also reveals something of the collaborative nature of the work on these decorative borders and suggests, not unexpectedly, that Don Simone operated at the head of a sizable and well-organized shop. Though the patterns and motifs used to decorate the initials in these two volumes may be seen to repeat themselves always in different combinations so that no two initials appear exactly the same, their execution varies in quality and even in technique from quire to quire. Thus, in volume 1, for example, the initials in the fourth quire are notably finer than those in the first three; the initials in the fifth quire (C on fol. 33v, E on fol. 36r, and E on fol. 38v) introduce a new technique, not unlike the young Lorenzo Monaco's, of hatching with black ink to indicate shading—Don Simone's usual approach to modeling in foliation is only to indicate schematic white highlights—and a tauter, more elegant calligraphy (which reappears in the twelfth quire) than is usual elsewhere in the book; and the eighth quire uses a slightly shifted color scheme with paler greens, darker yellows, and an unusual, dense pink, which is pitted and bubbled from improper drying. The execution of these foliate initials and borders appears to have been an efficiently organized aspect of the production of Don Simone's shop and may even have been subcontracted to him and his assistants on commissions for which other artists were responsible for the primary historiated decorations (see cat. no. 26).

LK

EX COLL.: Henry Probasco (1890).

LITERATURE: De Ricci and Wilson 1935–37, vol. 1, p. 529.

25. The Annunciation in an Initial A

Tempera and gold leaf on parchment
Overall: 23 3/8 × 17 1/4 in. (59.5 × 43.9 cm); initial: 9 5/8 × 8 5/8 in. (24.3 × 22 cm); stave H.: 1 1/2 in. (3.7 cm); interspace: 1 5/8 in. (4 cm)

The Brooklyn Museum Collection, New York (X 1015)

In the lower half of a blue initial A is the Annunciation set in the Virgin's bedchamber. At the right the Virgin, clad in a blue robe lined with green over a red dress, her arms crossed and her head lowered in a gesture of humility, is seated on a wooden chest in front of her russet-covered bed. At the left the angel, in white robes shaded blue and with red, white, and green wings, kneels before her on the marbleized pavement of the room. An open book lies on the wooden bench between the two figures. The upper half of the initial is filled with the full-length frontal figure of God the Father seated in a mandorla, wearing a red robe lined with green over a blue tunic, an open book in his left hand, his right hand raised in benediction. The mandorla is supported by a cloud of blue and orange cherubim and seraphim, with half-length figures of King David playing a lyre just to the right and a prophet, possibly Isaiah, just to the left (the readings for the first nocturn of the first Sunday in Advent, which this page illustrates, are from Is 1:1–9). The gold ground of the initial is bordered by a painted margin of yellow lined with brown, and the four corners of the initial are filled with half-length figures of prophets, all gazing at the Virgin and bearing scrolls of testimony to her purity (see cat. nos. 16c, 34b). The green, orange, white, and blue foliate decoration of the initial continues along all four sides of the page, enclosing a fantastic blue and green "duck" with a red bill and white and gold spots in the left margin and blue animal heads in the lower margin, which are signature devices of Don Simone's. In the center of the bottom margin is an eight-cornered medallion bearing the arms of Monte Oliveto Maggiore: a mount of six surmounted by a gold cross and a pair of green and white olive branches. Four heads of white-cowled Olivetan monks and one full-length Olivetan kneeling in adoration of the Virgin appear among the foliage in the right margin.

The initial A begins the response for the first nocturn of the first Sunday in Advent: "Aspiciens a longe ecce video Dei potentiam venientem et nebu[lam totam terram tegentem]" (Long had I been watching. Behold now do I see God coming in power, as in a cloud of light that covers the entire land). Typically it occurs as the first page (or the first illumination) of the first volume of an antiphonary, and not unusually the initial is

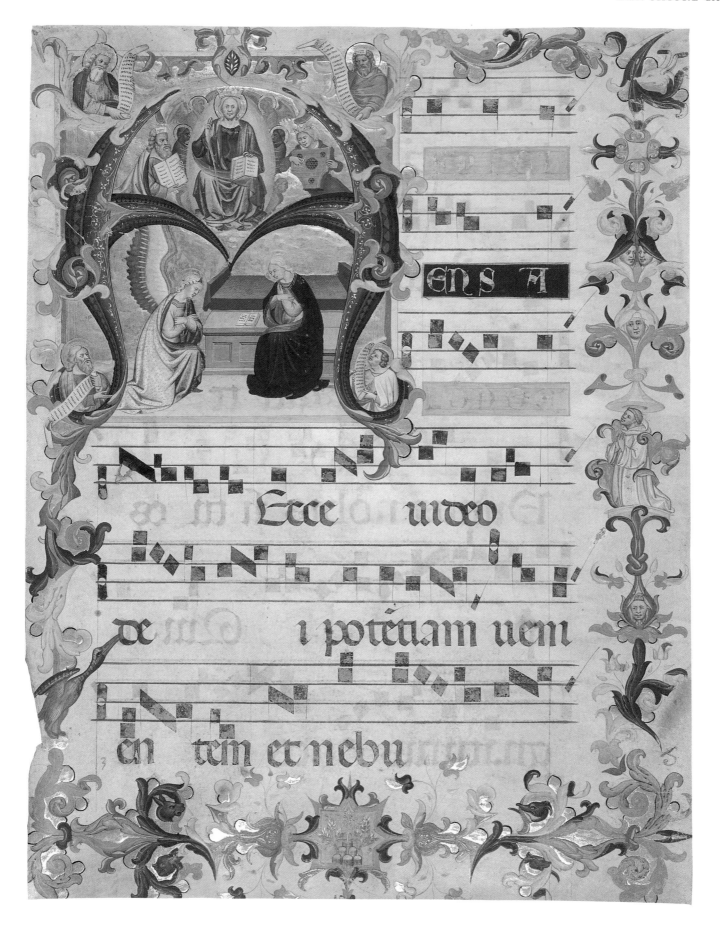

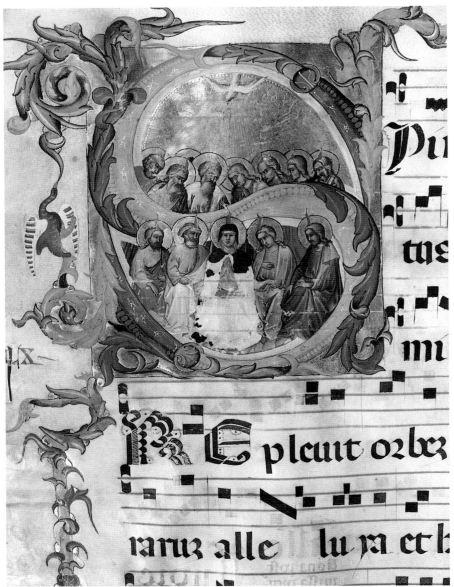

Figure 69. Don Simone Camaldolese or his workshop, The Pentecost in an initial
S. Museo Civico Medievale di Bologna (Cod. 539, fol. 160v)

painted with a scene of the Annunciation. Though the feast of the Annunciation is March 25, Advent is the penitential season of preparation for the coming of the Lord, the most common visual symbol for which was the Annunciation. The prominence of this initial within a set of antiphonaries accounts for the appearance at the bottom of the Brooklyn page of a coat of arms establishing its provenance and in its right margin of a full-length monk in adoration, which was undoubtedly meant to be construed as an idealized portrait of either the book's donor or the prior of the monastery for which it was commissioned. Alternatively, it has been proposed that references to the donor, including a coat of arms or emblematic portraits, in the context of an Annunciation scene are in-

tended as invocations to the Virgin in her role as intercessor (O'Brien 1992, with specific reference to a breviary painted for the Olivetan monastery of San Donato in Gubbio, which includes the arms of Monte Oliveto Maggiore in a *bas-de-page* medallion).

Though Sienese by birth, Don Simone is not known to have worked directly for Monte Oliveto Maggiore. He is, however, documented as having painted a gradual and several volumes of an antiphonary for the Olivetans at San Miniato al Monte in Florence between 1387 and 1389 (see cat. no. 26 for a reconstruction of the San Miniato al Monte Gradual). It is possible that the Brooklyn page is a fragment of one of these antiphonaries, but the style of the illumination argues for a date slightly later than the period of his work at San Miniato al Monte. The simplified setting of the Virgin's bedchamber and the schematized rendering of the figures is less like the lyrical realism of Cor. B at Santa Croce in Florence (ca. 1387), the Breslauer Resurrection of 1388 (cat. no. 21), or the Carmine antiphonaries of 1388–89 than it is like the more formulaic renderings of the Newberry Gradual (cat. no. 24) and other works putatively of the 1390s. If the Brooklyn page was, as seems to be the case, painted shortly after 1390, it is unlikely to have been part of the San Miniato al Monte antiphonaries, and it would have to be assumed that Don Simone undertook a second, later commission for another Olivetan house.

That this second Olivetan house could have been San Michele in Bosco, Bologna, ceded to the order in 1364 by Cardinal Androino della Rocca, legate for Pope Urban V, is suggested by the existence of two graduals painted by Don Simone, a sanctorale (N. 541) and a temporale (N. 542), in the Museo Civico Medievale, Bologna.[1] The first of these contains an illumination of Saint Benedict Presenting His Rule (fol. 19v), in which Benedict and four monks are all dressed in white (Olivetan) habits, and a full-page illumination (fol. 65v)—the most elaborate in either volume—for the Dedication of Saint Michael. These two volumes formed part of a larger series of books, which are all presumed to have come from San Michele in Bosco. Now divided between the Museo Civico Medievale, Bologna, the Biblioteca Estense, Modena (Fava and Salmi 1950–73, vol. 1, pp. 22–53; Di Pietro Lombardi et al. 1987, pp. 70–74), and elsewhere, they were for the most part painted by Niccolò di Giacomo da Bologna. One of the volumes by Niccolò di Giacomo at the Museo Civico Medievale, Cod. N. 539, includes two initials in part executed by Don Simone or his workshop. The Pentecost on folio 160v (fig. 69) was apparently painted on a design by Agnolo Gaddi, but the initial S ("Spiritus Domini replevit orbem terrarum" [The spirit of the Lord has filled the whole world]) is

clearly in Don Simone's style, as is the initial C ("Cibavit eos ex adipe frumenti" [He fed them with the finest wheat]), for the feast of Corpus Domini, on folio 163v (fig. 70).

All the fourteenth-century account books from San Michele in Bosco have been lost, and early descriptions of the artistic contents of the church and monastery are vague with respect to its illuminated choir books (see Malaguzzi Valeri 1895, pp. 12–13; Zucchini 1943, pp. 18–22, 60–62). Specific references to illuminated volumes in the monastery's vast library begin with payments to Stefano di Alberto degli Azzi in 1400, and neither Don Simone nor Niccolò di Giacomo is mentioned by name in any surviving notices relating to San Michele in Bosco.[2] Furthermore, the liturgical sequence of the various books believed to have come from there is unclear. The existence in some cases of more than one volume covering the same parts of the liturgical year implies that not all the books known to have come from San Michele in Bosco were necessarily painted for that house originally but may have been brought there from elsewhere.[3] Both N. 541 and N. 542 in Bologna, however, may reasonably be supposed to have been painted in the first instance for San Michele in Bosco, given the presence of Olivetan monks and the prominence of Saint Michael among their illuminations. As they are closely related to the Brooklyn Annunciation in style—like it, they may be dated to the first years of the 1390s, directly following the Carmine antiphonaries (1389) and probably shortly preceding the Newberry Gradual—and as the Brooklyn page also contains images of Olivetans (and the arms of Monte Oliveto), the evidence for associating them as parts of a single commission to Don Simone is, in the aggregate, strong, although in the absence of further documentation it cannot be conclusive.

LK

1. Firmani 1984, pp. 205–8, where Cod. N. 541 is incorrectly described as an antiphonary, following the inscription in the volume's incipit: *Incipit antiphonarium in festivitatibus sanctorum*. Firmani does not speculate on the provenance of either volume from San Michele in Bosco. Another volume of the gradual from San Michele in Bosco, N. 539 at the Museo Civico Medievale, is likewise referred to as an "antiphonarium" in its incipit.

2. Niccolò di Giacomo witnessed the sale of a piece of land by the monks at San Michele in Bosco on June 20, 1365 (Filippini and Zucchini 1947, p. 176), one year after the Olivetans took possession of the monastery, and this date has sometimes been assigned, though on no further evidence, as the general period of his activity there.

3. Cod. a.Q.1.6. (Lat. 1008) at the Biblioteca Estense, Modena, for example, contains fragments of three separate books with a provenance from San Michele in Bosco. The second of these

books (fols. 13–54 in its present sequence) is a gradual with the propers of the saints, duplicating the contents of N. 541 at the Museo Civico Medievale, Bologna, painted by Don Simone. The gradual at Modena is dated in its explicit 1351 and therefore could not have been written for the Olivetans at San Michele in Bosco, who took possession of the monastery only in 1364.

EX COLL.: There is no record at the Brooklyn Museum of any previous owners of X 1015, nor is there any record of the date at which it entered the museum's collection. Many of the choir books from San Michele in Bosco were acquired in the eighteenth century by Marchese Obizzi del Cataio, and the majority of these were donated to the Biblioteca Estense, Modena, in 1817.

Figure 70. Don Simone Camaldolese or his workshop, An initial C. Museo Civico Medievale di Bologna (Cod. 539, fol. 163v)

The San Miniato al Monte Choir Books

(Catalogue Number 26a, b)

The ancient church and monastery of San Miniato al Monte, standing on a hill overlooking Florence from the south, was reputedly founded in the fifth century, destroyed and rebuilt during the Carolingian era, and largely rebuilt again after 1018, becoming one of the wealthiest and most powerful houses in Tuscany by the end of the twelfth century. From the early eleventh century, it was the residence of a community of Cluniac Benedictines and the site, about 1036, of the miraculous conversion of Saint John Gualbert, who later founded a separate order at Vallombrosa. By the middle of the fourteenth century, the Benedictines at San Miniato had declined to a population of not more than five monks, and in 1373 the monastery buildings and benefices were awarded by Pope Gregory XI to the Olivetans, a relatively new reformed Benedictine order founded in 1319 at Monte Oliveto Maggiore near Siena, though officially recognized only in 1344 by Pope Clement VI (Moreni 1791–95, pt. 5; Berti 1850; Lugano 1902; Gurrieri, Berti, and Leonardi 1988).

Among the requirements of the monastery's new tenants was a set of choir books, some of which were written and illuminated at least in part by the Olivetans in their own scriptorium. In 1379 and 1380, a certain Fra Agostino, probably Fra Agostino Falchi of Florence, bought blue and ground cinnabar for the illuminations of a gradual. Another gradual (or the same one?) was illuminated by Fra Gregorio Mutii da Montalcino in 1385. Parchment for a gradual, to be written by Fra Mauro, was purchased in 1385; it is unclear whether this is the same volume illuminated by Fra Gregorio or another book altogether. Fra Gregorio had also illuminated a breviary in 1384, which was bound in 1385. Another breviary, possibly illuminated by Fra Agostino Falchi, was bound in 1386, as was a psalter. More parchment for a gradual was purchased in 1386, this time to be written by Fra Agostino Chiari, who is mentioned again in 1393 as the author of a(nother?) gradual. In 1387, payments were made to Don Simone Camaldolese for illuminations in a gradual, and more payments to him are recorded from 1387 to 1389 for work on several antiphonaries. An artist named Giovanni Federighi was also paid in 1387 and 1388 for illuminations in a gradual, probably the same book on which Don Simone had been working, and a certain Nanni, called il Malitia—who was perhaps the same Giovanni Federighi—was paid in 1389 for working with Don Simone on the antiphonaries. Other payments are recorded in 1390, 1391, and 1392 for illuminating and

binding antiphonaries, but these are vague with respect to the artist(s) involved (Levi D'Ancona 1962, pp. 7–8, 160–61, 239–40).

This confusing array of documents, referring to at least two and perhaps four volumes of a gradual, two volumes of a breviary, a psalter, and an unspecified number of antiphonary volumes and covering a period of fourteen years and a group of at least four artists, has recently been associated with a fragmentary set of cuttings and full pages preserved in the Biblioteca Apostolica Vaticana (Cod. Rossiano 1192, fols. 1, 3–10); the Robert Lehman Collection at The Metropolitan Museum of Art (acc. no. 1975.1.2476); the Bernard Breslauer collection, New York; the National Gallery of Art, Washington, D.C. (B13,523); and the Detroit Institute of Arts (acc. no. 24.108) (Levi D'Ancona *in litteris*; Voelkle and Wieck 1992, p. 190). The bases for this association are the recurrence of white-clad monks (Olivetans and Cistercians, in addition to the Camaldolese, wore white) in the borders and historiated initials on these pages; the evidence that three distinct artists, one of whom may be identified with Don Simone, were responsible for the painted initials; and the suppositious resemblance of the scene of the death of Saint Benedict portrayed on the Washington cutting to a fresco of that subject painted at San Miniato al Monte by Spinello Aretino about 1387. This final observation may, however, be discounted, since these two images do not compellingly resemble each other beyond the coincidence of their subject and since the Washington and Detroit cuttings demonstrably originate from a different set of books than those in New York and the Vatican. [1]

The eleven cuttings or full pages in the Biblioteca Vaticana and the Lehman and Breslauer collections were clearly removed from a single codex, a gradual. Though the figurated and historiated initials may be attributed to three distinct artists, the floriated borders are uniform and were all painted by Don Simone (or his shop). The initials are decorated, furthermore, with identical patterns of punch tooling in the margins of their gold grounds, though these patterns are not typical of Don Simone's work, and the tools seem to be Sienese in origin: two of the tools appeared earlier on panel paintings from the studio of Lippo Memmi and Naddo Ceccarelli and are unknown on Florentine paintings. Finally, the liturgical sequence of the cuttings is compatible with the folio numeration (itself consistent in style from sheet to sheet) preserved in the margins of some of the sheets. The liturgical sequence comprises:

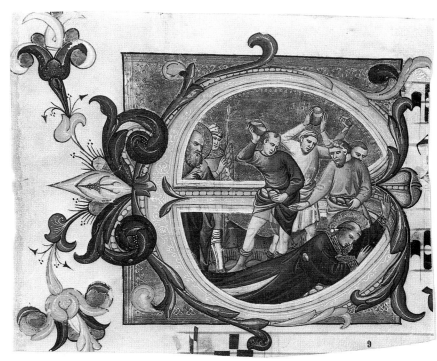

Figure 73. Don Simone Camaldolese and Master of the Breslauer Epiphany, The Stoning of Saint Stephen in an initial E. Biblioteca Apostolica Vaticana, Vatican City (Cod. Rossiano 1192.9)

Figure 71. Don Simone Camaldolese and Master of the Breslauer Epiphany, Christ and Two Prophets in an initial H. Biblioteca Apostolica Vaticana, Vatican City (Cod. Rossiano 1192.6)

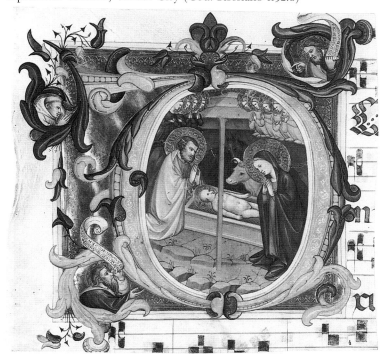

Figure 72. Don Simone Camaldolese, The Nativity in an initial D. Biblioteca Apostolica Vaticana, Vatican City (Cod. Rossiano 1192.4)

Figure 74. Don Simone Camaldolese and Master of the Breslauer Epiphany, Saint John the Evangelist in an initial I. Biblioteca Apostolica Vaticana, Vatican City (Cod. Rossiano 1192.7)

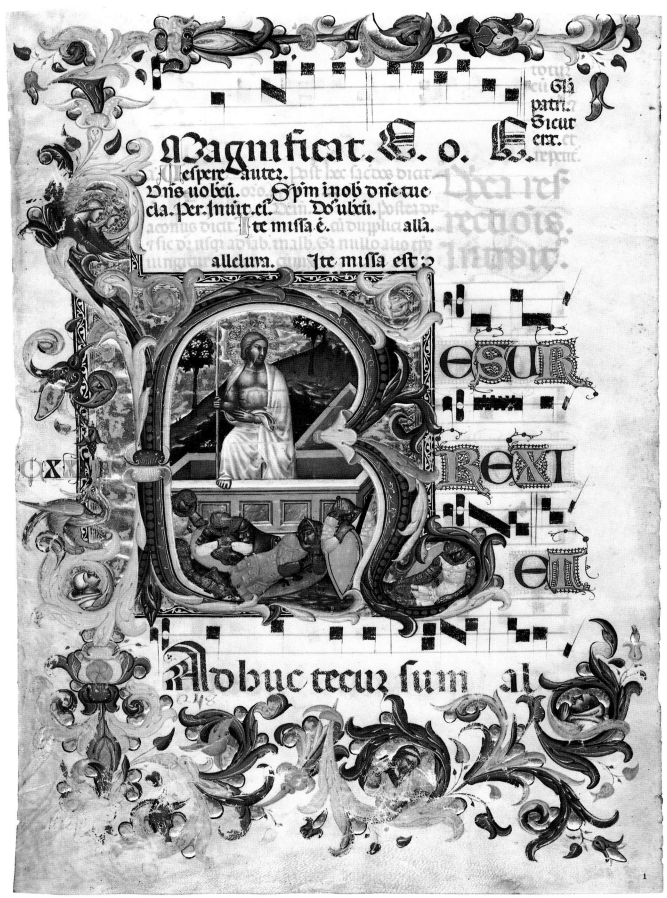

Figure 75. Master of the Codex Rossiano, The Resurrection in an initial R. Biblioteca Apostolica Vaticana, Vatican City (Cod. Rossiano 1192.1)

The Vigil of the Nativity (December 24): Christ and Two Prophets Appearing to Two White-Clad Monks in an initial H (fig. 71).[2]

The Nativity (December 25, first Mass): The Nativity in an initial D (fig. 72).[3]

Saint Stephen (December 26): The Stoning of Saint Stephen in an initial E (fig. 73).[4]

Saint John the Evangelist (December 27): Saint John the Evangelist in an initial I (fig. 74).[5]

Epiphany (January 6): The Adoration of the Magi in an initial E (cat. no. 26a).

Easter: The Resurrection in an initial R (fig. 75).[6]

The First Sunday after Easter (Quasimodo, or Low Sunday): The Doubting of Saint Thomas in an initial Q (fig. 76).[7]

The Ascension: The Ascension of Christ in an initial V (fig. 77).[8]

Trinity Sunday: The Trinity in an initial B (cat. no. 26b).

Corpus Domini: Celebration of the Eucharist in an initial C (fig. 78).[9]

The initials, borders, and foliation of all eleven leaves and cuttings, as has been said, can be attributed to Don Simone and his shop. The first five illuminations in liturgical sequence, from the vigil of the Nativity through Epiphany, were also painted by Don Simone and an unknown assistant, who will here be called the Master of the Breslauer Epiphany (see cat. no. 26a). The illuminations on the remaining pages and cuttings, from Easter through Corpus Domini, were all painted by a third artist, who has been called the Master of the Codex Rossiano (Boskovits 1975, pp. 116, 232 n. 120; see cat. no. 26b). The one illumination for which Don Simone was entirely responsible, the Nativity (fig. 72) can plausibly be dated about 1388 on stylistic grounds, based on the resemblance of its figure types to those in the artist's signed Resurrection (cat. no. 21) of that year. It is possible, therefore, that the gradual these fragments were cut from was, indeed, that for which Don Simone received payments from San Miniato al Monte in 1387 and on which Giovanni Federighi, Fra Gregorio Mutii, or Fra Agostino Falchi may also have been engaged, two of whom may then be identifiable with the masters of the Breslauer Epiphany and of the Codex Rossiano. Further evidence of the possible provenance of this gradual from San Miniato al Monte may be provided by the painted triptych partially visible on the altar behind the priest celebrating Mass in the illumination for Corpus Domini (fig. 78). In its left wing the triptych portrays a crowned martyr saint and in its right wing a monastic, apparently

Benedictine, saint; in all likelihood they are Saints Minias and John Gualbert.

The style of the Master of the Codex Rossiano has been characterized as Sienese, related to and perhaps identical with that of the so-called Kraków Master (Vailati Schoenburg Waldenburg 1990). As the punch tools used to decorate the borders of the gold grounds in the Breslauer, Lehman, and Vatican cuttings are certainly Sienese, it might be reasonable to conclude, following Mirella Levi D'Ancona, that the Master of the Codex Rossiano may be the Fra Gregorio Mutii da Montalcino mentioned in the San Miniato al Monte documents. Montalcino is in the Sienese territory, and Fra Gregorio spent a great deal of his career in and around Siena: at the monastery of San Benedetto, Siena, 1381–83; at Sant'Anna in Camprena (Pienza), where he was prior, 1385–87; at Monteoliveto di San Gimignano, where he was prior, 1387–88; at the Badia a Ruffeno (Asciano), 1388–89; at San Benedetto again, 1389–90; at Ruffeno again, where he was prior, 1390–91; at Sant'Anna in Camprena again, 1391–93; and again at San Benedetto, 1393–95, where he died (Lugano 1903a, pp. 29–31).

There are several difficulties, however, raised by the identification of the Master of the Codex Rossiano or the Kraków Master with Fra Gregorio Mutii. Fra Gregorio fulfilled a number of important posts, including that of prior, in several different Olivetan establishments, but he is mentioned as an illuminator only in the San Miniato documents of 1384–85. Most of the works by the Kraków Master appear to have been painted for patrons other than the Olivetans and are most plausibly datable after Fra Gregorio's death in 1395. Furthermore, Fra Gregorio was resident at San Miniato al Monte only in 1384 and 1385, two years before Don Simone is mentioned in any documents of payment for the choir books there, yet Don Simone is clearly responsible for the initials and borders of those pages painted by the Master of the Codex Rossiano, all of which fall in the second half of the gradual. Finally, it is probable that the gradual for which Fra Gregorio was paid in January 1385 was completed before October 7 of that year, when the monastery paid for a cover ("vesta") for it. It seems likely that despite the apparent coincidence of their nationality, Fra Gregorio Mutii and the Master of the Codex Rossiano are not the same person.

The other Olivetan illuminator named in the San Miniato al Monte documents, Fra Agostino Falchi, is no more likely a candidate for our artist than is Fra Gregorio. Fra Agostino is specifically denoted as Florentine and is not recorded at any of the Olivetan houses in Sienese territory, and his payments for work on graduals

Figure 76. Master of the Codex Rossiano, The Doubting of Saint Thomas in an initial Q. Biblioteca Apostolica Vaticana, Vatican City (Cod. Rossiano 1192.8)

at San Miniato are of 1379–80, six years before Don Simone is first mentioned there. A more plausible identification for the Master of the Codex Rossiano, assuming the Vatican and Lehman cuttings were, indeed, painted for San Miniato al Monte, might be with the otherwise unknown Giovanni Federighi, who received payments, through a certain "cherichino," from November 15, 1387, through the following May, "per miniatura del Messale." This missal is apparently the same as that on which Don Simone was engaged in June 1387, a sequence of work that fits not uncomfortably with the sequence of images in the Lehman/Vatican group. Nothing else is known of Giovanni Federighi that might support or disprove his identification with the Master of the Codex Rossiano, though if he was Sienese it may not be fortuitous that he is not mentioned in any other Florentine documents.

It is also possible that Giovanni Federighi could instead be identified with the Master of the Breslauer Epiphany. That artist seems to have worked on the Lehman/Vatican gradual as an assistant of Don Simone's rather than as an independent contractor, however. His illuminations for the vigil of the Nativity, feast of Saint John the Evangelist, and Epiphany all appear to have been designed by Don Simone, while that for the feast of Saint Stephen unequivocally was: the figures of Saint Stephen lying across the foreground and Saint Paul looking on at the left were painted as well as drawn by

Don Simone, whereas only the executioners were painted by the second, weaker hand. It may be that this assistant is the "garzone," otherwise unnamed, who received payments on Don Simone's behalf in October and November 1387 for work on the antiphonaries at San Miniato al Monte. On the other hand, another payment for these antiphonaries, made through the same *cherichino* who disbursed monies earlier to Giovanni Federighi, was recorded on July 22, 1389, on behalf of "Nanni chiamato il malitia i quagli ricevette per Don Simone" (Nanni, known as il Malitia, who collected for Don Simone). It is not yet possible to determine whether Don Simone's "garzone," Nanni il Malitia, and Giovanni Federighi are a single artist or two and perhaps three distinct painters.

LK

1. The Washington and Detroit cuttings employ different punch tools and patterns in their gold grounds than do the Lehman, Breslauer, and Vatican pages, which are all consistent among themselves and are ruled with staves of a different height (1 1/8 in. [3 cm], as opposed to 1 3/8 in. [3.6 cm] in the others). They are undoubtedly fragments of the same book as a Martyrdom of Saint Agatha formerly in the Kenneth Clark collection (sale, Sotheby's, London, July 3, 1984, lot 82) and probably also a Betrayal of Christ in the Städelsches Kunst-institut, Frankfurt (inv. no. 424), as well as a series of illuminations in the Jagiellońska Library, Kraków, all of which are decorated with the same punch patterns on their gold grounds. The Clark Saint Agatha came from the Dennistoun collection, where it was said to have been purchased in 1838 in Siena.

2. "Ho[die sci]e[tis quia] veniet Domi[nus et salvabit nos]" (This day you shall know that the Lord will come and save us), Biblioteca Vaticana, Cod. Rossiano 1192, folio 6. Overall: 16 × 10 inches (40.5 × 25.5 cm), initial: 9 1/8 × 6 3/8 inches (23.2 × 16.8 cm). Above the initial is a rubric: "In v[igilia nati]vitatis D[omini]." The page is numbered VI along its left margin and 12 alongside the bottom line of text. The reverse, numbered 11, is ruled with five fragmentary musical staves but is unlettered.

3. "Do[mi]n[us di]xi[t ad me: filius meus es tu ego hodie genui te]" (The Lord hath said to me: Thou art my son, this day have I begotten thee), Biblioteca Vaticana, Cod. Rossiano 1192, folio 4. Overall: 11 1/4 × 11 7/8 inches (28.7 × 30.1 cm), initial: 9 × 9 3/8 inches (22.9 × 23.8 cm). Three staves of music are preserved on the reverse, with the partial text of the Communion hymn for the Vigil of the Nativity: "Revela-[bitur] gloria domini [et] videbit omnes ca[ro salutare Dei nostri]" (The glory of the Lord shall be revealed, and all men shall see the salvation of God).

4. "E[t enim sederunt principes et adversum me loquebantur et iniqui persecuti sunt me]" (For princes met, and spoke against me, and the wicked persecuted me), Biblioteca Vaticana, Cod. Rossiano 1192, folio 9. Overall: 11 3/4 × 9 inches (29.7 × 23 cm), initial: 6 1/8 × 6 1/16 inches (15.5 × 15.4 cm). None of the text of the introit is preserved with the initial E. The reverse of this page contains the conclusion of the offertory from the third

Mass of the Nativity: "[Iustitia et iudicium prepa]ratio [sedis] tue" (Justice and judgment are the foundation of your throne), followed by the rubric for the Communion hymn.

5. "In [medio ecce]siae a[peruit os eius] et i[mplevit eum Dominus spiritu sapientiae et intellectus]" (In the gathering of the church the Lord opened his mouth and filled him with the spirit of wisdom and understanding), Biblioteca Vaticana, Cod. Rossiano 1192, folio 7. Overall: 15¹/₂ × 9⁵/₈ inches (39.4 × 24.4 cm), initial: 9¹/₂ × 4³/₈ inches (24 × 11.2 cm). The reverse contains the Communion hymn for the feast of Saint Stephen (December 26): "[Video caelos apertos et Jesum stantem a dextris virtu]tis dei [Domine Jesu] accipe spi[ritum meum] et ne sta[tuas illis hoc peccatum]" (I see the heavens opened, and Jesus standing at the right hand of the power of God. Lord Jesus, receive my spirit, and lay not this sin against them).

6. "Resurrexi et adhuc tecum sum" (I arose and am still with you), Biblioteca Vaticana, Cod. Rossiano 1192, folio 1. Full page: 23⁵/₈ × 16⁷/₈ inches (60.1 × 42.9 cm), initial: 9³/₈ × 9³/₈ inches (23.7 × 23.7 cm). This page is numbered CXXIIII along its left margin, 124 at the lower left, and 248 alongside the bottom line of text. On the reverse, numbered 247, is the Gospel for the Vigil of Easter: "Vespere autem sabbati que lucescit in prima sabbati venit maria magdalene et altera maria videre sepulchrum alleluia" (And in the end of the sabbath, when it began to dawn towards the first day of the week, came Mary Magdalen and the other Mary, to see the sepulchre [Mt 28:1]).

7. "Quasi modo geniti infantes, alleluia, rationabiles sine dolo lac concupiscite, alleluia" (Crave, as newborn babes, alleluia,

pure spiritual milk, alleluia), Biblioteca Vaticana, Cod. Rossiano 1192, folio 8. Overall: 8 × 8⁷/₈ inches (20.2 × 22.6 cm), initial: 6 × 6¹/₂ inches (15.3 × 16.4 cm). The page is numbered CXLVIII along its left margin. The subject of the illumination is drawn from the Gospel reading for this feast. On the reverse is a fragment of the offertory from the Mass for Easter Saturday: "[Benediximus vobis de domo do]mi[ni deus] domi[nus et i]lluxit no[bis]" (We bless you from the house of the Lord. The Lord is God, and he has given us light). Above the initial is a remnant of the Communion hymn for Easter Saturday: "[Omnes qui in christo baptizati e]stis christ[um induistis, alleluia]" (All you who have been baptized into Christ, have put on Christ, alleluia).

8. "Viri Galilaei quid admiramini aspicientes in caelum" (Men of Galilee, why do you stand looking up to heaven?), Biblioteca Vaticana, Cod. Rossiano 1192, folio 3. Overall: 11¹/₈ × 11¹/₂ inches (28.2 × 29.1 cm), initial: 9⁵/₈ × 9¹/₂ inches (24.3 × 24.2 cm). On the reverse is the Communion hymn for the Rogation Days (the Monday, Tuesday, and Wednesday before Ascension): "[Pulsa]te et aperietur vo[bis omn]is enim qui petit ac[cipi]t et qui q[uae]rit in[venit]" (Knock and it shall be opened to you; for everyone who asks receives, and he who seeks finds).

9. "Cibavit eos ex adipe frumenti" (He fed them with the finest wheat), Biblioteca Vaticana, Cod. Rossiano 1192, folio 5. Overall: 10¹/₈ × 10¹/₂ inches (25.8 × 26.8 cm), initial: 9¹/₈ × 9³/₄ inches (23.2 × 24.9 cm). On the reverse is the conclusion of the introit: "Alleluya alle[luya alle]luya. E[xsul]tate deo adjutor[i nostro jubilate Deo Jacob]" (Alleluia, alleluia, alleluia. Sing joyfully to God our helper: sing aloud to the God of Jacob).

Figure 77. Master of the Codex Rossiano, The Ascension of Christ in an initial V. Biblioteca Apostolica Vaticana, Vatican City (Cod. Rossiano 1192.3)

Figure 78. Master of the Codex Rossiano, The Celebration of the Eucharist in an initial C. Biblioteca Apostolica Vaticana, Vatican City (Cod. Rossiano 1192.5)

26a. The Adoration of the Magi in an Initial E

Tempera and gold leaf on parchment
Overall: 23¹/₄ × 16³/₈ in. (59.2 × 41.5 cm); stave H.: 1³/₈ in. (3.6 cm)

Bernard H. Breslauer, New York

The blue initial E, lined with yellow and decorated with orange, green, pink, gray, and blue foliage, is set against a tooled gold ground bordered by a ruled yellow-and-pink painted frame. The foliate decoration extends the full height of the page along its left margin and its full width along the top and bottom. At the right within the initial, the Virgin Mary, in a blue cloak worn over a pink dress, is seated on an intarsia throne set obliquely to the picture plane. She holds the Christ child on her lap while Saint Joseph, holding a golden pyx containing one of the gifts of the Magi, leans over the arm of the throne behind her. The eldest Magus, shown with a halo but no crown, kneels at the foot of the throne and looks up toward the benediction of the Christ child. Two younger Magi, crowned, one wearing an orange cape over a blue tunic, the other a pink cape lined with ermine over a yellow tunic, stand behind the kneeling king, and in turn two servitors stand behind them. The upper half of the initial is filled with the canopy of the Virgin's throne, a summary rocky landscape, and a train of horses and camels with their drivers following in the retinue of the Magi. In the upper and lower left corners of the gold ground, contained within curling tendrils of pink foliage, are two bust-length prophets, each holding a scroll and gesturing toward the scene of the Epiphany. The *bas-de-page* decoration includes two fantastic birds—signature devices of Don Simone—and two caricatured heads, one of which wears a white (probably Olivetan) cowl.

The initial E begins the introit to the Mass for the feast of the Epiphany (January 6): "Ecce a[d]venit dominator dominus et regnum in manu e[ius et potestas et imperium]" (Behold, the Lord, the ruler, is come. He has dominion over all and in his hand is power and might). Above the initial the page is rubricated "In die epyphanie. Introitus," with smaller rubrics in the top margin for the vigil of Epiphany. A roman numeral, XLI, in alternating blue and red characters, is painted at the center of the left margin, while an arabic 41 appears at the bottom of the left margin, and an arabic 82 alongside the bottom line of text at the left. This system of numeration conforms exactly to that on Cod. Rossiano 1192, folio 6 (The Vigil of the Nativity, fig. 71), numbered VI and 12; Rossiano 1192, folio 1 (Easter, fig. 75), numbered CXXIIII, 124, and 248; and Rossiano 1192, folio

8 (Low Sunday, fig. 76), numbered CXLVIII (see also cat. no. 26b).

A comparison of the scene of the Adoration of the Magi on this page with four other examples of the same subject painted by Don Simone—the Collegiata di San Lorenzo, Santa Croce sull'Arno, Cor. N. I, folio 17v; Chiesa Parrocchiale, Montopoli in Valdarno, gradual, folio 161v; Chiesa di Santa Maria delle Carceri, Prato, Cor. A, folio 40 (unfinished); and Newberry Library, Chicago, MS +74, vol. 1, folio 26r (cat. no. 24)—suggests that the design, though not the execution, of the Breslauer illumination must be attributed to that artist. In all these initials, the six principal figures (five in the last two, which omit Saint Joseph) are disposed in the same groupings and approximately the same attitudes as in the Breslauer page. Of these five initials, however, only that on the Breslauer page includes the retinue of the Magi, thereby expanding the narrative content of the image beyond Don Simone's usual emblematic or pictographic minimum. A similar interest in more expansive narrative detail is evinced by Don Simone in his nearly contemporary illuminations in Cor. B at Santa Croce, Florence. The Breslauer Epiphany is also the only one of the five versions of that subject to include an elaborately carved and inlaid throne for the Virgin—its ambitious perspective projection is another indication of Don Simone's design underlying this illumination—though it does not exploit the device of placing three or four figures in front of the crossbar of the initial and the rest behind it, as do all of the others except that from Santa Croce sull'Arno. The latter is the only one of the series plausibly datable earlier than the Breslauer page.

LK

EX COLL.: Museion, Olten, Switzerland (1984).

LITERATURE: Voelkle and Wieck 1992, pp. 190–91.

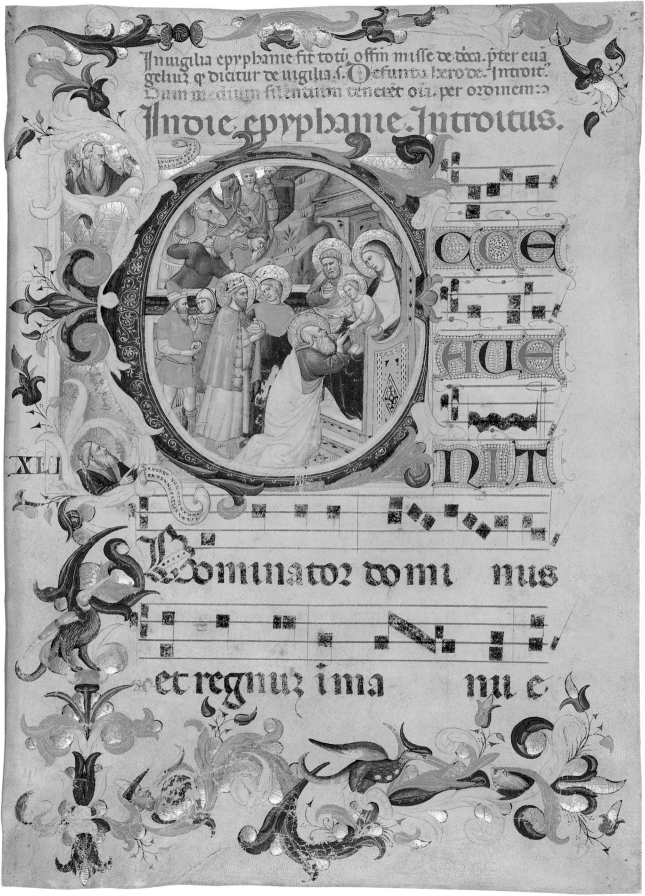

26a

26b. The Trinity in an Initial B

Tempera and gold leaf on parchment
Overall: 10½ × 10 in. (26.8 × 25.5 cm); initial: 10 × 9⅝ in.
(25.4 × 24.3 cm); stave H. (on the reverse): 1⅜ in. (3.6 cm)

The Metropolitan Museum of Art; Robert Lehman
Collection, 1975 (1975.1.2476)

The Trinity is represented in the upper half of the initial
B as three youthful bearded figures seated on a throne of
red seraphim. Each figure has a cruciform halo and is
dressed identically to the others in a blue cloak over a
white tunic; the central figure holds an open book in his
lap. The lower half of the initial is filled with ten seated
angels wearing white, one holding a spray of lilies,
another a scepter and globe. The initial is blue, pink, and
orange, with gray, blue, white, orange, and shell gold
foliation. In the upper corners of the gold ground, cra-
dled in tendrils of foliage, are two bust-length prophets
bearing scrolls and gesturing toward the Trinity. The
much-rubbed bust-length figure of an Olivetan(?) monk
in three-quarters lost profile is partially visible in the
lower left corner. The gold ground is bordered by a black
reveal ivy rinceau.

The initial B begins the introit to the Mass for Trinity
Sunday: "Benedicta sit sancta Trinitas atque indivisa
unitas; confitebimur ei quia fecit nobiscum misericordiam
suam" (Blessed be the Holy Trinity and undivided Unity.
We will give glory to him because he has shown mercy to
us). The last part of this text—"[Uni]tas confitebimur
e[i]"—is preserved on a fragmentary *bas-de-page* (fig. 79)
in the Biblioteca Apostolica Vaticana (Cod. Rossiano
1192, fol. 10) showing David and two white-clad (Olivet-
an?) monks, which was clearly cut from the same page as
the Lehman initial B. The reverse of the Vatican *bas-de-
page* is rubricated "f.a Sce. Trinitatis introitus" and
numbered in arabic 383. Its obverse (the verso of the page
when it was still bound in its original book) is numbered
384 to the left of the text and 192 in the lower left corner,
conforming to the system of numeration where it is still
preserved on other pages of the supposed San Miniato
al Monte gradual (see cat. no. 26a). The largely effaced
text on the reverse of the Lehman initial B is a fragment
of the Communion hymn from the Mass for Ember
Saturday after Pentecost, a prescribed day of fasting:
"[Spiritus ubi vult spirat et vo]cem eius audis al[leluia,
alleluia:] sed nescis unde [veniat] aut quo va[dat alleluia,
alleluia, alleluia]" (The wind blows where it will, and you
hear its sound, alleluia, alleluia! But you do not know
where it comes from or where it goes, alleluia, alleluia,
alleluia). The number 97 appearing in its right margin is
written in a later hand.

When it was exhibited with the Lehman collection in
Paris (1957) and Cincinnati (1959), this initial B was
catalogued as mid-fourteenth-century Bolognese, though
a more accurate proposal of "probably Florentine, ca.
1390" had already been advanced by Seymour De Ricci
(De Ricci and Wilson 1935–37, vol. 2, p. 1707). Miklós
Boskovits (1983, p. 269, fig. 17) first recognized its asso-
ciation with the cuttings in Cod. Rossiano 1192 at the Bi-
blioteca Vaticana, christening their author the Master of
the Codex Rossiano. Mirella Levi D'Ancona (*in litteris*)
objected to this epithet, since Cod. Rossiano 1192 is a
scrapbook of cuttings from various places and periods
(see also cat. nos. 29, 33). She correctly pointed out the
relationship of a number of the Rossiano cuttings to Don
Simone and proposed identifying them with that artist's
documented commission for San Miniato al Monte.

In her discussion of the place of the Lehman initial in
the San Miniato al Monte gradual, Levi D'Ancona cor-
rectly grouped it with the Resurrection (fol. 1; fig. 75),
the Doubting of Saint Thomas (fol. 8; fig. 76), the As-
cension (fol. 3; fig. 77), and the David with Two Monks
(fol. 10; fig. 79) in Cod. Rossiano 1192 as the work of a
single, probably Sienese, artist. She regarded the initial C
with the Celebration of the Eucharist (Cod. Rossiano
1192, fol. 5; fig. 78) as by a different, probably Florentine,
artist, however, and linked it with a Death of Saint Bene-
dict in the National Gallery of Art, Washington, D.C.
(B13,523) and a Saint Benedict Presenting His Rule in the
Detroit Institute of Arts (24.108), which she believed to
have also formed part of the San Miniato al Monte grad-
ual. All these illuminations are by a single hand, the
Sienese painter otherwise known as the Master of the
Codex Rossiano or the Kraków Master (Vailati Schoen-
burg Waldenburg 1990). The Washington and Detroit
initials, furthermore, are demonstrably from a different,
probably Sienese, book. While the possible identification
of the Kraków Master with Fra Gregorio da Montalcino
is not to be entirely excluded, it seems on the whole to
be unlikely.

LK

EX COLL.: A. S. Drey, Munich.

LITERATURE: De Ricci and Wilson 1935–37, vol. 2, p. 1707;
Paris 1957, no. 157, p. 109, pl. 71; Cincinnati 1959, no. 319;
Boskovits 1983, fig. 17; Szabo 1983, fig. 23.

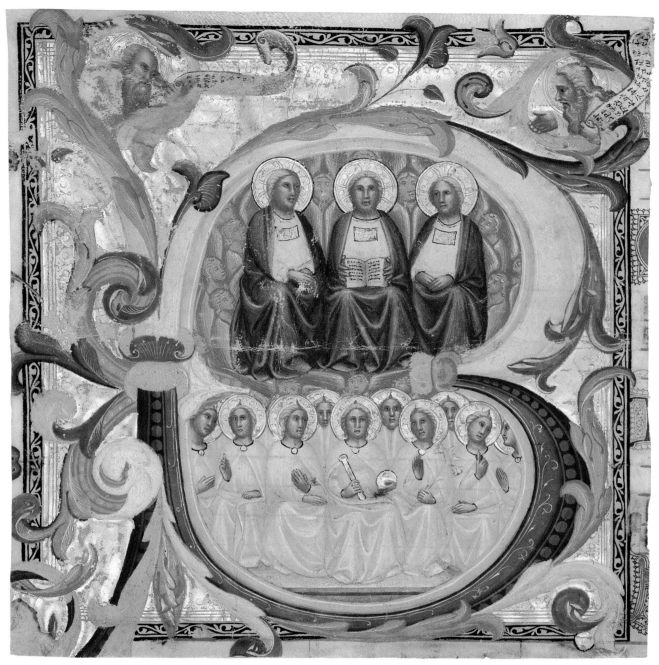

26 b

Figure 79. Master of the Codex
Rossiano, David with Two Monks.
Biblioteca Apostolica Vaticana, Vatican
City (Cod. Rossiano 1192.10)

LORENZO MONACO

Established facts concerning the life of Lorenzo Monaco are few. The date of his birth is unknown, and estimates have ranged from as early as 1367 (Gronau 1950, p. 218 n. 12) to as late as the mid-1370s (Eisenberg 1989, p. 4). Whether or not he was born in Siena, as has been suggested (Sirén 1905, p. 13), he was living in Florence in the parish of San Michele Visdomini by 1390 at the latest. In that year he entered the Camaldolese monastery of Santa Maria degli Angeli, professing minor orders in December 1391 and exchanging his given name, Piero di Giovanni, for his religious name, Lorenzo. Don Lorenzo was ordained a subdeacon in September 1392 and a deacon in 1396, but sometime after that date he left the monastery to operate his own studio. Presumably his life and work outside the cloister was sanctioned by the order as he never renounced his monastic vows, continuing to be known as the "frate degli Angeli" and exercising a virtual monopoly over Florentine Camaldolese commissions after the death of Don Silvestro dei Gherarducci (1399). Don Lorenzo also supplied altarpieces for other monastic orders and for lay patrons, as well as a quantity of smaller devotional panels for a flourishing domestic market in Florence, but none of his considerable body of work as an illuminator may be traced to a patron other than Santa Maria degli Angeli or the nearby hospital church of Santa Maria Nuova. The last preserved notice of the artist is of 1422, and it is reasonably assumed that he died in 1423 or 1424.

Though a number of dated works by Lorenzo Monaco survive, there is little scholarly agreement over the outlines of his career, and few attempts have been made to integrate his remarkable achievements as an illuminator with his better-known activity as a painter of panels and frescoes. The artist's early career is a subject of particular debate, confused by the uncertain dating of three choir books illuminated by him for Santa Maria degli Angeli (Biblioteca Laurenziana, Florence, Cod. Cor. 1, 5, 8; see cat. nos. 29, 30). The earliest panel paintings confidently attributable to him (see Gronau 1950; Zeri 1964–65) reveal an artist thoroughly indoctrinated in the workshop practice of Agnolo Gaddi, and it may be presumed that before undertaking his novitiate at Santa Maria degli Angeli, the young Piero di Giovanni was apprenticed to that master: the so-called Nobili predella (Louvre, Paris) may even have been painted as part of a commission to Agnolo Gaddi for an altarpiece (Bodemuseum, Berlin) that was set up in 1387–88 in Santa Maria degli Angeli. Whether the young artist's first independent altarpiece, painted for the convent church of San Gaggio outside Florence (Boskovits 1988, pp. 94–96), was executed before or after he entered the Camaldolese order in 1390 is unclear. Similarly it is not known whether his next major work, an altarpiece for the church of Santa Maria del Carmine, Florence (Boskovits 1988, pp. 96–99), was painted toward the end of his residence at Santa Maria degli Angeli or immediately upon leaving the monastery shortly after 1396.

While it is generally assumed that Lorenzo Monaco learned the craft of manuscript illumination in the scriptorium at Santa Maria degli Angeli under the tutelage of Don Silvestro dei Gherarducci, it is possible that he practiced in this medium as well before entering the monastery in 1390. To the extent that subtle differences can be distinguished between the broadly similar styles of the foliate decoration added to their initials by Don Silvestro and Don Simone Camaldolese—the former working almost exclusively in and for Santa Maria degli Angeli, the latter certainly not resident at Santa Maria degli Angeli and working almost exclusively for patrons elsewhere—it is paradoxically Don Simone's that most closely resembles Lorenzo Monaco's. That Don Lorenzo may have been briefly employed in the workshop of Don Simone is suggested by two books attributable to the latter (Butler Library, Columbia University, New York, MS no. X264Sa5Q; Museo Civico Medievale, Bologna, Cod. 539), the

former including several initials having foliate decoration executed in a technique reminiscent of Don Lorenzo, with stippled highlighting that does not otherwise occur in Don Simone's work, and the latter containing one initial (fig. 69) with foliate decoration painted by a member of Don Simone's shop and a scene of the Pentecost painted by a follower of Agnolo Gaddi who is perhaps to be identified with the young Lorenzo Monaco.

During the period of Lorenzo Monaco's residence at Santa Maria degli Angeli, the scriptorium there was engaged in the writing and illumination of two large series of antiphonaries (see "The Choir Books of Santa Maria degli Angeli" preceding cat. no. 29) and a set of graduals for their sister house of San Michele a Murano (cat. no. 17). Both volumes of the latter and the first three volumes of the former were painted by Don Silvestro, and two other volumes of the antiphonaries had been contracted to secular artists for illumination (cat. no. 20b). With the arrival of Don Lorenzo, however, the completion of these books seems to have been entrusted exclusively to him, beginning with Cod. Cor. 13 at the Biblioteca Laurenziana, one of the volumes of the antiphonary written for Santa Maria degli Angeli, and continuing with Cod. C 71 at the Museo Nazionale del Bargello, Florence, from the antiphonary volumes written for Santa Maria Nuova. Work on Cod. C 71 can be documented to the year 1396 (Levi D'Ancona 1979, pp. 469–71; Bent 1992, pp. 510–13), providing the only fixed point in Lorenzo Monaco's chronology during this crucial decade. Three further volumes of the antiphonary for Santa Maria degli Angeli (Biblioteca Laurenziana, Cod. Cor. 1, 5, 8) were painted significantly later, in the first half-decade of the fifteenth century (cat. nos. 29, 30), while additional volumes of antiphonaries and graduals for both Santa Maria degli Angeli (Cod. Cor. 3, 7, 18) and Santa Maria Nuova (Cod. E 70, H 74) were contributed by Lorenzo Monaco at regular intervals between 1406 and 1413 (cat. nos. 33, 37, 38).

More than any other painter of his generation, Lorenzo Monaco was alert to the innovations of two Florentine artists—Lorenzo Ghiberti and Gherardo Starnina—whose work heralded a new style that has come to be known as the International Gothic. In particular, the return of Starnina to Florence from Valencia in 1403 proved a decisive moment in Lorenzo Monaco's career. After that date, his paintings lost the restrained, artificial solemnity of his early attempts to compete with then successful and highly esteemed artists, such as Niccolò di Pietro Gerini, Giovanni del Biondo, or Spinello Aretino. His palette, heightened by previous experience of Agnolo Gaddi's unusual pastel hues, became more saturate and exaggerated in its use of bold contrasting colors. His contours, especially of draperies, became almost eccentric in the broad, looping curves they described across picture surfaces. His figures grew to elongated proportions and assumed gentle, swaying postures, often following the curved borders of his irregularly shaped picture fields or initial letters. The refinement and elegance of his work in this period, paralleling in two dimensions the accomplishments of Lorenzo Ghiberti in relief sculpture, became the standard to which a generation of younger painters, as well as such older, established masters as Lorenzo di Niccolò, aspired.

The progress of Lorenzo Monaco's development after 1403 can be traced in an unusually large number of dated altarpieces and devotional panels, beginning with two large works, both of 1404: the *Man of Sorrows* altarpiece in the Accademia, Florence (inv. no. 467), and an altarpiece of the *Madonna of Humility* in the Museo della Collegiata, Empoli (fig. 120). In many respects these two paintings are antithetical in style—one archaic and still rooted in the style of Niccolò di Pietro Gerini, the other "a paean to Gherardo Starnina's newly imported calligraphy, palette, and expressive content" (Kanter 1993, p. 633)—and the coincidence of their execution in the same year has long posed a conundrum to scholars. The tendency of Don Lorenzo's subsequent works, however, is clearly in the direction of the

loose Gothic rhythms of the Empoli altarpiece, becoming increasingly exaggerated in such paintings as the *Madonna of Humility* of 1405 in the Berenson collection at Villa I Tatti; the *Coronation of the Virgin* altarpiece of 1407 from San Benedetto fuori Porta a Pinti (now in the National Gallery, London, and elsewhere; fig. 100); the triptych of the *Agony in the Garden*, *Lamentation*, and *Three Marys at the Tomb* of 1408 (Musée du Louvre, Paris; Národni Galeri, Prague); the San Procolo *Annunciation* of 1409 (Accademia, Florence, and elsewhere; cat. no. 34); and the Monteoliveto altarpiece of 1410 (Accademia, Florence, inv. no. 468). The apogee of this period in Lorenzo Monaco's career, when the decorative potential of his style was in greatest accord with its heroic and expressive content, is represented by the illuminations he contributed sometime between 1409 and 1412 to one of the volumes of a gradual for Santa Maria degli Angeli (Biblioteca Laurenziana, Cod. Cor. 3), a commission that he abandoned incomplete, however, and that was finished only after his death by an artist of a very different inclination, Battista di Biagio Sanguigni (cat. no. 37).

During the last decade of his career, beginning with the large *Madonna of Humility* of 1413 in the National Gallery of Art, Washington, D.C., and the illuminations in Cod. H 74 at the Museo del Bargello, Florence (cat. no. 38), Lorenzo Monaco's paintings are generally darker than they had been previously, exploiting a more saturate though less high-key palette and pervaded by an intensified emotional and expressive content. His line becomes mannered and his figure style tense, at times almost caricatural. The key work of this period—his masterpiece and one of the singular monuments of Florentine painting—is the signed *Coronation of the Virgin* altarpiece of 1414 (Eisenberg 1989, fig. 44), formerly on the high altar of Santa Maria degli Angeli, a compendium of all those aspects of his style that made him the preeminent Florentine painter of the first quarter of the fifteenth century. Shortly after completing this monumental work, Don Lorenzo was engaged on at least one commission for Pisa (see cat. no. 40) and on the somber, almost eccentrically mannered frescoes and altarpiece in the Bartolini Salimbeni Chapel in Santa Trinita, Florence. In one of his last works, however, the lyrically beautiful *Adoration of the Magi* (fig. 118)—possibly to be identified with a commission of 1422–23 for an altarpiece in Sant'Egidio, Florence (Eisenberg 1989, pp. 118–20)—Lorenzo Monaco reintroduces a fuller figure style, looser and more graceful line, and a brighter palette reminiscent of his San Procolo *Annunciation* of 1409 or of the illuminations in Cod. Cor. 3, two works sometimes confused for products of this late period (Levi D'Ancona 1958b, pp. 180–81, n. 26; Eisenberg 1989, pp. 103–4, 109–11). Lorenzo Monaco's last endeavor, almost certainly left unfinished at his death in 1423 or 1424, was an altarpiece of the *Deposition* intended for the sacristy chapel in Santa Trinita, Florence. Commissioned by Palla Strozzi, the altarpiece was advanced by Don Lorenzo little further than the painted pinnacles (Museo di San Marco, Florence) and predella (Accademia, inv. nos. 8615–17). The majestic central panel was redesigned and completed a few years later by Lorenzo's successor as the great monastic painter of Florence, Fra Angelico.

LK

27. Virgin and Child Enthroned with Saint John the Baptist and Saint John the Evangelist(?)

Gold foil and oil paint on glass (*verre églomisé*)
6 3/4 × 6 7/8 in. (17.1 × 17.5 cm)

Musée du Louvre, Paris; Département des Objets d'Art, Legs Davillier, no. 186 (OA 3109)

The irregularly shaped hexagonal field of the *verre églomisé* plaque is filled with a carved throne of marbled and inlaid surfaces. The Virgin, in a red gown and blue mantle, is seated in the center before a red and gold cloth of honor draped over the back of the throne and upon a cushion with tasseled corners. Her halo, interrupted by a break in the glass running diagonally across the top corner, is inscribed in red: AV[E M]ARIA [G]RAT[IA PLE-NA] (Hail Mary, full of grace). Turned slightly to the left, she holds the Christ child in front of her. The child rests his right foot on his mother's wrist, reaches around her shoulder with his left arm, and holds a partially obliterated object in his right hand, perhaps a flower. The arms of the throne are carved with arched openings through which appear diminutive figures of Saint John the Baptist at the left, wearing a hair shirt and carrying a scroll let-

tered [ECC]E AGNUS (Behold the Lamb), and at the right a bearded saint holding a book, possibly meant to represent Saint John the Evangelist. The draperies of two more saints appear in arched openings above these, but the figures are truncated at the upper edges of the glass and are unidentifiable. The glass is broken at the bottom edge just below the level of the Virgin's knees.

This remarkable fragment, as rich in graphic detail as a copperplate engraving, was long known only as an anonymous Florentine work of the trecento (van Marle 1923–38, vol. 3 [1924], p. 274; Degenhart and Schmitt 1968, p. 109) until an attribution for it to Cenni di Francesco was proposed by Miklós Boskovits (1975, p. 291). Silvana Pettenati (1973, p. 73) was the first to recognize its relation to the early work of Lorenzo Monaco, an attribution more firmly advanced by Luciano Bellosi (1985a, pp. 21–22). Bellosi aptly compared the Louvre plaque to Don Lorenzo's triptych in the Pinacoteca Nazionale, Siena (fig. 83), and pointed out that the artist is otherwise known to have worked in the delicate medium of *verre églomisé* through examples in the Museo Civico, Turin, dated 1408 (fig. 80), and the Musée des Beaux-Arts, Lyons (Toesca 1951, p. 863; fig. 81).

The Turin *verre églomisé* plaque by Lorenzo Monaco provides numerous points of comparison for the technique and conception of the Louvre plaque, though the former is clearly a far more mature effort by the artist. The two compositions are similar, except that in Turin the enthroned Virgin has become a Madonna of Humility and the two saints are portrayed more nearly on the same scale as the central figures. More significant is a comparison of the pictorial devices exploited by the artist, from such minor details as the veining of the marble in the pavement of one and the throne of the other, together with the nearly identical patterns enlivening the cloths of honor, to the sophisticated effects of modeling achieved by dense and carefully controlled hatching, which congeals into deep, velvety pools of blue and black in the draperies. The unusual double tier of arched openings cut into the sides of the Virgin's throne in the Louvre plaque reappears in nearly identical form in the throne of the London *Coronation of the Virgin* altarpiece of 1407 (fig. 100) and in a drawing of *Saint Benedict Enthroned* in the Uffizi (Florence 1978, no. 28, fig. 45), probably of the same date. The Louvre plaque, however, must be considerably earlier than these works, likely having been designed closer in time to the Siena triptych, before the turn of the fifteenth century.

The painting by Lorenzo Monaco that most closely resembles the Louvre plaque in style—a resemblance

Figure 80. Lorenzo Monaco, *Madonna of Humility with Two Saints*. Museo Civico, Turin (V.O. 152-3024)

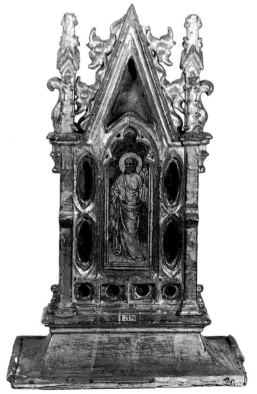

Figure 81. Lorenzo Monaco, *Saint Barnabas(?)*. Musée des Beaux-Arts, Lyons (D698)

heightened by their nearly identical size—is the *Virgin and Child Enthroned with Two Angels* in the Fitzwilliam Museum, Cambridge (fig. 82). The types of the two principal figures in these works are virtually interchangeable, but even such apparently minor details as the fall of the Virgin's veil and shawl, the looping folds of her draperies, the tassels at the corners of her cushion, the raised lozenges painted inside the arched back of her throne, and the diamond pattern engraved in the crossbars of the child's halo correspond so completely as to argue that these two works must be almost exactly contemporary. Since the Louvre *verre églomisé* was designed in reverse by scratching through the gold leaf applied to the back of the glass, it is quite possible that the figures of the Virgin in it and in the Fitzwilliam panel could have been elaborated from a single preparatory drawing.

The date of this hypothetical drawing may be deduced only approximately, by comparison with the illuminations from Cod. Cor. 13 at the Biblioteca Laurenziana, Florence. Cod. Cor. 13 is the earliest surviving example of Don Lorenzo's work as an illuminator, predating Cod. C 71 in the Bargello, Florence, which is known to have been in hand in 1396 (see "The Choir Books of Santa Maria degli Angeli," preceding cat. no. 29). Cod. Cor. 13 was possibly painted about the time of Don Lorenzo's profession of solemn vows at Santa Maria degli Angeli in 1391. In this regard, it may be significant that it and the Fitzwilliam *Virgin and Child* are the only works by Lorenzo Monaco in which the gold ground is decorated with engraving only. It is possible that having just entered the monastery, he no longer had access to the resources of a secular workshop, such as sets of punching tools.[1] When punches do reappear in Lorenzo Monaco's immediately subsequent work, such as the triptych in the Pinacoteca Nazionale, Siena, and the Chicago processional cross (cat. no. 28), they are few in number and extremely simple in form.

Comparison with the Fitzwilliam *Virgin and Child* also suggests the possible original format of the Louvre plaque, which has clearly been broken or cut at the upper corners and across the bottom. There can be no doubt that the arms of the Virgin's throne originally appeared complete, with a second set of saints above the two presently visible, and that the back of the throne terminated in some architecturally plausible superstructure as in the Fitzwilliam panel. It is also virtually certain that the Virgin's legs were originally shown complete and that her feet rested on some form of dais before the throne. The completed plaque was probably intended as the center panel of a small reliquary, as in slightly earlier examples by Francesco di Vannuccio (Berlin) and Lippo Vanni (Società di Esecutori di Pie Disposizioni, Siena), or that

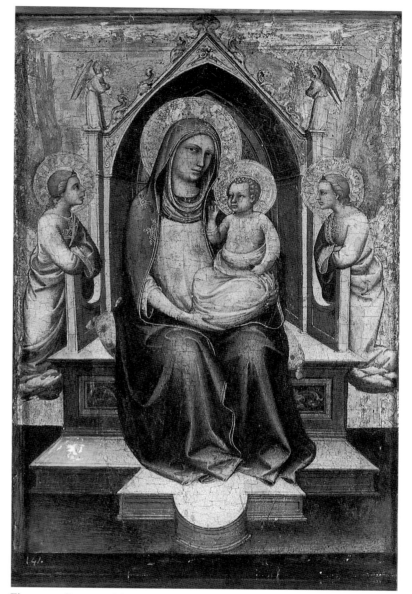

Figure 82. Lorenzo Monaco, *Virgin and Child Enthroned with Two Angels*. Fitzwilliam Museum, Cambridge (555)

by Lorenzo Monaco himself in Lyons. Cennino Cennini (1960, p. 112) specifically relates the technique of *verre églomisé* with the decoration of reliquaries:

> There is another process for working on glass, indescribably attractive, fine and unusual, and this is a branch of great piety, for the embellishment of holy reliquaries; and it calls for sure and ready draftsmanship.

Objects executed in this extremely fragile medium were almost invariably set into small but rigid carved structures like the reliquary frame dated 1347 preserved in The Cleveland Museum of Art (Wixom 1979, pp. 128–32). Given the probable date of its execution and the facts of Lorenzo Monaco's biography at that period, it is to be

wondered whether the reliquary in which the Louvre plaque was set may have been made for one of the altars in Santa Maria degli Angeli.

LK

1. See Skaug 1983, for a schematic chart of the diffusion of specific punch tools among Florentine workshops. Don Silvestro dei Gherarducci owned an elaborate set of tools, none of which were ever used by Lorenzo Monaco, and it may be wondered whether the older master actually maintained his studio at Santa Maria degli Angeli.

EX COLL.: Baron Jean-Charles Davillier (1871).

LITERATURE: Paris 1885, no. 534, p. 273; van Marle 1923–38, vol. 3 (1924), p. 274; Degenhart and Schmitt 1968, p. 109; Pettenati 1973, p. 73, fig. 51; Boskovits 1975, p. 291; Pettenati 1978, p. 16; Bellosi 1985a, pp. 21–22; Eisenberg 1989, p. 171.

28. Processional Cross

Tempera and gold leaf on panel
Overall: 22 1/2 × 11 in. (57.3 × 28 cm); picture surface: 20 1/8 × 9 1/8 in. (51 × 23.3 cm)

The Art Institute of Chicago; Mr. and Mrs. Martin A. Ryerson Collection (1933.1032)

The elaborate, cruciform picture field is formed of an elongated rectangular panel with five lobed extensions at the top and sides and an antependium with attached acanthus decoration. Most of the height of the painting is filled by the cross and the body of Christ, with blood running from his wounds down the shaft of the cross and spreading in rivulets over the rocky landscape below. At the foot of the cross kneel two figures in adoration of the crucified Christ: at the right is Saint Mary Magdalen in a long red robe, and at the left is a hermit, bearing the rays of a blessed instead of a halo and wearing a coarse brown tunic torn at the shoulder. Below them, emerging from a crevice in the rocky ground beneath the foot of the cross, is a bust-length figure of King David with a halo and a crown; he holds a scroll inscribed [MISE]RERE MEI D[EUS]. Above the arms of the cross, which extend into the upper side pair of lobes, hover two angels robed in blue highlighted in yellow green (left) and white (right). The angels are gesturing in adoration not of the crucified Christ but of an image of the Glorified Christ holding two palm branches and floating on a bank of clouds in a star-filled mandorla above the titulus of the cross.

This little-known masterpiece of Florentine Gothic painting has only recently been recognized as an early work of Lorenzo Monaco, an attribution still not universally acknowledged among scholars (see Lloyd 1993, with previous bibliography). Its extraordinarily rich palette, particularly in the beautifully preserved upper section where the white robes of the Glorified Christ are shot with yellow and rose shading to blue; its delicately rendered draperies; and the subtlety and precision of its painted lighting effects are all typical of Lorenzo Monaco throughout his career, while the figure types and the manner of drawing hands, feet, and profiles are frequently encountered among his works predating the *Agony in the Garden* altarpiece at the Accademia, Florence, and the illuminations in Cod. Cor. 1 at the Biblioteca Laurenziana, both of about 1400. The Chicago panel is especially close in all these respects to the triptych of the *Madonna and Child in Glory with Saints John the Baptist and Nicholas* in the Pinacoteca Nazionale, Siena (fig. 83), with which it also shares identical punch decoration of the margins of the gold ground and engraved halo decoration.

Both the Chicago and Siena panels, which are not only by the same artist but must also be almost exactly contemporary, are strongly reminiscent of works confidently attributable to Lorenzo Monaco and datable to the first half of the 1390s. Chief among these are the slightly stiffer, perhaps slightly earlier, *Virgin and Child Enthroned with Two Angels* in the Fitzwilliam Museum, Cambridge (fig. 82), and the illuminations in Cod. Cor. 13 from Santa Maria degli Angeli. Comparisons either of the Berlin Saint Paul in an initial E (fig. 85), cut from folio 2v of Cod. Cor. 13, with the bust of the Glorified Christ in Chicago or of the head of Moses on folio 89r from the same codex with that of the crucified Christ suggest that no great distance of time elapsed between the execution of one and the other; similar points of comparison may be drawn between the adoring angels in the Fitzwilliam *Virgin and Child* and their counterparts in the Chicago cross. As the Chicago cross and the Siena triptych are in every instance marginally more delicate in handling than comparable details in either Cod. Cor. 13 or the Fitzwilliam *Virgin and Child*, they may be presumed to shortly postdate those works, which are plausibly datable to about 1391 (see cat. no. 27), though they are markedly earlier in style than the illuminations in Cod. C 71 of 1396 from the Museo Nazionale del Bargello.

An attribution to Lorenzo Monaco and a dating of about 1392–93 for the Chicago cross raises the question of its original function and provenance. The panel's unusual shape and construction—it was carved in one piece with its frame and drilled with a hole at the bottom to

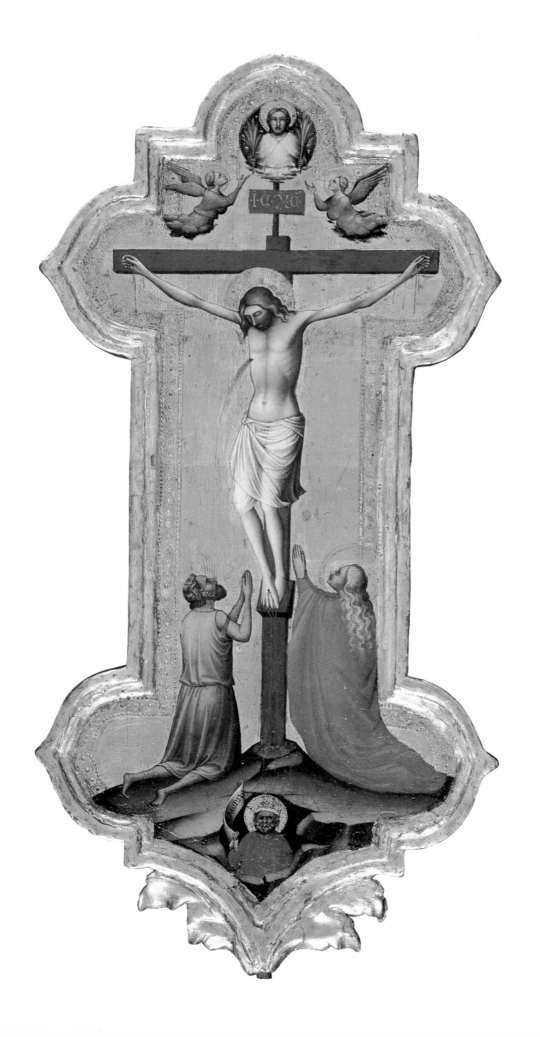

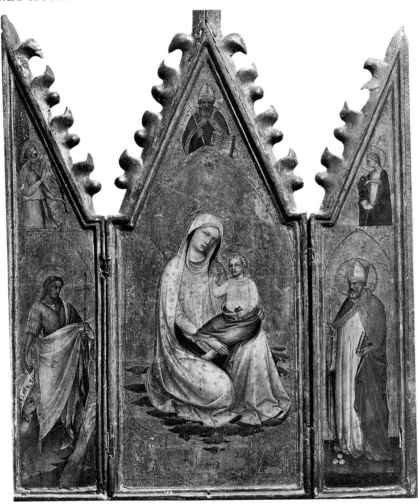

Figure 83. Lorenzo Monaco, *Madonna and Child in Glory with Saints John the Baptist and Nicholas*. Pinacoteca Nazionale, Siena (157)

receive a long dowel peg affixing it to some subjacent structure—imply that it is a fragment of some item of liturgical furniture. That it was probably not a pinnacle from an altarpiece is suggested by the lack of any evidence of batten supports on the back (the fictive porphyry surface of the reverse is old but not original) and by the stress damage to both the paint surface and the reverse caused by the dowel peg at the bottom. Such damage is the result of regular movement of the peg within its hole, which is little likely in an altar fixture but unavoidable in a processional cross. Mounted on a long pole and carried in processions around the church, such crosses were placed in stands alongside the altar table during celebration of the Mass (Costantini 1911, pp. 82–83). Because their function subjected them to far greater rigors of handling, they survive in fewer numbers than other types of religious painting; however, many surviving examples are related in shape and size to the Chicago panel. Conclusive evidence of its use as a processional

cross might have been provided by the decoration of the outer edge of its frame, but the frame of the Chicago panel was regessoed and regilt in a modern restoration.

A document recently discovered and kindly communicated by George Bent, which will be the subject of a forthcoming publication by him on the ritual of liturgical processions at Santa Maria degli Angeli, may further elucidate the original function of the Chicago cross. In a privilege granted by Pope Boniface IX on November 3, 1392, an indulgence of 140 days was granted to every member of the community at Santa Maria degli Angeli who visited each of the altars of the church in penitential procession on thirteen specified feast days during the year, praying for the salvation of the souls of the Holy Pontiff and of all good Christians. The coincidence of the timing of this document with the probable date of execution of the Chicago cross suggests that it may have been commissioned for use in these processions, a possibility underscored by the penitential iconography of the cross. As pointed out by Lloyd (1993, p. 88), the usual device of the pelican in her piety surmounting the cross, which symbolizes the charity of Christ's sacrifice, is replaced here by a vision of the Glorified or Risen Christ holding two palms, which represents his victory over death and the promise of eternal life. The scroll held by King David emerging from the ground (a tomb?) at the bottom of the picture is inscribed with the opening words of Psalm 50, verse 3: "Miserere mei, Deus, secundum magnam misericordiam tuam; et secundum multitudinem miserationum tuarum, dele iniquitatem meam" (Have mercy on me, O God, according to thy great mercy. And according to the multitude of thy tender mercies blot out my iniquity). Not only does this psalm relate textually to the concept of indulgences and remission from sin, but it is a standard part of the Office of the Dead and of the Office of Lauds on Maundy Thursday, Good Friday, and Holy Saturday, prefatory to the celebration of Christ's Resurrection and victory over death.

The identity of the figure kneeling at the left at the foot of the cross opposite Mary Magdalen is not explained by reference to this privilege of indulgences unless he is to be understood as a personification of the Christian soul. A more likely explanation, however, may be derived from the existence of an early copy of the Chicago cross—differing from it only in the shape of the top and bottom terminals and in the replacement of the angels and Glorified Christ at the top with the more standard image of a pelican in her piety—at the convent of the Montalve, La Quiete (Florence 1933, p. 90). The convent was founded at La Quiete only in 1650, when a Dominican community transferred there from San

Jacopo a Ripoli, Florence. The copy of the Chicago cross, which was probably painted about 1400–1410, cannot therefore have been commissioned for La Quiete, nor is it likely to have been brought there from San Jacopo a Ripoli, which had been abandoned in 1348 and was not rebuilt until 1458 (Richa 1754–62, vol. 4, pp. 100–119, 293–311). But adjoining the Villa La Quiete, in which the convent of the Montalve is housed, and attached to it by a long corridor or ambulatory, formerly stood a Camaldolese convent, San Giovanni Evangelista di Boldrone, which was founded in 1192 as a hermitage by a French pilgrim named Boldrone (Moreni 1791–95, vol. 1, pp. 73–78). By 1198 the hermitage of San Giovanni Evangelista di Boldrone was placed under the jurisdiction of the monastery of Camaldoli, and from 1291 it was occupied by a community of Camaldolese nuns and known as Monasterium Sancti Boldronis. Much of the property of this convent was transferred to La Quiete and to San Jacopo a Ripoli in the seventeenth century, making a provenance from San Giovanni Evangelista di Boldrone a virtual certainty for the Montalve cross and confirming a Camaldolese provenance for the Chicago cross, from which it was copied. The kneeling figure at the left of the Montalve cross, who differs from his prototype in Chicago only in being provided with a halo instead of incised rays, can unhesitatingly be identified as the hermit Boldrone, and in all likelihood it is also Boldrone who is portrayed in the Chicago cross, though no references to a special devotion to Boldrone at Santa Maria degli Angeli have yet come to light.

LK

Ex coll.: Achillito Chiesa, Milan (sale, AAA, New York, November 22–23, 1927, lot 110); [Kleinberger, New York]; Martin A. Ryerson, Chicago (1927).

Literature: Rich 1928, pp. 74–75; Berenson 1932a, p. 165; Valentiner [1932], n.p.; Berenson 1936, p. 142; Huth 1961, p. 516; Maxon 1970, p. 24; Fredericksen and Zeri 1972, pp. 111, 292, 571; Boskovits 1975, p. 340; Eisenberg 1989, p. 182; Lloyd 1993, pp. 85–89.

The Choir Books of Santa Maria degli Angeli

Admired by Lorenzo the Magnificent and Pope Leo X, who is said to have coveted them for the Basilica of Saint Peter's and was dissuaded from taking them "dando giusta ricompensa ai monaci" (giving just recompense to the monks) only because they were written according to Camaldolese and not Roman usage (Vasari 1906, vol. 2, p. 24), the choir books of Santa Maria degli Angeli are the crowning monuments of the art of illumination in early Renaissance Florence. Vasari, who claims to have seen them many times, was amazed that works of such refinement ("diligenza") could have been produced "in quei tempi che tutte l'arti del disegno erano poco meno che perdute" (in those times, when the arts of design were little less than lost) and described them as "i piu belli, quanto allo scritto, e maggiori che siano forse in Italia" (the most beautiful as regards the writing, as well as the largest that there are perchance in Italy [Vasari 1906, vol. 2, pp. 22–23]). He gave their number as twenty, though it is difficult to know whether he meant this as an accurate count or an estimate. Twenty codices, most of them missing pages where illuminated initials were presumably cut out and sold to collectors, were transferred to the Biblioteca Laurenziana from Santa Maria degli Angeli upon the suppression of the monastery at the beginning of the nineteenth century. Two of the twenty codices were, however, demonstrably not part of a set with the others,[1] and it is unclear how many volumes from the set are missing.[2]

The writing and illumination of the choir books from Santa Maria degli Angeli were protracted over a period of 135 years. The earliest of the series, Cod. Cor. 2, was the volume of the gradual containing the propers of the saints for the entire year (see cat. no. 16). Dated in its explicit the seventh day of the calends of February 1370, it is the only volume that can be shown to have been written before the Papal Interdict of 1376–78 and the sacking and burning of Santa Maria degli Angeli in 1378. In April 1382 the monastery received a large bequest from Francesco di Priore Baroncelli, which, united with an earlier bequest of the Albizzi, provided for the completion of a full set of choir books for both Santa Maria degli Angeli and its neighbor Santa Maria Nuova. The writing of these books—intended to be produced simultaneously—began in 1385, when the first volume of an antiphonary from San Pier Maggiore was lent to the scriptorium at Santa Maria degli Angeli to be copied (Levi D'Ancona 1979, pp. 462–64). A complete set of antiphonaries, in twelve volumes, was apparently finished (that is, written, but not necessarily illuminated) for Santa Maria degli

Figure 84. Lorenzo Monaco, Moses in an initial L. Biblioteca Medicea Laurenziana, Florence (Cod. Cor. 13, fol. 89r)

Angeli by 1397, though work on the more modest set of four volumes for Santa Maria Nuova was not concluded until 1424.[3]

Eleven of the volumes of the antiphonary from Santa Maria degli Angeli contain both movable and fixed feasts for a portion of the liturgical year as follows:

Volume 1: Cod. Cor. 9. First Sunday in Advent—Saint Andrew (November 30)—Saint Nicholas (December 6).

Volume 2: Cod. Cor. 16 (inscribed *Incipit II.a pars antiphanarii Sancte Marie de Angelis de Florentia*). Saint Lucy (December 13)—Nativity (December 25)—Saint John the Evangelist (December 27).

Volume 3: Cod. Cor. 14 (inscribed *Incipit III.a pars antiphanarii* . . .). Epiphany (January 6)—Saint Agnes (January 21).

Volume 4: Cod. Cor. 17. Septuagesima Sunday—Saint Blaise (February 3).

Volume 5: Cod. Cor. 13 (inscribed *Incipit V.a pars antiphanarii* . . .). First Sunday of Lent—Saint Gregory the Great (March 12)—Saint Benedict (March 21).

Volume 6: Cod. Cor. 12 (inscribed *Incipit VI.a pars antiphanarii* . . . and dated 1397 in a colophon on fol. 23v). Holy Week—Annunciation (March 25)—Saints Tiburtius and Valerius (April 14).

Volume 7: Cod. Cor. 1 (dated 1396 in a colophon on fol. 28r). Easter—Ascension—Pentecost—Trinity Sunday.

Volume 8: Cod. Cor. 8 (inscribed *Incipit VIII.a pars antiphanarii* . . . and dated 1395 in a colophon on fol. 158v). Corpus Domini—Saint Romuald (June 19)—Saint John the Baptist (June 24)—Saint Peter (June 29)—Saint Paul (June 30).

Volume 9: Cod. Cor. 19 (inscribed *Incipit IX.a pars antiphanarii* . . .). Saint Mary Magdalen (July 22)—Saint Augustine (August 28).

Volume 10: Cod. Cor. 5 (inscribed *Incipit X.a pars antiphanarii* . . . and dated 1394 in a colophon on fol. 35r). Saturday before the first Sunday in September—Beheading of the Baptist (August 29)—Birth of the Virgin (September 8)—Dedication of Saint Michael (September 29)—Saint Jerome (September 30).

Volume 11: Cod. Cor. 6. Saturday before the first Sunday in October—Saint Cecilia (November 22).

In addition to the eleven volumes of the antiphonary covering the fixed and movable feasts of the liturgical year, one volume with the commons of the saints—Cod. Cor. 11—was added at an uncertain date, probably in the 1390s (cat. no. 20b). In 1406 another volume, Cod. Cor. 7 (cat. no. 33) was added, containing further commons of the saints, votive offices, and those feasts in April and May—for example, Saint George (April 23), Saints Philip and James (May 3, according to the Camaldolese calendar), and the Invention of the Holy Cross (May 3)—that had been omitted from Cod. Cor. 11 and Cod. Cor. 1, volume 7 of the original set of books (cat. no. 29). Finally, the series of graduals begun in 1370 was completed in 1409 and 1410 with the addition of four further volumes, including Cod. Cor. 18, 3, and 4 (see cat. nos. 35, 37).

In studying the rich variety of illuminations present in thirteen of these volumes (Cod. Cor. 14 was never illuminated, and all the illuminations have been removed from Cod. Cor. 12, 17, and 18), as well as those cuttings in collections around the world that can confidently be traced to these books, it is apparent that they were not completed strictly in the order in which the books were written, and in some cases there was a considerable delay between writing and painting a given volume. The most notable instance of such delay is Cod. Cor. 4, which is dated 1410 in a colophon on folio 8v ("Completum est hoc opus anno Domini M.CCCC.X"), but which Attavante was paid to illuminate only a century later, in 1505–6 (Levi D'Ancona 1958b, p. 181 n. 26). It is probable that the first three volumes to be completed with illuminations were Cod. Cor. 9, 19, and 6, volumes 1, 9, and 11 of

Figure 85. Lorenzo Monaco, Saint Paul in an initial E. Staatliche Museen zu Berlin; Kupferstichkabinett (Min. 1232)

the antiphonary series, all painted by Don Silvestro dei Gherarducci.[4] The illuminations from Cod. Cor. 16, volume 2 of the series, and Cod. Cor. 11 were commissioned to artists outside the monastery (see cat. no. 20), while the remaining volumes of the antiphonary, Cod. Cor. 1, 5, 7, 8, and 13, may all be associated with the art of Lorenzo Monaco.

Four of the antiphonary volumes painted by Lorenzo Monaco are dated in colophons—1394 (Cod. Cor. 5), 1395 (Cod. Cor. 8), 1396 (Cod. Cor. 1), and 1406 (Cod. Cor. 7)—and while it is recognized that these dates refer to the completion of the text only, they are universally accepted as termini a quo for the execution of the miniatures as well. Accordingly, the first three books are all considered works of the period 1395–1400 (Eisenberg 1989, pp. 8, 109, 111, with a summary of previous literature). Most scholars, furthermore, see Lorenzo Monaco as directly responsible for only a limited number of the initials in these books, assigning the others to a variety of assistants, followers, or even precursors (two cuttings from Cod. Cor. 1 were attributed by Marvin Eisenberg to Don Silvestro dei Gherarducci), whereas

Figure 86. Lorenzo Monaco, A Prophet in an initial T. Suermondt-Ludwig-Museum, Aachen (24)

Figure 87. Lorenzo Monaco, Joseph in an initial V. Private collection

they are consistent in handling and quality within each volume. Cod. Cor. 13, which is undated and can only be said to have been written in all probability not later than 1396, is generally associated with a follower of Lorenzo Monaco, though it was correctly recognized by Miklós Boskovits (1975, p. 242 n. 196) as autograph. It is likely that Cod. Cor. 13 and a stylistically related volume among the antiphonaries from Santa Maria Nuova, Cod. C 71, in the Museo Nazionale del Bargello, Florence, represent Lorenzo Monaco's earliest surviving work as an illuminator.

Cod. Cor. 13 retains only one of its painted initials, a Moses in an initial L ("Locutus est Dominus ad Moysen dicens descende in Egyptum" [The Lord spoke to Moses saying, "Go Down to Egypt"]) on folio 89r, which begins the first responsory of matins for the fourth Sunday in Lent (fig. 84). The apparent coarseness of the figure (both Mirella Levi D'Ancona and Eisenberg attributed it to Bartolomeo di Fruosino) is belied by the firm, aggressive draftsmanship, the sophisticated modeling in light and shadow, and the subtle palette (Moses' robe is lavender shifting to blue in the shadows and yellow in the highlights), all typical of Lorenzo Monaco. An early date is suggested by the engraved rather than punched decoration filling Moses' halo and is

confirmed by comparison with the predella panels from the San Gaggio and Carmine altarpieces, particularly the former, where numerous figures of similar type may be found.

Four of the seven illuminations missing from Cod. Cor. 13 may be identified with some degree of confidence.[5] A Saint Paul in an initial E ("Ecce nunc tempus acceptabile, ecce nunc dies salutis" [Behold, now is the acceptable time; behold, now is the day of salvation!]) in Berlin (Kupferstichkabinett, Min. 1232; fig. 85), illustrating the first responsory of matins for the first Sunday in Lent (fol. 2v), is inseparable stylistically from the predella panels of the San Gaggio or Carmine altarpieces. A Prophet in an initial T ("Tolle arma tua, pharetram et arcum" [Take thy arms, thy quiver, and bow]) in the Suermondt-Ludwig-Museum, Aachen (fig. 86), illustrating the first responsory of matins for the second Sunday in Lent (fol. 29), is similarly related to the San Gaggio predella, as are the Joseph in an initial V ("Videntes Joseph a longe loquebantur mutuo fratres, dicentes: ecce somniatur venit, venite occidamus eum" [Seeing Joseph in the distance, the brothers said to one another: Here comes that dreamer, let us kill him]), recently discovered in a private collection (fig. 87), illustrating the first responsory of matins for the third Sunday in Lent, and the Saint Gregory the Great in an initial M ("Mutato enim saeculari habitu" [He shed the secular robes]) in Berlin (Kupferstichkabinett, Min. 4592; fig. 88), illustrating the second responsory of matins for the feast of Saint Gregory on March 12 (fol. 121r). All of these suggest a date for Cod. Cor. 13 shortly after completion of the San Gaggio altarpiece and probably shortly before the inception of work on the Carmine altarpiece, before Lorenzo Monaco had entirely shed his dependence on the example of Agnolo Gaddi.

This date may perhaps be more precisely deduced by comparison with the illuminations in the antiphonary Cod. C 71 from Santa Maria Nuova (Bargello). In an attempt to establish the artistic identity of Don Silvestro dei Gherarducci, Levi D'Ancona (1979, pp. 471–72) presented documentary evidence for attributing to him some of the illuminations in this codex, all of which are in fact attributable to the young Lorenzo Monaco, and for dating them to 1395, a date recently corrected to 1396 by George Bent.[6] More so than the illuminations from Cod. Cor. 13, the miniatures in Cod. C 71 beg comparison with the dispersed panels of the Carmine altarpiece and with a small number of panels stylistically related to them, such as the *Virgin and Child Enthroned with Six Saints* in the Museo Horne, Florence, or the *Virgin and Child in Glory with Saints Peter, Paul, and Two Angels* in the Walters Art Gallery, Baltimore (Zeri 1964–65). Tradi-

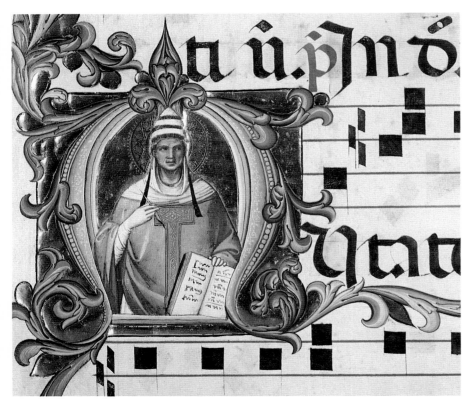

Figure 88. Lorenzo Monaco, Saint Gregory the Great in an initial M. Staatliche Museen zu Berlin; Kupferstichkabinett (Min. 4592)

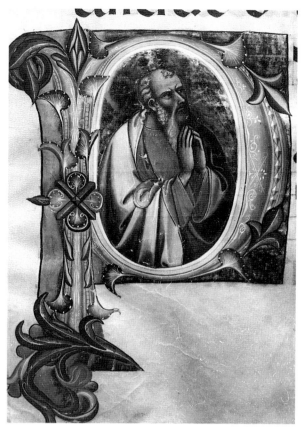

Figure 89. Lorenzo Monaco, Tobit in an initial P. Biblioteca Medicea Laurenziana, Florence (Cod. Cor. 5, fol. 20v)

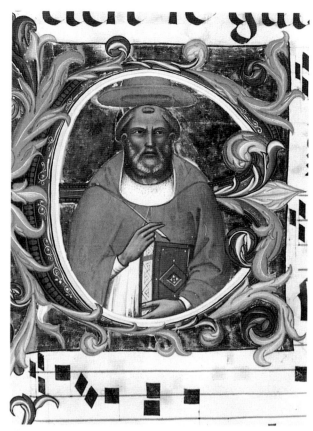

Figure 90. Lorenzo Monaco, Saint Jerome in an initial E. Biblioteca Medicea Laurenziana, Florence (Cod. Cor. 5, fol. 138r)

tionally thought to be Lorenzo Monaco's earliest independent work, shortly following the Nobili predella (Musée du Louvre, Paris) of 1387–88, which was painted as part of a commission to Agnolo Gaddi and followed in turn by the San Gaggio altarpiece, the Carmine altarpiece must instead postdate the San Gaggio altarpiece and the Agnolesque panels related to it, such as the *Virgin and Child with Saints and Angels* in the Accademia, Florence (inv. no. 3227; Boskovits 1975, 1989). Aside from the more rational development of the artist's figure style implied by this progression, a comparison of the landscape elements or the treatment of light in the Berlin *Martyrdom of Saint Catherine of Alexandria* from the San Gaggio predella with the same features in any of the predella panels from the Carmine altarpiece reveals the latter to be markedly more mature in conception and handling. If, therefore, the Carmine altarpiece can be dated shortly before 1396 by comparison with the illuminations of Cod. C 71, it is necessary to assume a date in the first half of that decade for the San Gaggio altarpiece and, by inference, the miniatures from Cod. Cor. 13 from Santa Maria degli Angeli.

Lorenzo Monaco's next assignment among the Santa Maria degli Angeli antiphonaries was not, as is com-

monly assumed, the illuminations in Cod. Cor. 5, the earliest (1394) of the dated volumes on which he worked, but rather Cod. Cor. 1, dated 1396 in its colophon (cat. no. 29), which the artist must have had in hand sometime about 1400 or 1401. This was followed in turn by work on Cod. Cor. 8 (cat. no. 30), dated 1395 in its colophon, but probably painted in 1403 or 1404. Though undoubtedly one of the first of the antiphonary volumes to be written, Cod. Cor. 5 was among the last to be provided with illuminations, sometime about 1406 or 1407. None of the four miniatures removed from this book has been successfully identified (Levi D'Ancona 1978, pp. 226–27), but three remain in place: Tobit in an initial P ("Peto Domine ut de vinculo improperii huius absolvas me" [I beg, O Lord, that You loose me from the bond of this reproach]), beginning the first responsory of matins for the third Sunday in September (fol. 20v; fig. 89); Saint Michael Casting Out the Demons in an initial F ("Factum est silentium in celo" [There was silence in heaven]), beginning the second responsory of the first nocturn for the Dedication of Saint Michael on September 29 (fol. 105r; fig. 102); and Saint Jerome in an initial E ("Ecclesie officium hic ordinavit" [He wrote this office of the church]), illustrating the feast of Saint Jerome on

September 30 (fol. 138r; fig. 90). All three may best be compared with the fragments of the London *Coronation of the Virgin* altarpiece of 1407, especially with the *Four Patriarchs* in The Metropolitan Museum of Art (cat. no. 32a), or with such panels as the Madonnas of Humility in Stuttgart (dated 1406) and Moscow. The completion of this book was followed immediately by the commission to illuminate Cod. Cor. 7 (cat. no. 33), the final volume of the antiphonaries, and this in turn was succeeded by four volumes of the gradual (see cat. nos. 35–37).

LK

1. Cod. Cor. 10 is a compendium of antiphons covering the period from the vigil of Saint Lawrence (August 9) through the feast of Saint Clement (November 23), and including the office for Trinity Sunday, which are all repeated in Cod. Cor. 19, 5, and 1. As the form of its incipit ("Ave Maria Gratia Plena Dominus Tecum Incip. septima pars antiphanarij nocturni") differs from that in all the other volumes, and as it bears the arms of Monte Oliveto Maggiore in two places (fols. 22v, 120v), it must be presumed to have been grouped accidentally with the Santa Maria degli Angeli choir books. Cod. Cor. 15 is not the third part of the antiphonary commons of the saints, as per Levi D'Ancona 1978, p. 216. It is a composite book, beginning with the feasts of the Madonna of the Snows (August 5) and Saint Ursula (October 21). At folio 55, the ruling of the staves changes to a different width, and the text is attributable to a different scribe. This portion of the book contains antiphons for the period July through November, changing again at folio 93 to a gradual for masses, including Saints Scholastica (February 11) and Romuald (June 19).

2. Levi D'Ancona (1978, p. 214) proposes that the first volume of a lectionary, covering the liturgical year from Advent through Holy Week, is missing, since the only lectionary preserved, Cod. Cor. 20, contains the lessons for Easter through the end of November, though she also expresses doubt that Cod. Cor. 20 was itself part of a set with the others. She also (1993) incorrectly maintains that the first two volumes of the gradual are missing and identifies these with the two volumes of a temporale illuminated by Don Silvestro dei Gherarducci for San Michele a Murano (cat. no. 17). See also cat. nos. 35, 36.

3. Levi D'Ancona 1979, p. 464. Of the four volumes of the antiphonary produced for Santa Maria Nuova, only the first appears to have been completed (both written and illuminated) by 1398. This is Cod. C 71 at the Museo del Bargello, covering the period from Advent through the Conversion of Saint Paul (January 25), or roughly the same as the first three volumes from Santa Maria degli Angeli (see below). The remaining volumes from Santa Maria Nuova all appear to have been produced between 1411 and 1424, including: Santa Maria Nuova Cod. D, covering the period from the Purification of the Virgin (February 2) through the Annunciation (March 25) and Holy Week, or roughly the equivalent of volumes 4–6 from Santa Maria degli Angeli; Museo del Bargello Cod. A 69, covering the period from Easter through Corpus Domini and Saint Paul (June 30), or

roughly the equivalent of volumes 7 and 8 from Santa Maria degli Angeli; and Santa Maria Nuova Cod. B, including the feasts of Saint Lawrence (August 10), All Saints (November 1), and All Souls (November 2), or roughly the equivalent of the last three volumes from Santa Maria degli Angeli.

4. Cod. Cor. 9 contains four illuminations by Don Silvestro dei Gherarducci and no missing pages. Cod. Cor. 19 retains only one illumination, an initial I with Saint Augustine on folio 149. Levi D'Ancona (1978, p. 234) correctly identified two of the three initials missing from this book as a D with Mary Magdalen (Kupferstichkabinett, Berlin; Min. 1233) and an L with Saint Lawrence (Fitzwilliam Museum, Cambridge; Marlay cutting I 13), both attributed by Boskovits (1975, pp. 389–90) to Mariotto di Nardo. The identification (Levi D'Ancona 1978, p. 235) of a Death and Assumption of the Virgin (British Library Add. MS 37,955 A) with the third initial missing from Cod. Cor. 19 is erroneous (see cat. no. 16g). Cod. Cor. 6 retains one miniature by Don Silvestro dei Gherarducci: an initial C with Saint Cecilia on folio 154v. Levi D'Ancona (1978, p. 227) correctly identified initial V with a Bearded Prophet in the Cini collection, Venice, as the missing folio 21 from Cod. Cor. 6. Of the other two missing pages from this volume, folio 67 may be identified with an initial V with Saint Placidus in a private collection (unpublished).

5. Levi D'Ancona 1978, pp. 231–32, correctly identified the two miniatures in Berlin (Kupferstichkabinett, Min. 1232, Min. 4592) as cuttings from this manuscript. Her tentative proposal to identify the missing folio 60 with the Joseph and His Brothers in an initial V in the Wildenstein Collection (Musée Marmottan, Paris) was based solely on iconography and is not supported by stylistic or other evidence. Her identification of folio 149 with a cutting sold by Quaritch (sale, 1931, p. 108, no. 154) was similarly tentative and cannot be confirmed in the absence of the cutting itself. The illumination in Detroit showing Saint Benedict Presenting His Rule in an initial F (acc. no. 24.108), identified by Levi D'Ancona as the missing folio 146 from Cod. Cor. 13, is Sienese and is discussed, together with other cuttings from the same manuscript, in cat. no. 26. Levi D'Ancona had earlier (1958b, p. 186) correctly intuited the provenance of the Suermondt Prophet from Cod. Cor. 13, but rejected this view in her reconstruction of 1978 in favor of a Jacob Blessing Isaac from the 1931 Quaritch sale (p. 109, no. 158).

6. Bent 1992, pp. 510 ff. Bent transcribes another document of November 1396 recording payment to Giovanni del Biondo for blue used in painting the antiphonaries. His attributions to Giovanni del Biondo of specific initials in Cod. C 71 are, however, unconvincing, and it is possible that the document is to be interpreted as a payment for the purchase of blue from, rather than on behalf of, Giovanni del Biondo.

Cod. Cor. 1

(Catalogue Number 29a–d)

Cod. Cor. 1 at the Biblioteca Laurenziana, Florence, is the seventh part of a twelve-volume antiphonary written for the Camaldolese monks at Santa Maria degli Angeli between 1385 and 1397 (see above). Like ten of the other volumes of the series, it contains the office for movable feasts for a portion of the liturgical year, in this case from Easter through Trinity Sunday. However, unlike any of the other volumes, it does not contain the hours for any fixed feasts during the same period. These feasts, including Saint George on April 23, Saint Mark on April 25, Saints Philip and James on May 3 (according to the Camaldolese calendar), the Invention of the Holy Cross also on May 3, Saint Zenobius on May 25, and Saints Justus and Clement on June 5, were subsequently included in Cod. Cor. 7, which was added to the antiphonary series in 1406 (cat. no. 33). Cod. Cor. 1, which lacks an incipit, is dated 1396 in a colophon on folio 28r: "Anno Domini M.CCCLXXXXVI completum est hoc opus." This date refers to the completion of the text and pen-work initials only.

Cod. Cor. 1 was originally provided with nine illuminated initials by Lorenzo Monaco, all but two of which have been removed from the book. The two illuminations still in situ represent Saint John the Evangelist in an initial D ("Dignus est domine accipere librum et aperire signacula ejus" [Thou art worthy, O Lord, to take the book, and to open the seals thereof]), introducing the first responsory of the first nocturn on Low Sunday (fol. 33r; fig. 91), and the Ascension in an initial P ("Post passionem suam per dies quadraginta apparens eis" [After his Passion, during forty days he appeared to them]), introducing the second responsory of the first nocturn on the feast of the Ascension (fol. 86r; fig. 92). Of the seven illuminations that were cut from the book, five have been successfully identified in European public collections, and four of these are catalogued here. The fifth, representing Abraham and the Three Angels in an initial B ("Benedicat nos Deus" [May God bless us]), began the fourth responsory of the first nocturn for Trinity Sunday on folio 146 and is now in the Victoria and Albert Museum, London (on loan from the National Gallery, no. 3089; fig. 93). The first of the two unidentified initials occurred on folio 1v. The recto of that leaf undoubtedly contained the volume's incipit, and the verso may have begun with the invitatory for matins on Easter Sunday: "Surrexit Dominus vere" (The Lord has truly risen), or for first vespers: "Angelus Domini descendit de caelo" (An angel of the Lord came

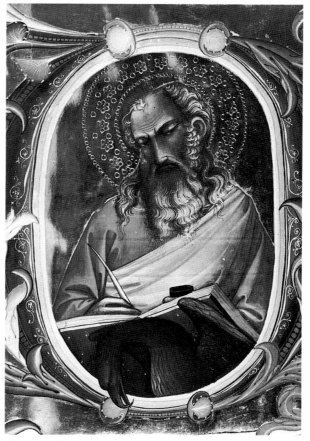

Figure 91. Lorenzo Monaco, Saint John the Evangelist in an initial D. Biblioteca Medicea Laurenziana, Florence (Cod. Cor. 1, fol. 33r)

down from heaven).[1] The subject of the illumination on the missing folio 23 is uncertain, but it may have illustrated the antiphon of the magnificat for second vespers on Easter Sunday, "Et respicientes viderunt revolutum lapidem" (And looking up they saw that the stone had been rolled back).

The wide variety of critical opinion that has been expressed concerning the decoration of Cod. Cor. 1 is symptomatic of the confusion surrounding Lorenzo Monaco's early career in general. Anna Maria Ciaranfi (1932, p. 301 n. 1) thought the two illuminations still present in the volume were close in style to Lorenzo Monaco's work, if not so refined as the artist's usual standard of production, and she related them to an illumination in one of the other volumes of the Santa Maria degli Angeli antiphonary, Cod. Cor. 13 (which may now be recognized as an even earlier work by Lorenzo Monaco). Mirella Levi D'Ancona (1958b, p. 184)

attributed only the Saint John the Evangelist on folio 33r of Cod. Cor. 1 to Lorenzo Monaco, an opinion seconded by Marvin Eisenberg (1989, p. 109), both of whom dated the image immediately after 1396. The Ascension on folio 86r was at first described by Levi D'Ancona as by a follower of Agnolo Gaddi, and subsequently it was grouped by her (1978, p. 220) with two of the cuttings removed from the book (London; Paris [cat. no. 29a]) as the work of Matteo Torelli, a vaguely defined follower of Lorenzo Monaco. Eisenberg (1989, p. 197) assigned the Ascension and the two related cuttings to Don Silvestro dei Gherarducci. Without establishing a connection between the various cuttings removed from Cod. Cor. 1 and the two miniatures remaining in the book, Luciano Bellosi (1965, p. 39) and Miklós Boskovits (1975, pp. 339, 341, 348, 353) recognized all of them as attributable to Lorenzo Monaco.

Figure 92. Lorenzo Monaco, The Ascension in an initial P. Biblioteca Medicea Laurenziana, Florence (Cod. Cor. 1, fol. 86r)

Considered together, the seven known miniatures from Cod. Cor. 1 represent the apogee of Lorenzo Monaco's early style as an illuminator in the breadth and strength of their draftsmanship, the boldness of their palette, the sophistication and subtlety of their light effects, and the drama of their compositions. In these works, more successfully than at any other point in his career, the artist was able to combine the delicacy and refinement of detail prized by miniaturists with the sweep and monumentality of painters accustomed to compositions on a grand scale. Certainly designed much later than the illuminations of 1396 in Cod. C 71 at the Bargello, which are still reminiscent of Agnolo Gaddi, they relate closely to the altarpiece of the *Agony in the Garden* at the Accademia, Florence (inv. no. 438), painted for Santa Maria degli Angeli at an unknown date about 1400, and to such panels by Lorenzo Monaco as the *Crucified Christ* in the Robert Lehman Collection (cat. no. 31b) of about 1403–4, in which the International Gothic tendencies of his mature works are slightly more evident. The paucity of documentation for this moment in Don Lorenzo's career makes more specific analysis difficult, but a date for the illuminations in Cod. Cor. 1 of about 1401 or 1402 is plausible.

LK

Figure 93. Lorenzo Monaco, Abraham and the Three Angels in an initial B. Victoria and Albert Museum, London (on loan from the National Gallery, London; 3089)

29a

1. This text is repeated as the fourth responsory of the first nocturn of matins on folio 4r of Cod. Cor. 1 (see cat. no. 29a). The corresponding volume of the antiphonaries for Santa Maria Nuova, Cod. A 69 at the Bargello, contains two illuminations for this text, one for vespers (fol. 2r), showing the Resurrection, and one for matins (fol. 4v), showing an Angel Seated on the Edge of the Empty Tomb of Christ, and it may be presumed that two similar illuminations appeared in Cod. Cor. 1. The artist of the illuminations in Cod. A 69, Bartolomeo di Fruosino, either chose or was directed to refer to Cod. Cor. 1 in planning his compositions, as two scenes, the Ascension (fol. 58v) and the Pentecost (fol. 72r), are virtual replicas of those in Cod. Cor. 1.

29a. The Three Marys at the Tomb in an Initial A

Tempera and gold leaf on parchment
18 1/4 × 18 7/8 in. (46.3 × 48 cm)

Musée du Louvre, Paris; Cabinet des Dessins (R.F. 830)

NOT IN EXHIBITION

The scene is divided into halves by the crossbar of the orange initial A and the empty tomb of Christ aligned diagonally behind it. In front of the tomb at the left are the three Holy Women led by Mary Madgalen, with long

blond hair trailing down her back, wearing red robes and carrying a jar of ointment. The heads of the three women appear in the upper half of the initial, interrupting the yellow border of the crossbar of the letter, while their bodies occupy the full height of the lower half of the initial and are shown as if positioned behind the crossbar and its yellow border. In the foreground at the lower right are three sleeping soldiers lying on the stony ground. The foremost wears a yellow cuirass over a blue skirt with a silver helmet and epaulettes, the soldier behind him wears a gold helmet and red greaves, while the helmet of the third soldier, just visible at the edge of the letter, is silver. At the upper right an angel dressed in white is seated on the edge of the tomb addressing the three Holy Women and gesturing heavenward with his right hand. The busts of two angels are silhouetted against the gold ground within the curling tendrils of foliage at the bottom corners of the initial, and the foliate rinceaux continuing along the margins of the page are enlivened by numerous drôleries of fanciful birds.

The Louvre Three Marys at the Tomb was first recognized by Mirella Levi D'Ancona (1978, p. 220) as a fragment of the missing folio 3 from Cod. Cor. 1. The initial A begins the first responsory for the first nocturn of Easter: "Angelus Domini descendit de celo et accedens revolvit lapidem et super eum sedit" (An Angel of the Lord came down from heaven and drawing near rolled back the stone and sat upon it). The completion of the word *Angelus*, in elaborate pen-work letters, appears alongside the initial at the right on the Paris page, while the remainder of the text continues at the top of folio 4r in Cod. Cor. 1. On the reverse of the Paris page (originally folio 3r in Cod. Cor. 1) appears a rubric ". . . et ad tertiam A" (the antiphons for the first nocturn of matins on Easter Sunday are repeated at terce) and the text "Alleluia stetit. Alleluia, alleluia, alleluia, alleluia, allelu[ia]." The three musical staves on this side of the sheet are each about 2 inches (5.2 cm) tall, corresponding to the height of the staves throughout Cod. Cor. 1.

In first calling attention to this cutting, Levi D'Ancona (1958a, p. 247 n. 10) attributed it to Matteo Torelli, a then unknown illuminator whom she characterized as an assistant and sometime imitator of Lorenzo Monaco and to whom she also attributed the Ascension in an initial P on folio 86r of Cod. Cor. 1 (fig. 92). Marvin Eisenberg (1989, p. 197) preferred to group the Ascension and the Three Marys at the Tomb with an illumination of Abraham and the Three Angels in an initial B (fig. 93) that Levi D'Ancona (1959, p. 22) had attributed to Don Silvestro dei Gherarducci. For Eisenberg, "The Louvre miniature is the most developed example of Don Silvestro's work as a miniaturist, which Lorenzo Monaco

may have referred to in designing the *Three Marys at the Tomb* of 1408." The latter, also in the Musée du Louvre (inv. no. 1348a), does in fact reflect the composition of the illumination, not as a quotation from another artist but as a later study by the same painter. The Three Marys at the Tomb in an initial A, along with the Ascension the largest and most elaborate of the illuminations from Cod. Cor. 1, is perhaps the masterpiece of Lorenzo Monaco's early career as a miniaturist.

LK

EX COLL.: His de LaSalle.

LITERATURE: Levi D'Ancona 1958a, p. 247 n. 10; idem 1978, p. 220; Eisenberg 1989, p. 197, fig. 269; Kanter 1993, p. 633.

29b. King David(?) in an Initial S

Tempera and gold on parchment
Overall: 13 5/8 × 12 3/8 in. (34.5 × 31.3 cm); initial: 8 3/4 × 8 in. (22.3 × 20.4 cm)

Staatliche Museen zu Berlin—Preussischer Kulturbesitz; Kupferstichkabinett (Min. 1231)

A half-length figure wearing a crown and holding a scepter and orb appears against a gold ground within an initial S, which is shaded to appear three-dimensional and bordered with a frieze of diamond-shaped lozenges and foliate decoration. The figure's robes are embellished with a repeat pattern of spots and covered at the breast with a gilt and elaborately tooled apparel.

The initial S begins the first responsory of matins for the fourth Sunday after Easter: "Si oblitus fuero tui, alleluia, obliviscatur mei dextera mea" (If ever I forget you, alleluia, let my right hand wither). This text, drawn from Psalm 136 (verse 5), suggests that the figure of a king within the painted initial may be intended to represent David. Though the Psalmist is usually represented by Lorenzo Monaco with a lyre rather than a globe and scepter and with shorter hair, he does appear in an illumination in Cod. Cor. 8 at the Biblioteca Laurenziana, Florence (fol. 34r), with similar facial features and the same short, curling beard, wearing the same robe, crowned, and holding a scepter. The figure has also been identified (Levi D'Ancona 1978, p. 218) with God the Father as Creator.

The Berlin initial S was correctly recognized by Levi D'Ancona (1978, p. 218) as a fragment of the missing folio

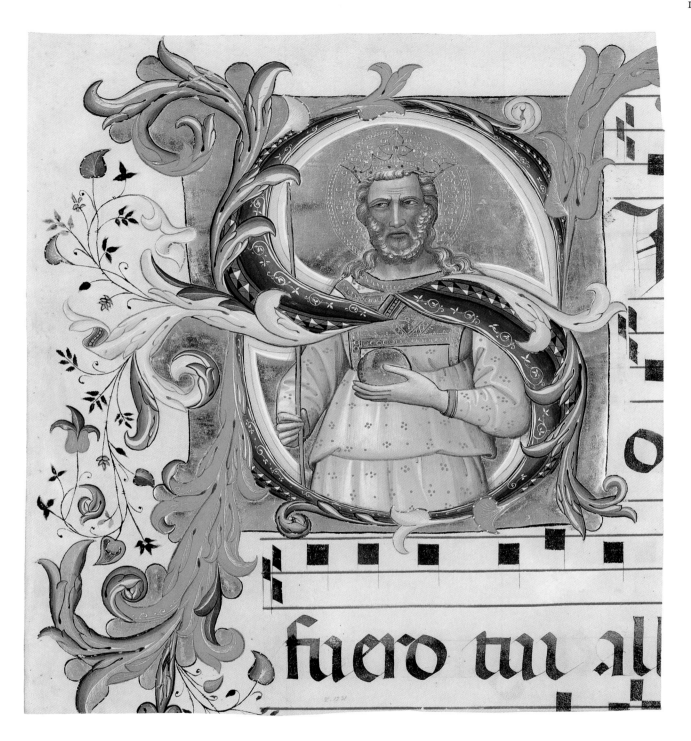

63 from Cod. Cor. 1 at the Biblioteca Laurenziana. The text of the responsory continues at the top of folio 64r: "Adhaereat lingua mea faucibus meis, si non meminero tui" (Let my tongue cleave to my jaws, if I do not remember you [Ps 136:6]). The subsequent versicle, "Super flumina Babylonis illic sedimus et flevimus, dum recordaremur tui, Sion" (Upon the rivers of Babylon, there we sat and wept: when we remembered Sion), is the opening verse of Psalm 136. The stave height in the Berlin cutting corresponds to that of the other folios in

Cod. Cor. 1, and its figure style and decorative motifs agree with those of the only two illuminations remaining in that book.

LK

EX COLL.: Von Nagler, Berlin (1835).

LITERATURE: Wescher 1931, p. 91, fig. 77; Boskovits 1975, p. 339, fig. 445; Levi D'Ancona 1978, p. 218; Eisenberg 1989, p. 86.

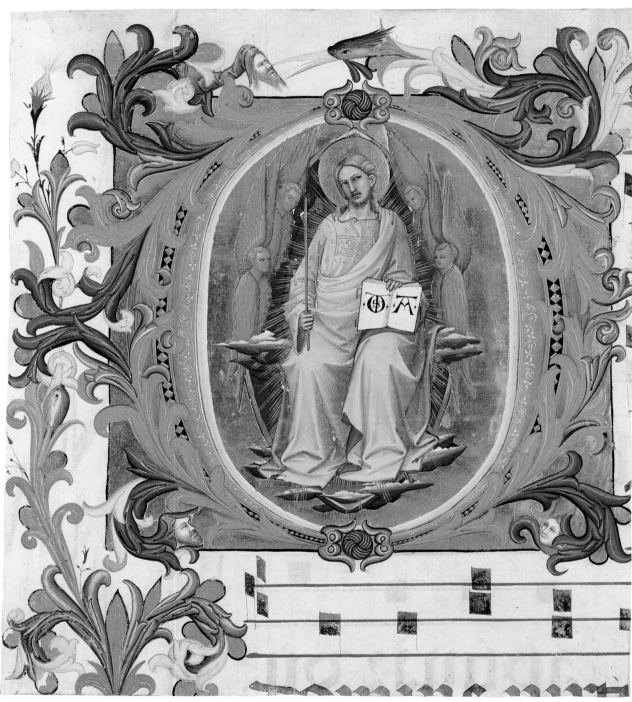

29c

29c. Christ in Glory in an Initial O

Tempera and gold on parchment
13 1/2 × 11 7/8 in. (34.3 × 30.2 cm), overall

Staatliche Museen zu Berlin—Preussischer Kulturbesitz;
Kupferstichkabinett (Min. 1240)

The full-length figure of Christ is seated on a bank of
clouds within a mandorla supported by four, four-
winged seraphim. He holds a scepter in his right hand
and an open book inscribed with a monogram for alpha
and omega (the monogram is reversed, with the A
appearing on the right page) in his left, while a burst of
gilt rays emerges from the clouds and mandorla behind
him. The initial O is decorated with a white filigree
pattern and lined with a frieze of diamond-shaped
lozenges. The foliate borders include three grotesque
masks and two birds' heads emerging from the tendrils.

The initial O begins the antiphon of the magnificat for
second vespers on the feast of the Ascension: "O Rex
gloriae, Domine virtutum, qui triumphator hodie super
omnes caelos acendisti" (O King of glory, Lord of hosts,
this day you ascended triumphantly above all heavens). It
was identified as a fragment of the missing folio 102 from
Cod. Cor. 1 by Mirella Levi D'Ancona (1978). In Cod.
Cor. 1 the continuation of the antiphon, "ne derelinquas
nos orphanos" (leave us not orphans), appears at the top
of folio 103r. One of the two illuminations still in place
in Cod. Cor. 1 also relates to the feast of the Ascension,
an initial P ("Post passionem suam per dies quadraginta
apparens eis" [After his Passion, during forty days he
appeared to them]) with the Ascension on folio 86r (fig.
92), which illustrates the second responsory of the first
nocturn. The two illuminations agree perfectly with each
other in style and share such decorative motifs as the
grotesque masks and birds' heads in the margins, and
both incorporate musical staves 2 inches (5.2 cm) in
height.

LK

Ex coll.: Von Nagler, Berlin (1835).

Literature: Wescher 1929, p. 99; Toesca 1930, p. 40, fig.
25; Wescher 1931, p. 90, fig. 74; Berenson 1932a, p. 298; idem
1963, vol. 1, p. 117; Bellosi 1965, p. 39; Boskovits 1975, p. 339;
Nordenfalk et al. 1975, p. 40; Levi D'Ancona 1978, p. 219;
Eisenberg 1989, p. 86, fig. 205.

29d. The Pentecost in an Initial D

Tempera and gold on parchment
13 3/8 × 14 7/8 in. (34 × 37.8 cm) overall

Biblioteca Apostolica Vaticana, Vatican City (Cod. Rossiano
1192.2)

In the upper half of the oval picture field framed by the
pink initial D, the Virgin Mary and Twelve Apostles
(including Matthias, chosen by lot to replace Judas [Acts
1:16–26]) congregate in a room on the upper floor of a
house (Acts 1:13) in which they receive the gifts of the
Holy Spirit, symbolized by a dove within a glory of gilt
rays floating in the center above the head of the Virgin.
The Virgin's hands are joined before her in an attitude of
prayer, while at the right Saint Peter raises his arm in
discourse or preaching. Below, outside the gate of the
house, kneel two figures: one with his back turned seems
to listen at the closed door, and the other, dressed in a
suit of armor, crosses his arms on his breast and gazes
upward. Possibly these are two of the men "out of every
nation under heaven," who heard the apostles preaching
in their own languages and "were all astonished, and
wondered, saying one to another, What meaneth this?"
(Acts 2:5–12). It is equally possible, however, that the
soldier kneeling at the right, who seems to be scowling,
is one of the skeptics who replied, "These men are full of
new wine" (Acts 2:13).

The initial D begins the second responsory of the first
nocturn for the feast of Pentecost: "Dum complerentur
dies Pentecostes erant omnes pariter" (When the days of
Pentecost were drawing to a close they were all together).
This complete text, less the initial D, appears at the top
of folio 112r in Cod. Cor. 1, placing the Vatican initial at
the bottom of the verso of the missing folio 111. The
preceding folio 110v concludes with the antiphon of the
magnificat for first vespers on the feast of Pentecost:
"Non vos reliquam orphanos, alleluia: vado et venio ad
vos, alleluia: et gaudebit cor vestrum" (I will not leave
you orphans, alleluia. I go away and I am coming to you,
alleluia; and your heart shall rejoice). The reverse of the
Vatican initial contains three musical staves, each 2 inches
(5.2 cm) tall, as are all the others in Cod. Cor. 1, and
three lines of text from the invitatory for matins for the
feast of Pentecost: "[Alleluia, Spi]ritus domini replevit
orbem terrarum venite adoremus alle[luia]" (Alleluia, the
Spirit of the Lord has filled the whole world; Come, let
us adore, alleluia).

Among the seven known illuminations from Cod. Cor.
1, the Vatican Pentecost is perhaps the most remarkable
for its range of color and sophisticated lighting effects,
including the illusion of a shadow cast by the initial itself

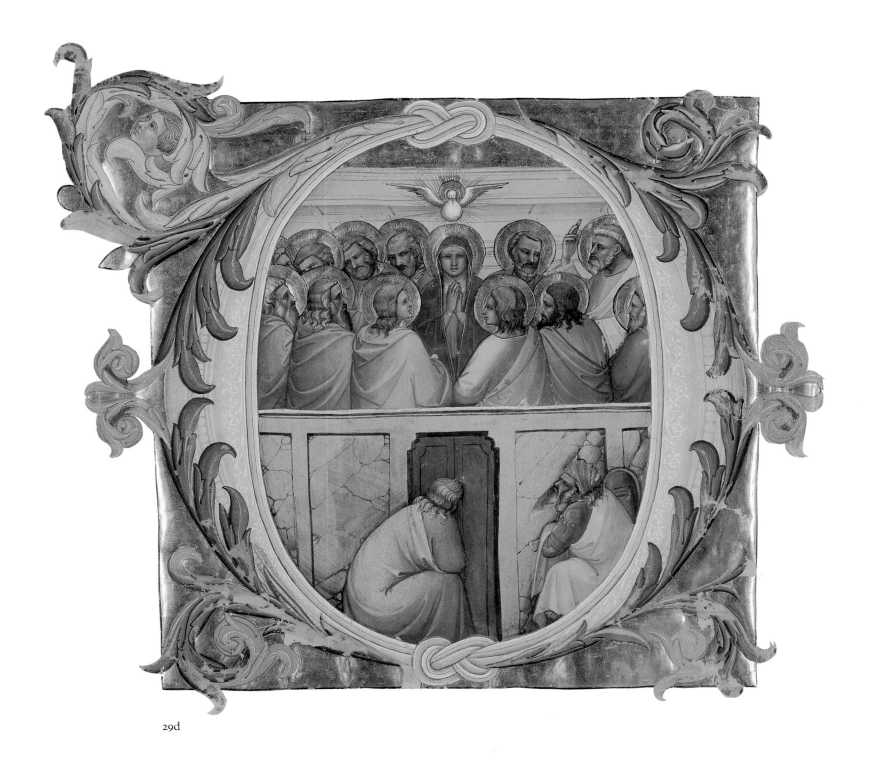

29d

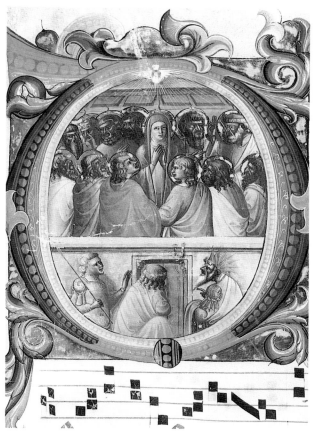

Figure 94. Bartolomeo di Fruosino, The Pentecost in an initial D. Museo Nazionale del Bargello, Florence (Cod. A 69, fol. 72r)

against the front wall and roof of the house in which the Virgin and apostles are congregated. The artist, Lorenzo Monaco, has also successfully overcome the pictorial obstacle of crowding thirteen figures, all with gilt halos, into a narrow band across the center of the initial by carefully delineating steeply recessive coffers in the roof above their heads and by lighting the back of the roof more brightly than the front in order to create a sense of great depth to the room in which they sit. Comparison with a copy of the Vatican Pentecost executed perhaps a decade later by Bartolomeo di Fruosino (Museo Nazionale del Bargello, Florence, Cod. A 69, fol. 72r; fig. 94) underscores how accomplished this solution is to problems of spatial representation. Bartolomeo, who has otherwise closely imitated Don Lorenzo's setting and the attitudes, gestures, and placement of his figures, has entirely misunderstood the perspective of the ceiling coffers and the purpose for their inclusion, reversing the direction of their convergence in an effort to follow the curves of the framing initial rather than to excavate a volume of space behind it. Bartolomeo has also attempted to clarify a certain ambiguity in Lorenzo Monaco's narrative by adding a soldier in the

left foreground, who is clearly meant to represent the skeptic doubting the word of the apostles, but he has forfeited all of the subtlety and engaging psychological intimacy of the original.

LK

EX COLL.: Giovan Francesco De Rossi, Vienna (until 1921).

LITERATURE: Tietze 1911, p. 167 n. 9; Boskovits 1975, p. 353, pl. 142c; Levi D'Ancona 1978, p. 219.

30a. Saint John the Baptist in an Initial F

Tempera and gold on parchment
Overall: 12 3/8 × 12 1/2 in. (31.4 × 31.7 cm);
initial: 8 1/2 × 6 3/8 in. (21.5 × 16.3 cm)

Staatliche Museen zu Berlin—Preussischer Kulturbesitz; Kupferstichkabinett (Min. 1239)

The half-length figure of the Baptist is set against a gold ground and before the crossbar of the initial F, which is decorated with white filigree ornament and bordered at the right and left by a frieze of stylized pearls. He holds a staff topped with a cross in his left hand and points to the right with his other hand. The saint's halo and the margin of the gold ground are decorated with punch designs interrupted by the curling tendrils of the foliate extensions of the initial. A fanciful bird amid the foliage at the upper right opens its beak to swallow two gilt neumes; the group forms a clef for the uppermost stave of music.

The initial F begins the second responsory of the first nocturn of matins for the feast of the Birth of the Baptist on June 24: "Fuit homo miss[us a Deo, cui nomen erat Ioannes]" (There was a man sent from God, whose name was John). A fragment of an antiphonary, it was correctly identified by Mirella Levi D'Ancona (1978, p. 229) as a cutting from Cod. Cor. 8 at the Biblioteca Laurenziana, Florence. Cod. Cor. 8 is the eighth part of a twelve-volume antiphonary written for the Camaldolese monks at Santa Maria degli Angeli between 1385 and 1397 (see above). The volume begins, following the rubric "Incipit VIII.a pars Antiphonarij Sce. Marie de Angelis de Florentia Ordinis Camaldulensis," on folio 1r with the text for the first antiphon of first vespers of Corpus Domini: "Sacerdos in aeternum Christus Dominus secundum ordinem Melchisedech, panem et vinum

obtulit" (Christ the Lord, Priest forever according to the order of Melchisedech, offered bread and wine). It concludes on folio 198 with the office for the feast of Saint Paul (June 30). It is dated 1395 in a colophon ("A.D. MCCCLXXXXV. Completum Est Hoc Opus") surrounding a Lombard initial Q on folio 158v. This date applies only to the completion of the text and the pen-work initials. Six illuminated initials were added at a later date by Lorenzo Monaco, who also embellished several of the larger Lombard initials—notably an O ("O sacrum convivium" [O holy banquet]) beginning the antiphon of the magnificat for second vespers of Corpus Domini on folio 32v—with painted foliate decoration and in one case—an H ("Hodie celestia regna petiit Beatus Romualdus" [Today the Blessed Romuald seeks the heavenly realm]) on folio 97v—with a small scene of Saint Romuald in glory seated in a mandorla borne by six seraphim (fig. 95).

Only three of the six illuminated initials painted by Lorenzo Monaco for this manuscript remain in situ. These appear on folio 34r, with King David in an initial

Figure 96. Lorenzo Monaco, King David in an initial D. Biblioteca Medicea Laurenziana, Florence (Cod. Cor 8, fol. 34r)

Figure 95. Lorenzo Monaco, Saint Romuald in Glory in an initial H. Biblioteca Medicea Laurenziana, Florence (Cod. Cor. 8, fol. 97v)

D ("Deus omnius exauditor est" [God hears everyone]), beginning the first responsory of the first nocturn for the second Sunday after Pentecost (fig. 96); on folio 76r, with Saint Romuald in an initial V ("Vir vite venerabilis magis elegit vitam monasticam" [The man who seeks a worthier existence chooses the monastic life]), beginning a responsory of the first nocturn for the feast of Saint Romuald on June 19 (fig. 97); and on folio 163r, with Saint Paul in an initial Q ("Qui operatus est Petro in apostolatum" [He who worked in Peter for the apostleship]), beginning the second responsory of the nocturn for the Commemoration of Saint Paul on June 30 (fig. 98). King David and Saint Paul are remarkable for both the intensity of their expressions and the rich color contrasts of their robes: David wears a red tunic and a green cloak with yellow highlights, his gilt crown and scepter glazed red in the shadows, while Saint Paul wears a green tunic with yellow highlights under a red violet cloak lined with blue. Saint Romuald, whose Camaldolese habit did not afford the artist an opportunity for coloristic excess, is drawn with the calligraphic surety and carefully studied effects of light characteristic of the artist's best work in the early years of the fifteenth century. All three saints are supplied with elaborately tooled halos, and the borders of the gold ground around the initials are engraved and punched. The initials themselves were clearly planned and may have been executed in part by Lorenzo Monaco himself. The artist must also have been responsible for designing the fleur-de-lis corners of the gold ground and the head of a bird with a gilt lozenge in its open beak above the initial with King David.

244

30a

The first of the three initials missing from Cod. Cor. 8 occurred on folio 9 and probably illustrated the second responsory of the first nocturn for the feast of Corpus Domini: "Immolabit hoedum multitudo filiorum Israel" (With the whole assembly of the sons of Israel present, the young goat shall be slaughtered). The conclusion of that verse, "edent carnes, et azymos panes" (they shall eat its flesh with unleavened bread), appears at the top of folio 10r. Folio 8v, however, ends with the first two words of a subsequent antiphon, "In voce [exsultationis resonent epulantes in mensa Domini]" (In a song of joy may the banqueters at the Lord's table be heard), which should be followed by the versicle, "Cibavit illos ex adipe frumenti" (He fed them with the finest wheat). Whether

Figure 97. Lorenzo Monaco, Saint Romuald in an initial V. Biblioteca Medicea Laurenziana, Florence (Cod. Cor. 8, fol. 76r)

Figure 98. Lorenzo Monaco, Saint Paul in an initial Q. Biblioteca Medicea Laurenziana, Florence (Cod. Cor. 8, fol. 163r)

it decorated an initial I or C, the illumination, which has not been identified, probably represented the Last Supper or, more likely, a Priest Elevating the Host During Mass, as in the corresponding volume of the antiphonary from Santa Maria Nuova (Museo Nazionale del Bargello, Florence; Cod. A 69, fol. 107), where the text illustrated is the antiphon "In voce exsultationis."

The second initial removed from Cod. Cor. 8 occurred on folio 102, and there can be no doubt that this is the Berlin F with Saint John the Baptist. The conclusion of the verse begun by this initial, "ille lux suum ut testimonium perhiberet de lumine, et pararet Domino plebem perfectam" (his light, which comes forward as a testimony of glory and prepares for the Lord a perfect people), appears at the top of folio 103r, and rubrics for the antiphons of the first vespers and the first nocturn of the feast of the Baptist appear on preceding folios (98v, 99v). Additionally, the Berlin Baptist conforms in style to the other miniatures still in place in Cod. Cor. 8, especially to the Saint Paul on folio 163r: its gold ground is similarly engraved and punched, and its musical staves are the same height (2 in. [5.1 cm]).

The third missing initial from Cod. Cor. 8 occurred on folio 134 and can be securely identified with an S with Christ Giving the Keys to Saint Peter in the National Gallery of Art, Washington, D.C. (cat. no. 30b).

LK

Ex coll.: Von Nagler (1835).

Literature: Wescher 1931, p. 91; Bellosi 1965, p. 39; González-Palacios 1970, p. 30, fig. 28a; Boskovits 1975, p. 339; Levi D'Ancona 1978, p. 229; Eisenberg 1989, p. 86, fig. 204.

30b. Christ Giving the Keys to Saint Peter in an Initial S

Tempera and gold leaf on parchment
13 1/2 × 16 1/4 in. (34.4 × 41.4 cm), overall

National Gallery of Art, Washington, D.C.; Rosenwald Collection (1958.8.105)

In a blue initial S decorated with orange, green, and pale yellow foliation, Saint Peter, wearing an orange tunic and yellow mantle, kneels in three-quarters lost profile before the standing figure of Christ. Christ, garbed in a dark blue cloak over a red robe, lays his right hand in blessing on Saint Peter's head and with his left hand presents two gold keys to the saint. The figures are divided from each

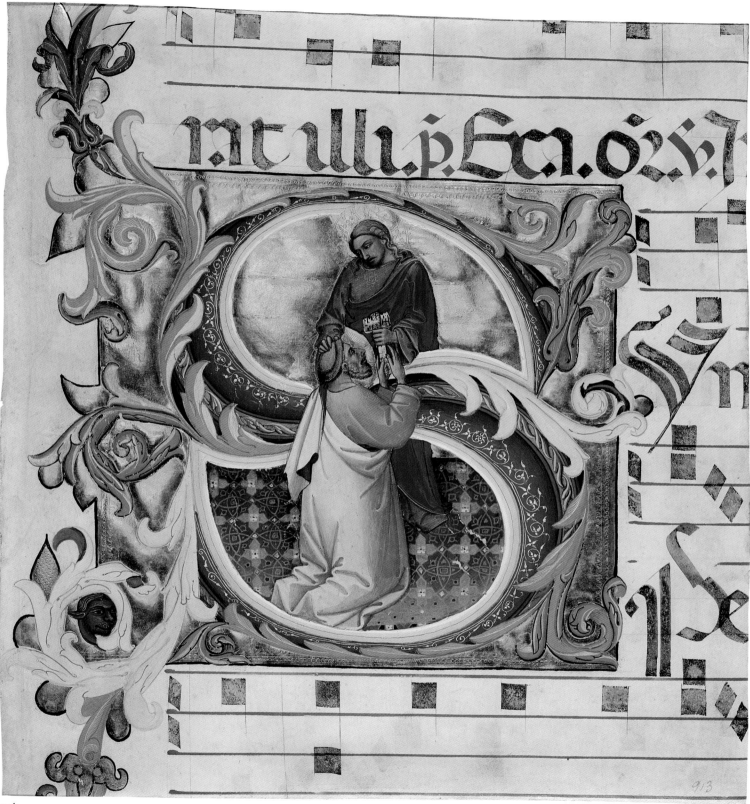

30b

other by the crossbar of the initial S, while the lower half of the picture field is largely filled by the orange and green patterned carpet on which they stand (or kneel). Both figures' halos are decorated with engraved patterns, though Christ's is ringed with a line of tooled punches, and the margins of the gold block of the initial are tooled.

Saint Peter, known as the Prince of Apostles and regarded as the source and emblem of papal authority throughout the history of the Latin Church, is generally identified by the attribute of the keys given him by Christ: "And I say to thee: That thou art Peter; and upon this rock I will build my church, and the gates of hell shall not prevail against it. And I will give you the keys of the kingdom of heaven. And whatsoever thou shalt bind upon earth, it shall be bound also in heaven: and whatsoever thou shalt loose on earth, it shall be loosed also in heaven" (Mt 16:18–19). The scene of the donation of the keys appears here as an illustration of the first responsory of the first nocturn of matins for the feast of Saints Peter and Paul on June 29: "Symon Petre, antequam de navi vocarem te, novi te, et super plebem meam principem te constitui; et claves regni celorum tradidi tibi" (Simon Peter, before I called you away from your boat, I knew you, and I have established you as prince over my people, and I have given you the keys to the kingdom of heaven).

The Washington initial S was correctly identified by Mirella Levi D'Ancona (1978, p. 229) as the third missing cutting (fol. 134) from Cod. Cor. 8 at the Biblioteca Laurenziana, Florence. At the top of the sheet appear the concluding syllables of the lesson for the first nocturn of the feast of Saints Peter and Paul begun on folio 133v: "[. . . et repleti sunt stupore et extasi in eo quod contige]rat illi" (. . . and they were filled with wonder and amazement at what had happened to him), followed by rubrics for the psalm and versicle. The initial S then begins the first responsory, "Sym[on] Pe[tre antequam de navi vocarem te]," which continues on the verso, "[no]vi te, et super plebem meam principem te constitui; et [claves regni celorum tradi-]," and concludes on folio 135r, "di tibi." The margin of the gold ground is decorated with an arcade of the same trilobe punch used in the Berlin Baptist in an initial F (cat. no. 30a) and in the initials with King David and Saint Romuald still in the codex, and the figure style and palette also conform in all four, except that the figures in the Washington cutting are shown full-length and the lower half of the initial is filled with a painted rather than gilt ground. The stave height (2 in. [5.1 cm]) and spacing between staves (1 15/16 in. [5 cm]) in the Washington cutting also correspond to those in Cod. Cor. 8.

Given the sophistication of the rendering of the two figures in the Washington initial and the visualization of their interaction in space across the center bar of the letter, it is difficult to understand the reluctance of scholars to accept an attribution for it directly to Lorenzo Monaco. It has been labeled "a caricature of Lorenzo's style" (Levi D'Ancona 1958b, p. 187), attributed to the problematic Matteo Torelli (Levi D'Ancona 1978, p. 229), and dismissed as generically Florentine of about 1400 (Nordenfalk et al. 1975, pp. 39–41; Eisenberg 1989, p. 206: "the style shows alliances with the work of Don Silvestro and the earliest book painting by Lorenzo Monaco"). The palette and draftsmanship are typical of Don Lorenzo in the early years of the fifteenth century, before his encounter with Gherardo Starnina about 1403–4, as are the elongated figural proportions and relatively stiff postures, which appear to have been conceived almost as exercises in prismatic geometry; the sharp creases of drapery folds; the bright, intensely focused lighting; and the exaggerated facial features. These last compare most closely with the figures in the Accademia *Man of Sorrows* dated 1404 and with the *Lamentation* predella of approximately the same date (see cat. no. 31a). Since these same comparisons are valid as well for the other initials in Cod. Cor. 8 and for the Berlin Baptist, it may be concluded that Lorenzo Monaco's commission to illuminate that volume did not follow immediately upon completion of the text (1395), as is commonly assumed. Certainly he did not work on it later than 1404, but it is equally unlikely that he undertook the project earlier than about 1403. Recognizing these five images as autograph but removing them from discussion of his work in the last decade of the fourteenth century helps to clarify the picture of his emergence as an artist (see the discussion of the illuminations in Cod. Cor. 5 above), which until now has been confused by the conflicting stylistic evidence of works thought to have been documented in the 1390s.

LK

EX COLL.: J. A. Ramboux, Cologne (no. 913); dukes of Sigmaringen; E. Rosenthal, Berkeley; L. J. Rosenwald, Jenkintown, Pa. (1955).

LITERATURE: Levi D'Ancona 1958b, p. 187; Boskovits 1975, p. 355; Nordenfalk et al. 1975, p. 39; Levi D'Ancona 1978, p. 229; Eisenberg 1989, p. 206.

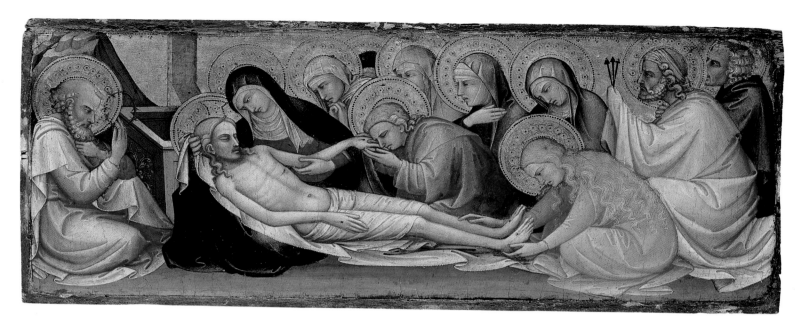

31a. Lamentation over the Dead Christ

Tempera and gold on panel

9 3/8 × 23 5/8 in. (23.8 × 60.1 cm)

Private collection

From the left of center in a long, narrow panel, the body of Christ stretches full-length to the right on a rose violet sheet resting on the ground, his torso propped up in the lap of the mourning Virgin. Behind his head are visible the empty tomb and the foot of the cross, and blood stains can be seen around the nail hole in the suppedaneum. Seated at the left edge of the panel is Joseph of Arimathea, in a red robe and white cloak, pulling his beard and displaying the crown of thorns. Saint John the Evangelist, kneeling in a red cloak in the center of the panel, holds Christ's left hand to his cheek, while Saint Mary Magdalen, in apricot robes, bends mournfully over Christ's feet. Behind the Magdalen kneels Nicodemus, in pink robes shot with bright yellow highlights, holding up the three nails, and behind him is an unidentified bearded saint wearing a dark blue cloak. Crowded behind the Virgin and above the figures of the Magdalen and the Evangelist are five Holy Women in various attitudes of grief and mourning.

In publishing this recently discovered panel for the first time, Gaudenz Freuler (London 1993) pointed out that its unusual composition resembles that of a panel with the *Lamentation* by Niccolò di Tommaso (active 1343–76) in the Pinacoteca Giuseppe Stuard, Parma. Niccolò's painting, which may repeat a lost example by Orcagna or Nardo di Cione, belongs to a category of in-

dependent devotional images that became very popular in the fourteenth century. Often they were complemented by an inscription inviting the viewer to partake in Christ's suffering; in this instance the words at the base of the panel refer to an often-quoted verse derived from the *Lamentations of Jeremiah* (1:12; see Meiss 1951, pp. 121–22): "O voi tutti che passate considerate e vedete se e dolore simile al dolore mio e per voi lo portai" (Oh all ye that pass by, behold and see if there be any sorrow like unto my sorrow, and for ye I bore it). Although lacking an inscription, Lorenzo Monaco's *Lamentation* clearly intends the same devotional message. It focuses attention on the emotional rather than narrative content of the event by reducing to a minimum the landscape elements that normally accompany the subject and by allowing the figures to occupy almost the entire picture space. Unlike Niccolò di Tommaso, however, Lorenzo Monaco does preserve an allusion to the dramatic event by showing a section of the empty tomb and the cross, placed off center at the left of the composition. In this last respect his painting represents a strikingly original compromise between Niccolò's iconic image and the more typical, narrative versions of the subject that had been common earlier, in which the cross is shown full-length and situated prominently, often dominating the center of the picture field (see cat. nos. 2, 9).

The exaggeratedly horizontal format of Lorenzo Monaco's *Lamentation* and the marks of an original wooden brace preserved on its back imply that it once formed the center of a long narrative predella. No other panels from this predella have yet been identified, but given the scale of the figures in the *Lamentation*, who, except for Christ, are all shown seated or kneeling yet fill the full height of the panel, it is unlikely that any of these companion panels could have shown further scenes from the Passion: the inevitable resultant disjunction of scale would be unprecedented in fourteenth- or fifteenth-century Passion cycles. Nonetheless, a scene of the Lamentation over the Dead Christ presupposes a scene of the Crucifixion, and it is likely that that subject appeared somewhere else in the altarpiece, either in the center panel of the main register or in the central pinnacle directly above (see cat. no. 31b).

The remarkably pure state of preservation of the *Lamentation*, which retains all its original surface glazes, allows for comparison of its palette more directly with Lorenzo Monaco's manuscript illuminations than with his panel paintings, especially with the initials from Cod. Cor. 1 at the Biblioteca Laurenziana, Florence (cat. no. 29). Like them, it is a masterpiece of coloristic audacity and carefully subdued emotional intensity, and like them it presents an ingenious solution to the demands of adapting its composition to an inappropriately shaped picture field. Among the artist's panel paintings, the *Lamentation* may best be related to the altarpiece of *Christ as the Man of Sorrows* in the Accademia, Florence (inv. no. 467), both for the similar tenor of their devotional content and for their closely comparable stylistic traits (Freuler, in London 1993). The *Lamentation* is unlikely to have stood in a predella beneath the *Man of Sorrows* altarpiece—their subjects, though not identical, would be redundant in a single complex, and the form of the frame surrounding the Accademia *Man of Sorrows*, which is original to it, implies that it was probably never completed with any ancillary panels. The two must, however, have been painted at virtually the same moment in Lorenzo Monaco's career. The *Man of Sorrows* altarpiece is dated by inscription 1404, the same year in which the artist completed work on the *Madonna of Humility* altarpiece in Empoli which, perhaps significantly, is lacking a predella (fig. 120). Close in time to both these undertakings, possibly predating them by no more than a year, is a lost altarpiece that is recorded today only by the survival of its truncated center panel showing the Virgin and Child Enthroned with Four Angels, in the Pinacoteca Nazionale, Bologna. The provenance of the Bologna panel is unknown, except that it was purchased for the Pinacoteca in 1894 from a Florentine dealer. Either it

or the Empoli altarpiece are plausible candidates for the original context of the *Lamentation* predella, but physical evidence is lacking to confirm either hypothesis.

LK

LITERATURE: Freuler, in London 1993, pp. 10–13.

31b. The Crucified Christ with the Virgin and Saint John the Evangelist

Tempera on panel
Overall: 33 5/8 × 14 11/16 in. (85.4 × 37.3 cm);
picture surface: 22 × 12 5/8 in. (56 × 32 cm)

The Metropolitan Museum of Art; Robert Lehman Collection, 1975 (1975.1.67)

The cross, bearing a red titulus and streaked with clotting blood, rises from an isolated outcropping of rock in the foreground of a stony landscape. It supports the limp body of Christ, which is crisply silhouetted against the gold ground of the panel and framed within the reflecting curves of two hills sweeping upward on either side in the background. The Virgin Mary, wrapped in a blue cloak, is seated at the left on a rocky plateau in the middle distance. Her hands are crossed at the knees, and she gazes with an expression of sadness or pain at the crucifix. Saint John the Evangelist kneels opposite her at the right, dressed in a rose-colored tunic and robe. He turns his head to avert his gaze from the body of Christ and raises his left hand in a gesture of resignation.

Within a long tradition of portrayals of the Crucifixion, the imagery of Lorenzo Monaco's panel in the Robert Lehman Collection is something of a novelty in Tuscan Gothic painting. There is no reference in it to the historical event of the Crucifixion, which is usually indicated by the inclusion of crowds of soldiers, the mourning Holy Women, or the Good and Bad Thieves on their crosses. Nor are there included any of the standard symbolic references to the significance of Christ's sacrifice, such as angels collecting the blood that drips from his wounds, a pelican nesting at the top of the cross and pecking her breast to feed her young, or the skull of Adam lying at the foot of the hill below the cross. Furthermore, the figures of the Virgin and Saint John are markedly larger in scale than that of Christ and, as Bernard Berenson (1926, p. 300) noted, are seated on the ground, not because there was no room to show them

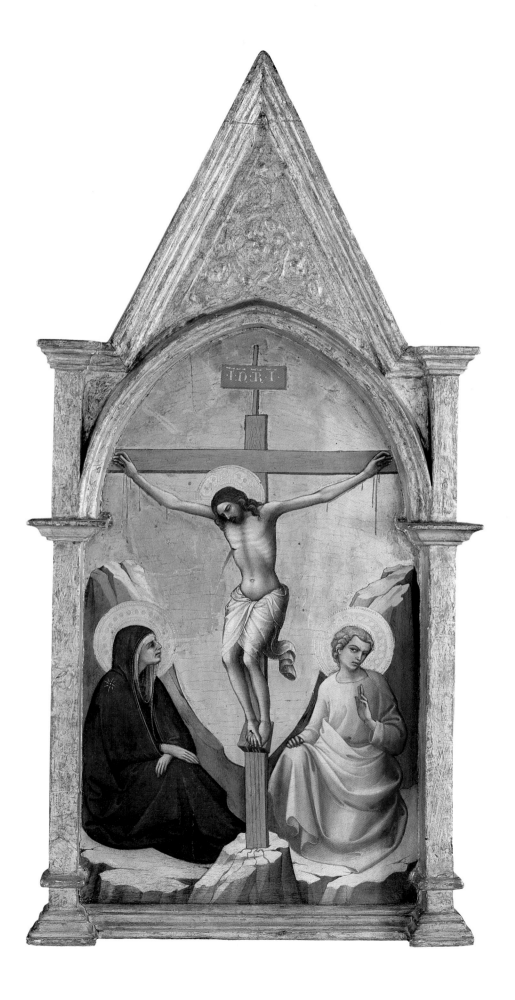

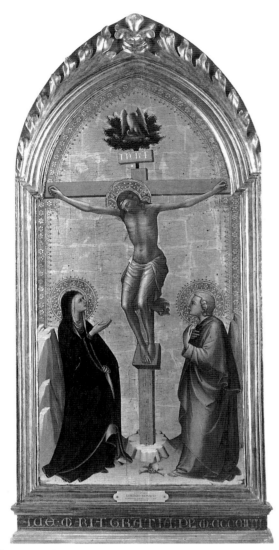

Figure 99. Lorenzo Monaco, *The Crucifixion with the Virgin and Saint John the Evangelist*. Seattle Art Museum (61.158)

otherwise, but for compositional and dramatic effect. The true subject of the panel is not their having borne witness at the Crucifixion but their present contemplation of the crucifix as painted counterparts to the viewer in his devotions to the same object. The crucifix itself, isolated on its own rocky base discontinuous with the rest of the painted landscape and smaller in scale than the Virgin and Saint John, is more an image of one of Lorenzo Monaco's own cutout crucifixes than part of the scene behind it, reinforcing the picture's mystical, devotional message.

The unusual presentation of a three-figured Crucifixion group in this panel raises the question of its probable original function. A smaller painting of an identical subject by Naddo Ceccarelli (Museum of Fine Arts, Boston) may have been used as a pax or, possibly, one valve of a

small portable diptych, though the radically different scale and shape of the Lehman panel argue against such a reconstruction in the present case. Related, if more conventional, panels by Lorenzo Monaco in the Seattle Art Museum (fig. 99) and the Yale University Art Gallery, New Haven, were apparently intended to serve as independent devotional images, while another, in the Museo Bandini, Fiesole, has been reconstructed as the center panel of an unusually shaped triptych (Bellosi 1979). Examination of the physical structure of the Lehman panel, however, suggests that it was painted as the central pinnacle of a multitiered altarpiece. The shape and profile of its engaged frame, which is substantially original[1] though entirely regilt, is typical of altarpiece pinnacles, and the back of the panel preserves traces of a vertical batten securing it to a subjacent panel.

A proposal by Alvar González-Palacios (1970) to identify the Lehman panel as the missing central pinnacle of Lorenzo Monaco's Empoli altarpiece of 1404 (fig. 120) was accepted by John Pope-Hennessy and Laurence Kanter (Pope-Hennessy 1987) on the basis of the two works' general compatibility of size and style. Though Marvin Eisenberg (1989) recognized the validity of associating these works stylistically, he disputed their reconstruction in a single complex on the grounds that the profiles of their frame moldings do not correspond—they are in fact all but identical—and that the combination of painted gable decoration in the lateral panels at Empoli with *pastiglia* decoration in the gable of the Lehman panel would be unprecedented. This last observation is largely correct (an altarpiece by Lorenzo di Bicci in Loro Ciuffena [Marcucci 1965, no. 89] combines *pastiglia* decoration in the lateral pinnacles and a painted central pinnacle), but it must be borne in mind that the form of the Empoli altarpiece is itself virtually unprecedented in combining a round-arched central panel with ogival arched laterals and in comprising lateral pinnacles built integral with the panels below them but with a central pinnacle designed as a separate architectural element. In this last respect Lorenzo Monaco or the local carpenter who prepared the panel for him may have been following the example of two earlier altarpieces, one by Niccolò di Pietro Gerini and another by Agnolo Gaddi, both preserved in the Museo della Collegiata, Empoli, in which the lateral panels were completed by painted triangular gables but the central panel was crowned by a separate, now-missing pinnacle, which may well have been decorated with *pastiglia* ornament.

As it is relatively certain that the Lehman *Crucified Christ with the Virgin and Saint John the Evangelist* once formed the central pinnacle of a large altarpiece— whether it was the altarpiece of 1404 at Empoli, the

unidentified altarpiece of about 1403, in which the *Virgin and Child Enthroned with Four Angels* in the Pinacoteca Nazionale, Bologna, formed the center panel, or another complex not known to survive today—it may be observed that such a placement for images of the Crucifixion is surprisingly rare in Florentine painting. God the Father Blessing is more frequently encountered in that position. None of Lorenzo Monaco's surviving altarpieces are crowned in the center by an image of the crucified Christ.[2] In most Florentine trecento structures in which the Crucifixion appears in the central pinnacle, it is accompanied in the center of the predella by a scene of the Lamentation or a depiction of the Man of Sorrows (it is most likely not coincidental that both the prototypes by Gerini and Gaddi in Empoli mentioned above include a *Man of Sorrows* in the center of the predella and therefore were probably completed with *Crucifixions* in their central pinnacles). Thus there are iconographic reasons, in addition to compelling stylistic evidence, to believe that a recently discovered predella panel showing the Lamentation over the Dead Christ (cat. no. 31a) may have come from the same altarpiece as the Lehman panel, though the identity of the rest of the structure from which these two originated remains a matter of some uncertainty.

LK

1. Contrary to the contention of Eisenberg (1989, p. 154), only the horizontal moldings at the spring of the arch and across the base of the frame have been added in modern times, presumably to enhance the impression of an independent tabernacle.
2. A panel by Lorenzo Monaco in the Accademia, Florence (inv. no. 2141), showing Christ on the cross flanked by the lance and the sponge, was certainly once the central pinnacle of an altarpiece, where it was flanked by lateral pinnacles showing the mourning Virgin and Saint John the Evangelist (Accademia inv. nos. 2140, 2169). Arranging these three figures in separate panels is elsewhere encountered only in the cutout crucifix in the church of San Giovannino dei Cavalieri, Florence; their transposition to the upper tier of an altarpiece is a novelty unrelated to the conventional trecento use of the three-figure group in a single pinnacle.

EX COLL.: Stefano Bardini, Florence (by 1902); Charles Loeser, Florence; Robert Lehman, New York (1958).

LITERATURE: Pope-Hennessy 1987, no. 71, pp. 168–69 (with previous literature); Eisenberg 1989, p. 154.

32a. Four Patriarchs: Abraham, Noah, Moses, and David

Tempera on panel
Abraham: 26 × 17 in. (66 × 43.1 cm) overall; 23 × 16 5/8 in. (58.4 × 42.2 cm) picture surface; Noah: 26 × 17 1/2 in. (66.3 × 44.4 cm) overall; 23 × 17 in. (58.4 × 43.1 cm) picture surface; Moses: 24 3/4 × 17 3/4 in. (62.8 × 45.1 cm) overall; 22 3/4 × 17 3/4 in. (57.8 × 45.1 cm) picture surface; David: 22 1/4 × 17 in. (56.5 × 43.1 cm) overall and picture surface

Abraham: The Metropolitan Museum of Art; Gwynne Andrews Fund, and Gift of G. Louise Robinson, by exchange, 1965 (65.14.1); Noah: The Metropolitan Museum of Art, Gwynne Andrews Fund, and Gift of Paul Peralta Ramos, by exchange, 1965 (65.14.2); Moses: The Metropolitan Museum of Art, Gwynne Andrews Fund, and Bequest of Mabel Choate in memory of her father, Joseph Hodges Choate, by exchange, 1965 (65.14.3); David: The Metropolitan Museum of Art, Gwynne Andrews and Marquand Funds, and Gift of Mrs. Ralph J. Hines, by exchange, 1965 (65.14.4)

The four patriarchs are each portrayed seated on a cut stone bench or chest set on a fictive marble dais, which is alternately pink with a strip of green in the foreground (Noah and David) or green with a strip of violet in the foreground (Abraham and Moses). Noah, in a blue robe and orange cape, balances a model of the ark on his left thigh and points skyward with his right hand. Abraham wears a pink tunic with green shadows, a violet cloak with pink highlights, and a white shawl draped over his shoulders. He holds a silver sword and a firebrand in his right hand and lays his left on the head of his son, Isaac, kneeling in profile before him, dressed in an orange tunic over a gray robe. Moses, in a blue tunic bound high above the waist with a knotted sash and covered by a violet cloak lined with yellow, with a blue shawl wrapped around his shoulders, supports the tablets of the Ten Commandments, one on each knee. David wears a green cloak lined with salmon pink over a blue robe with gilt collar, cuffs, and hem and blue shoes. He plays a lyre, which he holds before him on his left knee. All five figures (including Isaac) are adorned with tooled halos, that of Moses interrupted by engraved rays of light emanating from behind his head and that of David superimposed by a punched, gilt, and glazed crown. The gold ground of each panel terminates in an ogival arch, though all traces of the engaged frames or spandrel decoration that covered the bottom edge and upper corners of the rectangular wood supports have been lost. The panel of David, which has a different collection history than the other three, has been trimmed to the profile of the gold ground on all sides.

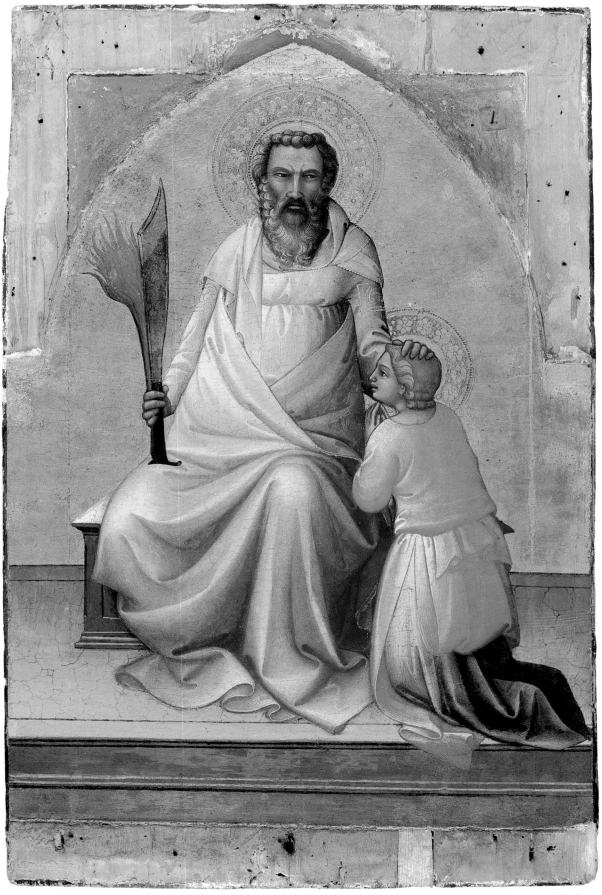

32a: Abraham

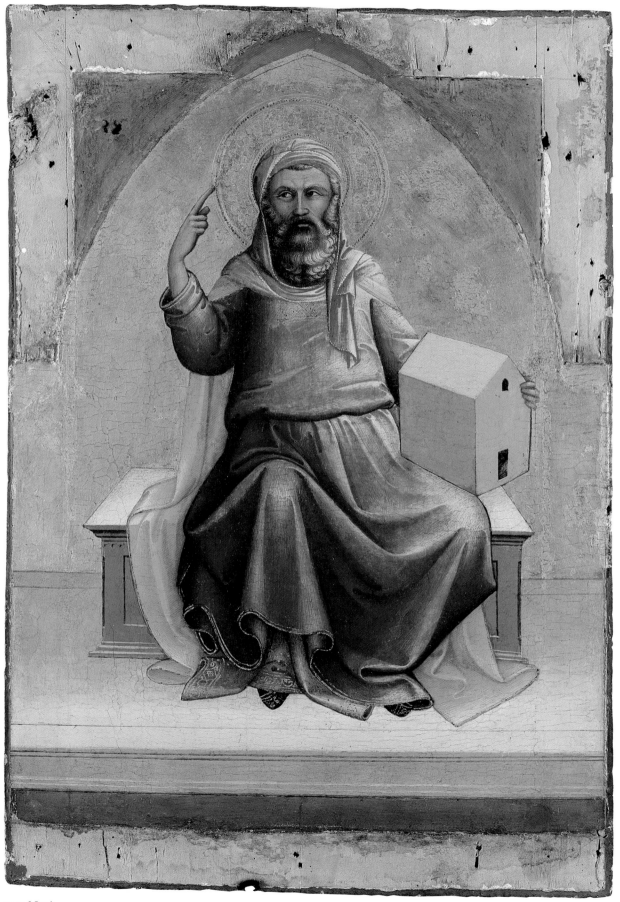

32a: Noah

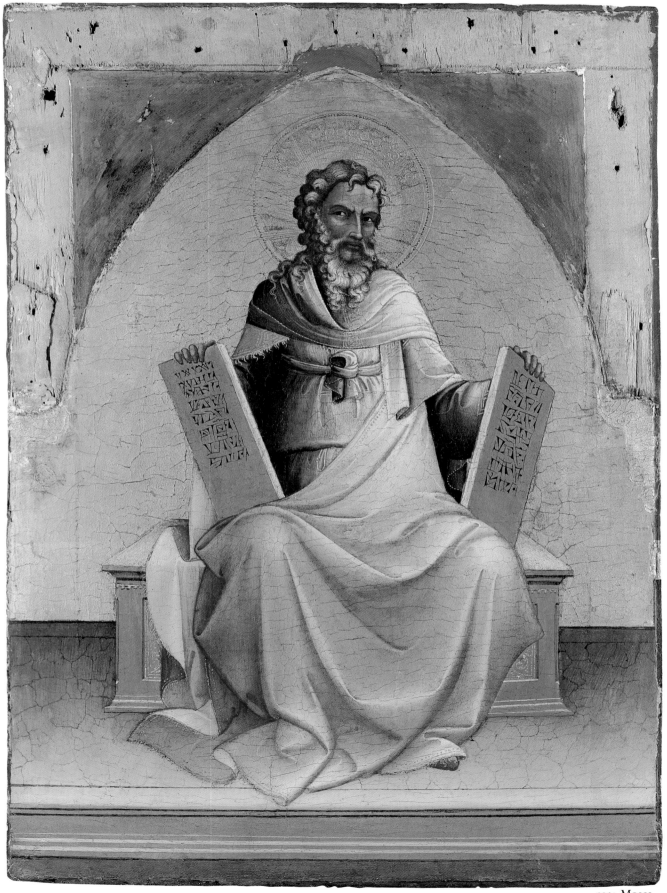

32a: Moses

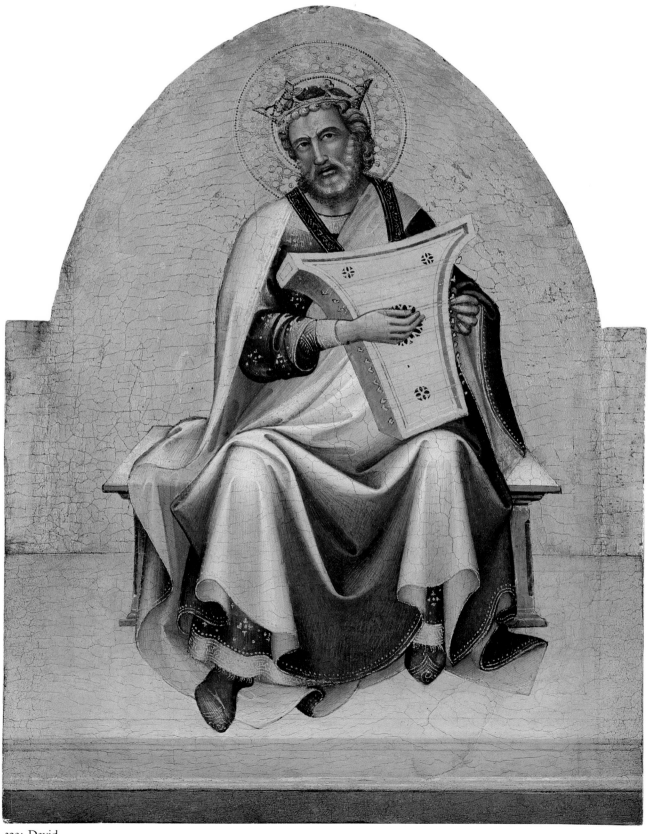

32a: David

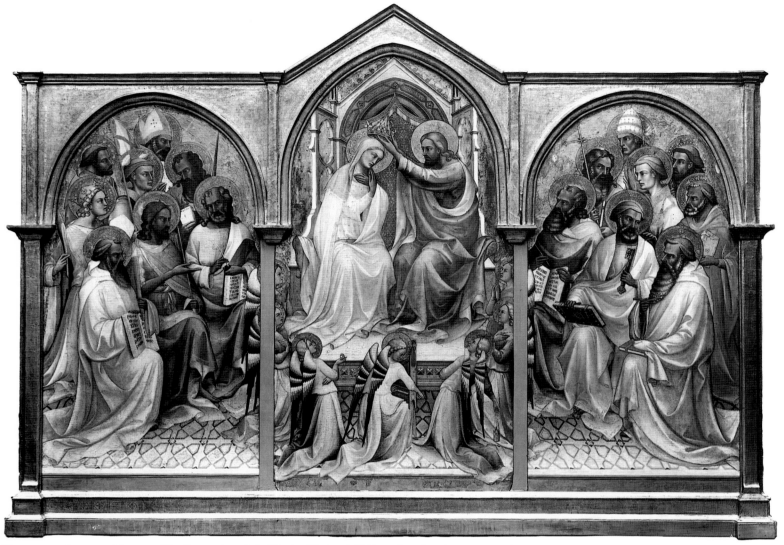

Figure 100. Lorenzo Monaco, *The Coronation of the Virgin*. National Gallery, London (215, 216, 1897)

The Four Patriarchs have recently (Eisenberg 1989, p. 22) been "ranked among [Lorenzo Monaco']s most authoritative works," for both the vibrancy of their palette and the monumentality of their presentation, like pigmented marble sculptures set majestically in floodlit spaces. In part their startling impression is due to the artist's exquisite draftsmanship, to the near-perfection of his tempera technique, and to the panels' admirable state of preservation, but in part it is due as well to their lack of context. Presented as four independently framed panel paintings they stand out as an anomaly in Italian Gothic painting, recalling no prototypes so much as they do later frescoes or *spalliera* panels of *uomini famosi* (famous men) or of enthroned Virtues, such as those painted in 1470 by Pollaiuolo and Botticelli for the Mercanzia (Galleria degli Uffizi, Florence). Indeed, a great deal has been written about their relationship to the series of

monumental seated saints carved for the facade of Florence cathedral by, among others, Donatello and Nanni di Banco, but the comparison must be understood as a paean to the quality of the Metropolitan Museum panels rather than serious art-historical argument, as the statues are considerably later than the paintings.

Reconstructing the original context of the Four Patriarchs has been the subject of widely ranging opinion. Millard Meiss noted that complementing the alternating colors of the painted platforms in each panel, the thrones on which the four figures sit seem to be projected from two distinct viewing angles, which suggests that one pair, Abraham and Moses, may have been situated in a register above the other, Noah and David. This hypothesis, coupled with the unusual thinness of the panels (about $2/3$ in. [1.7 cm]), led Marvin Eisenberg to suppose that they could have been built into the doors of a

custodia, or cupboard, enclosing another work of art, perhaps a sculpture, the thinness of the panels intended to lessen the weight of the movable structure. Though not inherently improbable, such a reconstruction raises two difficulties. In other surviving *custodia* or tabernacle wings, such as Giovanni di Paolo's *Scenes from the Life of Saint John the Baptist* (see Lloyd 1993, pp. 110–28) or Lorenzo Monaco's *Saints Michael and Francis* in the Museum of Fine Arts, Houston,[1] the painted panels are invariably the structure of the wing itself rather than set into an independent framework,[2] and none of the Metropolitan Museum panels bears traces of a hinge strong enough to support such a structure. Also, it is difficult to envision the subject of the painting or sculpture such wings might have enclosed, since there is no established iconographic tradition for these Four Patriarchs as an isolated group, either as objects of devotion in their own right or as antetypes or witnesses to one of the mysteries of Christian salvation. They are more appropriately encountered in the company of prophets and saints representing the orders of heaven (see Jacobus de Voragine) and the foundation of the Church; as such they appear, for example, accompanied by six prophets, in the pilasters of Lorenzo Monaco's great *Coronation of the Virgin* altarpiece of 1414 from Santa Maria degli Angeli (Uffizi, Florence; Eisenberg 1989, fig. 44).

The relative thinness of the Metropolitan Museum panels and their overall rectangular format do imply that they originally formed part of a much larger complex. Similar panels are frequently encountered in a median tier of an altarpiece, above and applied to the structure of a larger main tier and below superimposed pinnacles, as in a nearly contemporary example by Gherardo Starnina now in the Museum of Fine Arts, Boston (Kanter 1994, pp. 130–36). Such panels, however, are generally constructed as spandrels fitting between the arches of the panels beneath them. When they are themselves supplied with ogival arches and spandrels as in the present case, a form common in earlier Sienese altarpieces and not unknown in Florence, they are usually filled with half-length figures, as in examples by Antonio Veneziano (Boskovits 1975, pl. 83,a) and the Master of the Orcagnesque Misericordia (Boskovits 1975, fig. 218). Perhaps for this reason no attempts have been made to identify the Metropolitan Museum Patriarchs as fragments of any of Lorenzo Monaco's known altarpieces, but despite their unwonted compositions, such appears to have been their original context.

Attempts to identify the structure of which these four panels formed part have been frustrated not only by their unusual shape and iconography but also by the difficulty of accurately dating them within Lorenzo Monaco's ca-

reer. Thus, the only other panel consistently associated with them, a *Saint Peter Enthroned* now in the Alte Pinakothek, Munich, has given rise to lengthy if unnecessary justification of their unrelated iconographies and divergent sizes, on the assumption that their similarity of design must indicate a common origin. The *Saint Peter*, however, was painted significantly earlier than the Metropolitan Museum Patriarchs, certainly before the Accademia *Man of Sorrows* of 1404, and must have formed part of a different complex altogether. The Patriarchs, on the other hand, are universally recognized as products of the second half of the first decade of the fifteenth century. Their compositions represent a more mature reprise of that of the Munich *Saint Peter* and a less volumetrically developed effort than the iconic *Saint James Enthroned* of 1408 in the Museo dell'Opera at Santa Croce, Florence. Strictly on the basis of composition, their closest parallel among Lorenzo Monaco's autograph and workshop productions is to be found in the problematic *Saint Lawrence* altarpiece of 1407 in the Musée du Petit Palais, Avignon, the design for the central panel of which is essentially a reversal of the Metropolitan Museum *Moses*, enlarged and inappropriately supplied with elaborately swirling draperies otherwise reserved by Lorenzo Monaco for his Madonnas of Humility. A date of about 1407 is further suggested by the marked coincidence of figure types and poses between the Patriarchs and several saints in the *Coronation of the Virgin* altarpiece from the monastery of San Benedetto fuori Porta a Pinti (National Gallery, London; fig. 100) and by the near-identity of the figure of Isaac in profile in the Metropolitan Museum *Abraham* and the music-making angels at the foot of the throne in the central panel of the London *Coronation*.

The basis for dating the London *Coronation of the Virgin* to precisely the year 1407 is a little-known mention of the altarpiece in situ, which presumably records a now-missing inscription including that date. The document in question, first noted by Margaret-Louise Frawley (1975), is a later copy of a now-missing earlier description of the Camaldolese church of San Benedetto fuori Porta a Pinti, on the high altar of which once stood the damaged and inappropriately displayed but still impressive panels now in London. Though its wording is vague, the import of the document is clear, and its reliability is not open to question. Even a superficial comparison of the figures of Christ and the Virgin in the center panel in London with the *Saint James Enthroned*, dated 1408, at Santa Croce, will demonstrate their close chronological proximity, which is reinforced by the long-acknowledged similarities between the lateral panels in London and the San Procolo *Annunciation* altarpiece of 1409 (see cat. no. 34). There is no reason to question Eisenberg's recon-

Figure 101. Lorenzo Monaco, *God the Father Blessing*. Private collection, London

As was mentioned earlier, Noah, Abraham, Moses, and David all appear on the pilasters of Don Lorenzo's 1414 *Coronation of the Virgin* altarpiece now in the Uffizi. As parts of the London *Coronation*, the Metropolitan Museum Patriarchs would have been arranged side by side in pairs above the lateral panels, the present widths of which (41³/₈ in. [105 cm] left, 40 in. [101.5 cm] right), though altered slightly by cutting and by their ungainly modern frame, are more than adequate to accommodate such a grouping, since each pair would have been approximately 34⁵/₈ inches (88 cm) wide exclusive of any decorative framing elements not now in evidence. Above the right-hand pair would have stood a pinnacle with the Pasadena *Virgin Annunciate*, balanced by a missing *Annunciatory Angel* above the left-hand pair. The center panel of the altarpiece may or may not have been completed with a pair of prophets similar in design to the Metropolitan Museum panels, but it would certainly have been crowned with a pinnacle, in all likelihood showing God the Father Blessing. Perhaps a panel of that subject formerly on the art market, London (fig. 101), can be identified with the pinnacle for the central panel. Further figures of prophets would undoubtedly have filled painted pilasters at either side of the altarpiece.

Though physical evidence demonstrating the inevitability of such a reconstruction is lacking, the probability that it indicates the original function and situation of the Metropolitan Museum Patriarchs is compelling. In the context of the enormous and highly complex architectural structure of this altarpiece, which must have been one of the largest and most lavish to be seen in or around Florence at the time, the dramatic monumentality and coloristic brilliance of these figures would have been at once subdued by their containing framework and distance from the viewer and enhanced by the opulence of the panels around them and the majesty of the ensemble, a hint of which can perhaps be derived from the largely intact *Coronation* altarpiece of 1414.

LK

struction of the predella (London, Rome, Poznań) and right pinnacle (Pasadena) of the London altarpiece, but his elaborate arguments for dating it to the second half of Lorenzo Monaco's career must be dismissed out of hand.

Given the probable contemporaneity of the London altarpiece and the Metropolitan Museum Patriarchs, it is necessary to inquire whether the latter might not originally have been part of the former. Not only is the London altarpiece the only large complex known to have been executed by Lorenzo Monaco at this precise moment—the Santa Croce *Saint James* (1408), San Procolo *Annunciation* (1409), and Monteoliveto (1410) altarpieces all being later in style—but also its subject would appropriately accommodate the inclusion of figures of the patriarchs in its missing ancillary panels.

1. Though rejected by Eisenberg (1989, p. 195) as the work of a provincial pasticheur, the attribution of these panels to Lorenzo Monaco first proposed by Golzio (1927) and the dating for them to the last years of the artist's career proposed more recently by Bellosi (1984, p. 311) are not open to question. Eisenberg is also incorrect in describing what he believes are extensive alterations, primarily additions, made to the panels to adapt them for use as the wings of a *custodia*. Though the paint surfaces are damaged and partially restored, the entire structure of the panels is original, as is that of the tabernacle to which they are joined. The inside of the tabernacle was repainted, and its face moldings rebuilt and

regilt probably in the early twentieth century, at which time the arched tops of the wings were trimmed slightly to fit within the somewhat altered profile of the front opening. The back of the tabernacle retains an earlier, probably eighteenth-century, paint surface and shows the monogram of Christ associated with the cult of Saint Bernardino, indicating a probable provenance for the ensemble from a Franciscan Observant community.

2. Painted panels contained in separately constructed frames are unknown in Tuscany before about 1430 and did not become common before about 1470, when Cosimo Rosselli and a few related painters adopted the system, probably imported from Venice or northern Europe, as part of their workshop production method. Separately conceived and built frames and panels did not become the rule in Florence until late in the sixteenth century. The Metropolitan Museum Patriarchs retain clear evidence of the removal of engaged frames, suggesting that they were not painted on inserts but rather on parts of the supporting structure of whatever complex they originated from.

32b

EX COLL.: Vincenzo Biondi, Florence (until 1841); Chalandon, La Grange Blanche, Trévoux (until about 1958); [Wildenstein, New York] (Abraham, Noah, Moses). George Augustus Wallis, Florence (until 1847); Königliche Gemäldegalerie, Kassel (by 1903; until 1929); [A. S. Drey, Munich and New York]; Solomon R. Guggenheim, New York (1929–49); [Wildenstein, New York (1962–65)] (David).

LITERATURE: Eisenberg 1989, pp. 22–23, 151–53 (with previous literature).

32b. Jeremiah

Tempera and gold on panel
8 1/2 × 4 1/2 in. (21 × 11 cm)

Richard L. Feigen, New York

The prophet Jeremiah is shown half-length, in a green robe and white shawl, facing three-quarters to the left. In his right hand he holds the rolled end of a scroll or banderole inscribed: [HAEC DICIT DOMINUS] IUX[TA] VIAS GE[N]TIU[M] NOL[ITE DISCERE ET A SIGNIS CAELI NOLITE METUERE QUAE TIMENT GENTES] (Thus saith the Lord: Learn not according to the ways of the Gentiles: and be not afraid of the signs of heaven, which the heathens fear [Jer 10:2]).

The subject, size, and shape of this recently discovered panel, with the prophet framed within inverted lobed arches, indicate that it once stood in the right framing pilaster of an altarpiece. It undoubtedly occupied either

the base or the uppermost compartment of the pilaster, on analogy with such figures in the 1414 *Coronation of the Virgin* altarpiece in the Uffizi (Eisenberg 1989, fig. 44); all of Lorenzo Monaco's other known pilaster panels contain full-length figures. Six panels by Lorenzo Monaco showing full-length female saints framed in lobed compartments with sgraffito decoration in the spandrels similar to that in the *Jeremiah* are incorporated into the pilasters of Fra Angelico's altarpiece in San Domenico, Fiesole (fig. 17), but it is not clear where these panels originated or whether they formed part of a single complex with the *Jeremiah*.

The attribution of this panel to Lorenzo Monaco, proposed independently by Miklós Boskovits (oral communication), may be confirmed by comparison with the illuminations in Cod. Cor. 5 (see pp. 229–34) and Cod. Cor. 7 (cat. no. 33) at the Biblioteca Laurenziana, Florence, many of which show half-length figures in closely related attitudes, executed with an identically precise draftsmanship and bright palette with subtly rendered white highlights and a similarly ponderous figure style. These two antiphonary volumes also provide an approximate basis for dating the *Jeremiah*, which must be all but contemporary to the Saint Maurus on folio 95r or the King David and God the Father on folio 20r of Cod. Cor. 7 (figs. 105, 103), painted shortly after 1406. Given the coincidence of their dates, it is possible that the altarpiece from which the *Jeremiah* was excised was the San Benedetto *Coronation of the Virgin* (fig. 100) now in the National Gallery, London, a work of the year 1407. If this were the case, the *Jeremiah* would certainly have been employed in the same fashion as, and perhaps served as a prototype for, similar figures in the later altarpiece of the same subject in the Uffizi, formerly on the high altar of Santa Maria degli Angeli.

LK

33. The Last Judgment in an Initial C

Tempera and gold leaf on parchment
12 3/8 × 10 3/8 in. (31.5 × 26.5 cm)

The Metropolitan Museum of Art; Robert Lehman Collection, 1975 (1975.1.2485)

In a blue initial C lined with bands of yellow and red and decorated with yellow, orange, and green foliation, the half-length figure of Christ, loosely wrapped in a blue cloak, floats on a bank of clouds above a desolate rocky landscape. He raises his right hand in judgment, points downward with his left, and looks across to the right toward the now-missing text that would have followed the initial. At the left, cropped by the red band lining the initial, is an angel in a blue tunic sounding a long golden trumpet, summoning the quick and the dead to judgment. Below, the bodies of four of the resurrected dead emerge from holes in the cracked and barren ground. They are visible as heads or heads and shoulders only, two in profile and two in extreme foreshortening tilted backward and looking up at Christ. The halos of

Figure 102. Lorenzo Monaco, Saint Michael Casting Out the Demons in an initial F. Biblioteca Medicea Laurenziana, Florence (Cod. Cor. 5, fol. 105r)

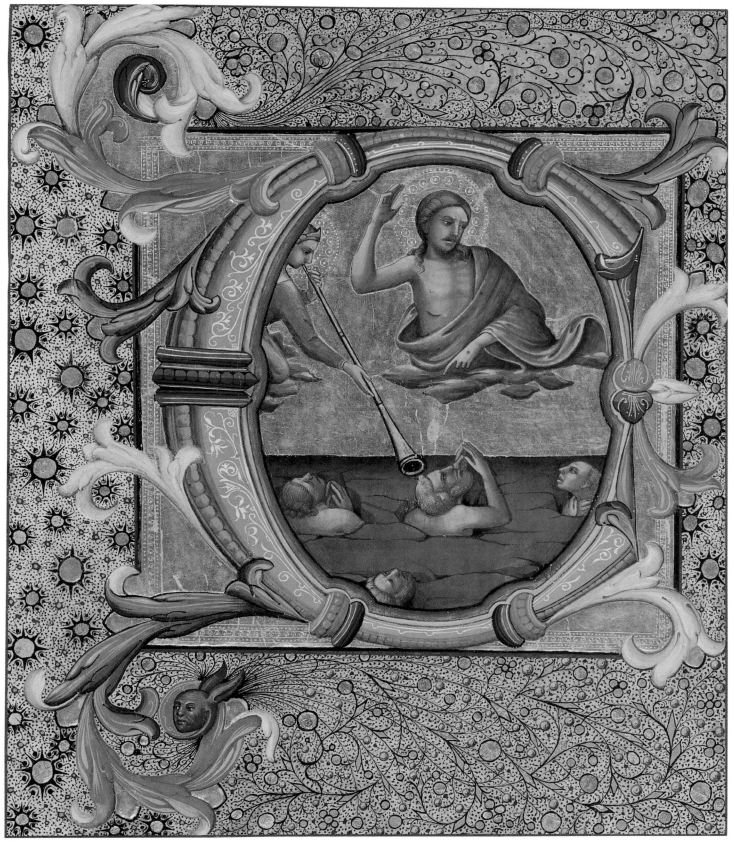

33

Figure 103. Lorenzo Monaco, God the Father Blessing and King David Playing a Psaltery in an initial B. Biblioteca Medicea Laurenziana, Florence (Cod. Cor. 7, fol. 20r)

Christ and the angel and the borders of the gold ground are decorated with simple punch motifs of rows of dots or circles with dotted centers. The initial has been trimmed to the edges of the gold and of the foliage tendrils all around and mounted on a larger board, which was then decorated, possibly in the late nineteenth century, with an elaborate overall pattern of gold foil dots and black ink "peacock feather" and starburst designs (some of the gold dots and starbursts at the left are original).

The Lehman Initial C with the Last Judgment was correctly identified by Mirella Levi D'Ancona (1978, p. 228) as one of three missing initials from Cod. Cor. 7 at the Biblioteca Laurenziana, Florence, an antiphonary volume that formed part of the famous series of choir books from Santa Maria degli Angeli. The initial C begins the second responsory of the first nocturn of matins in the Office of the Dead: "Credo quod Redemptor meus vivit, et in novissimo die de terra resurrecturus sum, et in carne mea videbo Deum, Salvatorem meum" (I believe that my Redeemer lives, and that on the last day I shall rise from the earth, and in my flesh I shall see God, my Savior). The initial appeared on folio 124v, now missing, following the rubric

Figure 104. Lorenzo Monaco, Saint Peter and Four Apostles in an initial V. Biblioteca Medicea Laurenziana, Florence (Cod. Cor. 7, fol. 36r)

Figure 105. Lorenzo Monaco, Saint Maurus in an initial P. Biblioteca Medicea Laurenziana, Florence (Cod. Cor. 7, fol. 95r)

"In agenda mortuorum" on folio 123r and the second antiphon of the first nocturn on folio 123v: "Convertere, Domine, et eripe animam meam, quoniam non est in morte, qui me[mor sit tui]" (Turn to me, Lord, and save my soul, for among the dead no one remembers you). The concluding lines of the responsory, beginning "meus vivit," are preserved at the top of folio 125r.

Cod. Cor. 7 is dated 1406 in a colophon ("Completum Est Hoc Opus Anno Domini M.CCCC.VI") decorating a Lombard initial D on folio 123r, which indicates that it was added as a supplement to the twelve volumes of the antiphonary written for Santa Maria degli Angeli between 1385 and 1397. Its contents are somewhat irregular, comprising some commons of the saints omitted from Cod. Cor. 11 (see cat. no. 20b), votive offices of the dead and of the dedication of a church, and offices for feasts in the months of April and May—among them are Saint George (April 23), Saint Mark the Evangelist (April 25), and Saint Zenobius (May 25)—that were omitted from Cod. Cor. 1, the volume of the antiphonary in which they ought to have been included (cat. no. 29). Three leaves at the end of the volume containing a portion of the office for the feast of Saint Cecilia (November 22) may have been removed from Cod. Cor. 6, which ends with that feast, and inappropriately rebound with Cod. Cor. 7 at a later date. In addition to folio 124, two other leaves are missing from the volume: folio 4, containing part of the office of matins from the common of several martyr saints,[1] and folio 45, beginning the office for the feast of the Invention of the Holy Cross on May 3.[2]

Cod. Cor. 7 retains three illuminated initials: God the Father Blessing and King David Playing a Psaltery in an initial B ("Beatus vir qui metuit Dominum" [Happy the man who fears the Lord]), illustrating the common of a single martyr (fol. 20r; fig. 103); Saint Peter and Four Apostles in an initial V ("Virtute magna reddebant Apostoli testimonium resurrectionis Iesu Christi Domini nostri" [With great power the Apostles gave testimony to the resurrection of Jesus Christ, our Lord]), illustrating the second responsory of the second nocturn for the feast of Saints Philip and James, which is May 3 according to the Camaldolese calendar (fol. 36r; fig. 104); and Saint Maurus in an initial P for the feast of Saint Maurus on January 15 (fol. 95r; fig. 105).[3] All of these are clearly related to the Lehman Last Judgment both in figure style and in the filigree and foliate decoration of their initials, and they all share identical punch patterns embellishing the margins of their gold grounds. The same punch patterns and figure style occur in an initial D with the Man of Sorrows in his tomb flanked by the Virgin and Saint John the Evangelist (Musée des Beaux-Arts, Dijon,

Figure 106. Lorenzo Monaco, The Man of Sorrows with the Virgin and Saint John the Evangelist in an initial D. Musée des Beaux-Arts, Dijon (1474)

inv. no. 1474; fig. 106), which is probably therefore a fragment of the missing folio 45 from Cod. Cor. 7. The initial D begins the antiphon "Dulce lignum, dulces clavos" (O sweet wood, sweet nails), which concludes at the top of folio 46r with the lines "dulce pondus sustinuit que digna fuit portare pretium huius seculi" (sweet weight he bore that was worthy of carrying the ransom of the ages).

The attribution and dating of the illuminations from Cod. Cor. 7 are a matter of some debate. They were initially related by Paolo D'Ancona (1914, vol. 2, p. 129) to the author of the illuminations in Cod. Cor. 13, whom he did not recognize as Lorenzo Monaco. Similarly Vincenzo Golzio (1931, pp. 34–36) assigned them to the artist responsible for the illuminations in Cod. Cor. 3 and a predella panel of the *Adoration of the Magi* in Poznań (since recognized as part of the predella to the London *Coronation of the Virgin* altarpiece of 1407; fig. 100), again Lorenzo Monaco. Levi D'Ancona (1958b, p. 189) attributed the initial B on folio 20r to Lorenzo Monaco but regarded the others as the work of Bartolomeo di Fruosino. Miklós Boskovits (1975, p. 342), who incorrectly listed folio 123 as illuminated, implied that all the miniatures in the codex were to be attributed to Lorenzo

Figure 107. Matteo Torelli, The Last Judgment in an initial C. Museo Nazionale del Bargello, Florence (Cod. E 70, fol. 84v)

denying both to Lorenzo Monaco. The illuminations in Cod. Cor. 5, which are certainly autograph, may plausibly be dated about 1406, and those from Cod. Cor. 7 must only very slightly postdate them. Among large-scale paintings by Lorenzo Monaco, their closest points of comparison are all to be found in the London *Coronation of the Virgin* altarpiece of 1407 and the *Saint James Enthroned* of 1408 at Santa Croce, Florence. Many of the same distortions of foreshortening that characterize the Lehman Last Judgment appear, albeit more refined in execution, in the *Nativity* (cat. no. 34a) and the *Adoration of the Magi* from the San Procolo predella of 1409 or the Louvre *Agony in the Garden* of 1408, though the miniature is unlikely to have been painted quite as late as that consummately delicate work. In all likelihood, Lorenzo Monaco supplied the illuminations for Cod. Cor. 7 immediately after completion of the text in 1406 and almost certainly before the close of the following year.

LK

Monaco, while Marvin Eisenberg (1989, p. 189) preferred to see them all as the work of Bartolomeo di Fruosino.

At the outset it must be noted that the Dijon Man of Sorrows, the Lehman Last Judgment, and the three illuminations still present in Cod. Cor. 7 are all uniform in handling and conception and must be considered the work of a single artist in design and execution; further, none of them bears even a superficial resemblance to any certain works by Bartolomeo di Fruosino. An attribution for the Lehman Last Judgment to another follower of Lorenzo Monaco, Matteo Torelli (suggested *in litteris* by Levi D'Ancona), may similarly be dismissed by comparing it with the initial C with the Last Judgment (fig. 107) in Cod. E 70 at the Museo Nazionale del Bargello, Florence, an antiphonary common of the saints from Santa Maria Nuova that is documented as the work of Torelli in 1412–13 (Levi D'Ancona 1958a, pp. 247ff.; idem 1992, p. 96). The latter folio is clearly dependent in design on the Lehman cutting and inferior to it in execution, implying a terminus ante quem for the Lehman cutting and Cod. Cor. 7.

Eisenberg (1989, p. 199) was correct in relating the organization of space in the Lehman Last Judgment to that in the initial F with Saint Michael and the Demons in Cod. Cor. 5 (folio 105r; fig. 102), though he erred in

1. Levi D'Ancona (1978, p. 229) identifies the missing initial from this page with an initial A with Christ and Saint Paul in the Wildenstein Collection at the Musée Marmottan, Paris (cat. 2), presumably illustrating the text "Absterget Deus omnem lacrimam ab oculis Sanctorum" (God will wipe away every tear from the eyes of the saints), the fourth antiphon for second vespers in the common of several martyrs outside of Paschaltide. The subject of this initial is not appropriate to that text, however, and the style of the initial is entirely unrelated to the rest of the illuminations from Cod. Cor. 7. A work probably of the 1420s, it may have been cut from the same antiphonary as two other fragments in the Wildenstein Collection: cats. 93 (an initial H with the Nativity) and 97 (an initial H with the Baptism of Christ). Furthermore, rubrics preceding the missing folio in Cod. Cor. 7 specify the common for several martyrs in Paschaltide, and the text of the missing initial may therefore have been "Stabant iusti in magna costantia" (The just will stand with great assurance). The antiphon "Absterget Deus" is preserved intact and illuminated in Cod. Cor. 11, folio 38r.

2. The missing illumination from this page was identified by Levi D'Ancona (1978, p. 228) with a Crucified Christ Between the Virgin and Saint John the Evangelist that was sold at Sotheby's, London, on July 11, 1966 (lot 193), but neither the format of this miniature, which is enclosed in a painted mosaic frame and does not include an initial letter, nor its style, clearly that of Bartolomeo di Fruosino in the 1410s or 1420s, corresponds to anything else in Cod. Cor. 7.

3. The feast of Saint Maurus is omitted from Cod. Cor. 14, where it ought to have been included. Most authors list four illuminations present in Cod. Cor. 7, including folio 72r. The initial I ("In dedicatione templi decantabat populus laudem" [At the dedication of the temple, the people sang songs of praise]) on this page is decorated only with foliation and a drôlerie of modest quality.

EX COLL.: Vicomte Bernard d'Hendecourt, Paris (1920).

LITERATURE: Comstock 1927, p. 56, illus. p. 51; De Ricci and Wilson 1935–37, vol. 2, p. 1709; Paris 1957, no. 166; Cincinnati 1959, no. 322; Levi D'Ancona 1978, p. 228; Eisenberg 1989, p. 199.

34a. The Nativity

Tempera on panel
8 ³/₈ × 12 ¹/₄ in. (21.4 × 31.2 cm)

The Metropolitan Museum of Art; Robert Lehman Collection, 1975 (1975.1.66)

The scene takes place before a cave in the center of a rocky, nighttime landscape. Built in front of the cave are a manger and a shed whose pitched roof, filling the center gable of the shaped quatrefoil panel, is supported in front by thin vertical posts that divide the picture field into thirds. Behind the manger, looking out from inside the cave, are an ox and an ass, while lying on the ground in front of the manger is the naked Christ child surrounded by a gilt radiance. The Virgin Mary, wearing a blue cloak lined with green over a lilac dress, kneels at the left before her son, her hands clasped in adoration or prayer; a cloud of golden angels hovers above her head. In the right foreground, filling one of the lobes of the *pastiglia* frame, Saint Joseph is seated on the ground. Seen from behind and looking up, he wears a red cloak over a lavender tunic with strong yellow highlights on the sleeve. In the background above him, occupying the right upper lobe of the frame, an angel announces the birth of Christ to two astonished shepherds, the scene lit from within by the heavenly brilliance of the messenger. The lateral projections of the frame have been trimmed, cropping a flock of sheep and perhaps a watchdog in the middle distance to the right of Saint Joseph and an extension of the barren, hilly landscape behind the Virgin to the left.

Long recognized as one of the most exquisite of Lorenzo Monaco's smaller narrative inventions and one of the most satisfying of his solutions to the problem of composing an irregular picture field, the Lehman *Nativity* is a tour de force of color harmonies, linear abstractions, and light effects that typify the artist's paintings both on panel and on parchment in the second lustrum of the fifteenth century. Its originality is even more evident when compared with a later rendering of the same subject by Lorenzo Monaco—one of the

compartments in the predella to the great *Coronation of the Virgin* altarpiece of 1414 in the Uffizi (Eisenberg 1989, fig. 44). The latter, somewhat taller in proportions than the Lehman panel, projects a deeply recessive space through the construction of the shed and manger in the center but disposes the three principal figures of the drama in a single plane parallel to the picture surface, emphasized by Saint Joseph's placement in pure profile at the right. The scene of the Annunciation to the Shepherds, filling the upper left lobe of the frame, is segregated from the main subject of the panel by the shed roof, and the spatial relation of the two scenes is as ambiguous as that of the eerily lit trees filling the upper right lobe. By contrast, the flattened projection of the shed roof (the receding sides of the manger are hidden behind the cave walls) in the Lehman panel is so extreme as to make it less a spatial than a decorative framing device, yet the Virgin, the Christ child, and Saint Joseph are carefully situated at different depths in space so that their interaction weaves forward and backward rather than side to side. The shepherds at the upper right are shown behind rather than merely above the shed, at an almost measurable distance back from Saint Joseph, whose dramatic, seen-from-behind posture makes him seem nearly to topple forward out of the picture space. Finally, the placement of the child in the Lehman panel, almost at the exact geometric center of the composition, intensifies the mystical and devotional quality of its subject. In the Uffizi predella the child has been lowered to the foreground, far from the convergence of orthogonals, and the design has lost some of the urgency of its meaning.

Though Raimond van Marle (1923–38, vol. 9 [1927]) believed the Lehman *Nativity* to be a late work by Lorenzo Monaco, Evelyn Sandberg Vavalà's (1937–38) contention that it must precede the *Nativity* from the 1414 *Coronation* altarpiece is correct, and a date late in the first decade of the fifteenth century has been accepted by nearly every writer to discuss it. As was noted by John Pope-Hennessy and Laurence Kanter (Pope-Hennessy 1987), a close parallel for the stylistic conceits in the Lehman panel is provided by Lorenzo Monaco's small triptych comprising *The Agony in the Garden*, *The Three Marys at the Tomb* (Musée du Louvre, Paris), and the *Lamentation over the Dead Christ* (Národni Galeri, Prague), dated by inscription 1408. The paintings are related by their palette, figure types, lighting effects, brushwork (allowing for the very slightly abraded surface of the Lehman panel), and compositional complexity and should be considered virtually contemporaneous.

From the time of its first notice by Gustavo Frizzoni (1902, pp. 290, 292), the Lehman *Nativity* has been

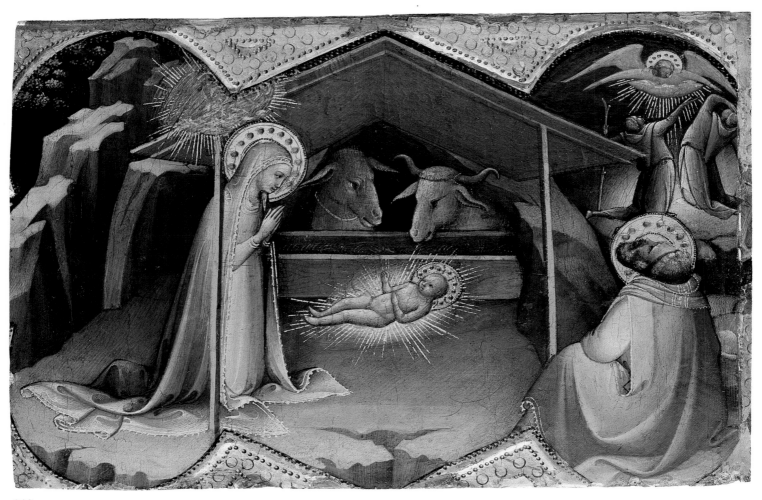

34a

associated with two panels of identical shape with similarly decorated and truncated *pastiglia* frames, which represent the Visitation and the Adoration of the Magi, in the Courtauld Institute Galleries, London (figs. 108, 109), and with another panel, whose borders and halos have been altered by regilding, which depicts the Flight into Egypt, in the Lindenau-Museum, Altenburg (fig. 110). The relation of these four panels to one another and their function as parts of a single predella have never been doubted, but the identity of the complex from which they might have come has not been firmly established. Osvald Sirén (1905, p. 57) suggested that they once stood beneath the San Procolo *Annunciation* in the Accademia, Florence, since a later altarpiece of the Annunciation by Lorenzo Monaco, in the Bartolini Salimbeni Chapel in the church of Santa Trinita, Florence, contains the same four scenes in its predella. This proposal was rejected by Pope-Hennessy and Kanter (Pope-Hennessy 1987), who contended that the San Procolo *Annunciation* was too late in style and too large to

have accommodated this predella. They suggested instead as a possible provenance the only altarpiece known to have been painted by Lorenzo Monaco close in time to the predella, the Monteoliveto altarpiece, which is also in the Accademia and was commissioned in 1406 and completed in 1410. Marvin Eisenberg concurred in dating the Lehman/Courtauld/Altenburg predella between 1406 and 1410 and in rejecting the San Procolo *Annunciation* as stylistically unrelated, but he pointed out that the Monteoliveto altarpiece was also inappropriately large and, citing the vague evidence of Andrea di Giusto's partial copy of it, that it may never have been completed by a predella.

The narrative sequence of the four scenes of the Lehman/Courtauld/Altenburg predella presupposes their inclusion in an altarpiece that also portrayed the Annunciation, the Circumcision, or another scene from the infancy of Christ, either in its main panel, as a missing fifth predella scene, or in pinnacle panels. The likeliest candidate among Lorenzo Monaco's surviving works is

the San Procolo *Annunciation*, as Sirén originally suggested. Though the painting is dated by most recent scholars to the last decade or so of Lorenzo Monaco's career, there is no reason to doubt its identification with the altarpiece of the Annunciation once in the Benedictine church of San Procolo, Florence, which is described by Bocchi (1677) and Follini and Rastrelli (1789–1802, vol. 5, p. 142); it had an inscription with the date 1409. The figure types and attitudes in this altarpiece are, as has often been noted, closely related to those in the London *Coronation of the Virgin* altarpiece of 1407 (fig. 100) and are all but indistinguishable from those in the Monteoliveto altarpiece of 1410 as well, from which it differs almost exclusively in the absence of the Gothic arcading and acanthus crockets that once lined its arches and of the spiral colonnettes that divided its central and lateral panels. Eisenberg's objection (1989, p. 104) that the Saint Proculus portrayed in the right wing of the *Annunciation* altarpiece is not the same as the titular saint of the church is insufficient reason to reject this identification. Both Saints Proculus, one an elderly bishop and the other a youthful martyr knight, share a single feast day (June 1), and both are believed to be buried in the same tomb at the Benedictine monastery of Saint Proculus in Bologna (Richa 1754–62, vol. 1, p. 234). The coincidence of an altarpiece of the Annunciation containing a figure of either Saint Proculus—both of whom are extremely rare in Florentine hagiography—datable on stylistic grounds to accord with the date reported in an inscription, is too important to be dismissed, and the enormity of the coincidence is further magnified by the fact that the Annunciation altarpiece was brought to the Accademia from the Badia in Florence, where several other paintings and sculptures known to have come originally from San Procolo were found (Paatz and Paatz 1940–54, vol. 4, p. 694).

Having reestablished the chronological proximity of the San Procolo *Annunciation* and the Lehman/Courtauld/Altenburg predella, it remains to address the disparity in their sizes. Previous reconstructions of the predella have failed to take fully into account the losses each panel has suffered, both by trimming in height and by more radical truncation in width. Completing the lost angles of the quatrefoil frame and its *pastiglia* surround for each panel results in a total width for each of about 19 to 19 ³/₄ inches (48.3–50.2 cm), or a combined length of approximately 78 ³/₄ inches (200 cm) for the entire predella, not allowing for the presence of any decorative *pastiglia* devices between the four scenes or for the intrusion of pilaster bases into the predella. Such a length is anything but incompatible with the overall width of the San Procolo *Annunciation*, 91 inches (231 cm), the struc-

Figure 108. Lorenzo Monaco, *The Visitation*. Courtauld Institute Galleries, London (32)

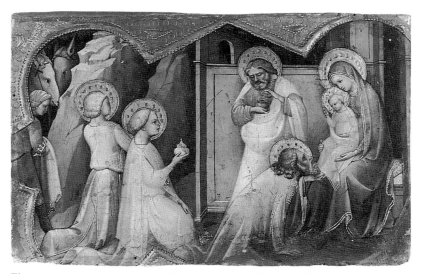

Figure 109. Lorenzo Monaco, *The Adoration of the Magi*. Courtauld Institute Galleries, London (32)

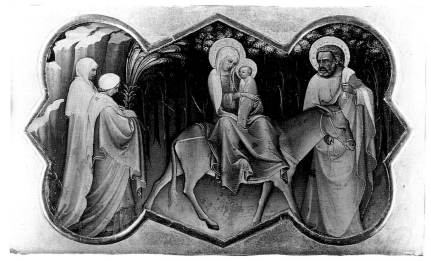

Figure 110. Lorenzo Monaco, *The Flight into Egypt*. Lindenau-Museum, Altenburg (90)

ture of which also implies a predella of four scenes only: two beneath the exceptionally wide (40 1/8 in. [102 cm]) central panel and one each beneath the narrower (25 3/8 in. [64.5 cm]) laterals. In the absence of specific evidence to the contrary, identifying the Lehman/Courtauld/Altenburg predella as part of the San Procolo *Annunciation* altarpiece of 1409 seems an inevitable conclusion.

LK

EX COLL.: M. Lauriani, Rome; James Dennistoun (until 1855); the Reverend Walter Davenport Bromley, Capesthorne Hall (until 1863); Richard von Kaufmann, Berlin (until 1917); Frank Channing Smith, Jr., Worcester, Mass. (from 1921); Robert Lehman, New York (from 1934).

LITERATURE: Frizzoni 1902, pp. 290, 292; Sirén 1905, p. 57; Berenson 1909, p. 152; Friedländer 1917, no. 5; van Marle 1923–38, vol. 9 (1927), pp. 166–68; Suida 1929, p. 392; Venturi 1931, pl. 143; Berenson 1932a, p. 301; Sandberg Vavalà 1937–38, pp. 34–38; Pudelko 1938–39, p. 77; Paris 1957, pp. 22–23; Berenson 1963, vol. I, p. 120; Boskovits 1975, p. 350; Szabo 1975, p. 27; Hibbard 1980, p. 228; Christiansen 1983, pp. 4–5; Pope-Hennessy 1987, pp. 170–72; Eisenberg 1989, pp. 19, 20, 43, 79, 88, 104, 138, 140, 153–54; Kanter 1993, p. 633.

34b. The Prophet Isaiah

Tempera on panel
Diam.: 7 5/8 in. (19.5 cm)

Richard L. Feigen, New York

The white-bearded prophet is shown bust-length, wrapped in a blue cloak and blue turban; his head is turned three-quarters to the left but his eyes are cast back toward the right. He points with his right hand, which is cropped at the bottom edge of the roundel, toward a scroll presumably held in his left hand, which is not shown. The scroll is lettered: ECCE VI[R]GO CO[N]CIP[IET ET PARIET FILIUM] (Behold, a virgin shall conceive, and bear a son [Is 7:14]), identifying the figure as Isaiah.

Isaiah is one of the four so-called greater prophets of the Old Testament, along with Jeremiah, Ezekiel, and Daniel. His image and the text of his prophecy of the virgin birth are frequently included in scenes of the Annunciation, often paired with an image of Ezekiel and the inscription PORTA HAEC CLAUSA ERIT; NON APERIETUR . . . (This gate shall be shut, it shall not be

opened [Ez 44:2]), referring again to Mary's virginity. The Feigen Isaiah, until recently known only on the basis of a lithographic reproduction in the catalogue of Alexis-François Artaud de Montor's collection (1843), was first identified as part of Lorenzo Monaco's *Annunciation* altarpiece from San Procolo by Marvin Eisenberg (1956), who proposed that it originally occupied the right gable of the altarpiece. Whether it filled the left or right gable (the torsion of the prophet's posture and the direction of his gaze would be equally appropriate in either position), it was undoubtedly paired with a roundel of the prophet Ezekiel in the remaining lateral gable.

For most of the altarpiece's modern history, the spandrels above the lateral panels of the San Procolo *Annunciation* have been reconstructed with roundels of angels by Bernardo Daddi that were removed from the San Pancrazio altarpiece in the Uffizi. These spandrels are entirely modern, however, the original panels having been truncated immediately above the level of the saints' halos. Presumably the restorations were designed to imitate the form of the gable above the central panel, which is preserved intact with a roundel showing God the Father looking down upon the scene of the Annunciation below. There is, therefore, no hard evidence that the lateral panels of this altarpiece ever contained painted roundels, though Eisenberg's reconstruction seems correct for both iconographic and stylistic reasons. Georg Pudelko's (1938–39, p. 248, n. 33) suggestion that the Isaiah came instead from the *Coronation of the Virgin* altarpiece of 1407 (fig. 100) could perhaps also be defended on iconographic grounds; however, the roundel's origin in the San Procolo *Annunciation* is implied by the closer relationship of the prophet's head to that of Saint Joseph in the Lehman *Nativity* (part of the probable predella to the San Procolo altarpiece) than to that of any figure in the London *Coronation of the Virgin* altarpiece.

LK

EX COLL.: Alexis-François Artaud de Montor (by 1843; until 1851).

LITERATURE: Artaud de Montor 1843, no. 51; Schmarsow 1898, p. 502; Sirén 1905, p. 44; Pudelko 1938–39, p. 248; Eisenberg 1956, pp. 333–35; Previtali 1964, pp. 231–32; Boskovits 1975, p. 352; Eisenberg 1989, pp. 103–4, 149–50.

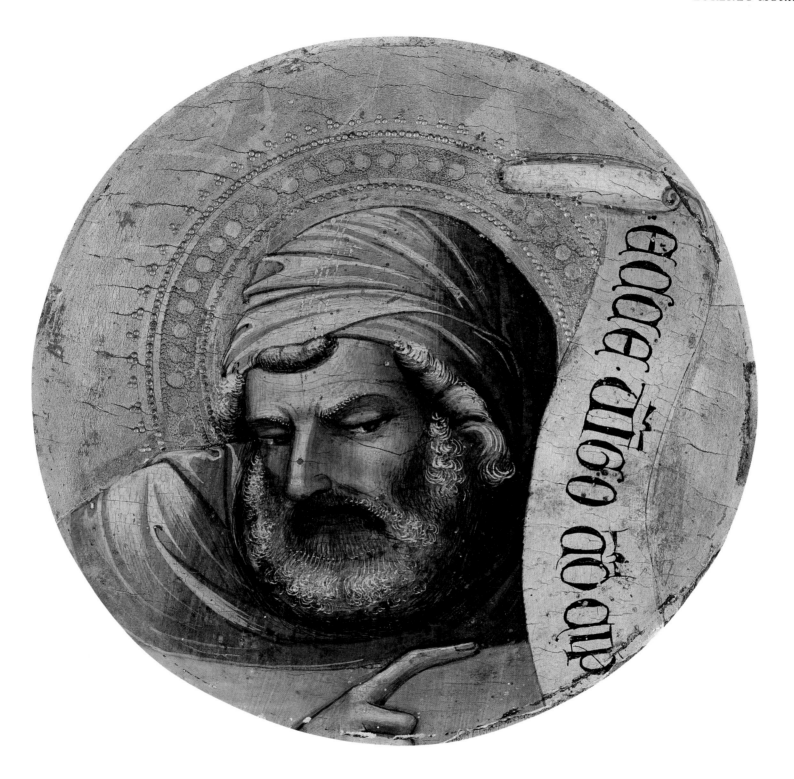

35. The Temptation of Christ

Ink on parchment
4 3/4 × 8 5/8 in. (12 × 21.9 cm)

Musée du Louvre, Paris; Département des Arts Graphiques
(R.F. 28970)

The drawing illustrates the third temptation of Christ
after he fasted forty days in the wilderness:

> Again the devil took him up into a very high
> mountain, and shewed him all the kingdoms of the
> world, and the glory of them, And said to him: All
> these will I give thee, if falling down thou wilt adore
> me. Then Jesus saith to him: Begone, Satan: for it
> is written, *The Lord thy God shalt thou adore, and*
> *him only shall thou serve.* Then the devil left him;
> and behold angels came and ministered to him.
> (Mt 4:8–11)

To the left of center in a mountainous landscape stands
the figure of Christ, full-length, turned three-quarters to
the right, with his right hand raised in command. Satan,
shown as a demon with bat wings, claw feet, and horns,
flees before him at the right. Behind Christ at the left
hover four attendant angels.

The Louvre drawing of the *Temptation of Christ* was
originally prepared for a *bas-de-page* illumination on folio
118r of Cod. Cor. 18 at the Biblioteca Laurenziana,
Florence. The page contains the introit to the Mass for
the first Sunday in Lent: "Invocabit me, et ego exaudiam
eum" (He shall call upon me, and I will answer him). As
with all but one of the introits in Cod. Cor. 18, space for
the initial letter on folio 118r is left blank; in this case the
I was planned to be at least three musical staves and lines
of text tall (11 in. [28 cm]) and approximately 3 1/8 inches
(8 cm) in width. The bottom of the folio has been cut
out on a slight diagonal immediately below the last line
of text. The missing fragment, 5 1/2 to 6 1/4 inches (14–
16 cm) tall and up to 19 1/4 inches (49 cm) wide, could
easily have accommodated the Louvre drawing, which
measures 4 3/4 × 8 5/8 inches (12 × 21.9 cm) and illustrates
the Gospel lesson for the first Sunday in Lent.

Cod. Cor. 18 is the first part of a four-volume tem-
porale from Santa Maria degli Angeli extending from
Advent through the second week of Lent. A colophon on
folio 140v records the completion of the book in 1410,
obviously referring to the text and pen-work initials only,
since spaces for all but one of the painted initials are
left blank. The one exception is an initial L ("Lux
fulgebit hodie super nos" [A light shall shine upon us

this day]) on folio 52r, beginning the introit to the Mass
at dawn on Christmas Day. This initial, which measures
$7^{1}/_{2} \times 6^{7}/_{8}$ inches (19.2 × 17.5 cm), is fully painted and gilt
in a style closely related to the simpler initials in Cod.
Cor. 3 (also at the Biblioteca Laurenziana, the third part
of the temporale from Santa Maria degli Angeli), except
that its center is left blank in preparation for a figurated
scene, possibly an Annunciation to the Shepherds. An
initial H ("Hodie scietis quia veniet Dominus" [This day
you shall know that the Lord will come]), beginning the
introit to the Mass for the Christmas Vigil, is faintly
sketched in ink in the space reserved for it on its page,
though without any indications of foliate decoration or
of a painted scene intended for its center.

In addition to the Louvre drawing of the *Temptation of
Christ* cut from the *bas-de-page* of folio 118r, two full
pages have been removed from Cod. Cor. 18 and may be
presumed to have been either illuminated or prepared for
illumination. The first of these is folio 1, which on the
model of the other volumes of the choir books from
Santa Maria degli Angeli would have contained an incipit
on its recto describing the contents of the book. The ver-
so of the page contained a large initial A and the first
line of the introit to the Mass for the first Sunday in
Advent: "Ad te levavi" (I lift up unto thee). The con-
tinuation of this text, " . . . animam meam deus meus"
(. . . my soul, O Lord), appears at the top of folio 2r.
A fragment of this page is to be identified with a draw-
ing on parchment in the British Museum (acc. no.
1860-6-16-42; fig. 111) representing the Annunciation in an
initial A—standard iconography for the first Sunday in
Advent (see O'Brien 1992). The drawing, which measures
$15^{5}/_{8} \times 12^{3}/_{4}$ inches (39.8 × 32.5 cm), corresponds to the jus-
tification of a page from Cod. Cor. 18, $19^{1}/_{4} \times 12^{3}/_{8}$ inches
(49 × 31.5 cm), minus room for a single stave of music and
line of text excised at the bottom. Its ruled border with
quatrefoil medallions at the corners and centers relates it
to comparably large initials from Cod. Cor. 3 from Santa
Maria degli Angeli (see cat. no. 37), which must have
been designed almost simultaneously with Cod. Cor. 18.
Sometimes ascribed to Mariotto di Nardo (Pouncey
1946), the British Museum drawing was perceptively re-
lated to the Louvre *Temptation of Christ* by Bernhard
Degenhart and Annegrit Schmitt (1968, no. 159), who,
however, did not accept the correct attribution of the
sheets to Lorenzo Monaco first proposed by Hans
Gronau (in Paris 1952).

The second missing page from Cod. Cor. 18, folio 56,
occurred in the same quire as the one painted initial in
the book (fol. 52), and like that initial it was left painted
and gilt by Lorenzo Monaco but with its figurated center
blank. A fragment of this page is to be identified with an

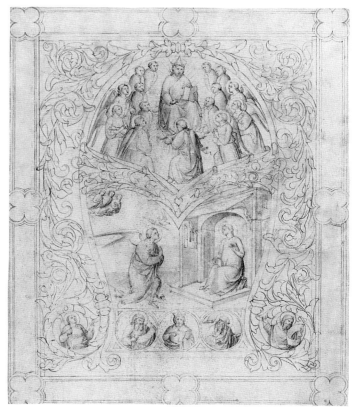

Figure 111. Lorenzo Monaco, The Annunciation in an Initial A.
British Museum, London (1860-6-16-42)

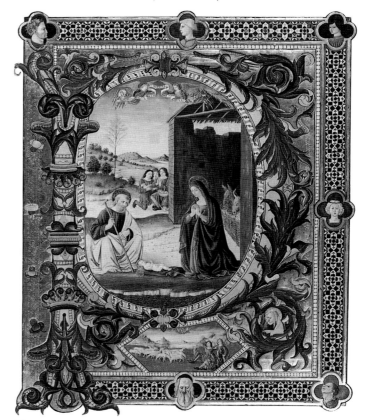

Figure 112. Workshop of Lorenzo Monaco and Attavante, The
Nativity in an initial P. British Library, London (Add.
MS 35,254 G)

initial P with the Nativity in the British Library (Add. MS 35,254 G; fig. 112), illustrating the introit to the third Mass for Christmas Day: "Puer natus est" (A child is born). The continuation of this text, " . . . nobis et filius datus est nobis" (. . . unto us and unto us a son is given), appears at the top of folio 57r in Cod. Cor. 18. The initial letter P with its foliate decoration and painted mosaic surround in this cutting were clearly painted in Lorenzo Monaco's studio at the same time as the large initials in Cod. Cor. 3, though the heads in the border medallions were apparently inserted later. The size of the cutting, 16 × 12 5/8 inches (40.5 × 32 cm), which is virtually identical to that of the British Museum Annunciation, corresponds to the justification of a page from Cod. Cor. 18, minus room for one stave of music and line of text at the bottom. The punch tools used to decorate its gold ground are the same as those used in the painted initial L on folio 52 of Cod. Cor. 18. The scene of the Nativity, however, is not attributable even in design to Lorenzo Monaco or any member of his studio, but to an artist of a significantly later generation, Attavante di Gabriello degli Attavanti (1452–1520/25). In 1505 and 1506 Attavante was paid for work on the graduals for Santa Maria degli Angeli (Levi D'Ancona 1958b, p. 181 n. 26), and all the painted initials in Cod. Cor. 4, the fourth volume of the temporale, are due to him. Like Cod. Cor. 18, Cod. Cor. 4 is dated 1410 in a colophon (fol. 8v). Both books must have been left at that time without painted initials, however, which were then supplied—in the one case entirely and in the other case only in part—nearly a century later.

LK

EX COLL.: Samuel Woodburn, London (Lugt 2584); A. Grahl (Lugt 1199); Walter Gay, Paris.

LITERATURE: Grahl sale 1885, lot 298; Paris 1952, no. 36; Degenhart and Schmitt 1968, no. 160; Boskovits 1975, p. 351; Florence 1978, p. xvii; Eisenberg 1989, pp. 186, 201.

36a. The Miracle of the Loaves and Fishes in an Initial L

Ink on parchment
12 7/16 × 9 1/8 in. (31.6 × 23.1 cm)

The Royal Museum of Fine Arts, Copenhagen; Department of Prints and Drawings (TU 3, 53)

The miracle of the loaves and fishes is based on the Gospel account of the feeding of the multitude, as found in John 6 : 3–13:

Jesus therefore went up into a mountain, and there he sat with his disciples. . . . When Jesus therefore had lifted up his eyes, and seen that a very great multitude cometh to him, he said to Philip: Whence shall we buy bread, that these may eat? And this he said to try him; for he himself knew what he would do. . . . One of his disciples, Andrew, the brother of Simon Peter, saith to him: There is a boy here that hath five barley loaves, and two fishes; but what are these among so many? Jesus then said: Make the men sit down. Now there was much grass in the place. The men therefore sat down, in number about five thousand. And Jesus took the loaves: and when he had given thanks, he distributed to them that were set down. In like manner also of the fishes, as much as they would. And when they were filled, he said to his disciples: Gather up the fragments that remain, lest they be lost. They gathered up therefore, and filled twelve baskets with the fragments of the five barley loaves, which remained over and above to them that had eaten.

Christ is seated at the top center of the composition with nine of his disciples, distinguished by their halos, standing around him. He gestures with his left hand toward a row of figures seated in the hilly landscape and inclines his head to speak with an elderly apostle, Andrew, who stands immediately to his right. Andrew indicates a young boy kneeling before Christ and holding a basket with five loaves of bread, which Christ blesses with his raised right hand. In the bottom half of the composition are a number of additional figures seated on the ground, some seen from behind and cropped by the arms of the initial letter framing the scene. Among them are the baskets, of which ten are visible, filled with the uneaten gleanings of bread. The initial is decorated with curling leaves of acanthus, a ring of disks at the left center, two delicately rendered flowers at the upper left, and two hanging pea pods at the lower left.

The Miracle of the Loaves and Fishes illustrates the Gospel lesson for the fourth Sunday in Lent, while the initial L begins the introit to the Mass for that feast: "Laetare, Jerusalem, et conventum facite, omnes qui diligitis eam" (Rejoice, O Jerusalem, and come together all you who love her). The conclusion of the offertory hymn and beginning of the Communion hymn from the Mass for the preceding Saturday appear on the verso of the sheet, continuing above the initial on the recto: "[Ut non dominetur mei omnis inj]ustitia [Domi]ne. Ne[mo te conde]mnavit, mu[lier? Nemo Domine. Nec ego te condemnabo,] iam amplius [noli peccare]" (And let no iniquity rule over me. Has no one condemned thee, woman? No one, Lord. Neither will I condemn them). A folio number xxx also appears on the verso of the sheet.

LK

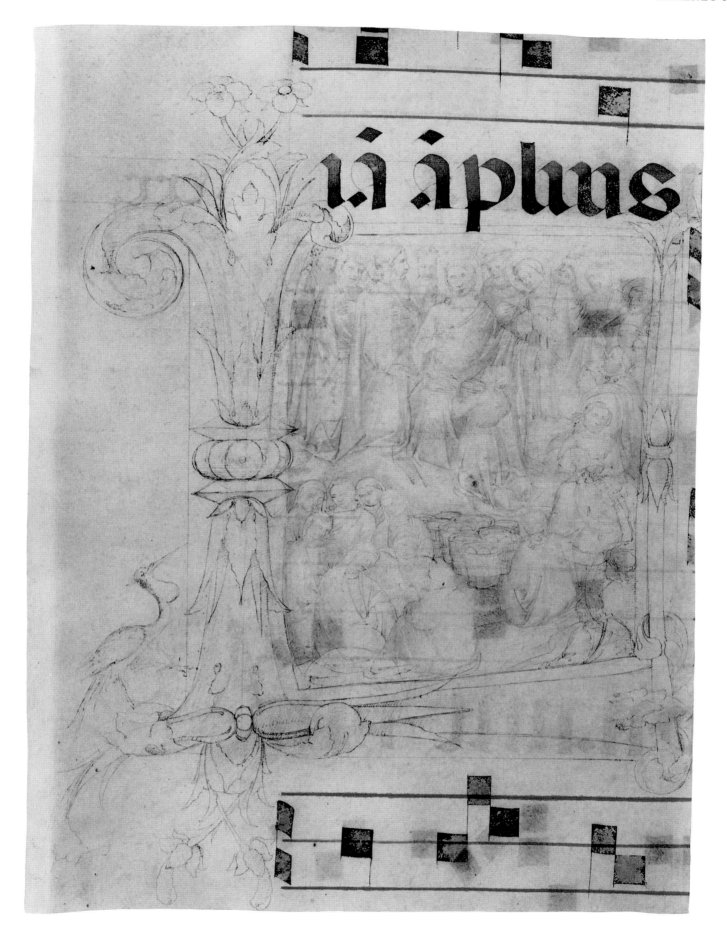

36b. The Entry into Jerusalem

Ink on parchment
12 1/4 × 16 3/4 in. (31 × 42.5 cm)

Biblioteca Apostolica Vaticana, Vatican City (Cod. Rossiano 1192.34)

The story of Christ's entry into Jerusalem is recounted in all four Gospels, but as it is portrayed here it most closely follows the text of Matthew (21:6–9):

And the disciples going, did as Jesus commanded them. And they brought the ass and the colt, and laid their garments upon them, and made him sit thereon. And a very great multitude spread their garments in the way: and others cut boughs from the trees, and strewed them in the way: And the multitudes that went before and that followed, cried, saying: *Hosanna to the Son of David: Blessed is he that cometh in the name of the Lord: Hosanna in the highest.*

In the lower center of the composition is Christ seated on a donkey with a foal walking alongside him, in fulfillment of the prophecy: *"Behold thy king cometh to thee, meek and sitting upon an ass, and a colt, the foal of her that is used to the yoke"* (Mt 21:5). Walking behind Christ are the Twelve Apostles, represented without halos, winding upward and back along the path to the right. Before Christ at the left is a crowd of children spreading cloaks and branches along the road and a line of older figures presumably shouting hosannas. One of the figures closest to Christ seems to be asking his companion, "Who is this?" to which he is answered, "This is Jesus the prophet, from Nazareth of Galilee" (Mt 21:10–11). The city of Jerusalem, surrounded by crenellated walls, is visible in the background at the upper left; it is identified by an inscription in a lunette over the gate: *yerusalem*. In the middle distance at the center are two young boys perched in trees, one of whom wrestles playfully with a third boy seated on the roof of a house.

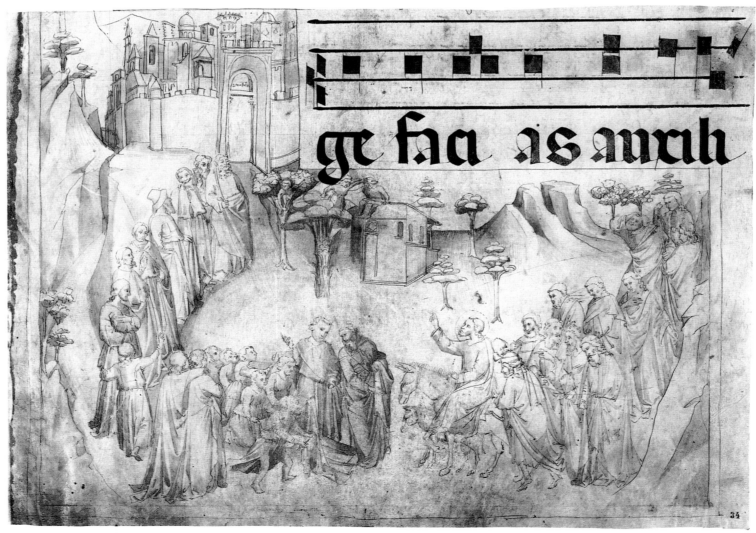

36b

Above the scene of the entry into Jerusalem, which is surrounded by an ink border drawn freehand, are a musical stave about 2 inches (5.2 cm) tall and a partial line of text from the introit to the Mass for Palm Sunday, the second Sunday of the Passion: "[Domine ne lon]ge facias auxili[um tuum a me]" (O Lord, be not far from me with your aid). The verso of the sheet is blank. The Entry into Jerusalem is the Gospel lesson for the Solemn Procession on Palm Sunday.

<div align="right">LK</div>

36c. Christ in the House of Mary and Martha

Ink on parchment
6 3/8 × 9 7/8 in. (16.2 × 25 cm)

Biblioteca Apostolica Vaticana, Vatican City (Cod. Rossiano 1192.37)

The story of Mary Magdalen anointing the feet of Christ is told in the Gospel of John (12:1–8):

> Jesus therefore, six days before the pasch, came to Bethania, where Lazarus had been dead, whom Jesus raised to life. And they made him a supper there: and Martha served: but Lazarus was one of them that were at table with him. Mary therefore took a pound of ointment of right spikenard, of great price, and anointed the feet of Jesus, and wiped his feet with her hair; and the house was filled with the odour of the ointment. Then one of his disciples, Judas Iscariot, he that was about to betray him, said: Why was not this ointment sold for three hundred pence, and given to the poor? . . . Jesus therefore said: Let her alone, that she may keep it against the day of my burial. For the poor you have always with you; but me you have not always.

The scene is composed in a loggia beneath a barrel-vaulted roof. A long trestle table is laid with a cloth and

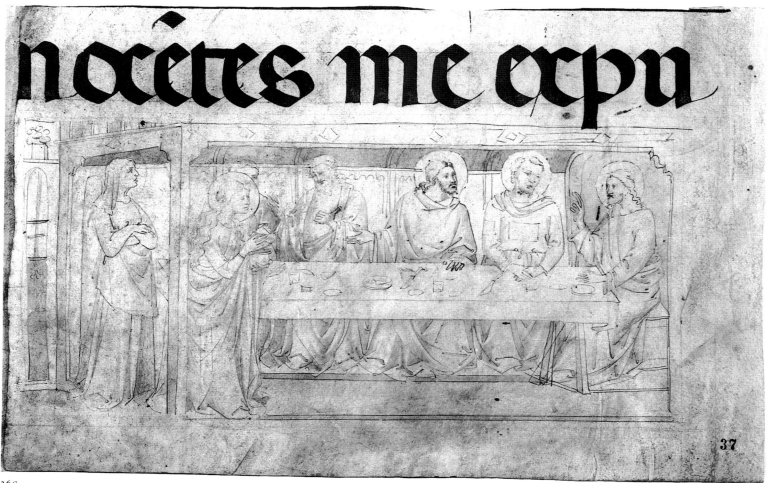

36c

set with dishes, glasses, and knives. Five men are seated around the table, three of them with halos: Christ at the far right, his hand raised in blessing, Lazarus next to him, and Judas Iscariot turned to question Christ. Mary Magdalen and Martha, both nimbed, appear in the doorway at the left, Martha standing with her arms folded before her and Mary Magdalen hurrying forward holding an ointment jar. The man seated behind the table next to Judas Iscariot, speaking to his neighbor but gesturing with his thumb toward Christ, may be meant to represent Simon the Pharisee, who, according to the Gospel of Luke (7:36–50), also questioned the propriety of Mary Magdalen's attentions. In the Gospels of Matthew (26:6) and Mark (14:3), the figure is identified as Simon the leper, in whose house at Bethany the supper was held.

The story of Christ at supper with the Magdalen bathing his feet is retold differently in each of the four Gospels. As it appears here, based on the text of John, it illustrates the Gospel lesson for Monday in Holy Week, and a fragment of the introit to the Mass for that feast appears above the scene: "[Judica, Domine,] nocentes me expu[gna impugnantes me]" (Fight, O Lord, against those who fight me). On the reverse of the sheet is a fragment of the Communion hymn concluding the Mass for Palm Sunday: "Pater si non p[otest hic calix transire, nisi bibam illum: fiat voluntas tua]" (Father, if this chalice cannot pass away unless I drink it, thy will be done).

LK

36d. Judas Receiving Thirty Pieces of Silver

Ink on parchment
6 × 14 1/4 in. (15.2 × 36.3 cm)

The Royal Museum of Fine Arts, Copenhagen; Department of Prints and Drawings (TU 3, 54)

The composition is divided into two scenes. At the right, in a plaza before an arcade of niches set on steps possibly meant to represent the temple in Jerusalem, a haloed figure extends his hand, while three older, bearded figures, one wearing a turban, drop a stream of coins into it. This scene has been interpreted as either the Betrayal of Judas (Degenhart and Schmitt 1968, no. 158) or, on the assumption that Judas would not have been portrayed with a halo, the Tribute Money (Gronau 1950, p. 222). The setting and the actions of the figures, however, indicate the story of Judas receiving thirty pieces of silver to betray Christ. Judas, as one of the Twelve Apostles, is not infrequently shown with a halo even in scenes of the Betrayal, as on Fra Angelico's silver chest from the church of the Santissima Annunziata, and it is certainly he who is shown, again with a halo, at the center of the table in the drawing of *Christ in the House of Mary and Martha* (cat. no. 36c).

The scene at the left is more difficult to interpret; it does not seem to have an identifiable scriptural basis. Within an open-fronted room, which is barrel-vaulted as is the room in the preceding drawing (cat. no. 36c), Christ and a Holy Woman are seated side by side on a

36d

bench. Christ raises his right hand in oration, while the woman places her left hand to her cheek in an attitude of careful listening. The subject of this scene was tentatively described as Christ in the House of Martha by Hans Gronau (1950, p. 222), referring to the episode in which Christ extolled the contemplative over the active life to the sisters Mary and Martha (Lk 10:38–42). Though the image could be intended as a visual summary of that story or at least of its moral, the story itself has no connection with the Betrayal of Judas, and Lorenzo Monaco's usual narrative inclination would require the presence in it of both sisters, not of Mary alone. Alternatively, Bernhard Degenhart and Annegrit Schmitt (1968, no. 158) proposed identifying the scene as Christ's farewell to his mother, though they too admit that it is unusual to find that subject paired with the Betrayal of Judas. Most likely it is not intended to be read as a separate scene but as part of the episode of Judas's betrayal. According to Matthew (26:1–16) and Mark (14:1–11), Judas sought out the chief priests directly after the supper at which he denounced Mary Magdalen for anointing the feet of Christ. The barrel-vaulted loggia, therefore, is probably meant to be the same as that in which the preceding scene (cat. no. 36c) was set, and the woman to whom Christ speaks is probably meant to represent the Magdalen.

The text visible above the drawing is a fragment of the introit to the Mass for Wednesday in Holy Week: "[In nomine Domini omne genuflectatur, celestium,] terrestrium et infer[norum]" (At the name of Jesus every knee should bend of those in heaven, on earth, and under the sun). A fragment of the conclusion of the introit is visible on the verso: "[Ideo dominus Jesus Christus in] gloria est Dei Pa[tris]" (Therefore our Lord Jesus Christ is in the glory of God the Father). The Gospel lesson for Wednesday in Holy Week, however, does not include the story of Judas's pact with the Pharisees.

LK

36e. The Last Supper

Ink on parchment
6 1/2 × 15 5/16 in. (16.5 × 38.9 cm)

Biblioteca Apostolica Vaticana, Vatican City (Cod. Rossiano 1192.35)

The Last Supper is here portrayed as it is described in the Gospel of John (13:21–26):

> When Jesus had said these things, he was troubled in spirit; and he testified, and said: Amen, amen, I say to you, one of you shall betray me. The disciples therefore looked one upon another, doubting of whom he spoke. Now there was leaning on Jesus' bosom one of his disciples, whom Jesus loved. Simon Peter therefore beckoned to him, and said to him: Who is it of whom he speaketh? He therefore, leaning on the breast of Jesus, saith to him: Lord, who is it? Jesus answered: He it is to whom I shall reach bread dipped. And

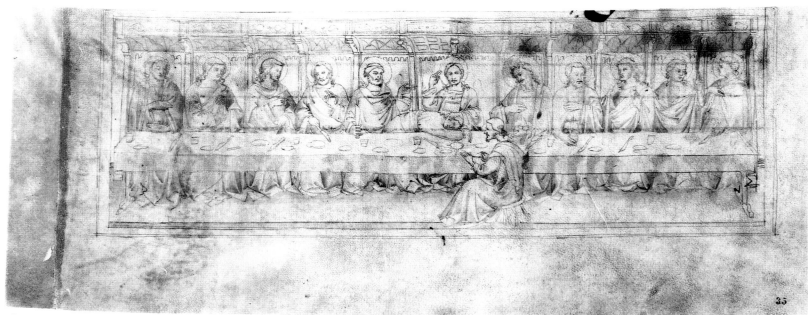

36e

when he had dipped the bread, he gave it to Judas Iscariot, *the son* of Simon.

The long, narrow composition is filled across its full width by an open arcade of twelve bays, in front of which is a long table laid with a cloth and set with dishes, glasses, and knives. Behind the table are seated Christ and eleven apostles. Ten of the apostles are each silhouetted in a single bay of the arcade, five at either side of Christ. Christ is seated in the exact center of the arcade, his right hand raised in an attitude of blessing and his left hand lying on the head of Saint John the Evangelist, the disciple "whom Jesus loved," who leans over the table "on Jesus' bosom." Isolated on the near side of the table to the right of center, balancing the figure of Saint John to the left, is Judas Iscariot seated on a low stool. Neither Judas nor Saint John have halos. With a scowling expression on his face, Judas reaches with his left hand toward the sop of bread lying before him on the table, while the other disciples ask one another of whom Christ spoke. Saint Peter, seated beside Saint John the Evangelist, seems to address this question to Christ directly.

The Last Supper preserves no fragments of accompanying text except for the lowest curve of a letter g above the head of the fourth apostle from the right. There can be no doubt, however, that it was intended to illustrate the introit to the Mass for Maundy Thursday, commemorating the Last Supper, "Nos autem gloriari oportet in cruce Domini nostri Jesu Christi" (But it is fitting that we should glory in the cross of our Lord Jesus Christ). The reverse of the sheet contains a portion of the Communion hymn concluding the Mass for Wednesday in Holy Week: "[. . . tu exsur]gens misereberis Syon, [quia venit tempus miserendi ejus]" (. . . you will arise and have mercy on Sion, for it is time to pity her).

<div align="right">LK</div>

36f. Christ Washing the Feet of the Apostles in an Initial D

Ink on parchment
11 5/8 × 9 1/4 in. (29.6 × 23.5 cm)

The Royal Museum of Fine Arts, Copenhagen; Department of Prints and Drawings (TU 3, 52)

The story of Christ washing the disciples' feet is recounted in John 13:3–9 and is part of the Gospel lesson for Maundy Thursday:

Knowing that the Father had given him all things into his hands, and that he came from God, and goeth to God; He riseth from supper, and layeth aside his garments, and having taken a towel, girded himself. After that, he putteth water into a basin, and began to wash the feet of the disciples, and to wipe them with the towel wherewith he was girded. He cometh therefore to Simon Peter. And Peter saith to him: Lord, dost thou wash my feet? Jesus answered, and said to him: What I do thou knowest not now; but thou shalt know hereafter. Peter saith to him: Thou shalt never wash my feet. Jesus answered him: If I wash thee not, thou shalt have no part with me. Simon Peter saith to him: Lord, not only my feet, but also my hands and my head.

Within the oval picture field enframed by the initial D are visible two bays of the open arcade beneath which the preceding scene of the Last Supper was set (cat. no. 36e). At the bottom center Christ kneels, a towel thrown over his shoulder and a washbasin on the ground before him. He dries the foot of Saint Peter seated at the right, who gazes back toward him, raising his right hand to his head. The other eleven apostles, including Judas, are ranged in a circle behind and around Christ and Saint Peter; all of them have halos.

Although the Gospel of Saint John records the episode of Christ washing the feet of the disciples before that of Christ announcing the betrayal of Judas, the order of the two scenes as portrayed in the Vatican and Copenhagen drawings has been reversed. The initial D surrounding the Washing of the Feet in Copenhagen begins the Communion hymn at the conclusion of the Mass for Maundy Thursday: "D[ominus Jesus, postquam cenavit cum discipulis suis, lavit pedes eorum]" (The Lord Jesus, after he had eaten the supper with his disciples, washed his feet). Above the initial is the conclusion of the offertory hymn: "[Dextera Do]mini fe[cit vir]tutem, dex[tera Dom]ini exalta[vit me: non moriar, sed vivam, et narrabo] opera Do[mini]" (The right hand of the Lord has exercised power, the right hand of the Lord has lifted me up. I shall not die, but live, and shall declare the works of the Lord).

Though occasionally discussed together (Degenhart and Schmitt 1968, nos. 156–58, 161–63; Eisenberg 1989, p. 188), the six drawings in Copenhagen and the Vatican have previously been recognized, if tentatively, as fragments of a single codex only by Miklós Boskovits (1975, p. 353). That they were intended to be read in series is indicated by their absolute uniformity of handling and quality; by the repetition of elements of their architectural backgrounds in successive scenes, as between *Christ*

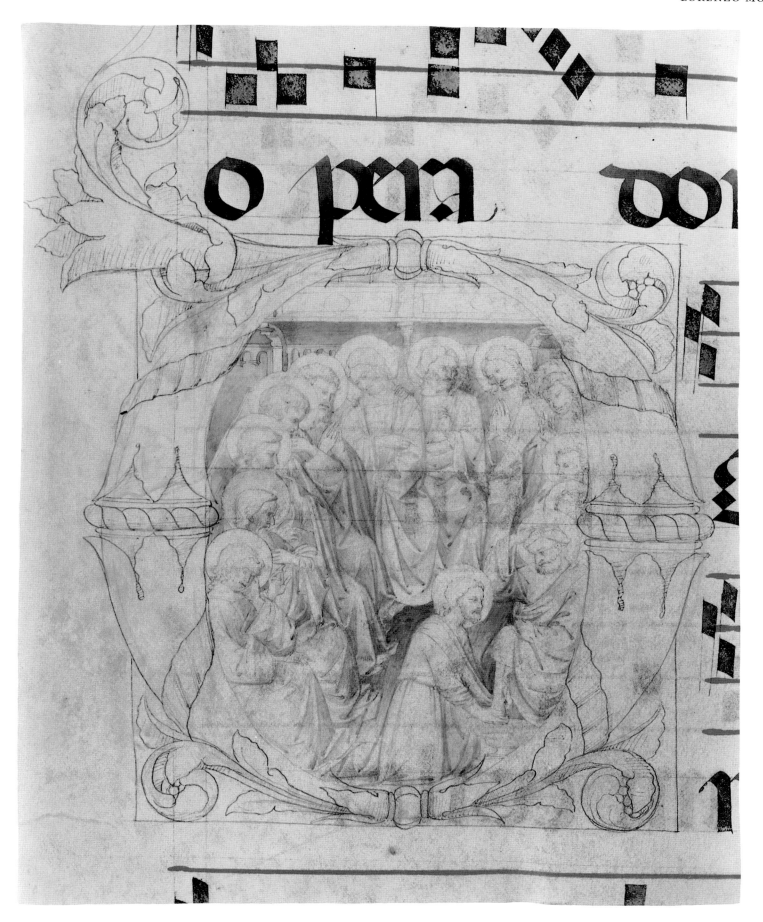

in the House of Mary and Martha and *Judas Receiving Thirty Pieces of Silver* or between *The Last Supper* and *Christ Washing the Feet*; and by the conformity of musical stave height and penmanship in their accompanying texts. All these texts derive from a concentrated period of time within the liturgical year—the fourth week in Lent and Holy Week. All of them, furthermore, are from a gradual and none of them repeat each other.

The period of liturgical time covered by these six drawings is exactly coincident with that of the missing second volume of the temporale from Santa Maria degli Angeli. Volume I of the series, Cod. Cor. 18 at the Biblioteca Laurenziana, Florence (cat. no. 35), includes feasts from the first Sunday in Advent through the second week of Lent,[1] while the third volume, Cod. Cor. 3, also at the Biblioteca Laurenziana (cat. no. 37), begins with Easter Sunday, omitting the last three weeks of Lent and Holy Week. The folio number XXX visible on the reverse of *The Miracle of the Loaves and Fishes* in Copenhagen, which illustrates the introit to the Mass for the fourth Sunday in Lent (none of the other drawings, most of which were prepared as *bas-de-pages*, retain their original numbering), would be consistent with its placement in a temporale volume beginning with the third week in Lent. The height of the musical staves in the three drawings in which they are preserved—*The Miracle of the Loaves and Fishes, The Entry into Jerusalem*, and *Christ Washing the Feet*—is exactly the same as that in the three surviving volumes of the series: 2 inches (5.2 cm). Finally, the often-noted resemblance of these six drawings to the two drawings in Paris and London (see cat. no. 35) that can be shown to have been removed from Cod. Cor. 18 should confirm their provenance from the same set of books.

Though apparently never finished, the missing volume 2 of the temporale from Santa Maria degli Angeli must have been intended to be as lavish or more so than its companion volumes (which were also all left unfinished), to judge from the size and complexity of the six drawings catalogued here and from the fact that two of them, *The Last Supper* and *Christ Washing the Feet*, were actually meant to illustrate different parts of the Mass for the same feast. Still unidentified are illuminations for the third Sunday in Lent, with which the book would have opened, Passion Sunday, Tuesday in Holy Week, Good Friday, and Holy Saturday. The last two feasts, like Maundy Thursday, may have been embellished with more than one image.

An attribution to Lorenzo Monaco for the three drawings in Copenhagen was advanced by Hans Gronau (1950) on the basis of similarities to the San Gaggio altarpiece, which probably dates to the early 1390s, an assessment seconded by Boskovits (1975) and Luciano Bellosi (1979) but dismissed by Bernhard Degenhart and Annegrit Schmitt (1968), who saw them, the Vatican drawings, and the two related drawings in Paris and London (cat. no. 35) as products of a number of different hands, one of whom might be Don Simone Camaldolese. For Marvin Eisenberg (1989, p. 186), all these drawings represent "a stylistic modality that is closely identifiable with the San Gaggio Altarpiece," although he finds an attribution directly to Lorenzo Monaco for any of them unpersuasive. Similarities to the San Gaggio altarpiece are, however, iconographic, not stylistic, and are limited to a repetition of the design for *The Last Supper* from the center panel of the predella (Gemäldegalerie, Berlin; inv. no. 1108). The eight drawings are far more sophisticated in their manipulation of space and rendering of architecture, more naturalistic in their figural proportions and attitudes, and looser in the flow of their draperies than are any of the panels from the San Gaggio predella. The two sets of works are indeed by the same artist, Lorenzo Monaco, but they were not conceived or executed close to each other in time.

The date on which the four volumes of the temporale for Santa Maria degli Angeli were commissioned is not recorded. Cod. Cor. 3 is dated 1409 in a colophon (fol. 3r), and Cod. Cor. 4 and 18 are dated 1410 in colophons (fols. 8v and 140v, respectively), but these dates refer to completion of the text and of the Lombard and filigree initials only. It is reasonable to assume that the missing second volume of the series was completed about the same time, perhaps as early as 1408 but not likely any later than 1411. There is no reason to suppose on the basis of style that any of the eight initials in Cod. Cor. 3 that were painted entirely by Lorenzo Monaco (see cat. no. 37) were executed much after 1409; certainly they were finished before the more developed initials in Cod. H 74 of 1413 (cat. no. 38). On circumstantial grounds alone it seems necessary to consider the drawings prepared for volumes 1 and 2 of the same series as products of the same years, and nothing about their compositions or figure style argues against such an assertion. A comparison of any of the drawings in Paris, London, Copenhagen, and the Vatican with any of the scenes from the predella of the San Procolo altarpiece of 1409 (cat. no. 34), or with the predella from the London *Coronation of the Virgin* altarpiece of 1407 (see cat. no. 32), reveals the same artistic intelligence at work. Whereas architectural details in the drawings actually relate more closely to the scenes from the predella of the 1414 *Coronation of the Virgin* altarpiece in the Uffizi (Eisenberg 1989, fig. 44), the figure style of that work is more pronouncedly angular and exaggerated.

Within the drawings the tendency for drapery folds to lie in heavy pleats on the ground rather than in looping and curling folds is the only immediately discernible difference between them and works by Lorenzo Monaco of about 1408–10. Apparently this distinctive affectation was conceived by Lorenzo Monaco as a decorative adjunct to his figures to be rendered in paint only, somewhat in the manner of his use of color, while his underlying designs were intended instead to establish the essential volume and structure of his figures. A beautiful pen drawing of *Saint Benedict Enthroned* in the Uffizi, which is close in handling to the Vatican drawing of *Christ in the House of Mary and Martha* but probably slightly later than it in date, is constructed in the same fashion, with the exaggerated swirls that would ultimately enliven the saint's draperies indicated as simple hooks at the end of a stroke. Lorenzo Monaco heightens the impression of a firm, structural basis for his figures by shading with a light wash in the Copenhagen and Vatican drawings as opposed to the rapid ink hatching in the Uffizi *Saint Benedict*, but this distinction is functional in nature: the choir book drawings were intended to be overlaid with partially transparent layers of pigment and are thus integral parts of a finished work of art, whereas the Uffizi drawing is a preliminary sketch or model for an entirely separate creation.

LK

1. Levi D'Ancona (1978, p. 234) inaccurately describes the contents of this book as extending through Lent, whereas in fact it extends into but not through Lent. It concludes on folio 172v with the Mass for Saturday before the third Sunday in Lent, followed by seven folios (173r–179r) of hymns and twenty-four folios (180r–203r) of kyries.

37. The Ascension in an Initial V

Tempera and gold on parchment, mounted on panel
15 7/8 × 12 7/8 in. (40.2 × 32.7 cm)

Bernard H. Breslauer, New York

The blue and pink initial V, decorated with a lining of gilt lozenges and with orange, blue, green, and pink foliage, is framed within a painted mosaic border punctuated by truncated quatrelobe medallions at the corners and centers, each containing a bust-length figure of a prophet. Within the initial is a rocky landscape with the Twelve Apostles kneeling in wonder as two angels point out to them the figure of Christ in glory on a bank

of clouds above their heads. Two palm trees, symbols of martyrdom, grow on hills in the distant background, and half-length angels appear among the tendrils of the foliate decoration at the corners of the initial, the two in the upper corners carrying olive branches and the two below adoring the risen Christ.

The initial V begins the introit to the Mass for the feast of the Ascension: "Viri Galilaei, quid admiramini aspicientes in caelum?" (Men of Galilee, why do you stand looking up to heaven?). It was identified by Marvin Eisenberg (1989, pp. 110–11) as the missing folio 59 from Cod. Cor. 3 at the Biblioteca Laurenziana, Florence, the third volume of a four-volume gradual from Santa Maria degli Angeli (see cat. nos. 35, 36). Mirella Levi D'Ancona (1978, p. 226) also identified a Procession of Children in an initial Q in the Woodner family collection (fig. 113) as one of the other two missing folios from Cod. Cor. 3 (fol. 31; a third missing illumination from folio 19 has not yet been identified). Both the Breslauer and Woodner initials share a number of similarities with the seventeen illuminations still in Cod. Cor. 3, such as their exuberant foliate decoration, the mosaic patterning in their frames, and the resemblance of their figure style to the early work of Fra Angelico.

Cod. Cor. 3, one of the most lavishly illuminated books of the fifteenth century and one of the most discussed, is dated 1409 in a colophon on folio 3r referring to the completion of the text and the Lombard and filigree initials only. It comprises seventeen historiated initials, in addition to the three that have been removed, as follows:

Folio 1v: The Resurrection in an initial R ("Resurexi et ad huc tecum sum" [I arose, and am still with you]), introit to the Mass for Easter Sunday.

Folio 6v: The Road to Emmaus in an initial I ("Introduxit vos Dominus in terram" [The Lord has brought you into a land]), introit to the Mass for Monday in the octave of Easter.

Folio 11r: The Apostles and a Vision of the Risen Christ in an initial A ("Aqua sapiente potavit eos" [He gave them the water of wisdom to drink]), introit to the Mass for Tuesday in the octave of Easter.

Folio 15r: Christ Summoning the Blessed in an initial V ("Venite benedicti patris mei" [Come, blessed of my father]), introit to the Mass for Wednesday in the octave of Easter.

[Folio 19]: V ("Victricem manum tuam, Domine, laudaverunt pariter" [They praised with one accord your victorious hand, O Lord]),¹ introit to the Mass for Thursday in the octave of Easter; the initial is missing and has not yet been identified.

Figure 113. Battista di Biagio Sanguigni (?), A Procession of Children in an initial Q. Woodner family collection

Folio 23v: Christ Appearing to the Apostles in an initial E ("Eduxit eos Dominus in spe" [The Lord led them on in hope]), introit to the Mass for Friday in the octave of Easter.

Folio 27v: Saints Peter, John the Evangelist, and Mary Magdalen at the Empty Tomb of Christ in an initial E ("Eduxit Dominus populum suum" [The Lord led forth his people]), introit to the Mass for Saturday in the octave of Easter.

[Folio 31]: A Procession of Children in an initial Q ("Quasi modo geniti infantes" [Crave, as newborn babes]), introit to the Mass for Low or Quasimodo Sunday (the octave of Easter); the initial is now in the Woodner family collection (fig. 113).

Folio 35r: A Patriarch Holding a City in an initial M ("Misericordia Domini plena est terra" [The earth is full of the mercy of the Lord]), introit to the Mass for the second Sunday after Easter.

Folio 38v: David in an initial I ("Iubilate Deo omnis terra" [Shout joyfully to God, all the earth]), introit to the Mass for the third Sunday after Easter.

Folio 41v: A Choir of Camaldolese Monks Chanting in an initial C ("Cantate Domini canticum novum" [Sing

to the Lord a new canticle]), introit to the Mass for the fourth Sunday after Easter.

Folio 46v: A Prophet in an initial V ("Vocem io-cunditatis annuntiate" [Declare it with the voice of joy]), introit to the Mass for the fifth Sunday after Easter.

Folio 57v: David and the Elders Dancing Around the Ark in an initial O ("Omnes gentes plaudite manibus" [Clap your hands, all you people]), introit to the Mass for the Vigil of the Ascension.

[Folio 59]: The Ascension in an initial V ("Viri Galilaei" [Men of Galilee]), introit to the Mass for the Ascension (cat. no. 37; see above).

Folio 65v: A Prophet in an initial E ("Exaudi Domine vocem meam" [Hear, O Lord, my voice]), introit to the Mass for Sunday within the octave of the Ascension.

Folio 80v: The Pentecost in an initial S ("Spiritus Domini replevit orbem terrarum" [The spirit of the Lord has filled the whole world]), introit to the Mass for the Pentecost.

Folio 86v: A Prophet in an initial C ("Cibavit eos ex adipe frumenti" [He fed them with the finest wheat]),

37

introit to the Mass for Monday in the octave of Pentecost.

Folio 89v: A Prophet in an initial A ("Accipite io-cunditatem gloriae vestrae" [Receive with joy the glory that is yours]), introit to the Mass for Tuesday in the octave of Pentecost.

Folio 93r: A Prophet in an initial D ("Deus dum egredereris coram populo tuo" [O God, when you went forth at the head of your people]), introit to the Mass for Ember Wednesday.

Folio 96v: A Prophet in an initial R ("Repleatur os meum laude tua" [Let my mouth be filled with your praise]), introit to the Mass for Ember Friday.

The eight initials (fols. 35r, 38v, 46v, 65v, 86v, 89v, 93r, 96v) showing half-length or three-quarter-length prophets are almost universally attributed to Lorenzo Monaco and are variously thought to have been executed about or shortly after 1409 (Ciaranfi 1932; Boskovits 1975; Eisenberg 1989) or at the very end of his career, about 1422–23 (Levi D'Ancona 1958b). One of the nine narrative illuminations, the initial E with Saints Peter, John the Evangelist, and Mary Magdalen at the empty tomb on folio 27v, is also sometimes attributed to Lorenzo Monaco (Boskovits 1975; Bellosi 1984), while the other eight narrative scenes are generally associated with the name of Fra Angelico. Among these, however, a distinction is frequently drawn between scenes plausibly designed by Lorenzo Monaco though executed later, such as the Resurrection on folio 1v or the Pentecost on folio 80v, and scenes that seem to betray the hand of a younger artist in their conception as well as handling.

There can be little doubt that the eight illuminated prophets are fully autograph works by Lorenzo Monaco, painted somewhat earlier than the related figures in Cod. H 74 at the Bargello, for which Don Lorenzo received payment in 1413 (cat. no. 38), and probably not long after the San Procolo altarpiece of 1409 (cat. no. 34) and the Monteoliveto altarpiece of 1410. It is also reasonably certain that Lorenzo Monaco was responsible for designing the full-page illuminations of the Resurrection and the Pentecost and that these designs were later simplified to produce the same scenes in Cod. H 74. Though the miniature of the Ascension of Christ is missing from Cod. H 74, it may be presumed that it too was devised as a simplification of Lorenzo Monaco's drawing underlying the Breslauer Ascension from Cod. Cor. 3. The organization of the scene is reminiscent of the composition of Don Lorenzo's *Agony in the Garden* of 1408 in the Louvre, as are the attenuated, swaying figure types and the swirling folds of drapery, though the heads and hands of all the figures are the invention of the

younger artist who ultimately painted the scene. The four angels in the corners of the initial, the eight prophets in medallions in the frame, and the foliate decoration of the letter, on the other hand, were designed and painted by an assistant of Lorenzo Monaco, who supplied similar details in the remaining illuminations in Cod. Cor. 3. This assistant may be identifiable with Lorenzo Monaco's sometime collaborator, Matteo Torelli (see cat. no. 38).

It is likely that the completion of the illuminations in Cod. Cor. 3, as with those in the concluding volume of the temporale—Cod. Cor. 4—was delayed for some time after the project was first abandoned, though the reasons for such a delay are not apparent and are difficult to surmise. The palette, the figure style, and the obsessive attention to naturalistic detail in the narrative scenes in Cod. Cor. 3 recall works by Fra Angelico in the 1420s more than they do Lorenzo Monaco at any stage of his career, and it may be that the death of Don Lorenzo in 1423 or 1424 occasioned the transfer of the commission to another studio.[2] This studio has sometimes been thought to have been that of Fra Angelico himself (Ciaranfi 1932; Salmi 1950; Orlandi 1964). While the quality of the illuminations in Cod. Cor. 3 is perhaps high enough to warrant such a contention, their approach to the organization of space and the depiction of the natural world is essentially different from Angelico's, and an attribution directly to the Dominican master was correctly disputed by John Pope-Hennessy (1952, p. 206) and Luciano Berti (1962–63, p. 34).

Among the many presumed followers of Fra Angelico, only Zanobi Strozzi is known to have practiced extensively as an illuminator, leading to the attribution to him of most illuminations painted vaguely in the style of Fra Angelico, including the Breslauer Ascension (Boskovits 1980). Strozzi, however, was an artist of a later generation and of much more modest talents than the illuminator of Cod. Cor. 3. Strozzi painted his own version of the Ascension, adapted from the composition of the Breslauer leaf, in one of the graduals for the cathedral in Florence, for which he was paid in 1463 (Biblioteca Laurenziana, MS Edili 149, fol. 80r). There the idiom of Lorenzo Monaco's design is translated into a conventional, mid-century Florentine compositional formula that is updated in its color scheme and command of spatial and atmospheric devices but devoid of the movement and expression that animates the original.

The only artist working in the 1420s in a style so closely allied to that of Fra Angelico and whose works show a fascination with naturalistic detail similar to that evidenced in Cod. Cor. 3 is the little-known Battista di Biagio Sanguigni (1393–1451). Roberto Longhi (1940 [1975], p. 49 n. 15) intuited an attribution to this artist

for Cod. Cor. 3, and this intuition is likely to be correct. Sanguigni's one firmly documented work, the antiphonary of San Gaggio in the Corsini collection in Florence, has been little accessible to scholars or the public, and critical assessment of it has been further complicated by confusion over the attribution of one of its miniatures to Zanobi Strozzi (Levi D'Ancona 1962).[3] Close examination of the antiphonary, the six illuminations in which have been brought to varying degrees of completion, allows for the attribution to the same hand of several other works that have been grouped under the names of either Angelico or Strozzi, including a full-page miniature of the Crucifixion in Santa Trinita, Florence; several predella panels now divided among museums in Antwerp, Chantilly, Houston, Philadelphia, and Zagreb (first identified by Carl Strehlke); a Journey of the Magi(?) in the Clark Art Institute, Williamstown; and possibly the predella to Angelico's San Niccolò altarpiece in Perugia, as well as the completion of Cod. Cor. 3 for Santa Maria degli Angeli.

The circumstances of Sanguigni's life as revealed in the numerous documents referring to him (Levi D'Ancona 1962) suggest that he may have been more important an artist than he is presently considered. Born in 1393, he entered the confraternity of San Niccolò al Carmine in 1415 and was named among its rectors in 1418. In 1417 he stood guarantor for the admission of Guido di Pietro, the future Fra Angelico, to the confraternity (Cohn 1955), and it has been suggested that he may have been Angelico's teacher, although the two artists were probably not much different in age. Sanguigni did act as a tutor to Zanobi Strozzi, and from at least 1435 he lived in Fiesole, next to Angelico's convent, in a house owned by Strozzi. Previously, from at least 1427 to 1433, Sanguigni rented a house or workshop from the "Frati degli Angeli," and in 1431 he is recorded as a debtor to Santa Maria degli Angeli for blue pigment provided to him by the monastery. It is tempting to believe that this transaction may have been directly related to the commission to finish the illuminations in Cod. Cor. 3 left incomplete years earlier by Lorenzo Monaco.

LK

1. This missing initial was incorrectly identified by Levi D'Ancona (1978, p. 225) with an I with Christ Blessing in the Fitzwilliam Museum, Cambridge (Marlay Cutting It 13ii), on the assumption that the missing folio 19 contained the introit to the Mass for Easter Monday. The Mass for Easter Monday, however, begins on folio 6v, and folio 18v concludes with the Communion hymn for Easter Wednesday.

2. In 1429 Ambrogio Traversari wrote to Leonardo Giustiniani in Venice, apologizing for the poor quality of the illuminations made for a book the latter had sent to Santa Maria degli Angeli to be decorated, and explained that "the monks who were best at that art have died, and the younger ones have not yet had time to perfect their craft" (Stinger 1978, p. 275).

3. Sanguigni received payment for the illuminations in this antiphonary in 1432. Fifteen years later, in 1447, Zanobi Strozzi was paid for adding a scene of Saint Catherine, and this scene was misidentified by Levi D'Ancona as that of the Mystic Marriage of Saint Catherine on folio 38r. The only miniature in this volume that differs appreciably in style from the others is the Beheading and Burial of Saint Catherine on folio 32v, and this in turn is close enough in its figure types, its decorative motifs, and the clumsiness of its composition to other works by Strozzi to merit an attribution to that master.

EX COLL.: Baron Hatvany.

LITERATURE: Boskovits 1980, p. 13; Eisenberg 1989, pp. 110–11; Voelkle and Wieck 1992, no. 74.

Cod. H 74 from Santa Maria Nuova

(Catalogue Number 38a, b)

By the terms of the testamentary gift that financed them, the great series of choir books begun in 1385 for Santa Maria degli Angeli was intended to be written and illuminated concurrently with a similar series for the nearby hospital church of Santa Maria Nuova. The task of writing the books for Santa Maria degli Angeli was concluded in 1409 and 1410 with the completion of four volumes of a temporale (see cat. nos. 35–37), joining another volume of the gradual, a sanctorale (see cat. no. 16), that had been written as early as 1370. Though not dated, the three corresponding volumes of the gradual written for Santa Maria Nuova (Museo Nazionale del Bargello, Florence; Cod. F 72, G 73, H 74) are likely to have been produced about the same time. The first of the three, Cod. F 72, contains the propers of the saints, from the feast of Saint Agatha on February 5 to the feast of Saint Clement on November 23 (feasts of December and January are included in Cod. G 73), the commons of the saints, and votive masses, corresponding in large part to the contents of Cod. Cor. 2 from Santa Maria degli Angeli (cat. no. 16). The remaining volumes form a two-part temporale covering the periods from the first Sunday in Advent through Holy Week (Cod. G 73)—the same period covered by Cod. Cor. 18 and a missing codex from Santa Maria degli Angeli (cat. nos. 35, 36)—and from Easter through the twenty-fourth Sunday after Pentecost (Cod. H 74), duplicating the contents of Cod.

Cor. 3 and 4 from Santa Maria degli Angeli (see cat. no. 37).

Cod. H 74 contains thirty-eight illuminated initials, all but one portraying single figures of prophets or saints (D'Ancona 1914, vol. 2, pp. 138–41, with correct pagination; the pagination adopted by Boskovits 1975, p. 345, and Eisenberg 1989, pp. 107–8, does not account for the seven folios missing from this book). The exception is the full-page opening illumination, on folio 3v, showing the Resurrection in an initial R, illustrating the introit to the Mass for Easter Sunday. In addition, at least two (Pentecost and Trinity Sunday) and perhaps three (the Ascension) of the seven missing folios contained large, perhaps full-page, narrative illuminations. The thirty-eight present and seven missing initials in this book comprise:

Folio 3v: The Resurrection in an initial R ("Resurrexi et ad huc tecum sum" [I arose and am still with you]), introit to the Mass for Easter Sunday (Frigerio 1988, fig. 156).

Folio 4v: A Prophet in an initial H ("Hec dies quam fecit Dominus esultemus" [This is the day the Lord has made; let us be glad]), gradual hymn from the Mass for Easter Sunday.

Folio 8v: A Prophet in an initial I ("Introduxit vos Dominus in terram fluentem lac et mel" [The Lord has brought you into a land flowing with milk and honey]), introit to the Mass for Monday in the octave of Easter.

Folio 11r: A Prophet in an initial A ("Aqua sapientiae potavit eos" [He gave them the water of wisdom to drink]), introit to the Mass for Tuesday in the octave of Easter (D'Ancona 1914, vol. 1, pl. L).

[Folio 13v]: V ("Venite, benedicti Patris mei" [Come, blessed of my father]), introit to the Mass for Wednesday in the octave of Easter; the initial is missing and its subject is unknown.

Folio 16r: A Prophet in an initial V ("Victricem manum tuam, Domine, laudaverunt pariter" [They praised with one accord your victorious hand, O Lord]), introit to the Mass for Thursday in the octave of Easter (D'Ancona 1914, vol. 1, pl. XLIX).

Folio 19r: A Prophet in an initial E ("Eduxit eos Dominus in spe" [The Lord led them on in hope]), introit to the Mass for Friday in the octave of Easter.

Folio 22r: A Prophet in an initial E ("Eduxit Dominus populum suum" [The Lord led forth his people]), introit to the Mass for Saturday in the octave of Easter.

Folio 24r: Saint Peter in an initial Q ("Quasi modo geniti infantes" [Crave, as newborn babes]), introit to the Mass for Low or Quasimodo Sunday (the octave of Easter).

Folio 26r: A Prophet in an initial M ("Misericordia Domini plena est terra" [The earth is full of the mercy of the Lord]), introit to the Mass for the second Sunday after Easter.

Folio 28v: King David in an initial I ("Iubilate deo omnis terra" [Shout joyfully to God, all the earth]), introit to the Mass for the third Sunday after Easter.

Folio 31r: A Prophet in an initial C ("Cantate Domini canticum novum" [Sing to the Lord a new canticle]), introit to the Mass for the fourth Sunday after Easter.

Folio 34r: A Prophet in an initial V ("Vocem iocunditatis annuntiate et audiatur" [Declare it with the voice of joy and let it be heard]), introit to the Mass for the fifth Sunday after Easter.

[Folio 40r]: V ("Viri Galilei quid admiramini aspicientes in caelum" [Men of Galilee, why do you stand looking up to heaven?]), introit to the Mass for the Ascension; the initial is missing but may be presumed to have represented the Ascension of Christ.

[Folio 43r]: A Prophet in an initial E ("Exaudi Domine, vocem meam, qua clamavi ad te" [Hear, O Lord, my voice as I cry to you]), introit to the Mass for Sunday within the octave of the Ascension; the initial is now in the National Gallery of Art, Washington, D.C. (cat. no. 38a).

[Folio 60v]: The Pentecost in an initial S ("Spiritus Domine replevit orbem terrarum" [The spirit of the Lord has filled the whole world]), introit to the Mass for Pentecost; the initial is now in the Detroit Institute of Arts (fig. 114).

Folio 67r: A Prophet in an initial C ("Cibavit eos ex adipe frumenti" [He fed them with the finest wheat]), introit to the Mass for Monday in the octave of Pentecost.

Folio 71r: A Prophet in an initial A ("Accipite iocunditatem glorie vestre" [Receive with joy the glory that is yours]), introit to the Mass for Tuesday in the octave of Pentecost (Frigerio 1988, fig. 157).

Folio 72v: A Prophet in an initial D ("Deus, dum egredereris coram populo tuo" [O God, when you went forth at the head of your people]), introit to the Mass for Ember Wednesday (Sirén 1905, pl. XXVII).

Folio 74v: A Prophet in an initial R ("Repleatur os meum laude tua" [Let my mouth be filled with your praise]), introit to the Mass for Ember Friday.

Folio 76v: A Prophet[1] in an initial K ("Karitas Dei diffusa est in cordibus vestris" [The charity of God is poured forth in our hearts]), introit to the Mass for Ember Saturday.

[Folio 81v]: The Trinity in an initial B ("Benedicta sit

Figure 114. Matteo Torelli, *The Pentecost* in an initial S. Detroit Institute of Arts; Gift of Dr. William R. Valentiner (37.133)

sancta Trinitas atque indivisa Unitas" [Blessed be the Holy Trinity and undivided Unity]), introit to the Mass for Trinity Sunday; the initial is now in the Wildenstein Collection at the Musée Marmottan, Paris (fig. 115).

Folio 84v: A Prophet in an initial D ("Domine in tua misericordia speravi" [O Lord, I have trusted in your mercy]), introit to the Mass for the first Sunday after Pentecost (Sirén 1905, pl. XXVII).

[Folio 87v]: C ("Cibavit eos ex adipe frumenti" [He fed them with the finest wheat]), introit to the Mass for Corpus Domini; the initial is missing and its subject is likely to have been the Last Supper or the Celebration of the Eucharist.

Folio 96r: A Prophet in an initial F ("Factus est Dominus protector" [The Lord came to my protection]), introit to the Mass for the second Sunday after Pentecost.

Folio 98v: A Prophet in an initial R ("Respice in me et miserere mei Domine" [Look upon me, O Lord, and have pity on me]), introit to the Mass for the third Sunday after Pentecost.

Folio 101v: A Prophet in an initial D ("Dominus illuminatio mea" [The Lord is my light]), introit to the Mass for the fourth Sunday after Pentecost.

Figure 115. Lorenzo Monaco, The Trinity in an initial B. Musée Marmottan, Paris; Wildenstein Collection

Folio 104v: A Prophet in an initial E ("Exaudi Domine vocem meam" [Hear, O Lord, my voice]), introit to the Mass for the fifth Sunday after Pentecost.

Folio 107v: A Prophet in an initial D ("Dominus fortitudo plebis sue" [The Lord is the strength of his people]), introit to the Mass for the sixth Sunday after Pentecost.

Folio 110v: A Prophet in an initial O ("Omnes gentes plaudite manibus" [Clap your hands, all you people]), introit to the Mass for the seventh Sunday after Pentecost.

Folio 113v: A Prophet in an initial S ("Suscepimus Deus misericordiam tuam" [We have received your kindness, O God]), introit to the Mass for the eighth Sunday after Pentecost.

Folio 116r: A Prophet in an initial E ("Ecce Deus adiuvat me" [Behold, God is my helper]), introit to the Mass for the ninth Sunday after Pentecost.

Folio 119r: A Prophet in an initial D ("Dum clamarem ad Dominum" [When I called upon the Lord]), introit to the Mass for the tenth Sunday after Pentecost.

[Folio 122v]: A Prophet in an initial D ("Deus in loco sancto suo" [God is in his holy place]), introit to the Mass for the eleventh Sunday after Pentecost; the initial is now in the Cleveland Museum of Art (cat. no. 38b).

Folio 125v: A Prophet in an initial D ("Deus in adiutorium meum" [O God, come to my assistance]), introit to the Mass for the twelfth Sunday after Pentecost.

Folio 129v: A Prophet in an initial R ("Respice Domine in testamentum tuum" [Advert to your covenant, O Lord]), introit to the Mass for the thirteenth Sunday after Pentecost (D'Ancona 1914, vol. 1, pl. L).

Folio 132v: A Prophet in an initial P ("Protector noster aspice Deus" [O God, our protector, look]), introit to the Mass for the fourteenth Sunday after Pentecost.

Folio 135r: A Prophet in an initial I ("Inclina Domine aurem tuam" [Incline your ear, O Lord]), introit to the Mass for the fifteenth Sunday after Pentecost.

Folio 138r: A Prophet in an initial M ("Miserere michi Domine" [Have pity on me, Lord]), introit to the Mass for the sixteenth Sunday after Pentecost (Levi D'Ancona 1958b, fig. 10).

Folio 141r: A Prophet in an initial I ("Iustus es Domine et rectum judicium tuum" [You are just, O Lord, and your judgment is right]), introit to the Mass for the seventeenth Sunday after Pentecost.

Folio 157v: A Prophet in an initial S ("Salus populi ego sum" [I am the salvation of the people]), introit to the Mass for the nineteenth Sunday after Pentecost.[2]

Folio 160v: A Prophet in an initial O ("Omnia que fecisti nobis Domine" [All that you have done to us, O Lord]), introit to the Mass for the twentieth Sunday after Pentecost.

Folio 163v: A Prophet in an initial I ("In voluntate tua Domine" [All things depend on your will, O Lord]), introit to the Mass for the twenty-first Sunday after Pentecost.

Folio 167r: A Prophet in an initial S ("Si iniquitates observaveris Domine" [If you, O Lord, shall mark my iniquities]), introit to the Mass for the twenty-second Sunday after Pentecost.

Folio 170r: A Prophet in an initial D ("Dicit Dominus ego cogito cogitationes pacis" [Said the Lord: "I think thoughts of peace"]), introit to the Mass for the twenty-third Sunday after Pentecost.

In addition, a fragmentary *bas-de-page* preserved in the Gabinetto Disegni e Stampe at the Uffizi, Florence (fig. 116), was undoubtedly cut from one of the missing pages of this manuscript. Based on the analogy of the nearly identical format of folio 3v with the Resurrection, it

stood below either the Detroit Pentecost on folio 60v, the Wildenstein Trinity on folio 81v, or the missing Ascension in an initial V on folio 40r.[3]

As is the case with all of Lorenzo Monaco's works on parchment, the attribution and dating of the illuminations in Cod. H. 74 have been the subject of little agreement among scholars. They were first published by Osvald Sirén (1905, pp. 71 ff.) and Paolo D'Ancona (1914, vol. 2, pp. 138–41; see also Ciaranfi 1932, pp. 379–83), who associated them with documents of 1413 recording payments to Lorenzo Monaco for illuminations among the antiphonaries of Santa Maria Nuova (see Eisenberg 1989, p. 212, for a transcription of the documents). This dating was first questioned by Mirella Levi D'Ancona (1958b, p. 182 n. 30, pp. 190–91), who moved back the period of their execution to the end of Lorenzo Monaco's career, about 1423–24, and who identified nine initials in the volume as in whole or in part the work of Don Lorenzo's assistants, among them Bartolomeo di Fruosino (three volumes of the antiphonary and the other two volumes of the gradual, Cod. F 72 and G 73, are unquestionably attributable to Bartolomeo di Fruosino, who is documented as having painted books for Santa Maria Nuova in 1411 and again at regular intervals from 1423 to 1438; Levi D'Ancona 1961a, pp. 82–83). Marvin Eisenberg (1989, p. 108) also recognized Bartolomeo di Fruosino as the author of some of the initials in Cod. H 74 (fols. 11, 129, 150),[4] and agreed in dating the book after 1420. Miklós Boskovits (1975, p. 345) considered the entire volume the work of Lorenzo Monaco and dated it between 1405 and 1410. Opinions concerning the cuttings removed from Cod. H 74 have been even more various, ranging from enthusiastic praise of the Washington E with a Prophet as one of Lorenzo Monaco's most singular late works and of the Wildenstein Trinity as a masterpiece of his early career to deprecation of the Detroit Pentecost and the Cleveland D with a Prophet as

the efforts of an assistant or an imitator of Lorenzo Monaco's style.

Though there is an undeniable variation in quality among the forty-three known illuminations from Cod. H 74, the majority of them are the work of a single painter, Lorenzo Monaco, both in conception and execution, and there is, furthermore, no reason to doubt Sirén's original intuition in associating them with one of two documents of payment to Lorenzo Monaco in 1413. The documents are imprecise and in fact refer to work on an antiphonary, not a gradual. It is likely, however, that this reference was intended not in a specific but in a generic sense, that is to say, meaning choir books, as is the case with two graduals in the Museo Civico Medievale, Bologna, which are described as antiphonaries in their own incipits (see cat. no. 25). Lorenzo Monaco was involved with illuminating only two of the five volumes of the antiphonary from Santa Maria Nuova: one of these, Cod. C 71, is a documented work of 1396; the other, Cod. E 70, is known to have been painted in 1413 by Lorenzo Monaco and Matteo Torelli (Levi D'Ancona 1992), but Don Lorenzo's personal share in its execution was very much smaller than his payment of ten florins, recorded in a second document of the same year, would imply. On the other hand, this amount is not difficult to reconcile with the number of illuminations he contributed to Cod H 74: while their number cannot be broken down to a precise schedule of payments equaling ten florins in total, such a payment would be proportionate to that recorded for Matteo Torelli's work on Cod. E 70 or on a later missal he painted for the church of San Francesco, Prato (Levi D'Ancona 1992).

The most telling stylistic comparisons of the prophets in Cod. H 74 to panel paintings by Don Lorenzo are to be found in the figures in the predella to the 1414 *Coronation of the Virgin* altarpiece in the Uffizi (Eisenberg 1989, fig. 44). The artist's "impressionistic" manner of

Figure 116. Lorenzo Monaco, *Bas-de-page*. Galleria degli Uffizi, Florence; Gabinetto Disegni e Stampe (485)

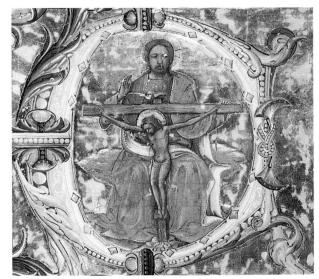

Figure 117. Matteo Torelli, The Trinity in an initial E. Museo Nazionale del Bargello, Florence (Cod. E 70, fol. 101v)

rendering highlights with stippling is typical of all his work after 1413 (the *Madonna of Humility* in the National Gallery of Art, Washington, D.C., for example), but the lean, angular proportions of the figures in Cod. H 74, which are shared with the figures in the 1414 predella and the only slightly later frescoes in the Bartolini Salimbeni Chapel at Santa Trinita, Florence, give way toward the end of his career to a fuller, more rotund figure type and freer arabesques in draperies, as best exemplified in the *Adoration of the Magi* altarpiece in the Uffizi (fig. 118) or the *Madonna of Humility* in the Brooklyn Museum (cat. no. 41). Marvin Eisenberg's analysis of the Wildenstein Trinity, cut from folio 81v of Cod. H 74, as having been painted before 1414 and after completion of the Monteoliveto altarpiece in 1410 is valid and may be extended to the contents of the entire volume.

While the great majority of the illuminations still present in or associable with Cod. H 74 are autograph works by Lorenzo Monaco, the hand of an assistant may be seen to intervene among them in a minor capacity, primarily in adding the drôleries and the small figures of prophets and monks scattered in the margins or across the *bas-de-pages* of a number of the folios as well as the busts filling the frame medallions in the larger illuminations of the Resurrection, Pentecost, and Trinity. However, in at least one of these larger illuminations, the Detroit Pentecost (fig. 114), the figurated scene in the center of the initial was also painted by a second hand, presumably over a design by Lorenzo Monaco. The closest parallels for the simple rounded outlines and summarily rendered features of the figures and the tentative hatching of the draperies in the Detroit Pentecost are

to be found in the eight illuminations in Cod. E 70 at the Bargello that have been convincingly associated with documented payments to Matteo Torelli in 1413 (Levi D'Ancona 1958a; 1992). The list of works assigned to Matteo Torelli by Mirella Levi D'Ancona in her fundamental studies of the artist is grossly inflated by the addition of numerous autograph works by Lorenzo Monaco, and the artist's identity has recently been called into question by Luciano Bellosi (1984) and Eisenberg (1989), who consider him to have been a professional "miniaturist" concerned exclusively with decorated initials and not with the painted figures or scenes contained within them (see also Boskovits 1972, p. 44; Freuler 1991, pp. 211–13, for an alternative identification of Matteo Torelli). The import of the 1413 documents is unambiguous, however, and their relevance to Cod E 70 is visually clear. The scope of the work for which Matteo Torelli was paid implies that he may well have been a professional miniaturist in the sense intended by Bellosi and Eisenberg, but it is also clear that he was responsible for painting figures as well, and there can be little doubt that his is the hand also responsible for painting the Detroit Pentecost in the contemporary Cod. H 74.

A core group of essentially homogeneous illuminations and monumental paintings—including the large *Annunciation* in the Stoclet collection and its probable wings in the Museo della Collegiata, Empoli,[5] and the frescoed scene of the Meeting of Joachim and Anna on the east wall of the Bartolini Salimbeni Chapel in Santa Trinita, Florence—may be assembled around the miniatures in Cod. E 70 as the work of a single artist. These reveal him to have been in all respects an imitator of Lorenzo Monaco, to the extent of mimicking the master's style as it developed over an extended period of time (he was referred to as "amicho de' frati degli Angnoli" as early as 1407 [Levi D'Ancona 1992, p. 90]). Matteo Torelli is chiefly distinguished by his competent but curiously slack draftsmanship and fussy modeling overlaid on faithful if perhaps simplified replicas of Don Lorenzo's designs. Levi D'Ancona's comparison of the Trinity in Cod. E 70 (fol. 101v; fig. 117) to its model by Lorenzo Monaco, the Wildenstein Trinity (which she did not realize formed part of Cod. H 74), may be extended to any other work by Torelli with equal validity.

It does not, however, follow that any work in the style of Lorenzo Monaco that does not rise to the level of quality expected from the master is to be attributed to Matteo Torelli. Torelli is an artist with a distinct personality, as the highly refined quality of the Detroit Pentecost reveals, with an identifiably personal manner of drawing and of visualizing bodies in space. Furthermore, if he were personally responsible for painting the deco-

rated initials in Cod. E 70, as the documents suggest, and undoubtedly the closely related ones in Cod. H 74 as well, then he is to be considered among the most gifted miniaturists of the early Renaissance in Florence. The decorative quality of these initials is unsurpassed in any earlier effort, save possibly Don Silvestro dei Gherarducci's in Cod. Cor. 2 at the Biblioteca Laurenziana, Florence (cat. no. 16), and is rivaled among contemporary books only by the foliated margins in Cod. Cor. 3, also at the Biblioteca Laurenziana (cat. no. 37), with which Torelli was in all likelihood personally involved. The coarse and deliberately caricatural heads in the medallions of the frame of the Detroit Pentecost, which recur throughout the margins of Cod. H 74, also appear in almost identical form in the borders of a number of initials in Cod. Cor. 3. They have been repeatedly attributed to Bartolomeo di Fruosino, based perhaps on their similarity to some related heads in border medallions in Cod. G 73 at the Bargello, but they must instead have been the models for Bartolomeo's unmistakably more eccentric, tensely drawn, and highly expressive figure types.

LK

1. This figure is one of only two in the volume (see also fol. 119r) without a halo. He holds a flame, which perhaps is symbolic of Charity (usually portrayed as a woman) in direct illustration of the text, or may possibly be an attribute of the patriarch Abraham (referring to the attempted sacrifice of his son, Isaac), who, however, is invariably shown with a halo.

2. The text for the eighteenth Sunday after Pentecost begins out of sequence on folio 178v and is unilluminated.

3. Forlani Tempesti et al. 1967, p. 22, no. 3; Bellosi 1984, p. 308. The Uffizi *bas-de-page* (Santarelli 48) measures $3^7/8 \times 14^1/2$ inches (9.8×36.8 cm); the average width of a folio in Cod. H 74 is $14^3/8$ inches (36.5 cm).

4. It is unclear which initials the author intends. He states that folio 129v according to the old numeration is new folio 128, whereas it is in fact folio 122. There is no illumination on folio 150v in either the old or new numeration.

5. Eisenberg (1989, p. 89) recognizes the common authorship and contemporaneity of these panels but claims that the difference in the heights of the consoles supporting their framing arches (36 in. [91 cm] in the center panel, 24 in. [61 cm] in the laterals) "proves that they were not part of the same altarpiece." Though atypical of the carpentry of Lorenzo Monaco's altarpieces, such a disparity in height is not uncommon in trecento and early quattrocento polyptychs generally and is insufficient evidence to countermand the stylistic arguments in favor of their association.

38a. A Prophet in an Initial E

Tempera and gold leaf on parchment
$5^1/8 \times 5^1/16$ in. (13.1×12.9 cm)

National Gallery of Art, Washington, D.C.; Rosenwald Collection (1952.8.277)

The green initial E is decorated with white and yellow filigree ornament, a row of pearls along its back edge, and a blue band studded with gilt diamonds—glazed red for an effect of relief—and gilt and silver circular "gems" highlighted with white along its inner edge. The foliate decoration of gray, pink, red, blue, and yellow, cropped at the edges of the gold ground at the right and at the upper and lower corners on the left, is carefully modeled with broad areas of wash shading and white or red pen highlighting. Within the initial is the half-length figure of a bearded prophet wearing a red robe and a white shawl and turban, his hands raised before him in prayer as he turns to look up and out of the initial toward the right. His halo is decorated with two sizes of circular punches and a ring of punched dots, while the margins of the gold ground are punched with a similar row of dots and an inverted trefoil arcade.

The verso preserves two staves (each $1^1/8$ in. [3 cm] high) of neumes and three fragmentary lines of text. The first two lines conclude the introit to the Mass for the Sunday within the octave of the Ascension, begun with the initial on the recto: "E[xaudi Domine vocem meam qua clamavi ad te, alleluia; tibi dixit cor meum quaesivi vultum tuum, vultum tuum Domine requiram; ne] avertas [faciem tuam a me,] alleluia, al[leluia]" (Hear, O Lord, my voice as I cry to you, alleluia! My heart has spoken to you; I have sought you. Your presence, O Lord, I will seek; hide not your face from me, alleluia, alleluia!). The final line of text on the verso, starting with a Lombard initial D cropped at the left margin, begins the subsequent psalm: "Dominus il[luminatio mea et salus mea]" (The Lord is my light and my salvation). Formerly part of folio 43 in Cod. H 74, the psalm was followed at the top of folio 44r by the opening lines of the versicle after the lesson: "Regnavit Dominus super omnes gentes" (God reigns over all the nations).

Opinions concerning the Rosenwald Prophet have run the full spectrum of critical possibility for a manuscript illumination of this period. It was unreservedly admired by Mirella Levi D'Ancona (1958b, p. 181), who first tentatively suggested its provenance from Cod. H 74 and who said of it: "The master is distinguishable from his assistant by the powerful emotive quality of his figure . . . by the intimate relation between emotion and gesture and by the shimmering light on the surface of the

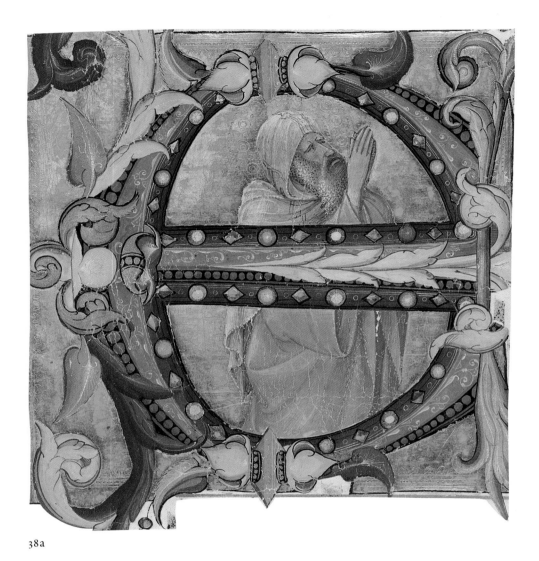

38a

fabrics. . . . The Rosenwald Prophet recedes in space and his body is modeled by the fluid drapery." For Marvin Eisenberg (1989, p. 173), whose opinion had earlier been cited and adopted by Carl Nordenfalk et al. (1975, p. 46), precisely the opposite was apparent: "The weakness in the drawing of the drapery . . . the inarticulate hands, and the overall mildness of expression . . . separate this miniature from the master's autograph works." The Rosenwald Prophet is a fully autograph work of extreme delicacy and psychological intimacy. Only in a poor reproduction is it possible to consider the drawing of the drapery as less than remarkably sophisticated and well beyond the capacities of any of Lorenzo Monaco's con-

temporaries. The type of the Prophet and the character of his expression are also not distinguishable from those of the best of the illuminations still in place in Cod. H 74, nor from those of a figure, such as the Saint Benedict in the second scene of the predella to the *Coronation of the Virgin* altarpiece of 1414 in the Uffizi, Florence.

LK

EX COLL.: Dr. Vladimir G. Simkhovitch, New York; L. J. Rosenwald, Jenkintown, Pa.

LITERATURE: Levi D'Ancona 1958b, pp. 177, 181; Boskovits 1975, p. 355; Nordenfalk et al. 1975, pp. 44–46; Eisenberg 1989, p. 173.

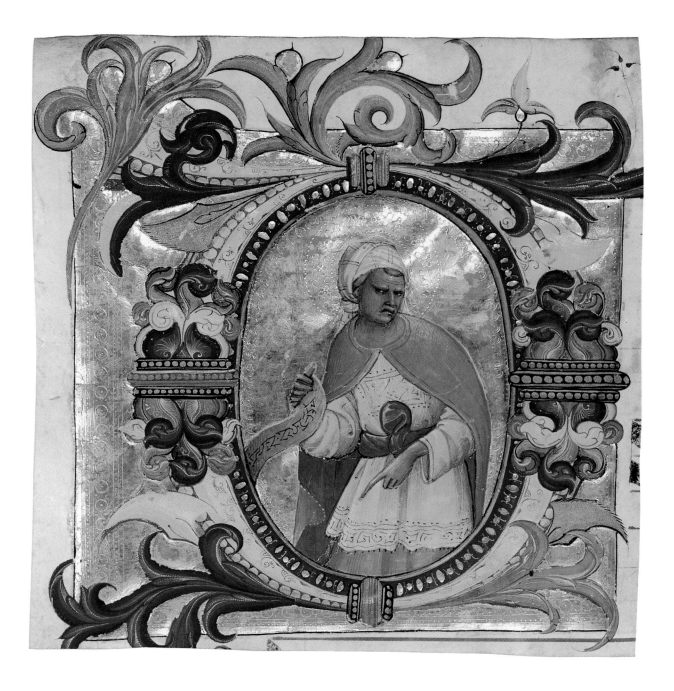

38b. A Prophet in an Initial D

Tempera and gold leaf on parchment
Overall: 6 ⁵/₈ × 6 ¹/₄ in. (16.8 × 16 cm); initial: 5 ³/₈ × 5 ¹/₂ in. (13.6 × 14.1 cm)

The Cleveland Museum of Art (49.536)

The pink and white initial D has an outer border of red embellished with a row of pearls and an inner border of blue decorated with gilt and glazed beads. Of extreme complexity, the green, blue, yellow, orange, gray, and pink foliate decoration is modeled with wash shadows

and densely hatched pen-work highlights in a manner similar to that in the Washington initial E described above. Within the initial is the figure of a young (that is, beardless) prophet cropped just above the knees and wearing a yellow turban, a melon-colored cape lined with blue, and a yellow tunic bound with a blue sash and worn over a melon skirt. He holds a lettered scroll in his right hand and points downward with his left, while turning his head in three-quarters profile to the right. His halo is decorated with a pattern of rosette and circular punches inside two rings of dots; the margins of the gold ground are also decorated with a row of circular punches inside two lines of dots; and the border of

the gold ground along the inner edge of the initial is decorated with a punched trefoil arcade.

The verso of the cutting contains two full staves (each 1 1/8 in. [3 cm] high), one partial stave of neumes, and two fragmentary lines of text. These lines end the offertory hymn from the Mass for the tenth Sunday after Pentecost begun on folio 121v of Cod. H 74: "... neque irrideant me inimici mei, et enim univer[si qui te exspectant] non confun[dentur]" (... nor let my enemies exult over me. No one who waits for you shall be left in confusion), and begin the Communion hymn for the same mass: "Accepta[bis sacrificium iustitie, oblationes et holocausta, super altare tuum Domine]" (You shall be pleased with sacrifices that are your due, with oblations and holocausts offered upon your altar, O Lord). The initial D on the recto begins the introit to the Mass for the eleventh Sunday after Pentecost: "D[eus in loco sancto suo]" (God is in his holy place). The subsequent psalm appears at the top of folio 123r in Cod. H 74: "[Exsurgat] Deus, et dissipentur inimici eius" (Let God arise and let his enemies be scattered). The Cleveland initial D, therefore, originally appeared at the top of folio 122v, now missing, in Cod. H 74.

The Cleveland Prophet was first attributed to Lorenzo Monaco by William Milliken (1950), an attribution rejected by Mirella Levi D'Ancona (1958b, p. 181)—who specifically contrasted its apparent weaknesses to the strengths of the Rosenwald Prophet (cat. no. 38a)— in favor of an ascription to Matteo Torelli. Marvin Eisenberg (1989, p. 91) concurred with Levi D'Ancona's assessment of the Cleveland miniature and related it stylistically to the figures in the pilasters of the 1414 *Coronation of the Virgin* altarpiece (Eisenberg 1989, fig. 44). The figure of Daniel from those pilasters is superficially related in type and in the torsion of his pose to the Cleveland Prophet, but the drawing of the latter is much freer and more forceful, and the realization of his dramatic contrapposto is more convincing. The rapid, confident rendering of the figure in Cleveland, with its highly unusual and imaginative blocking in of lights and shadows, is entirely typical of Lorenzo Monaco's autograph works of this period. In this regard it is more aptly compared to figures from the predella than the pilasters of the 1414 *Coronation* altarpiece, specifically to such figures as the attendants peering through the open doorway at the left of the scene of the Adoration of the Magi.

LK

Ex coll.: Dr. Vladimir G. Simkhovitch, New York.

Literature: Milliken 1950, pp. 43–45; Levi D'Ancona 1958b, p. 181; Cleveland 1963, no. 64, p. 210; Boskovits 1975, p. 340; Eisenberg 1989, p. 91.

39. Christ as the Man of Sorrows

Tempera on panel
Picture surface: 24 1/2 × 13 1/8 in. (62.2 × 33.3 cm)

Private collection

The half-length figure of the dead Christ rises from a pink marble sarcophagus, his hands crossed before his chest and his head nodding limply on his right shoulder. Behind his head are visible the arms and shaft of the cross, with a diminutive red titulus inscribed: I N R I. Christ's halo is decorated with a punched border of circles and six-petaled rosettes against a stippled ground, and the segments of its cruciform division are glazed red. The spandrels of the trilobe arched frame at the top are filled with blue sgraffito decoration.

Images of the Man of Sorrows are commonly encountered in Florentine trecento and early quattrocento painting in the predelle of altarpieces, where they are often paired with a scene of the Crucifixion in the central pinnacle above (see cat. no. 31). Though none of his own altarpieces employ such a scheme, an image of the Man of Sorrows was used by Lorenzo Monaco on more than one occasion to occupy the center roundel of a predella beneath a *Madonna of Humility* (for example, Toledo Museum of Art [fig. 121];[1] formerly Kaiser Friedrich Museum, Berlin, inv. no. 1123a; The Nelson-Atkins Museum of Art, Kansas City, inv. no. 40–40), and early in his career he used it in a composition closely related to that of the present panel (Accademia Carrara, Bergamo; inv. no. 918) as a wing of a diptych. The presence of original engaged moldings on all sides of the present panel and its relatively large size suggest that it was not conceived as a fragment of a larger complex, either as a predella or pinnacle to an altarpiece or as a valve of a diptych or triptych, but rather that it was meant as an independent object of private devotion. As such it is perhaps more closely related in intention to Don Lorenzo's monumental altarpiece *Christ as the Man of Sorrows* in the Accademia, Florence, dated 1404, though it was obviously conceived on a more domestic scale.

Once thought to be the work of Taddeo Gaddi, the *Man of Sorrows* was first attributed to Lorenzo Monaco almost sixty years ago by Raimond van Marle (1934–35, p. 304). Alvar González-Palacios (1970) somewhat tenuously related it to a cutout crucifix in the Musée des Augustins, Toulouse; Marvin Eisenberg (1989, p. 170) grouped both these pictures with the *Madonna of Humility* in the Toledo Museum of Art as the work of a single assistant within Lorenzo Monaco's studio. Comparisons to the Toledo *Madonna* are perhaps justified but are compromised by the damaged and repainted state of the

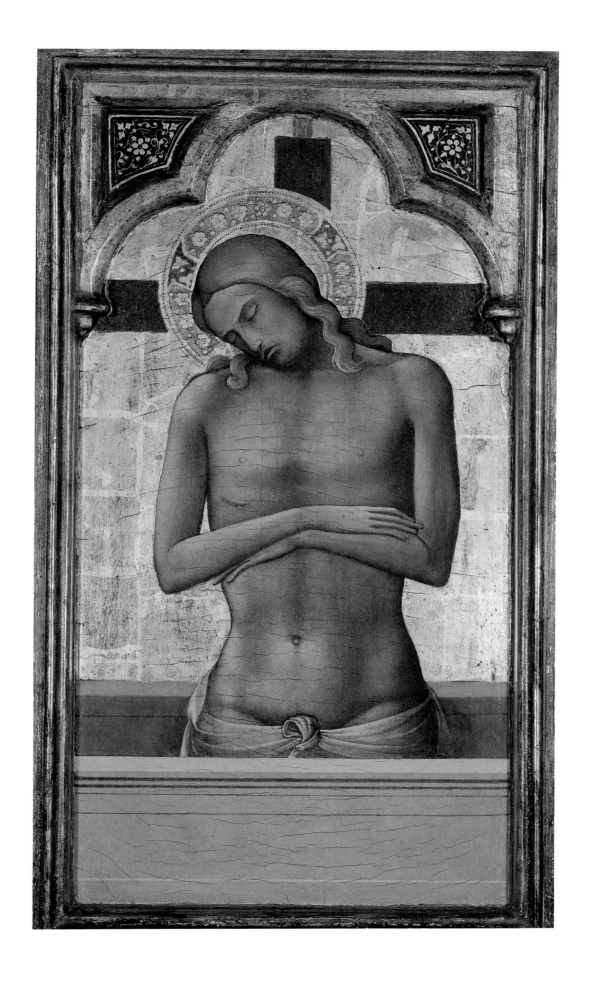

Madonna's face in that picture. Eisenberg is correct in noting the Morellian similarity of the rendering of hands in these two paintings, but this idiosyncrasy is no less true of the majority of Lorenzo Monaco's works after 1414 (see the pinnacle figures of the Uffizi *Coronation of the Virgin* [Eisenberg 1989, fig. 44]) and is especially noticeable in the masterpiece of his late career, the *Adoration of the Magi* altarpiece in the Uffizi, of about 1420–22(?) (fig. 118).

A firmer point of reference for the *Man of Sorrows* is provided by an unusual triptych of the Crucifixion (Museo Bandini, Fiesole) with the Stigmatization and Funeral of Saint Francis (Rijksmuseum, Amsterdam; Galleria Pallavicini, Rome, respectively; see Bellosi 1979), which employs similar figure types, lighting schemes, and decorative motifs (the sgraffito decoration of the spandrels, in particular, is almost identical in design). These panels in turn may be related to the frescoes and the altarpiece of the *Annunciation* in the Bartolini Salimbeni Chapel in the church of Santa Trinita, Florence, where numerous parallels for the treatment of the *Man of Sorrows* may be found as well.

Despite the total lack of documentation to that effect, it has become traditional to treat the decoration of the Bartolini Salimbeni Chapel as virtually the last enterprise undertaken by Lorenzo Monaco before his death in 1423 or 1424. However, all that is certainly known of the complex is that it cannot have been undertaken prior to 1405. In that year, Salimbene and Bartolomeo Bartolini Salimbeni determined to complete and decorate their family chapel and to provide for its endowment, and two years later they ceded certain rights to the chapel to the Arte del Cambio. Between that date and 1434 there are no further documentary references to the chapel other than annual payments for the celebration of Mass on the feast of the Annunciation (Eisenberg 1989, pp. 130–31).

The only justification for considering an extremely late date for the frescoes and altarpiece in the Bartolini Salimbeni Chapel is the dark palette and brooding, somber expression of the former and the supposedly sophisticated spatial construction of the latter (Golzio 1931, pp. 49–54; Pudelko 1938–39, p. 248), whereas in fact these impressions are largely due on the one hand to the extremely deteriorated condition of the frescoes and on the other to a misunderstanding of the confused rendering of architecture in the altarpiece, which is consistent with that in any other painting by Lorenzo Monaco. The figure style and compositional structure of these works actually compare more closely with those in the main panels and predella of the 1414 altarpiece of the *Coronation of the Virgin* in the Uffizi (on which the predella of the *Annunciation* altarpiece is imitatively,

almost slavishly, based) and on a smaller scale to the illuminations in Cod. H 74 at the Bargello (cat. no. 38). Lorenzo Monaco may well have received the commission for work in the Bartolini Salimbeni Chapel shortly after unveiling the Uffizi altarpiece, and a date much later than 1415–17 for its completion is highly improbable. A date shortly after the middle of the second decade of the fifteenth century is likely for the *Man of Sorrows* as well.

LK

1. The frame on this painting is not, as contended by Eisenberg (1989, pp. 169–70), a nineteenth-century, neo-Gothic accretion but is substantially original. It has been regilt and provided with modern colonnettes and crockets, but its basic structure—including the *pastiglia* decoration of its spandrels, the roundel of the *Blessing Redeemer* in its tympanum, the quatrefoil of the *Man of Sorrows* in its predella, and the gilt inner edge of the sight molding—is intact and integral to the original conception of the painting.

Ex coll.: Ludwig Gruner, London (until 1856); the Reverend John Fuller Russell, Greenhithe, Kent (1856–85); Charles Butler, London (1885–1911); Henry Wagner, London (1911–25); Michael van Gelder, Uccle (Brussels); William van Gelder, Uccle (until 1971).

Literature: Russell sale 1885, lot 93; Butler sale 1911, lot 32; Wagner sale 1925, lot 70; Amsterdam 1934, no. 242; van Marle 1934–35, p. 304; Pudelko 1938–39, p. 242 n. 24; González-Palacios 1970, p. 34; Christie's sale 1971, lot 13; Boskovits 1975, p. 349; Zeri and Rossi 1986, p. 68; Eisenberg 1989, pp. 89–90, 170.

40. Three Allegorical Figures and Studies of a Seated Old Man

Metalpoint with touches of brown wash and white highlights on reddish violet prepared paper
9 3/4 × 7 1/4 in. (24.9 × 18.5 cm)

The Metropolitan Museum of Art; Robert Lehman Collection, 1975 (1975.1.335)

The upper half of the sheet is filled by two large female figures seated on summarily rendered banks of clouds. The figure at the left, undoubtedly intended to portray Temperance, one of the four Cardinal Virtues (with Justice, Prudence, and Fortitude), is seated frontally while turning her head three-quarters to the left. She tilts a vase over her left shoulder, pouring water from it into another vase held at her right hip, a traditional emblem of Temperance derived from the practice of diluting wine with water. The figure at the right, turned in full profile to the left, is probably meant to represent Hope, one of the three Theological Virtues (with Faith and Charity). She raises both her hands before her, not in an attitude of prayer but as though reaching for something, perhaps a crown (a standard attribute of Hope), cropped at the top edge of the sheet.

Below the figure of Temperance at the left is a third allegorical figure, possibly but not necessarily female, wearing armor and a helmet and holding a sphere in the left hand and a sword in the right. A sword and sphere are frequently the attributes of Justice, who, however, is generally shown crowned, while a sword, armor, and helmet are more often associated with Fortitude. Alongside this figure at the right are three small sketches of an elderly man seated on the ground in various poses: in full profile to the right and looking out in front of him, in near profile to the left and looking upward, and in three-quarters profile to the right also looking upward. In two of these sketches, the figure holds a book, and in the third, at the bottom, a scroll, indicating that they are probably intended to portray prophets.

At the conclusion of his life of Lorenzo Monaco, Giorgio Vasari claims to have owned a drawing by the master:

Nel nostro libro dei disegni, ho di mano di Don Lorenzo le Virtù teologiche fatte di chiaroscuro, con buon disegno e bella e graziosa maniera, intanto che sono per avventura migliori che i disegni di qualsivoglia altro maestro di que'tempi. (Vasari 1906, vol. 2, p. 26)

In my book of drawings I have, by the hand of Don Lorenzo, the Theological Virtues done in chiaroscuro with good design and beautiful manner, and graceful insomuch that they are peradventure better than the drawings of any other master whatsoever of those times.

The Lehman drawing has been quite reasonably identified with the sheet described by Vasari in his own collection (Collobi Ragghianti 1974, pp. 36, 41). Not only does it represent three figures of Virtues—though it has been objected that only one of these is theological (Forlani Tempesti 1991, p. 170)—rendered in chiaroscuro, but also it bears in its upper right corner a pagination marking in ink (xxxiii) in a sixteenth-century hand, indicating that it once formed part of an album of drawings. The odd mixture of Theological and Cardinal Virtues on this sheet, and the filling of the vacant lower right quadrant with smaller sketches of seated prophets, suggests that at one time it may have been accompanied by a companion page representing the four remaining Virtues: Faith, Charity, Prudence, and Justice (or Fortitude, depending on the identification of the figure at the lower left of the Lehman drawing). It is possible that Vasari was not referring to "le Virtù teologiche" on a single page only, but if he were and if the Lehman drawing were indeed the sheet described in his album, he may have called it the Theological Virtues on the basis of nothing more than that they number three.

Through most of its modern history, the Lehman drawing has been considered the work of Giovanni dal Ponte, an attribution first applied to it in 1935 (Buffalo 1935, no. 2). In none of his surviving works, however, does Giovanni dal Ponte, the most talented of Gherardo Starnina's pupils, employ such cursive drapery forms, attenuated figural proportions, or dramatic lighting effects, and this attribution was correctly doubted by Sylvie Béguin (Paris 1957, no. 102) and Luciano Bellosi (Florence 1978, p. xix). No more convincing is the association with Giovanni dal Ponte's teacher, Gherardo Starnina, proposed by Anna Forlani Tempesti (1991). Though Starnina's draperies are frequently as decorative and calligraphic as those in the Lehman drawing, his figures are never of such elongated proportions, his use of light is invariably more schematic, and his facial types are always more caricatured. Least of all can any meaningful stylistic relationship be discerned to a sheet of figure studies in the Kunstmuseum Düsseldorf specifically adduced by Forlani Tempesti as "the closest parallel" for the Lehman drawing: the two works have only their *mise-en-page* in common and the fact that they both portray heavily robed, seated figures.[1]

Ironically, though barely considered by modern scholars, Vasari's attribution of the Lehman drawing (assuming its identity with the drawing in his "libro dei

disegni") to Lorenzo Monaco seems to be correct, as a consideration of the three small sketches of seated prophets at the lower right suggests. These are closely related in attitude to the figure of Saint Joseph seated in the left foreground of the Uffizi *Adoration of the Magi* altarpiece (fig. 118) and are almost identical in type and handling to figures in the panel representing scenes from the legend of Saint Onophrius in the Accademia, Florence (inv. no. 8615). Parallels for the larger figures may be found among Lorenzo Monaco's late works as well, such as the pinnacle prophets in the *Adoration of the Magi* altarpiece or the vault figures of Malachi and Micah from the Bartolini Salimbeni Chapel in Santa Trinita. The controlled, directional hatching of the white highlighting in the Lehman drawing is directly comparable with that in Lorenzo Monaco's two chiaroscuro drawings on parchment in Berlin (Kupferstichkabinett 608, 609; Degenhart and Schmitt 1968, nos. 171, 172, pls. 197a, b), in which the facial types of Fortitude (or Justice) and the kneeling Saint Elizabeth may also be juxtaposed. The remarkably refined and free use of metalpoint, most easily visible on the right side of the figure of Fortitude (or Justice) and in the robes of the three prophets, compares to Lorenzo Monaco's engraving technique in the Museo Civico, Turin, *verre églomisé* plaque of 1408 (fig. 80).

The Lehman drawing is undoubtedly a very late work by Lorenzo Monaco, executed probably after the Bartolini Salimbeni frescoes (ca. 1417) if perhaps not quite as late as the Uffizi *Adoration of the Magi* altarpiece (1420–22?) or the Accademia *Saint Onophrius* panel (1423–24?). As such it is contemporary with such projects as the Franciscan triptych now divided between the Museo Bandini, Fiesole, the Rijksmuseum, Amsterdam, and the Galleria Pallavicini, Rome (see cat. no. 39), and to the San Giovannino dei Cavalieri Crucifix—to which it bears a particularly striking resemblance—but no known altarpieces or fresco cycles were undertaken by the artist in this period for which it might have been a preparatory study or presentation drawing. A faint inscription scratched into the red ground of the paper to the left of the helmet of Fortitude (or Justice) may offer a clue to the drawing's original destination, however. Though the first part of the inscription is only partially legible, the last word is unmistakably PISA and may indicate a commission to Lorenzo Monaco for a large decorative campaign in that city, which either does not survive or was ultimately not executed. Vasari records "alcune tavole che sono ragionevoli" by Lorenzo Monaco in the Camaldolese monastery of San Michele in Pisa (Vasari 1906, vol. 2, p. 21), but these have never been positively identified.

LK

1. The Düsseldorf drawing was attributed by Berenson (1961, no. 1391H) and by Degenhart and Schmitt (1968, no. 195) to the Master of the Bambino Vispo, that is, Gherardo Starnina, and by Forlani Tempesti (1991, pp. 170–72) to either Starnina or Lorenzo Monaco. It is a mechanical effort more reminiscent of the heavy-limbed, coarse-featured figures typical of Giovanni Toscani, who is not to be confused with the Master of the Griggs Crucifixion (see cat. no. 46).

EX COLL.: Giorgio Vasari(?); Robert Lehman, New York (by 1935).

LITERATURE: Beck 1989, pp. 27–28; Forlani Tempesti 1991, no. 62, pp. 170–74 (with previous literature); idem 1992, pp. 308–9.

41. Madonna of Humility

Tempera on panel
Overall: 45 5/8 × 25 3/8 in. (115.8 × 64.4 cm); picture surface: 33 1/4 × 18 3/4 in. (84.5 × 47.5 cm)

The Brooklyn Museum Collection, New York; Bequest of Frank L. Babbott (34.842)

The Madonna, wearing a deep blue mantle lined with yellow over a gold-embroidered white dress, is seated on a green brocaded cushion decorated with gold tassels, which rests on a marbled pavement. She faces to her left in three-quarters profile and balances the Christ child on her raised left knee. The child, dressed in a rose tunic and robe, raises his right hand in benediction and clutches a spray of flowers in his left. The gold ground is incised with an overall pattern of radiant striations emerging from behind the two figures. On the face of the riser at the front edge of the pavement is painted the coat of arms of the Medici (or, eight palle gules).[1] The frame, though much repaired, is original and retains much of its original gilt surface across the base, including the inscription (AVE MARIA GRAZIA [*sic*] PLENA [Hail Mary, full of grace]) and the coat of arms in the right-hand pilaster base.[2] The coat of arms at the lower left is the invention of a modern restorer, and the paired spiral colonnettes at either side, together with their capitals and the lower of their two abaci, are replacements. The upper margin of the frame is lacking its applied acanthus decoration, a shadow of which is plainly visible against the blue ground color.

The Brooklyn *Madonna of Humility*, like the majority of Lorenzo Monaco's paintings intended for a domestic market, has been the subject of a variety of opinions

41

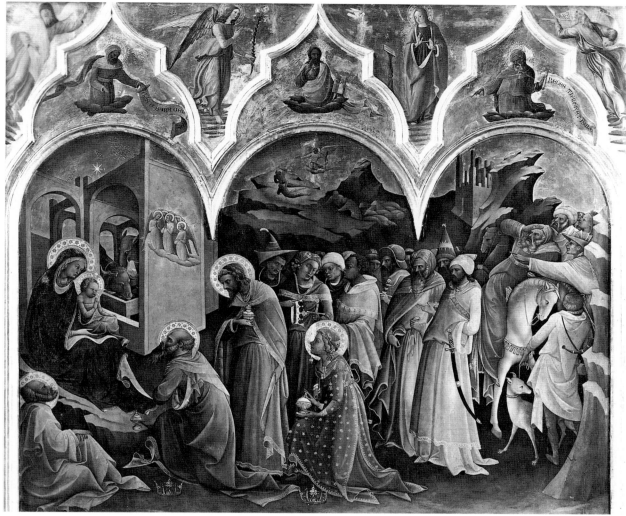

Figure 118. Lorenzo Monaco, *The Adoration of the Magi*. Galleria degli Uffizi, Florence (466)

reflecting the full spectrum of possibilities concerning the degree of the artist's participation in its conception and execution and its probable date within his career, with suggestions for the latter ranging from 1405 (van Marle 1923–38, vol. 9 [1927], p. 176), to 1415 (Fahy 1982, p. 241), to 1420 (Sirén and Brockwell 1917, no. 13). It is probably the most beautiful and almost certainly the best preserved of the artist's many Madonna of Humility compositions. Marvin Eisenberg (1989, p. 88), who misunderstood the painting's condition, assuming that the base of the frame, the arms of the Medici, and the incisions on the gold ground were all later additions, nonetheless correctly recognized both the superior quality of the painting's design and its intimate relation to Don Lorenzo's last major altarpiece, the Uffizi *Adoration of the Magi*, of about 1420–22 (fig. 118).

A proper assessment of the Brooklyn *Madonna of Humility* must take into account the commercial nature

of the painting and the great number of related objects produced in Lorenzo Monaco's studio as well as in the studios of nearly all his contemporaries, both painters and sculptors, which were intended to satisfy an apparently limitless demand in Florence. Don Lorenzo's earliest effort in the genre, the center panel of a triptych in the Pinacoteca Nazionale, Siena (fig. 83), painted probably in the early 1390s, follows a formula made popular by artists in the circle of Agnolo Gaddi (especially Tommaso del Mazza, formerly known as the Master of Santa Verdiana), in which the Madonna is actually seated in glory on a bank of clouds rather than in humility on the ground. The same figural group is easily adapted to a different iconography by the introduction of a pillow and pavement (in Siena and in northern Italy, painters preferred a garden or flowering meadow), but at first Don Lorenzo managed only an uneasy compromise in a painting of about 1395 in the

Perkins Collection at the Sacro Convento di San Francesco, Assisi, by substituting a richly carved marble dais for his earlier bank of clouds, retaining the majestic impression of a Madonna enthroned. He had, however, developed his final solution to the demands of the subject by the turn of the fifteenth century, in a large and very beautiful painting (possibly once the center of a small altarpiece) in a private collection (fig. 119), in which an unadorned marble pavement reaches the full width of the picture field and fills the foreground, and the Madonna's draperies cascade in looping folds around the cushion on which she sits and in a sweeping arc before her on the floor.

From that point forward, all of Lorenzo Monaco's many repetitions of the subject are essentially variations on a theme, whether intended as the center panel of a larger structure, as in the Empoli altarpiece of 1404 (fig. 120), or more commonly as a fully independent object

(two exceptions are panels in the Liechtenstein collection, Vaduz, and formerly at the Schaeffer Galleries, New York, in which the artist reverted to the earlier type of the Madonna in glory on a bank of clouds). Differences between these pictures are frequently a matter of little more than their relative size or the specific pose of the Madonna or the Christ child. In one picture, at Lastra a Signa, a cloth of honor is introduced behind the Madonna; in another, at the Toledo Museum of Art (fig. 121), the marble pavement is replaced by a richly patterned carpet; while a third, in the Nelson-Atkins Museum of Art, Kansas City, employs both a carpet and a cloth of honor. Though repetitive and at times almost mechanical in their formulation, the majority of these paintings are nonetheless autograph creations of great beauty, revealing the lively engagement of Lorenzo Monaco with his craft as a painter.

The Brooklyn *Madonna of Humility* is the last in a

Figure 119. Lorenzo Monaco, *Madonna of Humility*. Private collection

Figure 120. Lorenzo Monaco, *Madonna of Humility*. Museo della Collegiata, Empoli (2)

Figure 121. Lorenzo Monaco, *Madonna of Humility*. Toledo Museum of Art (1945.30)

Figure 122. Lorenzo Monaco, *Madonna of Humility*. Philadelphia Museum of Art; The John G. Johnson Collection (J10)

series of three surviving images based on a single design that was first elaborated on a smaller scale in a *verre églomisé* plaque in the Museo Civico, Turin, dated 1408 (fig. 80). *Verre églomisé* employs a reserve technique of etching through gold leaf applied to the back of a piece of glass, and the design of the Turin plaque, therefore, is to be read in reverse on the front. The earliest of the three images derived from it, in the Toledo Museum of Art, is damaged and heavily restored and thus only partially legible in style. It is one of the more hieratic and aloof versions of the subject painted by Don Lorenzo, its regal solemnity contrasting markedly with the intimate domesticity of the *verre églomisé*. A date for the work can be established only approximately. It is related in style

and technique (to the extent that these are still legible) to another damaged but beautifully restored *Madonna of Humility*, dated 1413, in the National Gallery of Art, Washington, D.C., but even more so to the altarpiece of the *Annunciation* in the Bartolini Salimbeni Chapel at the church of Santa Trinita, Florence, probably painted in the period 1415–17 (see cat. no. 39).

The figural grouping of the Toledo *Madonna* was reprised in a slightly later composition now in the John G. Johnson Collection at the Philadelphia Museum of Art (fig. 122). The Philadelphia *Madonna*, unfortunately also extensively damaged though relatively free of restorations, is not a mere repetition of a successful formula, however. It differs from its prototype in more

than such details as the folds of the Virgin's draperies, the position of the child's feet, and the return from a carpet to a marbled pavement. The figures are rounder, less attenuated in proportion and less rigidly vertical in posture, dispelling to a degree the iconic formality of the Toledo painting. The Christ child in Philadelphia is larger in relation to his mother than the one in Toledo, he leans more casually backward (his halo is barely contained within the profile of the Virgin's shoulder, whereas in Toledo it is bisected by her draperies), and he gazes innocently, almost beguilingly, upward, as if reaching to caress his mother's cheek rather than blessing the viewer with his raised right hand. Suggesting a date for the Philadelphia *Madonna* is difficult on account of both its deteriorated condition and the paucity of closely related examples, but it is unlikely to have been painted either much before or much after 1420.

Last in this sequence, the Brooklyn *Madonna of Humility* is paradoxically more like the 1408 *verre églomisé* plaque in Turin than either the Toledo or Philadelphia painting, both in the relative proportions of its figures and in the intimacy of their contact with each other, their heads brought close enough together for their halos to overlap. The near-perfect state of preservation of the Brooklyn *Madonna*, in contrast to the impaired surfaces of the other two, exaggerates the greater plasticity of its modeling and the subtlety of its painted light effects, which are set off by the warm patina of its gold ground, lending it an air of increased monumentality and grandeur that does not compromise the psychological immediacy of its subject. The Philadelphia *Madonna*, though less developed in its means of expression, aspires to a similar combination of monumentality and intimacy, which is essentially different from the impersonal elegance of the Toledo *Madonna*.

As Eisenberg (1989, p. 88) has noted, the date of the Brooklyn *Madonna of Humility* is indissolubly linked to that of the Uffizi *Adoration of the Magi* altarpiece, sometimes thought to be a documented work of 1420–22.[3] The two main figures in that painting are repeated almost exactly in the Brooklyn *Madonna of Humility*, and the handling of paint in both is closely comparable. Given such a date for the Brooklyn painting, it is worth speculating whether the appearance of the Medici coat of arms at its base—to accommodate which the composition was displaced noticeably upward, pressing the Madonna's halo against the inside arch of the frame (where it would

have been overlapped by the now missing crockets)—is at all linked to the coincidence of Cosimo and Lorenzo de' Medici's patronage of the Sant'Egidio altarpiece, toward the financing of which they contributed 46 florins on August 27, 1422 (Eisenberg 1989, p. 215).

LK

1. The present mud color of the shield may be a deteriorated bole or glue size for mordant gilding rather than an intentionally applied pigment. The number of balls in the Medici arms varied from six to ten, one of which was frequently charged with the Croce del Popolo (a red cross on a white ground). In 1466 Piero il Guttoso was granted the privilege of bearing the fleurs-de-lis of the House of Anjou by Louis XI, king of France, and a blue ball with three gilt fleurs-de-lis was substituted for the Croce del Popolo. Lorenzo the Magnificent later fixed the number of balls in the Medici arms at six.

2. These arms are only imperfectly legible, again due to uncertainty over the red of the ground color. They are closest in appearance to the arms of the Mangieri (or, a pale argent fimbriated sable), but only if the red may be understood as a deteriorated or improperly repaired preparation for gold, as in the Medici arms in the center of the painting. Otherwise they might be read as the arms of the Pepi (gules, a pale argent), though this description does not account for the clearly apparent black stripes on either side of the white (for silver) bar in the center and seems less probable.

3. This painting is frequently associated with documents of payment to Lorenzo Monaco for work on the high altarpiece of the church of Sant'Egidio, Florence, between 1420 and 1422 (see Eisenberg 1989, pp. 118–20, 214–15), but the sum he received for that project, totaling 182 florins, inclusive of payments for the carpentry and gilding, would seem to indicate a structure of much greater size and complexity than the modest panel preserved today in the Uffizi. Whether or not it is to be identified with the Sant'Egidio altarpiece, the Uffizi *Adoration of the Magi* must on stylistic grounds be considered the latest surviving monumental work by Lorenzo Monaco, and a date for it of about 1422 (or even 1423) is not implausible.

EX COLL.: Charles Loeser, Florence; Comm. Elia Volpi, Florence; George Gray Barnard, New York; Frank Lusk Babbott, Brooklyn (1916).

LITERATURE: Sirén 1905, p. 168; Sirén and Brockwell 1917, no. 13; van Marle 1923–38, vol. 9 (1927), pp. 130, 176; Berenson 1932a, p. 298; idem 1932b, p. 34; Platt and Price 1934, no. 4; Pudelko 1938–39, p. 76 n. 2; Berenson 1963, vol. 1, p. 117; Fredericksen and Zeri 1972, p. 111; Boskovits 1975, p. 350; Fahy 1982, p. 241; Eisenberg 1989, p. 88.

BARTOLOMEO DI FRUOSINO

Generally thought to have been a pupil and frequent collaborator of Lorenzo Monaco, Bartolomeo di Fruosino was actually a contemporary of the Camaldolese master. He was born in either 1366 or 1369, having reported his age as sixty-one in the *catasto* (register of taxable property) declaration of 1427 and sixty-four in the *catasto* of 1433. He registered in the Compagnia dei Pittori in 1394, and in the same year he is recorded as a pupil ("discepolo") of Agnolo Gaddi, working on the frescoes in the Cappella del Sacro Cingolo in Prato cathedral. Sometime before 1408 he registered in the Arte dei Medici e Speziali. From 1402 to 1438 he is mentioned at regular and frequent intervals in the account books of Santa Maria Nuova, for which he executed numerous commissions and from which he rented the house he shared with his brother, Giovanni di Fruosino, a sculptor and perhaps also a painter.[1] Bartolomeo di Fruosino died on December 7, 1441.

Following the fundamental documentary researches of Mirella Levi D'Ancona (1961a, pp. 81–97; 1962, pp. 44–48) and her reconstruction of the artistic personality of Bartolomeo di Fruosino, it has become customary to attribute to him nearly every work of art of a certain coarseness painted in a style vaguely reminiscent of Lorenzo Monaco, including the caricatural drôleries in the border decoration of Don Lorenzo's manuscript illuminations and the subsidiary parts of his large altarpiece and fresco commissions. None of these attributions, however, can be confirmed by comparison with any certain works by Bartolomeo di Fruosino, and there is no other evidence, visual or documentary, that he ever collaborated with Lorenzo Monaco. That the two artists were intimately familiar with each other's work and that Bartolomeo was heavily indebted to Don Lorenzo's example cannot be doubted. They both enjoyed a long-standing relationship with the hospital church of Santa Maria Nuova, for which they were concurrently engaged on the illumination of a series of choir books (see cat. no. 38), and Bartolomeo is described as a personal friend of Ambrogio Traversari, one of the principal Camaldolese intellectuals of his day and prior of Santa Maria degli Angeli.

Among the documents from Santa Maria Nuova connected with Bartolomeo di Fruosino's name are records of payment in 1411 for illuminations in an antiphonary and a painted crucifix. These have been identified (Levi D'Ancona 1961a) with a *crocifisso sagomato* now in the Accademia, Florence (inv. no. 3147) and with one or more volumes of the choir books from Santa Maria Nuova now either in the Museo del Bargello (Cod. A 69, F 72, G 73) or still in the hospital church (Cod. B, D, I). While these attributions are convincing, the association of these objects with the documents is tenuous, the crucifix in particular being a typical mature work of Bartolomeo di Fruosino painted significantly later than 1411. Though Bartolomeo is known to have been active as early as the 1390s, it has not yet been possible to identify paintings from his early career nor to trace the origins of his style when he emerged from the studio of Agnolo Gaddi. Attempts to identify his hand among the vault frescoes in the Cappella del Sacro Cingolo (Salvini 1934a, pp. 210–16), where he is documented at work alongside Gaddi in 1394, have been inconclusive, as have efforts to associate his name with some of the anonymous followers of Gaddi active in the first years of the fifteenth century.

An attempt to refine the large and heterogeneous corpus of panel paintings and illuminations assigned by Levi D'Ancona to Bartolomeo di Fruosino by isolating a group of works attributable to a Master of the Squarcialupi Codex (Bellosi 1984) has not met with universal acceptance (see Eisenberg 1989, p. 178). Though the Squarcialupi Master's oeuvre is not fully homogeneous, most of the paintings associated with his name are indeed not by Bartolomeo di Fruosino.[2] Other paintings attributed to

Bartolomeo by Levi D'Ancona are instead either autograph works by Lorenzo Monaco, such as the illuminations in Cod. Cor. 7, 8, and 13 at the Biblioteca Laurenziana, Florence, or works by Don Lorenzo and his assistants, such as the illuminations and marginal decoration in Cod. H 74 at the Bargello. Still others, such as the illuminations in Cod. Cor. 10 or MS Fiesol. 136 at the Biblioteca Laurenziana, are not specifically attributable to any known hand. The remaining panels and illuminated manuscripts, which include the three works catalogued here plus several others omitted from Levi D'Ancona's initial list—an illustrated Lives of the Saints in the Biblioteca Nazionale, Florence (MS II–113; Degenhart and Schmitt 1968, no. 188); an illuminated codex of the *Divine Comedy* in the Biblioteca Laurenziana (MS Plut. 40, 16; Degenhart and Schmitt 1968, no. 187); an illuminated missal in the Biblioteca Capitolare, Padua (MS B 29; Degenhart and Schmitt 1968, p. 286); and an illuminated antiphonary of 1417 in the Bibliothèque Municipale, Douai (MS 1171; Paris 1984, p. 112)—all reveal an artist of an accomplished if not innovative technique, highly idiosyncratic and expressive figure style, and energetic narrative sense, one of the last great masters of the Gothic tradition in Florence.

LK

1. A certain Michele di Frosino da Panzano is recorded as *Spedalingo* of Santa Maria Nuova from 1413 to 1443 (Richa 1754–62, vol. 8, p. 224). It is unclear whether he was related to Bartolomeo di Fruosino.
2. Two panel paintings given by Bellosi to the Master of the Squarcialupi Codex, the *Saint Lawrence* altarpiece of 1407 in Avignon and a *Crucifixion* in a private collection, as well as possibly the Squarcialupi Codex itself, may be early works by Francesco d'Antonio. Francesco d'Antonio certainly trained under Lorenzo Monaco, presumably before 1409, when he matriculated in the Arte dei Medici e Speziali. His earliest independent signed and dated work, an altarpiece of 1415 now in the Fitzwilliam Museum, Cambridge, bears suggestive morphological similarities to the predella and main panels of the *Saint Lawrence* altarpiece, which, however, was probably designed by Lorenzo Monaco. An illumination of the Crucifixion of about 1419 in the missal of San Pietro in Mercato (Corsini collection, Florence), attributed to Francesco d'Antonio by Longhi (1940, p. 186 n. 24; see Berti and Paolucci 1990, pp. 234–35), is probably by Matteo Torelli.

42. The Virgin and Child in an Initial H

Tempera and gold leaf on parchment
6 1/4 × 4 7/8 in. (15.8 × 12.4 cm)

Private collection, New York

The green initial H, decorated with pearls and white filigree ornament as well as orange, purple, blue, and rose foliation, is contained within a gilt block outlined in black. Inside the letter the Virgin Mary is shown in half-length turned in three-quarters profile to the right; she wears a blue cloak lined with gold over a light red robe, and her halo overlaps the red and gold lining of the initial at the top. She holds the Christ child, dressed in a red tunic, before her and lowers her head to press her cheek against his as he reaches around her neck with his right hand. Much of the gold leaf around the Virgin, in her halo, and in the outer block of the initial has flaked, exposing an apricot-colored bolus beneath, but the paint surface itself is extremely well preserved, having suffered only minor losses along the Virgin's right arm and hand and the child's left thigh.

The reverse of the cutting contains three lines of text and two musical staves, each 1 1/8 inch (3 cm) high and with 1 1/8 inch (3 cm) spacing between. The text forms part of the first antiphon of the first nocturn of matins for the common of feasts of the Virgin, "[Benedicta tu in mulieribus, et ben]edictus fructus [ventris tui]" (Blessed are you among women, and blessed is the fruit of your womb), followed by the second antiphon: "Sicut mi[rrha electa odorem d]edisti suavita[tis, Sancta Dei Genitrix]" (Like precious myrrh you gave forth an odor of sweetness, holy Mother of God). Above the initial H on the recto is the conclusion of the third antiphon of the same

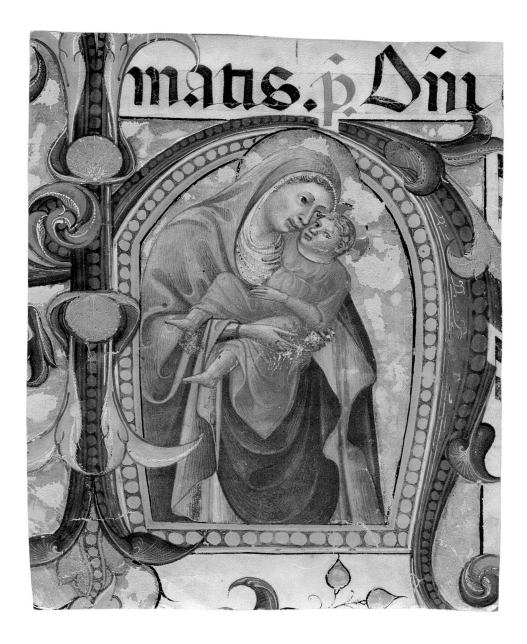

nocturn, "[Ante torum huius Virginis frequentate nobis dulcia cantica dra]matis" (Before the couch of this Virgin sing us the sweet songs of the drama again and again), followed by the rubric and the beginning of the twenty-third Psalm: "D[omi]ni [est terra et quae replent eam, orbis terrarum et qui habitant in eo]" (The earth is the Lord's and the fullness thereof: the world, and all they that dwell therein). The initial H then begins the first responsory of the first nocturn for the feast of the birth of the Virgin (September 8): "H[odie nata est beata Virgo Maria ex progenie David]" (Today the Blessed Virgin Mary was born of the line of David).

The style of the cutting of the Virgin and Child and its stave height of 1 1/8 inch (3 cm) link it to Bartolomeo

di Fruosino's work among the antiphonaries and graduals painted for Santa Maria Nuova. Only one page from these books is known to be missing: folio 148 from Cod. B at Santa Maria Nuova,[1] containing the office of matins (first nocturn) for the feast of the birth of the Virgin. The rubric for this feast, followed by the first line of the invitatory ("Nativatatem Virginis Mari[ae celebremus]" [Let us celebrate the nativity of the Virgin Mary]), appears at the bottom of folio 147v, while the conclusion of the responsory begun with the initial H is to be found at the top of folio 149r: "[Hodie nata est beata Virgo] Maria ex progenie David, per quam salus mundi credentibus apparuit, cuius vita gloriosa lucem dedit seculo" ([Today the Blessed Virgin] Mary was born of

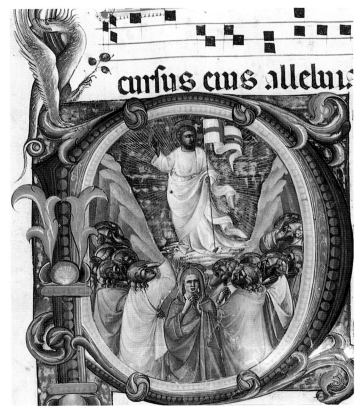

Figure 123. Bartolomeo di Fruosino, The Ascension. Museo Nazionale del Bargello, Florence (Cod. A 69, fol. 58v)

the line of David. Through her the salvation of the world was made visible to believers. Her glorious life gave light to the world).

The sequence of Bartolomeo di Fruosino's work on the five volumes from Santa Maria Nuova for which he was responsible (Bargello Cod. A 69, F 72, G 73; Santa Maria Nuova Cod. B, D) is not specified in the numerous though vague documents referring to them between 1411 and 1438 (see Levi D'Ancona 1962) and may be established only approximately by comparison with other dated works. One of these, Cod. A 69, is close enough to Agnolo Gaddi in style to suggest that it may have been among the earliest works for which Bartolomeo received payment and perhaps was the specific volume for which he was paid in 1411. Alone among the Santa Maria Nuova choir books, its compositions make no reference to those of Lorenzo Monaco in Cod. H 74 of 1413, also painted for Santa Maria Nuova (cat. no. 38). The Ascension on folio 58v (fig. 123) and the Pentecost on folio 72r (fig. 94) instead derive almost exactly from the same scenes in Cod. Cor. 1 from Santa Maria degli Angeli (fols. 86r and 111 [cat. no. 29d], respectively) of more than a decade earlier. The four remaining volumes of the Santa Maria Nuova choir books are demonstrably later: all of them

resemble Bartolomeo's dated works of the early 1420s, such as the Sant'Egidio Missal (Museo di San Marco, inv. no. 557) of 1421,[2] and two of them, Cod. F 72 and G 73 at the Bargello, quote designs and decorative motifs from Lorenzo Monaco's work in Cod. H 74. An absolute terminus post quem of 1413 may therefore be deduced for these two books, as well as for Cod. B and D still at Santa Maria Nuova, and consequently for the initial H with the Virgin and Child discussed and illustrated here. A probable terminus ante quem of 1424 is implied by a notice of the binding of the antiphonaries in that year (Levi D'Ancona 1979, p. 464). Within that span of time, Cod. B—the fourth part of the antiphonary series—may have been the last volume decorated, the present Virgin and Child and the five illuminations that remain in the book already looking forward to Bartolomeo di Fruosino's work in the fourth decade of the century.

LK

1. Cod. B at Santa Maria Nuova is inscribed on folio 1r: *Incipit IV pars antiphonari nocturnalis* (not third part, as per Ciaranfi 1932, p. 383 n. 2). It comprises 238 folios (plus two parchment folios and eight paper bifolia added at the end), each with six staves of four lines each, measuring 1⅛ inch (3 cm) in height with 1⅛ inch (3 cm) spacing between staves. Five illuminations remain in the book: Saint Lawrence in an initial L ("Levita Laurentius bonum opus operatus est" [The deacon Lawrence performed a pious act]) on folio 101v; the Virgin in Glory in an initial V ("Vidi speciosam sicut columbam" [I saw a woman as beautiful as a dove]) on folio 116v; the Assumption of the Virgin in an initial A ("Assumpta est Maria in celo" [Mary has been taken up into heaven]) on folio 124v; a Group of Saints in an initial I ("In dedicatione templi decantabat populus laudem" [At the dedication of the temple the people sang songs of praise]) on folio 185r; and a Christ in Glory Blessing in an initial V ("Vidi turbam magnam quam dinumerare nemo poterat" [I saw a great multitude that no man could number]) on folio 192v. Folio 148 has been removed from the book, and several preceding folios were partially cut through at that time.

2. Cod. I at Santa Maria Nuova, dated 1422, is generally associated with the Santa Maria Nuova antiphonaries (Ciaranfi 1932, p. 383 n. 2; Levi D'Ancona 1961a, p. 84) but appears instead to be a second volume of the Sant'Egidio Missal. It contains miscellaneous introits beginning with Trinity Sunday (fol. 1r) and Pentecost (fol. 4v), several commons and votive masses, and the Mass for the feast of Saint Egidio (fol. 32r). The book retains only one illumination, a much-damaged image of the Trinity by Bartolomeo di Fruosino on folio 1r.

43. Desco da parto: A Birth Scene (recto); A Putto (verso)

Tempera on panel
Diam.: 23 ¼ in. (59 cm)

The New-York Historical Society, on loan to The Metropolitan Museum of Art (L1979.11.2a, b)

On the front of the twelve-sided *desco da parto*, or tray, is portrayed a birth scene. The new mother reclines on a large bed in the center, with three maidservants bringing her refreshments behind. Seated on the ground before the bed are three more women, two caring for the newborn and one playing a harp. Two older, well-dressed women (the grandmothers?) enter through a doorway at the left; two more figures, one kneeling, fill another doorway at the right; while yet another figure, probably a servant, appears in a doorway leading onto the roof above the bedchamber. In a vestibule to the left of the house is a group of visitors bearing gifts for the mother. Two shields intended for coats of arms, either never completed or now effaced, are reserved at the left and right edges of the composition, and a distant seascape, with a large boat and mountainous coastline, closes off the scene at the top. An inscription across the bottom of the panel reads: QUESTO SI FE A DI XXV DAPRILE NEL MILLE QUATTROCENTO VENTOTTO (This was made on April 25, 1428), almost certainly commemorating the date of the birth depicted on the tray.

On its reverse the tray is painted with a large, coarsely rendered child seated on a rock in the middle of a stream or lake, urinating. The boy is naked except for a coral pendant worn around his neck. He holds a windmill in his right hand and a hobby horse in the crook of his left leg. Behind him is a meadow of wildflowers stretching back to a line of trees. Two coats of arms show, at the left, two wild boars, and at the right, a bull rampant on a hill of six monti. The scene is bordered by a partially effaced inscription running around all twelve sides of the panel: FACCIA IDDIO SANA OGNI DONNA CHFFIGLIA EPADRI LORO . . . RO . . . ERNATO SIA SANZA NOIA ORICHDIA ISONO UNBANBOLIN CHESULI[SOL?]A DIMORO FO LAPISCIA DARIENTO EDORO (May God grant health to every woman who gives birth and to their father . . . may [the child] be born without fatigue or peril. I am an infant who lives on [an island?] and I make urine of silver and gold).

The custom of presenting an expensive gift to a new mother on the occasion of giving birth was widespread among the upper middle classes in Renaissance Tuscany (Thornton 1991, pp. 252–53). Commonly these gifts took the form of either a five-piece maiolica *couchement* set

(including a broth bowl and cover, drinking cup, saltcellar, and lid) or a painted *desco da parto*, both of which were luxury imitations of functional objects, intended for presentation and display only. The imagery adapted for these objects was invariably secular, generally literary or mythological in source, frequently aristocratic or courtly in content, sometimes emblematic or moralizing in theme. Occasionally, as in the Historical Society example or in that of a celebrated tray attributed to Masaccio in the Gemäldegalerie, Berlin, the trays are painted reportage, with the birth scene itself figured on the recto, enacted in a contemporary interior by figures in contemporary dress: they function as precious documents of the social habits of the age.

Though it is not meant to convey an allegorical significance and does not portray a mythological or religious story, the birth scene on the recto of the Historical Society *desco* is not to be construed as reportage in the modern sense of an accurate depiction of an actual current event. It has been copied faithfully from a drawing by Lorenzo Monaco representing the Birth and Naming of Saint John the Baptist (Eisenberg 1989, fig. 197), incorporating only such alterations necessary to adapt the composition to a round format and a secular subject. Thus, the two figures standing in the doorway at the right do not have a topical relevance to the scene; they were simply copied directly from the drawing. The imaginative architecture of the building is also reproduced in accurate detail, including the doorway leading onto the open roof above the bedchamber and the exterior vestibule at the far left, which served as Zacharias's waiting room in the original but is little more than a decorative adjunct in the *desco*. It is also clear that the inclusion of a seascape with an oversized sailing ship at the top of the *desco* is not a veiled reference to the occupation of the child's father or in any other way meaningful, as it is again a direct replication of an image in Lorenzo Monaco's drawing. Another drawing by Lorenzo Monaco may be presumed to lie behind the design of the verso of the Historical Society *desco*, as a putto in an identical pose occurs in the margins of manuscripts produced by his shop (for example, Biblioteca Laurenziana, Florence; Cod. Cor. 3, fol. 1v).

The evident discrepancy in quality between the painting on the recto and verso of the Historical Society panel is typical of *deschi da parto* in the fifteenth century and can be discerned in almost every surviving example. It is also typical that on the verso many trays portray a large figure of an infant engaged in some emblematic activity, many of which are difficult to interpret today. Though the source, probably a now-forgotten popular saying, and specific meaning of the image on the verso

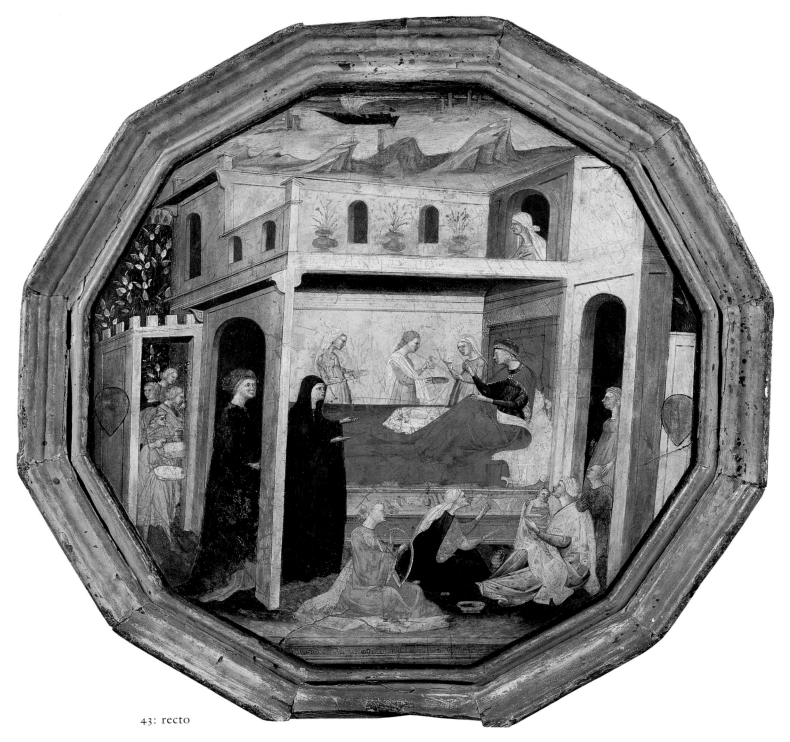

43: recto

of the Historical Society tray is obscure, its general
significance is clearly an augury of good fortune (Pope-
Hennessy and Christiansen 1980, p. 9). Additionally,
however, the putto's stream of gold and silver urine may
have been intended as a pun. The damaged coat of arms
at the right may be reconstructed as that of the Montauri
of Siena. Paolo di Tommaso Montauri was a goldsmith
who served on the board of governors of the Biccherna
(Exchequer) in 1480 (Borgia et al. 1984, pp. 182–83).
Though the family of his mother is unknown and his age

in 1480 is uncertain, it is not impossible that this tray
was commissioned to celebrate his birth. His father,
Tommaso di Paolo Montauri (doc. 1437–1469; Milanesi
1854–56, vol. 2, pp. 174, 278, 292, 328–29; Romagnoli 1976,
vol. 5, pp. 105–7) was also a prominent goldsmith, and
the putto's valuable urine may therefore have been a
pointed reference to the source of the family's future
security.

The attribution of the Historical Society *desco da parto*
to Bartolomeo di Fruosino was correctly established by

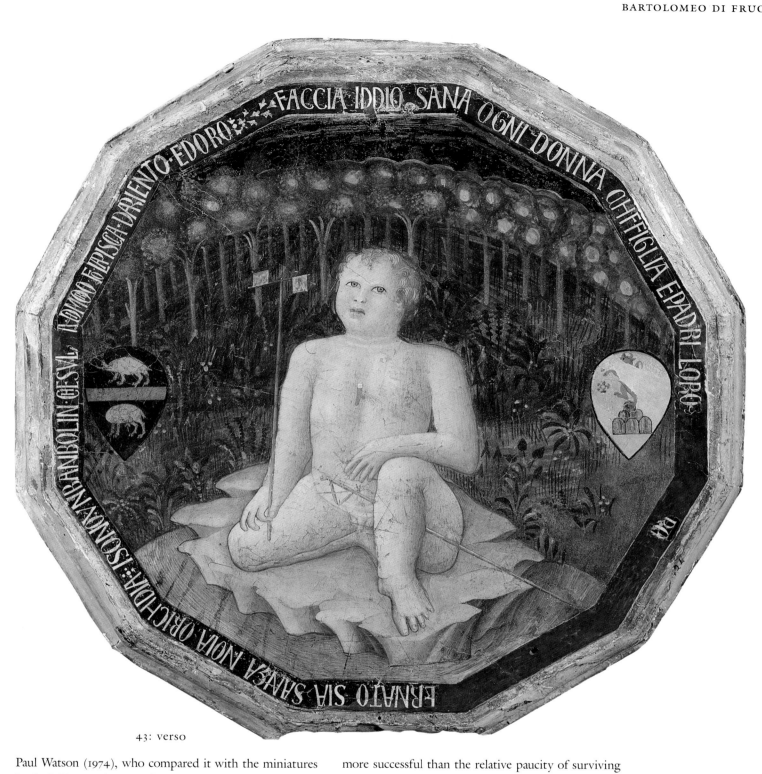

43: verso

Paul Watson (1974), who compared it with the miniatures in Cod. F 72 at the Bargello, one of the volumes of a gradual painted by Bartolomeo for Santa Maria Nuova probably after 1421. It is one of only a few known paintings on panel by the artist but may be the unique surviving example of what must have been a flourishing practice alongside his better-documented work as a miniaturist—providing painted narrative panels for a domestic market. From his tax declarations (Levi D'Ancona 1961a, p. 83), Bartolomeo appears to have been more successful than the relative paucity of surviving works by him might imply, and he is likely, furthermore, to have enjoyed something of a reputation for works of the genre of the Historical Society birth tray if it is true that the order for it came from a Sienese family.

The Historical Society *desco* also provides visual evidence confirming the implications of published documents (Levi D'Ancona 1962, p. 48) that Bartolomeo di Fruosino operated not as an independent craftsman but as the head of a workshop. This workshop, which he

shared with his younger brother Giovanni, included a kiln. As Giovanni is variously described as "scalpellatore" (sculptor) and "dipintore" (painter), it is possible that in addition to panel paintings and manuscript illuminations the workshop produced pigmented terracotta reliefs for private devotion. No basis for distinguishing the artistic personality of Giovanni di Fruosino has yet come to light, but he may have been the assistant responsible for painting the reverse of the Historical Society *desco*. The same hand may be identifiable alongside Bartolomeo's among the illuminations in the Dante codex at the Bibliothèque Nationale (cat. no. 44), which is datable close in time to the *desco da parto*, probably to the early 1430s.

LK

EX COLL.: Alexis-François Artaud de Montor, Paris (by 1843); J. J. Bryan, New York.

LITERATURE: Watson 1974 (with previous literature); Pope-Hennessy and Christiansen 1980, pp. 6–9, figs. 4, 5.

44. The Inferno, from *The Divine Comedy* by Dante Alighieri

Tempera, gold, and silver on parchment; 103 folios; page size, 14 3/8 × 10 3/8 in. (36.5 × 26.5 cm). Single text column framed by commentary

Bibliothèque Nationale, Paris; Département des Manuscrits (MS ital. 74)

The Paris codex contains the text of the *Inferno*, the first of the three books of the *Divine Comedy*, the masterpiece of the Florentine poet Dante Alighieri (1265–1321) and the most widely illuminated book of medieval literature. In a series of individual sections, each called a canto, Dante tells of a vision, his own spiritual odyssey, that took place between Maundy Thursday and Easter Sunday in 1300. Guided by Virgil as his classical mentor, he visits Hell, passing through each of nine circles to reach the mountain of Purgatory; there he meets his beloved Beatrice Portinari, who transports him to Paradise. Weaving Christian theology with overripe, sometimes scatological, images of illicit pleasures and grisly punishment involving historical, mythical, and contemporary figures, the *Inferno* understandably quickly attracted both commentary and illustration.

The Paris codex, containing the *Ottimo* commentary,[1] begins with two full-page illuminations. On folio 1v, which is edged by painted blue borders trimmed slightly at the top, Dante and Virgil stand within the doorway of Hell at the upper left and observe its nine different zones. Despite the losses of paint at the lower left and in the figures at the lower right, the overall intensity of this lurid vision is in no sense diminished. Dante and Virgil are to wade through successive circles teeming with images of the damned. The gates of Hell appear in the middle, a scarlet row of open sarcophagi before them. Devils orchestrate the movements of the wretched souls, including such figures as Paris and Helen, Tristan and Isolde, as well as groups of heretics.

In the second full-page miniature, on folio 2v, the palette and composition are utterly distinct. Dante, in a plum-colored gown and hood, is pursued by the three beasts in a darkling wood full of rocky promontories, though neither the landscape nor the beasts seem terribly threatening. Higher in the same picture plane, Dante encounters Virgil.

Canto 1 begins on folio 3r with a portrait of Dante in his study in a foliate and gilt initial N ("Nel mezzo del cammin di nostra vita" [In the middle of the journey of our life]). Surrounded by manuscripts, the poet sits at a slant-top desk, holding pen and scraper and writing in a bound volume open before him, like a medieval figure of an Evangelist or Father of the Church. The borders of the page, alive with birds, climbing roses, a putto chasing a butterfly, and golden sheaves of wheat, are decorated with seven lozenges containing classicizing personifications of the seven Liberal Arts, with their chief protagonists seated at their feet. Reading clockwise from upper left, they are: Geometry (Euclid), Arithmetic (Pythagoras), Logic (Aristotle), Astronomy (Ptolemy), Grammar (apparently Priscian, the name partly effaced), Rhetoric (Tulius, for Marcus Tullius Cicero), and Music (Tubal-chain, or -cain). A lozenge at the bottom center of the page contains a coat of arms consisting of a pair of interlocking silver horseshoes, one inverted, that pierce a field of brocaded red fabric. Each of the thirty-two remaining cantos is preceded by a square or rectangular scene with an often graphically detailed vision of Hell described in the text that follows.

The full-page illumination of Dante in the wilderness on folio 2v is a later addition to the manuscript, as is the coat of arms at the bottom of folio 3r. Both were probably added at the same time, when the book was rebound and folio 2 was added as a bifolium. Its first leaf left blank, the bifolium was wrapped around the slightly larger folio 1, the clipped border of which is pasted down along the edge of folio 2r. François Avril has identified the coat of arms as those of Jean Cossa, count of Troia, who was present at the court of René d'Anjou and a

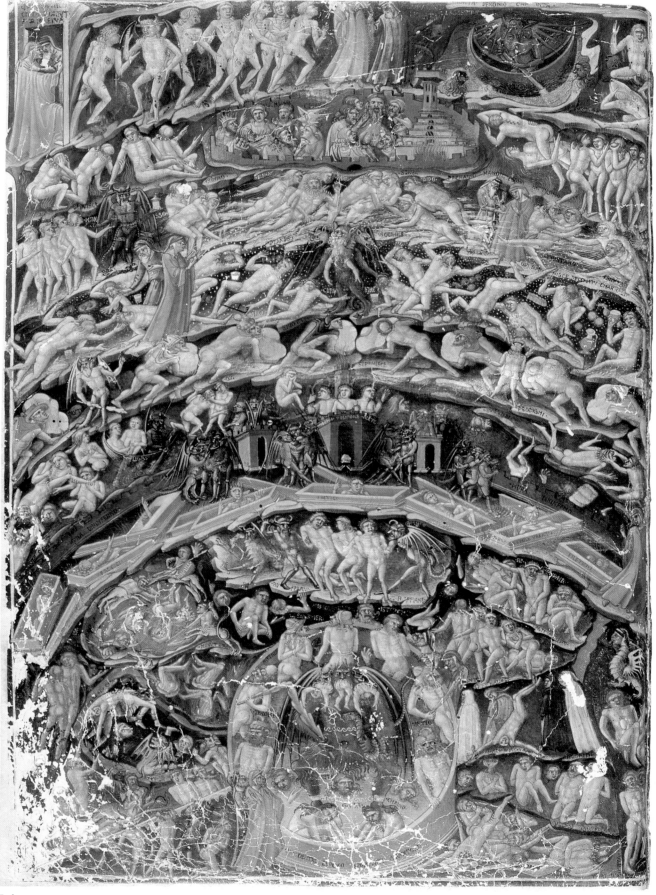

Fol. IV

member ("senateur") of the Ordre du Croissant.[2] The rebinding of the manuscript and insertion of the illumination of Dante in the wilderness must date after 1449, the year of the founding of the Ordre du Croissant, and probably to about 1458, when Jean Cossa is known to have been in Florence.

Originally the full-page illumination of Dante and Virgil surveying the topography of Hell on folio 1v probably faced the author portrait on folio 3r, following a standard scheme for manuscripts of the *Divine Comedy*. Both are autograph works by Bartolomeo di Fruosino, whose hand Peter Brieger and Millard Meiss first identified in this manuscript. The vision of the fiery inferno follows a convention established by Nardo di Cione's fresco in the church of Santa Maria Novella, Florence. Of remarkable vivacity and intensity of expression (hardly the "dry version of Monaco's style" signaled by Brieger and Meiss), they are executed in Bartolomeo's late style—after the 1428 *desco da parto* (cat. no. 43) and close to the 1435 missal in Prato (cathedral, Cor. C).

Cantos 2 (fol. 6r: Virgil shows Dante the Three Ladies) and 3 (fol. 9r: The lukewarm souls, stung by insects, run ceaselessly behind a banner, while Charon ferries souls across the river Styx) were both illuminated by Bartolomeo. Both scenes are deployed in square picture fields with gilt borders. At the bottom of folio 10v is a catchword, which was partly cut off during a later rebinding: "E 'l duca [lui: 'Caron, non ti crucciare']" (And my Leader: "Charon, do not torment thyself" [Inf. 3.94]). Folio 11r begins a section written in a smaller hand than the first ten folios, with prickings for line spacing (the first section is only pricked on folios 8 and 10). This second section, through folio 58v, comprises sixteen cantos, all of which were illuminated by an artist other than Bartolomeo, an artist who also seems to have been responsible for the illuminations in two other Dante codices: Biblioteca Nacional, Madrid, MS vit. 23–2 and Biblioteca Nazionale, Florence, MS palat. 320.[3] The picture fields are all rectangular rather than square and vary in size. None of them employs gold or silver leaf. The figure style and facial types are coarse, the attitudes stiff, the narrative rudimentary, and the stage-like treatment of landscape and space summary and

approximate. A second catchword appears at the foot of folio 58v: "Di nuova pena [mis conven far versi]" (Of new pain I must make verses [Inf. 20.1]). The scribe and pricking system continue uninterrupted through the third section to the end of the volume. All the illuminations in this last section are again the work of Bartolomeo, again square in format, and more imaginative in composition. These illuminations are also characterized by the liberal use of gold and silver, as in the image of Dante and Virgil observing four giants in a well, whose water is of silver leaf.

The explicit marking the end of the first book of the *Divine Comedy* appears on folio 103v; companion volumes of the *Purgatorio* and the *Paradiso* have not been identified. While a number of illustrated Dante manuscripts, especially of the fourteenth century, have illuminations only for the *Inferno* (Brieger, Meiss, and Singleton 1969, p. 46), it is also possible, given the late date of this manuscript for Bartolomeo, that the two subsequent volumes were painted by a different artist altogether.

BDB

1. Fifteen commentaries were written between about 1330 and 1440, the first by Dante's son Jacopo. The *Ottimo* commentary was written in Florence, probably before 1340 (see Brieger, Meiss, and Singleton 1969, p. 83).

2. The identification was first made in Paris 1984, no. 96, p. 114. The arms appear in a manuscript of all the senators in the order, Bibliothèque Nationale, Paris, MS fr. 25204, folio 51v. It also appears on the upper and lower covers of the leather binding of Leonardo Bruni's *Epistolae Platonis*, a Florentine manuscript of the third quarter of the fifteenth century (Bibliothèque Nationale, Paris; MS lat. 8656). We are grateful to François Avril for the information.

3. The illustration to canto 1 in both of these books is based on a drawing by Bartolomeo (Biblioteca Laurenziana, Florence; MS Plut. 40, 16, fol. 1v).

LITERATURE.: Colomb de Batines 1845–46, vol. 2, no. 419, p. 223; Auvray 1892, pp. 72–83, no. 30; Pope-Hennessy 1947, pp. 11–12, fig. IV; Salmi 1954b, pl. LVIII; Hughes 1959, p. 34; Offner 1960, p. 51; Levi D'Ancona 1961a; idem 1962, pp. 44 ff.; Salmi 1962, p. 178; Degenhart and Schmitt 1968, p. 284, fig. 389a; Brieger, Meiss, and Singleton 1969, pp. 314–16; Paris 1984, no. 96, p. 114, fig. p. 113, pl. XVII.

LIPPO D'ANDREA DI LIPPO

Virtually an exact contemporary of Lorenzo Monaco and nearly as prolific as the Camaldolese master, Lippo d'Andrea represents one of the more conservative trends in Florentine painting of the first third of the fifteenth century. He was born in 1370 or 1371 and enrolled in the Compagnia di San Luca in 1411, the same year that he received a commission, along with Niccolò di Pietro Gerini, Ambrogio di Baldese, and Alvaro di Pietro, for the fresco decoration of the facade of the Palazzo del Ceppo in Prato. An undocumented tradition assigning the frescoes in the Nerli Chapel at Santa Maria del Carmine, Florence, to a painter named Lippo in 1402 has reasonably been connected with Lippo d'Andrea (Padovani 1979), and it must be assumed that, like Lorenzo Monaco, he was active at least as early as the last decade of the fourteenth century. The only other notice referring to Lippo d'Andrea in connection with a work of art is of 1435–36, when he was selected along with Bicci di Lorenzo, Giovanni dal Ponte, and Rossello di Jacopo Franchi to paint frescoes of the apostles in the tribune chapels of Florence cathedral on the occasion of Pope Eugene IV's consecration of the newly completed dome (Procacci 1984). By 1442 Lippo d'Andrea had ceased painting, and in his tax declaration of 1447 he claimed to be unable to earn a living by his craft. The artist was dead by 1451.

The artistic personality of Lippo d'Andrea was unknown to art historians until recently, when he was convincingly identified with a painter otherwise known only as the Pseudo-Ambrogio di Baldese. This painter had first been isolated by Osvald Sirén (1909, p. 325; 1916, pp. 57–62; 1917, no. 45), who mistakenly believed him to be Ambrogio di Baldese, a late trecento master responsible for the ruinous and nearly illegible fresco decoration on the facade of the Palazzo del Bigallo, Florence. Raimond van Marle (1923–38, vol. 3 [1924], p. 612; followed by Offner 1927, p. 90) first recognized him as a fifteenth-century painter whose career must have run parallel to that of Bicci di Lorenzo and proposed calling him the Pseudo-Ambrogio di Baldese. Significant additions to his oeuvre were put forth by, among others, Georg Pudelko (1935, pp. 83–89), Federico Zeri (1963), and Miklós Boskovits (1979), establishing a considerable body of work on both a monumental and intimate scale by a competent if not innovative painter who must have enjoyed considerable success and esteem during his lifetime. An attempt by Enzo Carli (1971) to identify this master with Ventura di Moro (1395/1402–1486) was rejected by Boskovits (1979) and corrected to Lippo d'Andrea by Serena Padovani (1979) and Ugo Procacci (1984).

Though a decidedly minor master by comparison with his better-known contemporaries Lorenzo Monaco or Fra Angelico, Lippo d'Andrea may have been at least as successful as they commercially, to judge from the great numbers of his works surviving today and the relatively prestigious nature of some of his commissions. As with another of his better-known, if not in this case artistically more significant, contemporaries, Bicci di Lorenzo, the demand for his work indicates the strength of a lingering conservative taste in Florence that parallels the taste for Pacino di Bonaguida's manuscript illuminations at the beginning of the preceding century. Within the varying idioms of their respective ages, both artists' works are characterized by a competent craftsmanship, an easy narrative legibility, and a charming blend of modern and traditional stylistic traits calculated to appeal to a discriminating if unadventurous sensibility. A gauge of the increasing specialization attendant upon the expansion of the Florentine art market in the early fifteenth century is the predominance of panels for private devotional use in Lippo d'Andrea's output, compared with their relative scarcity in Pacino's. Conversely, where Pacino practiced with equal ease (and with comparable demand) in all media, only one manuscript illumination by Lippo d'Andrea (cat. no. 45) has to date been identified.

LK

45. The Annunciation; Saint Bridget and a Choir of Bridgettine Nuns

Tempera and gold leaf on parchment
21 7/8 × 14 5/8 in. (55.5 × 37 cm)

Bernard H. Breslauer, New York

The large, full-page illumination is divided into two scenes by a red frame painted as fictive moldings receding into depth. In the upper scene the Annunciation takes place within a two-story Gothic palace extending the full width of the picture field. The Virgin Mary, at the right, is seated within her bedchamber, a groin-vaulted room framed by arched openings and fitted with a curtained alcove for her bed at the rear. The Annunciatory Angel, in pink robes, kneels with his arms crossed on his chest in a broad, open vestibule at the left, while above, against a dark blue sky, God the Father is held aloft by three red seraphim; golden rays and the dove of the Holy Spirit descend from his upraised hand to the Virgin below. The lower scene is set in the nave of a church, with a row of Gothic bifora ranged along its back wall and an altar table set within a semicircular apse chapel at the right. Saint Bridget, dressed in a dark gray habit with a white wimple and veil, stands at the left. She holds a red processional cross, symbol of the Bridgettine convent of Santa Maria del Paradiso (see Manni 1739–86, vol. 28, p. 81), in her right hand, and a long unlettered banderole in her left, possibly meant to represent the rule of her order. Nine Bridgettine nuns, distinguished by their light gray habits, white wimples, black veils, and characteristic headpieces with five red dots symbolizing the wounds of Christ, are situated in the center of the composition, clustered before a lectern. The nuns appear to be chanting the Divine Office, as one of them steps up to the lectern to turn the page of a large choir book propped open on it.

Saint Bridget (ca. 1304–1373), a Swedish noblewoman, renounced her ties to the Swedish court (hence the crown lying at her feet in the present miniature) for a life of pilgrimage and devotion after being widowed in 1344. She was a prolific writer, her account of many of her mystical visions in the *Revelations* becoming an influential source for later fourteenth- and fifteenth-century painters, and a tireless crusader for the foundation of a strictly cloistered order of nuns, though she herself never professed monastic vows. The rule of the Order of the Holy Savior, also known as the Bridgettines, was approved by Pope Urban V in 1370, and Saint Bridget was canonized by Boniface IX in 1391. The only Bridgettine house in Tuscany, and the third house founded by the order, was

established in 1394 at Santa Maria del Paradiso in the Pian di Ripoli with an endowment from the Alberti family (Moreni 1791–95, vol. 3. pt. 5, pp. 127ff.). The first nuns entered the convent in 1395, but they abandoned the premises a few years later with the exile from Florence of their patron Antonio di Niccolò degli Alberti and the confiscation of his properties, including the land and buildings of the Paradiso. The monastery was reestablished, however, in 1401, and significantly expanded between 1404 and 1408 under the protection of the Florentine Republic and the Guelf party, quickly becoming one of the principal houses of the order.

The Breslauer page was formerly the frontispiece to a Bridgettine gradual written, presumably after 1401, for the convent of the Paradiso. The gradual, which was last recorded in a sale at Sotheby's, London, June 24, 1986, lot 121 (previously Christie's, London, July 17, 1985, lot 302; Voelkle and Wieck 1992), is a composite book of fifteenth-, seventeenth-, and eighteenth-century leaves bound together and inscribed on its title page: . . . *per uso delle RR monache de Paradiso fatte ristaurare . . . e scritto da me P. Bernardino Zanobini l'anno 1713* (. . . for the use of the reverend sisters of the Paradiso, restored . . . and written by me, Father Bernardino Zanobini, in the year 1713). One of the historiated initials still in the book, an R ("Rorate celi de super") with Two Kneeling Saints Adoring a Vision of the Swaddled Christ Child in a Mandorla—an unusual visual formulation for the Incarnation, more typically represented at this period by the Annunciation (which is also portrayed on the Breslauer page)—was painted by the same artist as the Breslauer cutting. This artist was first identified as Lippo d'Andrea by Miklós Boskovits (oral communication), an attribution that has been confirmed by Everett Fahy (*in litteris*).

A date for the Breslauer page and the gradual of which it formed part can be established with only relative certainty, as no mention of such a commission is preserved among the early records of the Paradiso (see Bacarelli, in Gregori et al. 1985, pp. 96ff.). Dated works by Lippo d'Andrea are scarce, and as they are frescoes, they are not directly relatable to the illuminations, even though the latter are effectively conceived as scaled reductions of monumental compositions. Each of the scenes on the Breslauer page is approximately the size of a painted predella panel and thus may be compared favorably with one of Lippo d'Andrea's most accomplished efforts as a panel painter: an unidentified Camaldolese altarpiece's predella representing Saint Benedict and the Annunciation (Statens Museum for Kunst, Copenhagen), the Nativity (Pinacoteca Vaticana; fig. 124), and Saint Romuald (Philbrook Art Center, Tulsa; cor-

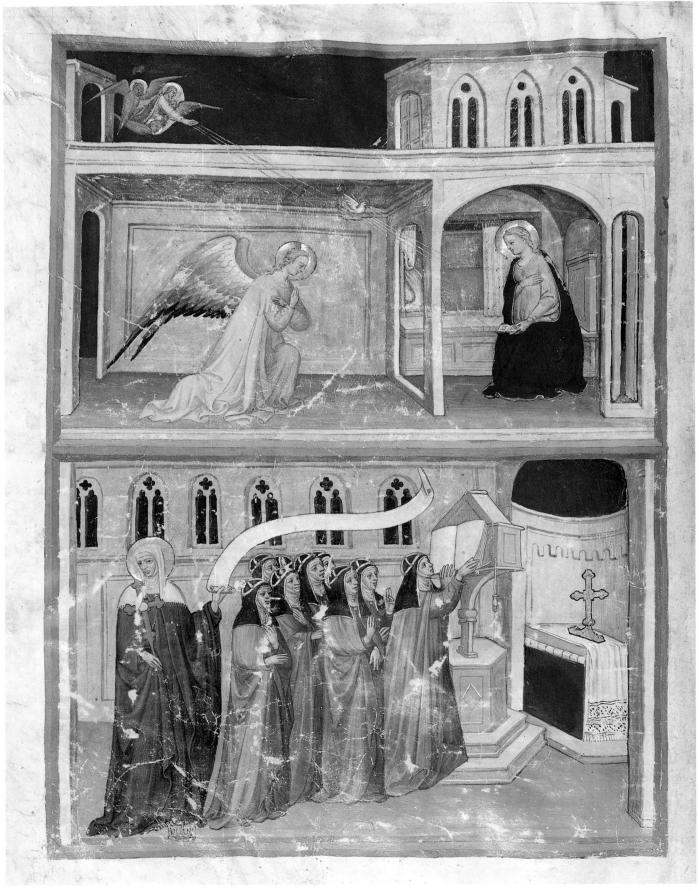

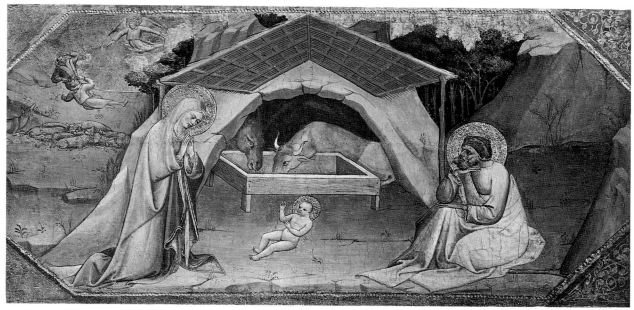

Figure 124. Lippo d'Andrea, *Nativity*. Pinacoteca Vaticana, Vatican City (194)

rectly attributed to Lippo d'Andrea by Pudelko 1935, and Zeri 1963, and reproduced in Eisenberg 1989, figs. 255, 256, 258, as "Imitator of Lorenzo Monaco"). The dependence of these images on the late works of Lorenzo Monaco makes improbable a date for them earlier than 1420, and a date much later than 1430–35 is rendered equally unlikely by their resemblance to paintings of the period (such as the predella to an altarpiece dated 1430 in the Pinacoteca Nazionale, Siena) by Bicci di Lorenzo, to whom the Breslauer page was formerly attributed (Kanter, cited in Voelkle and Wieck 1992, p. 196).

Though the gradual of which the Breslauer page formed part is, as mentioned, undocumented, at least two events of the 1420s and 1430s could have led to its commission at such a distance of time from the founding of the convent. In 1425, under the abbacy of Suor Margherita di Domenico d'Agnolo Riccoldi da Montevarchi (Manni 1739–86, vol. 10, p. 70), two members of the community at the Paradiso were requested by Pope Mar-

tin V, at the petition of Duchess Catherine of Bavaria, to establish a new Bridgettine house in Germany (Moreni 1791–95, vol. 3, pt. 5, p. 147), for which new choir books may have been requested. More likely an occasion for its commission, however, was the decision in 1432, under the abbacy of Suor Tommasa di Filippo da Diacceto, to construct a new monastery and chapel for the Bridgettines within the city walls, alongside the church of San Pier Gattolino near the Boboli Gardens. The cornerstone of the new monastery, to be called Santa Maria del Popolo, was laid in 1435, and though the building was never completed (Manni 1739–86, vol. 28, pp. 84 ff.), over two thousand florins were spent on its construction and furnishings. This possibly included a gradual for officiating at Mass in the new chapel.

LK

LITERATURE: Voelkle and Wieck 1992, pp. 196–97.

FRA ANGELICO (GUIDO DI PIETRO; FRA GIOVANNI DA FIESOLE)

Guido di Pietro, universally known as Fra Angelico, was born in the Mugello near Florence at an uncertain date, probably about 1400. He is first mentioned in a document of 1417, when he registered for membership in a religious confraternity named San Niccolò di Bari. The document calls him a frate, or brother, but does not state at which convent. The registration also gives his residence as Florence and his profession as painter. Furthermore, an addition to the entry informs us that he later became a Dominican friar in the Observant convent of San Domenico, Fiesole. The following year Angelico was paid for a now-lost altarpiece for the church of Santo Stefano al Ponte, Florence. This commission suggests that he was an independent artist. However, he had not enrolled in the painters' guild possibly because he soon entered San Domenico. He is first recorded as a friar there only in 1423.

None of Angelico's early works are documented. They most likely reflected the style of his probable master, Don Lorenzo Monaco. The picture that best fits that bill is the *Thebaid* (fig. 16) in the Uffizi, Florence, which has often been erroneously attributed to Gherardo Starnina. It was initially cited in 1492 as in the Medici palace and as by Fra Angelico. The first work that can actually be documented is a small *Saint Jerome* (fig. 19) of about 1424, in the Princeton University Art Museum, which belonged to Angelo di Taddeo Gaddi and his wife Maddalena Ridolfi.

As a friar Angelico divided his time between religious duties, which early sources mentioned he never neglected for painting; the decoration of his new convent of San Domenico; and outside commissions. His first large-scale work must have been the triptych made for the high altar of the convent (fig. 17). The principal figures in it reflect the manner of Lorenzo Monaco, while his subsequent works show the influence of Masaccio—Angelico's near-contemporary, who in the mid-1420s transformed Florentine painting as well as prevailing notions of what the aims of painting itself were. Angelico seems to have been with him step-by-step. The triptych made for the new Dominican Observant nunnery of San Pier Martire (fig. 18) evinces an awareness of Masaccio's early modes, whereas works that come in the late 1420s or early 1430s, such as the *Coronation of the Virgin* (fig. 22) in the Louvre, also originally in San Domenico, are veritable homages to the then-deceased Masaccio. The latter picture is the first truly modern altarpiece made in Florence, with its heavenly scene staged in a rationally measured three-dimensional environment.

Part of Angelico's achievement must also be gauged in relation to his dealings with the sculptor Ghiberti, who probably provided suggestions and models for him. They collaborated closely on at least one work—the tabernacle for the Linen Workers' Guild of 1433–36, now in the Museo di San Marco. Besides planning the frame, Ghiberti was also behind the design of the large-scale saints on the exterior of the wings.

The *Coronation of the Virgin*, the Linen Workers' tabernacle, the *Deposition* for the Strozzi Chapel in Santa Trinita, the *Last Judgment* for Santa Maria degli Angeli, and the *Annunciation* altarpiece for the Dominican Observant convent in Cortona testify to Angelico's preeminent position as the most modern painter in Florence in the years immediately following Masaccio's death. These pictures embody many of the ideas that impressed the architect Leon Battista Alberti when he was finally able to visit Florence and describe the city's achievements in the field of painting in the first theoretical tract ever written on the subject.

In Angelico forms are created with a sense of volume that is defined through light. Figures are placed in rational spaces based upon the new ideas of mathematical perspective put forward by Filippo Brunelleschi. Angelico was the first artist after Masaccio to take full account of this new science. He employed it as a way of constructing a boxlike stage for his measured narrative scenes, which he distilled to their bare essentials. However, human emotion has rarely met with such a spiritual underpinning and religious stories given such human understanding in the visual arts.

In two important paintings of the 1430s, the Annalena and San Marco altarpieces, Angelico created the first Renaissance *pale quadrate* — altarpieces that are windows on a new world which is square in shape and in which all Gothic paraphernalia has been abandoned for a classicizing architectural framework. These are known as *sacre conversazioni*, or sacred conversations, because the saints and the Virgin and Christ child are gathered together in unified spatial settings as if in silent communion with one another.

Angelico's accomplishments as an artist-theoretician cannot be separated from his equally important role as an artist-theologian. He intimately identified with the religious aims of the Observants, adherents to a rigorous, reform, "back-to-the-origins" branch of the Dominican order. Angelico served several times in administrative posts and was undoubtedly wrapped up in the order's politics. His great colleague Antonino Pierozzi, who would go on to become Florence's archbishop, probably acted as a sort of sounding board for the theological aspects of Angelico's painting. We know from Pierozzi's own writings that he was much concerned with the iconography of religious art. The two had their greatest opportunity to expound these ideas in the decoration of the Observants' new Florentine convent of San Marco, which, with Cosimo de' Medici's help, the order took over in 1436. Angelico provided the above-mentioned altarpiece for the church and frescoed the friars' cloister, chapter house, and cells. The cell frescoes represent the purest crystallization of Dominican concepts regarding the use of art as a catalyst for prayer and meditation.

Once the great undertaking of San Marco was over, Angelico worked in Rome, frescoing several chapels in the Vatican for Pope Nicholas V, of which one chapel—dedicated to the deacon saints Stephen and Lawrence—still survives. He also started a chapel in Orvieto cathedral, which was later completed by Luca Signorelli. While Angelico's workshop became an increasing presence in the last decades of his life and certain personalities like Benozzo Gozzoli and Alesso Baldovinetti emerge from it as individuals, Angelico probably relied throughout his career on a large group of collaborators. Such was the case whether he worked in Florence, Rome, Orvieto, or even Cortona and Perugia. There is no reason to imagine that the affairs of this artist-friar were conducted in any less businesslike a way than those of the many artist-artisans who populated the Florentine scene at the same time.

Fra Angelico died in Rome in 1455. The name that we commonly know him by, Fra or Beato Angelico, did not come into use until after his death. It was coined in homage to his supposedly seraphic qualities as a man and a painter.

CBS

46. The Crucifixion

Tempera and gold on panel
25 ¼ × 19 ¼ in. (64 × 49 cm), overall

The Metropolitan Museum of Art; Maitland F. Griggs
Collection, Bequest of Maitland F. Griggs, 1943 (43.98.5)

The Crucifixion entered Maitland Fuller Griggs's collection as a work by Masolino. It had also been attributed to a garden variety of artists: Giottino, Rossello di Jacopo Franchi, Pietro or Ambrogio Lorenzetti, and Archangelo di Cola da Camerino. In 1933 Richard Offner grouped a number of works around an artist whom he appropriately named after this picture, the Master of the Griggs Crucifixion. The artist was considered a proponent of the style of Gentile da Fabriano and Masaccio in Florence in the mid-1420s. In 1966 Luciano Bellosi identified several of the paintings in Offner's group as parts of a documented altarpiece painted by Giovanni Toscani (d. 1430) in 1423–24 for the Ardinghelli family's chapel in the church of Santa Trinita. The Ardinghelli were in-laws of Palla Strozzi, who at this very time hired Gentile da Fabriano to paint the altarpiece for his chapel in the same church. Toscani was much affected by Gentile's work—especially the way he treated flesh, giving it a ductile quality by modeling with layers of subtly differentiated colors (Angelico does the same in his early work, frequently ending up with rosy cheeks). In other works slightly later than the Ardinghelli altarpiece, Toscani evinces the influence of Masaccio. Toscani attracted very important patrons. He is recorded as painting altarpieces for Guidantonio Montefeltro of Urbino and Simone Buondelmonti, brother of Lorenzo, who had gone to Hungary with the painter Masolino. He also painted a picture of the Doubting Thomas for the courthouse of the Mercanzia, where commercial disputes were settled. The Griggs *Crucifixion* fits well into the pattern of Toscani's career for its seeming reminiscences of Gentile da Fabriano. Marvin Eisenberg (1976), in his article attributing the Princeton University Art Museum's *Penitent Saint Jerome* (fig. 19) to Toscani, made many comparisons with this picture. Certain figures derive from Gentile's Strozzi *Adoration* of 1423, particularly the man holding a pole with a sponge to the left of the cross and the soldier with tartar features next to him. Indeed, the groupings of the figures seem very influenced by the *Adoration*.

A recent reconsideration of Giovanni Toscani by Bellosi has led him to believe that the Griggs picture is actually by the young Fra Angelico. This opinion has also been put forward by his student Andrea De Marchi. The faces of the soldiers recall figures of the predella, now in the National Gallery in London, from the

triptych in San Domenico, Fiesole. Resemblances can also be found in several of the predella scenes from the Prado *Annunciation* (fig. 21) and the Abegg-Stiftung *Adoration of the Magi* (fig. 125). However, especially in these last two cases, many of the correspondences bespeak the common prototype: Gentile da Fabriano's altarpiece.

Where a Gentile model is less evident, the attribution of the Griggs picture to Angelico becomes more problematic. The fainting Virgin, the Three Marys, and Saint John the Evangelist in the foreground form a group of their own almost separate from the rest of the action in the picture. They seem almost to be by a different hand. The reason for this might be that the group is based upon a specific prototype. I do not know of any that corresponds exactly, but its rather staged quality evokes the Gothic theatricality of Archangelo di Cola, an artist from Camerino in the Marches. He arrived in Florence in 1420 at the same time as Gentile da Fabriano, to whom his own style is indebted. Archangelo's lost work for the chapel of Ilarione Bardi in Santa Lucia dei

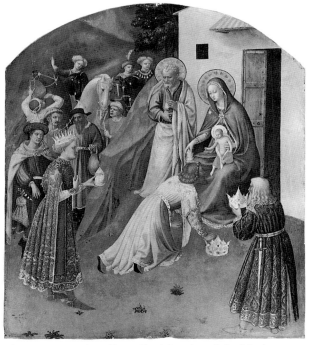

Figure 125. Fra Angelico, *The Adoration of the Magi*. Abegg-Stiftung, Riggisberg (14.127.75)

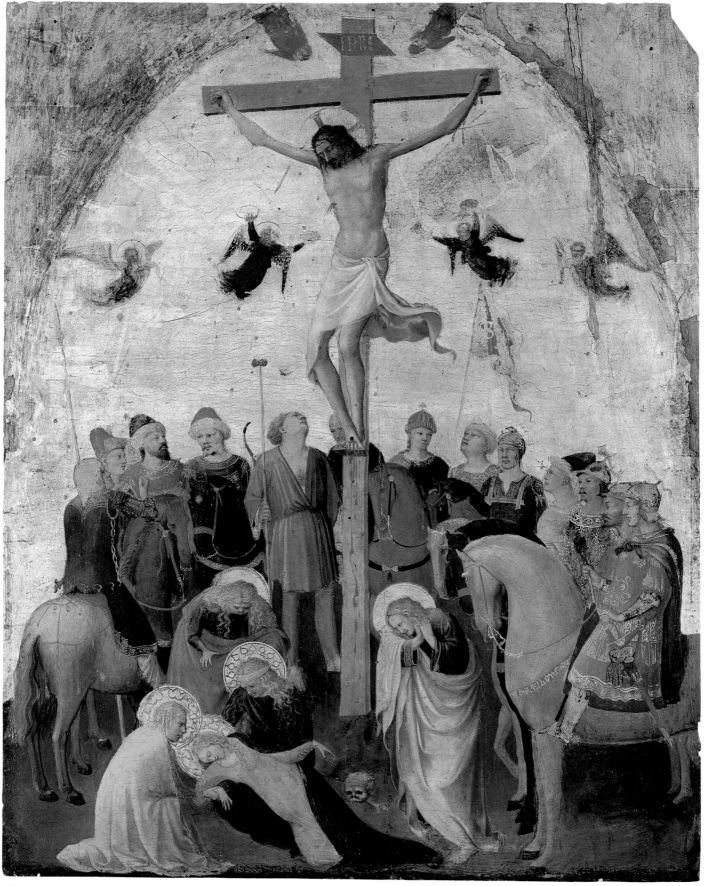

46

Magnoli was completed in 1422. This apparently gave Florentine artists a preview of what Gentile would do in the Strozzi *Adoration* altarpiece completed the following year, 1423. Very possibly as the soldiers in the Griggs *Crucifixion* reflect Gentile, the mourners may be based on or inspired by a lost Archangelo. For example, Archangelo's predella panel showing the Entombment of Christ (last recorded in a Florentine private collection; Longhi 1940 [1975], fig. 67b) betrays a similar interest in elegantly exaggerated expression. He loves intertwining rhythms that are often more acrobatic than balletic.

The original format of the complex from which the Griggs *Crucifixion* comes is unclear. It seems unlikely that it was part of a large altarpiece. The figures are too diminutive in size for it to have been a pinnacle. One possibility is that it was the center of a triptych or a valve of a diptych. Angelico's *Adoration of the Magi* ($24^3/4 \times 21^1/4$ in. [63×54 cm]) in the Abegg-Stiftung would be a likely candidate for the left-side valve. This panel has been cut down, but the picture surface is about the same size as the *Crucifixion*. The *Adoration* obviously belongs to Angelico's most Gentilesque period. However, it seems to date from slightly later than the *Crucifixion*, and whether the Griggs *Crucifixion* is by Angelico is still an open question.

CBS

EX COLL.: Charles A. Loeser, Florence; Count Gregory Stroganoff, Rome (until 1911); Princess Scerbàtov, Rome (until about 1914); private collection, Rome (until about 1925); [Edward Hutton, London(?)]; Maitland Fuller Griggs, New York (1925).

LITERATURE: New York 1930, no. 21; Chicago 1933, no. 89; Taylor 1944; Bellosi 1966, pp. 44, 57; Zeri and Gardner 1971, pp. 75–77 (with previous literature); Eisenberg 1976, pp. 275–83; Luciano Bellosi, in Milan 1988, p. 196; Andrea De Marchi, in Florence 1990b, p. 85.

47. Predella

(Catalogue Number 47a–c)

The four panels illustrate stories from the legends of the Virgin Mary, the apostle Saint James the Great, Saint John the Baptist, and Saints Francis and Dominic. They were originally painted on a single plank of wood that would have served as a predella supporting the upper section of the altarpiece. A fifth panel of the predella is lost. The altarpiece would have shown the Virgin and child and the same saints whose scenes are depicted in the predella. It is not known from what church it came, but the altarpiece was probably disassembled sometime in the third quarter of the eighteenth century. According to an inscription dated 1786 on the back of the Johnson Collection's panel (cat. no. 47c), it had once belonged to the Anglo-Florentine artist Ignazio Hugford (d. 1778). Hugford was a noted painter as well as a restorer and collector of early Italian paintings. After acquiring the predella, he likely broke it up into independent units. He also seems to have restored it. Each panel has had a strip of wood approximately $^3/8$ inch (1 cm) wide added at the top. This disguises damage that no doubt occurred when the predella was taken apart. The additional strips were painted to simulate Fra Angelico's work.

In 1987 Everett Fahy showed that the four panels belonged together. They not only obviously date to the same period early in Angelico's career, but they all also have similar dimensions, the added strip at the top, and distinctive gold borders with chamfered corners. This last feature is unusual in Angelico's oeuvre. It can only be found in one other work by him, the predella of the Prado *Annunciation* altarpiece (fig. 21). The present predella and that altarpiece must not date too far apart.

X-radiographs mapping the wood grain indicate that the original sequence from left to right was: *The Apostle Saint James the Great Freeing the Magician Hermogenes*, *The Naming of Saint John the Baptist*, *The Burial of the Virgin and the Reception of Her Soul in Heaven*, the missing panel, and *The Meeting of Saints Dominic and Francis of Assisi*. A visual connection in the two left-hand scenes is made in the architecture. The green building at the right in *Saint James Freeing Hermogenes* is the same as that at the left in *The Naming of the Baptist*. The two buildings are also tied together by a common molding.

The panels date to the period just after Masaccio cast his spell over Angelico. The inventive narrative, the studied relationship of the figures to the architecture and the outdoors, and the dominant role of light in modeling figures as well as illuminating architecture are all lessons that Angelico learned from Masaccio's frescoes in the church of Santa Maria del Carmine. Specific derivations from the Brancacci Chapel are detectable in most scenes. It is as if Angelico, Masaccio's most talented student, was still striving to get the professor's attention. Saint James the Great resembles Masaccio's Christ in *The Tribute Money*. The garden wall and the women standing around Zacharias in *The Naming of the Baptist* come from *The Resurrection of Theophilus and Saint Peter Enthroned*, as does the clever circular arrangement that carves out space in *The Meeting of Dominic and Francis*. *The Burial of the Virgin* depends somewhat more on traditional representa-

tions. However, the man at the far right corresponds to a figure from a fresco by Masaccio that is known as the *Sagra*. That fresco, which depicted the consecration of the Carmine, was destroyed about 1598–1600, but drawings after it attest to its impact. One made by the young Michelangelo shows the very same figure that enchanted Angelico (Strehlke 1993a, fig. 8).

The upper part of the altarpiece has not been identified. It has been suggested that a panel showing the apostle James in an unknown location was one of the pieces.[1] However, this is by no means certain. The other saints and the Virgin that would have been in the center are lost or unidentified.[2]

CBS

1. Illustrated in Strehlke 1993a, fig. 5. The dimensions of this panel are 35 × 17 inches (89 × 43 cm).
2. Laurence Kanter (letter dated November 30, 1993) has kindly suggested to me that the fragment of *Christ Blessing* in Hampton Court and *Two Angels* in the Galleria Sabauda, Turin (illustrated in Baldini 1970, figs. 21, 26), may have been the central gable elements of this altarpiece because they add up to about the same width of the predella panel in Philadelphia. They are also of about the same date. It has alternatively been suggested that these fragments came from Angelico's triptych in San Domenico (see cat. no. 49).

47a. The Apostle Saint James the Great Freeing the Magician Hermogenes

Tempera and gold on panel
Overall: 10 × 8⁷/₈ in. (25.4 × 22.5 cm); picture surface:
10 × 8⁵/₈ in. (25.4 × 21.9 cm)

Kimbell Art Museum, Fort Worth (AP 1986.03)

The best-known and complete account of this story is found in the popular *Golden Legend* written by the Genoese archbishop Jacobus de Voragine about 1267 (1941, pp. 369–71). Hermogenes was a magician who had sent a disciple named Philetus to confront James, one of Christ's original apostles. Philetus was won over by James and told Hermogenes such. Angered by his impertinence, Hermogenes cast a spell immobilizing the young man. The touch of James's kerchief released him. This display of power upset Hermogenes even more, and he sent devils to ensnare James. But the apostle turned them on Hermogenes. The devils bound him and pleaded with James for permission to torture him. Instead, James asked Philetus to free Hermogenes as an

act of Christian charity. James gave the magician his own staff as a future safeguard against demons. Shortly afterward Hermogenes was converted to Christ.

Angelico has focused on the most dramatic moment of the tale, when Philetus unbinds Hermogenes. James keeps the devils at bay by pointing his staff toward them.

CBS

EX COLL.: Ignazio Hugford(?), Florence (d. 1778); Comte Lafond, Paris (ca. 1865–79); François, duc des Cars, by descent (1932); [Wildenstein, New York].

LITERATURE: Pope-Hennessy 1974, pp. 18, 196 (with previous literature); Fahy 1987; Strehlke 1993a.

47b. The Naming of Saint John the Baptist

Tempera and gold on panel
10³/₄ × 9³/₄ in. (27.3 × 24.9 cm)

Museo di San Marco, Florence (Uffizi inv. no. 1499)

The painting depicts Zacharias writing down the name of his son John. Zacharias had been struck dumb for doubting an angelic messenger. This angel appeared to him in the temple announcing that his elderly wife would give birth to a child. The Gospel of Luke (1:59–64) narrates what happened after the birth: "And it came to pass, that on the eighth day they came to circumcise the child, and they called him by his father's name Zachary. And his mother answering, said: Not so; but he shall be called John. And they said to her: There is none of thy kindred that is called by this name. And they made signs to his father, how he would have him called. And demanding a writing table, he wrote, saying: John is his name. And they all wondered. And immediately his mouth was opened, and his tongue *loosed*, and he spoke, blessing God."

The scene was traditionally a subsidiary incident in depictions of John's birth. Angelico typically ignores previous iconography in order to be more faithful to the biblical text and to concentrate his representation on one significant moment.

CBS

EX COLL.: Ignazio Hugford(?), Florence (d. 1778); Vincenzo Prati (until 1778); Galleria degli Uffizi (from 1778).

LITERATURE: Florence 1955, no. 16; Vatican City 1955, no. 15; Bellosi, in Uffizi catalogue 1979; Fahy 1987; Berti and Paolucci 1990, no. 84; Strehlke 1993a.

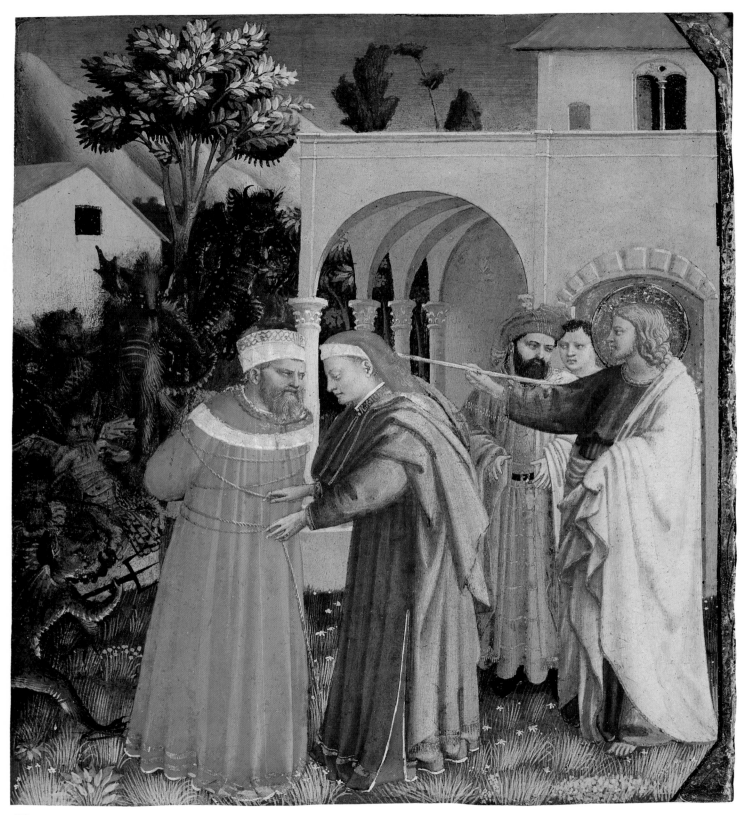

47a

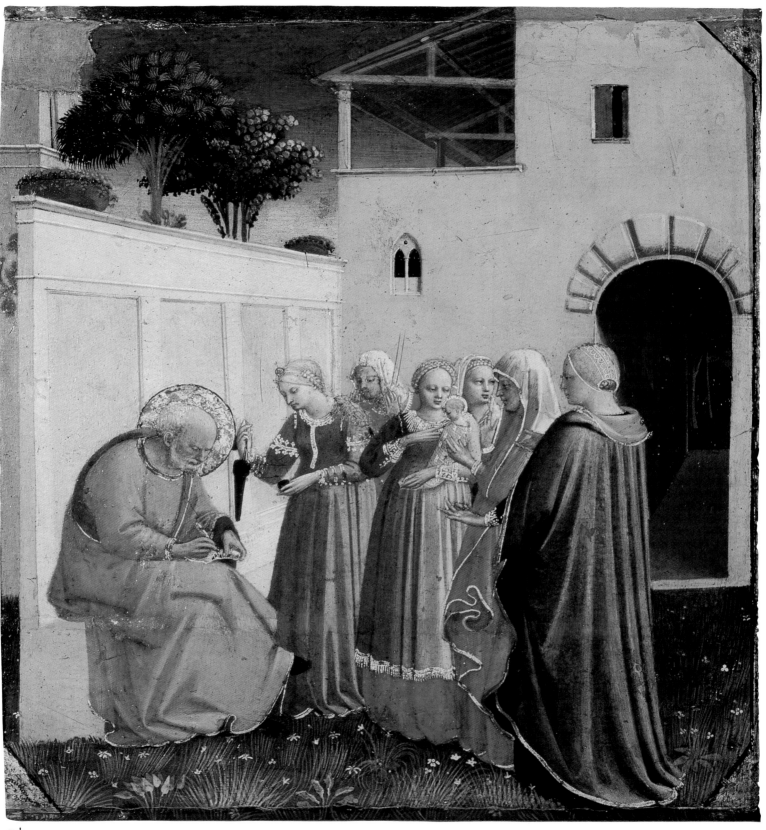

47b

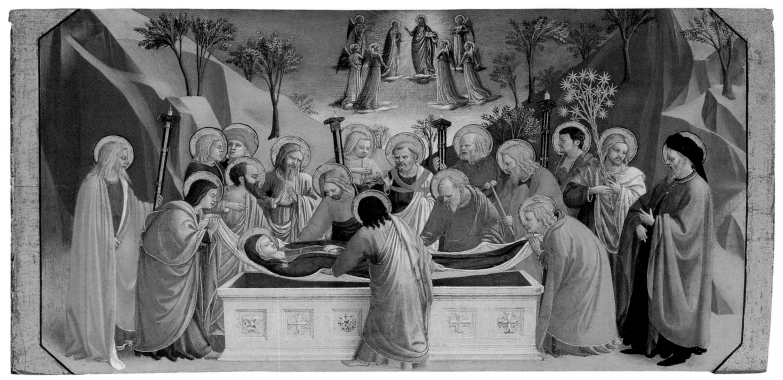

47C

47c. The Burial of the Virgin and the Reception of Her Soul in Heaven

Tempera, gold, and silver on panel
Overall: 10 5/16 × 20 5/8 in. (26.2 × 52.5 cm); picture surface:
9 5/8 × 19 in. (24.5 × 48.2 cm)

Philadelphia Museum of Art; The John G. Johnson
Collection (cat. 15)

The Virgin's body is shown being lowered by four apostles into a tomb. Other apostles and haloed figures, some of whom can be identified, gather around it. In the center the apostle Peter presides over the service. The balding man with a dark pointed beard seen behind the Virgin's head is probably the apostle Paul. At the right the Evangelist John holds a radiant golden palm.[1]

Interspersed with the biblical persons are two figures wearing contemporary fifteenth-century dress. At the far right is an older man clad in a long mantle and a hat typical of Florentine patricians. Another figure, in the left background facing the blond-haired saint in profile, has a red hat, also of contemporary Florentine fashion.

In the sky a heavenly vision is painted in blue tones. The Virgin is seen as a supplicant before Christ. While this may represent the bodily assumption of the Virgin into heaven, which is said to have occurred three days after her burial, it more likely shows the immediate

reception of her soul in heaven. Depictions of her dormition usually included Christ among the mourning apostles taking up her soul in his arms. The soul itself was often imagined as a small doll-like figure. In his other representations of the subject, Angelico bows to this tradition (cat. no. 50). However, the theologian Antonino Pierozzi, who was prior of the convent of San Domenico in Fiesole when Angelico joined, seems to have objected to such depictions. He advocated weeding out unusual or legendary episodes from religious art. For example, he disapproved of images of the Assumption of the Virgin that included the apostle Thomas receiving her girdle. In his *Chronicon*, a world history written in the last twenty years of his life, he also questioned apocryphal tales about the Virgin's funeral, even commenting on the uncertainty of the angelic host's participation. In sermons on the Assumption, Pierozzi emphasized the humbleness of her obsequies and did not acknowledge that Christ came to collect her soul; rather than taking a position himself, he preferred to cite other ecclesiastical sources. The absence of angels or Christ at the interment suggests that Angelico was responding to his prior's concerns for a straightforward religious iconography.

The panel was first attributed to Fra Angelico by Gustav F. Waagen (1837–39, vol. 1). He saw it in the William Young Ottley collection displayed as a Giotto. In

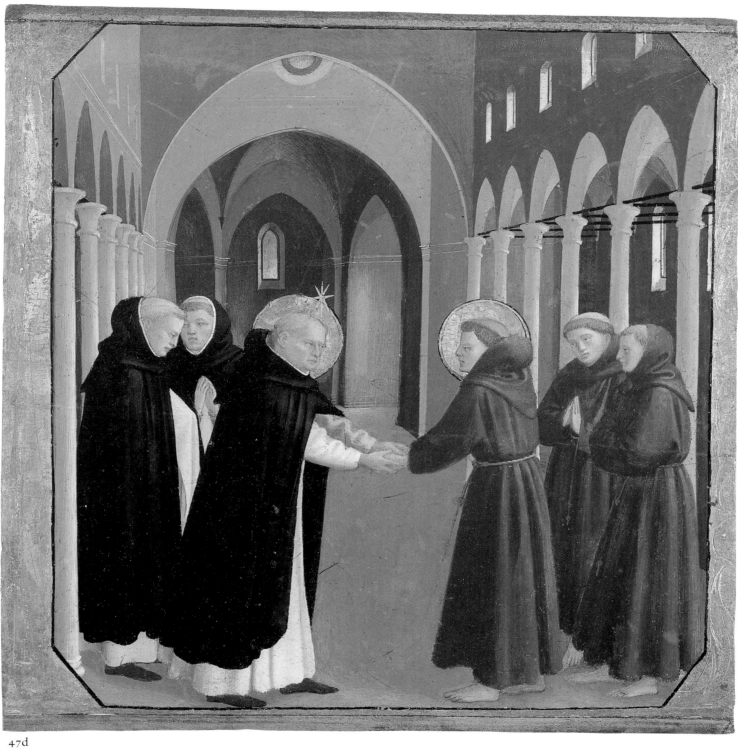

47d

Frida Schottmüller's Klassiker der Kunst monograph of 1911, it was classified as Studio of Angelico. Her opinion was followed in subsequent literature, except for Raimond van Marle (1923–38, vol. 10 [1928]), who judged it a work of Zanobi Strozzi. The painting did not appear in either edition of John Pope-Hennessy's Phaidon monograph (1952 and 1974). In 1987 Everett Fahy recognized it to be the centerpiece of an important early predella by Angelico.

<div align="right">CBS</div>

1. This refers to a story popularized in *The Golden Legend.* When the archangel announced to Mary her imminent death, he brought her a palm branch that "shone with a great brightness" (Voragine 1941, p. 450). Mary later told John that this palm must be borne before her funeral bier. After her death John asked Peter to carry it, but Peter refused, saying that he who was a virgin should bear the Virgin's palm.

Ex coll.: Ignazio Hugford, Florence (d. 1778); Lamberto Gori, Pisa (1789); William Young Ottley, London (d. 1836); Warner Ottley, London; (sale, Foster's, London, June 30, 1847, lot 30 [as School of Angelico], bought in); W. Maitland Fuller, Stanstead House (ca. 1854); [Agnew's, London]; John G. Johnson (1900).

Literature: New York 1944, opp. p. 89; Sweeny 1966, p. 3 (with previous literature); Fahy 1987; Strehlke 1993a.

47d. The Meeting of Saints Dominic and Francis of Assisi

Tempera and gold on panel
Overall: $10^{1}/_{2} \times 10^{1}/_{8}$ in. (26.7 × 25.7 cm); picture surface: $10 \times 9^{1}/_{4}$ in. (25.5 × 23.5 cm)

The Fine Arts Museums of San Francisco; gift of the Samuel H. Kress Foundation (61-44-7 [K289]).

The painting shows Saints Dominic and Francis clasping hands in the empty interior of a church. The story of their meeting was popularized in Jacobus de Voragine's life of Saint Dominic (Voragine 1941, pp. 417–18). One night while in Rome, Dominic dreamed that the Virgin first commended him to Christ and then did the same with Francis. In the dream "Dominic looked earnestly upon his companion, whom he never had before seen. And the next day he saw him in the church, and knew him without further sign, from the things which he had seen in the night. He ran to him and greeted him with pious kisses and embraces, saying 'Thou art my

companion, thou shalt run with me step for step!'" The scene was rarely depicted in earlier art.[1] Angelico and the Observant Dominicans seem to have been much attracted to the tale for its portrayal of the mystical beginnings of their order. In the sanctorale and commons from an Observant gradual (cat. no. 48) the subject is depicted with the Glory of Saint Dominic (fol. 67v). In a predella panel in the Staatliche Museen, Berlin, Angelico also included Dominic's visionary dream (Pope-Hennessy 1974, fig. 49).

The present panel would have been at the far right end of the predella. Indeed, the oblique angle of the church, viewed from the left, was specifically calculated for this position, which closes the predella. The vanishing point of all the scenes is in the center of *The Burial of the Virgin.*

<div align="right">CBS</div>

1. The only example cited in George Kaftal's repertories of saints' iconography is a ruined fresco in the cloister of Santa Croce, Florence, attributed by him to the school of Agnolo Gaddi (Kaftal 1952, cols. 388, 405).

Ex coll.: Ignazio Hugford(?), Florence (d. 1778); Alexis-François Artaud de Montor, Paris (1808–43; sale, Hôtel des Ventes Mobilières, Paris, January 17–18, 1843, lot 129 [as Baldovinetti]); Georges Chalandon, Lyons and Paris; R. Langton Douglas, London (1924); Mrs. Walter Burns, London; Contini-Bonacossi, Florence; Kress collection, New York; on view National Gallery of Art, Washington, D.C. (1941–50).

Literature: Waagen 1837–39, vol. 1, pp. 396–97; Schottmüller 1911, p. 243; van Marle 1923–38, vol. 10 (1928), p. 182; Florence 1955, no. 41; Vatican City 1955, no. 37; Shapley 1966, p. 97 (with previous literature); Fahy 1987; Strehlke 1993a.

48. Sanctorale and Common from a Gradual

Tempera and gold on parchment; 261 numbered folios plus 2 cover leaves; page size, $18^{3}/_{4} \times 13^{3}/_{4}$ in. (47.5 × 35 cm). Pages trimmed at top, bottom, and right side. Pages ruled with 6 staves of 4 lines each; stave height, $1^{1}/_{8}$ in. (3 cm). There are 36 large initials decorated with a tracery pattern in red or blue, measuring on average about $2^{3}/_{4} \times 2^{3}/_{4}$ in. (7 × 7 cm). There are 930 small initials with the same sort of pattern, measuring on average 2×2 in. (5 × 5 cm). In addition, there are 6 initials with a *bianchi girari,* or white vine, decoration. Folios recently numbered in pencil, skipping the folio

Fol. 41v

between 178 and 180. The first 8 folios are later additions. The original red-colored foliation in Roman numerals starts on folio 8. Modern leather binding measuring 19 1/2 × 14 1/2 in. (49.5 × 36.9 cm).

Museo di San Marco, Florence (Cod. 558)

The historiated initials are as follows:

Sanctorale

Folio 9r: The Calling of Peter and Andrew in an initial D ("Dominus secus mare Galilei vidit duos fratres Petrum et Andream" [And Jesus walking by the Sea of Galilee saw two brethren, Simon who is called Peter and Andrew, his brother]), introit to the Mass for the feast of Saint Andrew (November 30).

Folio 11v: Saint Stephen in an initial E ("Et enim sederunt principes et adversum me loquebantur" [For princes met, and spoke against me]), introit to the Mass for the feast of Saint Stephen (December 26).

Folio 13v: Saint John the Evangelist in an initial I ("In medio ecclesiae aperuit os eius et implevit eum Dominus" [In the gathering of the church the Lord opened his mouth and filled him]), introit to the Mass for the feast of Saint John the Evangelist (December 27).

Folio 16r: The Martyred Innocents in an initial E ("Ex ore infantium Deus et lactentium perfecisti laudem" [Out of the mouths of babes and sucklings, O God, you have fashioned praise]), introit to the Mass for the feast of the Holy Innocents (December 28).

Folio 19v: Saint Agnes in an initial M ("Me exspectaverunt peccatores ut perderent me" [The wicked have lain in wait to destroy me]), introit to the Mass for the feast of Saint Agnes (January 21).

Folio 21r: The Conversion of Saint Paul in an initial L ("Letemur omnis in domino" [Let us all rejoice in the Lord]), introit to the Mass for the feast of the Conversion of Saint Paul (January 25).

Folio 24v: The Presentation of Christ in the Temple or The Purification of the Virgin in an initial S ("Suscepimus Deus misericordiam tuam" [We have received your kindness, O Lord]), introit to the Mass for the feast of the Purification of the Virgin, also known as Candlemas (February 2).

Folio 31r: Saint Thomas Aquinas in an initial Q ("Quasi stella matutina" [Like the morning star]), tract to the Mass for the feast of Saint Thomas Aquinas (March 7).

Folio 33v: The Annunciation in an initial R ("Rorate caeli desuper et nubes pluant justam" [Drop down dew, you heavens, from above, and let the clouds rain the just one]), introit to the Mass for the feast of the

Annunciation (March 25); the prophet Isaiah in a roundel at the bottom of the page.

Folio 39r: Foliate decoration in an initial S ("Sancti tui domine" [Your saints, O Lord]), introit to the Mass for the feast of the martyrdom of Saints Tibertius, Valerian, and Maximus (April 14).

Folio 41v: The Assassination of Saint Peter Martyr in an initial P ("Protexisti me Deus a conventu malignantium" [Thou hast protected me from the assembly of the malignant]), introit to the Mass for the feast of Saint Peter Martyr (April 29).

Folio 43v: The Apostles Philip and James in an initial E ("Exclamaverunt ad te Domine in tempore afflictionis suae" [And in the time of their tribulation they cried to thee]), introit to the Mass for the feast of Saints Philip and James (May 1).

Folio 45v: The Crucifixion in an initial N ("Nos autem gloriari oportet in cruce domini nostri" [But it is fitting that we should glory in the cross of our Lord]), introit to the Mass for the feast of the Invention of the Holy Cross (May 3).

Folio 48r: The Crown of Thorns in an initial G ("Gaudeamus omnes in Domino" [Let us all rejoice in the Lord]), introit to the Mass for the feast of the Crown of our Lord (May 4).

Folio 53r: Rose in an initial L ("Loquetur Dominus pacem in plebem suam et super sanctos suos" [For he will speak peace unto his people: and unto his saints]), introit to the Mass for the feast of Saints Gervasius and Protasius (June 19).

Folio 55v: Saint John the Baptist in an initial D ("De ventre matris meae vocavit me Dominus nomine meo" [The Lord has called me by name from my mother's womb]), introit to the Mass for the feast of Saint John the Baptist (June 24).

Folio 57v: Foliate decoration in an initial M ("Multae tribulationes iustorum" [Many were the troubles of the just men]), introit to the Mass for the feast of the martyr saints John and Paul (June 26).

Folio 60v: The Apostle Peter in an initial N ("Nunc scio vere quia misit Dominus angelum suum" [Now I know for certain that the Lord hath sent his angel]), introit to the Mass for the feast of Saints Peter and Paul (June 29).

Folio 61v: The Apostle Paul in an initial S ("Scio cui credidi" [I know whom I have believed]), introit to the Mass for the Commemoration of Saint Paul (June 30).

Folio 64v: Noli me tangere in an initial G ("Gaudeamus omnes in Domino" [Let us all rejoice in the Lord]), introit to the Mass for the feast of Saint Mary Magdalen (July 22).

Folio 67v: The Glory of Saint Dominic with Eight Angels, and Saints Barnabas(?), Peter Martyr, Thomas Aquinas, and the Blessed John of Salerno(?) in the curls of foliage around the initial I ("In medio ecclesie aperuit os eius et implevit eum Dominus" [In the gathering of the church the Lord opened his mouth and filled him]), introit to the Mass for the feast of Saint Dominic (August 5); Saint Francis of Assisi Embracing Saint Dominic at the bottom of the page, full page.

Folio 68v: Saint Dominic in an initial P ("Pie pater" [Pious father]), versicle from the Mass for the feast of Saint Dominic; a Dominican friar in the tail of the P.

Folio 70v: Saint Lawrence in an initial C ("Confessio et pulchritudo in conspectu eius" [Praise and beauty go before him]), introit to the Mass for the feast of Saint Lawrence (August 10).

Folio 73v: The Assumption of the Virgin in an initial G ("Gaudeamus omnes in Domino" [Let us all rejoice in the Lord]), introit to the Mass for the feast of the Assumption of the Virgin (August 15).

Folio 80v: Saint Michael Archangel in an initial B ("Benedicite dominum omnes Angeli eius" [Bless the Lord, all you his angels]), introit to the Mass for the feast of Saint Michael Archangel (September 29).

Folio 85v: Eight Saints in an initial G ("Gaudeamus omnes in Domino" [Let us all rejoice in the Lord]), introit to the Mass for the feast of All Saints (November 1).

Folio 86v: Souls Released from the Fires of Purgatory in an initial R ("Requiem aeternam dona eis Domine et lux perpetua luceat eis" [Grant them eternal rest, O Lord, and let perpetual light shine upon them]), introit to the Mass for the feast of All Souls (November 2).

Common

Folio 93r: Christ Blessing in an initial M ("Mihi autem nimis honorati sunt amici tui Deus" [Your friends are greatly honored by me, O God]), introit to the Mass for the common of the Apostles; the Twelve Apostles in quatrefoils along the borders of the page.

Folio 100r: Christ Blessing in an initial L ("Laetabitur iustus in Domino" [The just man rejoices in the Lord]), introit to the Mass for the common of a single martyr not a bishop; a martyr saint in a quatrefoil at the bottom of the page.

Folio 109r: Christ Blessing in an initial I ("Intret in conspectu tuo Domine gemitus compeditorum" [Let the sighs of the imprisoned come before you, O Lord]), introit to the Mass for the common of several

martyrs out of paschal time; three martyrs in quatrefoils at the bottom of the page.

Folio 124r: Christ Handing the Pastoral Staff to a Kneeling Blessed Bishop or Abbot in an initial S ("Statuit ei Dominus testamentum pacis" [The Lord established a covenant of peace with him]), introit to the Mass for the common of a confessor bishop or martyr bishop.

Folio 137v: Singing Virgins in an initial G ("Gaudeamus omnes in Domino" [Let us all rejoice in the Lord]), introit to the Mass for the common of one or more virgins.

Folio 156v: Virgin of Mercy with Five Kneeling Friars in an initial S ("Salve sancta parens enixa puerpera regem qui caelum terramque regit in saecula saeculorum" [Hail, Holy Mother, who brought forth the king who rules heaven and earth forever and ever]), introit to the Mass for a feast of the Virgin Mary.

The original provenance of this manuscript is not absolutely certain, but in all likelihood it comes from the convent of San Domenico, Fiesole. Iconographic evidence suggests this. Dominic, the convent's titular saint, is celebrated in a full-page illumination (fol. 67v) showing him in glory with angels. In medallions created by the foliage intertwining the initial I on this page are portraits of an apostle, of Saint Peter Martyr, of Saint Thomas Aquinas, and of a Dominican friar with the rays of a blessed. The apostle has been identified with Barnabas and the Dominican blessed with John of Salerno (d. ca. 1235), who founded Santa Maria Novella, Florence (Cardile 1976, p. 217). If the identification of Barnabas is correct, the manuscript surely comes from San Domenico, as the second dedication of the church, made in October 1435, was to that apostle. This was in accordance with requirements of Barnaba degli Agli's bequest to the convent in 1418; he wanted his name saint so honored. At the bottom of this page is a depiction of the meeting of Saints Francis and Dominic. This may be an homage to the fact that the Franciscan Observant convent was not very far away on the hill in Fiesole (see Cardile 1976, p. 217).

Another possible confirmation of the provenance from San Domenico is a document published by Annarosa Garzelli (1985a, pp. 11–12 n. 1), in which it is noted that in 1447 the convent of San Marco in Florence borrowed the big gradual in San Domenico, Fiesole, to copy out the titles and verses for a gradual ordered by Cosimo de' Medici. This latter gradual still exists in San Marco (Cod. 557), and it indeed contains the same text as the one under discussion. The friars of San Marco also

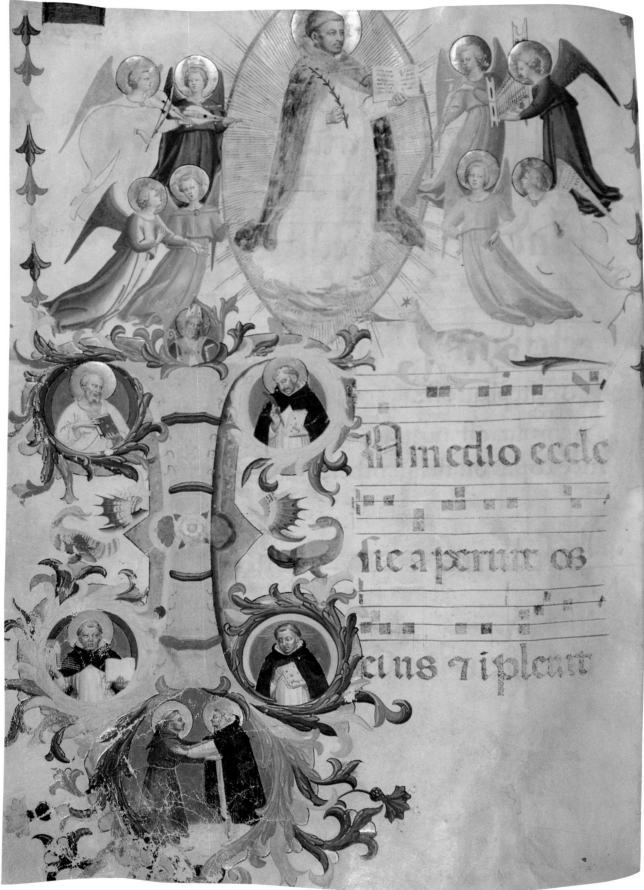

In medio eccle

sic aperuit os

eius 7 implent

borrowed a book from Santa Maria Novella to copy out other texts that were missing from the San Domenico gradual. Several illuminations in choir books executed by Zanobi Strozzi between 1446 and 1454 for the convent of San Marco are modeled on the illustrations of the present gradual. The reason may be that it was the very one that San Domenico lent to San Marco in 1447.

Evidence concerning Angelico's activity as an illuminator comes from Giorgio Vasari, who in the 1550 edition of his *Lives* simply says that in San Marco there are several books illuminated by the artist. In the second edition of the *Lives*, published in 1568, he expands the list considerably, mentioning books in the Vatican, the choir books of San Domenico and San Marco, and two very large books in Florence cathedral, which in his time were only visible on solemn feast days. Except for the present gradual from San Domenico, all these other books are by Strozzi.[1]

Although Angelico's early training was undoubtedly with Lorenzo Monaco at Santa Maria degli Angeli and may have included a period in that convent's scriptorium, he is never called a *miniatore* (illuminator). The first document concerning him, dating from 1417, specifically states that he is a painter. The two fields were always distinguished from each other in writings of the time, and therefore Angelico probably only occasionally painted illuminations. There is only one contemporary reference to the painter with regard to book production. A memorandum of May 2, 1449, concerning the San Marco choir books mentions that he must review Strozzi's work in them. The tone suggests that the quality of Strozzi's work was not being questioned but that the friars wanted to make sure that Angelico did review the books. He was then rarely in Florence, and in 1445 he had been one of the friars to sign a document legally separating the convents of San Domenico and San Marco. Angelico stayed with San Domenico. The memorandum requesting his review is a sure sign that Angelico was not involved in the choir books' daily production.[2]

The present manuscript contains the most miniatures that are likely to be by Angelico's hand.[3] Otherwise few other attributions of illuminations to him can be accepted.[4]

Angelico's approach to illumination is very much that of a painter for whom working pictures into small or confining letters was frustrating. For example, in the Annunciation (fol. 33v) Angelico seems rather impatient with the confines of the initial R. He places the three figures as if the R were a barrier around which they were playing a game of hide-and-seek. Angelico is more interested in the foreshortening of the Virgin's upturned face and of the head of Christ coming in on a cloud than

in working out a coherent relationship between figure and letter. Likewise, the John the Evangelist (fol. 13v) is more a sculpture floating on delicate blue clouds in front of a decorative letter than a figure integrated within the initial's decoration.

The Purification of the Virgin (fol. 24v) had to be fitted into the initial S. In order to do so Angelico brought all the actors together in the confining and shallow space of the upper part of the letter. Although their feet and the altar can be seen in the lower half, the figures are presented essentially in half-length. The concept is quite innovative: in the late quattrocento Andrea Mantegna and Giovanni Bellini would popularize such compositions in devotional panel paintings that depict either this same subject or the Circumcision. Angelico's own illumination is a beautiful solution for dealing with the unusual configuration of the letter. It also seems to me to be the way a panel painter would handle the problem. Angelico was most comfortable on the pages that let him break out of the confines of the letters' shapes. In fact, one of the most successful miniatures, the Glory of Saint Dominic (fol. 67v), is situated at the top of the page above the initial I.

Despite his hesitations about the medium, Angelico never ignores the text or the underlying theological significance of a scene. For example, the antiphon for the Purification is from a psalm declaring that mercy has been received. Angelico conveys this concept through the inner light that seemingly infuses the figures' faces. This light is made all the more apparent by the dark background. The Purification was celebrated as the feast of light (candles were even ceremoniously distributed that day) because of the high priest Simeon's prophecy that the child was "a light to the revelation of the Gentiles" (Lk 2:32). The friars held the Purification as particularly dear because Simeon's canticle, known as the Nunc Dimittis (Now thou dost dismiss [Lk 2:29]), was sung by them every evening at compline (Hood 1993, p. 224), following the rite of the Roman Church (Bonniwell 1945, p. 131).

The greatest illumination (fol. 68v) illustrates the versicle for Dominic's feast in the letter P, for "Pious father." The generously spacious letter contains a sensitive large-scale portrait of the saint, which was the most "loved" of all the book's illuminations. The page is quite worn probably because it was caressed and kissed by generations of friars wishing to touch an image of their founder.

In the tail of the P a friar mocks Dominic's gesture. This detail is not a charming decorative flourish, but rather a particularly appropriate representation of how the Observants conceived of Dominic as the order's pious

father. Antonino Pierozzi, Angelico's companion at San Domenico, wrote a life of the founding saint in which he included the text of the *De modo orandi*, a thirteenth-century tract dealing with Dominic's manner of prayer. Antonino laid it out as a model for his friars to imitate. William Hood (1986; 1993, esp. pp. 200–207) has shown how important the book was for the decoration of the friars' cells in San Marco. It must also have had some influence on this miniature. The beautiful hand gestures of the portrait correspond to poses suggested for prayers of meditation and intercession as they are illustrated in a fifteenth-century copy of the *De modo orandi* (Hood 1986, figs. 11, 15).

Fra Angelico did not paint all of the gradual's miniatures. Those that can be considered for the most part autograph are folios 11v, 13v, 16r, 24v, 33v, 41v, 45v, 48r, 55v, 60v, 67v, 68v, 73v, 86v, 93r(?), 100r(?), 109r(?), and 156v. The rest, although very close in conception, are not by his hand. More than one artist may have illuminated them. Luciano Berti proposed that some of them might be the work of the young Zanobi Strozzi. Since it is by no means clear how Angelico organized his growing workshop in the 1420s, it seems to me almost impossible to identify its participants with specific names. In later years Angelico worked largely with lay artists. His principal assistant in the frescoes of San Marco's cells was Benozzo Gozzoli, and he relied on Alesso Baldovinetti to paint some of the scenes for the doors of the reliquary cupboard of Santissima Annunziata. In the mid-1440s Angelico reserved for himself or was required to take on the role of overseer of the production of the San Marco choir books, but the work was hired out to Strozzi and Filippo di Matteo Torelli.

In the 1420s the production of a manuscript probably went beyond the capabilities of the convent of San Domenico. A scribe was needed as well as artists to execute the numerous letters with the more simple tracery patterns. The foliate decoration of the historiated initials, with their occasional population of birds and insects, was not necessarily done by the artist who painted the figures. In this book the planning of the initials seems rather haphazard, as if the artist who did the letter and the one who did the figures did not always work in tandem. A good example is the Virgin of Mercy (fol. 156v), which had to be adapted to the letter S. Angelico's solution was to cut the miniature into two, having the Virgin appear alone in the upper half and the kneeling friars below. When Strozzi illuminated the same scene for the San Marco choir books, he placed the Virgin and friars in front of the letter so that the composition would not be so broken (Florence 1990a, fig. 20). This suggests that Strozzi worked with the illuminator who did the decoration of the letters, who in those books was Torelli. In the present gradual Angelico seems to have arrived on the scene after the initials had been painted. The gradual's foliate decoration is directly derived from manuscripts typical of Santa Maria degli Angeli. The variegated birds and insects found in some of the borders specifically recall some of those in Cod. H 74 (cat. no. 38). It is possible that this book was actually produced there and that Angelico himself only occasionally collaborated on its production.

Execution of the gradual may have extended over several years. The illuminations can be compared with pictures that date to the mid-1420s, such as the San Pier Martire triptych (fig. 18), and the late 1420s, such as the Louvre's *Coronation of the Virgin* (fig. 22). The forcefulness and directness of the pose of the executioner in the Assassination of Saint Peter Martyr (fol. 41v) induced Berti to date the gradual after the triptych, in which the same scene appears in the upper spandrel. While Berti's dating is probably true, the poses correspond to the different requirements of an illuminated letter and a panel painting. The decisive modeling in Dominic's portrait particularly brings to mind the *Coronation*. Another page (fol. 93r), showing the apostles in individual medallions, recalls the predella of *The Virgin of the Stars* reliquary (fig. 128), which was probably executed sometime in the mid- to late 1420s. Dating of the gradual has varied. Berti suggested the period 1429–30, John Pope-Hennessy 1428–30, and Miklós Boskovits (1976a, p. 48) much before, during Angelico's novitiate, which was likely in the early 1420s. It would seem that its production took several years, probably from about 1425 to about 1430.

This is one of the first ecclesiastical manuscripts with letters decorated in white vine patterns, or, as they are commonly known, *bianchi girari*. This decoration would characterize Florentine humanist manuscripts for the next seventy-five years.

CBS

1. The books in the cathedral are probably the two antiphonaries now in the Biblioteca Laurenziana, Florence (MS Edili 150, 151). They were illuminated by Zanobi Strozzi and Francesco d'Antonio del Chierico in 1463.

2. In 1451 Angelico directed monies that came to San Domenico from the inheritance of Fra Alessio Albizi be paid to the bookbinder Vespiano da Bisticci. This indicates that San Domenico was involved in manuscript production (Orlandi 1959–60, vol. 1, p. 196). The 1461 will of Bernardo Bartolini, several times prior of San Domenico, contains references to several manuscripts, including a "beautiful parchment" that could have been made at his own convent (ibid., vol. 2, p. 152).

3. The gradual's attribution to Angelico is recorded in an inscription, dated 1867, on the inside cover sheet. The founding curator of the Museo di San Marco, Ferdinando Rondoni

(1872), described it as in the manner of Fra Angelico. Milanesi, in his notes to the *Lives* of Vasari (1878–85), judged it to be by Zanobi Strozzi. Wingenroth (1898) was the first to attribute it to Fra Angelico. Other authors, including D'Ancona (1908, 1914), stuck to Strozzi. The question of Angelico's authorship was not again seriously taken up until the exhibitions for the five-hundredth anniversary of his death. In the exhibition catalogue (Florence 1955) Ciaranfi fully described the text and made a case for the attribution of a number of illuminations to Angelico. She listed folios 13v, 24v(?), 31v(?), 33v, 41v (for the most part), 48r, 67v, 68v, 73v(?), 86v, 93r, 100r, 109r, 124r, and 156v (with collaboration). Berti made a detailed study of the manuscript, publishing a full set of color photographs in 1962 and 1963. He noted that it was principally by Angelico but also acknowledged the presence of at least two assistants, one of whom he thought might be Strozzi. Pope-Hennessy (1974) essentially agreed with Berti's conclusions. He named as by Angelico folios 9r(?), 11v, 13v, 16r, 24v, 33v, 41v, 45v, 48r, 55v, 60v, 67v, 68v, 73v, 86v, 93r, 100r, 109r, and 156v. Bellosi (in Turin 1990) has argued that the gradual is not the work of the master but of his workshop (see the note following).

4. The few illuminated initials in the Santa Maria degli Angeli temporale (Biblioteca Laurenziana, Cod. Cor. 3) that show a similarity to early Angelico were astutely called by Ciaranfi (1932) "Tendenza dell'Angelico." Salmi (1950, pp. 75–77) attributed them to Angelico himself. The traditional date of this manuscript is sometime shortly after 1409. But since Angelico's activity as a painter is not recorded until eight years after that date, it is unlikely that he worked on it even if its production extended into the 1410s or later. As Longhi (1940 [1975], p. 182 n. 15) noted, the initials in question are probably by Battista di Biagio Sanguigni (see cat. no. 37). (Bellosi [in Turin 1990, p. 42] attributed them to the Pseudo-Domenico di Michelino, who for many scholars must be identified with Zanobi Strozzi.) The same artist probably also illuminated a full-page Crucifixion in a book in the convent of Santa Trinita. It was attributed to Angelico by Berti (1962–63, pp. 30–34). Another Crucifixion, formerly in the Hoepli collection in Milan, may be by Angelico and datable to about 1424–25 (see Boskovits 1976b, pl. 9). Bellosi (in Florence 1990b, pp. 98–101) has identified as by Angelico some random historiated letters in two psalters of San Marco and a cutting in a private collection (in Turin 1990, pp. 39–41). They both date to the 1440s. In addition Miklós Boskovits will soon be publishing some newly discovered illuminations by Angelico in a choir book now in the Biblioteca Laurenziana (Cod. Cor. 43).

EX COLL.: Pietro Leopoldo Ricasoli, prior of the order of Santo Stefano (d. 1850); Leopold II, grand duke of Tuscany; Maria Antonio, grand duchess of Tuscany.

LITERATURE: Milanesi, in Vasari 1878–85, vol. 2, p. 528 n. 1; Wingenroth 1898, pp. 343–45; Douglas 1900, pp. 23, 180–81; D'Ancona 1908, p. 90; idem 1914, vol. 2, pp. 354–56, no. 776; van Marle 1923–38, vol. 10 (1928), p. 186; Muzzioli, in Rome 1953, no. 473, p. 301; Salmi 1954a, p. 49; Ciaranfi, in

Florence 1955, no. 65, pp. 97–98; Collobi Ragghianti 1955a, pp. 393–94; Salmi 1958, pp. 85–89; Berti 1962–63; Chiarelli 1968, pp. 21–24; Pope-Hennessy 1974, esp. pp. 9–10, 191; Boskovits 1976a, p. 37; idem 1976b, pp. 36, 48 n. 11; Cardile 1976, pp. 215–22, 263–74; Cole 1977a, pp. 333–39; Garzelli 1985a, pp. 11–13, esp. pp. 12–13 n. 1; Bellosi, in Turin 1990, pp. 39–40; Fabbri, in Berti and Paolucci 1990, p. 226; Scudieri, in Florence 1990a, pp. 16–17; Strehlke 1993a, pp. 19–20.

49. A Bishop Saint (John Chrysostom?)

Tempera and gold on panel
Overall: 6 1/4 × 6 1/8 in. (15.9 × 15.6 cm); diam. of painted surface: 5 7/8 in. (14.9 cm)

The Metropolitan Museum of Art; Bequest of Lucy G. Moses, 1990 (1991.27.2)

The saint holds a pastoral staff and wears a miter identifying him as a bishop or an abbot. An inscribed X and another illegible letter in gold in the background at the right might provide clues to his actual identity. It is likely that the X is an abbreviation of Christ and that the name should read as Chrysostom. The bishop would therefore be one of the early Greek Fathers of the Church, John Chrysostom (ca. 347–407), the archbishop of Constantinople known for his severe morality and his commentary on the Gospels. He is rarely depicted in Italian art. However, he does appear as a bishop in Angelico's frescoes in the Vatican painted for Pope Nicholas V. There he sports a long beard.

A tondo (fig. 126) of similar dimensions in the National Gallery, London, showing another bishop or abbot must come from the same complex. He too is unidentified, although the remains of an inscription read MEUS. It is unclear to whom this refers. It would be of some interest if both saints were Greek. Angelico's own Dominican order was much involved in the negotiations for the reunification of the Greek and Roman Churches.

The two panels could have come from a predella consisting of roundels with saints.[1] The panels' vertical grain would suggest that, if parts of a predella, they were at the base of pilasters, because predelle are usually painted on a single plank of horizontally grained wood. Or, as first noted by Martin Davies (1961, pp. 31–32), they may have been part of an altarpiece's frame.

Langton Douglas, in a letter in the National Gallery archives, identified the Metropolitan Museum's tondo as

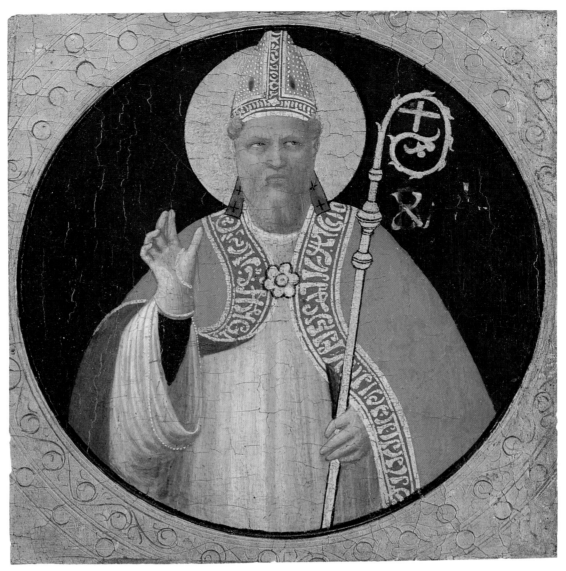

49

having come from the convent of San Domenico, Fiesole. Most authors have associated the two pictures with a group of fragments that are said to have been part of the framing of the triptych still in the church (fig. 17). The triptych, originally on the high altar, was completely transformed and reframed by Lorenzo di Credi in 1501. He "de-Gothicized" it by turning it into a rectangularly shaped altarpiece and by painting a landscape over the gold ground. The picture was tampered with again between the years 1792 and 1827. The predella showing Christ in Heaven surrounded by adoring angels and saints was removed and sold to the Prussian Consul in Rome. It is now in the National Gallery, London (Hood

1993, figs. 54a, b). In San Domenico it was replaced by a copy, and the altarpiece was given a new frame.

Inscriptions on the backs of four pilaster panels with standing saints in the Musée Condé, Chantilly, and the Fondation Rau, Marseilles, read that they are part of ten pieces removed from the triptych. Although in recent times they have been restored of later repaints, the backgrounds of all four had been repainted by Lorenzo di Credi. Proposals (Baldini 1970; Pope-Hennessy 1974; Baldini 1977) have been made about what the other surviving elements may be. They have included the Metropolitan Museum and National Gallery's two panels with bishop saints; two roundels respectively with the

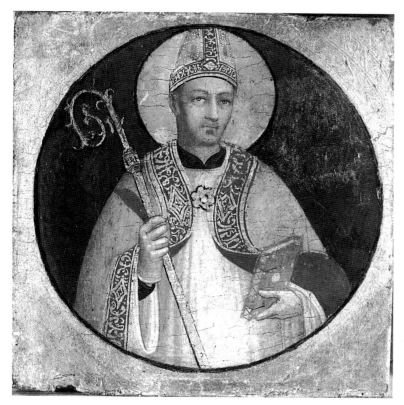

Figure 126. Fra Angelico, *Bishop Martyr*. National Gallery, London (2809)

Figure 127. Fra Angelico, *Saint Anthony of Padua*. San Francesco, Assisi; Federico Mason Perkins Collection

Archangel Gabriel and the Annunciate Virgin, formerly in the Tucker collection, Vienna; *Christ Blessing* in the British Royal Collections; and *Two Angels* in the Galleria Sabauda, Turin (Baldini 1970, figs. 9K, 9L, 21, 26). The group presents inconsistencies: The borders of the two panels with the bishop saints consist of a flat gold with a few simple punch marks, whereas the roundels with the Annunciation still retain an old-fashioned *pastiglia* decoration in their framing similar to the *pastiglia* borders of the predella of the Prado *Annunciation*. In addition, unlike the pilaster panels, none of these pictures show any evidence of transformation by Lorenzo di Credi, making their possible association with the original frame of the San Domenico triptych even more unlikely.

It may be of some relevance that in 1769 two small panels by Angelico could be seen in the sacristy of San Domenico (*Serie* 1769–75, vol. I, p. 102). They are described as "due piccole Tavole esistenti nella Sagrestia con due Santi in campo d'oro assai diligentemente lavorati" (two small panels in the sacristy with two saints on gold ground very finely worked). If these were the two bishop saints, the gold ground would refer to the gold borders. This account also describes the above-mentioned triptych in the church before the frame was

disassembled, suggesting that the two saints in the sacristy were never part of the triptych.

Like the two panels with the bishop saints, a panel (fig. 127) in the convent of San Francesco, Assisi, showing Saint Anthony of Padua in a diamond shape also comes from the frame of a lost altarpiece.[2] It is of similar date and its gold borders are treated analogously. The way the saint's name is inscribed is also close to the inscriptions on the two panels. Its dimensions are, however, slightly narrower in width. The *Saint Anthony* could have been part of the pilasters from which those panels came.

While the *Bishop Saint* in New York and its companion in London are comparable to the minor elements of the triptych, such as the pilaster panel of Saint Nicholas of Bari in the Fondation Rau, they might actually date a bit later. They evidence a more mature Angelico. The fall of light is softer and the lights and darks less sharply contrasted. Angelico plays the highlights against the shadows, leaving the greater part of the bishops' faces in the penumbra. Such sophisticated modeling suggests that he was fully cognizant of Masaccio's frescoes in the Brancacci Chapel.

CBS

341

1. Two predelle by Angelico have this scheme. One in the Courtauld Institute, London (Pope-Hennessy 1974, fig. 4), is probably the predella to the San Pier Martire triptych (fig. 18); another in the Kunstmuseum, Bern (Boskovits 1976a, figs. 26a, b), showing three saints and a donor, has also been attributed to Giovanni Toscani (Wagner 1974, pp. 91–94).

2. Zeri (1988, p. 87, no. 30) illustrated this in color. He does not believe the inscription is original and erroneously identifies the saint as Francis.

EX COLL.: Samuel Rogers, London (before 1856); Canon Sutton, London; Langton Douglas, London (by 1928); Mr. and Mrs. Henry H. Moses, New York (by 1932).

LITERATURE: Davies 1961, pp. 31–32; Baldini 1970, p. 98, no. 54; Pope-Hennessy 1974, p. 227, fig. 94; Cardile 1976, pp. 107, 248–49; Baldini 1977; Cole 1977a, p. 175; Boissard, in Boissard and Lavergne-Durey 1988, pp. 44–45; Christiansen 1991.

50. Reliquary Tabernacle with the Burial and Assumption of the Virgin

Tempera and gold on panel
24³/₈ × 15¹/₈ in. (61.8 × 38.5 cm)

Isabella Stewart Gardner Museum, Boston

The panel is divided into two sections: below, the Virgin Mary's obsequies are coming to an end, and above is her Assumption into paradise. In the lower register Christ has come to collect the Virgin Mary's soul, which he holds in the form of a small child. Few of the other fourteen participants can be specifically identified. Since according to legend the apostle Thomas was said to be absent, only eleven are apostles. Various medieval legends identify the others as Saints Paul, Dionysius the Areopagite, Timothy, and Hierotheus. Paul is undoubtedly the figure with the pointed beard at the foot of the Virgin's bier. The curly headed bearded figure to the right of Christ is probably the apostle Bartholomew. At the head of the bier, the apostle Peter reads from a psalter. John the Evangelist is at the far right; he carries a palm given to him by the Virgin. It had been brought to her by an archangel as a sign of her imminent death. Four of the men are about to pick up the bier and carry the Virgin's body to its resting place. This particular depiction of the scene adds action and variety to a subject that was often static and tied to tradition. The Virgin was brought to burial in the valley of Josaphat, which is alluded to by the two

hills seen in the upper part of the lower register behind the wall. Three days after her interment, the Virgin is said to have ascended bodily into heaven. In the upper register she is depicted as an orant on a cloud. Dancing and music-making angels accompany her to Christ, who is represented in the pinnacle at the top of the panel.

Although there is no specific documentary evidence, this panel reputedly was one of four reliquaries that Fra Angelico made for the Dominican church of Santa Maria Novella, Florence. The other reliquaries are in the Museo di San Marco, Florence. They represent: the Virgin of the Stars, which has a predella with Saints Dominic, Thomas Aquinas, and Peter Martyr (fig. 128); the Annunciation and the Adoration of the Magi, which has a predella with the Virgin and Child and Saints (fig. 129); and the Coronation of the Virgin, which has a predella of the Holy Family with Six Angels (fig. 130). The subject matter of the panel in the Gardner Museum is consistent with the paintings in the Museo di San Marco, suggesting that all four panels formed a set. The first two retain some elements of their original framing;

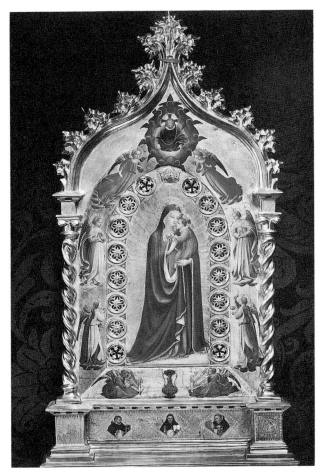

Figure 128. Fra Angelico, *The Virgin of the Stars* and *Saints Dominic, Thomas Aquinas, and Peter Martyr*. Museo di San Marco, Florence

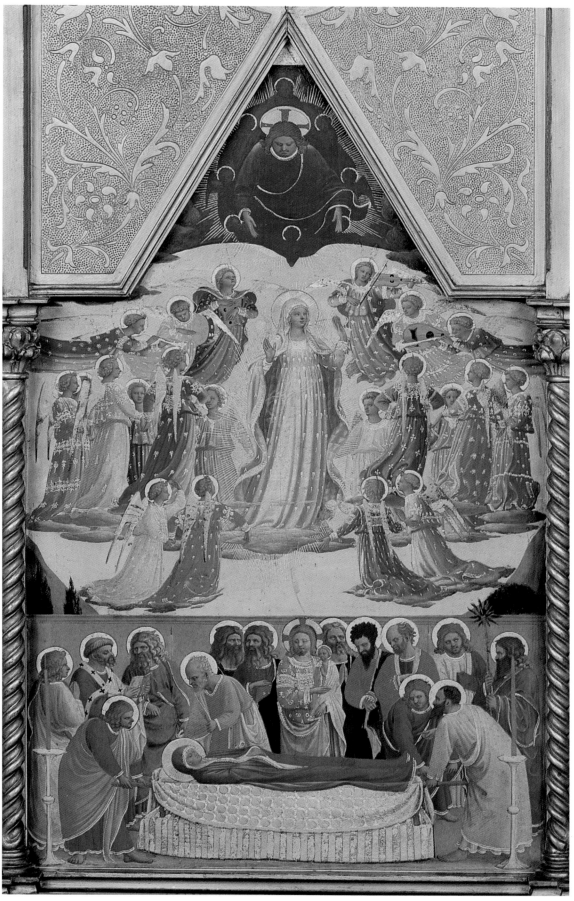

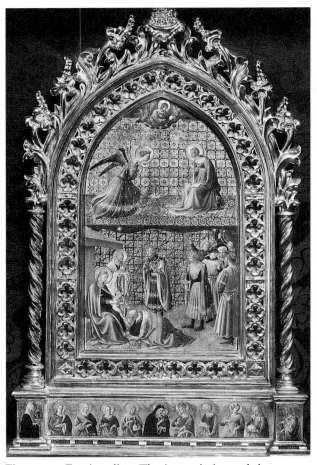

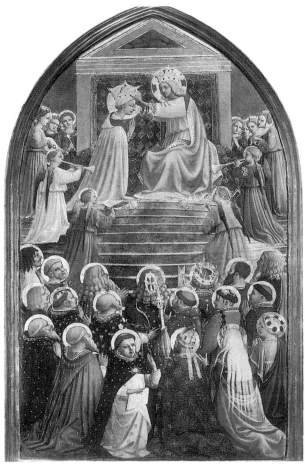

Figure 129. Fra Angelico, *The Annunciation and the Adoration of the Magi* and *The Virgin and Child and Saints*. Museo di San Marco, Florence

Figure 130. Fra Angelico, *The Coronation of the Virgin* and *The Adoration of the Child and Angels*. Museo di San Marco, Florence

The Coronation of the Virgin and the Gardner panel do not.

Father Billiotti's late-sixteenth-century chronicle (Marchese 1854, vol. 1, p. 270) states that the reliquaries were four in number and that their subject was the Virgin Mary, saints, and angels. Giuseppe Richa (1754– 62, vol. 3, p. 49) was more precise, saying that they represented "mysteries of the Virgin." Giorgio Vasari (1878–85, vol. 2, p. 513) mentioned that they were placed on the altar on high feast days. There is no specific record of the relics they contained, but Richa maintained that their frames were full of holy relics. As the panels do not seem to have been designed to be opened, the relics could not have been removed for ceremonial exhibition to the devout. They were probably small souvenirs that were permanently encased in the panels' frames. More important relics would have been given a housing of bejeweled silver or gold.

The four reliquaries have always been associated with a passage in the necrologia of Santa Maria Novella that contains obituaries of the friars. It is said that the

church's sacristan Fra Giovanni Masi had commissioned "plures reliquias sanctorum" (many reliquaries of saints [Orlandi 1955, vol. 1, p. 153]). These could well have been Angelico's panels, but there is no confirmation of this. Masi's death in June 1434 provides a possible terminus ante quem for their manufacture. The reliquaries were undoubtedly part of the considerable church furnishings and other decoration ordered by Santa Maria Novella in the decade after the 1420 consecration of the church by Cardinal Giordano Orsini. Fra Angelico himself played a considerable role in projects of this sort: he is recorded in Vasari and other early sources as decorating a paschal candlestick and the protective covering of the organ pipes as well as painting several frescoes. These other works do not survive.

There is no reason to suppose that the reliquaries were painted concurrently. However, it should be recognized that they were part of a single program and their manufacture probably was not protracted over a period of many years. Their styles would suggest slightly different times in the late 1420s or early 1430s. The scheme of the

Figure 131. Donato di Leonardo and Antonio di Salvi, Pax with *The Dormition and Assumption of the Virgin*. Walters Art Gallery, Baltimore (45.4)

executed by a follower of Angelico, such as Zanobi Strozzi, or in Angelico's workshop. However, the originality of both this panel and *The Virgin of the Stars* would suggest that these two at least are by the master himself.

Diane E. Cole (1977a, p. 307) noted that a later quattrocento niello pax by Donato di Leonardo and Antonio di Salvi in the Walters Art Gallery, Baltimore (fig. 131), is based upon the Gardner's picture.

CBS

EX COLL.: Probably the convent of Santa Maria Novella, Florence (until at least 1754); the Reverend John Sanford (by 1816; d. 1855); Lord Metheun, second baron of Corsham Court, by descent; Paul Sanford Metheun, third baron of Corsham Court; Isabella Stewart Gardner.

LITERATURE: Schottmüller 1911, pp. 23, 256; Collobi Ragghianti 1950b, p. 25 n. 20; Pope-Hennessy 1952, p. 200; Collobi Ragghianti 1955b, p. 43; Salmi 1958, pp. 15, 101; Berti 1962–63, p. 38 n. 101; Baldini 1970, p. 93; Hendy 1974, pp. 2–5 (with previous literature); Pope-Hennessy 1974, pp. 224–25; Cole 1977a, esp. pp. 306–12.

Annunciation relates closely to that of the *Annunciation* (fig. 21) now in the Prado, Madrid, which was then on an altar in Angelico's convent of San Domenico, Fiesole. I have argued for a date of about 1426 for it. *The Coronation of the Virgin* is likewise dependent on the picture in the Louvre (fig. 22), also once on an altar in San Domenico. That painting probably dates from about 1427 to 1429. The two reliquaries are of about the same size and may have been executed together about 1430. *The Virgin of the Stars* probably dates to some time later. Its frame seems to be based upon the design of the frame for the Linen Workers' tabernacle, which was executed between 1433 and 1436. The Gardner panel involved the most original thinking on the artist's part. Unlike the *Annunciation* or *Coronation*, it was not derived, even if only loosely, on a preexisting composition by Angelico. The figures in it and in *The Virgin of the Stars* are of about the same size, as are also the panels themselves. These latter two were probably made at approximately the same time, about 1433.

Many authors have suggested that the reliquaries were

51. The Archangel Gabriel Annunciate

Tempera and gold on panel
12³/₈ × 10 in. (31.4 × 25.5 cm)

The Virgin Mary Annunciate

Tempera and gold on panel
12³/₈ × 10 in. (31.4 × 25.5 cm)

The Detroit Institute of Arts; Bequest of Eleanor Clay Ford, 1977 (77.1.1, 2)

The two panels represent the Annunciation at the moment when the angel Gabriel greets the Virgin. She responds in a gesture of humble acceptance, crossing her arms over her chest. In her right hand she holds a small red bound book. She has marked the place by her finger. The costumes of the two figures are embellished with fake Kufik characters, as is the Virgin's halo.

The original provenance and function of these two panels is uncertain. Though they are clearly fragments, it has never been ascertained whether they had been cut out of a larger composition, were the subsidiary parts of an altarpiece, or constituted the valves of a diptych. Several proposals have been made. John Pope-Hennessy (1952, p. 197) suggested that they had been the pinnacles of the

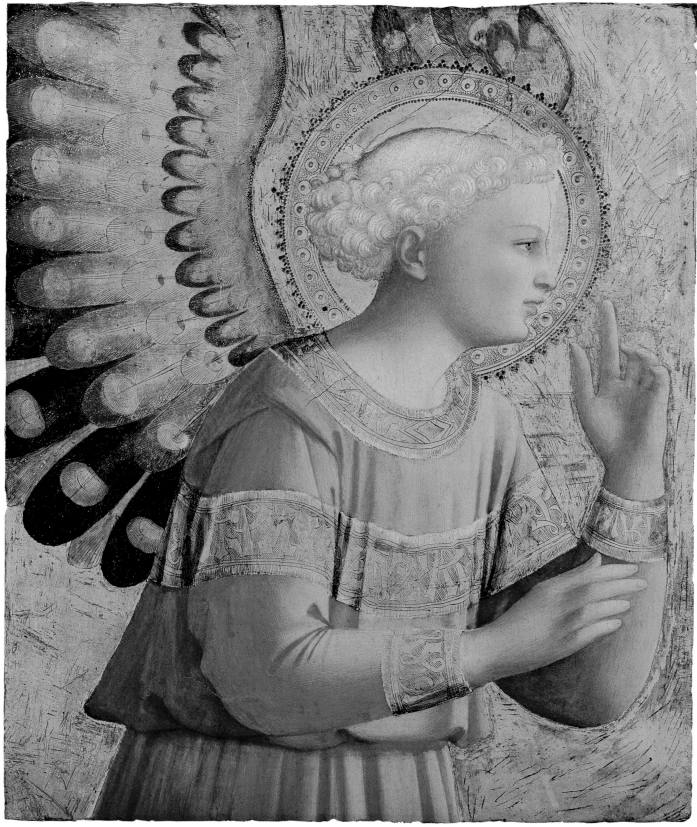

51

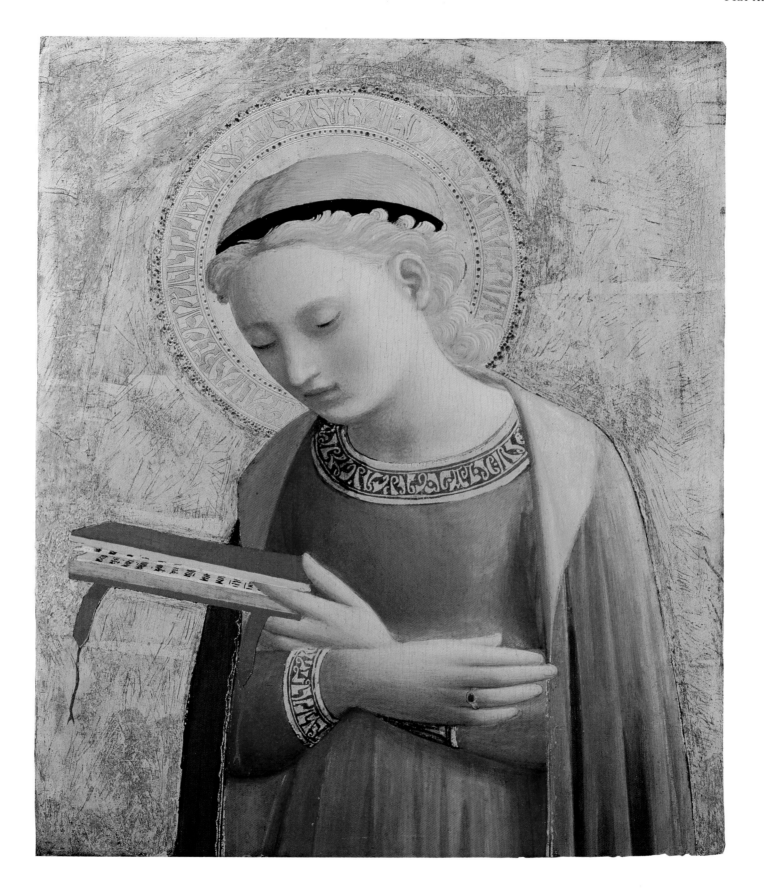

347

Louvre's *Coronation of the Virgin* (fig. 22). The dimensions are such that the Detroit *Annunciation* could have filled the voids in the upper corners of that altarpiece. Lionello Venturi (1931, nos. 147–48) thought that they might be fragments of a larger panel, such as an altarpiece or a tondo. His idea was accepted by Burton Fredericksen (note in the Detroit Institute of Arts files) and, more recently, by Paul Joannides (1989), who proposed an elaborate reconstruction of what he perceived to be the altarpiece's original appearance. His reconstruction was based on Angelico's three well-known Annunciation altarpieces in the Prado, Montecarlo, and Cortona, as well as on the fresco in the dormitory of San Marco. He suggested that two predella panels in the Museo di San Marco showing the Marriage and Dormition of the Virgin belonged to this hypothetical altarpiece. In addition, he thought that the gilding was new and that the panels had had a painted background.

A close examination of the panels and their X rays made by Laurence Kanter in March 1994 has yielded new information about their condition and possible original form. The upper right corner of the *Archangel* is an insert measuring 2 7/8 by 2 3/8 inches (7.4 × 6.1 cm), as is the upper left corner of the *Virgin*. This latter measures 6 1/8 by 3 1/2 inches (15.6 × 9 cm). The X ray of the *Archangel* reveals an area of white lead to the right of Gabriel's brow, which is covered by repaired gilding and cropped by the insert. It would seem to indicate an architectural detail, possibly a corbel. A similar indication of architecture is found in the X ray of the *Virgin*—a painted arc of white lead at the left, close to the contour of the insert and tangent to the top of the panel denoting an arch that continued to a point above the Virgin's neck. The arch disappears, implying that the panel was originally lobed at the top. This evidence leads to a conclusion that the two fragments were probably cut out of the wings of a larger complex. The wings themselves had a lobed shape. The figures may have been shown in full-length and perhaps in a sort of architectural setting. The absence of an arch above the angel implies that that fragment was oriented lower in the picture field than the Virgin was. The angel was possibly kneeling. Its fully extended wings

could have been accommodated beneath the lobed framing of the panel.

Although patched and restored in parts, the panels' gilding is original. This means that except for a few summary references to architecture, the backgrounds were gilded. The panels could well have been the wings of a triptych or tabernacle on the order of the Linen Workers' tabernacle now in the Museo di San Marco. On the other hand, they may have been the doors to a sacristy cupboard or an organ. Stefano Orlandi (1964, pp. 60, 196) suggested that the two Detroit panels may have been the ones the friars of San Domenico, Fiesole, are recorded as donating to Cardinal Desiderio Scaglia in 1621. If the panels are to be identified with that donation, they probably came from a painting or other decoration originally made for San Domenico. Since the church was already provided with an altarpiece of the *Annunciation* (fig. 21) by Angelico, it is more likely that the Detroit panels were fragments of a piece of sacristy furnishing.

The dating of the *Annunciation* presents fewer problems. Indeed as Pope-Hennessy noted, it is contemporary with the Louvre's *Coronation*. I have argued that the work in Paris dates from about 1428–30. The volumetric forms of the Gabriel and Mary come closer to the statuesque figure style of that picture than to anything else in Angelico's oeuvre. Even the tooling of the halos of the Virgin is the same in both. The panels therefore probably date to the early 1430s.

CBS

EX COLL.: Possibly the convent of San Domenico, Fiesole; possibly Cardinal Desiderio Scaglia (1621); Baron Dominique Vivant-Denon (sale, Paris, May 1–, 1836, lot 41); the duke of Hamilton, Hamilton Palace, Glasgow (sale, June 24, 1882, no. 356); Winckworth (1882); John Edward Taylor, London (sale, Christie's, London, July 5, 1912, lot 11); [Galerie Sedelmeyer, Paris (until after 1913)]; Carl Hamilton, New York; Edsel Ford, Detroit (1925); Eleanore Clay Ford (1943).

LITERATURE: Venturi 1931, nos. 147–48; Pope-Hennessy 1952, p. 197; Salmi 1958, p. 33; Orlandi 1964, pp. 59–60, 196; Baldini 1970, p. 94; Pope-Hennessy 1974, p. 223; Joannides 1989, pp. 305–6.

ZANOBI DI BENEDETTO DI CAROCCIO DEGLI STROZZI, KNOWN AS ZANOBI STROZZI

Zanobi Strozzi, who was from a wealthy Florentine family, was recorded in the 1427 tax return of his older brother, Francesco, as living in the parish of San Martino a Brozzi, near Florence. He, his brother, and a sister, Maddalena, were orphans. Soon after, Strozzi moved to Palaiuola, a locality not far from Fra Angelico's convent of San Domenico, Fiesole, and apprenticed with the illuminator Battista di Biagio Sanguigni. He seems to have lived with Sanguigni until his own marriage to a cousin, Nanna di Francesco Strozzi, in 1438. Strozzi's relationship with Sanguigni was very close. In 1432, when Strozzi's sister Maddalena entered the Augustinian convent of San Gaggio, just outside the gates of Florence, Sanguigni helped provide the dowry, which presumably was the breviary she took with her. In 1442 Strozzi promised lifelong support for the older illuminator, and in 1446 the Strozzi property at Palaiuola was deeded to him. Strozzi himself moved from Fiesole to the parish of San Paolo in Florence.

Strozzi's earliest known work is in two psalters of Florence cathedral (Museo dell'Opera del Duomo, Psalter N, inv. 3 [Levi D'Ancona 1959, fig. 1]; Psalter D, inv. 4) for which he was paid in February 1445. On November 20, 1447, he was reimbursed for an illumination of the Mystic Marriage of Saint Catherine in an antiphonary for his sister's convent (Corsini collection, Florence; Levi D'Ancona 1959, fig. 4). The rest of the illuminations in the antiphonary are by Sanguigni.

From June 4, 1446, to February 20, 1454, Strozzi was paid for choir books commissioned by Cosimo de' Medici for San Marco.[1] Filippo di Matteo Torelli acted as an intermediary, in addition to painting the borders. According to a memorandum of May 2, 1449, Strozzi's miniatures had to be reviewed by Fra Angelico. The humanist bookseller and biographer Vespasiano da Bisticci bound the books. About 1450 Strozzi illuminated a miniature of a miracle of Saint Zenobius for a lectionary of Florence cathedral (Biblioteca Laurenziana, Florence; MS Edili 146, fol. 114; Levi D'Ancona 1959, fig. 9; Garzelli 1985a, fig. 7). In 1450 Strozzi was reimbursed for a psalter destined for a cook of the Badia; in 1456–57, and again with Torelli, he received payment for miniatures in an antiphonary of San Pancrazio (see cat. no. 52); and in 1458 he was paid for a Crucifixion in a missal for the cathedral (Biblioteca Laurenziana, MS Edili 104, fol. 150v). In 1463 he took on a joint commission with Francesco d'Antonio del Chierico to illuminate two antiphonaries for the cathedral (Biblioteca Laurenziana, MS Edili 150, 151; Levi D'Ancona 1959, fig. 17; Garzelli 1985a, fig. 6). Strozzi died on December 6, 1468, and was buried in Santa Maria Novella. It has been said that the artist's aristocratic origins may explain the absence of his name from the registers of Florentine artisans' guilds, but this is by no means certain.

Besides his activity as an illuminator, Strozzi is also recorded as a panel painter. Between 1434 and 1439 he was reimbursed for an altarpiece in the Chapel of Saint Agnes in Sant'Egidio,[2] and in 1448 he was paid for the cross to be used at funerals for the San Marco friars. The cross has been identified with one now in the parish church of Mocegno, near Modena (Ghidiglia Quintavalle 1960, figs. 1–10). This painting and the documented miniatures for San Marco and the cathedral are the basis for the reconstruction of his oeuvre. On stylistic grounds it is possible to match Strozzi with the artist known as the Master of the Buckingham Palace Madonna, after a painting in the British Royal Collections (currently Clarence House, inv. no. 252; Shearman 1983, pl. 213). The painter has been confused with Domenico di Michelino, to whom Bernard Berenson (1932a, pp. 364–65; 1932c, pp. 521–24; 1963, pp. 60–61) attributed paintings by Strozzi. Roberto Longhi (1948, p. 162) and Federico Zeri (1974, p. 92) baptized the master the Pseudo-Domenico di Michelino to distinguish his pictures from the rest of

Berenson's grouping, whereas it was Longhi (in 1953, in an oral communication to Michel Laclotte [Paris 1956, p. 68]) who created the more independent name of the Master of the Buckingham Palace Madonna. Mario Salmi (1950) and Licia Collobi Ragghianti (1950b) proposed the identification with Strozzi.

The artist's most important painting is the *Saint Jerome* altarpiece from the Hieronymite convent in Fiesole (Musée du Petit Palais, Avignon; inv. no. 139). It was commissioned by Giovanni de' Medici probably about 1455, shortly after Strozzi was finished with the choir books of San Marco.[3]

CBS

1. The manuscripts are in the Biblioteca del Convento di San Marco. They are as follows: in 1446, Antiphonaries 552, 517, 518; in 1447, Antiphonaries 520, 521; in 1448, Gradual 515; in 1451, Gradual 524; in 1452, Gradual 525; in 1453, Gradual 527; and in 1453–54, Gradual 516. For illustrations see Florence 1955, pls. LXXXIII, LXXXIV; Levi D'Ancona 1959, esp. pp. 12–16, figs. 2, 7, 11, 13, 14; Berti 1962–63, figs. 1, 11; Garzelli 1985a, figs. 1–5, 9, 10, 13, 14, and colorpl. 1; and Florence 1990a, figs. 17–21 (in color).

2. The central section of this altarpiece may be the *Virgin and Child with Angels* (46 1/2 × 41 in. [118 × 104 cm]; Uffizi inv. no. 3204) in the Museo di San Marco, Florence, as was proposed by Collobi Ragghianti 1950b, pp. 458, 468 n. 12, fig. 389. Levi D'Ancona (1961b) disagreed with this identification because of the absence of Saint Agnes, but the saint could have been depicted in a side panel.

3. 86 5/8 × 105 7/8 in. (220 × 269 cm); illustrated in Laclotte and Mognetti 1987, p. 144, and colorpl. 139. On its possible dating after 1460, see Davies 1961, p. 121 n. 8.

52. Initial B with David in Prayer

Tempera and gold on parchment
5 1/2 × 5 5/16 in. (14 × 13.5 cm)

The Metropolitan Museum of Art; Robert Lehman Collection, 1975 (1975.1.2470)

The image was cut from a psalter. The text is from the first verse of Psalm 1: "Beatus vir . . ." (Blessed *is* the man who hath not walked in the counsel of the ungodly, nor stood in the way of sinners, nor sat in the chair of pestilence). Inscribed on the inner band of the initial B is: *Hoc est verbum Domini in corde eius mandata porte et regnum celorum pro nobis est quia eius eredes sumus gratis cum Christo* (This is the word of the Lord, commanded in his heart from the gate and kingdom of heaven for us who are his heirs, most thankfully in Christ). Inscribed on the back is: *[Et omnia quaecumque] faciet prosperabuntur [non sic impii, no]n sic: sed tamquam [pulvis quem] proiicit ventus [a face terrae] [ideo non resurge]nt inpii in iudi[cio] [neque peccator]es in concilio [justorum]* (And all whatsoever he shall do shall prosper. Not so the wicked, not so: but like the dust, which the wind driveth from the face of the earth. Therefore the wicked shall not rise again in judgement: nor sinners in the council of the just [Pss 1:3–5]).

The miniature appropriately shows the kneeling psalmist David receiving God's blessing. His kingly crown and psalmist's harp lie on the ground by him as evidence of the humbleness of his supplication. Little of the initial's decoration has survived its removal from the manuscript: at the right an angel tugs at the ornamental foliage; at the lower left the head of a tonsured Benedictine monk can still be seen; and at the upper left part of the body of a monk is visible.

Licia Collobi Ragghianti (1950b) published the initial as by Zanobi Strozzi. Sylvie Béguin (in Paris 1957) suggested that it may be by Fra Benedetto Toschi. Her attribution was based on a comparison with the illumination of Saint John Gualbert (fig. 132) in the Fondazione Cini, Venice. Because it is inscribed with Toschi's name, it was thought to be by him (Salmi 1954a, p. 49). However, Mirella Levi D'Ancona (1959) discovered that Toschi was actually the abbot of San Pancrazio in Florence and that he had commissioned

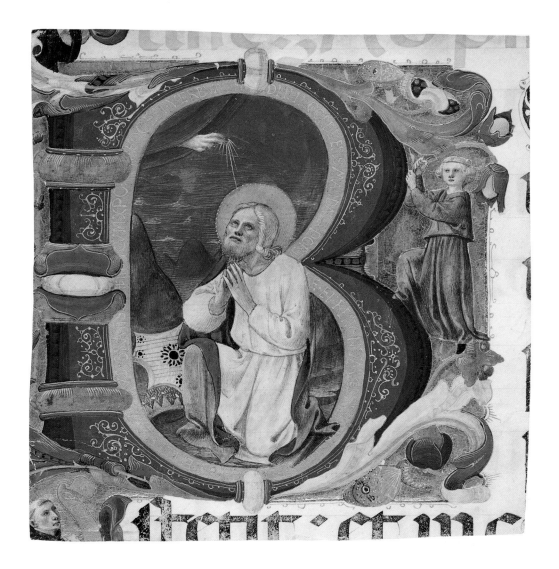

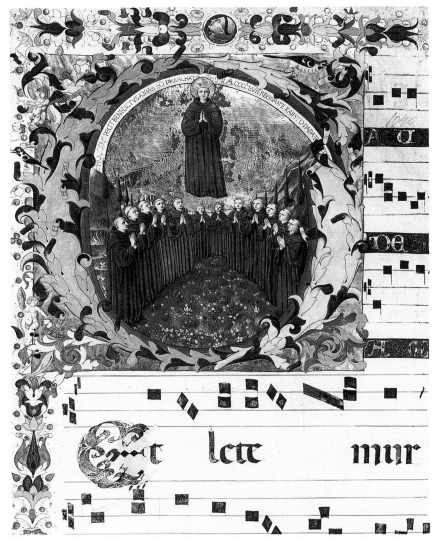

Figure 132. Zanobi Strozzi, Saint John Gualbert. Fondazione Cini, Venice (2151)

the Rudolphe Kann collection has also been attributed, incorrectly, to Strozzi (Suida 1947, fig. 1).

An aside to Strozzi's and Torelli's work as illuminators for the Vallombrosans is that Fra Angelico also seems to have illuminated a Vallombrosan manuscript. A beautiful cutting by him shows Saints Benedict, Maurus, and Placidus in typical Vallombrosan black tunics. It was painted late in Angelico's career.[1]

CBS

1. See Luciano Bellosi, in Turin 1990, pp. 39–42, illustrated in color on p. 38. It is in a private collection. A Crucifixion sometimes attributed to Angelico, now in the Vallombrosan church of Santa Trinita, is not of Vallombrosan origin. As Saint Dominic appears in the lower border, it was probably made for a Dominican house. The donation to Santa Trinita dates to this century. The attribution was first made by Luciano Berti (1962–63, pl. 27; Marchini and Micheletti 1987, fig. 312). Bellosi (in Turin 1990, p. 42) has called it the Pseudo-Domenico di Michelino. In correspondence Laurence Kanter has suggested that this miniature is actually by Battista di Biagio Sanguigni.

EX COLL.: F. Fairfax Murray, Florence (until 1924); von Beckerath (1924); Robert Lehman, New York.

LITERATURE: Collobi Ragghianti 1950b, p. 20, fig. 2; Salmi 1954a, p. 49; Béguin, in Paris 1957, no. 167, pp. 119–20.

53. Book of Hours for the Use of Rome

Tempera and gold on parchment; 278 folios; page size, $5^5/_{16} \times 3^5/_8$ in. (13.5 × 9.3 cm). 1 column of text consisting of 12 lines in Latin in gothic script. The book contains a calendar (fols. 2r–13v), the Hours of the Virgin (fols. 15r–122v), the Hours of the Passion (fols. 124–161v), the Hours of the Cross (fols. 163r–168r), the Seven Penitential Psalms (fols. 170r–203v), and the Office of the Dead (fols. 205r–277v). Binding, $5^1/_2 \times 3^3/_4 \times 2^1/_2$ in. (14 × 9.5 × 6.5 cm).

Courtesy of the Walters Art Gallery, Baltimore (MS W. 767)

The book contains the following illuminations:

Folio 14v: The Annunciation. Full page.
Folio 15r: The Nativity in an initial D ("Domine labia mea aperies" [O Lord, thou wilt open my lips]); six putti supporting a quatrefoil with the Adimari coat of arms in the lower margin.
Folio 45v: The Flight into Egypt in an initial D ("Deus in adiutorium meum intende" [O God, come to my assistance]).

Strozzi to illuminate the monastery's choir books. The frontispiece with Saint John Gualbert was made in 1456. Comparison of it with the Lehman cutting confirms that the latter is also by Strozzi and of approximately the same period. The dark tunics of the two monks in the border suggest that they might be Vallombrosans, the same order as the monks of San Pancrazio. The Lehman cutting could have come from one of the San Pancrazio books that were executed by Strozzi in 1456–57 and for which Filippo di Matteo Torelli painted the border decoration. There does, however, also exist a document of payment to Strozzi for illuminating two frontispieces of psalters for the Benedictine abbey of Florence (Levi D'Ancona 1962, p. 265). In 1450 he was paid for a "Beatus vir" and a "Dixit Dominus meus." A cutting of a frontispiece of a psalter containing a "Beatus vir" once in

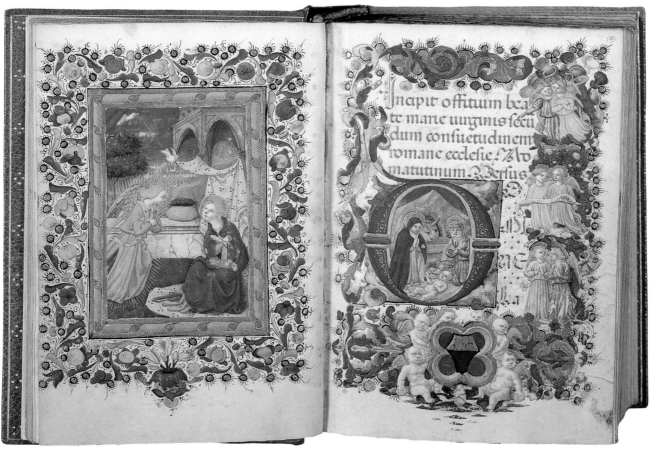

Fols. 14v–15r

Folio 64r: The Presentation in the Temple in an initial D ("Deus in adiutorium meum intende" [O God, come to my assistance]).

Folio 71r: The Adoration of the Magi in an initial D ("Deus in adiutorium meum intende" [O God, come to my assistance]).

Folio 78r: Christ Among the Doctors in an initial D ("Deus in adiutorium meum intende" [O God, come to my assistance]).

Folio 84r: The Death of the Virgin in an initial D ("Deus in adiutorium meum intende" [O God, come to my assistance]).

Folio 90v: The Assumption of the Virgin in an initial D ("Deus in adiutorium meum intende" [O God, come to my assistance]).

Folio 102r: The Coronation of the Virgin in an initial C ("Converte nos Deus salutaris noster" [Convert us, O God our savior]).

Folio 123v: The Crucifixion. Full page.

Folio 124r: The Agony in the Garden in an initial D ("Domine labia mea aperies" [O Lord, thou wilt open my lips]); the Sleeping Apostles in the lower border; and a diamond ring in the upper border.

Folio 162v: The Lamentation. Full page.

Folio 163r: Saint Helen with the True Cross in an initial P ("Patris sapientia, veritas divina" [Father of wisdom, divine truth]); Saint Helen Testing the True Cross in the lower margin.

Folio 169v: David with the Head of Goliath. Full page.

Folio 170r: David in Prayer in an initial D ("Domine ne in furore tuo arguas me" [O Lord, rebuke me not in thy indignation]); Saints Mary Magdalen, John the Baptist, and Onophrius in the lower margin; and two putti holding a diamond ring in the left border.

Folio 204v: A Funeral Service. Full page.

Folio 205r: The Triumph of Death (The Grim Reaper) in an initial D ("Dilexi quoniam exaudiet Dominus" [I have loved because the Lord will hear); friars holding a skull in the lower margin.

The manuscript is certainly one of the most pleasing books of hours to have been made in Florence in the

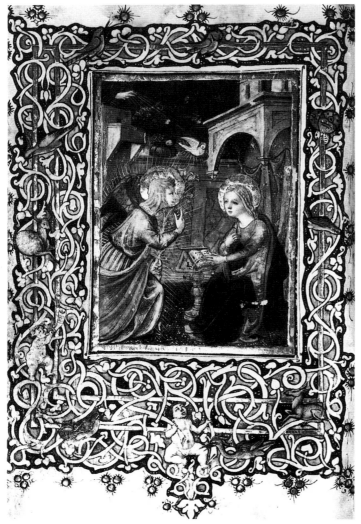

Figure 133. Zanobi Strozzi, The Annunciation. Biblioteca Riccardiana, Florence (MS 457, fol 1v)

Hall, where it was displayed with an inscription that began: "For those who strive bravely for their fatherland."

The Lamentation on folio 162v and Saint Helen and the Proof of the True Cross on the opposite page show the elegance of which Strozzi was capable, especially when he did not slavishly follow a prototype by Fra Angelico. When he repeats a model, the work becomes formulaic and wooden. This is true of the Annunciation (fol. 14v), whose composition derives from Angelico's altarpiece of the same subject in the Prado (fig. 20). Strozzi painted the Annunciation in a similar way several times: it corresponds to the panel discussed in this volume (cat. no. 55) as well as several other illuminations he painted (figs. 133, 134).

The Adimari arms appear on folio 15r. The Adimari were a large and prominent Florentine family, and any one of a number of them could have commissioned this book. The book also contains a personal *impresa*, or emblem, consisting of a single diamond ring. One example is in the border of the page opposite the young David (fol. 170r), and the other appears in the border of the page with the Agony in the Garden (fol. 124r). Annarosa Garzelli (1985a, p. 17) thought that this might signify a connection between the owner and the Medici. The diamond ring was used in several noted Medici *imprese* (Ames-Lewis 1979, pp. 126–29), the two most common of which are three interlocking rings or a single ring with two or three ostrich feathers. It appears as a symbol on buildings commissioned by Cosimo de' Medici as well as his son Piero. Piero also used it as an *impresa* for books in his library. The ring is not, however, exclusively Medicean; it was also part of the personal emblems of at least two other Florentines, Giovanni Rucellai and Francesco Sassetti (Ames-Lewis 1979, pp. 129–31). Both men enjoyed close relationships with the Medici, but whether the emblems were meant to suggest that is uncertain. Unlike the Medici and others' use of the diamond, in the Adimari Book of Hours the rings are not interlaced with feathers; the foliate decoration of the border is simply intertwined with them.

Because of its hardness, the diamond signifies eternity, and the symbolism may end there. However, because the diamond was associated with the Medici and the youthful David with Florence, a connection cannot be ruled out completely. There are no known marriages between the Adimari and Medici, and even if the manuscript had been made for a wedding, the other spouse's arms would have been shown, not just a personal *impresa*. However, the Adimari held prominent political offices during this period, indicating their acquiescence with the Medici regime (see Alessandro

mid-fifteenth century. Zanobi Strozzi's illuminations are masterpieces of the genre. The most original is the full page (fol. 169v) with the young David at the beginning of the penitential psalms. Sling and machete in one hand and the severed head of the Philistine Goliath in the other, he stands triumphant on top of the giant's armored body. The more traditional illustration for this section of a book of hours, which shows the contrite and elderly David praying in the wilderness, is included in the initial D on the opposite page. The triumphant young David is a typically Florentine image. Florentines of the period related him to their republican self-image. For example, Donatello's marble David of 1408–9, now in the Bargello, Florence (Pope-Hennessy 1993, fig. 29, p. 39), in 1416 was brought to the Palazzo della Signoria, or City

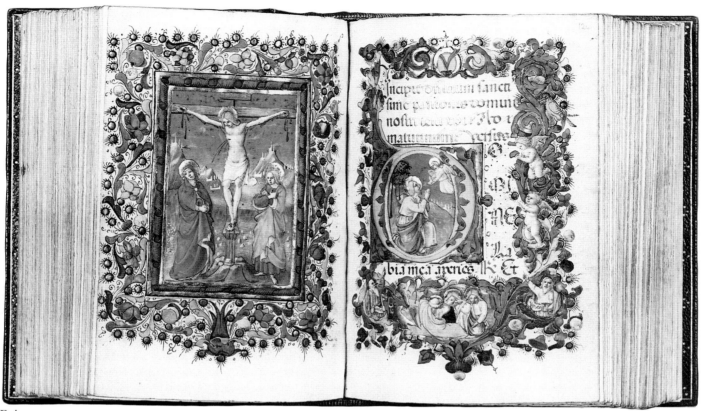

Fols. 123v–124r

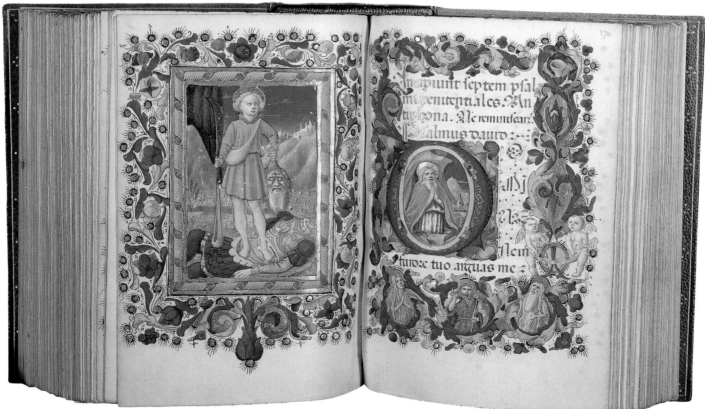

Fols. 169v–170r

Adimari's *Memorie appartenenti alla famiglia degli Adimari*, in Ildefonso di San Luigi 1778, pp. 219–68).

The diamond was also an *impresa* of the Sforza of Milan and appears in manuscripts owned by Francesco Sforza (Ames-Lewis 1979, pp. 129–30).[1] This may be of some significance for the present book of hours, as one member of the family, Bernardo di Guglielmo Adimari, was named a *familares domestici conmensales* (household member) of Francesco Sforza on May 3, 1445.[2] Florentines constituted a thriving community in Francesco Sforza's Milan, and Sforza himself seems to have appreciated Florentine art.[3]

Garzelli dated this book late in Strozzi's career—about 1463—because of the similarity of the border decoration to Francesco del Chierico's work. Strozzi collaborated with him in the 1460s on choir books for the cathedral. The Adimari Book of Hours does not necessarily have to date so late. Strozzi's style shows little sign of significant change after the 1450s. If the book had been ordered by Bernardo Adimari, it may date as early as 1445.

<div align="right">CBS</div>

1. Pellegrin (1969, pls. 124, 127–29) illustrates examples of the *impresa*. See also the color illustrations in López et al. 1978, figs. 24, 192, 305. The most usual form was three intertwined rings. The single ring was, however, also a Sforza *impresa*, for which see Catalano 1956, fig. p. 7.
2. This is reported in the commentary to sonnet 44 of Adimari 1639, pp. 104–5. Adimari also gives the date of 1449 for Bernardo's activity. I thank Moreno Bucci for this information.
3. See Agosti 1990, pp. 50–51. In 1459 his son Galeazzo Maria was in Florence, from which he and his tutor sent back glowing descriptions of the city (Hatfield 1970). In 1462 Francesco Sforza tried to commission two stucco reliefs from Desiderio da Settignano (Spencer 1968). On other Sforza relations with Florence, see Welch 1988.

EX COLL.: The Reverend Walter Sneyd (sale, Sotheby's, London, December 16, 1903, lot 55); Charles Fairfax Murray; C. W. Dyson Perrins (1906; sale, Sotheby's, London, December 1, 1959, lot 80).

LITERATURE: London 1908, no. 255; Miner 1960; idem 1971, pp. 93–99; Garzelli 1985a, pp. 18–19; idem 1985b, pp. 240–41; Wieck 1988, no. 116, pp. 97–98, 223–24; Strehlke 1990, p. 432.

54. Book of Hours for the Use of Rome

Tempera, gold leaf, and brown ink on parchment, edges gilt and gauffered; 235 folios; page size, 2 3/4 × 1 3/4 in. (7 × 4.5 cm). Leaves slightly cut, 1 column of 13 lines of text in Latin written in humanistic minuscule. The text consists of the calendar (fols. 2r–3v), the Hours of the Virgin (fols. 14r–99v), the Office of the Dead (fols. 100r–149v), the Hours of Christ Crucified (fols. 155r–90r), the Hours of the Cross (fols. 191r–96v), the Seven Penitential Psalms, and accessory texts, including a votive Mass of the Virgin (fols. 197r–232v), and 3 further leaves and the back flyleaf with prayers to Christ and several different saints. There are 14 decorated initials, 2 gilt initials, 5 historiated initials, and 2 full-page miniatures. Red velvet binding over wooden boards, 5 1/2 × 3 15/16 in. (14 × 10 cm).

Mrs. Alexandre Rosenberg

The miniatures and historiated initials are:

Folio 1v: An Astronomer Enthroned, Surrounded by Six Kneeling Astronomers. Full page.
Folio 14r: The Nativity of Christ in an initial D ("Domine labia me aperies" [O Lord, thou wilt open my lips]); a scrolling vine border inhabited by cherubim, animals, birds, and insects; and the Virgin and Child Surrounded by Angels in the lower center.

Fol. 1v

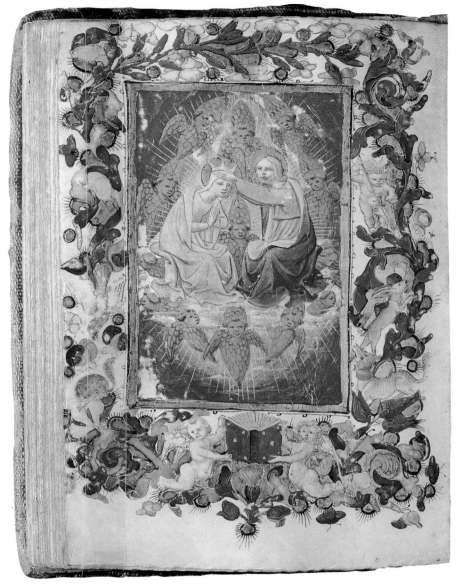

Fol. 71v

Folio 71v: The Coronation of the Virgin; a foliate and floral border with a putto wielding a spear, a dog biting the tail of a hare, and two putti opening a book. Full page.

Folio 100r: Sacrament of Extreme Unction in an initial D ("Dilexit quoniam exaudiet dominus" [I have loved because the Lord will hear]); a scrolling vine border inhabited by animals, birds, a hooded putto with a skull, and a putto with a helmet of armor; and the Quick and the Dead in an oculus at the bottom center.

Folio 155r: The Crucifixion in an initial D ("Domine labia mea aperies" [O Lord, thou wilt open my lips]); a vine border inhabited by putti, animals, birds, and insects.

Folio 191r: The Descent from the Cross in an initial P ("Patris sapientia veritas divina" [Father of wisdom, divine truth]); the Entombment in an oculus at the bottom center; and a vine border inhabited by putti, animals, birds, and insects.

Folio 197r: King David in a Landscape in an initial D ("Domine ne in furore tuo arguas me" [O Lord, rebuke me not in thy indignation]); a youthful David with a sling in an oculus at the bottom center; and a vine border inhabited by a boy with a drum, animals, birds, and insects.

The frontispiece with the enthroned astronomer is by Francesco d'Antonio del Chierico, and the full-page illumination of the Coronation of the Virgin on folio 71v is by Zanobi Strozzi. The other historiated initials, all of which have figures on a much smaller scale, seem to be by a third artist. Annarosa Garzelli (1985b, p. 239) has

identified him as the Master of the Riccardi Lactantius.[1] On a leaf pasted onto the back binding at the lower right in a box is the inscription *Di gerardo miniatore fiorentino 1470*. But this is not original to the manuscript and is probably incorrect, as the "Gerardo" probably refers to Gherardo di Giovanni, a follower of Domenico Ghirlandaio.

Francesco del Chierico and Strozzi are documented as having worked together on antiphonaries for the cathedral (Biblioteca Laurenziana, Florence; MS Edili 149–151) in 1463. This book is probably the fruit of their collaboration in this period and is unlikely to date much before this time. On the other hand Garzelli proposed a dating of about 1450–55.

The provenance of the book is not known, but the presence of a number of specifically Benedictine saints in the calendar at the beginning would suggest that it was commissioned by a wealthy monk or nun belonging to one of the Benedictine orders. The repeated appearance in the calendar of saints of the name Felice or its derivatives, such as Felicianus or Felicita, gives some indication. Among these are Felice of Foligno, Felice in Pincio, Perpetua e Felicita, Felice, Primus and Felicianus, as well as Felice and Audacius. The book's owner may have had one of these names. Alternatively, these saints could suggest ownership by a man or a nun associated with either of two churches in Florence: Santa Felicita and San Felice in Piazza. The identification of the titulars of these two churches was much-discussed in the Renaissance (Fiorelli Malesci 1986, pp. 28–30; Meoni 1993, pp. 13–16). Since Felice in Pincio appears in the calendar, the book probably comes from San Felice in Piazza, because the Felice of that church was most commonly identified with the martyr to whom the Roman church of San Felice in Pincio was dedicated (Meoni 1993, p. 16).

The full-page illustration of an enthroned astronomer with an armillary sphere is an unusual, but suitable, frontispiece for a book of hours. Garzelli identified the astronomer as the second-century Alexandrian Ptolemy. Such a specific identification is unlikely, as the group of figures around him is probably meant to be discussing the date of Christ's Incarnation, although Ptolemy was born after Christ. In the Florentine Brunetto Latini's small mid-thirteenth-century encyclopedia, *Li livres dou Tresor*, the father of astronomy was identified as Noah's son Jonitus (Latini 1975, p. 34 [21.3]). Two allegories of astronomy appear in trecento Florentine art. Andrea Pisano's relief for the cathedral belltower (Becherucci and Brunetti [1969–70], vol. 1, figs. 57, 58) shows the first astronomer as an old man. He is generally considered to be the Jonitus of Latini's *Tresor* (Schlosser 1896, p. 70). The inscription identifying the astronomer in Andrea di

Bonaiuto's frescoes of 1367 in the chapter house of Santa Maria Novella is no longer legible, and there is no consensus as to his identity (Offner and Steinweg 1979, pl. I.21, p. 25, n. 16). He is often called Ptolemy because he wears a crown. Although the astronomer had nothing to do with the Ptolemaic kings of Egypt, the confusion may have existed. In the book of hours, an identification of the enthroned astronomer with Zoroaster or Hermes Trismegistus may also be possible. Pia Palladino and Maria Pernis (in correspondence dated March 1994) have kindly pointed out to me that in the preface to *Pimander*, Marsilio Ficino's translation of the *Corpus Hermeticum*, completed in 1463, Zoroaster is given prominence equal to the mythical Hermes Trismegistus, the father of theology and an astronomer-philosopher who through his knowledge of the universe and astrological laws predicted the coming of Christ (see also Garin 1976, p. 77). The group of seven astronomers (seven being a symbolic number) would be in the act of measuring the heavens through which they gather knowledge of divine things. The position of the illumination at the beginning of the calendar and the absence of an Annunciation common to most such books argue for the Christian context of this otherwise seemingly secular subject.

CBS

1. On this master see Garzelli 1985a, pp. 200–201, where his work is amply illustrated. The artist was a close follower and collaborator of Mariano del Buono (1433–1504).

EX COLL.: (Sale, Sotheby's, London, December 7, 1982, lot 90).

LITERATURE: De Hamel, in Sotheby's sale 1982, lot 90; Garzelli 1985b.

55. The Annunciation

Tempera and gold on panel
Overall: 14 $^{5}/_{8}$ × 11 $^{3}/_{4}$ × 3 $^{1}/_{2}$ in. (37.1 × 30 × .9 cm); picture surface: 12 × 11 in. (30.5 × 27.8 cm)

Philadelphia Museum of Art; The John G. Johnson Collection (J 22)

A simulated pink and red porphyry frame surrounds the image of the angel Gabriel on clouds approaching the Virgin Mary. The angel's white lily symbolizes the selection of Mary among the virgins of Israel, and his headdress of red and white roses represents the Virgin's

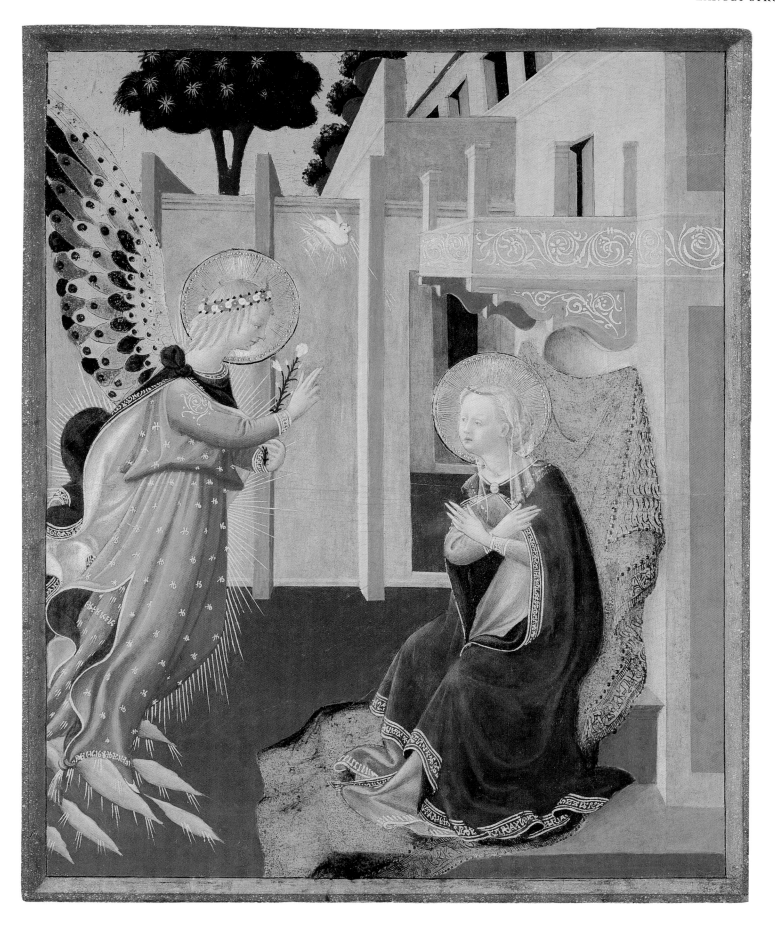

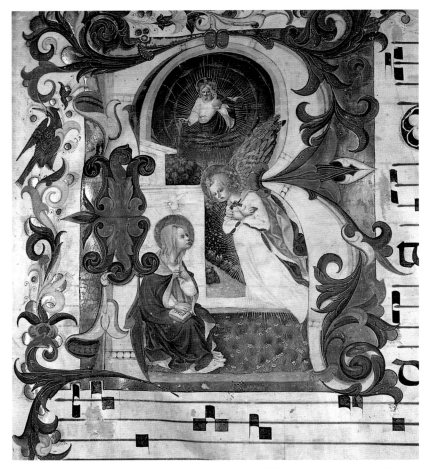

Figure 134. Zanobi Strozzi, The Annunciation. Biblioteca del Convento di San Marco, Florence (MS 516, fol. 3r)

Herbert Horne, in a letter to John G. Johnson, dated Florence, February 28, 1912, attributed the painting to Strozzi based on an illumination (fig. 134) in a choir book from San Marco (Strehlke 1990). On documentary evidence Paolo D'Ancona (1908) had associated this illumination with a payment of 1453 to Strozzi. Two other images of the Annunciation in books of hours illuminated by Strozzi use the same composition and are a further confirmation of the attribution of the Johnson painting. One of them appears in the Adimari Hours (fol. 14v).

Despite the documentary and visual evidence, Bernard Berenson (1913), followed by most other writers, attributed the picture to Domenico di Michelino, another follower of Fra Angelico. Licia Collobi Ragghianti (1950b) correctly attributed the *Annunciation* to Strozzi, suggesting that it might have been part of the predella of the altarpiece to which the *Virgin of Humility and Angels* in the British Royal Collections (Shearman 1983, pl. 213) also belonged. While the Johnson Collection's painting may possibly have been a predella panel, it is unlikely that it came from the same altarpiece as that picture.

The iconography of the *Annunciation* is unusual in that it shows the angel flying in on clouds. Fra Angelico, who exerted the greatest influence on Strozzi's work, did not ever, save once, paint the angel in this way. The exception is an illumination of the Annunciation in a letter R of the gradual included here (cat. no. 48, fol. 33v). Angelico's gradual was made for the convent of San Domenico, Fiesole, but Strozzi could have studied it in 1447, when it was lent to the convent of San Marco for a scribe there to copy out its text for another gradual (Garzelli 1985a, pp. 11–12 n. 1). This was but a year after Strozzi had begun working on the illuminations of the San Marco choir books, a project that Angelico was nominally in charge of. Angelico's illumination illustrates an introit sung at masses dedicated to the Virgin: "Rorate caeli desuper et nubes pluant justum: aperiatur terra, et germinet salvatorem" (Drop down dew, you heavens, from above, and let the clouds rain the just one: let the earth be opened, and bud forth a savior). The angel's arrival on clouds is obviously a direct response to the imagery of the text. The reuse of a motif in a painting demonstrates how Strozzi's formation as an illuminator had a decisive effect on his activity as a panel painter.

Two features depend on other pictures by Angelico. The Virgin's pose can be found in the Prado *Annunciation* (fig. 21) and the *Annunciation* in the Museo di San Marco, painted for a reliquary of Santa Maria Novella sometime before 1434 (fig. 129). The distinctive gold tufts of thread in Gabriel's costume in the reliquary

purity. In Dante's *Paradiso* (33.73) she is called "the rose in which the divine word was made flesh." Her arms are crossed against her chest in a gesture of humility, while she sits on a raised ledge covered with a gold and green hanging. The Holy Spirit in the form of a dove with a cruciform halo approaches from above. Another nimbed figure, no longer visible, may have been God the Father.

The panel has a horizontal grain, suggesting that it may have been part of a predella. Predelle were usually painted on a single flank of horizontally grained wood. However, it would be somewhat unusual to have an *Annunciation* in a predella, as it most frequently appears in altarpieces as the main scene or in pinnacles. More likely, the panel was an independent picture or a valve of a diptych of which the other panel is lost. The simulated frame would seem to second this assumption. Giorgio Vasari in his life of Fra Angelico published in 1568 (Vasari 1878–85, vol. 2, p. 520) says that Zanobi Strozzi painted pictures for houses all over Florence. This small panel is probably one of them.

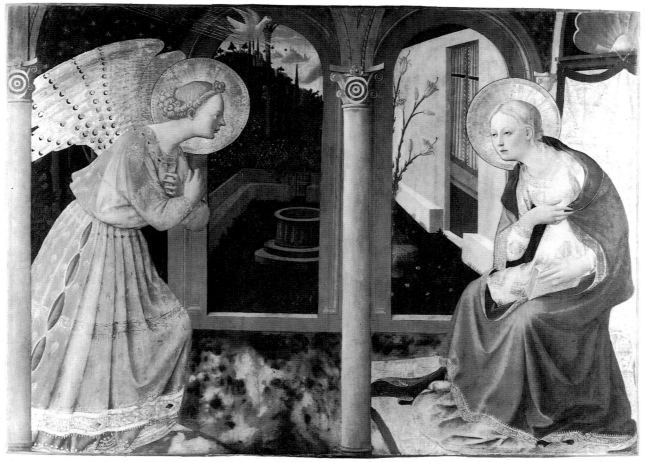

Figure 135. Zanobi Strozzi, *The Annunciation*. National Gallery, London (1406)

reappear in the present panel by Strozzi. In addition, Strozzi himself made an almost exact copy (fig. 135) of the Prado *Annunciation* for an altarpiece commissioned by a member of the Lanfredini family for the Franciscan Observant church of San Salvatore del Monte.[1] CBS

1. Davies (1961, pp. 34–35) attributes the painting to a follower of Angelico. I do not know which Lanfredini commissioned this. Orsino di Lanfredino, who was buried in the Carmine (Paatz and Paatz 1940–54, vol. 3, pp. 221–22) was a business partner of the Strozzis. His son Giovanni ran the Medici bank in Venice (Roover 1963, p. 253). The combined account

books of the Strozzi, Chante di Giovanni and company, and the Lanfredini (Orlandi 1964, p. 181; Christiansen 1982, pp. 162–64) contain the payments to Gentile da Fabriano for the Strozzi *Adoration* and Giovanni Toscani for the Ardinghelli altarpiece in Santa Trinita.

EX COLL.: Carfax, London; John G. Johnson, Philadelphia (by 1904).

LITERATURE: Berenson 1913, p. 17; Collobi Ragghianti 1950b, p. 463; Sweeny 1966, p. 27; Fredericksen and Zeri 1972, p. 127; Strehlke 1990, pp. 429, 432; Strehlke 1993a, pp. 19–20.

Bibliography

List of Abbreviations

AA.SS.—*Acta Sanctorum*, ed. Bollandists. 67 vols. Paris, 1863–1931

ASF—Archivio di Stato, Florence

ASPMF—Archivio di San Pier Martire at the Conservatorio delle Mantellate, Florence

BMLF—Biblioteca Medicea Laurenziana, Florence

BNCF—Biblioteca Nazionale Centrale, Florence

CRS—Compagnie Religiose Soppresse, Archivio di Stato, Florence

SBASF—Soprintendenza per i Beni Artistici e Storici, Florence

References

Adimari, Alessandro
1639 *La Clio; ovvero, Cinquanta sonetti, sopra piu persone della famiglia o casata degli Adimari. . . .* Florence.

Agosti, Giovanni
1990 *Bambaia e il classicismo lombardo.* Turin.

Alexander, J. J. G.
1978 *The Decorated Letter.* New York.

Ameisenowa, Sofia
1939 "Opere inedite del Maestro del Codice di San Giorgio." *Rivista d'arte* 21, pp. 97–125.

Ames-Lewis, Frances
1979 "Early Medicean Devices." *Journal of the Warburg and Courtauld Institutes* 92, pp. 122–43.

Amsterdam
1934 *Italiaansche Kunst in Nederlandsch Bezit.* Exh. cat. Amsterdam: Stedelijk Museum.

Antal, Frederick
1948 *Florentine Painting and Its Social Background.* London.

Apel, W.
1966 *Gregorian Chant.* 3d ed. Bloomington, Ind. First published 1958.

Aronberg Lavin, Marilyn
1955 "Giovannino Battista: A Study in Renaissance Religious Symbolism." *Art Bulletin*, n.s. 37 (June), pp. 85–101.

Artaud de Montor, Alexis-François
1843 *Peintres primitifs: Collection de tableaux rapportée d'Italie et publiée par le Chevalier Artaud de Montor. . . .* Paris.

Ashburnham, Bertram, 4th earl of
1861 *Catalogue of the Manuscripts at Ashburnham Place: Appendix.* Compiled by John Holmes. London.

Auvray, Louis
1892 *Les manuscrits de Dante des bibliothèques de France: Essai d'un catalogue raisonné.* Paris.

Avignon
1983 *L'art gothique siennois.* Exh. cat. Avignon: Petit Palais.

Bacchi, Giuseppe
1930–31 "La Compagnia di Santa Maria delle Laudi e di Sant'Agnese nel Carmine di Firenze," parts 1, 2.

Rivista storica carmelitana 2, pp. 137–51; 3, pp. 12–39, 97–122.

Bach, C. M.
1964 *Materials and Technique.* Denver.

Baetjer, Katharine
1980 *European Paintings in The Metropolitan Museum of Art by Artists Born in or Before 1865: A Summary Catalogue.* 3 vols. New York.

Baldini, Umberto
1970 *L'opera completa dell'Angelico.* Introduction by Elsa Morante. Milan.
1977 "Contributi all'Angelico: Il trittico di San Domenico di Fiesole e qualche altra aggiunta." In *Scritti di storia dell'arte in onore di Ugo Procacci*, vol. 1, pp. 236–46. Milan.

Bale sale
1881 *The Bale Collection: Catalogue of the Charles Sackville Bale Sale.* 6 parts. Sale catalogue, Christie, Manson and Woods, London, May 13–June 14.

Baltimore
1949 *Illuminated Books of the Middle Ages and Renaissance*, by Dorothy Miner. Exh. cat. Baltimore: Baltimore Museum of Art.
1962 *The International Style: The Arts in Europe Around 1400.* Exh. cat. Baltimore: Walters Art Gallery.

Barr, Cyrilla
1988 *The Monophonic Lauda and the Lay Religious Confraternities of Tuscany and Umbria in the Late Middle Ages.* Kalamazoo, Mich.
1989 "A Renaissance Artist in the Service of a Singing Confraternity." In Marcel Tetel, Ronald G. Witt, and Rona Goffen, eds., *Life and Death in Fifteenth-Century Florence*, pp. 105–19, 216–23. Durham, N.C.
1990 "Music and Spectacle in Confraternity Drama of Fifteenth-Century Florence: The Reconstruction of a Theatrical Event." In Timothy Verdon and John Henderson, eds., *Christianity and the Renaissance: Image and Religious Imagination in the Quattrocento*, pp. 376–404. Syracuse.

Bartalini, Roberto
1987 Catalogue entry. In *Antichi maestri pittori: 18 opere dal 1350 al 1520.* Exh. cat. Turin: Galleria Giancarlo Gallino. Unpaged.

Baxandall, Michael
1972 *Painting and Experience in Fifteenth Century Italy.* London.

Bec, Christian
1981 *Cultura e società a Firenze nell'età della Rinascenza.* Rome.

Becherucci, Luisa, and Giulia Brunetti
[1969–70] *Il Museo dell'Opera del Duomo a Firenze.* 2 vols. Florence.

Beck, James
1989 "Leon Battista Alberti and the 'Night Sky' at San Lorenzo." *Artibus et Historiae* 19, pp. 9–35.

Bellosi, Luciano

1965 "Da Spinello Aretino a Lorenzo Monaco." *Paragone*, no. 187, pp. 18–43.

1966 "Il Maestro della Crocifissione Griggs: Giovanni Toscani." *Paragone*, no. 193, pp. 44–58.

1972 "Jacopo di Mino del Pelliciaio." *Bollettino d'arte* 57, pp. 73–77.

1974 *Buffalmacco e il Trionfo della Morte*. Turin.

1977a *Il Museo dello Spedale degli Innocenti a Firenze*. Milan.

1977b "Una precisazione sulla Madonna di Orsanmichele." In *Scritti di storia dell'arte in onore di Ugo Procacci*, vol. 1, pp. 152–56. Milan.

1979 "Un trittico molto insolito." In Antonio Boschetto, ed., *Itinerari: Contributi alla storia dell'arte in memoria di Maria Luisa Ferrari*, vol. 1, pp. 61–65. Florence.

1982 "Il Maestro del Codice di San Giorgio." In Siena 1982, pp. 166–67.

1984 "Due note in margine a Lorenzo Monaco miniatore: Il 'Maestro del Codice Squarcialupi' e il poco probabile Matteo Torelli." In *Studi di storia dell'arte in memoria di Mario Rotili*, vol. 1, pp. 307–14. Naples.

1985a "Su alcuni disegni italiani tra la fine del Due e la metà del Quattrocento." *Bollettino d'arte* 70, pp. 1–42.

1985b "Francesco di Michele, il Maestro di S. Martino a Mensola." In *Paragone*, no. 419–23, pp. 57–63.

1992 "Miniature del 'Maestro della Carità.'" *Prospettiva*, no. 65, pp. 24–30.

Benson, Robert

1927 *The Holford Collection, Dorchester House*. 2 vols. Oxford.

Bent, George R.

1992 "The Scriptorium at S. Maria degli Angeli and Fourteenth Century Manuscript Illumination: Don Silvestro dei Gherarducci, Don Lorenzo Monaco, and Giovanni del Biondo." *Zeitschrift für Kunstgeschichte* 61, pp. 507–23.

Berenson, Bernard

1909 *The Florentine Painters of the Renaissance, with an Index to Their Works*. 3d ed. New York and London.

1911 *The Central Italian Painters of the Renaissance*. 2d ed. New York and London.

1913 *Catalogue of a Collection of Paintings and Some Art Objects*. Vol. 1, *Italian Paintings*. Philadelphia: John G. Johnson.

1926 "Due illustratori italiani dello Speculum Humanae Salvationis." *Bollettino d'arte* 5, no. 7 (January), pp. 289–320.

1930 *Studies in Medieval Painting*. New Haven.

1931 "Quadri senza casa: Il Trecento fiorentino, I." *Dedalo* 11, no. 14 (July), pp. 957–88.

1932a *Italian Pictures of the Renaissance: A List of the Principal Artists and Their Works with an Index of Places*. 3 vols. Oxford.

1932b "Quadri senza casa: Il Trecento fiorentino, IV–V." *Dedalo* 12, no. 1 (January), pp. 5–34; no. 3 (March), pp. 173–93.

1932c "Quadri senza casa: Il Quattrocento fiorentino, I." *Dedalo* 12, no. 7 (July), pp. 512–41.

1936 *I pittori italiane del Rinascimento: Catalogo dei principali artisti e delle loro opere con un indice dei luoghi*. Translated by Emilio Cecchi. Milan.

1961 *I disegni dei pittori fiorentini*. Revised and expanded. 3 vols. Milan.

1963 *Italian Pictures of the Renaissance: A List of the Principal Artists and Their Works, with an Index of Places: Florentine School*. 2 vols. London.

Berkeley

1963 *Pages from Medieval and Renaissance Illuminated Manuscripts from the Xth to the Early XVIth Centuries*. Exh. cat. Berkeley: University of California, University Art Gallery.

Berti, Giovanni Felice

1850 *Cenni storico-artistici per servire di guida ed illustrazione alla insigne Basilica di S. Miniato al Monte e di alcuni dintorni presso Firenze*. Florence.

Berti, Luciano

1962–63 "Miniature dell'Angelico (e altro)," parts 1, 2. *Acropoli* 2, no. 4, pp. 277–308; 3, no. 1, pp. 1–38.

1992 Ed. *Nel raggio di Piero: La pittura nell'Italia centrale nell'età di Piero della Francesca*. Exh. cat. Venice: Borgo San Sepolcro, Casa di Piero.

Berti, Luciano, and Antonio Paolucci, eds.

1990 *L'età di Masaccio: Il primo Quattrocento a Firenze*. Exh. cat. Florence: Palazzo Vecchio.

Bietti Favi, Monica

1990 "Indizi documentari su Lippo di Benivieni." *Studi di storia dell'arte* 1, pp. 243–52.

Billi, Antonio

1892 *Il libro di Antonio Billi*. Edited by Karl Frey. Berlin.

Birmingham

1955 *Exhibition of Italian Art from the Thirteenth Century to the Seventeenth Century*. Exh. cat. Birmingham: City of Birmingham Museum and Art Gallery.

Bocchi, Francesco

1677 *Le bellezze della città di Firenze*. Edited by Giovanni Cinelli. Florence. First published 1591.

Boerner sale

1912 *Manuskripte und Miniaturen des XII. bis XVI. Jahrhunderts*. Sale catalogue, no. 110, C. G. Boerner, Leipzig, November 28.

Boinet, Amédée

1926 *La collection de miniatures de M. Édouard Kann*. Paris.

Boissard, Elisabeth de, and Valérie Lavergne-Durey

1988 *Chantilly, Musée Condé: Peintures de l'école italienne*. Inventaire des collections publiques françaises, vol. 34. Paris.

Bologna, Ferdinando

1969 *Novità su Giotto: Giotto al tempo della cappella Peruzzi*. Turin.

Bonniwell, William R.

1945 *A History of the Dominican Liturgy, 1215–1945*. New York.

Borenius, Tancred

1913 *A Catalogue of the Paintings at Doughty House, Richmond, and Elsewhere in the Collection of Sir Frederick Cook*. Vol. 1, *Italian Schools*. London.

Borgia, Luigi, et al.

1984 *Le Biccherne: Tavole dipinte delle magistrature senesi (sec. XIII–XVIII)*. Rome.

Boskovits, Miklós

1965 "Un' opera probabile di Giovanni di Bartolommeo Cristiani e l'iconografia della 'Preparazione alla Crocifissione.'" *Acta Historiae Artium* 11, pp. 65–94.

1966 "'Giotto Born Again': Beiträge zu den Quellen Masaccios." *Zeitschrift für Kunstgeschichte* 29, pp. 51–66.

1968a "Sull'attività giovanile di Mariotto di Nardo."
 Antichità viva 7, no. 5 (September–October),
 pp. 3–13.
1968b "Some Early Works of Agnolo Gaddi." *Burlington
 Magazine* 110 (April), pp. 208–15.
1968c "Ein Vorläufer der spätgotischen Malerei in
 Florenz: Cenni di Francesco di Ser Cenni."
 Zeitschrift für Kunstgeschichte 31, pp. 273–92.
1968d *Tuscan Paintings of the Early Renaissance.* Translated
 from Hungarian by Eva Rácz. Budapest.
1972 "Su Don Silvestro, Don Simone e la Scuola degli
 Angeli." *Paragone*, no. 265, pp. 35–61.
1975 *Pittura fiorentina alla vigilia del Rinascimento, 1370–
 1400.* Florence.
1976a *Un'adorazione dei magi e gli inizi dell'Angelico.*
 Bern.
1976b "Appunti sull'Angelico." *Paragone*, no. 313,
 pp. 30–54.
1979 "In margine alla bottega di Agnolo Gaddi."
 Paragone, no. 335, pp. 54–62.
1980 Commentary. In *The Hatvany Collection.* Vol. 1,
 Highly Important Old Master Drawings. Sale
 catalogue, Christie, Manson and Woods, London,
 June 24.
1983 "Il gotico senese rivisitato: Proposte e commenti
 su una mostra." *Arte cristiana* 71, no. 698
 (September–October), pp. 259–76.
1984 *A Critical and Historical Corpus of Florentine
 Painting.* Section 3, vol. 9, *The Fourteenth Century:
 The Painters of the Miniaturist Tendency.* Florence.
1987 *A Critical and Historical Corpus of Florentine
 Painting.* Section 3, vol. 2 [part 1], *The Fourteenth
 Century: Elder Contemporaries of Bernardo Daddi.*
 New ed. Florence.
1988 *Frühe italienische Malerei: Gemäldegalerie, Berlin.
 Katalog der Gemälde.* Berlin.
1989 *A Critical and Historical Corpus of Florentine
 Painting.* Section 3, vol. 3, *The Fourteenth Century:
 The Works of Bernardo Daddi.* With Enrica Neri
 Lusana. New ed. Florence.
1990 *The Thyssen-Bornemisza Collection: Early Italian
 Painting, 1290–1470.* With the assistance of Serena
 Padovani; translated from Italian by Françoise
 Pouncey Chiarini. London.
Boston
1939 *Art in New England.* Exh. cat. Boston: Museum of
 Fine Arts.
Boyle, Leonard E.
1972 *A Survey of the Vatican Archives and of Its Medieval
 Holdings.* Toronto.
Bradley, John William
1889 *A Dictionary of Miniaturists, Illuminators,
 Calligraphers, and Copyists. . . .* Vol. 3. London.
Braunfels, Wolfgang
1954 *Die heilige Dreifältigkeit.* Düsseldorf.
Brieger, Peter, Millard Meiss, and Charles S. Singleton
1969 *Illuminated Manuscripts of the Divine Comedy.*
 2 vols. Princeton.
Buenos Aires
1947 *Exposición de arte gótico: Colección Paula de
 Koenigsberg.* Exh. cat. Buenos Aires: Museo
 Municipal de Arte Hispano Americano Isaac
 Fernandez Blanco.
Buffalo
1935 *Master Drawings Selected from the Museums and
 Private Collections of America*, by Agnes Mongan.

 Exh. cat. Buffalo: Buffalo Fine Arts Academy,
 Albright Art Gallery.
Burger, W. [Étienne Joseph Théophile Thoré]
1857 *Trésors d'art exposés à Manchester en 1857.* Paris.
Butler sale
1911 *Catalogue of Highly Important Pictures by Old
 Masters, the Property of the Late Charles Butler. . . .*
 Sale catalogue, Christie, Manson and Woods,
 London, May 25–26.
Cabrol, Fernand
1932 *The Books of the Latin Liturgy.* London.
Caffarini, Thomas Antonii de Senis
1974 *Libellus de Supplemento Legende Prolixe Virginis Beate
 Catherine de Senis.* Edited by I. Cavallini and I.
 Foralosso. Rome.
Cahn, Walter, and James H. Marrow
1978 "Medieval and Renaissance Manuscripts at Yale: A
 Selection." *Yale University Library Gazette* 52, no. 4
 (April), pp. 173–284.
Calkins, Robert
1983 *Illuminated Books of the Middle Ages.* Ithaca.
Callmann, Ellen
1957 "A Quattrocento Jigsaw Puzzle." *Burlington
 Magazine* 99 (May), pp. 149–55.
1975 "Thebaid Studies." *Antichità viva* 14, no. 3 (May–
 June), pp. 3–22.
Calzolai, Carlo Celso
1976 *La storia della Badia a Settimo.* 2d ed. Florence.
1980 "Il 'Libro dei Morti' di Santa Maria Novella
 (1290–1436)." In *Santa Maria Novella, un Convento
 nella Città: Memorie Domenicane*, n.s., no. 11,
 pp. 15–218.
Cämmerer-George, Monika
1966 *Die Rahmung der toskanischen Altarbilder im
 Trecento.* Strasbourg.
Cannon, Joanna
1980 "Dominican Patronage of the Arts in Central
 Italy: the Provincia Romana, c.1220–c.1320."
 Thesis, Courtauld Institute, University of London.
Cardile, Paul Julius
1976 "Fra Angelico and His Workshop at San
 Domenico (1420–1435): The Development of His
 Style and the Formation of His Workshop." Ph.D
 dissertation, Yale University, New Haven.
Carli, Enzo
1971 "Chi è lo Pseudo-Ambrogio di Baldese." In *Studi
 di storia dell'arte in onore di Valerio Mariani*,
 pp. 109–12. Naples.
Carocci, Guido
1968 *I dintorni di Firenze.* New ed. 2 vols. Rome.
Casella, M.
1924 "Studi sul testo della Divina Commedia." *Studi
 Danteschi* 8, pp. 6 ff.
Castelnuovo, Enrico
1962 *Un pittore italiano alla corte di Avignone: Matteo
 Giovannetti e la pittura di Provenza nel sec. XIV.*
 Turin.
Catalano, Franco
1956 "La nuova signoria: Francesco Sforza." In
 Fondazione Treccani degli Alfieri per la Storia di
 Milano, *Storia di Milano*, vol. 7, *L'età sforzesca dal
 1450 al 1500*, part 1, pp. 3–224. Milan.
Cavallo, Adolph S.
1960 "A Newly Discovered Trecento Orphrey from
 Florence." *Burlington Magazine* 102 (December),
 pp. 505–10.

Celotti sale
1825 *A Catalogue of a Highly Valuable and Extremely Curious Collection of Illumined Miniature Paintings, of the Greatest Beauty, and of Exquisite Finishing, Taken from the Choral Books of the Papal Chapel in the Vatican, During the French Revolution; and Subsequently Collected and Brought to This Country by the Abate Celotti.* Sale catalogue. Mr. Christie, London, May 26.

Cennini, Cennino
1960 *The Craftsman's Handbook.* Translated by D. V. Thompson. New York.

Centi, Tito S.
1984 *Il beato Giovanni pittore Angelico (biografia critica).* Siena.

Chelazzi Dini, Giulietta
1977 "Osservazioni sui miniatori del panegirico di Roberto d'Angio nel British Museum." In *Scritti di storia dell'arte in onore di Ugo Procacci*, vol. 1, pp. 140–45. Milan.
1979 "Miniatori toscani e miniatori umbri: Il caso del Laudario B.R. 18 della Biblioteca Nazionale di Firenze." *Prospettiva*, no. 19, pp. 14–35.

Cherubini, Filippo [Gregorio Farulli]
1723 *Cronologia degli uomini insigni, che sono usciti dall'antica e nobile famiglia de' Giugni di Firenze, marchesi di Campo Oresuoli, e di Antrodoco. . . .* Lucca.

Chiarelli, Renzo
1968 *I codici miniati del Museo di S. Marco a Firenze.* Florence.
1981 [Reprint] of 1968 edition. Florence.

Chicago
1933 *Catalogue of a Century of Progress Exhibition of Paintings and Sculptures, Lent from the American Collections.* Exh. cat. Chicago: Art Institute.

Christiansen, Keith
1982 *Gentile da Fabriano.* Ithaca.
1983 "Early Renaissance Narrative Painting in Italy." *Metropolitan Museum of Art Bulletin* 41, no. 2 (Fall).
1990 "Exhibition Reviews: Florence. Masaccio and the 'Pittura di Luce.'" *Burlington Magazine* 132 (October), pp. 736–39.
1991 "A Bishop Saint." In *Recent Acquisitions: A Selection, 1990–1991, Metropolitan Museum of Art Bulletin* 49, no. 2 (Fall), p. 39.

Christie's sale
1971 *Fine Pictures by Old Masters.* Sale catalogue, Christie, Manson and Woods, London, May 14.

Chronica
1516 "Chronica quadripartita." Manuscript begun in 1516 by Fra Giovanni Maria di Ser Leonardo Toscoli and continued to the nineteenth century. Fiesole, Archivio del Convento di San Domenico.

Ciaranfi, Anna Maria
1932 "Lorenzo Monaco Miniatore," parts 1, 2. *L'arte* 35 (July), pp. 285–317; (September), pp. 379–99.

Ciardi Dupré dal Poggetto, Maria Grazia
1973 "La miniatura gotica in Toscana." In *Atti del I Convegno sulle Arti Minori in Toscana, Arezzo, 11–15 maggio 1971*, pp. 53–63. Florence.
1981 *Il Maestro del Codice di San Giorgio e il Cardinale Jacopo Stefaneschi.* Florence.
1984 "I Francescani a Firenze: Due antifonari della scuola di Pacino." In *Studi di storia dell'arte in memoria di Mario Rotili*, pp. 243–49. Naples.

1989 "'Narrar Dante' attraverso le immagini: Le prime illustrazioni della 'Commedia.'" In *Pagine di Dante: Le edizioni della Divina Commedia dal torchio al computer*, pp. 81–102. Exh. cat. Foligno: Oratorio del Gonfalone; Ravenna: Biblioteca Classense. Florence.

Cicognara, Leopoldo
1826 "Lettera al Canonico Moreni intorno l'antichità di alcune miniature de codici della Biblioteca Laurenziana." *Antologia* 21, pp. 3–16. Reprinted in P. Barocchi, *Gli scritti d'arte della Antologia di G. P. Vieusseux, 1821–1833*, vol. 3, pp. 157–70. Florence, 1975.

Cincinnati
1959 *The Lehman Collection, New York.* Edited by Gustave von Groschwitz. Exh. cat. Cincinnati: Cincinnati Art Museum.

Clark, Kenneth
1930 "Italian Drawings at Burlington House." *Burlington Magazine* 56 (April), pp. 175–87.

Cleveland
1936 *Catalogue of the Twentieth Anniversary Exhibition of the Cleveland Museum of Art: The Official Art Exhibit of the Great Lakes Exposition.* Exh. cat. Cleveland: Cleveland Museum of Art.
1963 "A Missal for a King: A First Exhibition," by William D. Wixom. *Bulletin of the Cleveland Museum of Art* 50, pp. 158–215.
1966 *Handbook of the Cleveland Museum of Art.* Cleveland.

Cockerell, Sydney C., and Edward F. Strange
1908 *Catalogue of Illuminated Manuscripts, Part II: Miniatures, Leaves, and Cuttings.* London: Victoria and Albert Museum.
1923 *Catalogue of Miniatures, Leaves, and Cuttings from Illuminated Manuscripts.* London: Victoria and Albert Museum.

Cohn, Werner
1955 "Il Beato Angelico e Battista di Biagio Sanguigni: Nuovi documenti." *Rivista d'arte* 30, pp. 207–16.
1956 "Nuovi documenti per il B. Angelico." *Memorie domenicane*, 73d year, n.s. 32, no. 4 (October–December), pp. 218–20.
1957 "La seconda immagine della Loggia di Orsanmichele." *Bollettino d'arte* 42, pp. 335–38.

Cole, Bruce
1977 *Agnolo Gaddi.* Oxford.

Cole, Diane
1977a "Fra Angelico: His Role in Quattrocento Painting and Problems of Chronology." Ph.D. dissertation, University of Virginia, Charlottesville.
1977b "Fra Angelico—a New Document." *Mitteilungen des Kunsthistorischen Institutes in Florenz* 21, no. 1, pp. 95–100.

Cole Ahl, Diane
1980 "Fra Angelico: A New Chronology for the 1420s." *Zeitschrift für Kunstgeschichte* 43, no. 4, pp. 360–81.
1981 "Fra Angelico: A New Chronology." *Zeitschrift für Kunstgeschichte* 44, no. 2, pp. 133–58.

Collobi Ragghianti, Licia
1950a "Domenico di Michelino." *Critica d'arte*, ser. 3, anno 8, no. 5, fasc. 31 (January), pp. 363–78.
1950b "Zanobi Strozzi pittore," parts 1, 2. *Critica d'arte*, ser. 3, anno 8, no. 6, fasc. 32 (March), pp. 454–73; anno 9, no. 1, fasc. 33 (May), pp. 17–27.
1955a "Una mostra dell'Angelico." *Critica d'arte nuova*, n.s., no. 10 (July), pp. 389–94.

1955b "Studi angelichiani." *Critica d'arte nuova*, n.s., no. 7 (January), pp. 22–47.

1974 *Il Libro de' disegni del Vasari*. 2 vols. Florence.

Colnaghi, Dominic E.

1928 *A Dictionary of Florentine Painters from the 13th to the 17th Centuries*. London.

Colomb de Batines, Paul

1845–46 *Bibliografia dantesca*. 2 vols. Prato.

Colorado Springs

1951 *Paintings and Bronzes from the Collection of Mr. Robert Lehman*. Exh. cat. Colorado Springs: Colorado Springs Fine Arts Center.

Compton, Michael

1960–61 "William Roscoe and Early Collectors of Italian Primitives." *Liverpool Bulletin* 9, pp. 27–51.

Comstock, Helen

1927 "The Robert Lehman Collection of Miniatures." *International Studio* 86 (April), pp. 47–57.

Condello, Emma

1987 "I codici Stefaneschi: Uno scriptorium cardinalizio del Trecento tra Roma e Avignone?" *Archivio della Società Romana di Storia Patria* 110, pp. 22–61.

1989 "I codici Stefaneschi: Libri e committenza di un cardinal avignonese." *Archivio della Società Romana di Storia Patria* 112, pp. 195–218.

Conti, Alessandro

1971 "Appunti pistoiesi." In *Annali della Scuola Normale Superiore di Pisa*.

Conway, William Martin

1884 *The Gallery of Art of the Royal Institution*. Liverpool.

Corsi, Dinora

1984 "Gherardo da Villamagna: Storia di una leggenda." In *La Terra Benedetta: Religiosità e tradizioni nell'antico territorio di Ripoli*, pp. 47–86. Exh. cat. Florence: Bagno a Ripoli.

Costantini, Celso

1911 *Il crocifisso nell'arte*. Florence.

Covi, Dario A.

1963 "Lettering in Fifteenth Century Florentine Painting." *Art Bulletin* 45, pp. 1–17.

Crowe, Joseph A., and Giovanni Battista Cavalcaselle

1864–66 *A New History of Painting in Italy*. 3 vols. London.

D'Achiardi, Pietro

1929 *I quadri primitivi della Pinacoteca Vaticana*. Rome.

D'Achille, Anna Maria

1991 "Sull'iconografia trinitaria medievale: La Trinità del Santuario sul Monte Autore presso Vallepietra." *Arte medievale*, ser. 2, anno 5, no. 1, pp. 49–73.

Da Costa Greene, Belle

1930 *The Pierpont Morgan Library (1924–29)*. New York.

Da Costa Greene, Belle, and Meta P. Harrsen

1934 *The Pierpont Morgan Library: Exhibition of Illuminated Manuscripts Held at the New York Public Library*. New York.

D'Ancona, Paolo

1908 "Un ignoto collaboratore del Beato Angelico (Zanobi Strozzi)." *L'arte* 11, pp. 81–95.

1914 *La miniatura fiorentina (secoli XI–XVI)*. 2 vols. Florence.

1925 *La miniature italienne du Xe au XVIe siècle*. Paris and Brussels.

Davidsohn, Robert

1896–1908 *Forschungen zur Geschichte von Florenz*. 4 vols. Berlin.

Davies, Martin

1961 *The Earlier Italian Schools*. 2d ed. National Gallery Catalogues. London.

1988 *The Early Italian Schools Before 1400*. Revised by Dillian Gordon. National Gallery Catalogues. London.

De Benedictis, Cristina

1976 "I Corali di San Gimignano, I: Le miniature di Niccolò Tegliacci." *Paragone*, no. 313, pp. 103–20.

1979 *La pittura senese, 1330–1370*. Florence.

De Farcy, Louis

1890 *La broderie du XIe siècle jusqu'à nos jours*. Angers.

Degenhart, Bernhard

1975 "Das Marienwunder von Avignon: Simone Martinis Miniaturen für Kardinal Stefaneschi und Petrarca." *Pantheon* 33, pp. 191–203.

Degenhart, Bernhard, and Annegrit Schmitt

1968 *Corpus der italienischen Zeichnungen, 1300–1450*. Vol. 1, *Süd- und Mittelitalien*. 4 parts. Berlin.

De Hamel, Christopher

1986 *A History of Illuminated Manuscripts*. Boston.

Dei, Bonaventura

1907 *S. M. del Fiore sui colli di Fiesole (ora S. Francesco)*. Florence.

Deimling, Barbara

1991 "Il Maestro di Santa Verdiana, un polittico disperso e il problema dell' identificazione." *Arte cristiana* 79, no. 747, pp. 401–11.

Del Furia, Francesco

1843 "Commentario della vita di Messer Bernardo Giugni composta da Vespasiano da Bisticci." *Archivio storico italiano* 4, no. 1, pp. 330–38.

De Marchi, Andrea

1985 "Per la cronologia dell'Angelico: Il trittico di Perugia." *Prospettiva*, no. 42, pp. 53–57.

1992 "Una fonte per Ghiberti e per il giovane Angelico." In *Artista: Critica d'arte in Toscana*, pp. 130–51. Florence.

De Marinis, Tammaro. *See* Marinis, Tammaro de.

De Nicola, Giacomo

1908 "Opere del miniatore del Codice di San Giorgio." *L'arte* 11, pp. 385–86.

Derbes, Anne

n.d. *Picturing the Passion in Late Medieval Italy*. Cambridge. Forthcoming.

De Ricci, Seymour

1932 *A Handlist of Manuscripts in the Library of the Earl of Leicester at Holkham Hall, Abstracted from the Catalogues of William Roscoe and Frederic Madden and Annotated by Seymour De Ricci*. Oxford.

De Ricci, Seymour, and William J. Wilson

1935–37 *Census of Medieval and Renaissance Manuscripts in the United States and Canada*. 2 vols. New York.

Detroit Institute of Arts

1944 *Catalogue of Paintings*. Detroit.

Di Pietro Lombardi, Paola, et al.

1987 *Biblioteca Estense, Modena*. Florence.

Diringer, David

1958 *The Illuminated Book: Its History and Production*. London.

Dominici, Giovanni

1969 *Lettere spirituali*. Edited by Maria T. Casella and Giovanni Pozzi. Fribourg.

Douglas, R. Langton

1900 *Fra Angelico*. London.

Doyle, Leonard J., trans.

1948 *Saint Benedict's Rule for Monasteries*. Collegeville, Minn.

Dreger, Moritz

1904 *Künstlerische Entwicklung der Weberei und Stickerei: Innerhalb des europäischen Kulturkreises von der spätantiken Zeit bis zum Beginne des XIX Jahrhunderts*. 3 vols. Vienna.

Dublin

1928 *Catalogue of Pictures and Other Works of Art in the National Gallery of Ireland and the National Portrait Gallery*. Dublin.

1932 *National Gallery of Ireland: Catalogue of Oil Pictures in the General Collection*. Dublin.

1956 *National Gallery of Ireland: Catalogue of Pictures of the Italian Schools*. Dublin.

1971 *National Gallery of Ireland: Catalogue of the Paintings*. Dublin.

1981 *National Gallery of Ireland: Illustrated Summary Catalogue of Paintings*. Dublin.

Dykmans, Marc

1975 "Jacques Stefaneschi, élève de Gilles de Rome et Cardinal de Saint Georges." *Rivista di storia della chiesa in Italia* 29, pp. 536–54.

1981 *Le cérémonial papal de la fin du Moyen Age à la Renaissance, II: De Rome en Avignon ou le cérémonial de Jacques Stefaneschi*. Bibliothèque de l'Institut Historique Belge de Rome, fasc. 25. Brussels and Rome.

Ehrle, Franz

1890 *Historia Bibliothecae Romanorum Pontificum tum Bonifatianae tum Avenionensis*. Vol. 1. Rome.

Eisenberg, Marvin

1956 "Un frammento smarrito dell'‘Annunciazione’ di Lorenzo Monaco nell'Accademia di Firenze." *Bollettino d'arte* 41, pp. 333–35.

1976 "‘The Penitent Saint Jerome’ by Giovanni Toscani." *Burlington Magazine* 118 (May), pp. 275–83.

1989 *Lorenzo Monaco*. Princeton.

Eisler, Colin

1989 *The Genius of Jacopo Bellini: The Complete Paintings and Drawings*. New York.

Elam, Caroline, and Ernst Gombrich

1988 "Lorenzo de' Medici and a Villa Project." In Peter Denley and Caroline Elam, eds., *Florence and Italy: Renaissance Studies in Honour of Nicolai Rubinstein*, pp. 481–92. London.

Eubel, Conrad

1913–68 *Hierarchia Catholica Medii et Recentioris Aevi*. 7 vols. Munich and Padua.

Fahy, Everett

1971 "Florentine Paintings in the Metropolitan Museum: An Exhibition and a Catalogue." *Metropolitan Museum of Art Bulletin*, n.s. 29 (June), pp. 431–43.

1982 "Babbott's Choices." *Apollo* 115 (April), pp. 238–43.

1987 "The Kimbell Fra Angelico." *Apollo* 125 (March), pp. 178–83.

Faillon, Étienne Michel

1848 *Monuments inédits sur l'apostolat de Sainte Marie Madeleine en Provence*. Paris.

Farulli, Gregorio [*see also* Cherubini, Filippo]

1710 *Istoria cronologica del nobile ed antico monastero degli Angioli di Firenze*. Lucca.

Fastnedge, Ralph W.

1954 "A Note on the Roscoe Collection." *Liverpool Libraries, Museums, and Arts Committee Bulletin* 4, pp. 23–47.

Fava, Domenico, ed.

1939 *La Biblioteca Nazionale Centrale di Firenze e le sue insigni*. Milan.

Fava, Domenico, and Mario Salmi

1950–73 *I manoscritti miniati della Biblioteca Estense di Modena*. 2 vols. Florence.

Faye, Christopher Urdahl, and W. H. Bond

1962 *Supplement to the Census of Medieval and Renaissance Manuscripts in the United States and Canada*. Originated by C. U. Faye; continued and edited by W. H. Bond. New York.

Fehm, Sherwood A., Jr.

1986 *Luca di Tommè: A Sienese Fourteenth Century Painter*. Carbondale.

Ferguson, George

1972 *Signs and Symbols in Christian Art*. Reprint. New York. First published 1954.

Ferretti, Lodovico

1901 *La chiesa e il convento di San Domenico di Fiesole*. Florence.

Ficarra, Annamaria, ed.

1968 *L'Anonimo Magliabecchiano*. Naples.

Filippini, Francesco, and Guido Zucchini

1947 *Miniatori e pittori a Bologna: Documenti dei secoli XIII e XIV*. Florence.

Fiorelli Malesci, Francesca

1986 *La Chiesa di Santa Felicita a Firenze*. With archaeological notes by Guglielmo Maetzke; introduction by Ugo Procacci; preface by Mina Gregori. Florence.

Firmani, Domenico G.

1984 "Don Simone Camaldolese and Manuscript Production in Late Trecento Florence: A Codicological Examination." Ph.D. dissertation, University of Maryland, College Park.

Florence

1933 *Mostra del tesoro di Firenze sacra*. Exh. cat. Florence: Convento di San Marco.

1937 *Mostra giottesca*. Exh. cat. Florence: Uffizi.

1955 *Mostra delle opere del Beato Angelico*. 3d ed. Exh. cat. Florence: Museo Nazionale di San Marco.

1960 *Mostra dei tesori segreti delle case fiorentine*. Exh. cat. Florence: Circolo Borghese e della Stampa.

1966 *Dipinti salvati dalla piena dell'Arno*. Florence.

1978 *I disegni antichi degli Uffizi: I tempi del Ghiberti*, by Luciano Bellosi, Fiora Bellini, and Giulia Brunetti. Exh. cat. 51. Florence: Gabinetto Disegni e Stampe degli Uffizi.

1987 *Uomini, bestie, e paesi nelle miniature laurenziane*. Exh. cat. Florence: Biblioteca Medicea Laurenziana.

1989 *Arti del Medio Evo e del Rinascimento: Omaggio ai Carrand, 1889–1989*. Exh. cat. Florence: Museo Nazionale del Bargello.

1990a *La chiesa e il convento di San Marco a Firenze*. Vol. 2. Florence.

1990b *Pittura di Luce: Giovanni di Francesco e l'arte fiorentina di metà Quattrocento*. Edited by Luciano Bellosi. Exh. cat. Florence: Casa Buonarroti.

1992 *Il Giardino di San Marco: Maestri e compagni del giovane Michelangelo*. Edited by Paola Barocchi. Exh. cat. Florence: Casa Buonarroti.

Follini, Vincenzo, and Modesto Rastrelli

1789–1802 *Firenze antica e moderna illustrata*. 8 vols. Florence.

Forlani Tempesti, Anna

1991 *The Robert Lehman Collection.* Vol. 5, *Italian Fifteenth- to Seventeenth-Century Drawings.* New York.

1992 "Validità di un metodo." In Monika Cämmerer, ed., *Kunst des Cinquecento in der Toskana,* pp. 308–15. Munich.

Forlani Tempesti, Anna, et al.

1967 *Disegni italiani della collezione Santarelli, sec. XV–XVIII.* Florence: Gabinetto Disegni e Stampe degli Uffizi.

Frawley, Margaret-Louise

1975 "Lorenzo Monaco and His Patrons." M.Phil. dissertation, University of London.

Fredericksen, Burton B., and Federico Zeri

1972 *Census of Pre-Nineteenth-Century Italian Paintings in North American Public Collections.* Cambridge, Mass.

Freeman, Margaret B.

1962 "The Avignon Panels: A Preliminary View." *Metropolitan Museum of Art Bulletin,* n.s. 20 (June), pp. 303–7.

Freuler, Gaudenz

1984 "Die Verkündigung mit dem fliegenden Engel." In *De Arte et Libris,* pp. 153–71. Amsterdam.

1985 "Bartolo di Fredis Altar für die Annunziata-Kapelle in S. Francesco in Montalcino." *Pantheon* 43, pp. 21–39.

1986 *Biagio di Goro Ghezzi a Paganico: L'affresco nell'abside della chiesa di S. Michele.* Florence.

1987 "Andrea di Bartolo, Fra Tommaso d'Antonio Caffarini, and Sienese Dominicans in Venice." *Art Bulletin* 69 (December), pp. 570–86.

1991 *"Manifestatori delle cose miracolose": Arte italiana del '300 e '400 da collezioni in Svizzera e nel Liechtenstein.* Exh. cat. Lugano-Castagnola: Villa Favorita, Fondazione Thyssen-Bornemisza.

1992 "Presenze artistiche toscane a Venezia alla fine del Trecento: Lo scriptorium dei Camaldolesi e dei Domenicani." In Mauro Lucco, ed., *La pittura nel Veneto: Il Trecento,* vol. 2, pp. 480–502. Milan.

1994 *Bartolo di Fredi Cini: Ein Beitrag zur sienesischen Malerei des 14. Jahrhunderts.* Disentis, Switz.

n.d. *A Critical and Historical Corpus of Florentine Painting.* Section 4, vol. 7, *Don Silvestro dei Gherarducci.* Florence. Forthcoming.

Friedländer, Max J.

1917 *Die Sammlung Richard von Kaufmann, Berlin.* Vol. 1, *Die italienische Gemälde.* Berlin.

Frigerio, Salvatore

1988 *Ambrogio Traversari: Un monaco e un monastero nell'umanesimo fiorentino.* Siena.

Frizzoni, Gustavo

1902 "Ricordi di un viaggio artistico oltralpe." *L'arte* 5, pp. 290–301.

Frugoni, Arsenio

1950 "La figura e l'opera del Cardinale Jacopo Stefaneschi." *Atti dell'Accademia Nazionale dei Lincei,* ser. 8, 5, pp. 397–424.

Fry, Roger

1911 "Exhibition of Old Masters at the Grafton Galleries, I." *Burlington Magazine* 20 (November), pp. 66–77.

Gaeta Bertelà, Giovanna, and Marco Spallanzani

1992 *Il libro d'inventario dei beni di Lorenzo il Magnifico.* Florence.

Galerie Georges Petit sale

1926 *Catalogue des enluminures de hautes époques tirées de manuscrits et antiphonaires français, italiens, flamands, allemands, espagnols, et hollandais . . . appartenant à Madame X. . . .* Sale catalogue, Galerie Georges Petit, Paris, December 6.

Gardner, Julian

1974 "The Stefaneschi Altarpiece: A Reconsideration." *Journal of the Warburg and Courtauld Institutes* 37, pp. 57–103.

Garin, Eugenio

1976 *Lo zodiaco della vita: La polemica sull'astrologia dal Trecento al Cinquecento.* Rome.

Garzelli, Annarosa

1985a *Miniatura fiorentina del Rinascimento, 1440–1525: Un primo censimento.* With a contribution by Albina de la Mare. 2 vols. Scandicci.

1985b "Zanobi Strozzi, Francesco di Antonio del Chierico, e un raro tema astrologico nel libro d'ore." In Andrew Morrogh, Fiorella Superbi Gioffredi, Piera Morselli, and Eve Borsook, eds., *Renaissance Studies in Honor of Craig Hugh Smyth,* vol. 2, pp. 237–53. Florence.

Gatherings

1974 *Gatherings in Honor of Dorothy E. Miner.* Edited by Ursula E. McCracken, Lilian M. C. Randall, and Richard H. Randall. Baltimore.

Gaye, Giovanni [Johann Wilhelm]

1839 *Carteggio inedito d'artisti dei secoli XIV, XV, XVI.* Vol. 1. Florence.

Ghidiglia Quintavalle, Augusta

1960 "La 'croce per morti' di Zanobi Strozzi." *Bollettino d'arte* 45, pp. 68–72.

Gibson, Katharine

1929 *The Goldsmith of Florence.* New York.

Giglioli, Odoardo

1933 *Fiesole.* Rome.

Gilbert, Creighton

1984 "The Conversion of Fra Angelico." In *Scritti di storia dell'arte in onore di Roberto Salvini,* pp. 281–87. Florence.

Goldthwaite, Richard A.

1993 *Wealth and the Demand for Art in Italy, 1300–1600.* Baltimore.

Golzio, Vincenzo

1927 "Lorenzo Monaco e una sua nuova opera." *Corriere d'Italia* (Rome) 22, no. 220 (September 16), p. 3.

1931 *Lorenzo Monaco.* Rome.

Gombrich, Ernst H.

1962 "Alberto Avogadro's Description of the Badia of Fiesole and of the Villa of Careggi." In *Italia medioevale e umanistica,* vol. 5, pp. 217–29. Padua.

Gómez-Moreno, Carmen

1968 *Medieval Art from Private Collections: A Special Exhibition at the Cloisters.* Exh. cat. New York: The Cloisters.

González-Palacios, Alvar

1970 "Indagini su Lorenzo Monaco." *Paragone,* no. 241, pp. 27–36.

Goodich, Michael

1982 *Vita Perfecta: The Ideal of Sainthood in the Thirteenth Century.* Stuttgart.

Gosebruch, Martin

1971 "Sulla necessità di colmare la lacuna tra Padova e le cappelle di S. Croce nella biografia artistica di Giotto." In *Giotto e il suo tempo,* pp. 233–51. Rome.

Gozzoli, Maria Cristina
1970 *L'opera completa di Simone Martini*. Milan.
Grahl sale
1885 *Catalogue of the Collection of Drawings Formed by the Late Prof. August Grahl*. Sale catalogue, Sotheby's, London, April 27–28.
Gregori, Mina, et al.
1985 *Il "Paradiso" in Pian di Ripoli: Studi e ricerche su un antico monastero*. Florence.
Gronau, Hans D.
1950 "The Earliest Works of Lorenzo Monaco—I, II." *Burlington Magazine* 92 (July), pp. 183–88; (August), pp. 217–22.
Grönwoldt, Ruth
1961 "Florentiner Stickereien in den Inventaren des Herzogs von Berry und der Herzöge von Burgund." *Mitteilungen des Kunsthistorischen Institutes in Florenz* 10, no. 1 (May), pp. 33–58.
1969 "A Florentine Fourteenth-Century Orphrey in the Toledo Museum of Art." *Apollo* 89 (May), pp. 350–55.
1989 "An Unknown Trecento Embroidery." *Textile History* 20, no. 2 (Autumn), pp. 245–47.
Guidi, Fabrizio
1968 "Per una nuova cronologia di Giovanni di Marco." *Paragone*, no. 223, pp. 27–46.
Guidotti, Alessandro
1979 "Precisazioni sul Maestro Daddesco in alcuni codici miniati della Badia a Settimo." In *La miniatura italiana in età romanica e gotica: Atti del I Congresso di Storia della Miniatura Italiana*, pp. 419–41. Florence.
1990 "Maestro Daddesco." In Laura Dal Prà, ed., *Bernardo di Chiaravalle nell'arte italiana dal XIV al XVIII secolo*, pp. 102–5. Exh. cat. Florence: Certosa di Firenze, Pinacoteca.
Gurrieri, Francesco, Luciano Berti, and Claudio Leonardi
1988 *La Basilica di San Miniato al Monte a Firenze*. Florence.
Hall, Edwin C.
1968 "Cardinal Albergati, St. Jerome, and the Detroit van Eyck." *Art Quarterly* (Detroit) 31, no. 1 (Spring), pp. 3–34.
Harrsen, Meta, and George K. Boyce
1953 *Italian Manuscripts in the Pierpont Morgan Library*. New York.
Hartford
1965 *An Exhibition of Italian Panels and Manuscripts from the Thirteenth and Fourteenth Centuries in Honor of Richard Offner*. Exh. cat. Hartford: Wadsworth Atheneum.
Hatfield, Rab
1970 "Some Unknown Descriptions of the Medici Palace in 1459." *Art Bulletin* 52, no. 3 (September), pp. 232–49.
Hautecoeur, Louis
1931 *Les primitifs italiens*. Paris.
Heinemann, Rudolf J.
1930 *Sammlung Schloss Rohoncz—Gemälde*. Exh. cat. Munich: Neue Pinakothek.
1937 *Stiftung Sammlung Schloss Rohoncz*. Vols. 1–2. Lugano-Castagnola.
Heinemann, Rudolf J., et al.
1971 *Sammlung Thyssen-Bornemisza*. Castagnola.
Henderson, John
1994 *Piety and Charity in Late Medieval Florence*. Oxford.

Hendy, Philip
1974 *European and American Paintings in the Isabella Stewart Gardner Museum*. Boston.
Hesbert, Renato-Joanne, ed.
1965 *Corpus Antiphonalium Officii*. Vol. 3. Rome.
Hibbard, Howard
1980 *The Metropolitan Museum of Art*. New York.
Holford sale
1927 *The Holford Library*. Part 1, *Catalogue of Illuminations Forming Part of the Collections at Dorchester House, the Property of Sir George Holford*. Sale catalogue, Sotheby's, London, July 12.
Hood, William
1986 "Saint Dominic's Manners of Praying: Gestures in Fra Angelico's Cell Frescoes at San Marco." *Art Bulletin* 68, no. 2 (June), pp. 195–206.
1993 *Fra Angelico at San Marco*. New Haven.
Horner, Susan, and Joanna Horner
1873 *Walks in Florence*. 2 vols. Florence.
Howett, John
1968 "The Master of the Codex of St. George." Ph.D. dissertation, University of Chicago.
1976 "Two Panels by the Master of the St. George Codex in the Cloisters." *Metropolitan Museum Journal* 11, pp. 85–102.
Hueck, I.
1972 "Le matricole dei pittori fiorentini prima e dopo il 1320." *Bolletino d'arte* 57, pp. 114–21.
Hughes, Andrew
1982 *Medieval Manuscripts for Mass and Office: A Guide to Their Organization and Terminology*. Toronto.
Hughes, D. G.
1959 "Trecento Illustrations of the Divina Commedia." *Annual Report of the Dante Society*, no. 77, pp. 1–40.
Huskinson, J. M.
1969 "The Crucifixion of St. Peter: A Fifteenth-Century Topographical Problem." *Journal of the Warburg and Courtauld Institutes* 32, pp. 135–61.
Huth, Hans
1961 "Italienische Kunstwerke im Art Institute von Chicago, USA." In *Miscellanea Bibliothecae Hertzianae*, pp. 514–20. Munich.
Ildefonso di San Luigi, ed.
1778 *Delizie degli eruditi toscani*. [Florence.]
Istituti
1980 *Dizionario degli istituti di perfezione*. Vol. 6. Rome.
Joannides, Paul
1989 "Fra Angelico: Two Annunciations." *Arte cristiana* 77, pp. 303–8.
1993 *Masaccio and Masolino: A Complete Catalogue*. London.
Jones, Roger
1984 "Palla Strozzi e la sagrestia di Santa Trinita." *Rivista d'arte* 37, pp. 9–106.
Jungmann, Joseph A.
1959 *The Mass of the Roman Rite: Its Origins and Development*. Edited by Charles K. Riepe; translated from German by Francis A. Brunner. New York.
Kaftal, George
1952 *Saints in Italian Art*. Vol. 1, *Iconography of the Saints in Tuscan Painting*. Florence.
Kanter, Laurence B.
1986 "Giorgio di Andrea di Bartolo." *Arte cristiana* 74, pp. 15–28.

1993 Review of *Lorenzo Monaco*, by Marvin Eisenberg. *Burlington Magazine* 135 (September), pp. 632–33.

1994 *Italian Paintings in the Museum of Fine Arts, Boston.* Vol. 1, *13th–15th Century*. Boston.

Kermer, W.

1967 *Studien zum Diptychon in der Sakralen Malerei von den Anfängen bis zur Mitte des sechzehnten Jahrhunderts.* Inaugural dissertation, Tübingen.

King, Donald

1963 *Opus Anglicanum: English Medieval Embroidery.* Exh. cat. London: Victoria and Albert Museum, 1963.

1987 "Embroidery and Textiles" and "598: Orphreys for a Chasuble." In Jonathan Alexander and Paul Binski, eds., *Age of Chivalry: Art in Plantagenet England, 1220–1400.* London.

King, Monique, and Donald King

1990 *European Textiles in the Keir Collection: 400 B.C. to 1800 A.D.* London.

Klesse, Brigitte

1967 *Seidenstoffe in der italienischen Malerei des 14. Jahrhunderts.* Bern.

Koch, Robert A.

1959 "Elijah the Prophet, Founder of the Carmelite Order." *Speculum: A Journal of Medieval Studies* 34, no. 4 (October), pp. 547–60.

Kraus, H. P. (Firm)

1961 *Twenty-Five Manuscripts.* Catalogue no. 95. New York.

1962 *Thirty-Five Manuscripts.* Catalogue no. 100. New York.

1965 *Dante and the Renaissance in Florence.* Catalogue no. 110. New York.

Krautheimer, Richard

1982 *Lorenzo Ghiberti.* With the assistance of Trude Krautheimer-Hess. Princeton Monographs in Art and Archaeology, 31. 3d ed. Princeton. First published 1956.

Kroos, Renate

1970 *Niedersächsische Bildstickereien des Mittelalters.* Berlin.

Kugler, Franz

1847 *Handbuch der Geschichte der Malerei seit Constantin dem Grosser.* 2d ed. Vol. 1. Berlin.

Laclotte, Michel, and Élisabeth Mognetti

1987 *Avignon, Musée du Petit Palais: Peinture italienne.* 3d ed. Paris.

Ladis, Andrew T.

1981 "Fra Angelico: Newly Discovered Documents from the 1420s." *Mitteilungen des Kunsthistorischen Institutes in Florenz* 25, no. 3, pp. 378–79.

1982 *Taddeo Gaddi: Critical Reappraisal and Catalogue Raisonné.* Columbia, Mo.

Landini, Cristoforo

1974 *Scritti critici e teorici.* Edited by Roberto Cardini. 2 vols. Rome.

Lanza, Antonio

1989 *Polemiche e berte letterarie nella Firenze del primo Rinascimento (1375–1449).* 2d ed. Rome.

Lanzi, Luigi

1795–96 *Storia pittorica dell'Italia dal Risorgimento delle Belle Arti fin presso al fine del XVIII secolo.* 3 vols. Bassano.

Latini, Brunetto

1975 *Li livres dou Tresor.* Critical edition by Francis J. Carmody. Geneva.

Lehman, Robert

1928 *The Philip Lehman Collection, New York: Paintings.* Paris.

Leone de Castris, Pierluigi

1979 "Un reliquario senese a vetri dorati." *Antichità viva* 18, no. 5–6, pp. 7–14.

Levi D'Ancona, Mirella

1957 "Don Silvestro dei Gherarducci e il 'Maestro delle Canzoni.'" *Rivista d'arte* 32, pp. 3–37. Published 1959.

1958a "Matteo Torelli." *Commentarii* 9, pp. 244–58.

1958b "Some New Attributions to Lorenzo Monaco." *Art Bulletin* 40 (September), pp. 175–91.

1959 "Zanobi Strozzi Reconsidered." *La bibliofilia* 61, no. 1, pp. 1–38.

1961a "Bartolomeo di Fruosino." *Art Bulletin* 43 (June), pp. 81–97.

1961b "La pala del 1436 di Zanobi Strozzi." *Rivista d'arte* 35 (1960), pp. 103–6.

1962 *Miniatura e miniatori a Firenze dal XIV al XVI secolo: Documenti per la storia della miniatura.* Florence.

1970 "Battista di Biagio Sanguigni, 1392/93–1451." *La bibliofilia* 72, pp. 1–35.

1978 "I corali di S. Maria degli Angeli ora nella Biblioteca Laurenziana e le miniature da essi asportate." In *Miscellanea di studi in memoria di Anna Saitta Revignas*, pp. 213–35. Florence.

1979 "Arte e Politica: L'interdetto, gli Albizzi e la miniatura fiorentina del tardo Trecento." In *La miniatura italiana in età Romanica e Gotica, Atti del I Congresso di Storia della Miniatura Italiana,* pp. 461–87. Florence.

1985 "La miniatura fiorentina tra Gotico e Rinascimento." In Emanuela Sesti, ed., *La miniatura italiana tra Gotico e Rinascimento, II: Atti del II Congresso di Storia della Miniatura Italiana, Cortona, 24–26 settembre 1982,* vol. 1, pp. 451–64. Florence.

1992 "Precisazioni su Matteo Torelli." *La bibliofilia* 94, pp. 89–101.

1993 *The Choir Books of Santa Maria degli Angeli in Florence.* Vol. 2, *The Reconstructed "Diurno Domenicale" from Santa Maria degli Angeli.* Florence.

Lisbon

1982 *Calouste Gulbenkian Museum: Catalogue.* 3d ed. Lisbon.

Litta, Pompeo

1819–1902 *Famiglie celebri italiane: Catalogo delle famiglie in ordine alfabetico.* 13 vols. Milan.

Liuzzi, Fernando

1935 *La lauda e i primordi della melodia italiana.* 2 vols. Rome.

Liverpool

1893 *Catalogue of the Roscoe Collection Deposited by the Trustees of the Royal Institution.* Liverpool: Walker Art Gallery.

1915 *Catalogue of the Roscoe Collection.* Liverpool: Walker Art Gallery.

1928 *Catalogue of the Roscoe Collection, and Other Paintings, Drawings, and Engravings . . . Deposited by the Trustees of the Liverpool Royal Institution,* by Maurice Walter Brockwell. Liverpool: Walker Art Gallery.

1963 *Foreign Schools Catalogue.* Liverpool: Walker Art Gallery.

1966 *Foreign Schools Catalogue*. Liverpool: Walker Art Gallery.

1977 *Foreign Catalogue: Paintings, Drawings, Watercolors, Tapestry, Sculpture, Silver, Ceramics, Prints, Photographs*. Compiled by Edward Morris and Martin Hopkinson. 2 vols. Liverpool: Walker Art Gallery.

Lloyd, Christopher

1993 *Italian Paintings Before 1600 in the Art Institute of Chicago: A Catalogue of the Collection*. With contributions by Margherita Andreotti, Larry J. Feinberg, and Martha Wolff. Chicago.

London

1874 *Illuminated Manuscripts*. Exh. cat. London: Burlington Fine Arts Club.

1879 *Winter Exhibition*. Exh. cat. London: Royal Academy of Arts.

1884 *Illuminated Manuscripts*. Exh. cat. London: Burlington Fine Arts Club.

1886 *Illuminated Manuscripts*. Exh. cat. London: Burlington Fine Arts Club.

1908 *Exhibition of Illuminated Manuscripts*. Exh. cat. London: Burlington Fine Arts Club.

1925 *Catalogue of Additions to the Manuscripts in the British Museum in the Years MDCCCXI–XV*. London.

1929 *National Gallery Catalogue*. London.

1965 *The Art of Painting in Florence and Siena from 1250 to 1500*. Edited by Denys Sutton; compiled by St. John Gore. Exh. cat. London: Wildenstein.

1983 *Early Italian Paintings and Works of Art, 1300–1480*. Exh. cat. London: Mattheisen Fine Arts.

1993 *Master Paintings, 1400–1800*. Exh. cat. London and New York: P. D. Colnaghi and Co.

Longhi, Roberto

1940 "Fatti di Masolino e di Masaccio." *Critica d'arte* 5, pp. 145–91. Reprinted in R. Longhi, *"Fatti di Masolino e di Masaccio" e altri studi sul Quattrocento, 1910–1967*, pp. 3–70. Florence, 1975.

1948 "Il Maestro della Predella Sherman." *Proporzioni* 2, pp. 161–62.

1955 "'Il Maestro degli Ordini.'" *Paragone*, no. 65, pp. 32–36.

López, Guido, et al.

1978 *Gli Sforza a Milano*. Milan.

Los Angeles

1953–54 *Medieval and Renaissance Illuminated Manuscripts*. Exh. cat. Los Angeles: Los Angeles County Museum.

1954 *A Catalogue of Italian, French, and Spanish Paintings, XIV–XVIII Century*. Los Angeles: Los Angeles County Museum.

1987 *European Painting and Sculpture in the Los Angeles County Museum of Art: An Illustrated Summary Catalogue*, by Scott Schaefer and Peter Fusco, with Paula-Teresa Wiens. Los Angeles.

Lugano, Placido

1902 *S. Miniato a Firenze: Storia e leggenda*. Florence.

1903a *Memorie dei più antichi miniatori e calligrafi olivetani*. Florence.

1903b *Origine e primordi dell'ordine di Montoliveto, 1313–1450*. Florence.

Luzzati, Michele

1968 "Bini, Bernardo." In *Dizionario biografico degli italiani*, pp. 503–6. Rome.

M'Cormick, William B.

1925 "Otto H. Kahn Collection." *International Studio* 80, no. 332 (January), pp. 279–86.

Maetzke, Anna Maria

1979 *Arte nell'Aretino: Seconda mostra di restauri dal 1973 al 1979*. . . . Exh. cat. Arezzo: San Francesco.

Maione, Italo

1914 "Fra Giovanni Dominici e Beato Angelico." *L'arte* 17, pp. 281–88, 361–68.

Malaguzzi Valeri, Francesco

1895 *La chiesa e il convento di San Michele in Bosco*. Bologna.

Manni, Domenico Maria

1739–86 *Osservazioni istoriche sopra i sigilli antichi de secoli bassi*. 30 vols. Florence.

Marchese, Vincenzo

1854 *Memorie dei più insegni pittori, scultori, e architetti domenicani*. 2d ed. 2 vols. Florence.

Marchini, Giuseppe, and Emma Micheletti

1987 *La chiesa di Santa Trinita a Firenze*. Florence.

Marcucci, Luisa

1965 *Gallerie Nazionali di Firenze: I dipinti toscani del secolo XIV*. Rome.

Mariani Canova, Giordana

1988 "Cristoforo Cortese." In Milan 1988, pp. 230–39.

Marinis, Tammaro de

1947–52 *La biblioteca napoletana dei re d'Aragona*. 4 vols. Milan.

van Marle, Raimond

1921–22 "La scuola di Pietro Cavalini a Rimini." *Bolletino d'arte* 1, pp. 248–61.

1923–38 *The Development of the Italian Schools of Painting*. 19 vols. The Hague.

1934–35 "La pittura italiana alla esposizione d'arte antica italiana di Amsterdam." *Bollettino d'arte* 27, pp. 293–312.

Marrai, Bernardo

1907 *La primavera del Botticelli, Le cantorie di Luca della Robbia e di Donatello, La sepoltura di Lemmo Balducci: Opere d'arte dell' Arcispedale di Santa Maria Nuova*. Florence.

Maxon, John

1970 *The Art Institute of Chicago*. New York.

Medea, Alba

1940 "L'iconografia della scuola di Rimini." *Rivista d'arte* 22, pp. 1–50.

Mehus, Lorenzo

1759 *Ambrosii Traversarii Generalis Camaldulensium Aliorumque ad Ipsum et ad Alios de Eodem Ambrosio Latinae Epistolae*. Florence. Photostatic reprint, Bologna, 1969.

Meiss, Millard

1936 "The Madonna of Humility." *Art Bulletin* 18 (December), pp. 435–64.

1951 *Painting in Florence and Siena After the Black Death: The Arts, Religion, and Society in the Mid-Fourteenth Century*. Princeton.

1969 "The Smiling Pages." In Brieger, Meiss, Singleton, 1969, pp. 31–80.

Meoni, Lucia

1993 *San Felice in Piazza a Firenze*. Florence.

Mercati, Giovanni, Cardinal

1938 *Codici latini Pico Grimani Pio e di altra biblioteca ignota del secolo XVI esistenti nell'Ottoniana e i codici greci Pio di Modena, con una digressione per la storia dei codici di S. Pietro in Vaticano*. Vatican City.

Meyers, Joseph
1958 "L'art au Musée de Luxembourg." *Revue française*, suppl. to no. 100 (April).

Middeldorf, Ulrich
1955 "L'Angelico e la scultura." *Rinascimento* 6, no. 2 (December), pp. 179–94.
1971 "Additions to Lorenzo Ghiberti's Work." *Burlington Magazine* 113 (February), pp. 75–76.
1975 Review of *Painting and Experience in Fifteenth Century Italy*, by Michael Baxandall. *Art Bulletin* 57 (June), pp. 284–85.

Milan
1988 *Arte in Lombardia tra gotico e rinascimento*, by Miklós Boskovits et al. Exh. cat. Milan: Palazzo Reale.

Milanesi, Gaetano
1854–56 *Documenti per la storia dell'arte senese*. 3 vols. Siena.
1901 *Nuovi documenti per la storia dell'arte toscana*. Florence.

Milliken, William Mathewson
1925 "Illuminated Miniatures in the Cleveland Museum of Art." *Bulletin of the Cleveland Museum of Art* 12 (April), pp. 61–71.
1930 "An Illuminated Miniature, Assumption of the Virgin, Attributed to Lorenzo Monaco." *Bulletin of the Cleveland Museum of Art* 17 (July), pp. 131–33.
1950 "Miniatures by Lorenzo Monaco and Francesco del Cherico." *Bulletin of the Cleveland Museum of Art* 37 (March), pp. 43–46.

Miner, Dorothy
1958 "The Development of Medieval Illumination as Related to the Evolution of Book Design." *Catholic Life Annual* 1.
1960 "A New Renaissance Manuscript." *Bulletin of the Walters Art Gallery* 12, no. 6 (March), pp. 1, 3–4.
1971 "Since De Ricci—Western Illuminated Manuscripts Acquired Since 1934. A Report in Two Parts: Part II." *Journal of the Walters Art Gallery* 31–32 (1968–69), pp. 41–123.

Mini, T.
1706 *Historia del sacro eremo di Camaldoli*. Camaldoli.

Mittarelli, Giovanni Benedetto
1779 *Bibliotheca Codicum Manuscriptorum Monasterii S. Michaelis Venetiarum una cum Appendice Librorum Impressorum Saeculi XV*. Venice.

Moleta, Vincent
1978 "The Illuminated *Laudari* Mgl¹ and Mgl²." *Scriptorium* 32, pp. 29–50.

Montagna, Davide M.
1963 "I conventi di Brescia, Vicenza, e Cremona e il decennio decisivo per la fondazione dell'Osservanza dei Servi." In *Santa Maria di Monte Berico: Miscellanea storica prima*, pp. 113–51. Vicenza.

Morçay, Raoul
1913 "La cronaca del convento fiorentina di San Marco: La parte più antica, dettata da Fra Giuliano Lapaccini." *Archivio storico italiano* 71, pp. 1–29.
1914 *Saint Antonin, fondateur du convent de Saint-Marc, Archevêque de Florence, 1389–1459*. Tours and Paris.

Moreni, Domenico
1791–95 *Notizie istoriche dei contorni di Firenze*. 6 parts. Florence.

Moschetti, Andrea
1905 "La sala delle rarità bibliografiche." *Bollettino del Museo Civico di Padova* 8, pp. 162–76.

1938 *Il Museo Civico di Padova*. Padua.

Muller, N.
1978 "The Methods of Modelling the Virgin Mantle in Early Italian Painting." *Journal of the American Institute for Conservation* 17, pp. 10–18.

Munby, A. N. L.
1972 *Connoisseurs and Medieval Miniatures, 1750–1850*. Oxford.

Müntz, Eugène, and A. L. Frothingham, Jr.
1883 *Il tesoro della Basilica di San Pietro in Vaticano dal XII al XV secolo in una scelta d'inventari inediti*. Rome.

Murray, Peter
1957 "Art Historians and Art Critics—IV: XIV uomini singhularii in Firenze." *Burlington Magazine* 99 (October), pp. 330–36.

Nelson, Bernadette
1991 "Ruskin's 'Fairy Cathedrals.'" *Ashmolean*, no. 21, pp. 12–14.

New York
1930 *Exhibition of Italian Primitive Paintings*. Exh. cat. New York: Century Association.
1944 "Notes. *Seven Joys of Our Lady*: A Christmas Exhibition at the Cloisters." *Metropolitan Museum of Art Bulletin*, n.s., 3, no. 4 (December), p. 88, ill. opp. p. 89.
1967 *Exhibition of Works of Art Lent from American Collections, the Italian Heritage, for the Benefit of the Committee to Rescue Italian Art*. Exh. cat. New York: Wildenstein and Co.
1984 *Italian Manuscript Painting, 1300–1550*. Exh. cat. New York: Pierpont Morgan Library.

New-York Historical Society
1915 *Catalogue of the Gallery of Art of the New-York Historical Society*. New York.

Nordenfalk, Carl
1979 *Bokmålningar från medeltid och renässans i Nationalmusei samlingar*. Stockholm.

Nordenfalk, Carl, et al.
1975 *Medieval and Renaissance Miniatures from the National Gallery of Art*. Washington, D.C.

Northwick sale
1925 *Catalogue of Illuminated Miniatures and Initials: The Property of the Late John, Lord Northwick*. Sale catalogue, Sotheby and Co., London, November 16.

O'Brien, C.
1992 "The Illustration of the First Sunday in Advent in Fourteenth and Fifteenth Century Italian Breviaries." In *Il codice miniato. Rapporti tra codice, testo e figurazione: Atti del III Congresso di Storia della Miniatura*, pp. 147–57. Florence.

O'Connell, John B.
1964 *The Celebration of Mass: A Study of the Rubrics of the Roman Missal*. 4th ed. Milwaukee.

Oertel, Robert
1933 "Die Frühwerke des Masaccio." *Marburger Jahrbuch für Kunstwissenschaft* 7, pp. 191–289.

Offner, Richard
1922 "Pacino di Bonaguida, a Contemporary of Giotto." *Art in America* 11 (December), pp. 3–27.
1927 *Studies in Florentine Painting: The Fourteenth Century*. New York.
1930 *A Critical and Historical Corpus of Florentine Painting*. Section 3, vol. 2, *The Fourteenth Century*, part 1, *Elder Contemporaries of Bernardo Daddi*; part

2, *Works Attributed to Jacopo del Casentino.* Florence.

1933 "The Mostra del Tesoro di Firenze Sacra—II." *Burlington Magazine* 63, pp. 166–78.

1947 *A Critical and Historical Corpus of Florentine Painting.* Section 3, vol. 5, *The Fourteenth Century.* New York.

1956 *A Critical and Historical Corpus of Florentine Painting.* Section 3, vol. 6, *The Fourteenth Century: Close Following of the St. Cecilia Master.* New York.

1957 *A Critical and Historical Corpus of Florentine Painting.* Section 3, vol. 7, *The Fourteenth Century: The Biadaiolo Illuminator; Master of the Dominican Effigies.* New York.

1958 *A Critical and Historical Corpus of Florentine Painting.* Section 3, vol. 8, *The Fourteenth Century: Workshop of Bernardo Daddi.* New York.

1960 *A Critical and Historical Corpus of Florentine Painting.* Section 4, vol. 2, *The Fourteenth Century: Nardo di Cione.* New York.

1967 *A Critical and Historical Corpus of Florentine Painting.* Section 4, vol. 4, *The Fourteenth Century: Giovanni del Biondo (Part I).* Edited by Klara Steinweg. New York.

1969 *A Critical and Historical Corpus of Florentine Painting.* Section 4, vol. 5, *The Fourteenth Century: Giovanni del Biondo (Part II).* Edited by Klara Steinweg. New York.

1981 *A Critical and Historical Corpus of Florentine Painting: A Legacy of Attributions.* Edited by Hayden B. J. Maginnis. New York.

Offner, Richard, and Klara Steinweg

1979 *A Critical and Historical Corpus of Florentine Painting.* Section 4, vol. 6, *The Fourteenth Century: Andrea Bonaiuti.* New York.

Orlandi, Stefano

1954 "Il Beato Angelico." *Rivista d'arte* 29, pp. 161–97. Published 1955.

1955 "'Necrologio' di S. Maria Novella: Testo integrale dall'inizio (MCCXXXV) al MDIV; corredato di note biografiche tratte da documenti coevi.* Introduction by Innocenzo Taurisano, O.P. 2 vols. Florence.

1959–60 *Sant'Antonino.* 2 vols. Florence.

1964 *Beato Angelico: Monografia storica della vita e delle opere, con un'appendice di nuovi documenti inediti.* Florence.

van Os, Henk W.

1969 *Marias Demut und Verherrlichung in der sienesischen Malerei, 1300–1450.* The Hague.

1984 *Sienese Altarpieces, 1215–1460: Form, Content, Function.* Vol. 1, *1215–1344.* Groningen.

1990 *Sienese Altarpieces, 1215–1460: Form, Content, Function.* Vol. 2, *1344–1460.* Groningen.

Ottley sale

1838 *Catalogue of the Very Beautiful Collection of Highly Finished and Illuminated Miniature Paintings, the Property of the Late William Young Ottley, Esq.* Sale catalogue, Sotheby and Co., London, May 11–12.

Paatz, Walter, and Elisabeth Paatz

1940–54 *Die Kirchen von Florenz: Ein kunstgeschichtliches Handbuch.* 6 vols. Frankfurt am Main.

Padoa Rizzo, Anna

1979 "Cenni di Francesco." In *Dizionario biografico degli italiani,* vol. 23, p. 536. Rome.

1982 "Nota breve su Colantonio, Van der Weyden, e l'Angelico." *Antichità viva* 20, no. 5 (September–October 1981), pp. 15–17.

Padovani, Serena

1972 "Su Belbello da Pavia e sul 'Miniatore di San Michele a Murano.'" *Paragone,* no. 339, pp. 24–34.

1979 Catalogue entry. In *Tesori d'arte antica a San Miniato,* pp. 50–52. Genoa.

Paris

1885 *Donation du Baron Charles Davillier.* Paris: Musée du Louvre.

1952 *Trésors d'art du Moyen Age en Italie.* Exh. cat. Paris.

1956 *De Giotto à Bellini: Les primitifs italiens dans les musées de France,* by Michel Laclotte. Exh. cat. Paris: Musée de l'Orangerie.

1957 *Exposition de la collection Lehman de New York,* by Charles Sterling, Olga Raggio, Michel Laclotte, and Sylvie Béguin. Exh. cat. Paris: Musée de l'Orangerie.

1980 *La Collection Wildenstein.* Paris: Musée Marmottan.

1984 *Dix siècles d'enluminure italienne.* Exh. cat. Paris: Bibliothèque Nationale.

Parronchi, Alessandro

1964 *Studi su la dolce prospettiva.* Milan.

Partsch, Susanna

1981 *Profane Buchmalerei der bürgerlichen Gesellschaft im spätmittelalterlichen Florenz: Der Specchio Umano des Getreidehändlers Domenico Lenzi.* Worms.

Pastor, Ludwig, Freiherr von

1969 *The History of the Popes from the Close of the Middle Ages; Drawn from the Secret Archives of the Vatican and Other Original Sources.* Vol. 1. London.

Peintures anciennes

1967 *Peintures anciennes: Collection du Musée d'Histoire et d'Art.* Luxembourg.

Pellechia Nejemy, Linda

1979 "The First Observant Church of San Salvatore al Monte in Florence." *Mitteilungen des Kunsthistorischen Institutes in Florenz* 23, no. 3, pp. 273–96.

Pellegrin, Élisabeth

1969 *La bibliothèque des Visconti et des Sforza.* Florence. First published Paris, 1955.

Perrins sale

1958 *The Dyson Perrins Collection.* Part 1, *Catalogue of Forty-Five Exceptionally Important Illuminated Manuscripts of the 9th to the 18th Century. . . .* Sale catalogue, Sotheby and Co., London, December 9.

Pettenati, Silvana

1973 "Vetri a oro del Trecento padano." *Paragone,* no. 275, pp. 71–80.

1978 *I vetri dorati graffiti e i vetri dipinti del Museo Civico di Torino.* Turin.

Pieraccini, Eugenio

1901 *Gli Uffizi.* Florence.

Pisa

1993 *Nel secolo di Lorenzo: Restauri di opere d'arte del Quattrocento.* Edited by Mariagiulia Burresi. Exh. cat. Pisa: Museo Nazionale di San Matteo.

Pittura

1987 *La pittura in Italia: Il Quattrocento.* Edited by Federico Zeri. 2 vols. Milan.

Platt, Dan F., and F. Newlin Price

1934 *The Collection of Frank Lusk Babbott.* New York.

Plummer, John

1964 *Liturgical Manuscripts for the Mass and the Divine*

Office. Exh. cat. New York: Pierpont Morgan Library.

Polzer, Joseph
1981 "The 'Master of the Rebel Angels' Reconsidered." *Art Bulletin* 63 (December), pp. 563–84.

Pope-Hennessy, John
1947 *A Sienese Codex of the Divine Comedy*. London.
1952 *Fra Angelico*. London.
1974 *Fra Angelico*. 2d ed. Ithaca.
1987 *The Robert Lehman Collection*. Vol. 1, *Italian Paintings*. With the assistance of Laurence B. Kanter. New York.
1993 *Donatello, Sculptor*. New York.

Pope-Hennessy, John, and Keith Christiansen
1980 "Secular Painting in 15th-Century Tuscany: Birth Trays, Cassone Panels, and Portraits." *Metropolitan Museum of Art Bulletin* 38, no. 1 (Summer).

Popoff, Michel
1991 *Repertoires d'héraldique italienne: Florence, 1302–1700*. Paris.

Pouncey, Philip
1946 "An Initial Letter by Mariotto di Nardo." *Burlington Magazine* 88 (March), pp. 71–72.

Powell sale
1848 *Catalogue of the Very Curious and Valuable Library of the Late Rev. D. T. Powell. . . .* Sale catalogue, Messrs. Puttick and Simpson, London, July 31.

Previtali, Giovanni
1964 *La fortuna dei primitivi: Dal Vasari ai neoclassici*. Turin.
1967 *Giotto e sua bottega*. Milan.
1974 *Giotto e sua bottega*. 2d ed. Milan.

Procacci, Ugo
1951 *La Galleria dell'Accademia di Firenze*. 2d ed. Rome.
1960 Review of *Corpus of Florentine Painting* by Richard Offner, vols. 6–8 (1956–58). *Rivista d'arte* 33 (1958), pp. 121–39.
1984 "Lettera a Roberto Salvini con vecchi ricordi e con alcune notizie su Lippo di Andrea modesto pittore del primo Quattrocento." In *Scritti di storia dell'arte in onore di Roberto Salvini*, pp. 213–26. Florence.

Pudelko, Georg
1935 "The Minor Masters of the Chiostro Verde." *Art Bulletin* 17 (March), pp. 71–89.
1938–39 "The Stylistic Development of Lorenzo Monaco— I, II." *Burlington Magazine* 73 (December), pp. 237–48; 74 (February), pp. 76–81.

Quaritch, Bernard, Ltd., London
1895 *Catalogue (No. 149) of Illuminated Manuscripts*. London.
1931 *A Catalogue of Illuminated and Other Manuscripts, Together with Some Works on Palaeography*. London.

Radda, Francesco
n.d. "Continuazione delle memorie del precedente [Giuseppe Lapi]: Sia la prima che la seconda opera sono una raccolta di documenti dell'Archivio di S. Maria Novella." Seventeenth-century manuscript. Florence, Archivio del Convento di Santa Maria Novella.

Ragusa, Isa, and Rosalie B. Green, eds.
1961 *Meditations on the Life of Christ: An Illustrated Manuscript of the Fourteenth Century*. Translated by Isa Ragusa. Princeton.
1977 Reprint of 1961 edition. Princeton.

Ramboux, J. A.
1862 *Katalog der Gemälde alter italienischer Meister (1221– 1640) in der Sammlung des Conservators J. A. Ramboux*. Cologne.

Razzo, Don Silvano
1593 *Vite de' Santi e Beati Toscani*. Florence.

Réau, Louis
1955–59 *Iconographie de l'art chrétien*. 3 vols. in 6. Paris.

Reinach, S.
1928 "Sir Hercules Read's Gothic Tapestry" (letter to the editor). *Burlington Magazine* 53 (December), p. 330.

Reiset, [Marie] Frédéric de
1856–60 *Inventaire des objets d'art compris dans la donation mobilière de la couronne; Musées impériaux: Dessins*. Paris.

Repetti, Emanuele
1833–46 *Dizionario geografico fisico storico della Toscana*. 6 vols. Florence.

Rich, D. C.
1928 "A Crucifixion by Bernardo Daddi." *Bulletin of the Art Institute of Chicago* 22, pp. 74–75.

Richa, Giuseppe
1754–62 *Notizie istoriche delle chiese fiorentine divise ne' suoi quartieri*. 10 vols. Florence.

Ridderbos, Bernhard
1984 *Saint and Symbol: Images of Saint Jerome in Early Italian Art*. Groningen.

Ridolfi, Enrico
1899 "La Galleria dell'Arcispedale S. Maria Nuova in Firenze." *Le Gallerie Nazionali Italiane: Notizie e documenti* 4, pp. 162–86.
1902 "Le Gallerie di Firenze." *Le Gallerie Nazionali Italiane: Notizie e documenti* 5, pp. 9–11.
1905 *Il mio Direttorato delle Regie Gallerie Fiorentine*. Florence.

Robertson, David A.
1978 *Sir Charles Eastlake and the Victorian Art World*. Princeton.

Robinson, John C.
1876 *Descriptive Catalogue of Drawings by the Old Masters Forming the Collection of John Malcolm of Poltalloch*. London. First published 1869.

Rogers sale
1856 *Catalogue of the Collection of Works of Art, the Property of Samuel Rogers Deceased*. Sale catalogue, Christie, Manson and Woods, London, May 6.

Romagnoli, Ettore
1835 *Biografia cronologica de' bell'artisti senesi. . . .* 13 vols. Siena.
1976 Facsimile of 1835 ed. Florence.

Rome
1937 *L'antico tessuto d'arte italiano*. Exh. cat. Rome: La Libreria dello Stato.
1953 *Mostra storica nazionale della miniatura*, by Giovanni Muzzioli; introduction by Mario Salmi. Exh. cat. Rome: Palazzo di Venezia.

Rondoni, Ferdinando
1872 *Guida del R. Museo di S. Marco*. Florence.

Roover, Raymond de
1967 *San Bernardino of Siena and Sant'Antonino of Florence: Two Great Economic Thinkers of the Middle Ages*. Cambridge, Mass.

Roscoe sale
1816 *Catalogue of the Genuine and Entire Collection of*

Prints, Books of Prints Etc., the Property of William Roscoe, Esq., sold . . . by Mr. Winstanley. Sale catalogue, Liverpool, September 9.

Rothschild, C.
1939 "Recent Museum Acquisitions." *Parnassus* 11, pp. 25–27.

Rotili, Mario
1968 *La miniatura gotica in Italia.* Vol. 1. Naples.

Rotili, Mario, and A. Putaturo Murano
1970 *Introduzione alla storia della miniatura e delle arti minori in Italia.* Naples.

Rubinstein, Nicolai
1990 "Lay Patronage and Observant Reform in Fifteenth-Century Florence." In Timothy Verdon and John Henderson, eds., *Christianity and the Renaissance: Image and Religious Imagination in the Quattrocento,* pp. 63–82. Syracuse.

Ruda, Jeffrey
1993 *Fra Filippo Lippi: Life and Work, with a Complete Catalogue.* London.

Russell, Francis
1977 "Don Silvestro dei Gherarducci and an Illumination from the Collection of William Young Ottley." *Burlington Magazine* 119 (March), pp. 192–95.
1979 "A 'Signature' Unmasked." *Nelson Gallery and Atkins Museum Bulletin* 5, pp. 38–40.

Russell sale
1885 *Catalogue of Early Italian, Flemish, German and Other Pictures; the Property of the Late Rev. J. Fuller Russell.* Sale catalogue, Christie, Manson and Woods, April 18.

Saint Benedict's Rule. See Doyle 1948.

Salmi, Mario
1929 Review of *Studies in Florentine Painting: The Fourteenth Century,* by Richard Offner. *Rivista d'arte* 11, pp. 133–45.
1931 "Il Paliotto di Manresa e l' 'Opus Florentinum.'" *Bollettino d'arte* 10, pp. 385–406.
1931–32 "Un cimelio artistico della Società Colombaria." In *Atti della Società Colombaria di Firenze,* pp. 259–64.
1950 "Problemi dell'Angelico." *Commentari* 1, no. 2 (May–June), pp. 75–81; no. 3 (July–September), pp. 146–56.
1952 "La miniatura fiorentina medioevale." *Accademie e biblioteche d'Italia* 20, nos. 1–2, pp. 8–23.
1954a *Italian Miniatures.* New York.
1954b *La miniatura fiorentina gotica.* Rome.
1955 "La pittura e la miniatura gotiche." In Fondazione Treccani degli Alfieri per la Storia di Milano, *Storia di Milano,* vol. 6, *Il Ducato Visconteo e la Repubblica Ambrosiana (1392–1450),* part 7, pp. 767–855. Milan.
1956 *La miniatura italiana.* 2d ed. Milan. First published 1955.
1958 *Il Beato Angelico.* Spoleto.
1962 "Problemi figurativi dei codici danteschi del Tre- e del Quattrocento." In *Atti del I Congresso Nazionale di Studi Danteschi,* pp. 174–81. Florence.

Salvini, Roberto
1934a "In margine ad Agnolo Gaddi." *Rivista d'arte* 16, pp. 205–28.
1934b "Opere inedite di Agnolo Gaddi." *Rivista d'arte* 16, pp. 29–44.
1936 *L'Arte di Agnolo Gaddi.* Florence.

Sandberg Vavalà, Evelyn
1936 Review of *L'arte di Agnolo Gaddi,* By Roberto Salvini. *Art Bulletin* 18 (September), pp. 420–43.
1937–38 "Early Italian Paintings in the Collection of Frank Channing Smith, Jr." *Worcester Art Museum Annual* 3, pp. 23–44.

Santi, Giovanni
1985 *La vita e gesta di Federico da Montefeltro duca d'Urbino.* Edited by Luigi Michelini Tocci. 2 vols. Vatican City.

Sartain, John
1900 *Reminiscences of a Very Old Man.* New York.

Scartazzini, Giovanni A., ed.
1896 *La Divina Commedia di Dante Alighieri.* 2d ed., revised by Luigi Polacco. Milan.

Schaefer, Scott, and Peter Fusco. See Los Angeles 1987.

Scharf, Alfred
1950 *A Catalogue of Pictures and Drawings from the Collection of Sir Thomas Merton, F.R.S., at Stubbings House, Maidenhead.* London.

Schlosser, Julius von
1896 "Giusto's Fresken in Padua und die Vorläufer der Stanza della Segnatura." *Jahrbuch der Kunsthistorischen Sammlungen des allerhöchsten Kaiserhauses* 17, pp. 13–100.

Schmarsow, A.
1898 "Maîtres italiens à la Galerie d'Altenburg et dans la collection A. de Montor." *Gazette des Beaux-Arts,* ser. 3, 20, pp. 494–510.

Schottmüller, Frida
1911 *Fra Angelico da Fiesole: Des Meisters Gemälde.* Klassiker der Kunst in Gesamtausgaben, vol. 18. Stuttgart and Leipzig.

Schubring, Paul
1923 *Cassoni: Truhen und Truhenbilder der italienischen Fruhrenaissance. Ein Beitrag zu Profanmalerei im Quattrocento: Supplement.* Leipzig.

Serie
1769–75 *Serie degli uomini i più illustri nella pittura, scultura, e architettura, con i loro elogi e ritratti.* 12 vols. Florence.

Shailor, Barbara A.
1984–87 *Catalogue of Medieval and Renaissance Manuscripts in the Beinecke Rare Book and Manuscript Library, Yale University.* 2 vols. Binghamton, N.Y.

Shapley, Fern Rusk
1966 *Paintings from the Samuel H. Kress Collection.* Vol. 1, *Italian Schools, XIII–XV Century.* London.

Shearman, John
1983 *The Early Italian Pictures in the Collection of Her Majesty the Queen.* Cambridge.

Shorr, Dorothy C.
1954 *The Christ Child in Devotional Images in Italy During the XV Century.* New York.

Siena
1982 *Il gotico a Siena: Miniature, pitture, oreficerie, oggetti d'arte,* by Ferdinando Bologna et al. Exh. cat. Siena: Palazzo Pubblico.

Simone Martini
1988 *Simone Martini: Atti del convegno, Siena, 27, 28, 29 marzo 1985.* Edited by Luciano Bellosi. Florence.

Sinibaldi, Giulia, and Giulia Brunetti
1943 *Pittura italiana del Duecento e Trecento: Catalogo della Mostra Giottesca di Firenze del 1937.* Florence.

Sirén, Osvald

1905 *Don Lorenzo Monaco*. Strasbourg.

1909 "Trecento Pictures in American Collections—III." *Burlington Magazine* 14 (February), pp. 325–26.

1914 "Pictures in America of Bernardo Daddi, Taddeo Gaddi, Andrea Orcagna, and His Brothers," part 2. *Art in America* 2, pp. 325–36.

1916 *A Descriptive Catalogue of the Pictures in the Jarves Collection Belonging to Yale University*. New Haven.

1926 "Ueber einige früheitalienische Gemälde im Museum der bildenden Künste zu Budapest." *Jahrbücher des Museums der bildenden Künste zu Budapest* 4, pp. 10–29.

Sirén, Osvald, and Maurice W. Brockwell

1917 *Catalogue of a Loan Exhibition of Italian Primitives in Aid of the American War Relief*. Exh. cat. New York: F. Kleinberger Galleries.

Skaug, Erling

1983 "Punch Marks—What Are They Worth? Problems of Tuscan Workshop Interrelationships in the Mid-Fourteenth Century: The Ovile Master and Giovanni da Milano." In H. W. van Os, ed., *La pittura nel XIV e XV secolo: Il contributo dell'analisi tecnica alla storia dell'arte. Atti del XXIV Congresso Internazionale di Storia dell'Arte (Bologna, 10–18 September 1979)*, vol. 3, pp. 253–82. Bologna.

Smart, Alastair

1971 *The Assisi Problem and the Art of Giotto*. Oxford.

Sotheby's sales

1895 Sale catalogue, Sotheby and Co., London, January 30.

1960 *Catalogue of Important Western and Oriental Manuscripts and Miniatures*. Sale catalogue, Sotheby and Co., London, February 1–2.

1982 *Catalogue of Western Manuscripts and Miniatures*. Sale catalogue, Sotheby, Parke-Bernet and Co., London, December 7.

Spencer, John R.

1968 "Francesco Sforza and Desiderio da Settignano: Two New Documents." *Arte lombarda* 13, pp. 131–33.

Stinger, Charles

1977 *Humanism and the Church Fathers: Ambrogio Traversari and Christian Antiquity in the Italian Renaissance*. Albany.

1978 "Ambrogio Traversari and the 'Tempio degli Scolari' at S. Maria degli Angeli in Florence." In Sergio Bertelli and Gloria Ramakus, eds., *Essays Presented to Myron P. Gilmore*, vol. 1, pp. 271–86. Florence.

Stokstad, Marilyn

1972 "Romanesque and Gothic Art" [in the William Rockhill Nelson Gallery, Kansas City]. *Apollo* 96 (December), pp. 486–93.

Strehlke, Carl Brandon

1990 "Bernhard and Mary Berenson, Herbert P. Horne, and John G. Johnson." *Prospettiva*, no. 57–60, pp. 427–38.

1993a "Fra Angelico and Early Florentine Renaissance Painting in the John G. Johnson Collection at the Philadelphia Museum of Art." *Philadelphia Museum of Art Bulletin* 88, no. 376 (Spring), pp. 5–26.

1993b Review of *Fra Angelico at San Marco*, by William Hood. *Burlington Magazine* 135 (September), p. 635.

Suida, William E.

1929 "Lorenzo Monaco," in U. Thieme and F. Becker, *Allegemeines Lexikon der bildenden Künstler*, vol. 23, pp. 391–93. Leipzig.

1947 "Italian Miniature Paintings from the Rodolphe Kann Collection." *Art in America* 35 (January), pp. 19–33.

1954 *Paintings and Sculpture of the Samuel H. Kress Collection*. Exh. cat. Denver: Denver Art Museum.

Sutton, Denys

1979 "Robert Langton Douglas, Part 3. 15: The War Years." *Apollo* 109 (June), pp. 428–38.

Sweeny, Barbara

1966 *John G. Johnson Collection: Catalogue of Italian Paintings*. Foreword by Henri Marceau. Philadelphia.

Szabo, George

1975 *The Robert Lehman Collection, a Guide*. New York.

1983 *Masterpieces of Italian Drawing in the Robert Lehman Collection, The Metropolitan Museum of Art*. New York.

Tantini, Zanobi, comp.

1864 "Vita della Beata Paola e del Beato Salvestro." In *Leggende di alcuni Santi e Beati venerati in S. Maria degli Angeli di Firenze, testi del Buon Secolo*, part 2, pp. 85–128. Bologna. Reprinted 1968.

Taylor, Francis Henry

1944 "The Maitland F. Griggs Collection." *Metropolitan Museum of Art Bulletin*, n.s. 2, no. 5 (January), pp. 153–58.

Tenneroni, Annibale

1909 *Inizii di antiche poesie italiane religiose e morali, con prospetto dei codici che le contengono e introduzione alle Laudi spirituali*. Florence.

Tesi, Mario

1986 Manuscript entries. In *Biblioteca Medicea Laurenziana*. Contributions by Mario Tesi, Antonietta Morandini, and Guglielmo De Angelis d'Ossat. Florence.

Testi Cristiani, Maria Laura

1990 "Circostanze Avignonesi: Il crocifisso *double-face* del Cardinale Godin a Tolosa, I." *Critica d'arte*, anno 55, no. 4 (October–December), pp. 42–61.

Thompson sale

1919 *Catalogue of Twenty-Eight Illuminated Manuscripts . . . of Henry Yates Thompson*. Sale catalogue, Sotheby and Co., London, 3 June.

Thornton, Peter

1991 *The Italian Renaissance Interior, 1400–1600*. London.

Tietze, Hans

1911 *Die illuminierten Handschriften der Rossiana in Wien-Lainz. Beschreibendes Verzeichnis der illuminierten Handschriften in Oesterreich*, vol. 5. Leipzig.

Todini, Filippo

1993 *Una collezione di miniature italiane dal Duecento al Cinquecento*. Milan.

Toesca, Pietro

1930 *Monumenti e studi per la storia della miniatura italiana: La collezione di Ulrico Hoepli*. Milan.

1951 *Il Trecento*. Turin.

Torriti, Piero

1977 *La Pinacoteca Nazionale di Siena: I dipinti dal XII al XV secolo*. Genoa.

Toscani, B.
1983 "Contributo alla storia della lauda durante il Trecento." *Studi musicali* 13, pp. 3–21.

Trachsler, Beat
1977 "Die Reflexe von Giottos Malerei in den Wandbildzyklen von Brione (Verasca), Stugl/Stuls, und Campione." *Zeitschrift für schweizerische Archäologie und Kunstgeschichte* 34, pp. 157–86.

Turin
1990 *Da Biduino ad Algardi: Pittura e scultura a confronto*. Edited by Giovanni Romano. Exh. cat. Turin: Antichi Maestri Pittore.

Uffizi catalogue
1979 *Gli Uffizi: Catalogo generale*. Edited by Luciano Berti and Caterina Caneva. Florence.

Vagaggini, Sandra
1952 *La miniatura fiorentina nei secoli XIV e XV*. Florence.

Vailati Schoenburg Waldenburg, Grazia
1990 "L'Antifonario H.1.7 e le miniature di Cracovia." In *Lecceto e gli eremi agostiniani in terra di Siena*, pp. 337–53, 441–48. Siena.

Valentiner, Wilhelm R.
[1932] "Paintings in the Collection of Martin A. Ryerson." Typescript, Archives, Art Institute of Chicago.
1944 *Italian Gothic Painting*. Detroit.

Vancouver
1953 *The Italian Renaissance: A Loan Collection*, by J. A. Morris. Exh. cat. Vancouver: Vancouver Art Gallery.

Van Fossen, David
1968 "A Fourteenth-Century Embroidered Florentine Antependium." *Art Bulletin* 50, no. 2 (June), pp. 141–52.

Vasari, Giorgio
1878–85 *Le vite de' più eccellenti pittori, scultori, ed architettori*. Edited by Gaetano Milanesi. 9 vols. Florence. Based on the 2d ed. of 1568.
1906 *Le vite de' più eccellenti pittori, scultori, et architettori*. Edited by Gaetano Milanesi. 2d ed. 9 vols. Florence.
1912–14 *Lives of the Most Eminent Painters, Sculptors, and Architects*. Translated by Gaston Du C. De Vere. 10 vols. London.
1986 *Le vite de' più eccellenti architetti, pittori, et scultori italiani, da Cimabue insino a' tempi nostri*. Edited by Luciano Bellosi and Aldo Rossi. Introduction by Giovanni Previtali. Turin. Based on the first edition of 1550.

Vatican City
1933 *Guida della Pinacoteca Vaticana*. Vatican City.
1955 *Mostra delle opere di Fra Angelico: Nel quinto centenario della morte*. Exh. cat. Vatican City: Palazzo Apostolico Vaticano.

Venice
1968 *Miniature italiane della Fondazione Giorgio Cini dal medioevo al Rinascimento*. Exh. cat. Venice: Fondazione Giorgio Cini.

Venturi, Adolfo
1907 *Storia dell'arte italiana*. Vol. 5, *La pittura del Trecento*. Milan.

Venturi, Lionello
1931 *Pitture italiane in America*. Milan.
1933 *Italian Paintings in America*. 3 vols. Milan.

Vespasiano da Bisticci
1976 *Le vite di uomini illustri*. Edited by Aulo Greco. 2 vols. Florence.

Vienna
1962 *Europäische Kunst um 1400*. Exh. cat. Vienna: Kunsthistorisches Museum.

Vigorelli, G.
1970 *Giotto*. Milan.

Voelkle, William M.
1984 *Italian Manuscript Painting, 1300–1550*. Exh. cat. New York: Pierpont Morgan Library.

Voelkle, William M., and Roger S. Wieck
1992 *The Bernard H. Breslauer Collection of Manuscript Illumination*. Exh. cat. New York: Pierpont Morgan Library.

Volbach, Wolfgang Fritz
1987 *Il Trecento: Firenze e Siena*. Catalogo della Pinacoteca Vaticana, vol. 2. Vatican City.

Volpe, Carlo
1951 "Una Crocifissione di Niccolò Tegliacci." *Paragone*, no. 21, pp. 39–41.
1973 "Alcune restituzioni al Maestro dei Santi Quirico e Giulitta." *Quaderni di emblema* 2, pp. 17–21.

Volpi, Guglielmo
1934 "Lorenzo de' Medici e Vallombrosa." *Archivio storico italiano* 92, no. 2, pp. 121–32.

Voragine, Jacobus de
1941 *The Golden Legend*. Translated and adapted from Latin by Granger Ryan and Helmut Ripperger. New York, London, and Toronto.
1969 Reprint of 1941 edition. New York.

van Waadenoijen, Jeanne
1983 *Starnina e il gotico internazionale a Firenze*. Florence.

Waagen, Gustav F.
1837–39 *Kunstwerke und Künstler in England und Paris*. 3 vols. Berlin.
1838 *Works of Art and Artists in England*. Vol. 2. London.
1854–57 *Treasures of Art in Great Britain; Being an Account of the Chief Collections of Paintings, Drawings, Sculptures, Illuminated Manuscripts, Etc.* 4 vols. London.
1857a *Galleries and Cabinets of Art in Great Britain. . . .* Suppl. vol. to *Treasures of Art in Great Britain*. London.
1857b *A Walk Through the Art Treasures Exhibition at Manchester: A Companion to the Official Catalogue*. London.

Wagner, Hugo
1974 *Kunstmuseum Bern: Italienische Malerei, 13. bis 16. Jahrhundert*. Bern.

Wagner, Peter
1907 *Origin and Development of Forms of Liturgical Chant*. London.

Wagner sale
1925 *Henry Wagner Collection of Pictures and Drawings*. Sale catalogue, Christie, Manson and Woods, January 16.

Wainwright, Valerie
1988 "Late Illuminations by Lippo Vanni and His Workshop." *Pantheon* 46, pp. 26–36.

Walcher Casotti, Maria
1962 *Miniature e miniatori a Venezia nella prima metà del XIV secolo*. Trieste.

Wardwell, Anne E.
1979 "A Rare Florentine Embroidery of the Fourteenth Century." *Bulletin of the Cleveland Museum of Art* 66 (December), pp. 322–33.

Warner, George F.
1920 *Descriptive Catalogue of Illuminated Manuscripts in the Library of C. W. Dyson Perrins.* 2 vols. Oxford.

Warsaw
1990 *Opus Sacrum: Catalogue of the Exhibition from the Collection of Barbara Piasecka Johnson.* Edited by Józef Grabski. Exh. cat. Warsaw: Royal Castle.

Washington, D.C.
1941 *Preliminary Catalogue of Paintings and Sculpture: Descriptive List with Notes.* Washington, D.C.: National Gallery of Art.

Waterhouse, E. K.
1962 "Some Notes on William Young Ottley's Collection of Italian Primitives." In *Italian Studies Presented to E. R. Vincent*, pp. 272–80. Cambridge.

Watson, Paul F.
1974 "A *Desco da Parto* by Bartolomeo di Fruosino." *Art Bulletin* 56 (March), pp. 4–9.

Weimar
1848 *Goethes Kunstsammlungen*, by Ch. Schuchardt. Vol. 1. Jena.

Weissman, Ronald F. E.
1991 "Cults and Contexts: In Search of the Renaissance Confraternity." In Konrad Eisenbichler, ed., *Crossing the Boundaries: Christian Piety and the Arts in Italian Medieval and Renaissance Confraternities*, pp. 201–20. Kalamazoo, Mich.

Welch, Evelyn Samuels
1988 "Sforza Portraiture and SS. Annunziata in Florence." In Peter Denley and Caroline Elam, eds., *Florence and Italy: Renaissance Studies in Honour of Nicolai Rubinstein*, pp. 235–40. London.

Wescher, Paul R.
1929 "Florentinische Buchminiaturen im Berliner Kupferstichkabinett." *Jahrbuch der preuszischen Kunstsammlungen* 50, pp. 96–104.
1931 *Beschreibendes Verzeichnis der Miniaturen, Handschriften, und Einzelblätter des Kupferstichkabinetts der Staatlichen Museen, Berlin.* Leipzig.

Wieck, Roger S.
1988 *Time Sanctified: The Book of Hours in Medieval Art and Life.* With essays by Lawrence R. Poos, Virginia Reinburg, and John Plummer. Exh. cat. Baltimore: Walters Art Gallery.

Wilde, J. G.
1930 "Giotto-Studien." *Wiener Jahrbuch für Kunstgeschichte* 7, pp. 45–94.

Wilson, Blake
1992 *Music and Merchants: The Laudesi Companies of Republican Florence.* Oxford.

Wingenroth, Max
1898 "Beiträge zur Angelico-Forschung," parts 1, 2. *Repertorium für Kunstwissenschaft* 21, no. 4, pp. 335–45; no. 6, pp. 427–38.

Wixom, William D.
1963 *See* Cleveland 1963.
1979 "Eleven Additions to the Medieval Collection." *Bulletin of the Cleveland Museum of Art* 66 (March–April), pp. 87–151.

Wohl, Hellmut
1980 *The Paintings of Domenico Veneziano, ca. 1410–1461: A Study in Florentine Art of the Early Renaissance.* Oxford.

Wormald, Francis, and Phyllis M. Giles
1982 *A Descriptive Catalogue of the Additional Illuminated Manuscripts in the Fitzwilliam Museum Acquired Between 1895 and 1979 (Excluding the McClean Collection).* 2 vols. Cambridge.

Zeri, Federico
1963 "La mostra 'Arte in Valdelsa' a Certaldo." *Bollettino d'arte* 48, pp. 245–58.
1964–65 "Investigations into the Early Period of Lorenzo Monaco—I, II." *Burlington Magazine* 106 (December), pp. 554–58; 107 (January), pp. 3–11.
1965 "Italian Primitives at Messrs Wildenstein." *Burlington Magazine* 107 (May), pp. 252–56.
1968 "Sul catalogo dei dipinti toscani del secolo XIV nelle Gallerie di Firenze." *Gazette des Beaux-Arts*, ser. 6, 71, pp. 65–78.
1974 "Major and Minor Italian Artists at Dublin." *Apollo* 99, no. 144 (February), pp. 88–103.
1987 *See* Pittura 1987.
1988 *La collezione Federico Mason Perkins.* Turin.

Zeri, Federico, and Elizabeth Gardner
1971 *Italian Paintings. A Catalogue of the Collection of The Metropolitan Museum of Art: Florentine School.* New York.
1980 *Italian Paintings. A Catalogue of the Collection of The Metropolitan Museum of Art: Sienese and Central Italian Schools.* New York.

Zeri, Federico, and Francesco Rossi
1986 *La raccolta Morelli nell'Accademia Carrara.* Milan.

Ziino, Agostino
1978 "Laudi e miniature fiorentine del primo Trecento." *Studi musicali* 7, pp. 39–83.
1988 "Il canto delle laudi durante il Trecento. Tre città a confronto: Firenze, Fabriano, e Gubbio." In *La musica nel tempo di Dante (Ravenna, 12–14 settembre 1986)*, pp. 113–29. Milan.
1989 "La laude musicale del Due-Trecento: Nuove fonti scritte e tradizione orale." In *Miscellanea di studi in onore di Aurelio Roncaglia a cinquant'anni dalla sua laurea*, pp. 1465–1502. Modena.

Zucchini, Guido
1943 "S. Michele in Bosco a Bologna (documenti)." *L'archiginnasio* 38, pp. 18–70.

Index

Page numbers for figures are indicated in italics.

Photograph Credits